The Manual of Photography

Ninth Edition

The Manual of Photography
Photographic and digital imaging

Ninth Edition

Ralph E. Jacobson

MSc, PhD, CChem, FRSC, ASIS Hon., FRPS, FBIPP

Sidney F. Ray

BSc, MSc, ASIS, FBIPP, FMPA, FRPS

Geoffrey G. Attridge

BSc, PhD, ASIS, FRPS

Norman R. Axford

BSc

Focal Press

OXFORD AUCKLAND BOSTON JOHANNESBURG MELBOURNE NEW DELHI

Focal Press
An imprint of Butterworth-Heinemann
Linacre House, Jordan Hill, Oxford OX2 8DP
225 Wildwood Avenue, Woburn, MA 01801-2041
A division of Reed Educational and Professional Publishing Ltd

 A member of the Reed Elsevier plc group

The Ilford Manual of Photography
First published 1890
Fifth edition 1958
Reprinted eight times

The Manual of Photography
Sixth edition 1970
Reprinted 1971, 1972, 1973, 1975
Seventh edition 1978
Reprinted 1978, 1981, 1983, 1987
Eighth edition 1988
Reprinted 1990, 1991, 1993, 1995 (twice), 1997, 1998
Ninth edition, 2000

British Library Cataloguing in Publication Data
The manual of photography: photographic and
 digital imaging – 9th ed.
 1. Photography – Handbooks, manuals, etc.
 I. Jacobson, Ralph E. (Ralph Eric), 1941–
 771

ISBN 0 240 51574 9

Library of Congress Cataloguing in Publication Data
The manual of photography: photographic and digital imaging. – 9th ed./Ralph E.
Jacobson . . . [et al.].
 p.cm.
 Originally published in 1890 under the title: The Ilford manual of photography.
 Includes bibliographical references and index
 ISBN 0 240 51574 9 (alk. paper)
 1. Photography. I. Jacobson, R. E.

 TR145 .M315 2000
 771–dc21 00-042984

Composition by Genesis Typesetting, Rochester
Printed and bound in Great Britain

Contents

Preface to the first edition of *The Ilford Manual of Photography* (1890) ix

Preface to the ninth edition xi

1 Imaging systems 1

Ralph E. Jacobson

The production of images 1
Photographic and digital imaging 2
General characteristics of reproduction
 systems 5
Imaging chains 6
The reproduction of tone and colour 6
Image quality expectations 7

2 Fundamentals of light and vision 9

Ralph E. Jacobson

Light waves and particles 9
Optics 10
The electromagnetic spectrum 10
The eye and vision 11

3 Photographic light sources 16

Sidney F. Ray

Characteristics of light sources 16
Light output 21
Daylight 25
Tungsten-filament lamps 25
Tungsten–halogen lamps 26
Fluorescent lamps 27
Metal-halide lamps 27
Pulsed xenon lamps 27
Expendable flashbulbs 28
Electronic flash 29
Other sources 38

4 The geometry of image formation 39

Sidney F. Ray

Interaction of light with matter 39
Image formation 41
The simple lens 42
Image formation by a compound lens 43
Graphical construction of images 45

The lens conjugate equation 45
Field angle of view 48
Covering power of a lens 49
Geometric distortion 49
Depth of field 50
Depth of field equations 53
Depth of focus 56
Perspective 57

5 The photometry of image formation 61

Sidney F. Ray

Stops and pupils 61
Aperture 62
Mechanical vignetting 62
Image illumination 63
Image illuminance with wide-angle
 lenses 66
Exposure compensation for close-up
 photography 67
Light losses and lens transmission 68
Flare and its effects 68
T-numbers 69
Anti-reflection coatings 69

6 Optical aberrations and lens performance 72

Sidney F. Ray

Introduction 72
Axial chromatic aberration 72
Lateral chromatic aberration 74
Spherical aberration 75
Coma 76
Curvature of field 77
Astigmatism 77
Curvilinear distortion 78
Diffraction 79
Resolution and resolving power 80
Modulation transfer function 81

7 Camera lenses 83

Sidney F. Ray

Simple lenses 83
Compound lenses 83

Development of the photographic lens 85
Modern camera lenses 88
Wide-angle lenses 91
Long-focus lenses 93
Zoom and varifocal lenses 95
Macro lenses 98
Teleconverters 99
Optical attachments 100
Special effects 102

8 **Types of camera** **104**

Sidney F. Ray

Survey of development 104
Camera types 107
Special purpose cameras 113
Automatic cameras 115
Digital cameras 120
Architecture of the digital camera 125

9 **Camera features** **131**

Sidney F. Ray

Shutter systems 131
The iris diaphragm 136
Viewfinder systems 138
Flash synchronization 143
Focusing systems 144
Autofocus systems 151
Exposure metering systems 154
Battery power 160
Data imprinting 161

10 **Camera movements** **163**

Sidney F. Ray

Introduction 163
Translational movements 165
Rotational movements 165
Lens covering power 166
Control of image sharpness 168
Limits to lens tilt 170
Control of image shape 171
Perspective control lenses 173
Shift cameras 174

11 **Optical filters** **176**

Sidney F. Ray

Optical filters 176
Filter sizes 178
Filters and focusing 178
Colour filters for black-and-white
 photography 179
Colour filters for colour photography 182
Special filters 183
Polarizing filters 186
Filters for darkroom use 189

12 **Sensitive materials and image
 sensors** **191**

Ralph E. Jacobson

Latent image formation in silver
 halides 191
Image formation by charge-coupled
 devices 193
Production of light-sensitive materials
 and sensors 195
Sizes and formats of photographic and
 electronic sensors and media 200

13 **Spectral sensitivity of
 photographic materials** **205**

Geoffrey G. Attridge

Response of photographic materials to
 short-wave radiation 205
Response of photographic materials to
 visible radiation 206
Spectral sensitization 207
Orthochromatic materials 208
Panchromatic materials 208
Extended sensitivity materials 208
Infrared materials 209
Other uses of dye sensitization 209
Determination of the colour sensitivity
 of an unknown material 210
Wedge spectrograms 210
Spectral sensitivity of digital cameras 211

14 **Principles of colour photography** **213**

Geoffrey G. Attridge

Colour matching 213
The first colour photograph 214
Additive colour photography 214
Subtractive colour photography 214
Additive processes 215
Subtractive processes 217
Integral tripacks 217

15 **Sensitometry** **218**

Geoffrey G. Attridge

The subject 218
Exposure 218
Density 219
Effect of light scatter in a negative 220
Callier coefficient 220
Density in practice 221
The characteristic (H and D) curve 222
Main regions of the negative
 characteristic curve 223
Variation of the characteristic curve
 with the material 225
Variation of the characteristic curve
 with development 225

Gamma-time curve 226
Variation of gamma with wavelength 227
Placing of the subject on the
 characteristic curve 227
Average gradient and \bar{G} 228
Contrast index 228
Effect of variation in development on
 the negative 228
Effect of variation in exposure on the
 negative 229
Exposure latitude 230
The response curve of a photographic
 paper 231
Maximum black 231
Exposure range of a paper 232
Variation of the print curve with the
 type of emulsion 232
Variation of the print curve with
 development 233
Requirements in a print 234
Paper contrast 234
The problem of the subject of high
 contrast 235
Tone reproduction 236
Reciprocity law failure 238
Sensitometric practice 239
Sensitometers 240
Densitometers 241
Elementary sensitometry 244
Sensitometry of a digital camera 245

16 The reproduction of colour 247

Geoffrey G. Attridge

Colours of the rainbow 247
Colours of natural objects 247
Effect of the light source on the
 appearance of colours 248
Response of the eye to colours 248
Primary and complementary colours 249
Complementary pairs of colours 250
Low light levels 250
Black-and-white processes 250
Colour processes 251
Formation of subtractive image dyes 254
Colour sensitometry 254
Imperfections of colour processes 258
Correction of deficiencies of the
 subtractive system 259
Masking of colour materials 260
Problems of duplication 261
The chemistry of colour image
 formation 263
Chromogenic processes 263
Silver-dye-bleach process 268
Instant colour processes 269
Alternative method for instant
 photography 271

17 Photographic processing 273

Ralph E. Jacobson

Developers and development 273
Developing agents 273
Preservatives 276
Alkalis 276
Restrainers (anti-foggants) 277
Miscellaneous additions to developers 277
Superadditivity (synergesis) 278
Monochrome developer formulae in
 general use 279
Changes in a developer with use 282
Replenishment 283
Preparing developers 284
Techniques of development 285
Obtaining the required degree of
 development 289
Quality control 292
Processing following development 293
Rinse and stop baths 293
Fixers 294
Silver recovery 296
Bleaching of silver images 298
Washing 299
Tests for permanence 300
Drying 301

**18 Speed of materials, sensors and
 systems 302**

Ralph E. Jacobson

Speed of photographic media 302
Methods of expressing speed 302
Speed systems and standards 305
ISO speed ratings for colour materials 306
Speed of digital systems 307
Speed ratings in practice 308

19 Camera exposure determination 310

Sidney F. Ray

Camera exposure 310
Optimum exposure criteria 311
Exposure latitude 311
Subject luminance ratio 312
Development variations 313
Exposure determination 313
Practical exposure tests 315
Light measurement 315
Exposure meter calibration 316
Exposure values 318
Incident light measurements 318
Exposure meters in practice 320
Photometry units 323
Spot meters 324
In-camera metering systems 324
Electronic flash exposure metering 329
Automatic electronic flash 333

20 Hard copy output media **336**

Ralph E. Jacobson

Hard copy output 336
Photographic papers 336
Type of silver halide emulsion 336
Paper contrast 337
Paper surface 338
Paper base 339
Colour photographic papers 339
Processing photographic paper 340
Pictrography and Pictrostat 344
Dry Silver materials 345
Cylithographic materials/Cycolor 346
Thermal imaging materials 346
Materials for ink-jet printing 347

21 Production of hard copy **348**

Ralph E. Jacobson

Photographic printing and enlarging 349
Types of enlargers 349
Light sources for enlarging and
 printing 353
Lenses for enlargers 354
Ancillary equipment 355
Exposure determination 355
Conventional image manipulation 358
Colour printing 359
Colour enlarger design 362
Types of colour enlarger 363
Methods of evaluating colour negatives
 for printing 365
Digital output 367
Evaluating the results 370

22 Life expectancy of imaging media **372**

Ralph E. Jacobson

Life expectancy of photographic media 372
Processing conditions 373
Storage conditions 375
Atmospheric gases 376
Toning 377
Light fading 378
Life expectancy of digital media 379

23 Colour matters **383**

Geoffrey G. Attridge

Specification by sample 383
The physical specification of colour 384
Specification of colour by synthesis 384
Colour gamuts 389
Summing up 392

24 Theory of image formation **393**

Norman R. Axford

Sinusoidal waves 394
Images and sine waves 395
Imaging sinusoidal patterns 397
Fourier theory of image formation 398
Measuring modulation transfer
 functions (MTF) 406
Discrete transforms and sampling 408
The MTF for a CCD imaging array 411
Image quality and MTF 411

25 Images and information **413**

Norman R. Axford

Image noise 413
Photographic noise 413
Quantifying image noise 417
Practical considerations for the
 autocorrelation function and the
 noise power spectrum 419
Signal-to-noise ratio 420
Detective quantum efficiency (DQE) 422
Information theory 426

**26 Digital image processing and
 manipulation** **428**

Norman R. Axford

Linear spatial filtering (convolution) 428
Frequency domain filtering 429
Non-linear filtering 433
Statistical operations (point, grey-level
 operations) 434
Image restoration 438
Edge detection and segmentation 442
Image data compression 443

Index **447**

Preface to the first edition of *The Ilford Manual of Photography* (1890)

This handbook has been compiled at the request of the Ilford Company, in the hope that it may be of service to the large numbers of Photographers who apply the art to pictorial, technical, or scientific purposes, and are content to leave to others the preparation of the sensitive materials that they use. It makes no pretence of being a complete treatise on the principles of the art, and it is not written for those for whom the experimental side of Photography has the most attraction. Its aim will be reached if it serves as a trustworthy guide in the actual practice of the art. At the same time, an endeavour has been made to state, in a simple way, sufficient of the principles to enable the reader to work intelligently, and to overcome most of the difficulties that he is likely to meet with. No claim is made for originality in respect of any of the facts, and it has therefore not seemed necessary to state the sources from which even the newer items of information have been collected.

C. H. Bothamley

1890

Preface to the ninth edition

This textbook on photography and imaging has probably the longest publishing history of any in the field, in any language. The first edition was written by C. H. Bothamley and originally published in 1890 by Ilford Limited of London as *The Ilford Manual of Photography*. This version went through many printings and revisions for some forty years, until an edited revision by George E. Brown was produced in the mid-1930s and began the tradition of using multiple specialist authors. The official second edition was published in 1942 and edited by James Mitchell, also of Ilford Limited. Third and fourth editions followed quickly in 1944 and 1949 respectively.

Under the editorship of Alan Horder the fifth edition was published in 1958, and still retained the title of *The Ilford Manual of Photography*. Alan Horder also edited the sixth edition of 1971, when the title was changed to *The Manual of Photography* and the publishers changed from Ilford Limited to Focal Press. This was also the first occasion on which two of the present authors first made contributions. The seventh edition of 1971, under the editorship of Professor Ralph E. Jacobson, was fully revised by the present four authors, as was the eighth edition of 1988.

This process has continued and here we have the ninth edition of 2000, surely one of the few books with a presence in three centuries. Comparison of this new edition with the first of 1890 shows the progress made in the intervening 110 years. The first edition contained a surprising amount of physics and chemistry with the necessary accompanying mathematics. These dealt with the optics of image formation and image properties and the processing and printing of a range of photographic materials. Emphasis was on practical techniques and a complete catalogue of Ilford products was appended for reference.

This new edition takes the opportunity to document and explain progress in imaging in the past decade, most notably concerning digital imaging, but also in the topics of each chapter. A balance has been maintained between traditional chemical processes and current digital systems and between explanations of theoretical principles in relation to practice. The titles of many chapters have been changed to reflect the change in emphasis and content, which is also reflected in the new title. Many of the detailed explanations of chemical practices associated with earlier generations of photographic materials have been substantially reduced to make way for explanations concerning the principles and practices associated with the new digital media. This edition, like the first edition, contains information on the physics, mathematics and chemistry of modern systems with the balance shifting in favour of the physics and mathematics associated with current practice.

The process of total automation of picture making is now virtually complete, with most cameras having means of automatic focusing, exposure determination, flash and film advance. The simplicity of use disguises the complexity of the underlying mechanisms, mostly based on microchip technology. There have been significant advances in the properties and use of electronic flash as a light source, with complex methods of exposure determination and use of flash in autofocusing. The introduction of new optical materials and progress in optical production technology as well as digital computers for optical calculations have produced efficient new lens designs, particularly for zoom lenses, as well as the micro-optics necessary for autofocus modules.

Camera design has progressed, with new film formats introduced and others discontinued. Although capable of a surprising versatility of use, special purpose cameras still find applications. Digital cameras are not constrained by traditional camera design and many innovative types have been introduced, with the technology still to settle down to a few preferred types. Large format cameras use most of the new technologies with the exception to date of autofocusing. The use of an ever increasing range of optical filters for cameras encourages experimentation at the cameras stage with their digital counterparts becoming increasingly popular.

Both input and output of image data have been substantially revised to reflect the changes in technology and the wide range of choices in media and systems for producing pictures. More emphasis is now placed on electronic and hybrid media in the new digital age. Like digital cameras, the production of hard copy is settling down but there are a number of different solutions to the production of photographic or 'near photographic' quality prints from digital systems in the desktop environment, which are included in this edition.

Contemporary interest in black-and-white printing and its control suggested a sensitometric description

of exposure effects and this is included, for the first time, in this edition. Other novel features include the spectral sensitivities of extended sensitivity monochrome films, monochrome and colour charge coupled device (CCD) sensors used in digital cameras, the inclusion of the mechanisms of CCDs and how their sensitivities are measured. Current concerns with the life expectancy of both traditional and digital media are discussed in this edition with explanations of the principles on which predictions are based.

A new chapter, 'Colour Matters', is devoted to an understanding of the measurement and specification of colour with applications to colour reproduction. This is designed to equip the reader to understand and take advantage of the colour information provided by digital imaging and image manipulation software.

Current optical, photographic and digital imaging systems all share certain common principles from communications and information theory. At the same time, digital systems introduce special problems as well as advantages that the critical user will need to understand. These aspects are considered in this edition. A new chapter, 'Image Processing and Manipulation', presents an overview of the field of digital image processing. Particular attention is paid to some of the more important objective methods of

pixel manipulation that will be found in most of the commonly available image processing packages. The chapter contains over 30 images illustrating the methods described.

The nature of the material covered in a number of chapters means that some important mathematical expressions are included. However, it is not necessary to understand their manipulation in order to understand the ideas of these chapters. In most cases the mathematics serves as an illustration of, and a link to, the more thorough treatments found elsewhere.

The aims of the ninth edition are the same as those of previous editions which are:

- to provide accessible and authoritative information on most technical aspect of imaging;
- to be of interest and value to students, amateurs, professionals, technicians, computer users and indeed anyone who uses photographic and digital systems with a need for explanations of the principles involved and their practical applications.

Professor Ralph E. Jacobson, Sidney F. Ray,
Professor Geoffrey G. Attridge, Norman R. Axford

July 2000

1 Imaging systems

The production of images

Currently, it has been estimated that around 70 billion photographs are produced annually worldwide and images are being produced at a rate of 2000 per second. Imaging is in a very rapid period of change and transformation. In the early 1980s there existed a single prototype electronic still camera and the desktop personal computer had just been invented but was yet to become popular and in widespread use. Currently, personal computers are almost everywhere, there are more than 125 digital cameras commercially available and new models are being released at ever-decreasing intervals in time. At the opening of the twenty-first century it is suggested that there are 120 million multimedia personal computers and approximately 30 per cent of users envisage a need for image manipulation. Digital photography or imaging is now an extremely significant mode involved in the production of all types of images. However, the production of photographs by the conventional chemical photographic system is still an efficient and cost-effective way of producing images and is carried out by exposing a film, followed by a further exposure to produce a print on paper. This procedure is carried out because the lighter the subject matter the darker the photographic image. The film record therefore has the tones of the subject in reverse: black where the original is light, clear where the original is dark, with the intermediate tones similarly reversed. The original film is therefore referred to as a negative, while a print, in which by a further use of the photographic process the tones of the original are re-reversed, is termed a positive. Popular terminology designates colour negative films as colour print films. Any photographic process by which a negative is made first and employed for the subsequent preparation of prints is referred to as a negative–positive process.

It is possible to obtain positive photographs directly on the material exposed in the camera. The first widely used photographic process, due to Daguerre, did produce positives directly. The first negative–positive process, due to Talbot, although announced at about the same time as that of Daguerre, gained ground rather more slowly, though today negative–positive processes are used for the production of the majority of photographs. Although processes giving positive photographs in a single operation appear attractive, in practice negative–positive

processes are useful because two stages are required. In the first place, the negative provides a master which can be filed for safe keeping. Secondly, it is easier to make copies from a transparent master than from a positive photograph, which is usually required to be on an opaque paper base. Also, the printing stage of a two-stage process gives an additional valuable opportunity for control of the finished picture. However, in professional work, especially colour, it has been the practice to produce transparencies, or direct positives, from which printing plates can be made for subsequent photomechanical printing. However, the advent of modern digital technology makes the application of the terms negative and positive less significant due to the ease with which images can be reversed (interchanged from negative to positive) and the ability to scan and digitize original photographic slides or prints.

Negatives are usually made on a transparent base and positives on paper, though there are important exceptions to this. For example, positives are sometimes made on film for projection purposes, as in the case of motion-picture films. Such positives are termed slides, or transparencies. So-called colour slide films (e.g. Kodachrome, Fujichrome and other films with names ending in '-chrome') are intended to produce colour positive transparencies for projection as slides, for direct viewing for scanning into the digital environment, or for originals for photomechanical printing which is now carried out by digital methods. The action of light in producing an image on negative materials and positive materials is essentially the same in the two cases. The traditional negative–positive photographic chemical process has evolved over a period of more than 100 years to reach its current stage of perfection and widespread application.

The move from conventional photochemical imaging processes to digital systems is rapidly gaining momentum in all areas of application, from medical imaging where it now dominates, to professional and amateur photography in which hybrid (combination of conventional photographic with digital devices, see also Imaging Chains below) approaches are being used. Image processing and manipulation facilities are now available at very modest cost and are being used in most areas of reproduction of images from the simple mini-labs for printing snapshots to pictures in newspapers and magazines. Photography has now

become a subset of a much broader area of imaging and multimedia which embraces image capture (photographic and electronic), storage, manipulation, image databases and output by a variety of modalities. Today there are a bewildering array of devices and processes for the production of images. Hard copy output (prints) is now provided by a number of technologies which are being provided, commercially more and more inexpensively. These include, conventional photographic printing, laser printing, ink-jet printing and thermal dye diffusion or sublimation printing which now supplement and are beginning to replace the more traditional photographic negative–positive chemical systems. Expectations have changed and the modern image creator has a need for instantaneous access to results and the ability to modify image quality and content and to transmit images to areas remote from where they are produced. These needs are met by digital imaging.

Photographic and digital imaging

The photographic process involves the use of light sensitive silver compounds called silver halides as the means of recording images. It has been in use for more than a hundred years and, despite the introduction of electronic systems for image recording, is likely to remain an important means of imaging,

although in many areas it is being replaced by digital methods for the reasons given earlier. A simple schematic diagram which compares image formation by silver compounds and by a charge coupled device (CCD) electronic sensor is shown in Figure 1.1.

When sufficient light is absorbed by the silver halide crystals which are the light-sensitive components, suspended in gelatin, present in photographic layers, an invisible latent image is formed. This image is made visible by a chemical amplification process termed development which converts the exposed silver halide crystal to metallic silver whilst leaving the unexposed crystals virtually unaffected. The process is completed by a fixing step which dissolves the unaffected and undeveloped crystals and removes them from the layer. The basic steps of conventional photography are given in Table 1.1 and further details can be found in later chapters.

From Table 1.1 it is immediately apparent that the single most obvious limitation of the conventional photographic process is the need for wet chemicals and solutions. This limits access time, although there are a number of ways in which access time may be substantially shortened.

Despite the limitation mentioned above, silver halide conventional photographic systems have a number of advantages, many of which are also shared with digital systems and are summarized below. Currently their most significant advantages when

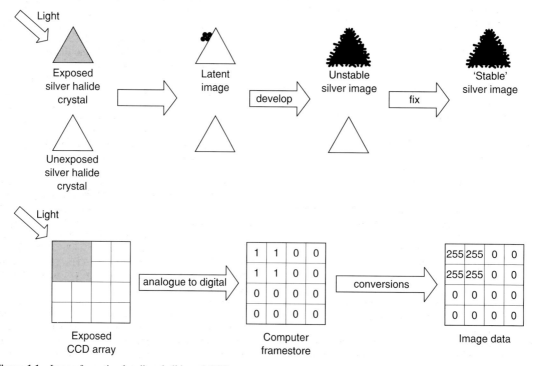

Figure 1.1 Image formation by silver halide and CCD sensors

Table 1.1 The photographic process

Event	Outcome
Exposure	Latent image formed
Processing:	
Development	Visible image formed
Rinsing	Development stopped
Fixing	Unused sensitive material converted into soluble chemicals which dissolve in fixer
Washing	Remaining soluble chemicals removed
Drying	Removal of water

compared with electronic systems are that they are mature processes which yield very high quality results at a modest cost, are universally available and conform to well established standards.

(1) Sensitivity: Silver materials are available with very high sensitivity, and are able to record images in low levels of illumination. For example, a modern high-speed colour-negative film can record images by candlelight with an exposure of 1/30 s at f/2.8.

(2) Spectral sensitivity: The natural sensitivity of silver halides extends from cosmic radiation to the blue region of the spectrum. It can be extended to cover the entire visible spectrum and into the infrared region. Silver halides can also be selectively sensitized to specific regions of the visible spectrum, thus making the reproduction of colour possible.

(3) Resolution: Silver materials are able to resolve very fine detail. For example, special materials are available which can resolve in excess of 1000 cycles/mm and most general purpose films can resolve detail of around 100–200 cycles/mm.

(4) Continuous tone: Silver halide materials are able to record tones or intermediate grey levels continuously between black and white.

(5) Versatility: They may be manufactured and/or processed in a variety of different ways to cover most imaging tasks, such as holography to electron beam recording and computer hard copy output.

(6) Information capacity: This is very high. For example, photographic materials have maximum capacities from around 10^6–10^8 bits/cm^2.

(7) Archival aspects: If correctly processed and stored, black-and-white images are of archival permanence.

(8) Shelf-life: For most materials this is of the order of several years before exposure, and with appropriate storage can be as long as 10 years after exposure, though it is recommended that exposed materials should be processed as soon after exposure as practicable.

(9) Silver re-use: Silver is recoverable from materials and certain processing solutions and is recycled.

(10) As a sensor material they can be manufactured in very large areas at a very high rate.

The main disadvantages of the silver halide system may be summarized as follows:

(1) Complex manufacturing process which relies heavily on a number of chemical components of very high purity. This limitation also applies to the manufacture of electronic sensors and components.

(2) Silver halides have a natural sensitivity to ionizing radiation which, although an advantage if there is need for recording in this region, is also a disadvantage which could cause the materials to become fogged (exposed to non-imaging radiation) and reduce their usefulness and shelf-life.

(3) There is a reciprocal relationship between sensitivity and resolving power (the ability to record fine detail). That is high speed or very sensitive materials have poorer resolving power than low speed materials which are inherently of higher resolving power.

(4) The efficiency of silver halide materials is far less than that of electronic systems. For example, the most efficient silver-based materials have a maximum Detective Quantum Efficiency (DQE) of about 4% (see Chapter 25) whilst electronic sensors may have values of around 80%.

(5) Can only be used once for recording images.

(6) Wet processing solutions require disposal or recycling which could create environmental issues and this form of processing leads to relatively long access times. However, it should not be assumed that electronic systems are free from environmental problems both in their manufacture, their use and eventual disposal.

Electronic means of recording also have a number of advantages but are becoming increasingly important because of their rapidity of access, ease of transmission and manipulation of images in a digital form. At present they still suffer from a relatively high cost and limitations in the quality of results for the production of images in the form of hard copy (prints) but there are many signs that these limitations are being overcome.

Figure 1.1 gives a very simple diagram of an electronic recording process which shows some similarity to the conventional silver-based system. The solid state light-sensitive device, a CCD, comprises a regular array of sensors which convert absorbed light energy to electronic energy which is

Table 1.2 Silver halide and CCD sensors

Property	Silver halide	CCD array
Detector	AgBr/Cl/I	Si
Detector size (μm^2)	~0.5–10	~81–144
Pixel size (μm^2)	~5–50	~81–144
Detector distribution	random	regular
Quantum efficiency	~2%	10–50%
Reproduction	binary	multilevel
Sensitivity	ISO 10–3200	<200
Storage	detector	external
Array size (mm^2)	24 × 36	<24 × 36
Capacity (pixels)	1.7×10^7–1.7×10^8	6×10^6
Capacity (pixels/mm^2)	2×10^4–2×10^5	7×10^4

appropriate software the digitized image is manipulated and transferred to a suitable output system, which can be a cathode ray tube display or some form of hard copy output (print) to render the stored image visible. Table 1.2 makes some basic comparisons between the silver halide and CCD sensors. The differences between a photographic and a digital image are shown in Figure 1.2.

Recording of digital images places high demands on storage, transfer and manipulation of large amounts of data. For example, if we consider the array of 3072 × 2048 pixels for the monochrome image represented in Figure 1.2, for 256 grey levels (an 8 bit system, 2^8) this will require a file of 6 Mb, determined as follows. The array size (2048 × 3072) = 6 291 456 pixels2. For 256 levels (8 bits per pixel) this becomes 50 331 648 bits. Since 1 byte = 8 bits the number of bytes is 6 291 456 bytes. To convert bytes to megabytes divide by (1024 × 1024), hence the file size becomes 6 Mb. For a colour image the file size becomes 18 Mb because there are three channels (red, green and blue).

initially in a continuous or analogue form. This is then converted to a digital or stepped form and stored in the computer, or a solid state storage medium in the image capture device. Then via

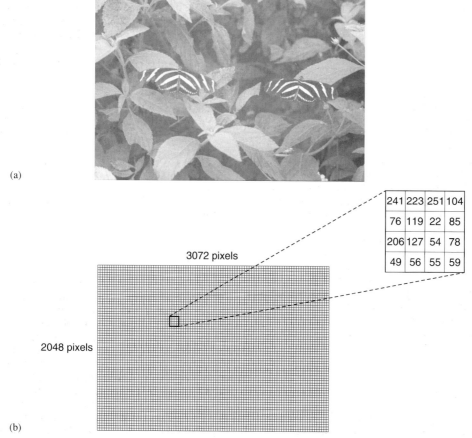

Figure 1.2 Analogue and digital reproduction. (a) Continuous tone (analogue) image – continuously varying grey levels; (b) high resolution monochrome digital image – a matrix of discrete grey levels (pixel values)

General characteristics of reproduction systems

For success in the production of image consideration must be given to each of the following four factors.

Composition

Composition means the choice and arrangement of the subject matter within the confines of the finished picture. The camera can only record what is imaged on the sensor, and the photographer must control this, for example, by choice of viewpoint: its angle and distance from the subject; by controlling the placing of the subject within the picture space; or by suitable arrangement of the elements of the picture. Today with digital imaging and appropriate software it is now possible for the photographer to change the composition after having taken the original picture. This requires the same creative skills as carrying out this process at the image capture stage and transfers this aspect to a postproduction workroom situation.

Illumination

Images originate with light travelling from the subject towards the camera lens. Although some objects, e.g. firework displays, are self-luminous, most objects are viewed and captured by diffusely-reflected light. The appearance of an object, both visually and photographically, thus depends not only on the object itself but also upon the light that illuminates it. The main sources of illumination in the day are sun, clear sky and clouds. Control of lighting of subject matter in daylight consists largely in selecting (or waiting for) the time of day or season of the year when natural lighting produces the effect the photographer desires. Sources of artificial light share in varying degree the advantage that, unlike daylight, they can be controlled at will. With artificial light, therefore, a wide variety of effects is possible. However, it is good practice with most subjects to aim at producing a lighting effect similar to natural lighting on a sunny day: to use a main light in the role of the sun, i.e. casting shadows, and subsidiary lighting to lighten these shadows as required.

Image formation

To produce an image, light from the subject must be collected by a light-sensor, and must illuminate it as an optical image which is a two-dimensional replica of the subject. The faithfulness of the resemblance will depend upon the optical system employed; in particular upon the lens used and the relation of the lens to the sensitive surface.

Image perpetuation

Finally, the image-forming light must produce changes in the imaging system so that an impression of the image is retained; this impression must be rendered permanent. This fourth factor is the one that originally was generally recognized as the defining characteristic of photography and now applies to digital recording, although there is much discussion as to what 'permanent' actually implies (see Chapter 22).

Each of the above factors plays an important role in the production of the finished picture, and the photographer, or image maker, should be familiar with the part played by each, and the rules governing it. The first factor, composition, is much less amenable to rules than the others, and it is primarily in the control of this – coupled with the second factor, illumination – that the personality of the individual photographer has greatest room for expression. For this reason, the most successful photographer is frequently one whose mastery of camera technique is such that his or her whole attention can be given to the subject.

Among the features characteristic of any imaging system are the following:

(1) A real subject is necessary.
(2) Perspective is governed by optical laws.
(3) Colour may be recorded in colour, or in black-and-white, according to the type of sensor being used.
(4) Gradation of tone is usually very fully recorded – a minimum of 256 levels (8 bit) for digital systems.
(5) Detail is recorded quickly and with comparative ease.

Perspective

The term perspective is applied to the apparent relationship between the position and size of objects when seen from a specific viewpoint, in a scene examined visually. The same principle applies when a scene is captured by an imaging system, the only difference being that the camera lens takes the place of the eye. Control of perspective in photography is therefore achieved by control of viewpoint.

Painters or digital photographers are not limited in this way; objects can be placed anywhere in the picture, and their relative sizes adjusted at will. If, for example, in depicting a building, they are forced by the presence of other buildings to work close up to it, they can nevertheless produce a picture which, as far

ANALOGUE DIGITAL

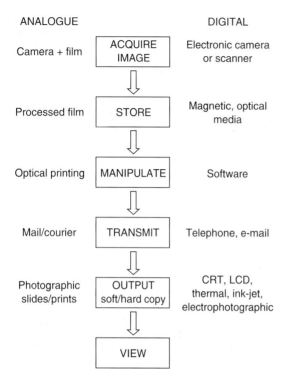

Figure 1.3 Imaging chains

Figure 1.4 Spatial dithering

print them with an ink-jet printer. A number of mini-lab systems also use scanning to transfer photographically recorded images in to the digital domain and subsequent manipulation followed by hard copy output on to photographic paper which combines the best aspects of both systems.

The reproduction of tone and colour

In photographic reproduction, the effects of light and shade are obtained by variation of the tone of the print. Thus, a highlight of uniform brightness in the subject appears as a uniform area of very light grey in the print. A shadow of uniform depth appears as a uniform area of dark grey, or black, in the print. Between these extremes all shades of grey may be present. These continuously variable grey levels arise from the number, size and shape of the developed silver grains per unit volume of the sensitive layer (see Chapter 15). Photographs are therefore referred to as continuous-tone or analogue reproductions.

Most digital systems use up to 256 shades of grey. Generally the pixel values range from 0 (black) to 255 (white). Values between 0 and 255 correspond to intermediate tones. Various ways of achieving gradation of tone are employed in the graphic arts and digital media. Digital methods involve the conversion of continuously varying intensities in the scene being converted to discrete numbers. For these to reproduce tones correctly they have to be converted to analogue signals, for example in the display of images on a screen of a cathode ray tube. For some hard copy output devices, such as ink-jet printers, they have to be converted into a number of dots per inch, or dots of varying size, or dots containing differing quantities of ink, in order that tones can be reproduced successfully. A process known as *dithering* may be used to increase the number of grey levels and colours that can be produced via a digital device. Figure 1.4 shows what is meant by dithering for the much simplified case of a 2×2 array of pixels (the smallest addressable part of a digital image in the framestore of the computer), which enables five grey levels to be obtained, rather than two, by making some sacrifice in spatial resolution.

Colour photography did not become a practicable proposition for the average photographer until nearly 100 years after the invention of photography,

as perspective is concerned, appears to have been seen from a distance. The traditional photographer cannot do this unless the original image is digitized and manipulated appropriately and with great skill. Selection of viewpoint is thus of great importance to the photographer, if a given perspective is to be achieved.

Imaging chains

Because of the current diversity in the means of recording and handling images the concept of the 'imaging chain' was introduced in the early 1990s by Eastman Kodak. This concept is illustrated in Figure 1.3 and gives rise to the idea of 'hybrid' imaging, a term in common use today, which indicates the possible combination of conventional photochemical systems with digital technology and techniques.

The left side of Figure 1.3 lists the traditional photographic imaging chain whilst on the right is a completely electronic scheme. Each stage or link in the chain is a significant part of the process but it is possible to cross from one extreme to the other and to leap-frog some of the steps. A current cost-effective route which involves both systems is to acquire images on photographic film, scan them in to a digital system, followed by any manipulations, and then

but has now displaced black-and-white photography in virtually all applications with the possible exceptions of fine art photography. Although there are some advantages in monochrome recording by digital means which include smaller file sizes for storing image data and the potential for higher spatial resolution, practically all digital systems have been devised primarily for the recording of colour.

To reproduce an original subject of many different colours in an acceptable manner, colour media such as prints for viewing by reflected light, transparencies for viewing by transmitted light and displays on a CRT are used. The fact that colours can be reproduced by these diverse systems in an acceptable way is surprising when we consider that the colours of the image are formed by combinations of three synthetic colorants. However, no reproduction of colour is identical with the original. Indeed, certain preferred colour renderings differ from the original. However, acceptable colour reproduction is achieved if the *consistency principle* is obeyed. This principle may be summarized as follows:

(1) Identical colours in the original must appear identical in the reproduction.
(2) Colours that differ one from another in the original must differ in the reproduction.
(3) Any differences in colour between the original and the reproduction must be consistent throughout.

The entire area of colour reproduction is very complex and involves considerations of both objective and complex subjective effects. Apart from the reproduction of hues or colours, the saturation and luminosity are important. The saturation of a colour decreases with the addition of grey. Luminosity is associated with the amount of light emitted, transmitted or reflected by the sample under consideration. These factors depend very much on the nature of the surface and the viewing conditions. At best, colour reproductions are only representations of the original

scene, but, as we all know, colour imaging media carry out their task of reproducing colours and tone remarkably well, despite differences in colour and viewing conditions between the original scene and the reproduction. In order to increase the number of possible colours produced in a digital system by three colorants dithering is also used, in which the missing colours are simulated by intermingling pixels of two or more colours, a more complex version of that shown in Figure 1.4.

Image quality expectations

The objective of manufacturers of imaging media has been the provision of as high quality output as technology, costs and marketing factors allow. There are a number of physical attributes of image quality which have been used as aim-points and bench-marks for defining quality. These measures are given in Table 1.3.

Tone and colour have been outlined in previous sections and the other measures are, in many cases, very complex but are explained in later chapters. All are finding use in quantifying single aspects of image quality and in characterizing imaging systems and processes. However, at the end of an imaging chain is an observer who makes a judgement as to the quality of any output medium and image quality is also evaluated by panels of observers. This process when properly quantified is termed *psychophysics*, which is the science of investigations of the quantitative relationships between physical events and the corresponding psychological events, i.e., quantitative relationships between stimuli and responses, whilst *psychometrics* provides quantification of qualitative attributes such as sharpness, image quality etc. All manufacturers and those concerned with evaluating image quality make full use of physical and psychophysical techniques to quantify image quality and improve the technology.

Table 1.3 Examples of physical measures of image quality

Attribute	Physical measure
Tone (contrast)	Tone reproduction curve, characteristic curve, density, density histogram, pixel values
Colour	Chromaticity (CIE 1931 xy, CIE 1960 uv, CIE 1976 u'v') CIE 1976 L*u*v*, CIE 1976 L*a*b*
Resolution (detail)	Resolving power (cycles/mm, lpi, dpi, pixels/inch)
Sharpness (edges)	Acutance, PSF, LSF, MTF
Noise (graininess, electronic)	Granularity, noise–power (Wiener) spectrum, autocorrelation function, standard deviation, RMSE
Other	DQE, information capacity, file size in Mb, life-expectancy (years)

CIE = Commission Internationale de l'Eclairage (International Commission on Illumination); xy, uv, u'v' = chromaticity co-ordinates; L* = 'lightness'; u*,v*, a*,b* = chromatic content; PSF = Point Spread Function; LSF = Line Spread Function; MTF = Modulation Transfer Function; lpi = lines/inch; dpi = dots/inch; RMSE = Root Mean Square Error.

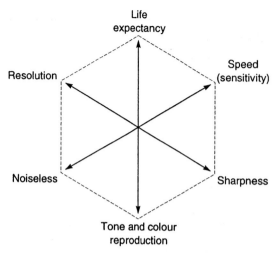

Figure 1.5 Image quality aims

in the original scene, such as low frequency lines, oversharp edges and contours, blocks of tone or colour and jagged edges to straight lines.

Figure 1.5 gives an indication of the aims for various image quality attributes of a typical imaging system shown as a quality hexagon. The aim being to achieve maximum values for each of the attributes given. Many of these attributes are interdependent; speed, for example, will also have an influence on all the other measures and has been included here because high sensitivity has always been an objective sought by those devising and improving existing imaging systems. It is a matter of much current research as to what represents the maximum value for any of the attributes given in Figure 1.5, what the scaling is and how these attributes should be measured.

For digital systems, however, other considerations of image quality must be introduced. The possibility exists for a number of image artefacts to be introduced which have not been included in Table 1.3 or Figure 1.5. These are caused by various components in the imaging chain which include the scanning or sampling of the scene during image capture and subsequent image processing and manipulations. Manipulation of pixel values is necessary, to sharpen images that were optically blurred to minimise *aliasing*, to convert analogue to digital data and vice versa, to compress and decompress image data values, to adjust grey levels and colour reproduction and change resolution etc. The outcome of these digital changes can manifest themselves in the formation of image artefacts which were not present

Bibliography

Hunt, R.W.G. (1994) *The Reproduction of Colour*, 5th edn, esp. ch. 30. Fountain Press, Kingston-upon-Thames.

Jackson, R. MacDonald, L. and Freeman, K. (1994) *Computer Generated Colour*. Wiley, Chichester.

Jacobson, R.E. (1995) Approaches to total quality for the assessment of imaging systems, *Information Services & Use*, **13**, 235–46.

Lynch, G. (1998) Digital photography – it's a solution thing, *IS&T Reporter* **13** (3), 1–4.

Parulski, K.A., Tredwell, T.J. and McMillan, L.J. (1992) Electronic photography in the 1990s, *IS&T Reporter*, **7** (4), 1–6.

Proudfoot, C.N (ed.) (1997) *Handbook of Photographic Science and Engineering*, 2nd edn. IS&T, Springfield, VA.

2 Fundamentals of light and vision

Light radiated by the sun, or whatever other source is employed, travels through space and falls on the surface of the subject. According to the way in which it is received or rejected, a complex pattern of light, shade and colour results. This is interpreted by us from past experience in terms of three-dimensional solidity. The picture made by the camera is a more-or-less faithful representation of what a single eye sees, and, from the light and shade in the positive image, the process of visual perception can arrive at a reasonably accurate interpretation of the form and nature of the objects portrayed. Thus, light makes it possible for us to be well informed about the shapes, sizes and textures of things, whether we can handle them or not.

Light waves and particles

The nature of light has been the subject of much speculation. In Newton's view light was *corpuscular*, i.e. consisted of particles, but this theory could not be made to fit all the known facts, and the *wave theory* of Huygens and Young took its place. Later still, Planck found that many facts could be explained only on the assumption that energy is always emitted in discrete amounts, or *quanta*. Planck's *quantum theory* might appear at first sight to be a revival of Newton's corpuscular theory, but there is only a superficial similarity. Today, interpretations of light phenomena are made in terms of both the wave and quantum models (*duality*). The quantum of light is called the *photon*.

Many of the properties of light can be readily predicted if we suppose that it takes the form of waves. Unlike sound waves, which require for their propagation air or some other material medium, light waves travel freely in empty space with a velocity, c, of 2.998×10^8 metres per second (approximately 300 000 kilometres per second). In air, its velocity is very nearly as great, but in water it is reduced to three-quarters and in glass to about two-thirds of its value in empty space.

Many forms of wave besides light travel in space at the same speed as light; they are termed the family of *electromagnetic waves*. Electromagnetic waves are considered as vibrating at right-angles to their direction of travel. As such, they are described as transverse waves, as opposed to longitudinal waves such as sound waves, in which the direction of vibration is along the line of travel. The distance in the direction of travel from one wavecrest to the corresponding point on the next is called the *wavelength* of the radiation, usually denoted by the Greek letter λ (lambda). The number of waves passing any given point per second is termed the *frequency* of vibration, usually denoted by the Greek letter ν (nu). The velocity of light is given by the following equation:

$$c = \nu\lambda \qquad (1)$$
velocity = frequency × wavelength

Different kinds of electromagnetic waves are distinguished by their wavelength or frequency. The amount of displacement of a light wave in a lateral direction is termed its *amplitude*. Amplitude is a measure of the intensity of the light.

Figure 2.1 shows an electromagnetic wave at a fixed instant of time, and defines the terms wavelength (λ) and amplitude. In the figure, the ray of light is shown as vibrating in two planes, the electric field in the y direction and the magnetic field in the z direction. The direction of propagation is in the x direction.

In the early 1900s the photoelectric effect was discovered and investigated. In this effect it was observed that negatively charged plates of certain metals lose their charge (emit electrons) when exposed to a certain critical wavelength. This effect depended only on wavelength and not on intensity. This could only be explained on the basis that light energy is in the form of packets (photons) which on

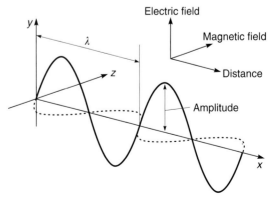

Figure 2.1 Electromagnetic wave

absorption by the metal causes emission of a photon, each emitted electron arising from the absorption of a single photon. The energy of the photon is proportional to the frequency of the electromagnetic radiation, given by the following equation:

$$E = h\nu \tag{2}$$

Energy of a photon = Planck's constant × frequency

The constant of proportionality in the above equation is a universal constant, Planck's constant, with a value of 6.626×10^{-34} Joule seconds.

Optics

The study of the behaviour of light is termed *optics*. It is customary to group the problems that confront us in this study in three different classes, and to formulate for each a different set of rules as to how light behaves. The science of optics is thus divided into three branches. *Physical optics* is the study of light on the assumption that it behaves as waves. A stone dropped into a pond of still water causes a train of waves to spread out in all directions on the surface of the water. Such waves are almost completely confined to the surface of the water, the advancing wavefront being circular in form. A point source of light, however, is assumed to emit energy in the form of waves which spread out in all directions, and hence, with light, the wavefront forms a spherical surface of ever-increasing size. This wavefront may be deviated from its original direction by obstacles in its path, the form of the deviation depending on the shape and nature of the obstacle. Phenomena which can be explained under the heading of physical optics include *diffraction, interference* and *polarization* which have particular relevance to the resolving power of lenses, lens coatings and special types of filters, respectively and are considered in Chapters 4, 5 and 6.

The path of any single point on the wavefront referred to above is a straight line with direction perpendicular to the wavefront. Hence we say that light travels in straight lines. In *geometrical optics* we postulate the existence of light rays represented by such straight lines along which light energy flows. By means of these lines, change of direction of travel of a wavefront can be shown easily. The concept of light rays is helpful in studying the formation of an image by a lens. Phenomena which are explained by this branch of optics include *reflection* and *refraction,* which form the basis of imaging by lenses and are fully described in Chapter 4.

Quantum optics assumes that light consists essentially of quanta of energy and is employed when studying in detail the effects that take place when light is absorbed or emitted by matter, e.g. a photographic emulsion or other light-sensitive material.

The electromagnetic spectrum

Of the other waves besides light travelling in space, some have shorter wavelengths than that of light and others have longer wavelengths. The complete series of waves, arranged in order of wavelengths, is referred to as the *electromagnetic spectrum*. This is illustrated in Figure 2.2. There is no clear-cut line between one wave and another, or between one type of radiation and another – the series of waves is continuous.

The various types forming the family of electromagnetic radiation differ widely in their effect. Waves of very long wavelength such as radio waves, for example, have no effect on the body, i.e. they cannot be seen or felt, although they can readily be detected by radio receivers. Moving along the spectrum to shorter wavelengths, we reach infrared radiation, which we feel as heat, and then come to waves that the eye sees as light; these form the visible spectrum. Even shorter wavelengths provide radiation such as ultraviolet, which causes sunburn, X-radiation, which can penetrate the human body, and gamma-radiation, which can penetrate several inches of steel. Both X-radiation and gamma-radiation, unless properly controlled, are harmful to human beings.

The energy values in Figure 2.2 were obtained from a combination of the previous two equations for

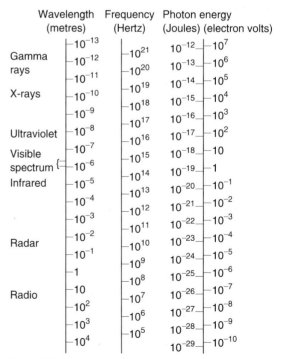

Figure 2.2 Electromagnetic spectrum and the relationship between wavelength, frequency and energy

wavelength (1) and for the energy of photons (2). Thus rearranging equation (1) gives: $\nu = c/\lambda$, which on substituting in to equation (2) gives:

$$E = hc/\lambda \qquad (3)$$

Since h and c are constants, equation (3) allows us to determine the energy associated with each wavelength (λ). Putting the known values for h an c in to equation (3) gives the following equation from which it is easy to determine the energy for any wavelength and provides the basis for the values given in Figure 2.2:

$$E = 1.99 \times 10^{-25}/\lambda \text{ Joules} \qquad (4)$$

This equation is valid provided that the λ is expressed in metres.

Energies also are quoted in electron volts, particularly for electronic transitions in imaging sensors (see Figure 12.1). The conversion of Joules to electron volts is given by multiplying by 6.24×10^{18}.

The *visible spectrum* occupies only a minute part of the total range of electromagnetic radiation, comprising wavelengths within the limits of approximately 400 and 700 nanometres (1 nanometre (nm) = 10^{-9} metre (m)). Within these limits, the human eye sees change of wavelength as a change of hue. The change from one hue to another is not a sharp one, but the spectrum may be divided up roughly as shown in Figure 2.3. (See also Chapter 16.)

The eye has a slight sensitivity beyond this region, to 390 nm at the short-wave end and about 760 nm at the long-wave end, but for most photographic purposes this can be ignored. Shorter wavelengths than 390 nm, invisible to the eye, are referred to as *ultraviolet* (UV), and longer wavelengths than 760 nm, also invisible to the eye, are referred to as *infrared* (IR). Figure 2.3 shows that the visible spectrum contains the hues of the rainbow in their familiar order, from violet at the short-wavelength end to red at the long-wavelength end. For many photographic purposes we can usefully consider the visible spectrum to consist of three bands only: blue–violet from 400 to 500 nm, green from 500 to 600 nm and red from 600 to 700 nm. This division is only an approximation, but it is sufficiently accurate to be of help in solving many practical problems, and is readily memorized.

The eye and vision

The eye bears some superficial similarities to a simple camera, as can be seen in Figure 2.4. It is basically a light-tight box contained within the white *scelera,* having a lens system consisting of the *cornea* and the *eyelens* which focuses the incoming light rays on the *retina* at the back of the eyeball to form an inverted image. The *iris* controls the amount of light entering the eye which, when fully open has a diameter of approximately 8 mm in low light levels and around 1.5 mm in bright conditions. It has *effective apertures* from f/11 to f/2 and a *focal length* of around 16 mm. The retina comprises a thin layer of cells containing the light-sensitive photoreceptors.

The electrical signals from light sensitive receptors are transmitted to the brain via the *optic nerve*. These light-sensitive receptors consist of two types – *rods* and *cones* – which are not distributed uniformly throughout the retina, as shown in Figure 2.5, and are responsive at low light levels (*scotopic* or night

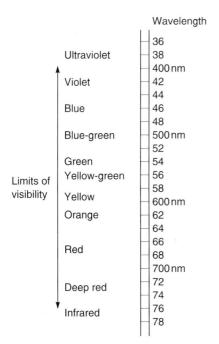

Figure 2.3 The visible spectrum expanded

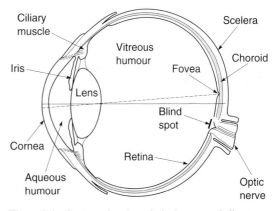

Figure 2.4 Cross-section through the human eyeball (adapted from *Colour Physics for Industry*, R. McDonald, ed.)

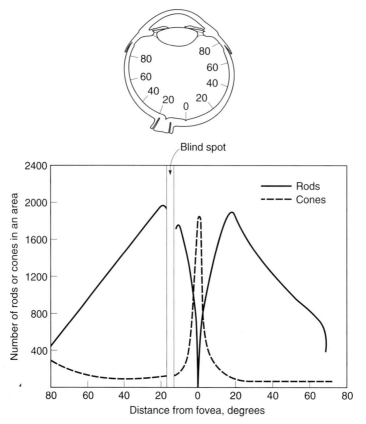

Figure 2.5 The distribution of rods and cones

vision) and high light levels (*photopic* or day vision), respectively. Also, the cones are responsible for colour vision, which is explained in Chapter 16.

From Figure 2.5 it can be seen that there is a very high density of cones at the fovea but no rods, and the gap or *blind spot* where there are no rods or cones is where the optic nerve is located. At the centre of the retina is the *fovea* which is the most sensitive area of around 1.5 mm in diameter into which are packed the highest number of cones, more than 100 000.

The mechanisms of vision which involve the organization of the receptors, the complex ways in which the signals are generated, organized, processed and transmitted to the brain are beyond the scope of this book. However, they give rise to a number of visual phenomena which have been extensively studied and have a number of consequences in our understanding and evaluation of imaging systems. A few examples of important aspects of vision are outlined below, although it must be emphasized that these should not be considered in isolation. Colour has not been included here, partly for simplicity and because those aspects of colour of particular relevance to imaging are considered in later chapters.

Dark and light adaptation

When one moves from a brightly lit environment to a dark or dimly lit room, it immediately appears to be completely dark, but after about 30 minutes the visual system adapts as there is a gradual switching from the cones to the rods and objects become discernible. Light adaptation is the reverse process with the same mechanism but takes place more rapidly, within about 5 minutes.

Luminance discrimination

Discrimination of luminance (changes in luminosity – lightness of an object or brightness of a light source) is governed by the level. As luminance increases, we need larger changes in luminance to perceive a just noticeable difference, as shown in Figure 2.6.

This is known as the Weber–Fechner Law and over a fairly large luminance range the ratio of the change in luminance (ΔL) to the luminance (L) is a

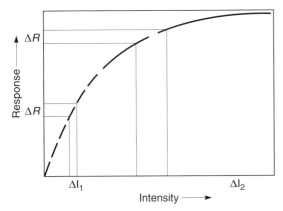

Figure 2.6 Response and intensity

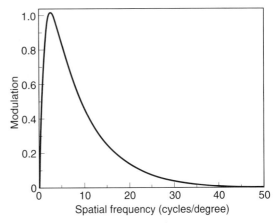

Figure 2.8 Spatial contrast sensitivity function for the human visual system

constant of around 0.01 under optimum viewing conditions:

$$\Delta L/L = \text{constant}$$

The *ratio* of light intensities is the significant feature of our perception. Figure 2.7 gives a visual indication of reflected light intensities in which each step increases by an equal *ratio* of 1, 2, 4, 8, i.e., a logarithmic scale.

Spatial aspects

The human visual system's (HVS) ability to discriminate fine detail has been determined in terms of its *contrast sensitivity function* (CSF). The CSF is defined as the threshold response to contrast where

contrast (or *modulation*) is the difference between the minimum (L_{\min}) and maximum (L_{\max}) luminances of the stimulus divided by their sum:

$$\text{Contrast} = (L_{\max} - L_{\min})/(L_{\max} + L_{\min})$$

A typical CSF for luminance shown by the HVS is shown in Figure 2.8.

Because of the distribution of rods and cones in the retina the CSF for the colour channels are different from those shown in Figure 2.8, with lower peaks and cut-off frequencies. For luminance the HVS has a peak spatial contrast sensitivity at around 5 cycles per degree and tends to zero at around 50 cycles per degree.

White light and colour mixtures

More than three hundred years ago Newton discovered that sunlight could be made to yield a variety of hues by allowing it to pass through a triangular glass prism. A narrow beam of sunlight was *dispersed*

Figure 2.7 Equal steps in lightness, each step differing by an equal *ratio*

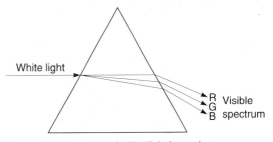

Figure 2.9 Dispersion of white light by a prism

Table 2.1 Additive mixing of blue, green and red light

Colours of light mixed	Visual appearance
Blue + green	Blue/green, or cyan
Blue + red	Red/purple, or magenta
Green + red	Yellow
Blue + green + red	White

Table 2.2 Subtractive mixing of cyan, magenta and yellow colorants

Colours mixed	Visual appearance
Cyan (white–red)	Blue + green
Magenta (white–green)	Blue + red
Yellow (white–blue)	Yellow
Cyan + magenta	Blue
Cyan + yellow	Green
Magenta + yellow	Red
Cyan + magenta + yellow	Black

into a band showing the hues of the rainbow. These represent the visible spectrum, and the experiment is shown diagrammatically in Figure 2.9. It was later found that recombination of the dispersed light by means of a second prism gave white light once more.

Later experiments showed that by masking off parts of the spectrum before recombination a range of colours could be produced. Young showed that if small parts of the spectrum were selected in the blue, green and red regions, a mixture of appropriate amounts of blue, green and red light appeared white. Fifty years after Young's original experiments (in 1802), Helmholtz was successful in quantifying these phenomena. Variation of the blue, green and red contents of the mixture resulted in a wide range of colours. Almost any colour could be produced, including magenta, or purple, which did not appear in the visible spectrum. The results of mixing blue, green and red light are listed in Table 2.1 and illustrated in Figure 2.10.

The results of mixing blue, green and red light suggested that the human eye might possess three types of colour sensitivity, to blue, green and red light respectively. This triple-sensitivity theory is called the *Young–Helmholtz theory of colour vision*. It provides a fairly simple explanation for the production of any colour from appropriate proportions of these primaries. This type of colour mixing is applied in cathode ray tube displays which have red, green and blue light-emitting phosphors in their faceplates, whereas subtractive colour mixtures are applied in most colour photographic materials, colour hard copy output devices and liquid crystal displays. Subtractive colour mixing, which involves the overlaying of cyan, magenta and yellow colorants, is shown in Table 2.2.

Bibliography

Bruce, V., Green, P.R. and Georgeson, M.A. (1996) *Visual Perception: Physiology, Psychology and Ecology*. Psychology Press, Hove.

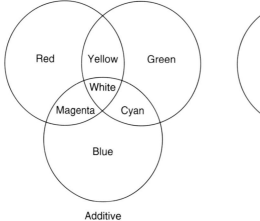

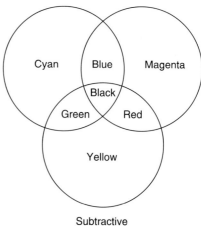

Figure 2.10 Additive mixing blue, green and red light and subtractive colour synthesis using yellow, magenta and cyan colorants

Falk, D. and Stork, D. (1986) *Seeing the Light: Optics in Nature, Photography, Color, Vision and Holography.* Harper and Row, New York.

Jackson, R., MacDonald, L. and Freeman, K. (1994) *Computer Generated Colour.* Wiley, Chichester.

McDonald, R. (ed.) (1987) *Colour Physics for Industry.* Society of Dyers and Colorists, Bradford.

Ray, S. (1994) *Applied Photographic Optics*, 2nd edn. Focal Press, London.

3 Photographic light sources

Photographs are taken by the agency of light travelling from the subject to the photoplane in the camera. This light usually originates at a source outside the picture area and is reflected by the subject. Light comes from both natural and artificial sources. Natural sources include the sun, clear sky and clouds. Artificial sources are classified by the method used to produce the light (see Table 3.1).

Characteristics of light sources

Light sources differ in many ways, and the selection of suitable sources for photographic purposes is based on the order of importance of a number of significant characteristics. A summary of properties of photographic sources is given in Table 3.2. The more important characteristics are discussed in detail below.

Spectral quality

The radiation from most sources is a mixture of light of various wavelengths. The *hue* of the light from a source, or its *spectral quality*, may vary depending on the distribution of energy at each wavelength in its spectrum. Most of the sources used for photography emit what is usually termed *white light*. This is a vague term, describing light that is not visibly deficient in any particular band of wavelengths, but not implying any very definite colour quality. Most white-light sources vary considerably among themselves and from daylight. Because of the perceptual phenomenon of *colour constancy* these differences matter little in everyday life, but they can be very important in photography, especially when using colour materials or where there is 'mixed' lighting. It is essential that light quality is described in precise terms. Light is a specific region of the electromagnetic spectrum and is a form of radiant energy. Colour quality may be defined in terms of the *spectral power distribution* (SPD) throughout the spectrum. There are several ways this can be expressed, with varying degrees of precision. Each method has its own advantages, but not all methods are applicable to every light source.

Spectral power distribution curve

Using a *spectroradiometer*, the *spectral power distribution* of light energy can be measured and displayed as the SPD curve. Curves of this type are shown in Figure 3.1 for the sun and in Figure 3.2 for some other sources. Such data show clearly small differences between various forms of light. For example, the light sources in Figure 3.1 seen separately would, owing to colour constancy effects, probably be described as white, yet the curves are different. Light from a clear blue sky has a high blue content, while light from a tungsten lamp has a high red content. Although not obvious to the eye such

Table 3.1 Methods of producing light

Method	Source of light	Examples
Burning	Flame from flammable materials	Candles, oil lamps, matches, magnesium ribbon, flash powder and flash-bulbs
Heating	Carbon or tungsten filament	Incandescent electric lamps, e.g. domestic lamps, studio lamps, tungsten-halogen lamps
Electric spark or arc	Crater or flame of arc	Carbon arcs, spark gaps
Electrical discharge	Gas or metallic vapour	Electronic flash, fluorescent lighting, metal halide lamps
Luminescence	Phosphors	Sodium and mercury vapour lamps

Table 3.2 The properties of some light sources used in photography

Source	Type of spectrum: C. continuous, L. line, B. line plus continuum	Colour temperature (kelvins)	Efficacy (lumens per watt)	Average lamp life (hours)	Light output: H. high, M. moderate, L. low	Constancy of output: P. poor, G. good, E. excellent, V. variable	Costs: L. low, M. moderate, H. high — Initial	Running	Size of unit: S. small, M. medium, L. large	Ease of operation: D. difficult, M. moderate, S. simple
Daylight	C	2000–20 000			H–L	P	L	L		S
Tungsten filament lamps:										
General service	C	2760–2960	†13	1000	L	P	L	L	M	S
Photographic	C	3200	†20	100	L	G	M	M	M	S
Photoflood	C	3400	†40	3–10	M	P	L	M	S	S
Projector	C	3200	†20	25–100	M	G	M	M	S	S
Tungsten–halogen lamps	C	2700–3400	15–35	25–200	M	E	M	H	S,M	S
Mercury vapour discharge lamps:										
Low pressure	L		6		M	G	H	L	M	S
High pressure	L		35–55	1000–2000	H	G	H	L	M	S
Fluorescent lamps	B	*3000–6500	†62	7000–8000	M	P	M	L	L	M
Sodium vapour discharge lamps:										
Low pressure	L		170	10–16 000	H	E	M	L	M	M
High pressure	L		100		H	E	H	L	M	M
Metal halide lamps	B	5600–6000	85–100	200–1000	H	E,V	H	H	M	M
Pulsed xenon lamps	B	5600	25–50	300–1000	H	G	H	L	M,S	M
Flash bulbs	C	3800 or 5500		used once only	H	E	L	H	S	S
Electronic flash	B	*6000	40		M	G	H,M,L	L	L,M,S	M

*correlated value
†typical value

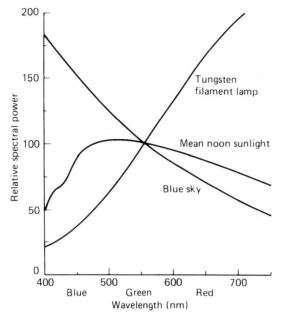

Figure 3.1 Spectral power distribution curves of sunlight, light from a blue sky and light from a tungsten lamp

differences can be clearly shown by colour reversal film. Colour film has to be balanced for a particular form of lighting.

Analysis of SPD curves show that there are three main types of spectrum emitted by light sources. The sources in Figure 3.1 have *continuous spectra*, with energy present at all wavelengths in the region measured. Many sources, including all incandescent-filament lamps, have this type of spectrum. Other sources have the energy confined to a few narrow spectral regions. At these wavelengths the energy is high, but elsewhere it is almost nil. This is called a *discontinuous* or *line spectrum*, and is emitted typically by low-pressure discharge lamps such as sodium- and mercury-vapour lamps.

A third type of spectrum has broad bands of energy with a continuous background spectrum or *continuum* of varying magnitude, and is given by discharge sources by increasing the internal pressure of the discharge tube, e.g. a high-pressure mercury-vapour lamp. Alternatively, the inside of the discharge tube may be coated with 'phosphors' that fluoresce, i.e. emit light at longer wavelengths than the spectral lines which stimulate them. Another method is to include gases in the tubes such as xenon or argon, and metal halide vapour.

Colour temperature

For photographic purposes a preferred method of quantifying the light quality of an incandescent

source is by means of its *colour temperature*. This is defined in terms of what is called a *Planckian radiator*, a *full radiator* or simply a *black body*. This is a source emitting radiation whose SPD depends only on its temperature and not on the material or nature of the source.

The colour temperature of a light source is the temperature of a full radiator that would emit radiation of substantially the same spectral distribution in the visible region as the radiation from the light source. Colour temperatures are measured on the *thermodynamic* or *Kelvin* scale, which has a unit of temperature interval identical to that of the Celsius scale, but with its zero at −273.15 °C.

The idea of colour temperature can be appreciated by considering the progressive change in colour of the light emitted by a piece of metal as its temperature is raised, going from dull black through red and orange to white heat. The quality of the light emitted depends on the temperature of the metal. Luminous sources of low colour temperature have an SPD relatively rich in red radiation. With progression up the colour scale the emission of energy is more balanced and the light becomes 'whiter'. At high values the SPD is rich in blue radiation. It is unfortunate that reddish light has been traditionally known as 'warm' and bluish light as 'cold', as the actual temperatures associated with these colours are the other way round.

The idea of colour temperature is strictly applicable only to sources that are full radiators, but in practice it is extended to those that have an SPD approximating to that of a full radiator or *quasi-Planckian source*, such as a tungsten-filament lamp. The term is, however, often applied incorrectly to fluorescent lamps, whose spectra and photographic effects can be very different from those of full radiators. The preferred term describing such sources is *correlated colour temperature*, which indicates a visual similarity to a value on the colour temperature scale (but with an unpredictable photographic effect, particularly with colour reversal film).

The approximate colour temperatures of light sources used in photography are given in Table 3.3.

In black-and-white photography, the colour quality of light is of limited practical importance. In colour photography, however, it is vitally important, because colour materials and *focal plane arrays* (FPA) are balanced to give correct rendering with an illuminant of a particular colour temperature. Consequently, the measurement and control of colour temperature must be considered for such work, or the response of the sensor adjusted, usually termed 'white balance'.

Colour rendering

With fluorescent lamps, which vary greatly in spectral energy distribution, covering a wide range of

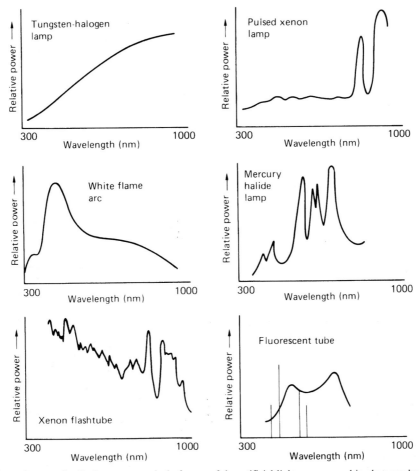

Figure 3.2 Spectral power distribution curves typical of some of the artificial light sources used in photography

Table 3.3 Colour temperatures of some common light sources

Light source	Approximate colour temperature	Mired value
Standard candle	1930 K	518
Dawn sunlight	2000 K	500
Vacuum tungsten lamp	2400 K	417
Acetylene lamp (used in early sensitometric work)	2415 K	414
Gas-filled tungsten lamp (general service)	2760–2960 K	362–338
Warm-white fluorescent lamp	3000 K	333
Photographic lamp	3200 K	312
Photoflood lamp	3400 K	294
Clear flashbulb	3800 K	263
Daylight fluorescent lamp	4500 K	222
Mean noon sunlight	5400 K	185
Photographic daylight	5500 K	182
Blue flashbulb	6000 K	167
Electronic flashtube	6000 K	167
Average daylight (sunlight and skylight combined)	6500 K	154
Colour-matching fluorescent lamp	6500 K	154
Blue sky	12 000–18 000 K	83–56

correlated colour temperatures, the results given by two lamps of nominally the same properties may be quite different if used for visual colour matching or for colour photography. Various objective methods have been devised to give a numerical value to the colour rendering given by such sources as compared with a corresponding full radiator, or with visual perception. A *colour rendering index* (CRI) or value is defined based on the measurement of luminance in some six or eight spectral bands and compared with the total luminance, coupled with weighting factors, a value of 100 indicating ideal performance. Typical values vary from 50 for a 'warm-white' type to greater than 90 for a 'colour-matching' version.

Percentage content of primary hues

For many photographic purposes, the visible spectrum can be considered as consisting of three main bands: blue, green and red. The quality of light from a source with a continuous spectrum can be approximately expressed in terms of the percentages in which light of these three hues is present. The method is imprecise; but it is the basis of some *colour temperature meters*, where the ratios of blue-green and red-green content are compared. (The same principles are used to specify the colour rendering given by a lens, as absorption of light at the blue end of the spectrum is common in optical glass.)

Measurement and control of colour temperature

In colour photography, the colour temperature (CT) of the light emitted by all the separate sources illuminating a subject must agree in balance with that for which the process is being used. The tolerance permissible depends on the process and to some extent on the subject. A departure of 100 K from the specified value by all the sources (which may arise from a 10 per cent variation in supply voltage) is probably the maximum tolerable for colour reversal material balanced for a colour temperature of around 3200 K. Colour negative material (depending on how it is CT balanced) may allow a greater departure than this, because a certain amount of colour correction is possible at the printing stage.

A particular problem is that of *mixed lighting*, where part of the subject may be unavoidably illuminated by a light source of markedly different colour quality from the others. A localized *colour cast* may then appear in the photograph. Another example is the use of tungsten lamps fitted with blue filters to match daylight for fill-in purposes, where some

mismatch can occur. Note that both blue flashbulbs and electronic flash may be used successfully as fill-in sources when daylight is the main illuminant. A visual comparison of the colour quality of two light sources is possible by viewing the independently illuminated halves of a folded sheet of white paper with its apex pointing towards the observer. Any visually observable difference in colour would be recorded in a photograph, so must be corrected (see later).

Instrumental methods such as colour temperature meters are more convenient. Most incorporate filtered photocells which sample specific regions of the spectrum, such as red, green and blue. A direct readout of colour temperature is given, usually together with recommendations as to the type of light-balancing or colour-correction filters needed for a particular type of film.

A *matrix array* of several hundred CCD photocells filtered to blue, green and red light, together with scene classification data can also be used in-camera to measure the colour temperature of a scene.

The CT balance of colour films to illuminants is specified by their manufacturers. The colour temperature of a lamp may be affected by the reflector and optics used; it also changes with variations in the power supply and with the age of the lamp. To obtain light of the correct quality, various precautions are necessary. The lamps must be operated at the specified voltage, and any reflectors, diffusers and lenses must be as near to neutral in colour as possible. Voltage control can be by a constant-voltage transformer. The life of filament lamps can be extended by switching on at reduced voltage and arranging the subject lighting, then using the correct full voltage only for the actual exposure. Variable resistances or solid-state dimmer devices can be used with individual lamps for trim control. To raise or lower the colour temperature by small amounts, *light-balancing filters* may be used over the lamps. Pale blue filters raise the colour temperature while pale yellow or amber ones lower it.

As conventional tungsten-filament lamps age, the inner side of the envelope darkens from a deposit of tungsten evaporated from the filament. Both light output and colour temperature decrease as a result. Bulb replacement is the only remedy; in general, all bulbs of a particular set should be replaced at the same time. Tungsten–halogen lamps maintain a more constant output throughout an extended life, as compared with ordinary filament lamps.

To compensate for the wide variations encountered in daylight conditions for colour photography, camera filtration may be necessary by means of light-balancing filters of known *mired shift value* as defined below. To use colour film in lighting conditions for which it is not balanced, *colour conversion (CC) filters* with large mired shift values are available (see Chapter 11).

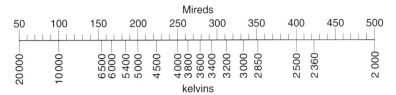

Figure 3.3 Comparison of equivalent values on the mired and kelvin scales

The mired scale

A useful method of specifying the colour balance of an incandescent source is by the *mired scale*, an acronym derived from *micro reciprocal degree*. The relationship between *mired value* (MV) and colour temperature (T) in kelvins is:

$$MV = \frac{10^6}{T} \qquad (1)$$

Figure 3.3 can be used for conversion from one scale to the other. Note that as colour temperature increases the mired value decreases and vice versa.

The main advantage of the mired scale, apart from the smaller numbers involved, is that equal variations correspond to approximately equal visual variations in colour. Consequently, a light-balancing filter can be given a *mired shift value* (MSV) which indicates the change in colour quality given, regardless of the source being used. Yellowish or amber filters, for raising the mired value of the light, i.e. lowering its colour temperature in kelvins, are given positive mired shift values; bluish filters, for lowering the mired value, i.e. raising the colour temperature in kelvins, are given negative values. Thus a bluish light-balancing filter with a mired shift value of −18 is suitable for converting tungsten light at 3000 K (333 mireds) to approximately 3200 K (312 mireds). It is also suitable for converting daylight at 5000 K (200 mireds) to 5500 K (182 mireds). Most filters of this type are given values in *decamireds*, i.e. mired shift value divided by 10. Thus a blue daylight-to-tungsten filter of value −120 mireds is designated B12. A suitable equation for calculating the necessary MSV to convert a CT of T_1 to one of T_2 is

$$MSV = \left(\frac{1}{T_2} - \frac{1}{T_1} \right) 10^6 \qquad (2)$$

Light output

Units

The output power of a source is an important characteristic. A source can emit energy in a wide

spectral band from the ultraviolet to the infrared regions; indeed, most of the output of incandescent sources is in the infrared. For most photography only the visible region is of importance. Three related photometric units are used to define light output: *luminous intensity, luminance* and *luminous flux*.

Luminous intensity is expressed numerically in terms of the fundamental SI unit, the *candela* (cd). One candela is the luminous intensity in the direction of the normal to the surface of a full radiator of surface area 1/600 000 of a square metre, at the temperature of solidification of platinum. It should be noted that luminous intensity of a source is not necessarily uniform in all directions, so a mean spherical value, i.e. the mean value of luminous intensity in all directions, is sometimes used. Luminous intensity was at one time known as 'candlepower'.

Luminance is defined as luminous intensity per square metre. The unit of luminance is the candela per square metre (cd m^{-2}). An obsolescent unit sometimes encountered is the *apostilb* (asb) which is one lumen (see below) per square metre (lm m^{-2}), and refers specifically to light reflected from a surface rather than emitted by it. The luminance of a source, like its luminous intensity, is not necessarily the same in all directions. The term luminance is applicable equally to light sources and illuminated surfaces. In photography, luminances are recorded by a film as analogue optical densities of silver or coloured dyes.

Luminous flux is a measure of the amount of light emitted into space, defined in terms of unit solid angle or *steradian*, which is the angle subtended at the centre of a sphere of unit radius by a surface of unit area on the sphere. Thus, an area of 1 square metre on the surface of a sphere of 1 metre radius subtends at its centre a solid angle of 1 steradian. The luminous flux emitted into unit solid angle by a point source having a luminous intensity of one candela in all directions within the angle is 1 *lumen* (lm). Since a sphere subtends 4π steradians at its centre (the area of the surface of a sphere is $4\pi r^2$), a light source of luminous intensity of 1 candela radiating uniformly in all directions emits a total of 4π lumens, approximately 12.5 lm (this conversion is only approximately applicable to practical light sources, which do

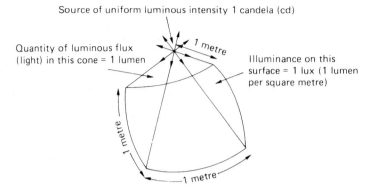

Figure 3.4 Relationships between luminous intensity of a source, luminous flux and illumination on a surface

not radiate uniformly in all directions). The lumen provides a useful measure when considering the output of a source in a reflector or other luminaire or the amount of light passing through an optical system.

Illumination laws

The term 'illumination' refers to light falling on a surface and depends on the luminous flux falling on a surface and its area. The quantitative term is *illuminance* or incident *luminous flux* per unit area of surface. The unit is the *lux* (lx); 1 lux is an illuminance of 1 lumen per square metre. The relationship between the various photometric units of luminous intensity, luminous flux and illumination is shown in Figure 3.4. The illumination E on a surface at a distance d from a point source of light depends on

the output of the source, its distance and the inclination of the surface to the source. The relationship between illumination and distance from the source is known as the inverse square law of illumination and is illustrated in Figure 3.5. Light emitted into the cone to illuminate base area A at distance d_1 with illumination E_1 is dispersed over area B at distance d_2 to give illumination E_2. It is readily shown by geometry that if d_2 is twice d_1, then B is four times A, i.e. illumination is inversely proportional to the square of the distance d. Hence:

$$\frac{E_1}{E_2} = \frac{d_2{}^2}{d_1{}^2} \tag{3}$$

Also, from the definition of the lumen, the illumination in lux as given by a source at any distance from it, may be found by dividing the luminous intensity of the lamp by the square of the distance in metres. Thus the illumination on a surface 5 metres from a source of 100 candelas is $100/(5)^2 = 4\,\mathrm{lx}$. Recommended values of illumination for different areas range from 100 lx for a domestic lounge to at least 400 lx for a working office.

The reduced amount of illumination on a tilted surface is given by Lambert's *cosine law of illumination*, which states that the illumination on an inclined surface is proportional to the cosine of the angle of incidence of the light rays falling on the surface (Figure 3.6). For a source of luminous intensity I at a distance d from a surface inclined at an angle θ, the illuminance E on the surface is given by

$$E = \frac{I \cos \theta}{d^2} \tag{4}$$

The inverse square law strictly applies only to point sources. It is approximately true for any source that is small in proportion to its distance from the subject. The law is generally applicable to lamps used in shallow reflectors, but not deep reflectors. It is not

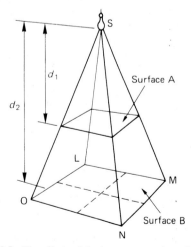

Figure 3.5 The effects of the inverse square law of illumination

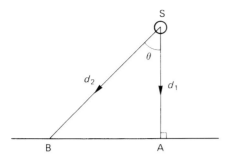

Figure 3.6 Lambert's cosine law of illumination. The illuminance E at point A distant d_1 from source S of intensity I is given by $E = I/d_1^2$, but at point B on the same surface receiving light obliquely the reduced illuminance is given by $E = I \cos \theta/d_2^2$

applicable to the illumination provided by a spotlight due to the optical system used to direct the light beam.

Reflectors and luminaires

Most light sources are used with a *reflector*, which may be an integral part of the lamp or a separate item. A reflector has a considerable influence on the properties of the lighting unit as regards distribution of illumination or evenness and colour of the light. The design of the reflector and housing or 'luminaire' of a light source is important for uniformity and distribution of illumination over the area of coverage of the lamp. Reflectors vary in size, shape and nature of surface. Some are flat or very shallow, others deeply curved in spherical or paraboloidal form. The surface finishes vary from highly polished to smooth matt or even lenticular. Some intermediate arrangement is usually favoured to give a mixture of direct and diffuse illumination. An effective way of showing the light distribution of a source plus reflector or optical system is to plot the luminous intensity in each direction in a given horizontal plane through the source as a curve in polar coordinates, termed a *polar distribution curve* (Figure 3.7). In this figure the source is at the origin (0°) and the length of the radius from the centre to any point on the curve gives the luminous intensity in candelas in that particular direction.

The effect of a reflector is given in terms of the *reflector factor* which is the ratio of the illuminance on the subject by a light source in a reflector to that provided by the bare source. Depending on design, a flashgun reflector may have a reflector factor from 2 to 6 in order to make efficient use of the light output, which is directed into a shaped beam with very little illumination outside the primary area.

In many instances flashguns are used with a large reflector of shallow box- or umbrella-like design and construction, often called 'softboxes' and 'brollies'. A variety of surface finishes and diameters are available, serving to convert the flashgun from a small source giving hard shadows on the subject when used direct, to a large, diffuse source offering softer lighting when used as the sole illuminant, albeit with considerable loss of efficiency. Bare-bulb technique, where the flash source is used without reflector or diffuser, is sometimes used for its particular lighting quality.

By way of contrast, a *spotlight* provides a high level of illumination over a relatively small area, and as a rule gives shadows with hard edges. The illumination at the edges of the illuminated area falls off quite steeply.

The use of diffusers gives softer shadows, and 'snoots' give well-defined edges. A spotlight consists of a small incandescent or flash source with a filament or flashtube at the centre of curvature of a concave reflector, together with a condenser lens, usually of *Fresnel lens* construction to reduce weight. (Figure 3.8). By varying the distance between source and condenser the diameter of the beam of light may be varied. For a near-parallel beam, the source is positioned at the focus of the condenser lens. With compact light sources, such as tungsten–halogen lamps, where it is possible to reduce the physical size of spotlights and floodlights, the optical quality of reflectors and condensers needs to be high to ensure even illumination.

Many small electronic flash units allow the distance of the flashtube from the Fresnel lens to be varied to provide a narrower beam that will concentrate the light output into the field of view of lenses of differing focal lengths. This 'zoom flash' action may even be motorized and under computer control from a camera and change automatically when a lens of the appropriate focal length is attached to the camera, or when a zoom lens is used.

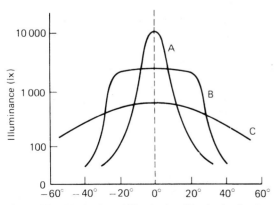

Figure 3.7 Distribution of illumination. Illumination levels at 5 m distance from a light source: (a) a 2 kW spotlight in 'spot' mode; (b) in 'flood' mode; (c) a 2.5 kW 'fill-in' light

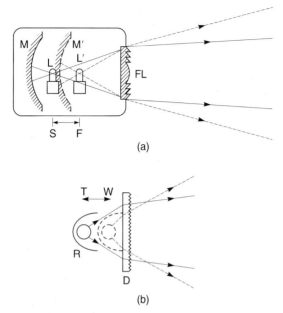

(a)

(b)

Figure 3.8 Effects of moving the light source in a luminaire. (a) Principle of the spotlight: when light source *L* is in 'spot' position S at the focus of spherical mirror M and Fresnel lens FL, a narrow beam of some 40° results. At 'flood' position F, a broader beam of some 85° results. (b) A 'zoom' flash system. The flash tube and reflector assembly R move behind the diffuser D to increase light coverage from telephoto T to wide-angle W setting of a camera lens

The housing, reflector, diffuser and electrical supply arrangements of a lighting unit or fitting for photography are often referred to collectively as the *luminaire*.

Constancy of output

Constant light output and quality are necessary characteristics of photographic light sources, especially for colour work. Daylight, although an intense and cheap form of lighting, is by no means constant: its intensity and quality vary with the season, time of day and weather. Artificial light sources are more reliable, but much effort can go into arranging lighting set-ups to simulate the desirable directional qualities of sunlight and diffuse daylight.

Electric light sources need a reliable power supply in order to maintain a constant output. If the frequency and/or voltage of the mains supply fluctuates, appreciable variation in light intensity and quality may result (Figure 3.9). Incandescent lamps give a reliable output if used with some form of constant voltage control; but inevitably with age they darken, causing a lowering of both output and colour temperature. Sources using the tungsten–halogen

cycle largely circumvent these problems. Fluorescent lamps have a long life, but they too gradually decrease in light output as they age.

An advantage of flashbulbs and electronic flash is the reliability of light output and quality that can be obtained. Flashbulbs in particular have an output which is dependent only on manufacturing tolerances. Electronic flash gives an acceptably constant output provided adequate recharging time is allowed between successive flashes. The ready-light indicators fitted to many units glow when only about 80 per cent of the charging voltage is reached; at this point the energy available for the flash is only some two-thirds of full charge. A further time must be allowed to elapse before discharge, to ensure full capacity is available.

Digital cameras used for still life photography, when either three successive colour-filtered exposures are given, or a triple linear photosensor array is scanned across the format with a short time exposure, require that the light output of the source is dependably constant to prevent the appearance of colour banding in the image. Sources such as HMI lamps and high intensity fluorescent sources are found to be suitable for this demanding task.

Efficiency

The efficiency of a light source for photographic use is related to factors determining its usefulness and economy in particular circumstances. These include control circuitry utilizing design techniques to give a low power consumption and choice of reflector to concentrate light output in a particular direction. Electronic flash units are examples of efficient reflector design, with little of the luminous output wasted.

The photographic effectiveness of a light source relative to a reference source is called its *actinity*, and takes into account the SPD of the source and the spectral response of the sensitized material or photosensor array. Obviously it is inefficient to use a source poor in ultraviolet radiation with materials whose sensitization is predominantly in the blue and ultraviolet spectral regions. A measure of the efficiency of a light source is *efficacy*. This is the ratio of luminous flux emitted to the power consumed by the source and is expressed in lumens per watt. A theoretically perfect light source emitting white light of daylight quality would have an efficacy of about 220 lumens per watt. Values obtained in practice for some common light sources are given in Table 3.2 above. The obsolete term 'half-watt' was formerly applied to general-purpose filament lamps, which were presumed to have an efficacy of 1 candle-power per half-watt, corresponding roughly to 25 lumens per watt. This value was optimistic.

Operation and maintenance

Reliability is one of the most desirable attributes of a photographic light source. Incandescent sources often fail when switched on, due to power surges and physical changes in the filament. Power control devices such as dimmers and series-parallel switching arrangements can reduce such occurrences. Extensive switching operations and vibration in use should be avoided. Electronic flash units may be very reliable in operation but cannot be repaired by the user. Because of the high voltages and currents involved, electronic flash apparatus should always be treated with respect. Most flash units have some form of automatic 'dump' circuit to dispose of redundant charge when output is altered or the unit switched off. Modern lighting units of compact dimensions, light weight, ease of portability and incorporating devices such as automatic control of output as in electronic flashguns, certainly ease the task of operation, but the disposition of the lighting arrangements on the subject for effect is still a matter of skill on the part of the user.

Some maintenance is necessary for every light source, varying with the particular unit. It may be as simple as ensuring reflectors are cleaned regularly or batteries are replaced or recharged as recommended. The ability of a light source to operate on a variety of alternative power sources such as batteries, mains or a portable generator may be a decisive factor in its choice. Other convenience factors relate to the comfort of the operator and subject, such as the amount of heat generated and the intensity of the light. Undoubtedly, electronic flash lighting is superior in these aspects.

Daylight

A great deal of photographic work is done out of doors in ordinary daylight. Daylight typically includes direct light from the sun, and scattered light from the sky and from clouds. It has a continuous spectrum, although it may not be represented exactly by any single colour temperature. However, in the visible region (though not outside it) colour temperature does give a close approximation of its quality. The quality of daylight varies through the day. Its colour temperature is low at dawn, in the region of 2000 K if the sun is unobscured. It then rises to a maximum, and remains fairly constant through the middle of the day, to tail off slowly through the afternoon and finally fall rapidly at sunset to a value which is again below that of a tungsten-filament lamp. The quality of daylight also varies from place to place according to whether the sun is shining in a clear sky or is obscured by cloud. The reddening of daylight at sunrise and at sunset is due to the absorption and scattering of sunlight by the atmosphere. These are greatest when the sun is low, because

the path of the light through the earth's atmosphere is then longest. As the degree of scattering is more marked at short wavelengths, the unscattered light which is transmitted contains a preponderance of longer wavelengths, and appears reddish, while the scattered light (skylight) becomes more blue towards sunrise and sunset.

These fluctuations prohibit the use of ordinary daylight for sensitometric evaluation of photographic materials. Light sources of fixed colour quality are essential. For many photographic purposes, especially in sensitometry, the average quality of sunlight is used as the standard (skylight is excluded). This is referred to as *mean noon sunlight*, and approximates to light at a colour temperature of 5400 K. Mean noon sunlight was obtained by averaging readings taken in Washington by the (then) US National Bureau of Standards at the summer and winter solstices of 21 June and 21 December in 1926. Light of similar quality, but with a colour temperature of 5500 K, is sometimes referred to as 'photographic daylight'. It is achieved in the laboratory by operating a tungsten lamp under controlled conditions so that it emits light of the required colour temperature, by modifying its output with a *Davis–Gibson liquid filter*. Sunlight SPD is of importance in sensitometry, not so much because it may approximately represent a standard white, but because it represents, perhaps better than any other single energy distribution, the average conditions under which the great majority of camera photographic materials are exposed.

Near noon, the combination of light from the sun, sky and clouds usually has a colour temperature in the region of 6000 to 6500 K. An overcast (cloudy) sky has a somewhat higher colour temperature, while that of a blue sky may become as high as 12 000 to 18 000 K. The colour temperature of the light from the sky and the clouds is of interest independently to that of sunlight, because it is *skylight* alone which illuminates shadows and gives them a colour balance that differs from that of a sunlit area.

Tungsten-filament lamps

In an incandescent photographic lamp, light is produced by the heating action of electric current through a filament of tungsten metal, with melting point of 3650 K. The envelope is filled with a mixture of argon and nitrogen gas and can operate at temperatures up to 3200 K. A further increase, to 3400 K gives increased efficacy but a decrease in lamp life. 'Photoflood' lamps are deliberately overrun at the latter temperature, to give a high light output, at the expense of a short life.

A *tungsten-filament lamp* is designed to operate at a specific voltage, and its performance is affected by deviation from this condition, as by fluctuations in supply voltage. Figure 3.9 shows how the

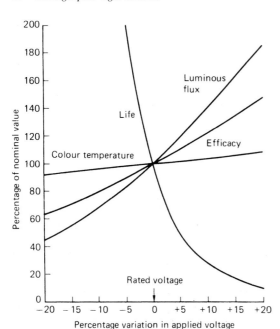

Figure 3.9 Variations in the characteristics of a tungsten lamp when voltage is altered by small amounts

characteristics of a filament lamp are affected by changes to normal voltage: for example, a 1 per cent excess voltage causes a 4 per cent increase in luminous flux, a 2 per cent increase in efficacy, a 12 per cent decrease in life and a 10 K increase in colour temperature for a lamp operating in the range 3200–3400 K.

Tungsten lamps are manufactured with a variety of different types of cap, designated by recognized abbreviations such as BC (bayonet cap), ES (Edison screw) and SCC (small centre contact). Certain types of lamp are designed to operate in one position only. Reference to manufacturers' catalogues will furnish details as to burning position as well as cap types and wattages available.

There are various photographic tungsten lamps in use:

- General service lamps are the type used for normal domestic purposes and available in sizes from 15 W to 200 W with clear, pearl or opal envelopes. The colour temperature of the larger lamps ranges from about 2760 K to 2960 K, with a life of about 1000 hours.
- *Photographic lamps* are a series of lamps made specially for photographic use, usually as reflector spotlights and floodlights. The colour temperature is nominally 3200 K, which is obtained at the expense of a life of approximately 100 hours only. The usual power rating is 500 W. Such

lamps have been superseded by more efficient, smaller tungsten–halogen lamps with greater output and longer life.
- *Photoflood lamps* produce higher luminous output and more actinic light by operating at 3400 K; they have an efficacy of about 2.5 times that of general service lamps of the same wattage. Two ratings are available. The smaller No. 1 type is rated at 275 W, with a life of 2–3 hours. The larger No. 2 type is rated at 500 W, with a life of 6–20 hours. Photoflood lamps are also available with internal silvering in a shaped bulb, and these do not need to be used with an external reflector.
- *Projector lamps* are available in a variety of types, with wide variations in cap design, filament shape, and size. They may include reflectors and lenses within the envelope. Operation is at mains voltage or reduced voltage by step-down transformer. Wattages from 50 to 1000 are available. Colour temperature is in the region of 3200 K and lamp life is given as 25, 50 or 100 hours. Once again, the compact size of the tungsten–halogen lamp has great advantages in such applications; and operation at low voltages such as 12 or 24 V allows use of a particularly robust filament. Many colour enlargers use projector lamps as their light source.

Tungsten–halogen lamps

The *tungsten–halogen lamp* is a type of tungsten lamp with a quantity of a halogen added to the filling gas. During operation a regenerative cycle is set up whereby evaporated tungsten combines with the halogen in the cooler region of the vicinity of the envelope wall, and when returned by convection currents to the much hotter filament region the compound decomposes, returning tungsten to the filament and freeing the halogen for further reaction. There are various consequences of this cycle. Evaporated tungsten is prevented from depositing on the bulb wall which thus remains free from blackening through age. Filament life is also considerably extended owing to the returned tungsten, but eventually the filament breaks as the redeposition is not uniform. The complex tungsten–halogen cycle functions only when the temperature of the envelope exceeds 250 °C, achieved by using a small-diameter envelope of borosilicate glass or quartz (silica). The increased mechanical strength of such a construction permits the gas filling to be used at several atmospheres pressure. This pressure inhibits the evaporation of tungsten from the filament and helps increase the life of such lamps as compared with that of conventional tungsten lamps of equivalent rating. The small size of tungsten–halogen lamps has resulted in lighter, more efficient luminaires and lighting units as well as improved performance from projection optics.

Early lamps of this type used iodine as the halogen and the lamps were commonly known as 'quartz-iodine' lamps. Other halogens and their derivatives are now used. Tungsten–halogen lamps are available as small bulbs and in tubular form, supplied in a range of sizes from 50 to 5000 W with colour temperatures ranging from 2700 to 3400 K. Special designs can replace conventional 500 W tungsten lamps in spot-lights and other luminaires with the added advantage of some 200 hours life and near-constant colour temperature. Replacement costs are higher, however. Most tungsten–halogen lamps operate at low voltages (12 or 24 V), which means that a much more compact filament can be used than with conventional filament lamps.

Fluorescent lamps

A *fluorescent lamp* is a low-pressure mercury-vapour discharge lamp with a cylindrical envelope coated internally with a mixture of fluorescent materials or *phosphors*. These absorb and convert short-wave UV radiation into visible light, the colour of which depends on the mixture of phosphors used. The resultant light quality can be made a close visual match to continuous-spectrum lighting.

Fluorescent lamps emit a line spectrum with a strong continuous background; their light quality can be expressed approximately as a *correlated colour temperature*. The *colour rendering index* may also be quoted. There are many subjective descriptive names for fluorescent lamps, such as 'daylight', 'warm white' and 'natural', but there is little agreement between manufacturers as to the precise SPD of a named variety. Lamps are also classified into two main groups, 'high-efficiency' and 'de-luxe'. The former group have approximately twice the light output of the latter for a given wattage, but are deficient in red. They include 'daylight' lamps of approximately 4000 K and 'warm white' lamps of approximately 3000 K, a rough match to domestic tungsten lighting. The de-luxe group gives good colour rendering by virtue of the use of lanthanide (rare-earth element) phosphors, and includes colour matching types at equivalent colour temperatures of 3000, 4000, 5000 and 6000 K.

Colour images recorded using fluorescent lamps, even if only present as background lighting, may result in unpleasant green or blue colour casts, especially on colour reversal film, needing corrective filtration by means of suitable colour-compensating filters over the camera lens.

Fluorescent lamps are supplied in the form of tubes of various lengths for use in a variety of domestic and industrial fittings. Domestic lamps operate at mains voltage and use a hot cathode, to maintain the discharge, which is usually initiated by a switch starter which produces a pulse of high voltage sufficient to ionize the gas. Cold-cathode fluorescent lamps use an emissive cathode at much higher voltages, and have instant-start characteristics. Such lamps, in grid or spiral form, were once used in large-format enlargers. However, such light sources are unsuitable for colour printing purposes. The life of a fluorescent tube is usually of the order of 7000 to 8000 hours, and the output is insensitive to small voltage fluctuations.

Metal-halide lamps

Originally the only metals used in discharge lamps were mercury and sodium, as the vapour pressures of other metals tend to be too low to give adequate working pressure. However the halides of most metals have higher vapour pressures than the metals themselves. In particular the halides of lanthanide elements readily dissociate into metals and halides within the arc of a discharge tube. The ionized metal vapour emits light with a multi-line spectrum and a strong continuous background, giving what is virtually a continuous spectrum. The metals and halides recombine in cooler parts of the envelope. Compounds used include mixtures of the iodides of sodium, thallium and gallium, and halides of dysprosium, thulium and holmium in trace amounts. The discharge lamp is a very small ellipsoidal quartz envelope with tungsten electrodes and molybdenum seals. Oxidation of these seals limits lamp life to about 200 hours, but by enclosing the tube in an outer casing and reflector with an inert gas filling, life can be increased to 1000 hours.

The small size of this lamp has given rise to the term *compact-source iodide* lamp (CSI). Light output is very high, with an efficacy of 85 to 100 lumens per watt. A short warm-up time is needed. The *hydra-gyrum metal iodide* (HMI) lamp uses mercury and argon gases with iodides of dysprosium, thulium and holmium to give a daylight-matching spectrum of precisely 5600 K and CRI of 90 with a high UV output also.

When these sources are operated on an AC supply the light output fluctuates at twice the supply frequency. Whereas the resulting variation in intensity is about 7 per cent for conventional tungsten lamps it is some 60–80 per cent for metal halide lamps. This can cause problems when used for short exposure durations in photography, unless a three phase supply or special ballast control gear is used. Ratings of up to 5 kW are available.

Pulsed xenon lamps

Pulsed xenon lamps are a continuously operating form of electronic flash device. By suitable circuit design a quartz tube filled with xenon gas at low

pressure discharges at twice the mains frequency, i.e. 100 Hz for a 50 Hz supply, so that although pulsed, the light output appears continuous to the eye. The spectral emission is virtually continuous, with a colour temperature of approximately 5600 K (plus significant amounts of ultraviolet and infrared radiation). Forced cooling may be needed. The physical dimensions of such lamps are small, and they have replaced traditional carbon-arc lamps and especially used for film projection. Power ratings up to 8 kW are available, and lamp life is 300 to 1000 hours depending on type.

Expendable flashbulbs

The traditional flashbulb is now obsolescent with only a very few types available. They still have specific uses however, such as for lighting very large interiors or for high speed recording where a series of bulbs fired in a 'ripple' give an intense compact source for a short time. Electronic flash units are now very compact in size and have replaced the traditional flashgun for expendable photochemical flashbulbs. However it is useful to document the properties and features of flashbulbs.

Flashbulbs contain fine metal ribbon in an atmosphere of oxygen at low pressure, enclosed in a glass envelope with a lacquer coating to prevent shattering when fired. The metal ribbon in smaller bulbs was hafnium or zirconium; larger bulbs use an aluminium–magnesium alloy. On ignition by the passage of electric current through a filament, a bright flash of light is emitted as the metal burns, of duration about 0.01 to 0.02 seconds, the larger bulbs emitting a longer flash. The emission spectrum is continuous, with a CT of about 3800 K. A transparent blue lacquer coating converts this CT to 5500 K. Blue flashbulbs were originally intended for use with colour film, but they are equally suitable for black-and-white materials. In the case of *flashbulb arrays* such as 'flashcubes', four small clear flashbulbs were each housed with their individual reflectors in an outer enclosure of transparent blue plastic material which acted as a colour conversion filter.

Flashbulbs are triggered from batteries with a voltage range from about 3 to 30 volts. Although a circuit which connects a 3 V or 4.5 V DC voltage directly across the bulb will fire the bulb, for greater reliability a *battery-capacitor circuit* is used (Figure 3.10). A battery charges a capacitor through a high resistance. The discharge of the capacitor then fires the bulb. A small 15 V or 22.5 V battery is commonly used in such a circuit; these cannot be used on their own to fire the flashbulb because of their high internal resistance. In the circuit shown in Figure 3.10 the capacitor is charged only when a bulb is inserted into a socket, so that battery life is conserved if the flashgun is stored without a bulb in place. The resistor

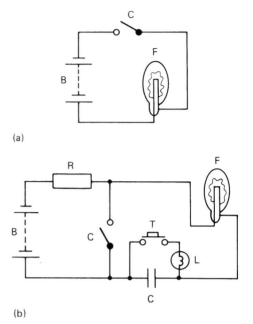

Figure 3.10 Flashbulb firing circuits. (a) Direct ignition from battery B (3–45 volts DC) to flashbulb F using shutter synchronization or 'open flash' contacts C. (b) Capacitor ignition where B is 15 or 22.5 volts, resistor R is 3–5 kilohms and capacitor C is 100–250 microfarads. Pushbutton switch T is for charge test lamp L

is of a value sufficiently high to ensure that the capacitor-charging current will not fire the flashbulb, but is low enough to give a short charging time. A test lamp is used to check on the state of charge. Such a circuit may be used to fire several flashbulbs simultaneously in a multiple-flash set-up. The limitations to this arrangement are the resistances of the connecting wires, which may be quite long. A better arrangement is to use *slave units* connected to the individual extension flashguns so one flashbulb is triggered from the camera shutter contacts, and the light emitted by it operates *photocell switches* installed in the slave units to give near-simultaneous firing.

To avoid the necessity for batteries, alternative methods were used for firing flashcubes and other arrays of bulbs in units intended primarily for simple cameras. The 'Magicube' type used mechanical firing of a special bulb containing a tube loaded with a priming chemical. Each bulb had its own external torsion spring. On releasing the shutter the primer tube was struck by the spring. The primer ignited and fired the filling. The time from firing to peak output intensity was a usefully short 7 milliseconds.

Alternatively, a piezo-electric crystal in the camera body produced the firing pulse when struck by a striker mechanism coupled to the camera shutter

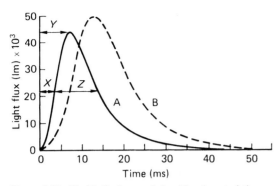

Figure 3.11 Flashbulb characteristics. The characteristics are shown on a graph of light output in lumens against time in milliseconds for a Magicube A and a Flip-Flash B. The time to half-peak is *X*, time to peak is *Y* and effective flash duration is *Z*, measured between half-peaks. For bulb A, *X*, *Y* and *Z* have values of 4, 7 and 9.5 ms respectively. For bulb B, *X*, *Y* and *Z* have values of 7, 13 and 14.5 ms respectively

release. Bulbs in a spatial array were fired sequentially by current-steering thermal switches which in turn closed circuit paths to the next bulb. Both of these arrangements required cameras with the firing arrangements included in their construction.

Flashbulb performance is shown as a graph of emitted luminous flux plotted against time, as in Figure 3.11, and various parameters can be determined. *Effective flash duration* is a measure of the motion-stopping power of the flash and is the time interval between half-peak points. The camera shutter must be fully open at the point of peak output. The total light output (in lumen seconds) is given by the area under the curve.

A *guide number* or *flash factor* can be used to calculate camera exposure. A guide number (*G*) is the product of the f-number (*N*) of the camera lens and the subject distance (*d*) in metres for film of speed 100 ISO.

$$G = dN \qquad (5)$$

Guide numbers are quoted for a range of film speeds and exposure times for leaf shutters. They are subject to modification to suit the particular conditions of use, being influenced by the reflective properties of the surroundings of the subject. Guide numbers are estimated from the following formula:

$$G = \sqrt{(0.004\ LtRS)} \qquad (6)$$

where *L* is the maximum light flux in lumens, *t* is the exposure duration in seconds, *R* is the reflector factor and *S* is the arithmetic film speed. A modification necessary for units with built-in reflectors such as flashcubes, is to

$$G = \sqrt{(0.05\ EtS)} \qquad (7)$$

where *E* is the *effective beam intensity* of the bulb. This quantity is measured by an integrating light meter across the entire angle of coverage of the reflector and is not influenced by hot spots. It replaces the alternative *beam candle power* (BCP), which was measured at the centre of the beam only, and could be misleading.

The problems of flash synchronization with the shutter are discussed in Chapter 9.

Electronic flash

Flash circuitry

In an electronic flashtube, an electrical discharge takes place in an atmosphere of a gas such as xenon, krypton or argon or a mixture of these gases, causing emission of a brief, intense flash of light. Unlike the contents of expendable flashbulbs, the active components are not consumed by this operation and the tube may be flashed repeatedly, with a life expectancy of many thousands of flashes.

The essentials of an electronic flash circuit are shown in Figure 3.12. A capacitor is charged from a solid-state high-voltage DC supply of the order of 350 to 500 V, through a current-limiting resistor. This resistor allows a high-power output from a low-current-rated supply with suitably long charging times, of the order of several seconds; also, because the charge current is limited the gas becomes de-ionized and the flash is extinguished after the discharge. At the charging voltage the high internal resistance of the gas in the flashtube prevents any flow of current from the main capacitor; but by apply a triggering voltage (typically a short pulse of 5–15 kV) by means of an external electrode, the gas is ionized and becomes conducting, allowing the capacitor to discharge rapidly through it, resulting in a brief flash of light. This voltage is a spark coil arrangement using a capacitor and transformer, and is usually triggered by the shutter contacts in the camera. The voltage is limited to less than 150 V and 500 μA by positioning it on the low-voltage side of the spark coil, so that this voltage appears only on the contacts, preventing possible accidental injury to the user and damage to the shutter contacts. The trigger electrode may be in the form of fine wire around the flashtube or a transparent conductive coating.

The SPD of the flash discharge is basically the line spectrum characteristic of xenon, superimposed on a very strong continuous background. The light emitted has a correlated colour temperature of about 6000 K. The characteristic bluish cast given by electronic flash with some colour reversal materials may be corrected either by a light-balancing filter with a low positive mired shift value, or by a pale yellow colour-compensating filter. Often the flashtube or reflector is

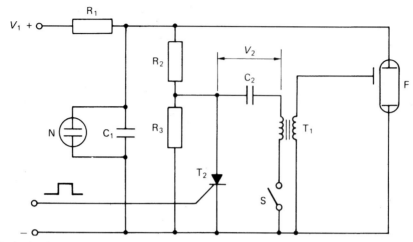

Figure 3.12 Basic electrical circuit for an electronic flashgun. The input voltage V_1 charges the main capacitor C_1 via limiting resistor R_1. The neon light N shows the state of charge reached. The trigger capacitor C_2 is charged by a primary trigger voltage V_2. R_2 and R_3 are limiting resistors. Closure of shutter contacts S and receipt of a pulse by the triggering thyristor T_2 causes C_2 to discharge through primary of trigger transformer T_1 to give a high voltage pulse to the external electrode of the flashtube F. The tube becomes conducting and C_1 discharges through it to produce a brief flash of light

tinted yellow or yellow-green as a means of compensation. The flashtube may be of borosilicate glass or quartz, the former giving a cut-off at 300 nm, the latter at 180 nm. Both transmit wavelengths up to 1500 nm in the infrared region. By suitable design of control circuitry, ultraviolet or infrared output can be enhanced, so an electronic flashgun can be a useful source of these radiations as well as visible light.

Flash output and power

The power output is altered by switching additional capacitors in or out of circuit, or the current may be divided between two tubes or separate heads or by thyristor control. The output can be 'symmetrical' or 'asymmetrical', e.g. 1000 Ws^{-1} divided either into 2 × 500 or 4 × 250, or into 500 plus 2 × 250 Ws^{-1} respectively. Alternative low-power settings typically offer alternative outputs from 1/2 to 1/32 of full power in halving steps. Extension heads may be used for multiple flash arrangements and each head may have its own capacitor. If the extension head shares the main capacitor output the connecting lead must be substantial, to reduce resistance losses. For greatest efficiency the connection between capacitor and flashtube must be as short and of as low resistance as possible. One-piece or 'monobloc' studio flash units are examples of this type. The use of slave units for synchronization facilitates multiple-head flash operation.

The *energy input* E_i per flash in watt-seconds (Ws^{-1}), often still called 'joules' (J), not all of which is available as output, is given by

$$E_i = \frac{CV^2}{2} \qquad (8)$$

where C is the capacitance in microfarads and V is the voltage in kilovolts. The *energy output* E_o is estimated by a formula for flash energy conversion such as

$$E_o = E_i K_1 K_2 K_3 K_4 \qquad (9)$$

where K_1 is the conversion efficiency (some 50–60 per cent), K_2 is the percentage of spectral bandwidth used, K_3 is the percentage of the emitted light directed at the subject by the optical system, and K_4 is an empirical factor.

Small integral units are rated at 5–20 Ws^{-1} (joules), hand-held units for on-camera at 20–200 Ws^{-1}, while large studio flash units are available with ratings of some 200–5000 Ws^{-1}. The state of charge of the capacitor, i.e. readiness for discharge, is indicated by a neon light or beeping sound circuit which is usually set to strike at about 80 per cent of maximum voltage, i.e. at about two-thirds full charge. Several seconds must be allowed to elapse after this to ensure full charge. If the flash is not then triggered, various forms of monitoring circuitry may be used to switch the charging circuitry on and off to maintain full charge ('top-up') with minimum use of the power supply while conserving battery power. Some units may be equipped with monitoring circuitry that switches it off if not used within a set period. The stored energy is 'dumped' as a safety measure.

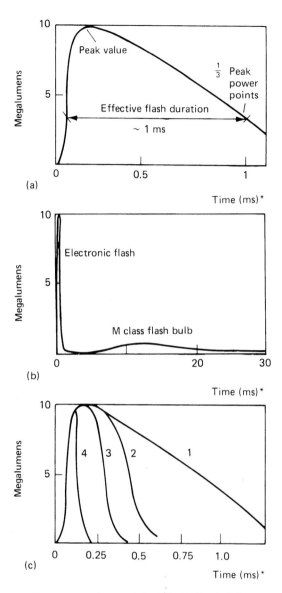

(a)

(b)

(c)

*as measured from point where shutter is fully open

Figure 3.13 Characteristics of electronic flash.
(a) Conventional graph of light output in megalumens against time in milliseconds. (b) Comparison of electronic flash and a medium size flashbulb. (c) Variation of effective flash duration, curves 1 to 4, as the discharge is quenched for automatic exposure by a thyristor circuit

Changes to the flash circuitry allow the flash tube to be operated in a *strobe mode*, i.e emit a series of short flashes as well as a longer single flash. This allows a series of 'preflashes' to be emitted for red-eye reduction or for scene analysis, or during the shutter operation to give a multiple exposure strobe effect or to allow high shutter speeds to be used.

Flash duration and exposure

The characteristics of an electronic flash discharge are shown in Figure 3.13. The *effective flash duration* (t) is usually measured between one-third-peak power points, and the area under the curve between these points represents approximately 90 per cent of the light emitted, measured in lumen-seconds or effective beam-candela-seconds. The flash duration t, as defined above, in a circuit whose total tube and circuit resistance is R with a capacitor of capacitance C is given approximately by

$$t = \frac{RC}{2} \tag{10}$$

So, for a 1 millisecond duration flash, the requirements are for high capacitance, low voltage and a tube of high internal resistance. The flash duration is usually in the range 2 ms to 0.02 ms to effect a compromise between ability to stop motion and avoidance of the possible effects of high-intensity reciprocity law failure. Units may have a variable output, controlled either by switching in or out of additional capacitors or by automatic 'quenching' controlled by monitoring of scene or image luminance (see later), giving a suitable variation in either intensity or flash duration. For example, a studio flash unit on full power may have a flash duration of 2 ms, changing to 1 ms and 0.5 ms when half- and quarter-power respectively are selected. Some special *micro-flash* units for scientific applications may have outputs whose duration is of the order of 1 micro-second but with only about $1\,Ws^{-1}$ of energy. The output efficacy (P) of a flashtube is defined as being

$$P = \frac{Lt}{JE_i} \tag{11}$$

where L is the peak output (in lumens). The guide number of a flash unit with reflector factor R used with a film of arithmetic speed rating S is given by

$$G = \sqrt{0.005\,RSPE_i} \tag{12}$$

A useful practical point is that for a given flash unit the flash guide number for distance in metres for ISO 100 film is usually incorporated in the designation number of the unit, e.g. 45 means $G = 45$.

The usual practical restrictions apply to guide number values. The silvered reflectors used with electronic flashguns are highly efficient and direct the emitted light into a well-defined rectangular area with sharp cut-off, approximating to the coverage of a semi-wide-angle lens on a camera. Coverage may be altered to greater or lesser areas to correspond with the coverage of other lenses or a zoom lens by the addition of clip-on diffusers or by moving a Fresnel type condenser lens in front of the flashtube to an

alternative position. A moving tube 'zoom' feature may even be controlled automatically by the camera itself as a zoom lens is operated.

The use of diffusers and 'bounce' or indirect flash severely reduces the illumination on the subject and often needs corrective filtration with colour materials owing to the nature and colour of the reflective surface. This can be used to advantage, as when a golden-surfaced umbrella reflector is used to modify the slight blue cast given by some flash units, which may have colour temperatures of 6000 K or more. The main result of 'bounce' lighting is to produce softer, more even illumination. An umbrella-type reflector of roughly paraboloidal shape, made of translucent or opaque material, with white or metallic silver or gold finish, is a widely used accessory item, as are translucent umbrellas and 'soft boxes' to diffuse the light.

Portable units

A portable flash unit is small enough to be carried conveniently and attached to a camera without strain on the hotshoe connection (see Figure 3.14a), although a side bracket may be preferred (see Figure 3.14b). The power supply is normally batteries. There are various alternatives and occasionally a mains adapter may be available. The simplest is a high-voltage dry battery, but this is heavy and expensive.

The preferred alternative is a low-voltage battery giving 6–9 V with suitable circuitry to convert this into high voltage. This can be a transistorized oscillator to convert DC into AC (producing a characteristic whining noise); the voltage is increased by a step-up transformer and then rectified to DC once more.

Batteries may be of the zinc–carbon variety, or alkaline–manganese for improved performance. Alternatively, rechargeable nickel–cadmium (NiCd) or lead–acid cells may be used. A set of NiCd batteries may have a capacity only enough for about 40 full-power flashes (enough for a 36 exposure film) in the absence of energy-saving circuitry (see later). Circuitry may be incorporated inside the flash unit for the recharging cycle using mains power. A visual state-of-charge indicator in the forms of floating coloured balls has been used with lead–acid cells, as the relative density of the acid varies with the level of discharge. NiCd batteries are completely sealed and need no maintenance other than an occasional full discharge to prevent loss of capacity due to a 'memory' effect if they are frequently recharged before being fully exhausted. This memory effect does not occur with other types such as nickel metal hydride and lithium ion batteries. An LED display may show the state of charge or discharge of a set of batteries, very convenient in use. Where size and weight is crucial, small but powerful lithium batteries can be used, but these are usually single-use types only.

(a) (b)

Figure 3.14 Attachment of flash units to a camera. (a) Using a hotshoe on the pentaprism housing. The flash unit has dual tubes for a mixture of direct and bounce flash. (b) Using a side bracket. The box connected to the hotshoe contains circuitry to interface the flashgun with the camera to provide a range of automatic features

A range of accessories is available. The reflectors may be interchangeable from 'bare-bulb' to a deep paraboloid to give different beam shapes and lighting effects. Various modes of use include direct flash at full power, tilting reflectors for bounce flash, fractional output for close-up work or fill-in flash in sunlight, automatic exposure mode, programmed mode or stroboscopic mode. A data display panel using liquid crystal technology gives a comprehensive readout of the operational mode in use.

Studio flash

A *studio flash unit* is of substantial size and weight (Figure 3.15) and usually used indoors but is transportable. Output is from 250 to $5000\,\mathrm{Ws^{-1}}$. The power supply is from the mains (a special supply may be needed) or a generator for location work, or even a large battery pack. The discharge tube may be in a linear or helical shape or possibly circular to give a 'ring-flash'. Studio units have the convenience of a 'modelling lamp' positioned near the discharge tube to give a preview of the proposed lighting effect. The modelling lamp may be a photoflood or tungsten–

Figure 3.16 A studio flash head with remote control of output via a handset. A display on the unit shows the status of the unit

halogen lamp, often with fan-assisted cooling, and its output may be variable, with the flash output selected so as to facilitate visual judgement of lighting balance. The flash output of a studio unit may be selected manually by switches or by remote control (Figure 3.16), or by a cordless infrared programming unit used in the hand from the camera position. The flash output may be set within limits as precisely as one-tenth of a stop, a great convenience in balancing lighting rather than by shifting lights about, and allowing a smaller studio to be used.

The calculation of the appropriate lens aperture setting may be arrived at by using guide numbers, practical experience, exposure meter readings using modelling light illumination, or usually by the use of an integrating *flash meter*. Automatic methods include the use of photocells to monitor the scene luminance or the image luminance on the film surface by reflected light to a photocell in the camera body during the flash discharge. This is termed *off-the-film* (OTF) flash metering. As a confirmation and to give confidence in the outcome, a sheet of Polaroid self-developing film may be exposed to evaluate exposure and lighting, as well as to check that everything is operating satisfactorily.

Automatic flash exposure

A significant development in flashgun design was the automation of camera exposure determination and consequent power-saving advantages. This feature uses solid-state rapid acting devices called *thyristor switches*.

A rapid-acting photosensor such as a phototransistor or silicon photodiode (SPD) monitors the subject luminance when being illuminated by the flash discharge, and the resultant output signal

Figure 3.15 A two-head studio flash unit with stands, generator and case for transportation. The deep parabolic reflector units are interchangeable for other types

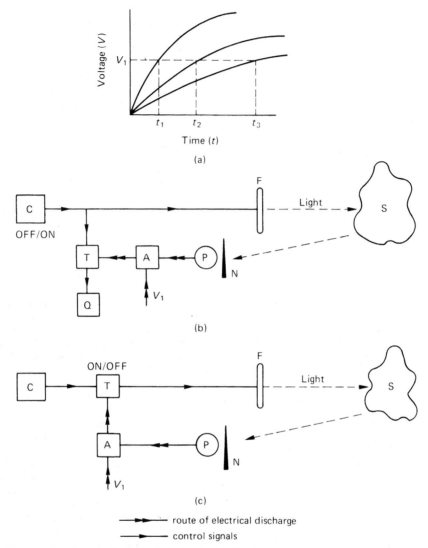

Figure 3.17 The operation of automatic electronic flash units. (a) Charging characteristics of the integrating capacitor shown as voltage against time. Voltage V_1 is the preset triggering level. (b) Arrangement of the quench tube and thyristor switch. (c) Preferred power-saving arrangement. Key: C main capacitor, F flashtube, S subject, P photocell, T thyristor switch, Q quench tube, N neutral density wedge, A integrating amplifier preset to give a pulse to the thyristor at voltage V_1 of the charging curve of the timing capacitor as shown in (a). t_1, t_2 and t_3 are various flash durations determined by the operating conditions

integrated until it reaches a preset level. The flash discharge can then be abruptly cut off to give the correct exposure, subject to some limitations. The switch-off level is determined by the film speed and lens aperture in use. Typically, the integrating circuit is a capacitor which charges up to a preset voltage level, the time taken being a function of the intensity and duration of light reaching the photocell (Figure 3.17).

The discharge is switched off by the thyristor. There are two possibilities. First, the discharging

capacitor may have its residual energy diverted into an alternative 'quench' tube, which is a low-resistance discharge tube connected in parallel with the main tube. The quench circuit is activated only when the main tube has ignited so as to prevent effects from other flashguns in use in the vicinity. There is no light output from the quench tube and the dumped energy is lost. The effective flash duration, dependent on subject distance, reflectance and film speed, may be as short as 0.02 ms, with concomitant motion-stopping ability.

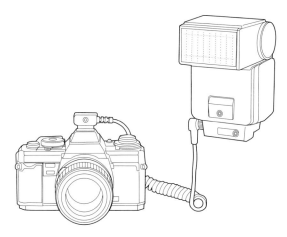

Figure 3.18 A small flash unit connected to the hotshoe by an extension lead terminating in a small housing containing the photocell for automatic operation

The second, preferred switching arrangement saves the residual charge in the capacitor and thereby reduces recharging time per successive flash and also increases the total number of flashes available from a set of batteries. This *energy-saving circuitry* has the thyristor switch positioned between the main capacitor and the flashtube. The characteristic of the thyristor is that it may be closed on command, i.e. when the flash is initiated, and then opened almost instantaneously on receiving a pulse from the light-monitoring circuit to terminate the flow of current sustaining the flash. Obviously a high current-handling ability is needed. An added advantage is that full flash discharge is possible in manual mode simply by taking the monitoring photocell out of circuit or covering it over so that the 'open' pulse is never given. To allow for the use of different film speeds and lens apertures the photocell may be biased electrically or mechanically. The former method would cause alterations in the firing voltage of the timing capacitor, so the latter is usually preferred and is also much easier, requiring only a vane-type mask or a turret of neutral-density filters over the photocell. The two types of circuit arrangement are shown in Figure 3.17. The circuitry also allows for a choice of maximum outputs to suit a range of subject distances with a selected f-number, so that overexposure does not occur say with close-up photography, or that there can be some control of depth of field. The flash duration reduces as the flash is quenched more rapidly over a range of usually 30 or 50 to 1, i.e. from 1 ms at full power to 0.02 ms at minimum power. This is useful for capturing motion of a subject. Flash colour temperature may also change with output duration, tending to rise as duration reduces.

The photocell can be in a small hotshoe-mounted housing attached to the flash unit by a flying lead (Figure 3.18), which allows monitoring of scene luminance irrespective of the flash-head position, and, in particular, allows for the use of bounce flash. It is desirable with flashguns having an integral photocell that this is positioned to face the subject irrespective of the direction in which a rotatable or swivelling flashtube assembly may be pointed. Often a second supplementary flashtube is integrated into the gun, giving a small direct flash towards the subject to offset some of the less desirable effects of the bounce lighting from the main tube (Figure 3.19). Two or more automatic flashguns can be combined for multiple flash work using suitable connecting leads. The hotshoe connection on the camera provides a single central 'X' flash synchronization connection. Depending on the camera system, several other connections may be provided to interface the flashgun with the camera to provide features such as automatic selection of a shutter speed for correct synchronization when the flash is attached, a 'thunderbolt' readylight indication in the viewfinder, use of a short 'preflash' for autofocus use or exposure determination and control of a zoom flash feature. The flash synchronization may be selectable to be *first blind* or *second blind* type where it is triggered

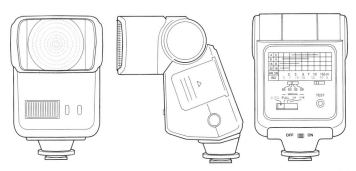

Figure 3.19 Front, side and rear views of a small automatic flashgun. The combined Fresnel lens and diffuser shapes the output beam. A secondary flashtube gives direct flash. The flash head can be tilted and swivelled for indirect flash. A simple display on the back shows operating range

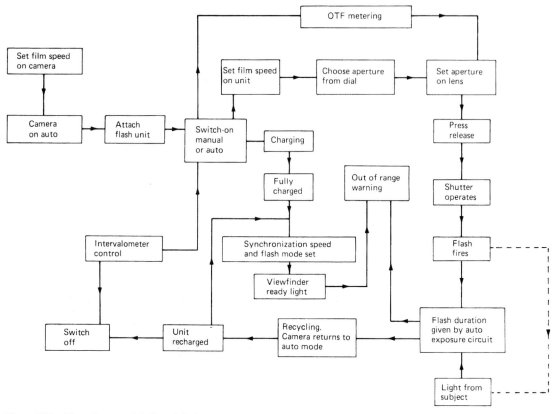

Figure 3.20 Flow diagram of dedicated flashgun operation. The major stages of operational sequences and the features offered by such flashguns are shown

either by the first blind uncovering the film gate or by the second blind just before it starts to cover up the gate. This latter feature is useful for combined flash and short time exposures with moving subjects to give an enhanced impression of motion. The problems of flash synchronization to the camera shutter are dealt with in Chapter 9.

The flash unit may be controlled by a photocell located inside the camera which monitors the luminance of the image of the scene actually on the film surface while the camera shutter is fully open at the flash synchronization speed when the film gate is fully uncovered. The photocell used may be a segmented type to provide a weighted analysis of the tonal range and distribution in the scene, often referred to as 'matrix flash'. In particular, for use in ambient light to provide fill-in by 'synchro-sunlight' techniques, this scene analysis can provide exactly the right amount of supplementary flash to give a more pleasing image. A typical block diagram for dedicated-flash operation is shown in Figure 3.20.

An automatic flashgun may only operate fully with a particular camera, when it is called a 'dedicated'

flashgun. Independent manufacturers supply interchangeable modules to allow a flashgun to be used fully with different cameras.

Integral flash units

As flash units have decreased in size but still retain a useful output, more cameras are provided with an inbuilt or *integral flash* unit. This can be just a fixed output flash arrangement as in the case of single-use cameras or a more sophisticated system with a range of modes in other cameras. In compact cameras the flash is automatically activated when the light level is too low for an ambient-light exposure. The flash output may be just a single full discharge, the necessary lens aperture being set to the required value according to the guide number for the unit by using subject distance information from the autofocus system used in the camera. This has been referred to as a 'flashmatic' system. In more complex cameras, particularly the SLR type, the flashgun is often fully automated with a photocell for through-the-lens and

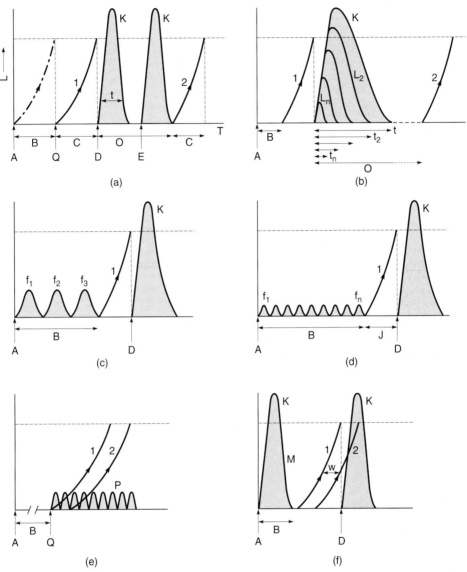

Figure 3.21 Flash modes and shutter synchronization. (a) First and second blind synchronization: 1, first (leading) blind; 2, second (trailing) blind; A, shutter triggered; B, reflex mirror time; C, blind travel time; D, flash triggered by first blind (X synchronization); E, flash triggered by second blind; O, film gate fully uncovered (flash synchronization speed); L, flash output; T, elapsed time; t, flash duration (nominal); K, main flash; Q, start of blind travel. (b) Quenched electronic flash: t_2, reduced flash duration; L_2 reduced flash output. (c) Red-eye reduction by bright preflashes: f_1, f_2, f_3, preflashes. (d) Matrix metering of scene using faint preflashes: f_1 to f_n, weak preflashes; J, data processing. (e) Flash with high shutter speeds, e.g. to 1/12 000 second, using high frequency strobe flashes: P, pulsed strobe flash. (f) Flash synchronization errors: M, incorrect use of M instead of X synchronization setting; W, shutter speed too short for synchronization, a travelling slit is formed

off-the-film operation. The user may be able to select from a menu of modes such as 'automatic', i.e selected according to subject luminance, 'off' when no flash fires, 'on' when the flash fires irrespective of light conditions and always at full power, or 'red-eye reduction' to alleviate this disturbing effect.

Redeye avoidance

An unfortunate optical consequence of an integral flash is that the flashtube is located rather too close to the lens so that the light is directed essentially along the optical axis. This direct *axial lighting* can be a

problem with reflective subjects when a glare spot is given in the picture, but even more so when a subject is looking at the camera. Light enters the eye via the pupil, which is usually fully dilated in the dim light conditions requiring the use of flash, and illuminates the retina at the back of the eye which is rich in red blood vessels. The result is a characteristic bright red pupil instead of the expected black. This red-eye effect can be reduced or removed in various ways. The ambient light can be increased to cause the pupil to contract, or a small projector in the camera or flashgun can direct a pencil beam of light at the face to same effect or the flashgun can emit a number of short preflashes before the main exposure, when hopefully the pupil will have reacted. Other methods require the sitter to look away from the camera lens, but the most effective method is to move the flashtube as far away from the camera lens as possible. This influences camera design and the integral flash unit may be on a short extension of the camera body for use. The same problems occur with portable flash units and they should not be used attached to the camera if possible but on an extension cable. The choice and disposition of lighting to suit the 'treatment' of the subject is beyond the scope of this book.

The various forms of flash synchronization and output, whether full, quenched and pulsed, are shown and compared in Figure 3.21.

Other sources

A number of other light and radiation sources find use in photography and digital imaging, for both image capture and illumination systems.

Light emitting diodes

The *light emitting diode* or LED is a very small solid-state device encapsulated in a housing with integral lens to direct and shape the emitted beam. Operation is by electroluminescence using forward biasing of a p–n junction in materials such as gallium arsenide or gallium phosphide. Light output is monochromatic and, typically, red (649 nm), green (570 nm) or infrared (850 nm). The LED can be mains or battery powered and has very modest power consumption, but can still be a significant drain on the limited capacity of the battery in a camera. It has a principal use as an indicator light for equipment operational conditions or modes. The small source can be used alone or behind a patterned mask to give an alphanumerical or symbolic display, as in a view-finder or flashgun data readout. The usual states are off, on, pulsing or dimmed (given by altering a flashing rate from a pulsed supply).

To provide a more intense beam suitable for illumination purposes, LEDs are used in arrays of multiple sources, e.g. emitting in the near infrared as used for covert work to illuminate a scene for recording by a suitable infrared system. An illuminator operating from a 12 V supply can illuminate a scene up to 25 m distant. Illuminators can be rectangular, linear or annular in shape to suit the illumination task. A pulse rate up to 150 Hz is typical. The red monochromatic emission finds use also in the darkroom as a bright safelight for room illumination or as a portable unit for hand-held local illumination.

Diode lasers

The *diode laser* or 'microlaser' is a semiconductor crystal derived from gallium arsenide that emits intense coherent light at a few wavelengths by stimulated emission, as compared to the spontaneous emission of an LED that produces incoherent light with a wider spectral range. The astigmatic shape of the output beam requires optical correction to a circular form. The devices can be assembled in rectangular array, linear (bar) or single source form. Laser wavelengths of 750 to 780 nm are typically used in optical disc (compact disc CD) reader systems with a single source. Wavelengths of 670 and 780 nm are suited to printing plate technology using digital data direct from computer image files.

These devices can have an intense monochromatic output suited to three-colour (red, green, blue) exposure systems in various forms of printer to provide a hard copy output from digital files and may even use three different infrared wavelengths to expose the three colour-forming image layers. Display systems may use red (656 nm), green (532 nm) and blue (457 nm) modulated microlaser beams to form a direct write display.

Bibliography

Carlson, V. and Carlson, S. (1991) *Professional Lighting Handbook*, 2nd edn. Focal Press, Boston, MA.

Cayless, M. and Marsden, A. (eds) (1983) *Lamps and Lighting*, 3rd edn. Edward Arnold, London.

Edgerton, E. (1970) *Electronic Flash, Strobe*. McGraw-Hill, New York.

Fitt, B. and Thornley, J. (1997) *Lighting Technology*. Focal Press, Oxford.

Minnaert, M. (1993) *Light and Colour in the Outdoors*. Springer-Verlag, New York.

Ray, S. (1994) *Applied Photographic Optics*, 2nd edn. Focal Press, Oxford.

Ray, S. (1999) *Scientific Photography and Applied Imaging*. Focal Press, Oxford.

4 The geometry of image formation

Interaction of light with matter

Imaging generally records the interaction of light or radiation with the subject, except for self-luminous or emissive subjects and uses lenses or optical systems to form an image at the photoplane of a camera. There are four principal effects of the interaction of light with an object, namely *absorption, reflection, transmission*, and *chemical change*. The first two of these always occur to some extent: transmission occurs in the case of translucent or transparent matter; and chemical change occurs under appropriate circumstances. The absorbed light energy is not destroyed, but converted to another such as heat, or sometimes electrical or chemical energy. This chapter details the behaviour of reflected or transmitted light, and the formation of an optical image.

Transmission

Some transparent and translucent materials allow light to pass completely through them apart from absorption losses. Such light is said to be *transmitted* and the *transmittance* (*T*) of the material is the ratio of emergent luminous flux to incident luminous flux. *Direct transmission* (sometimes miscalled 'specular transmission') refers to light transmitted without scatter, as for example by clear optical glass. If *selective absorption* takes place for particular wavelengths of incident white light, then the material is seen as coloured by transmitted light, as in the case of a camera filter. If *scattering* occurs, as in a translucent medium, the light undergoes *diffuse transmission*, which may be uniform or directional or preferential. The transmittance of such a medium may be defined as in either a general or in a specific direction.

Reflection

Depending on the nature of the surface, particularly its smoothness, the reflection of light may be *direct* or *diffuse*. *Direct* or *specular reflection* is the type of reflection given by a highly polished surface such as a mirror, and is subject to the *laws of reflection* (Figure 4.1). Light incident on the surface is reflected at an angle equal to the angle of incidence. (The angles of incidence and reflection are both measured

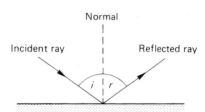

Figure 4.1 Specular reflection of an incident light ray by a plane mirror; $i = r$

from the *normal*, i.e. the line perpendicular to the surface at the point of incidence.) The surface brightness of a directly reflecting surface is highly dependent on viewpoint. A perfectly diffuse or *Lambertian surface*, on the other hand, reflects the incident light equally in all directions; thus its *brightness* or *luminance* is seen as constant irrespective of viewpoint. Few surfaces have such extreme properties; shiny surfaces usually produce some scattered light, and matt surfaces (Figure 4.2) may show a 'sheen'. Reflection from most surfaces combines both direct and diffuse reflection and is known as *mixed reflection*. Depending on the properties of the incident light, the nature of the material and angle of incidence, the reflected light may also be partially or completely polarized. Objects are seen mainly by diffusely reflected light which permits the perception of detail and texture, qualities not found in specular surfaces such as mirrors.

Reflectance (*R*) is defined as the ratio of the reflected luminous flux to the incident luminous flux, and (as with transmittance) this may be defined as either general or in a specific direction. Surfaces

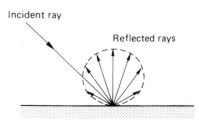

Figure 4.2 The diffuse reflection of an incident light ray by a matt surface

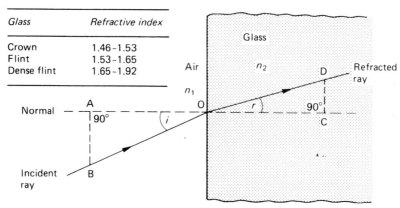

Glass	Refractive index
Crown	1.46–1.53
Flint	1.53–1.65
Dense flint	1.65–1.92

Figure 4.3 An obliquely incident light ray undergoing refraction when passing from air to glass

commonly encountered have reflectances in the range 0.02 (2 per cent) (matt black paint) to 0.9 (90 per cent).

Refraction

When a ray of light being transmitted in one medium passes into another of different optical properties its direction is changed at the interface except in the case when it enters normally, i.e. perpendicular to the interface. This *deviation*, or *refraction* of the ray results from a change in the velocity of light in passing from one medium to the next (Figure 4.3). Lenses utilize the refraction of glass to form *images*. Light travels more slowly in a denser medium, and a decrease (increase) in velocity causes the ray to be bent towards (away from) the normal. The ratio of the velocity in empty space to that within the medium is known as the *refractive index* (n) of the medium. For two media of refractive indices n_1 and n_2 where the angles of incidence and refraction are respectively i and r, then the amount of refraction is given by *Snell's Law*:

$$n_1 \sin i = n_2 \sin r \tag{1}$$

Taking n_1 as being air of refractive index approximately equal to 1, then the refractive index of the medium n_2 is given by

$$n_2 = \frac{\sin i}{\sin r} \tag{2}$$

The velocity of light in an optical medium depends on its wavelength, and refractive index varies in a non-linear manner with wavelength, being greater for blue light than for red light. A quoted value for

refractive index (n_λ) applies only to one particular wavelength. The one usually quoted (n_d) refers to the refractive index at the wavelength of the *d* line in the helium spectrum (587 nm).

When light is transmitted by clear optical glass solids or prisms, refraction causes effects such as *deviation*, *dispersion* and *total internal reflection* (Figure 4.4). Deviation is the change of direction of the emergent ray with respect to the direction of the incident ray. In the case of a parallel-sided glass block, the emergent ray is not deviated with respect to the original incident ray; but it is *displaced*, the amount depending on the angle of incidence and the thickness of the block and its refractive index. A non-parallel-sided prism deviates the ray by two refractions, the deviation D depending on the refracting angle A of the prism, and on its refractive index. But when white light is deviated by a prism it is also dispersed to form a *spectrum*. The dispersive power of a prism is not directly related to its refractive index and it is possible to almost neutralize dispersion by using two different types of glass together, whilst retaining some deviation. In *achromatic lenses* this allows rays of different wavelengths to be brought to a common focus (see Chapter 6).

For a ray of light emerging from a dense medium of refractive index n_2 into a less dense medium of refractive index n_1, the angle of refraction is greater than the angle of incidence, and increases as the angle of incidence increases until a *critical value* (i_c) is reached. At this angle of incidence the ray will not emerge at all, it will undergo *total internal reflection* (TIR).

At this *critical angle* of incidence, $i_c = \sin^{-1}(n_1/n_2)$. For air ($n_1 = 1$), also for glass with $n_2 = 1.66$, i_c is 37 degrees. TIR is used in reflector prisms to give almost 100 per cent reflection as compared with 95 per cent at best for uncoated front-surface mirrors. A 45 degree prism will deviate a *collimated* (i.e. parallel) beam through 90 degrees by TIR; but for a

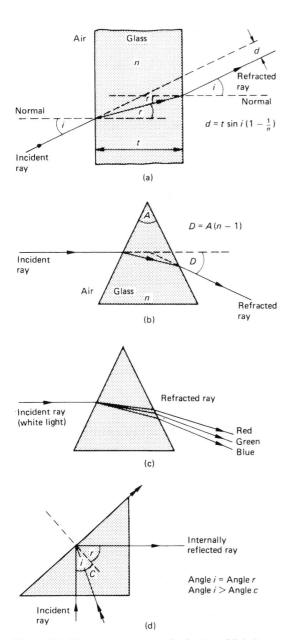

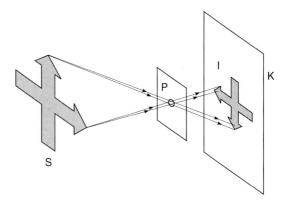

Figure 4.5 Formation of an image by a pinhole. The bundles of rays from points on the subject S pass through pinhole P and diverge to form an image I on photoplane surface K. The image is inverted, reversed, smaller and lacks sharpness

Figure 4.4 Various consequences of refraction of light by glass prisms. (a) A monochromatic light ray passing obliquely through a parallel-sided glass block, and resultant displacement *d*. (b) Refraction of monochromatic light caused by its passage through a prism, and resultant deviation *D*. (c) Dispersion of white light by a prism. (d) Total internal reflection in a right-angled prism, critical angle *C*

Image formation

When light from a subject passes through an optical system, the subject may appear to the viewer as being in a different place (and probably of a different size). This is due to the formation of an *optical image*. An optical system may be as simple as a plane mirror or as complex as a highly corrected camera lens. A simple method of image formation is via a *pinhole* in an opaque material (Figure 4.5). Two properties of this image are that it is *real*, i.e. it can be formed on a screen as rays from the object pass through the pinhole, and that, as light travels in straight lines, the image is *inverted*, and *laterally reversed* left to right as viewed from behind a scattering (focusing) screen. The ground-glass focusing screen of a technical camera when used with a pinhole shows such an image.

A pinhole is limited in the formation of real images, as the sharpness depends on the size of the pinhole. The optimum diameter (K) for a pinhole is given by the approximate formula:

$$K = \frac{\sqrt{v}}{25} \tag{3}$$

where v is the distance from pinhole to screen. A larger hole gives a brighter but less sharp image. A smaller hole gives a less bright image, but this is also less sharp owing to diffraction (see Chapter 6). Although a pinhole image does not suffer from curvilinear distortion, as images produced by lenses may do, its poor transmission of light and low resolution both limit its use to a few specialized applications.

widely diverging beam the angle of incidence may not exceed the critical angle for the whole beam, and it may be necessary to metallize the reflecting surface.

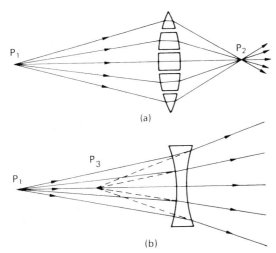

(a)

(b)

Figure 4.6 Negative and positive lenses. (a) A simple positive lens considered as a series of prisms. (b) Formation of a virtual image of a point object by a negative lens

The simple lens

A lens is a system of one or more pieces of glass or *elements* with (usually) spherical surfaces, all of whose centres are on a common axis, the *optical* (or *principal*) *axis*. A *simple* or *thin* lens is a single piece of glass or *element* whose axial thickness is small compared with its diameter, whereas a *compound* or *thick* lens consists of several air spaced *components*, some of which may comprise several elements cemented together, to correct for *aberrations*. A simple lens may be regarded as a number of prisms, as shown in Figure 4.6. Light diverging from a point source P_1 and incident on the front surface of the positive lens is redirected by refraction to form a real image at point P_2. These rays are said to come to a *focus*. Alternatively, by using a negative lens, the incident rays may be further diverged by the refraction of the lens, and so appear to have originated from a *virtual focus* at point P_3.

The front and rear surfaces of the lens may be convex, concave or plane; the six usual configurations of simple spherical lenses are shown in cross-section in Figure 4.7. A meniscus lens is one in which the *centres of curvature* of the surfaces are both on the same side of the lens. Simple positive meniscus lenses are used as *close-up lenses* for cameras. While the same refracting power in *dioptres* is possible with various pairs of curvatures, the *shape* of a close-up lens is important in determining its effect on the quality of the image given by the lens on the camera.

The relationships between the various parameters of a single-element lens of refractive index n_d, axial thickness q and radii of curvature of the surfaces R_1

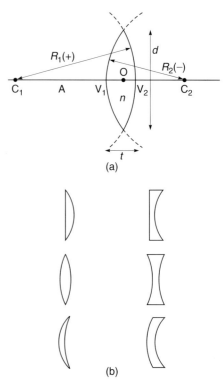

(a)

(b)

Figure 4.7 Simple lens. (a) Lens parameters; A, optical axis; C_1, C_2, centres of curvature with radii R_1 and R_2; V_1 and V_2, vertices of spherical surfaces; O, optical centre; n, refractive index; t, axial thickness; D, diameter. (b) Shape configurations: plano-convex, plano-concave, equi-biconvex, equi-biconcave, positive meniscus, negative meniscus

and R_2 required to give a *focal length f* or *(refractive) power K* are given by the general 'lensmakers' formula':

$$K = \frac{1}{f} = (n_d - 1)\left(\frac{1}{R_1} - \frac{1}{R_2}\right) + \left(\frac{(n_d - 1)q}{n_d R_1 R_2}\right) \quad (4)$$

For f measured in millimetres, power $K = 1000/f$ in dioptres. For a thin lens, equation (4) simplifies to

$$K = \frac{1}{f} = (n_d - 1)\left(\frac{1}{R_1} - \frac{1}{R_2}\right) \quad (5)$$

Image formation by a simple positive lens

Irrespective of their *configuration* of elements, camera lenses are similar to simple lenses in their image-forming properties. In particular, a camera lens always forms a real image if the object is at a distance of more than one focal length. The formation of the image of a point source has been discussed, now let

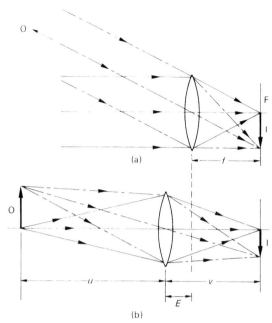

Figure 4.8 Image formation by a positive lens. (a) For a distant subject: F is the rear principal focal plane; (b) for a near subject: focusing extension $E = (v - f)$; I is an inverted real image

us consider the formation of the image of an extended object.

If the object is near the lens, the position and size of the optical image can be determined from the refraction of light diverging to the lens from two points at opposite ends of the object. Figure 4.8 shows this for a simple lens. The image is inverted, laterally reversed, minified, behind the lens and real.

To a first approximation, a distant object can be considered as being located at *infinity*. The rays that reach the lens from any point on the object are effectively parallel. As before the image is formed close to the lens, inverted, laterally reversed and real. The image plane in which this image is formed is termed the *principal focal plane* (F). For a flat distant object and an 'ideal' lens, every image point lies in this plane. The point of intersection of the focal plane and the optical axis is termed the *rear principal focus* (or simply the *focus*) of the lens, and the distance from this point to the lens is termed the *focal length* (*f*) of the lens. Only for an object at infinity does the *image distance* or *conjugate* (*v*) from the lens correspond to the focal length. As the object approaches the lens (i.e. object distance *u* decreases), the value of *v* increases (for a positive lens). If the lens is turned round, a second focal point is obtained; the focal length remains the same. The focal lengths of thick lenses are measured from different points in the lens

configuration (see below). Finally, the distance of the focus from the rear surface of a lens is known as the *back focus* or *back focal distance*. This is of importance in camera design so that optical devices such as reflex mirrors or beam-splitting prisms can be located between lens and photoplane.

Image formation by a compound lens

A lens is considered as 'thin' if its axial thickness is small compared to its diameter and to the object and image distances and its focal length, so that measurements can be made from the plane passing through its centre without significant error (Figure 4.9a). With a compound lens of axial thickness that is a significant fraction of its focal length, these measurements plainly cannot be made simply from the front or back surface of the lens or some point in between. However, it was proved by Gauss that a thick or compound lens could be treated as an equivalent thin one, and thin-lens formulae used to compute image properties, provided that the object and image conjugate distances were measured from two theoretical planes fixed with reference to the lens. This is referred to as *Gaussian optics*, and holds for *paraxial* conditions, i.e. for rays whose angle of incidence to the optical axis is less than some 10 degrees.

Gaussian optics uses six defined *cardinal* or *Gauss points* for any single lens or system of lenses. These are two *principal focal points*, two *principal points* and two *nodal points*. The corresponding planes through these points orthogonal to the optical axis are called the *focal planes*, *principal planes* and *nodal planes* respectively (Figure 4.9b). The focal length of a lens is then defined as the distance from a given principal point to the corresponding principal focal point. So a lens has two focal lengths, an object focal length and an image focal length; these are, however, usually equal (see below).

The definitions and properties of the cardinal points are as follows:

(1) *Object principal focal point* (F_1): The point whose image is on the axis at infinity in the image space.
(2) *Image principal focal point* (F_2): The point occupied by the image of an object on the axis at infinity in the object space.
(3) *Object principal point* (P_1): The point that is a distance from the object principal focal point equal to the object focal length F_1. All object distances are measured from this point.
(4) *Image principal point* (P_2): The point at a distance from the image principal focal point equal to the image focal length F_2. All image distances are measured from this point. The principal planes through these points are

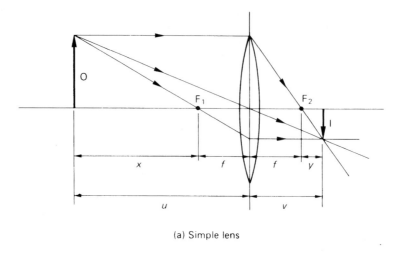

(a) Simple lens

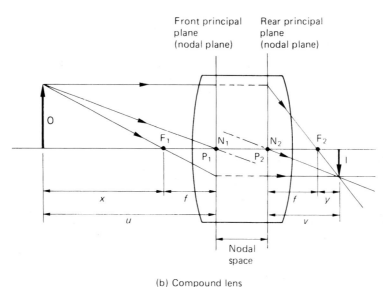

(b) Compound lens

Figure 4.9 Image formation by simple and compound lenses. (a) For a simple lens, distances are measured from the optical centre of the lens; distance y is the focusing extension. (b) For a compound lens, distances are measured from the principal or nodal planes (the principal planes coincide with the nodal planes when the lens is wholly in air)

important, as the thick lens system can be treated as if the refraction of the light rays by the lens takes place at these planes only. An important additional property is that they are planes of unit magnification for conjugate rays.

(5) *Object nodal point* (N_1) and
(6) *Image nodal point* (N_2) These are a pair of planes such that rays entering the lens in the direction of the object nodal point leave the lens travelling parallel to their original direction as if they came from the image nodal point. Any such ray is displaced but not deviated. If a lens is

rotated a few degrees about its rear nodal point the image of a distant object will remain stationary. This property is used to locate the nodal points, and is the optical principle underlying one form of panoramic camera.

If the lens lies wholly in air, the object and image focal length of the numerous elements in the configuration (known as the *effective* or *equivalent focal length*) are equal, and the positions of the principal and nodal points coincide. This considerably simplifies imaging calculations. The value

of Gaussian optics is that if the positions of the object and cardinal points are known, the image position and magnification can be calculated with no other knowledge of the optical system. Positions of the cardinal points and planes can be used for graphical construction of image properties such as location and magnification.

Usually the nodal points lie within the lens, but in some types, either or both of the nodal points may be outside the lens, either in front of it or behind it. In a few cases the nodal points may actually be 'crossed'. The distance between the nodal points is called the *nodal space* or hiatus; in the case of crossed nodal points this value is taken as negative.

Graphical construction of images

The refraction by a lens can be determined if the paths of some of the image-forming rays are traced by simple graphical means. For a positive lens four rules are used, based on the definitions of lens properties.

(1) A ray passing through the centre of a thin lens is undeviated.
(2) A ray entering a lens parallel to the optical axis, after refraction, passes through the focal point of the lens on the opposite side.
(3) A ray passing through the focal point of a lens, after refraction, emerges from the lens parallel to the optical axis.
(4) A meridional ray (one in a plane containing the optical axis), entering the front nodal plane at a height X above the axis, emerges from the rear nodal plane at the same height X above the axis on the same side and undeviated (see Figure 4.9b).

These rules (except the last) are illustrated in Figure 4.10, together with their modification to deal with image formation by negative lenses and concave and convex spherical mirrors. Image formation is shown for a range of types of lenses and mirrors. Note that in practice other surface shapes are used such as ellipsoidal and paraboloidal as well as aspheric, principally in the optics of illumination systems for projection and enlarging. Increasingly, aspheric surfaces are used in camera lenses to reduce the number of spherical surfaces otherwise required for adequate aberration correction.

The lens conjugate equation

A relationship can be derived between the conjugate distances and the focal length of a lens. With

reference to Figure 4.11, a positive lens of focal length f with an object distance u forms an image at distance v.

From similar triangles ABC and XYC,

$$\frac{AB}{XY} = \frac{BC}{YC} = \frac{u}{v} \qquad (6)$$

From the figure,

$$BF_1 = u - f \qquad (7)$$

Also from similar triangles ABF and QCF

$$\frac{BF_1}{CF_1} = \frac{AB}{QC} = \frac{AB}{XY} \qquad (8)$$

By substituting equations (6) and (7) in (8) we obtain

$$\frac{u - f}{f} = \frac{u}{v}$$

Rearranging and dividing by uf we obtain the *lens conjugate equation*

$$\frac{1}{u} + \frac{1}{v} = \frac{1}{f} \qquad (9)$$

This equation may be applied to thick lenses if u and v are measured from the appropriate cardinal points.

The equation is not very suitable for practical photographic use as it does not make use of object size AB or image size XY, one or both of which are usually known. Defining *magnification* (m) or *ratio of reproduction* or *image scale* as XY/AB = v/u, and substituting into the lens equation and solving for u and v we obtain

$$u = f\left(1 + \frac{1}{m}\right) \qquad (10)$$

and

$$v = f(1 + m) \qquad (11)$$

Because of the conjugate relationship between u and v as given by the lens equation above, these distances are often called the *object conjugate distance* and *image conjugate distance* respectively. These terms are usually abbreviated to 'conjugates'.

A summary of useful lens formulae is given in Figure 4.12, including formulae for calculating the combined focal length of two thin lenses in contact or separated by a small distance. A suitable sign convention must be used. For most elementary photographic purposes the 'real is positive' convention is usually adopted. By this convention, all

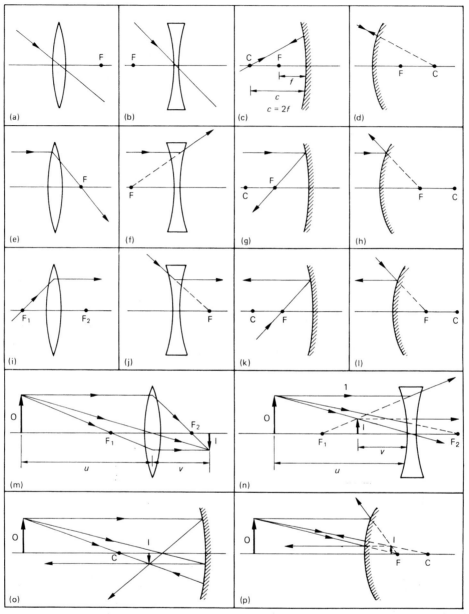

Figure 4.10 The graphical construction of images formed by simple lenses and spherical mirrors. (a) A ray passing through the centre of a positive (i.e. convex) lens is undeviated. (b) A ray passing through the centre of a negative (i.e. concave) lens is undeviated. (c) A ray passing through the centre of curvature of a concave mirror is directed back upon itself. (d) A ray directed towards the centre of curvature of a convex mirror is directed back upon itself. (e) A ray travelling parallel to the optical axis of a positive lens, after refraction passes through the far focal point of the lens. (f) A ray travelling parallel to the optical axis of a negative lens, after refraction appears as if it had originated at the near focal point of the lens. (g) A ray travelling parallel to the optical axis of a concave mirror, after reflection passes through the focus of the mirror. (h) A ray travelling parallel to the optical axis of a convex mirror, after reflection appears as if it had originated from the focus of the mirror. (i) A ray passing through the near focal point of a positive lens, after refraction emerges from the lens parallel to the optical axis. (j) A ray travelling towards the far focal point of a negative lens, after refraction emerges from the lens parallel to the optical axis. (k) A ray passing through the focus of a concave mirror, after reflection travels parallel to the optical axis. (l) A ray directed towards the focus of a convex mirror, after reflection travels parallel to the optical axis. (m) An example of image construction for a positive lens using the three rules illustrated above. (n) An example of image construction for a negative lens. (o) An example of image construction for a concave mirror. (p) An example of image construction for a convex mirror

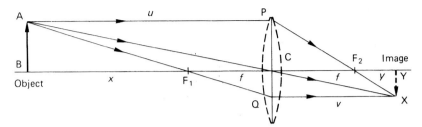

Figure 4.11 Derivation of the lens equation

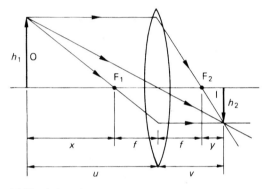

(a) Simple lens

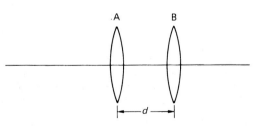

(b) Compound lens

1. $\dfrac{1}{u} + \dfrac{1}{v} = \dfrac{1}{f}$

2. $\dfrac{h_2}{h_1} = \dfrac{I}{O} = \dfrac{v}{u} = m$

$\left.\begin{array}{c} \\ \\ \end{array}\right\}$ $u = f\left(1 + \dfrac{1}{m}\right)$

$v = f(1 + m)$

3. For $u = \infty$, or for $u \gg v$, $v = f$ so that $m = \dfrac{f}{u}$

4. $xy = f^2$

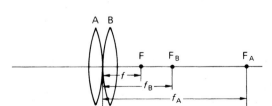

(c) Thin lenses in contact

$\dfrac{1}{f} = \dfrac{1}{f_A} + \dfrac{1}{f_B}$ or,

$\dfrac{1}{f} = P = P_A + P_B$

P is the 'power' (expressed in dioptres)

(d) Thin lenses separated by a small distance

$\dfrac{1}{f} = \dfrac{1}{f_A} + \dfrac{1}{f_B} - \dfrac{d}{f_A f_B}$

Figure 4.12 Some useful lens formulae for lens calculations

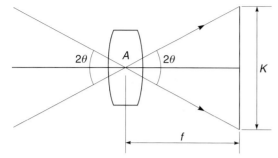

Figure 4.13 Field (angle) of view (FOV) of a lens related to format dimension

Table 4.1 Table for deriving field of view of an orthoscopic lens

Diagonal/focal length (K/f)	Field of view* (2θ) degrees
0.35	20
0.44	25
0.54	30
0.63	35
0.73	40
0.83	45
0.93	50
1.04	55
1.15	60
1.27	65
1.40	70
1.53	75
1.68	80
1.83	85
2.00	90
2.38	100
2.86	110
3.46	120

*These values are for a lens which produces geometrically correct perspective.

distances to real objects and real images are considered to be positive. All distances to virtual images are considered as negative. The magnification of a virtual image is also negative. An alternative Cartesian convention takes the lens or refracting surface at the origin so distances measured to the right are positive, and distances to the left are negative.

It is useful to note that when the object conjugate u is very large, as for a distant subject, the corresponding value of the image conjugate v may be taken as f, the focal length. Consequently, the magnification is given by $m = f/u$. Thus, image magnification or scale depends directly on the focal length of the camera lens for a subject at a fixed distance. From a fixed viewpoint, to maintain a constant image size as subject distance varies a lens with variable focal length is required, i.e. a zoom lens (see Chapter 7).

Field angle of view

The focal length of a lens also determines the angle of the *field of view* (FOV) relative to a given film or sensor format. The FOV is defined as the angle subtended at the (distortion-free) lens by the diagonal (K) of the format when the lens is focused on infinity (Figure 4.13).

Given that the FOV angle A is twice the semi-angle of view θ, then:

$$A = 2\theta = 2 \tan^{-1}\left(\frac{K}{2f}\right) \qquad (12)$$

The field of view for a particular combination of focal length and film format may be obtained from Table 4.1. To use this table, the diagonal of the negative should be divided by the focal length of the lens; the FOV can then be read off against the quotient obtained.

As the lens to subject distance decreases, the lens to film distance increases, and the FOV decreases from its infinity-focus value. At unit magnification the FOV has approximately half its value at infinity focus.

Photographic lenses can be classified according by FOV for the particular film format for which they are designed. There are sound reasons for taking as 'standard' a lens that has a field of view approximately equal to the diagonal of the film format. For most formats this angle will be around 52 degrees. Wide-angle lenses can have FOVs up to 120 degrees or more, and long focus lenses down to 1 degree or less. Table 4.2 gives a classification of lenses for various formats based on FOV.

Occasionally confusion may arise as to the value of the FOV of a lens as quoted, because a convention exists in many textbooks on optics to quote the semi-angle θ, in which cases value given must be doubled for photographic purposes. It should also be noted that the FOV for the *sides* of a rectangular film format is always less than the value quoted for the diagonal. The horizontal FOV is perhaps the most useful value to quote.

The term 'field of view' becomes ambiguous when describing lenses that produce distortion, such as fisheye and anamorphic objectives. In such cases it may be preferable to describe the angle subtended by the diagonal of the format at the lens as the 'angle of the field' and the corresponding angle in the object space as the 'angle of view'.

Table 4.2 Lens type related to focal length and format coverage

Focal length (mm)	Nominal format (mm)	Angle of view (degrees on diagonal)	Lens type
15	24 × 36	110	EWA
20	24 × 36	94	EWA
20	APS	75	WA
24	24 × 36	84	WA
24	APS	67	WA
35	24 × 36	63	SWA
35	APS	50	S
40	24 × 36	57	S
40	60 × 60	94	EWA
40	APS	47	S
50	24 × 36	47	S
50	60 × 60	81	WA
50	60 × 70	85	WA
65	24 × 36	37	MLF
65	60 × 60	66	SWA
65	4 × 5 in	103	EWA
80	60 × 60	56	S
90	24 × 36	27	MLF
90	APS	22	MLF
90	4 × 5 in	84	WA
135	24 × 36	18	LF
135	60 × 60	35	MLF
135	4 × 5 in	62	S
150	60 × 60	32	LF
150	4 × 5 in	57	S
200	24 × 36	12	LF
200	8 × 10 in	78	WA
250	60 × 60	19	LF
300	24 × 36	8	VLF
300	8 × 10 in	57	S
500	24 × 36	5	VLF
500	60 × 60	10	LF
500	4 × 5 in	19	LF
1000	24 × 36	2.5	ELF
1000	60 × 60	5	VLF
1000	4 × 5 in	9	LF
1000	8 × 10 in	19	LF

EWA extreme wide-angle; WA wide-angle; SWA semi wide-angle; S standard; MLF medium long-focus; LF long-focus; VLF very long-focus; ELF extreme long-focus.

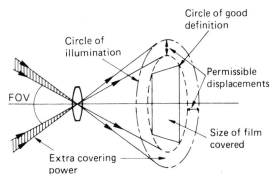

Figure 4.14 The covering power of a lens and image format

from the centre of the field outwards, at first gradually and them more rapidly. By defining an acceptable standard of image quality, it is possible to locate a boundary defining a *circle of good or acceptable definition* within this circle of illumination. The sensor format should be located within this region (Figure 4.14).

The extent of the circle of acceptable definition also determines the practical performance of the lens as regards the covering power relative to a given format. The *covering power* is usually expressed as an angle of view which may be the same as or greater than that given by the format in use. A greater FOV than set by the format is called *extra covering power* and is essential for a lens fitted to a technical camera or a *perspective-control* (PC) or 'shift' lens when lens displacement movements are to be used. The extra covering power permits displacement of the format within the large circle of good definition until vignetting occurs, indicated by a marked decrease in luminance at the periphery of the format.

Covering power is increased by closing down the iris diaphragm of a camera lens, because mechanical vignetting is reduced, and off-axis lens aberrations are decreased by this action. The covering power of lenses for technical cameras is quoted for use at *f*/22 and with the lens focused on infinity. Covering power increases as the lens is focused closer; for close-up work a lens intended for a smaller format may cover a larger format, with the advantage of a shorter bellows extension for a given magnification.

Covering power of a lens

Every lens projects a fuzzy edged disc of light as the base of a right circular cone whose apex is at the centre of the exit pupil of the lens. The illumination of this disc falls off towards the edges, at first gradually and then very rapidly. The limit to this *circle of illumination* is due to *natural vignetting* as distinct from any concomitant mechanical vignetting. Also, owing to the presence of residual lens aberrations, the definition of the image within this disc deteriorates

Geometric distortion

A wide-angle lens, i.e. a lens whose FOV exceeds some 75 degrees, is invaluable in many situations, such as under cramped conditions, and where use of the 'steep' perspective associated with the use of such lenses at close viewpoints is required. The large angle of view combined with a flat film plane (rather than

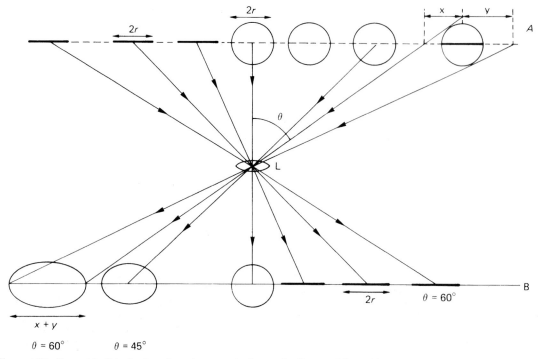

Figure 4.15　Geometric distortion by a lens. An array of spheres of radius *r* and lines of length 2*r* in the subject plane A are imaged by lens L in image plane B at unit magnification. The lines retain their length independent of field angle *θ* but the spheres are progressively distorted into ellipses with increase in *θ*

the saucer-shaped surface that would intuitively be thought preferable), makes shape distortion of three-dimensional objects near the edge of the field of view very noticeable. The geometry of image formation by a lens over a large field is shown in Figure 4.15, producing *geometrical distortion* which must not be confused with the *curvilinear distortion* caused by lens aberrations. Flat objects are of course not distorted in this way so a wide-angle lens can be used for the copying of flat originals. As an example of the distortion occurring with a subject such as a sphere of diameter 2*r*, the image is an ellipse of minor diameter 2*r* and major diameter *W*, where $W = 2r \sec\theta$, given unit magnification and that *r* is small relative to the object distance. The term $\sec\theta$ is the *elongation factor* of the image.

Depth of field

Image sharpness

Any subject can be considered as made up of a large number of points. An ideal lens would image each of these as a point image (strictly, an Airy diffraction pattern) by refracting and converging the cone of light from the subject point to a focus. The purpose of

focusing the camera is to adjust the image conjugate to satisfy the lens equation. The image plane is strictly correct for all object points in a conjugate plane, provided all points of the object *do* lie in a plane. Unfortunately, objects in practice do not usually lie in a plane, and so the image also does not lie in a single plane. Consider just two of the planes through the object (Figure 4.16). For an axial point in both planes, each point can be focused in turn but both cannot be rendered sharp simultaneously. When the image of one is in focus the other is represented by an image patch, called more formally a *blur circle*. These discs or *circles of confusion* are cross-sections of the cone of light coming to a focus behind or in front of the surface of the film.

This purely geometrical approach suggests that when photographing an object with depth, only one plane can be in sharp focus and all other planes are out of focus. Yet in practice pictures of objects are obtained with considerable depth that appear sharp all over. The reason is that the eye is satisfied with something less than pin-point sharpness. In the absence of other image-degrading factors such as lens aberrations or camera shake, a subjective measure of image quality is its perceived *sharpness*, which may be defined as the adequate provision of resolved detail in the image. Inspection of a photograph

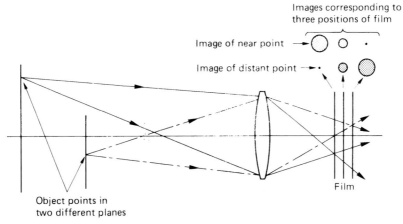

Figure 4.16 Object points at different distances and their images at different photoplanes

containing subject matter covering a considerable depth shows that the sharpness of the image does vary with depth. Detail both in front of and behind the point of optimum focus may, however, be rendered adequately sharp, giving a zone of acceptably sharp focus; this zone is termed the *depth of field*. (The term applies only to the object space and should not be confused with the related *depth of focus*, which applies to the conjugate region through the focal plane in the image space.) Depth of field is of great importance in most types of photography, the manipulation of its positioning and extent being an

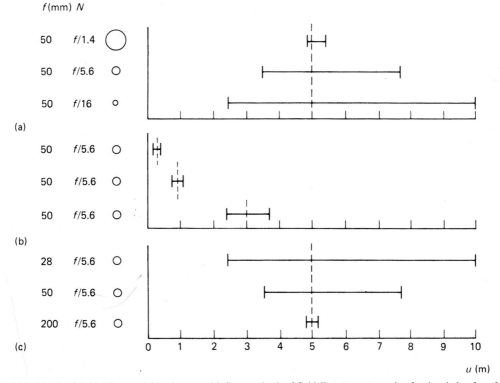

Figure 4.17 Depth of field. Three variables in general influence depth of field T at a constant value for the circle of confusion. (a) Lens aperture N, varying from $f/1.4$ to $f/16$ with a 50 mm lens focused at 5 m. (b) Focused distance u, varying from 0.5 to 3 m with a 50 mm lens at $f/5.6$ (c) Focal length f varying from 28 to 200 mm at $f/5.6$ focused on 5 m

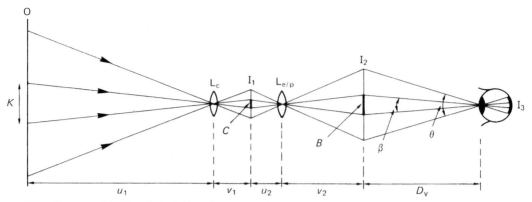

Figure 4.18 Geometry of the blur circle. Subject plane O with detail K is imaged by camera lens L_C at I_1, then re-imaged by enlarger or projector lens $L_{e/p}$ at I_2 and finally imaged on the retina at I_3. The circle of confusion C is seen as blur circle B in the cone of vision angle θ. Visual acuity is $1/\beta$. Relationships are: $m = v_1/u_1$, $M = v_2/u_2$, $K = C/m$, $B = CM$, $\beta = B/D_v$

important creative control. Knowledge of the means of extending, restricting or simply achieving depth of field is a vital skill in practical photography.

Manipulation of a camera and lens will demonstrate the control of depth of field possible by a choice of the focal length and aperture of the lens together with the focused subject distance (Figure 4.17) for a chosen circle of confusion. The various movements of a technical camera can also be used, and described in Chapter 10.

Depth of field can be quantified and calculated in terms of four variables, but first it is necessary to define 'an acceptable standard of sharpness' for a photographic record such as a print viewed in the hand. The depth of field boundaries are not as a rule sharply defined; usually there is a blending of acceptably sharp into less sharp detail. Much depends on the viewing conditions and also on aperture shape to some extent.

Visual acuity

Perception of detail, judgement of its sharpness, and depth of field in a photograph depend largely upon viewing distance and visual acuity, though other factors such as image contrast and ambient illumination are also significant. Normal vision requires muscular action to alter the refractive state of the eye in order to focus. This internal focusing is called *accommodation*, and physiological limitations set a comfortable *near distance of distinct vision* (D_v) of some 250 mm. The resolving power of the eye, or *visual acuity*, is the ability to discriminate fine details of objects in the visual field of view, and it decreases radially. It may be specified as the width of an object at a specific distance or as the angle subtended by this object or even as the width of its retinal image that is

just resolved by the eye. For example, in ideal conditions a high-contrast line of width 0.075 mm can be perceived at D_v subtending an angle of approximately 1 minute of arc, and representing an image on the retina of the eye of some 5 micrometres in width. The performance is limited by the structure of the retina, which consists of light receptors of finite size. The limiting performance is seldom achieved, and a lower value of 0.1 mm line width at D_v is commonly adopted. Converted into resolving power, an acuity of 0.1 mm corresponds to a spatial cycle of 0.2 mm, being the width of the line plus an adjacent identical space such as is used on a bar-type resolution test target, giving a value of 5 cycles per mm for the average eye. The accuracy of focusing aids such as split-image rangefinders depends upon visual acuity in aligning two parts of a subject detail with a horizontal separation or 'split'.

Circle of confusion

For a photograph viewed at D_v, any subject detail resolved and recorded optically that is smaller than 0.2 mm in general dimensions may not be perceptible to the unaided eye. Thus any detail finer than this size is not required. This leads to a practical definition of resolution. A limit is set to the diameter of an image blur circle that is not distinguishable from a true point (by the unaided eye), and this is called the (minimum permissible) *circle of confusion* (C). This is arrived at by empirical means. A photograph is viewed in a *cone of vision* where acceptable visual acuity is given over a FOV of some 50 to 60 degrees. The *comfortable viewing area* has a diameter of some 290 mm at D_v. The acceptable circle of confusion is derived from what is accepted as satisfactory definition within this area.

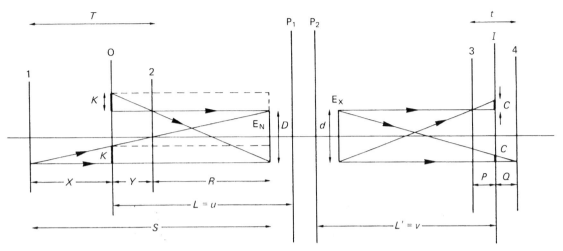

Figure 4.19 Geometry of image formation for depth of field

The obsolete 'whole-plate' size of 6.5 × 8.5 inches (165 × 216 mm, with a diagonal of some 270 mm), fitted neatly into the cone of vision at a distance of about 10 inches, and indeed for early photography was the usual size for contact prints for hand viewing. The standard lens for this format had a focal length of 10 inches (250 mm), and a contact print viewed at D_v gave correct perspective. A value of approximately 0.2 mm could be used for C to determine the required lens performance and depth of field.

Smaller formats, especially 24 × 36 mm, require enlargement to give a print for viewing at D_v with correct perspective (Figure 4.18). According to the 'rules' of perspective, a satisfactory visual rendering is given of an image corresponding spatially to the original scene when viewed at a distance equal to the focal length of the taking lens. Strictly a 24 × 36 mm image taken with a 50 mm lens should be viewed as a contact print at 50 mm, which is less than D_v. In practice an enlargement is viewed at 250 mm, but correct perspective is retained providing the proportional increase in viewing distance corresponds numerically to the degree of enlargement or print magnification M.

Obviously the value of C in the camera image must be related to subsequent enlargement and correspondingly reduced as enlargement increases. A linear enlargement of ×8 from a 24 × 36 mm negative is common practice: it gives a resultant print of 192 × 288 mm, suited to 8 × 10 inch (203 × 254 mm) print material, a size readily viewable within the cone of vision. This implies a minimum resolving power of 40 cycles/mm or lp mm^{-1} for the camera lens, the product of ×8 enlargement and visual performance of 5 lp mm^{-1}. The latter value also relates usefully to the

resolving power of photographic printing paper which is approximately 6 lp mm^{-1}.

To summarize, the permissible diameter of the circle of confusion must be reduced if subsequent enlargement is to take place. In practice values of C from 0.025 to 0.033 mm are used for the 24 × 36 mm format to allow ×8 enlargement. Values of 0.06 mm and 0.1 mm are used for medium and large formats respectively.

It is worth noting that in the early days of small-format photography a criterion of 1/1000 of the focal length of the lens was used for C, giving 0.05 mm for the 50 mm lens, which was for a long time the standard lens used for the 24 × 36 mm format, and correspondingly different values for different focal lengths. This criterion was in use for many years and is still quoted by some sources. It gives values for depth of field which imply different degrees of enlargement for different focal lengths. Some confusion has arisen on depth of field matters, especially in the provision of tables and scales, as well as comparisons between equivalent lenses from different sources. The idea of $C=f/1000$ is now deprecated, and instead the value of C is taken as constant for a given format, for the whole range of lenses.

Depth of field equations

Derivations

Useful equations for the calculation of depth of field (and depth of focus) are derived from the geometry of image formation, as shown in Figure 4.19. A lens of focal length f is focused on subject plane O, distant L from the front principal plane P_1, with conjugate

image plane I distant L' from P_2. Image magnification is m. The entrance and exit pupils E_N and E_X have diameters D and d respectively. Plane O is also distant u from E_N. There are two other planes, 1 and 2, at distances R and S from E_N, rays from which to E_N intersect plane O in small circles of diameter K to be imaged in plane I as circles of confusion, diameter C, where $C = mK$.

In the object space, from similar triangles,

$$S = \frac{uD}{D - K} \tag{13}$$

$$R = \frac{uD}{D + K} \tag{14}$$

Now $m = L'/L = v/u$, and the effective aperture $N' = v/D$, so that $D = um/N'$. Taking $D = uL'/N'L$ and also $K = CL/L'$, then, substituting for D and K in equations (13) and (14),

$$S = \frac{u\left(\dfrac{uL'}{N'L}\right)}{\left(\dfrac{uL'}{N'L}\right) - \left(\dfrac{CL}{L'}\right)} \quad \text{and} \quad R = \frac{u\left(\dfrac{uL'}{N'L}\right)}{\left(\dfrac{uL'}{N'L}\right) + \left(\dfrac{CL}{L'}\right)}$$

So that

$$S = \frac{u^2(L')^2}{u(L')^2 - N'CL} \quad \text{and} \quad R = \frac{u^2(L')^2}{u(L')^2 + N'CL}$$

Considering the general photographic case, for distant subjects where m is less than unity, the object plane is near infinity, so we may put L' approximately equal to f. Likewise, N', the effective aperture, may be replaced by N, the relative aperture. For simple and symmetrical lenses, the pupils are located in the principal planes, so we may take $L = u$. Hence

$$S = \frac{uf^2}{f^2 - NCu} \tag{15}$$

$$R = \frac{uf^2}{f^2 + NCu} \tag{16}$$

The values of S and R define the far and *near* limits respectively of the depth of field, when the lens is focused on distance u. The values may be tabulated in various ways, displayed in graphical form or provided as depth of field scales on the focusing mounts of lenses (Figure 4.20).

If depth of field (T) is defined as $T = S - R$ then

$$T = \frac{2f^2u^2NC}{f^4 - N^2C^2u^2} \tag{17}$$

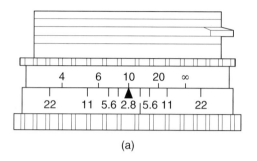

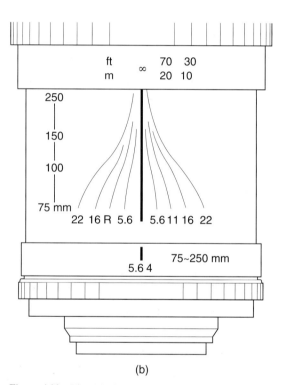

Figure 4.20 Visual indication of depth of field. (a) Depth of field indicator scale. (b) Converging scales on a 75–250 mm $f/4$ zoom lens, including an infrared focus correction mark R

For practical purposes the $N^2C^2u^2$ term in the denominator may be disregarded, so to a first approximation

$$T = \frac{2u^2NC}{f^2} \tag{18}$$

This equation finds many useful applications.

Depth of field is directly proportional to the diameter of the circle of confusion, the f-number and the square of the focused distance, and inversely

proportional to the square of the focal length of the lens. Subject distance and focal length have the greatest influence; doubling the value of u increases T fourfold, while doubling focal length reduces T (at a fixed distance) by a factor of four.

It is of interest to note that equation (16) shows that a short-focus lens yields more depth of field than one of longer focus, provided that both are used to give the same magnification of a particular subject, in which case the two values of u differ. For example, using $C = 0.025$ mm, a lens of focal length 100 mm focused at 5 m and with an aperture of $f/4$ gives a magnification of 0.0204 and depth of field 501 mm. If a lens of focal length 25 mm is used, with u reduced to 1.25 m to give the same magnification, the depth of field at $f/4$ is now 521 mm, a little greater. However, subjective effects regarding the changed viewpoint for the subject and different performances from the two lenses can give a further subjective impression of a greater depth of field, as there is no fixed boundary that separates 'sharp' from 'unsharp'.

When the subject is closer, say 2 m for the 100 mm lens and a corresponding 0.5 m for the 25 mm lens, the depth of field at $f/4$ is 80 mm for both lenses, so that, in theory, there should be no difference.

The differences in practice are due to the approximations and assumptions made in deriving the formulae. Use of the simplified equation (17) gives identical results in both examples. In the alternative case of a fixed viewpoint and constant u, with the value of f altered by use of zoom lens (or interchangeable lens) followed by different degrees of enlargement to give the same final print magnification, then when viewed at D_v the depth of field will be seen to remain essentially constant when the actual diameter of the aperture of the lens remains unaltered. Thus combinations of 100 mm at $f/11$, 50 mm at $f/5.6$ and 25 mm at $f/2.8$, all have the same depth of field for a fixed viewpoint.

Note that the use of the criterion of $C = f/1000$ gives different values for both lenses in the example above and would indicate that depth of field is greater for the longer focal length in such circumstances, which is incorrect.

Departures from theory

The theory developed above assumes a truly circular circle of confusion; but this is not always so and marked departures from circular are found in anamorphic lenses, lenses with uncorrected aberrations and catadioptric (mirror) lenses. The 'circle of confusion' for the last of these is an annulus (caused by the central opaque disc inside the lens), and its effect can clearly be seen in out-of-focus detail. In the special case of a soft-focus lens, where undercorrected spherical aberration is used to give the desired soft effect with a core of sharpness, the diameter of the blur circle cannot be defined and calculations are meaningless. The so-called *deep-field lens* is often incorrectly taken to mean a lens possessing enhanced depth of field, but the effect is due to anti-reflection coatings which provide increased light transmittance, so that a reduced aperture may be used for a given exposure level compared with a lens of lower transmittance. It is the smaller aperture that gives the increased depth of field, not any special correction of aberrations. In practice, for an ordinary aberration-limited lens, progressive stopping down brings the depth of field closer to predicted values until diffraction effects occur.

Hyperfocal distance

Maximum depth of field in any situation is obtained by use of the hyperfocal distance. The value of S, the far limit of T, is given by equation (15). The *hyperfocal distance* (h) is defined as the value of a particular focus setting u of the lens, which makes S equal to infinity. The necessary condition is $f^2 = NCu$; then, as $u = h$,

$$h = \frac{f^2}{NC} \qquad (19)$$

The concept of h allows simplification of equations (15) and (16) to

$$S = \frac{hu}{h - u} \qquad (20)$$

$$R = \frac{hu}{h + u} \qquad (21)$$

And likewise

$$T = \frac{2hu^2}{(h^2 - u^2)} \qquad (22)$$

From equation (21), if u equals h, then R is $h/2$; when u is infinity, then R equals h. So if the lens is focused at a distance u so that u equals h, then the near limit of the depth of field is $h/2$. This gives the maximum depth of field, from infinity to $h/2$, for a given aperture N.

Cameras with fixed-focus lenses have the focus set on the hyperfocal distance (for the maximum aperture if this is variable) so as to give maximum depth of field.

Close-up depth of field

Close-up photography is defined as photography where the distance from the subject to the lens is such

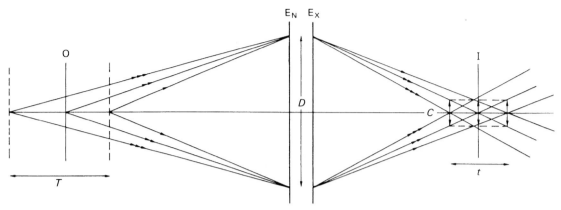

Figure 4.21 Conjugate relationship between depth of field T and depth of focus t, where $T = mt$

that magnification m is in the range 0.1 to 1.0. Referring again to Figure 4.19, the close-up depth of field T may be taken as the sum of distances X and Y, the respective distances of planes 1 and 2 from the plane of focus O, where

$$X = \frac{uK}{D - K}$$

$$Y = \frac{uK}{D + K}$$

As these planes are close to the entrance pupil, the value of K is much smaller than D and so can be neglected in the denominators, giving

$$X = Y = \frac{uK}{D}$$

Now u/D can be replaced by N'/m, and also $C = mK$, therefore

$$X = Y = \frac{CN'}{m^2}$$

The effective aperture N' may be replaced by $N(1 + m)$, where N is the marked f-number. As $T = X + Y$, we have

$$T = \frac{2CN(1 + m)}{m^2} \qquad (23)$$

Equation (23) does not involve focal length directly, so for a given magnification a long focal length is preferable to a short focal length, as it gives a longer working distance and better perspective by virtue of its more distant viewpoint, without any change in depth of field for a given f-number. Unlike general photography, the final magnification Z in the print of the subject is usually stated. So for a print enlargement of M, $Z = mM$.

Depth of focus

The term *depth of focus* applies only to the image space (Figure 4.21) and is the tolerance in the position of the film plane I, which depends on the acceptable diameter C of the circle of confusion (Figure 4.19). Alternatively, it may be regarded as the distance between the conjugate planes 3 and 4 either side of image plane I, corresponding to planes 1 and 2 respectively, which define depth of field. Planes 3 and 4 are distant P and Q respectively from plane I, and the cones of light from the exit pupil E_X of diameter d coming to focus on planes 3 and 4 form blur circles of diameter C on plane I, which is distant v from P_2, the rear principal plane. From similar triangles,

$$P = \frac{vC}{d + C}$$

$$Q = \frac{vC}{d - C}$$

But C is small compared with d and may be removed from the denominators, so

$$P = Q = \frac{vC}{d}$$

Remembering $N' = v/d$ and also $N' = N(1 + m)$, the depth of focus (t) is the sum of P and Q, so

$$t = 2CN(1 + m) \qquad (24)$$

$$t = \frac{2CNv}{f} \qquad (25)$$

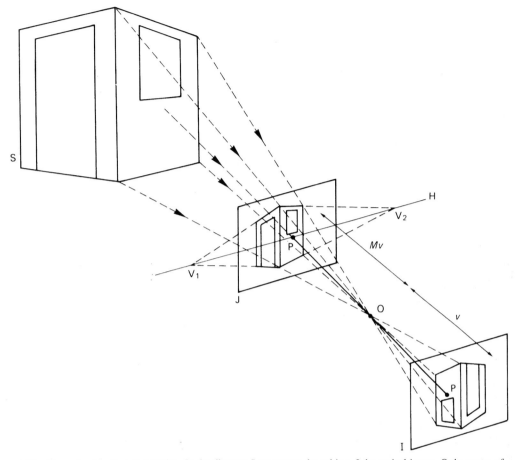

Figure 4.22 Elements of central perspective. In the diagram S represents the subject, I the optical image, O the centre of perspective, P the principal point, OP the principal distance, J the perspective of the subjected or picture plane, V_1 and V_2 the vanishing points, H the horizon line

For general photography where m is small, equations (24) and (25) reduce to

$$t = 2CN \qquad (26)$$

For a large-aperture lens the depth of focus is small and the film gate or photoplane must be accurately perpendicular to the optical axis. The necessary tolerances can be relaxed for large formats where C is greater and small apertures are used; but even so, a 75 mm $f/4.5$ wide-angle lens used on a 4×5 inch format has only 0.9 mm depth of focus at full aperture (assuming C is 0.1 mm), so the position of the film surface in a dark-slide or roll film back must correspond very accurately to the plane of the focusing screen.

When a lens is focused close up, so that m has a significant value, the depth of focus is increased. The use of small apertures also increases depth of focus.

Perspective

Viewpoint

The term 'perspective' literally means 'to look through', and an accurate record of the spatial relationships of objects in a scene can be obtained by placing a glass plate, 'the picture plane', in the observer's FOV, and tracing the necessary outlines on it. The reduced-size facsimile records the intersection of the projection of each subject point, converging to the *centre of perspective* or *viewpoint* (Figure 4.22), then diverging to the image plane.

The *viewpoint* is the centre of the pupil of the eye of the observer. Conventionally the picture plane is vertical, so that vertical lines in the subject remain vertical and parallel. Horizontal lines in planes parallel to the picture plane also remain horizontal and parallel, but in inclined subject planes they will

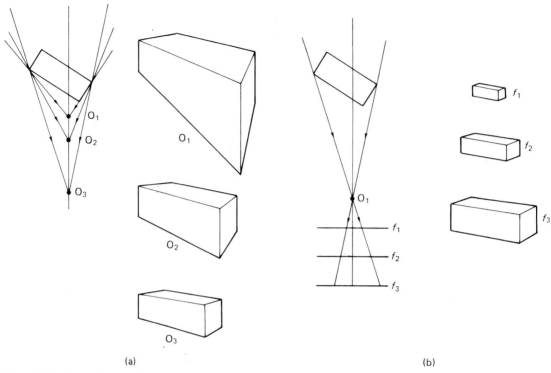

Figure 4.23 Perspective in an image related to camera viewpoint and focal length. (a) Subject appearance due to reducing the viewpoint distance and increasing the field of view of the lens. (b) From a fixed viewpoint, an increase in principal distance or focal length leaves the perspective unchanged but size altered

converge to one or more *vanishing points*, positioned on the *horizon line* of the facsimile where the visual axis intersects it at the *principal point*. The orthogonal distance between the picture plane and viewpoint is the *principal distance* of the perspective record.

By the geometry of the situation, alteration of the principal distance alters only the size of the picture and not the perspective of the spatial relationships. However, alteration of the viewpoint in terms of distance from the subject will alter the convergence and hence alter perspective.

The perspective of the scene is correctly reconstructed only by viewing from the principal distance, which is then termed the *viewing distance (D)*.

Camera viewpoint

A camera records a three-dimensional scene as a two-dimensional planar image in the photoplane and in the print. By placing the camera lens at the visual viewpoint, familiar photographic parameters replace the terminology of perspective as defined above.

The convergent rays form a *central perspective* by passing through the lens, and continue diverging beyond the viewpoint to an image plane conjugate to the subject plane. The principal distance is now the image conjugate v, commonly taken as the focal length f for distant scenes. The facsimile or photographic record is now inverted and laterally reversed but can be contact printed and 'flopped' to position in the picture plane for viewing at correct distance $D = v$.

Various points need clarification. By altering the lens to one of longer focal length, v is increased and the image enlarged; but it retains identical perspective. So a charge of focal length for a given viewpoint does not alter perspective but only image size. By altering viewpoint by changing the object conjugate u, the perspective *does* change, the more obviously since a lens of large FOV may be used to include the same area of the subject from a closer viewpoint (Figure 4.23). Such 'steep' perspective can be used to dramatic effect. Figure 4.24 illustrates the alteration of perspective given by a change of viewpoint with a building chosen as the subject to show also two possible pictorial 'treatments' of the subject. A distant central viewpoint with a medium long focus lens gives an accurate view of the front elevation. A closer off-centre viewpoint with a wide-

(a)

(b)

Figure 4.24 Perspective and viewpoint. (a) Distant central viewpoint. (b) Closer oblique viewpoint

angle lens plus some rising front movement changes the shape to retain verticals, while giving more depth to the subject.

Perspective distortion

The centre of perspective or viewpoint of a camera lens is the centre of the entrance pupil for object space. The centre of the exit pupil is the centre of projection for image space. The correct viewing distance is then given by

$$D = v = f(1 + m) \tag{27}$$

This theoretical value of D cannot usually be used, especially if it is less than D_v. Small images need to be enlarged by magnification M for comfortable viewing and the viewing distance is then given by

$$D = Mv \tag{28}$$

For distant scenes, v is replaced by f as usual.

The correct-viewing-distance criterion is seldom observed for photographic images, prints being viewed at a convenient distance, irrespective of the values of f and M used (usually these are not known to the observer). Incorrect viewing gives rise to perspective distortions. In pictorial terms, a near viewpoint gives a 'steep perspective' with large changes of scale in a subject, while a distant viewpoint gives a 'flattened perspective' with only small changes of scale even in a subject of considerable depth. The perspective of a print viewed from too great a distance tends to appear steep, while that of a print viewed from too short a distance tends to appear flat. This is the reverse of the perspective effects achieved on taking the picture.

Bibliography

Blaker, A. (1985) *Applied Depth of Field*. Focal Press, Stoneham, MA.

Freeman, M. (1990) *Optics*, 10th edn. Butterworths, London.

Hecht, E. (1998) *Optics*, 3rd edn. Addison-Wesley, Reading, MA.

Jenkins, F. and White, H. (1981) *Fundamentals of Optics*, 4th edn. McGraw-Hill, London.

Kingslake, R. (1992) *Optics in Photography*. SPIE, Bellingham, WA.

Ray, S. (1984) *Applied Photographic Optics*, 2nd edn. Focal Press, Oxford.

5 The photometry of image formation

The light-transmitting ability of a photographic lens, which principally determines the illuminance of the image at the film plane, is usually referred to as the *speed* of the lens. Together with the effective emulsion 'speed' or photosensor sensitivity and the subject luminance, this determines the exposure duration necessary to give a correctly exposed result. The separate problem of the determination of camera exposure is dealt with in Chapter 19. In the sections below the factors influencing image illuminance are examined in detail.

Stops and pupils

An optical system such as a camera and lens normally has two 'stops' located within its configuration. The term *stop* originates from its original construction of a hole in an opaque plate perpendicular to the optical axis. One of these two is the *field stop*, which is the film gate or photosensor array; this determines the extent of the image in the focal plane and also the field of view of the lens.

The *aperture stop* is usually located within the lens or close to it, and controls the transmission of light by the lens. It also influences depth of field (Chapter 4) and lens performance, in terms of the accuracy of drawing and resolution in the image.

In a simple lens the aperture stop may either be fixed, or only have one or two alternative settings. A compound lens is usually fitted with a variable-aperture stop called an *iris diaphragm* because of its similar function to the iris in the human eye. The iris diaphragm is continuously adjustable between its maximum and minimum aperture sizes. The usual construction is five or more movable blades, providing a more or less circular opening. The aperture control ring may have click settings at whole and intermediate *f-number* values. In photography the maximum aperture as well as the aperture range is important, as aperture value is one of the primary creative controls in picture making.

In a compound lens with an iris diaphragm located within its elements, the apparent diameter of the iris diaphragm when viewed from the object point is called the entrance pupil (E_N). Similarly, the apparent

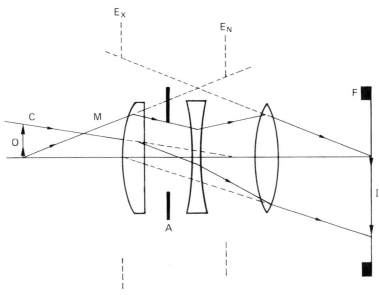

Figure 5.1 Location of the stops and pupils of a triplet lens and the passage of light through the system. O, object; I, image; A, aperture stop (iris diaphragm); F, field stop (film gate and format size); C, principal ray; M, marginal ray; E_N, entrance pupil; E_X, exit pupil

diameter of the iris diaphragm when viewed from the image point is called the exit pupil (E_X) (Figure 5.1). These two are virtual images of the iris diaphragm, and their diameter is seldom equal to its actual diameter. To indicate this difference the term *pupil factor* or *pupil magnification* (*p*) is used; this is defined as the ratio of the diameter of the exit pupil to that of the entrance pupil ($p = E_X/E_N$). Symmetrical lenses have a pupil factor of approximately one, but telephoto and retrofocus lenses have values that are respectively less than and greater than unity. Pupil magnification influences image illuminance, as shown below. Note that the pupils are not usually coincident with the principal planes of a lens, indeed the exit pupil can be at infinity.

Aperture

The light-transmitting ability of a lens, usually referred to as *aperture* (due to the control exercised by the iris diaphragm) is defined and quantified in various ways. Lenses are usually fitted with iris diaphragms calibrated in units of *relative aperture*. This is represented by a number *N*, which is defined as the equivalent focal length *f* of the lens divided by the diameter *d* of the entrance pupil ($N = f/d$). This diameter is sometimes referred to incorrectly as the effective aperture of the lens in contrast to the actual aperture of the lens, which is the mean diameter of the actual aperture formed by the diaphragm opening (this is not necessarily circular). The term *effective aperture* properly refers to the relative aperture value when corrected for a lens that is not focused on infinity.

Relative aperture is $N = f/d$ (for infinity focus) so a lens with an entrance pupil 25 mm in diameter and a focal length of 50 mm has a relative aperture of 50/25, i.e. 2. The numerical value of relative aperture is usually prefixed by the italic letter *f* and an oblique stroke, e.g. *f*/2, which serves as a reminder of its derivation. The denominator of the expression used alone is usually referred to as the *f-number* of the lens. Aperture value on many lenses appears as a simple ratio, so the aperture of an *f*/2 lens is shown as '1:2'.

The relative aperture of a lens is commonly referred to simply as its 'aperture' or even as the '*f*-stop'. The maximum aperture is the relative aperture corresponding to the largest diaphragm opening that can be used with it. For simple lenses the lens diameter (*D*) itself, or the stop diameter close to the lens, is substituted for the entrance pupil: thus the *f*-number of a simple lens is its focal length divided by its diameter ($N = f/D$).

To simplify exposure calculations, *f*-numbers are usually selected from a standard series of numbers, each of which is related to the next in the series by a constant factor calculated so that the amount of light passed by the lens when set to one number is half that passed by the lens when set to the previous number, as the iris diaphragm is progressively closed. As the amount of light passed by a lens is inversely proportional to the *square* of the *f*-number, the numbers in the series increase by a factor of $\sqrt{2}$, i.e. 1.4 (to 2 figures). The standard series of *f*-numbers is *f*/1, 1.4, 2, 2.8, 4, 5.6, 8, 11, 16, 22, 32, 45, 64. Smaller or larger values are seldom encountered.

The maximum available aperture of a lens may, and frequently does, lie between two of the standard *f*-numbers above, and in this case will be marked with a number not in the standard series.

A variety of other series of numbers have been used in the past, using a similar ratio, but with different starting points. Such figures may be encountered on older lenses and exposure meters. In the case of automatic exposure in cameras offering shutter priority and program modes, the user may have no idea whatsoever of the aperture setting of the camera lens. An alteration in relative aperture corresponding to a change in exposure by a factor of 2 either larger or smaller is referred to as a change of 'one stop'. Additional exposure by alteration of 'one-third of a stop', 'half a stop' and 'two stops' refer to exposure factors of 1.26, 1.4 and 4 respectively. When the lens opening is made smaller, i.e. the *f*-number is made numerically larger, the operation is referred to as 'stopping down'. The converse is called 'opening up'.

The exposure control choices of either changing shutter speeds or alteration of the effective exposure index of a film (by adjusted processing) are often also referred to by their action on effective exposure in terms of 'stops', e.g. a 'one-stop push' in processing to double the film speed value.

Mechanical vignetting

The aperture of a lens is defined in terms of a distant axial object point. However, lenses are used to produce images of extended subjects, so that a point on an object may be well away from the optical axis of the lens, depending on the field of view. If the diameter of a pencil of rays is considered from an off-axis point passing through a lens, a certain amount of obstruction may occur because of the type and design of the lens, its axial length and position of the aperture stop, and the mechanical construction of the lens barrel (Figure 5.2). The effect is to reduce the diameter of the pencil of rays that can pass unobstructed through the lens and hence the amount of light reaching the focal plane. This is termed *mechanical vignetting* or 'cut-off', and the image plane receives progressively less light as the field angle increases. This causes darkening at the edges of images and is one factor determining image illumi-

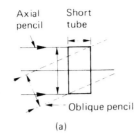

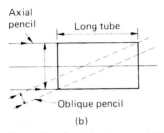

Figure 5.2 Cause of mechanical vignetting. (a) With a short lens barrel, the area of cross-section of the oblique beam is only a little less than that of the axial beam. (b) With a long barrel, the area of the cross-section of the oblique beam is much smaller than that of the axial beam

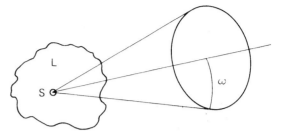

Figure 5.3 The light flux F emitted by a small area S of a surface of luminance L into a cone of semi-angle ω is given by $F = \pi LS \sin^2 \omega$

nance as a function of field angle and hence the circle of illumination. Mechanical vignetting must not be confused with the *natural* fall-off of light due to the geometry of image formation (see later). Vignetting may be reduced by designing lenses with oversize front and rear elements, and by careful engineering of the lens barrel. The use of an unsuitable lens hood or two filters in tandem, especially with a wide-angle lens, also cause cut-off and increases peripheral darkening.

Image illumination

A camera lens projects an image formed as the base of a cone of light whose apex is at the centre of the exit pupil (centre of projection). It is possible to deduce from first principles an expression for the illumination or *illuminance* at any point in the image of a distant, extended object. To do this however, it is necessary to make use of two relationships (the derivations of which are beyond the scope of this book), concerning the light flux reflected or emitted by a surface and the luminance (brightness) of the aerial image given by the lens.

Luminous flux emitted by a surface

In Figure 5.3, the flux F emitted by a small area S of a uniformly diffusing surface (i.e. one that appears

equally bright in all directions) of luminance L into a cone of semi-angle ω is given by the equation

$$F = \pi LS \sin^2 \omega \tag{1}$$

Note that the flux emitted is independent of the distance of the source. This equation is used to calculate the light flux entering a lens.

Luminance of an image formed by a lens

The transmission of a lens is measured by transmittance (T), the ratio of emergent flux to incident flux. For an object and an image that are both uniformly diffuse, and whose luminances are L and L' respectively, it may be shown using equation (1) that for an 'ideal' lens of transmittance T

$$L' = TL \tag{2}$$

In other words, the image luminance of an aerial image is the same as the object luminance apart from a small reduction factor due to the transmittance of the lens, within the cone of semi-angle ω. Viewing the aerial image directly gives a bright image, but this cannot easily be used for focusing, except by passive focusing devices or no-parallax methods. Instead the image has to be formed on a diffuse surface such as a ground glass screen and viewed by scattering of the light. The processes of illumination also cause this image to be much less bright than the direct aerial image.

Image illuminance

The projected image formed at the photoplane suffers light losses from various causes, so the illumination or illuminance is reduced accordingly. Consider the case shown in Figure 5.4, where a thin lens of diameter d, cross-sectional area A and transmittance T is forming an image S' at a distance v from the lens, of a small area S of an extended subject at a distance u from the lens. The subject luminance is L and the

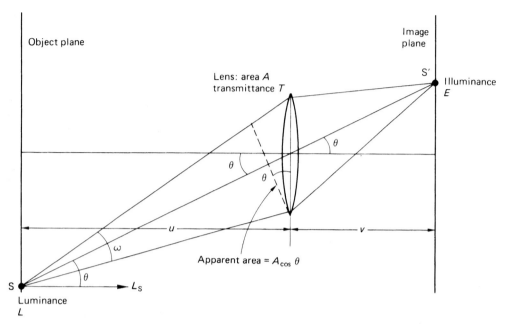

Figure 5.4 The factors determining image illuminance

small area S is displaced from the optical axis such that a principal ray (i.e. one through the centre of the lens) from object to image is inclined at angle θ to the axis. The solid angle subtended by the lens at S is ω. The apparent area of the lens seen from S is $A \cos \theta$. The distance between the lens and S is $u/\cos \theta$.

The solid angle of a cone is defined as its base area divided by the square of its height. Consequently,

$$\omega = \frac{A \cos \theta}{\left(\dfrac{u}{\cos \theta}\right)^2} = \frac{A \cos^3 \theta}{u^2}$$

The flux leaving S at the normal is LS, so the flux leaving S at an angle θ into the cone subtended by the lens is $LS \cos \theta$. Thus the flux K entering the lens is given by:

$$K = (LS \cos \theta) \frac{A \cos^3 \theta}{u^2} = \frac{LSA \cos^4 \theta}{u^2}$$

Hence from equation (2), the flux K' leaving the lens is given by

$$K' = \frac{TLSA \cos^4 \theta}{u^2}$$

Now, illumination is defined as flux per unit area, so image illuminance E is

$$E = \frac{K'}{S'} = \frac{TLA \cos^4 \theta S}{u^2 S'}$$

From geometry, by the ratio of the solid angles involved,

$$\frac{S}{S'} = \frac{u^2}{v^2}$$

Hence

$$E = \frac{TLA \cos^4 \theta}{v^2} \tag{3}$$

An evaluation of the variables in equation (3) gives a number of useful results and an insight into the factors influencing image illuminance and exposure.

The value of E is independent of u, the subject distance, although the value of v is related to u by the lens equation.

The axial value of illuminance is given when $\theta = 0$, then $\cos \theta = 1$ and $\cos^4 \theta = 1$. Hence

$$E = \frac{TLA}{v^2} \tag{4}$$

Now lens area A is given by

$$A = \frac{\pi d^2}{4}$$

so that

$$E = \frac{\pi L T d^2}{4v^2} \quad (5)$$

For the subject at infinity, $v = f$. By definition, the relative aperture N is given by $N = f/d$. By substitution into equation (5) we thus have:

$$E = \frac{\pi T L}{4N^2} \quad (6)$$

Equation 6 gives us the important result that, for a distant subject, on the optical axis in the focal plane, E is inversely proportional to N^2. Hence image illuminance is inversely proportional to the square of the f-number. For two different f-numbers N_1 and N_2, the ratio of corresponding image illuminances is given by

$$\frac{E_1}{E_2} = \frac{N_2^2}{N_1^2} \quad (7)$$

Thus, for example, it is possible to calculate that the image illuminance at $f/4$ is one-quarter of the value at $f/2$.

The *exposure* H received by a film during exposure duration t is given by

$$H = Et \quad (8)$$

Consequently, for a fixed exposure time, as H is proportional to E, then from equation (7)

$$\frac{H_1}{H_2} = \frac{N_2^2}{N_1^2} \quad (9)$$

Also, from equation (8), E is inversely proportional to t, so $E_1/E_2 = t_2/t_1$, hence the exposure time t_1 and t_2 required to produce equal exposures at f-numbers N_1 and N_2 respectively are given by

$$\frac{t_1}{t_2} = \frac{N_1^2}{N_2^2} \quad (10)$$

Also, from equation (7), E is inversely proportional to N^2. In other words, image illuminance is proportional to the square of the lens diameter, or effective diameter of the entrance pupil. Thus by doubling the value of d, image illuminance is increased fourfold. Values may be calculated from

$$\frac{E_1}{E_2} = \frac{d_1^2}{d_2^2} \quad (11)$$

To give a doubling series of stop numbers, the value of d is altered by a factor of $\sqrt{2}$, giving the standard f-number series.

An interesting result also follows from equation (6). By suitable choice of photometric units, such as

by taking E in lux (lumen/m^2) and L in apostilbs ($1/\pi$ cd/m^2), we have

$$E = \frac{TL}{4N^2}$$

So for a lens with perfect transmittance, i.e. $T = 1$, the maximum value of the relative aperture N is $f/0.5$, so that $E = L$. (Values close to $f/0.5$ have been achieved in special lens designs.)

When the object distance u is not large, i.e. close-up photography or photomacrography, we cannot take $v = f$ in equation (5), but instead use $v = f(1 + m)$ from the lens equation. Consequently

$$E = \frac{\pi T L d^2}{4f^2(1 + m)^2} \quad (12)$$

The relative aperture $N = f/d$, so

$$E = \frac{\pi T L}{4N^2(1 + m)^2} \quad (13)$$

Alternatively, the effective aperture $N' = N(1 + m)$, so

$$E = \frac{\pi L T}{4(N')^2} \quad (14)$$

Usually it is preferable to work in terms of relative aperture as an f-number (N) which is marked on the aperture control of the lens, and magnification (m) which is often known or set, so equation (13) is preferred to equation (14). In addition, for photomacrography, when non-symmetrical lenses, and particularly retrofocus lenses may be chosen used in reverse mode, the pupil factor $p = E_X/E_N$ must be taken into account for the effective aperture. The relationship is that $N' = N(1 + m/p)$ and is due to the non-correspondence of the principal planes from which u and v are measured and the pupil positions from which the image photometry is derived. Substituting into equation (14),

$$E = \frac{\pi T L}{4N^2 \left(1 + \dfrac{m}{p}\right)^2} \quad (15)$$

For most subjects not in the close-up region, equation (6) is sufficient.

When we consider image illumination off-axis, θ is not equal to 0. Then $\cos^4 \theta$ has a value less than unity, rapidly tending to zero as θ approaches 90 degrees. In addition, we have to introduce a *vignetting factor* (V) into the equation to allow for vignetting effects by the lens with increase in field

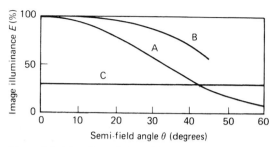

Figure 5.5 The effect of the cos⁴ θ law of illumination. (A) Natural light losses due to the law. (B) Improvements possible by utilizing Slussarev effects. (C) Use of a graduated neutral-density 'anti-vignetting' or 'spot' filter

angle. So our equation for image illuminance, allowing for all factors, is now:

$$E = \frac{V\pi TL \cos^4 \theta}{4N^2 \left(1 + \dfrac{m}{p}\right)^2} \quad (16)$$

From equation (16) we see that E is proportional to $\cos^4 \theta$. This is the embodiment of the so-called *cos⁴ θ law of illumination*, or 'natural vignetting' as it is sometimes called, which may be derived from the geometry of the imaging system, the inverse square law of illumination and Lambert's cosine law of illumination. The effects of this law are shown in Figure 5.5 (ignoring the effects of 'mechanical' vignetting). It can be seen that even a standard lens with a semi-angle of view of 26 degrees has a level of image illuminance at the edge of the image of only two-thirds of the axial value. For a wide-angle lens with a semi-angle of view of 60 degrees, peripheral illuminance is reduced to 0.06 of its axial value. For wide-angle lens designs, corrective measures are necessary to obtain more uniform illumination over the image area.

Image illuminance with wide-angle lenses

There are several possible methods of achieving more uniform illumination in the image plane; these are related to the design of a lens and its particular applications.

Mechanical methods

An early method of reducing illumination fall-off was a revolving star-shaped device in front of the lens,

used on the unique Goerz Hypergon lens, which at *f*/16 had an angle of field of 120 degrees. A more modern remedy is a *graduated neutral density filter* or *spot filter*, in which density decreases non-linearly from a maximum value at the optical centre to near-zero at the periphery; this can provide a fairly precise match for illumination fall-off. Such filters are widely used with wide-angle lenses of symmetrical configuration. There is a penalty in the form of a +2 EV exposure correction factor. Oversize front and rear elements are also used to minimize mechanical vignetting.

Negative outer elements

As shown, a major cause of illumination fall-off is that the projected area of the aperture stop is smaller for rays that pass through it at an angle. This angle can be reduced if the lens is designed so that its outermost elements are negative and of large diameter. Lens designs such as quasi-symmetrical lenses with short back foci, and also retrofocus lenses, both benefit from this technique. The overall effect is to reduce the 'cos⁴ θ effect' to roughly $\cos^3 \theta$.

The Slussarev effect

Named after its discoverer, this approach uses the deliberate introduction of the aberration known as *coma* into the pencils of rays at the entrance and exit pupils of the lens. Their cross-sectional areas are thereby increased, so that illuminance is increased at the periphery, but the positive and negative coma effects cancel out and have little adverse effect on image quality.

Uncorrected distortion

Finally, the theoretical consideration of image illuminance applies only to well-corrected lenses that are free from distortion. If distortion correction (which becomes increasingly difficult to achieve as angle of field increases) is abandoned, and the lens design deliberately retains barrel distortion so that the light flux is distributed over proportionally smaller areas towards the periphery, then fairly uniform illuminance is possible even up to the angles of view of 180 degrees or more. 'Fish-eye' lenses are examples of the application of this principle. The relationship between the distance y of an image point from the optical axis changes from the usual $y = f \tan \theta$ of an orthoscopic lens to $y = f \theta$ (θ in radians) for this type of imagery.

Exposure compensation for close-up photography

The definition of relative aperture (N) assumes that the object is at infinity, so that the image conjugate v can be taken as equal to the focal length f. When the object is closer this assumption no longer applies, and instead of f in the equation $N = f/d$, we need to use v, the lens extension. Then N' is defined as equal to v/d where N' is the *effective f-number* or *effective aperture*.

Camera exposure compensation may be necessary when the object is within about ten focal lengths from the lens. Various methods are possible, using the values of f and v (if known), or magnification m, if this can be measured. Mathematically, it is easier to use a known magnification in the determination of the correction factor for either the effective f-number N' or the corrected exposure duration t'. The required relationships are, respectively:

$$\frac{t'}{t} = \frac{(N')^2}{N^2} \tag{17}$$

or

$$t' = t(1 + m)^2 \tag{18}$$

and

$$N' = N\left(\frac{v}{f}\right) \tag{19}$$

i.e.

$$N' = N(1 + m) \tag{20}$$

These expressions are readily derived from the lens equation and equation (10). The exposure correction factor increases rapidly as magnification increases. For example, at unit magnification the exposure factor is ×4 (i.e. +2 EV), so that the original estimated exposure time must be multiplied by four or the lens aperture opened up by two whole stops.

For copying, where allowance for bellows extension must always be made, it may be more convenient to calculate correction factors based on an exposure time that gives correct exposure at unit magnification. Table 5.1 gives a list of exposure factors.

The use of cameras with through-the-lens (TTL) metering systems is a great convenience in close-up photography, as compensation for bellows extension is automatically taken into account. TTL metering is also essential with lenses using internal focusing and for zoom lenses with variable aperture due to mechanical compensation, as the effective aperture may not vary strictly according to theory since focal

Table 5.1 Exposure correction factors for different scales of reproduction (magnification)

1 *Object distance*	2 *Bellows extension*	3 *Linear scale of reproduction*	4 *Marked f-number must be multiplied by:*	5 *Exposure indicated for object at infinity must be multiplied by**	6 *Exposure indicated for same size reproduction must be multiplied by:**
u	v	$m = v/f - 1$	$1 + m$	$(1 + m)^2$	$(1 + m)^2/4$
Infinity	f	0	×1	×1	×0.25
	$1.125f$	0.125	×1.125	×1.25	×0.31
	$1.25f$	0.25	×1.25	×1.5	×0.375
	$1.5f$	0.5	×1.5	×2.25	×0.5
	$1.75f$	0.75	×1.75	×3	×0.75
$2f$	$2f$	1(same-size)	×2	×4	×1
	$2.25f$	1.5	×2.5	×6	×1.5
	$3f$	2	×3	×9	×2.25
	$4f$	3	×4	×16	×4
	$5f$	4	×5	×25	×6

*The exposure factors in columns 5 and 6 are practical approximations.

length changes with alteration of focus too. Similarly, due to the pupil magnification effect, the use of telephoto and retrofocus design lenses with a reversing ring may need an exposure correction factor differing from that calculated by equations (16) and (18). The variable m must be replaced by m/p, where p is the pupil magnification. Lenses that use internal focusing where an inner group is moved axially have a change of effective focal length and hence the marked value of N for close-up work. A set of correction tables is needed or again the use of TTL metering gives automatic compensation.

Light losses and lens transmission

Some of the light incident on a lens is lost by reflection at the air–glass interfaces and a little is lost by absorption. The remainder is transmitted, to form the image. So the value of transmittance T in equation (2) and subsequent equations is always less than unity. The light losses depend on the number of surfaces and composition of the glasses used. An average figure for the loss due to reflection might be 5 per cent for each air–glass interface. If k (taken as 0.95) is a typical transmittance at such an interface, then as the losses at successive interfaces are multiplied, for n interfaces with identical transmittance, the total transmittance $T = k^n$. This means that an uncoated four-element lens with eight air–glass interfaces would have reflection losses amounting to some $(0.95)^8 = 35$ per cent of the incident light, i.e. a transmittance of 0.65.

Flare and its effects

Some of the light reflected at the lens surfaces passes out of the front of the lens and causes no trouble other than loss to the system; but a proportion is re-reflected from other surfaces (Figure 5.6) and may ultimately reach the film. Some of this stray diffuse non-image-forming light is spread uniformly over the surface of the film, and is referred to as *lens flare* or *veiling glare*. Its effects are greater in the shadow areas of the image and cause a reduction in the image illuminance range (contrast). The flare light may not be spread uniformly; some may form out-of-focus images of the iris diaphragm ('flare spots') or of bright objects in the subject field ('ghost images'). Such flare effects can be minimized by anti-reflection coatings, baffles inside the lens and use of an efficient lens hood. Light reflected from the inside of the camera body, e.g. from the bellows of a technical camera, and from the surface of the film or photosensor, produces what is known as 'camera flare'. This effect can be especially noticeable in a technical camera when the field covered by the lens gives an

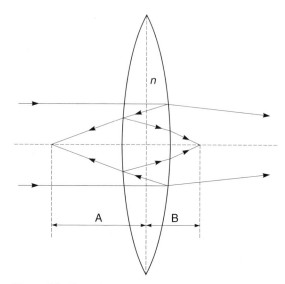

Figure 5.6 Formation of flare spots by a simple lens. Images of the source are formed at distances A and B, where:

$$A = \left(\frac{n-1}{an-1}\right)f \qquad B = \left(\frac{n-1}{bn-1}\right)f$$

and $a = 2, 4, 6 \dots$, $b = 3, 5, 7, \dots$ For $n = 1.5$, $A = f/4$, $f/10$, $f/16$ etc. and $B = f/7$, $f/13$, $f/19$ etc.

image circle appreciably greater than the film format. Such flare can often be considerably reduced by use of an efficient lens hood.

The number obtained by dividing the subject luminance range (SLR) by the image illuminance range (IIR) is termed the flare factor (FF), so $FF = SLR/IIR$. Flare factor is a somewhat indeterminate quantity, since it depends not only on the lens and camera but also on the distribution of light within and around the subject area. The value for an average lens and camera considered together may vary from about 2 to 10 for average subject matter. The usual value is from 2 to 4 depending on the age of the camera and lens design. A high flare factor is characteristic of subjects having high luminance ratio, such as back-lit subjects.

In the camera, flare affects shadow detail in a negative more than it does highlight detail; in the enlarger (i.e. in the print), flare affects highlight detail more than shadow detail. In practice, provided the negative edges are properly masked in the enlarger, flare is seldom serious. This is partly because the density range of the average negative is lower than the log-luminance range of the average subject, and partly because the negative is not surrounded by bright objects, as may happen in the subject matter. In colour photography, flare is likely to lead to a desaturation of colours, as flare light is usually a mixture approximating to white. Flare may also lead to colour casts caused by coloured objects outside the subject area.

T-numbers

In practice, because lens transmission is never 100 per cent, relative aperture or *f*-number *N* (as defined by the geometry of the system) does not give the light-transmitting capability of a lens. Two lenses of the same *f*-number may have different transmittances, and thus different speeds, depending on the type of construction, number of components, and type of lens coatings. The use of lens coatings to reduce reflection losses markedly improves transmission, and there is a need in some fields of application for a more accurate measure of the transmittance of a lens. Where such accuracy is necessary, *T-numbers*, which are photometrically determined values taking into account both imaging geometry and transmittance, may be used instead of *f*-numbers. The *T*-number of any aperture of a lens is defined as the *f*-number of a perfectly transmitting lens which gives the same axial image illuminance as the actual lens at this aperture. For a lens of transmittance *T* and a circular aperture,

$$T\text{-number} = \frac{N}{\sqrt{T}} = NT^{-1/2} \tag{21}$$

Thus a *T*/8 lens is one which passes as much light as a theoretically perfect *f*/8 lens. The relative aperture of the *T*/8 lens may be about *f*/6.3. The concept of *T*-numbers is of chief interest in cinematography and television, and where exposure latitude is small. It is implicit in the *T*-number system that every lens should be individually calibrated.

Depth of field calculations still use *f*-numbers as the equations used have been derived from the geometry of image formation.

Anti-reflection coatings

Single coatings

A very effective practical method of increasing the transmission of a lens by reducing the light losses due to surface reflection is by applying thin coatings of refractive material to the air–glass interfaces or lens surfaces. The effect of single anti-reflection coating is to increase transmittance from about 0.95 to 0.99 or more. For a lens with, say, eight such interfaces of average transmittance 0.95, the lens total transmittance increases from $(0.95)^8$ to $(0.99)^8$, representing an increase in transmittance from 0.65 to 0.92, or approximately one-third of a stop, for a given *f*-number. In the case of a zoom lens, which may have 20 such surfaces, the transmittance may be increased from 0.36 to 0.82, i.e. more than doubled. Equally important is the accompanying reduction in lens flare, giving an image of improved contrast where, without

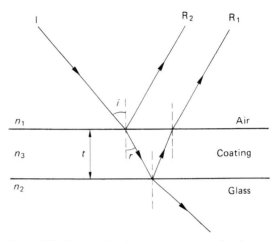

Figure 5.7 An anti-reflection coating on glass using the principle of destructive interference of light between reflections R_1 and R_2

the use of such coatings, such a lens design would be of little practical use.

The effect of a surface coating depends on two principles. First, the surface reflectance *R*, the ratio of reflected flux to incident flux, depends on the refractive indexes n_1 and n_2 of the two media forming the interface; in simplified form (from Fresnel's equations) this is given by

$$R = \frac{(n_2 - n_1)^2}{(n_2 + n_1)^2} \tag{22}$$

In the case of a lens surface, n_1 is the refractive index of air and is approximately equal to 1, and n_2 is the refractive index of the glass. From equation (22) it can be seen that reflectance increases rapidly with increase in the value of n_2. In modern lenses, using glasses of high refractive index (typically 1.7 to 1.9), such losses would be severe without coating.

Secondly, in a thin coating there is interference between the light wavefronts reflected from the first and second surfaces of the coating. With a coating of thickness *t* and refractive index n_3 applied to a lens surface (Figure 5.7), the interaction is between the two reflected beams R_1 and R_2 from the surface of the lens and from the surface of the coating respectively. The condition for R_1 and R_2 to interfere destructively and cancel out is given by

$$2n_3 t \cos r = \frac{\lambda}{2} \tag{23}$$

where *r* is the angle of refraction and λ the wavelength of the light. Note that the light energy lost

to reflection is transmitted instead. For light at normal incidence this expression simplifies to

$$2n_3t = \frac{\lambda}{2} \qquad (24)$$

Equation 24 shows that to satisfy this condition the 'optical thickness' of the coating, which is the product of refractive index and thickness, must be $\lambda/4$, i.e. one-quarter of the wavelength of the incident light within the coating. This type of coating is termed 'quarter-wave coating'. As the thickness of such a coating can be correct for only one wavelength it is usually optimized for the middle of the spectrum (green) and hence looks magenta (white minus green) in appearance. By applying similar coatings on other lens surfaces, but matched to other wavelengths, it is possible to balance lens transmission for the whole visible spectrum and ensure that the range of lenses available for a given camera produce similar colour renderings on colour reversal film, irrespective of their type of construction.

The optimum value of n_3 for the coating is also obtained from the conditions for the two reflected wavefronts to interfere destructively and cancel. For this to happen the magnitudes of R_1 and R_2 need to be the same. From equation (22) we can obtain expressions for R_1 and R_2:

$$R_1 = \frac{(n_2 - n_3)^2}{(n_2 + n_3)^2}$$

$$R_2 = \frac{(n_3 - n_1)^2}{(n_3 + n_1)^2}$$

By equating $R_1 = R_2$ and taking $n_1 = 1$, then $n_3 = \sqrt{n_2}$.

So the optimum refractive index of the coating should have a value corresponding to the square root of the refractive index of the glass used.

For a glass of refractive index 1.51, the coating should ideally have a value of about 1.23. In practice the material nearest to meeting the requirements is magnesium fluoride, which has a refractive index of 1.38. A quarter-wave coating of this material results in an increase in transmittance at an air–glass interface from about 0.95 to about 0.98 as the light energy involved in the destructive interference process is not lost but is transmitted.

Types of coating

Evaporation

The original method of applying a coating to a lens surface is by placing the lens in a vacuum chamber in which is a small container of the coating material. This is electrically heated, and evaporates, being deposited on the lens surface. The deposition

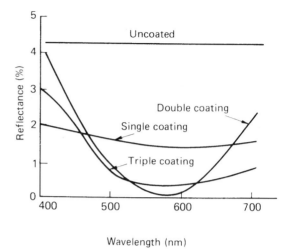

Figure 5.8 The effects on surface reflection of various types of anti-reflection coatings as compared with uncoated glass (for a single lens surface at normal incidence)

is continued until the coating thickness is the required value. This technique is limited to materials that will evaporate at sufficiently low temperatures.

Electron beam coating

An alternative technique to evaporative coating is to direct an electron beam at the coating substance in a vacuum chamber. This high-intensity beam evaporates even materials with very high melting points which are unsuitable for the evaporation technique. Typical materials used in this manner are silicon dioxide ($n = 1.46$) and aluminium oxide ($n = 1.62$). The chief merit of the materials used in electron beam coating is their extreme hardness. They are also used to protect aluminized and soft optical glass surfaces.

Multiple coatings

Controlled surface treatment is routinely applied to a range of other optical products. With the advent of improved coating machinery and a wider range of coating materials, together with the aid of digital computers to carry out the necessary calculations, it is economically feasible to extend coating techniques by using several separate coatings on each air–glass interface. A stack of 25 or more coatings may be used to give the necessary spectral transmittance properties to *interference filters*, as used in colour enlargers and specialized applications such as spectroscopy and microscopy. By suitable choice of the number, order,

thicknesses and refractive indexes of individual coatings the spectral transmittance of an optical component may be selectively enhanced to a value greater than 0.99 for any selected portion of the visible spectrum (Figure 5.8).

The use of double and triple coatings in modern photographic lenses is now almost universal, and numbers of coatings between 7 and 11 are claimed by some manufacturers. The use of lens coatings has made available a number of advanced lens designs that would otherwise have been unusable because of flare and low transmittance.

Bibliography

Freeman, M. (1990) *Optics*, 10th edn. Butterworths, London.

Hecht, E. (1998) *Optics*, 3rd edn. Addison-Wesley, Reading, MA.

Jenkins, F. and White, H. (1981) *Fundamentals of Optics*, 4th edn. McGraw-Hill, London.

Kingslake, R. (1992) *Optics in Photography*. SPIE, Bellingham, WA.

Ray, S. (1994) *Applied Photographic Optics*, 2nd edn. Focal Press, Oxford

6 Optical aberrations and lens performance

Introduction

In previous chapters lenses have been considered as 'ideal', forming geometrically accurate images of subjects. In practice actual lenses, especially simple lenses, only approximate to this ideal. There are three reasons for this:

(1) The refractive index of glass varies with wavelength.
(2) Lens surfaces are usually spherical in shape.
(3) Light behaves as if it were a wave motion.

These departures from ideal imaging are called *lens errors* or *optical aberrations*. Effects due to (1) are called *chromatic aberrations*, those due to (2) are *spherical aberrations* and those due to (3) are *diffraction effects*. In general, the degrading effects of aberrations increase with both aperture and angle of field.

There are seven primary chromatic and spherical errors that may affect an image. Two *direct errors* or *axial aberrations* affect all parts of the image field as well as the central zone, known as *axial chromatic aberration* and *spherical aberration*. The other five errors affect only rays passing obliquely through the lens and do not affect the central zone. The effects of these *oblique errors*, or *off-axis aberrations*, increase with the distance of the image point from the lens axis. They are called *transverse* (or *lateral*) *chromatic aberration* (formerly called 'lateral colour'), *coma*, *curvature of field*, *astigmatism*, and (curvilinear) *distortion*. Their degrading effects appear in that order as the field angle of field increases.

Axial and lateral chromatic aberration are chromatic effects; spherical aberration, coma, curvature of field, astigmatism and distortion are spherical effects. The latter are also called *Seidel aberrations* after L. Seidel, who in 1856 gave a mathematical treatment of their effects. They are also known as *third-order aberrations*, from their mathematical formulation. Although lens aberrations are to a large extent interconnected in practice, it is convenient to discuss each aberration separately. Modern highly corrected lenses have only residual traces of these primary aberrations. The presence of less easily corrected higher orders of aberration (such as *fifth-order aberrations*) sets practical limits to lens performance.

Axial chromatic aberration

The refractive index of transparent media varies with the wavelength of the light passing through, shorter wavelengths being refracted more than longer wavelengths, giving *spectral dispersion* and *dispersive power*. The principal focus of a simple lens therefore varies with the transmitted wavelength, i.e. focal length varies with the colour of light. This separation of focus along the optical axis of a positive lens is shown in Figure 6.1; the focus for blue light is closer to the lens than the focus for red light. The image suffers from *axial chromatic aberration*. Early photographic lenses were of simple design, and the non-coincidence of the visual (yellow–green) focus with the 'chemical' or 'actinic' (blue) focus for the blue-sensitive ('ordinary') materials then in use presented a serious problem. It was necessary to allow for the shift in focus either by altering the focus setting or by using a small aperture to increase the depth of focus. The latter method allows simple lenses to be used in inexpensive cameras, with reasonable results, even with colour film.

In 1757 Dollond showed that that if a lens is made from two elements of different optical glass, the chromatic aberrations in one can be made to effectively cancel out those in the other. Typically, a combination of positive 'crown' glass and a negative 'flint' glass elements was used. The convergent crown element had a low refractive index and a low (small) dispersive power, while the divergent flint element had a higher refractive index and more dispersive power. To make a practical lens, the crown element has a greater refractive power than the flint

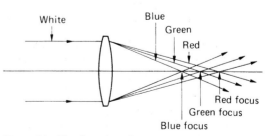

Figure 6.1 The dispersive effects of chromatic aberration in a simple lens

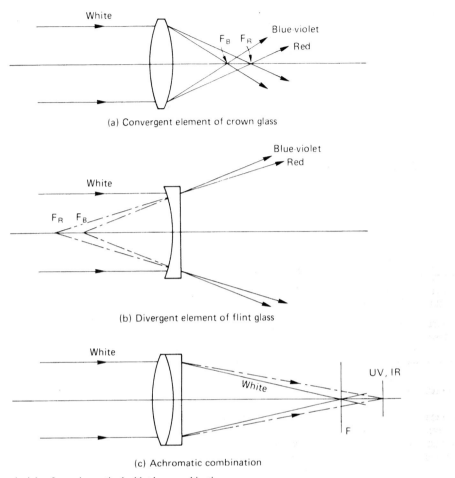

White

Blue-violet

F_B F_R

Red

(a) Convergent element of crown glass

Blue-violet

Red

White

F_R F_B

(b) Divergent element of flint glass

White

UV, IR

White

F

(c) Achromatic combination

Figure 6.2 The principle of an achromatic doublet lens combination

element, resulting in a combination that is positive overall, but with the positive and negative dispersions equal and cancelling out. The two elements may be separated or cemented together. A *cemented achromatic doublet* lens made in this way is shown in Figure 6.2. Other errors such as spherical aberration and coma may be simultaneously corrected by this configuration, giving satisfactory results over a narrow field at a small aperture.

The chromatic performance of a lens is usually shown by a graph of wavelength against focal length, as shown in Figure 6.3. The variation of focus with wavelength for an uncorrected lens is an approximately straight line; that of an achromatic lens is approximately a parabola. The latter curve indicates the presence of a residual uncorrected *secondary spectrum*. The two wavelengths chosen to have the same focus positions are usually in the red and blue regions of the spectrum, for example the C and F Fraunhöfer lines (other pairs of lines were chosen in

early lenses for use with non-panchromatic materials). For some applications, such as colour-separation work, a lens may be corrected to bring three colour foci into coincidence, giving three coincident images of identical size when red, green and blue colour-separation filters are used. A lens possessing this higher degree of correction is said to be *apochromatic*. Note that this term is also used to describe lenses that are corrected fully for only two wavelengths, but use special low-dispersion glasses to give a much-reduced secondary spectrum. It is also possible to obtain a higher degree of correction and to bring four wavelengths to a common focus. Such a lens is termed a *superachromat*. The wavelengths chosen are typically in the blue, green, red and infrared regions, so that no focus correction is needed between 400 and 1000 nm. Using materials such as silica and fluorite, an achromatic lens may be made for UV recording, needing no focus correction after visual focusing.

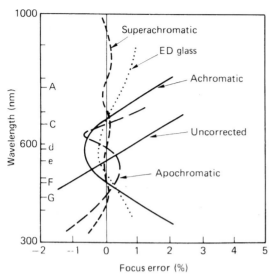

Figure 6.3 Types of chromatic correction for lenses. The letters on the vertical axis represent the wavelengths of the Fraunhofer spectral lines used for standardization purposes. Residual aberration is shown as a percentage change in focal length

Optical materials other than glass also require chromatic correction. Plastics (polymers) are used in photographic lenses either as individual elements or as hybrid glass–plastic aspheric combinations. It is possible to design an achromatic combination using plastics alone, given the choice of optical-quality polymer materials available.

The use of reflecting surfaces which do not disperse light, in the form of 'mirror lenses', offers another solution; but most mirror designs are for long-focus lenses only. Most of these, too, are *catadioptric lenses* with some refracting elements and these still require some colour correction.

Lateral chromatic aberration

Lateral or *transverse chromatic aberration*, sometimes also called either *lateral colour* or *chromatic difference of magnification*, is a particularly troublesome error which appears in the form of dispersed colour fringes at the edges of the image (Figure 6.4). It is an off-axis aberration, i.e. it is zero at the optical centre of the focal plane but increases as the angle of field increases. Whereas axial chromatic aberration concerns the focused distance from the lens at which the image is formed, lateral chromatic aberration concerns the size of the image. It is not easy to correct: its effects worsen with an increase in focal length, and are not reduced by closing down the lens aperture. It effectively once set a limit on the performance of long-focus lenses, especially those used for photomechanical colour-separation work. 'Mirror' lenses may offer an alternative in some cases, but they have their own limitations. Lateral chromatic aberration can be minimized by a symmetrical lens construction and the use of at least three different types of optical glass. Fortunately, almost full correction is possible by use of alternative special optical materials (Figure 6.5). These include optical glass of anomalous or *extra-low dispersion* (ED) which may be used in long lenses, giving few problems other than increased cost. Another material which has exceptionally low dispersion characteristics is *fluorite* (calcium fluoride). It has been used in its natural form, when it is found in very small pieces of optical quality, for use in microscope objectives. It

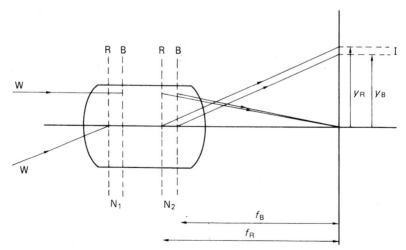

Figure 6.4 Lateral (or transverse) chromatic aberration for off-axis points in a lens that has been corrected for longitudinal chromatic aberration only. The effect is a variation in image point distance *y* from the axis for red and blue light

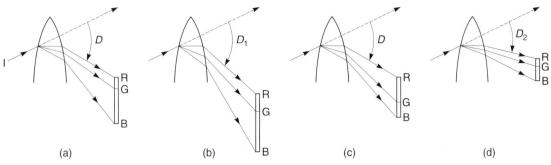

Figure 6.5 Refraction and dispersion by optical materials. The refractive power of a material is shown by the deviation angle D of incident light I. Dispersion by refraction is indicated by the length of spectrum RGB. Relative partial dispersion is indicated by the ratio of lengths RG and GB. (a) Conventional optical glass: dispersion is greater at short wavelengths. (b) High index glass: deviation increases but so does dispersion: $D_1 > D$. (c) ED glass: anomalous low dispersion at short wavelengths. (d) Fluorite: low deviation and anomalous dispersion: $D_2 < D$

is now possible to grow large flawless crystals for use in photographic lenses. Unfortunately, fluorite is attacked by the atmosphere, so it must be protected by outer elements in the lens construction. Also, the focal length of fluorite lenses varies with temperature, and this means problems with the focusing calibration for infinity focus. The cost of lenses using fluorite elements is significantly higher than that of equivalent conventional designs.

Spherical aberration

The deviation or amount of refraction of a ray of light depends on the angles of incidence made with the surfaces of the lenses in its path as well as the refractive index of the elements. Lens surfaces are almost always spherical, because such shapes are easy to manufacture. However, a single lens element with one or two spherical surfaces does not bring all paraxial (near axial) rays to a common focus. The exact point of focus depends on the region or *zone* of the lens surface under consideration. A zone is an annular region of the lens centered on the optical axis. Rays passing through the outer ('marginal') zones come to a focus nearer to the lens than the rays through the central zone (Figure 6.6). Consequently, a subject point source does not produce a true image point. The resultant unsharpness is called *spherical aberration*. In a simple lens, spherical aberration can be reduced by stopping-down to a small aperture. As aperture is reduced the plane of best focus may shift, a phenomenon characteristic of this aberration. Spherical aberration in a simple lens is usually minimized by a suitable choice of radii of curvature of the two surfaces of the lens, termed 'lens bending'.

Correction of spherical aberration is by choosing a suitable combination of positive and negative elements whose spherical aberrations are equal and opposite. This correction may be combined with that necessary for chromatic aberration and for coma (see below). Such a corrected combination is termed *aplanatic*. It is difficult to provide complete correction for spherical aberration, one reason is that, like chromatic aberration, it has both axial and lateral components affecting the whole image. This limits the maximum useful aperture of some useful lens designs, for example to $f/5.6$ for some symmetrical designs. More elaborate designs such as those derived from the double-Gauss configuration, with six or more elements, allow apertures of $f/2$ and greater, with adequate correction. The cost of production is also greater.

The use of an *aspheric surface* can give a larger useful aperture, or alternatively allow fewer elements necessary for a given aperture. Optical production technology now provides aspheric surfaces at reasonable cost and they find a variety of uses. Another alternative is to use optical glasses of very high refractive index which then need lower curvatures for a given refractive power, with a consequent reduction in spherical aberration.

A problem in lens design is the variation in spherical aberration with focused distance. A lens that has been computed to give full correction of spherical aberration when focused on infinity may perform less well when focused close up. One solution used in multi-element lenses is to have one group of elements move axially for spherical correction purposes as the

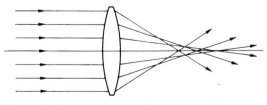

Figure 6.6 Spherical aberration in a simple lens

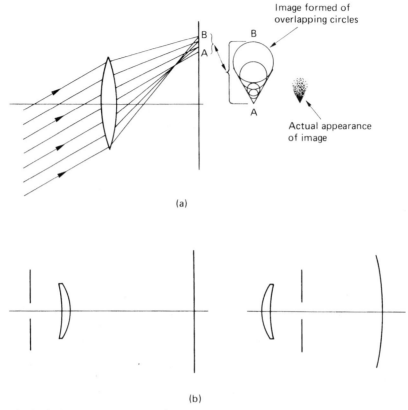

Figure 6.7 (a)

(b)

Figure 6.7 Coma in simple lenses. (a) Formation of coma patterns. (b) Use of meniscus lenses in simple cameras

lens is focused. This movement may either be coupled to the focusing control, or can be set manually after focusing. This arrangement is termed a *floating element*, and is a result of experience gained in zoom lens design. Most 'macro' lenses for close-up photography incorporate such a system.

A few lenses have been designed to have a controllable amount of residual uncorrected spherical aberration to give a noticeable 'soft-focus' effect, particularly useful for portraiture. The Rodenstock Imagon is a well-known example. The degree of softness may be controlled either by specially shaped and perforated aperture stops to select particular zones of the lens, or by progressive separation of two of the elements of the lens.

Coma

In an uncorrected simple lens, oblique (off-axis) rays passing through different annular zones of the lens intersect the film at different distances from the axis, instead of being superimposed. The central zone forms a point image that is in the correct geometrical

position. The next zone forms an image that is not a point but a small circle that is displaced radially outwards from the geometric image. Successive zones form larger circles that are further displaced, the whole array adding together to give a V-shaped patch known as a *coma patch*, from its resemblance to a comet. A lens exhibiting this defect is said to suffer from *coma* (Figure 6.7a). Coma should not be confused with the lateral component of spherical aberration; it is a different term in the Seidel equations, and a lens may be corrected for lateral spherical aberration and coma independently. In a lens system coma may be either outward (away from the lens axis, as in Figure 6.7), or inward, with the tail pointing towards the lens axis. Coma, like spherical aberration, is significantly reduced by stopping down the lens. This, however, may cause the image to shift laterally (just as the image shifts axially if spherical aberration is present), and this may reveal a further aberration called 'distortion' (see below). Coma can be reduced in a simple lens by employing an aperture stop in a position that restricts the area of the lens over which oblique rays are incident. This method is used to minimize coma (and also tangential astigma-

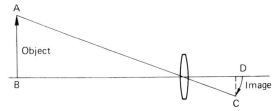

Figure 6.8 Curvature of field in a simple lens

tism) in simple box camera lenses (Figure 6.7b). In compound lenses coma is reduced by balancing the error in one element by an equal and opposite error in another. In particular, symmetrical construction is beneficial. Coma is particularly troublesome in wide-aperture lenses.

Curvature of field

From the basic lens conjugate formula, the locus of sharp focus for a planar object is the so-called *Gaussian plane*. In a simple lens, however, this focal surface is in practice not a plane at all, but a spherical surface, called the *Petzval surface*, centred approximately on the rear nodal point of the lens (Figure 6.8).

With a lens suffering from this aberration it is impossible to obtain a sharp image all over the field: when the centre is sharp the corners are blurred, and vice versa. This is to be expected, as points in the object plane that are away from the optical axis are farther from the centre of the lens than points that are near the axis, and accordingly form image points that are nearer to the lens than points near the axis. Petzval was the first person to design a lens (in 1840) by mathematical computation, and he devised a formula, known as the *Petzval sum*, describing the curvature of field of a lens system in terms of the refractive indexes and surface curvatures of its components. By choosing these variables appropriately, the Petzval sum can be reduced to zero, giving a completely flat field. Unfortunately, this cannot be done without leaving other aberrations only partly corrected, and in some scientific instruments such as wide field telescopes where curvature of field is unavoidable it may be necessary to use very thin glass plates that can be bent to the required curvature. Some large-aperture camera lenses are designed with sufficient residual curvature of field to match the image surface or 'shell' of sharp focus to the natural curvature of the film in the gate; a number of slide-projector lenses have been designed in this way. Lens designs derived from the double-Gauss configuration are capable of giving a particularly flat image surface, e.g. the Zeiss Planar series of lenses.

Astigmatism

The imaging situation is complicated further in that the Petzval surface represents the locus of true point images only in the absence of the aberration called *astigmatism*. This gives two additional curved surfaces close to the Petzval surface, which may also be thought of as surfaces of sharp focus, but in a different way. They are called *astigmatic surfaces*. The term 'astigmatic' comes from a Greek expression meaning 'not a point', and the two surfaces are the loci of images of points in the object plane that appear in one case as short lines radial from the optical axis, and in the other as short lines tangential to circles drawn round the optical axis. Figure 6.9 shows the geometry of the system, and illustrates the reason for the occurrence of astigmatism. When light from an off-axis point passes through a lens obliquely, a plane sheet of rays parallel to a line joining the point to the optical axis passes through the lens making angles of incidence and emergence that differ from the minimum-deviation conditions; they are therefore brought to a focus closer to the lens than are axial rays. At the same time, sheets of rays perpendicular to this line pass through the lens obliquely, so that the lens appears thicker and its curvature higher; these are also brought to a focus closer to the lens than are axial rays. But this 'tangential' focus is in a different position from the other, 'radial' (or 'sagittal') focus (it is, typically, nearer to the lens, as shown in Figure 6.9 a). The result is that on one of these surfaces all images of off-axis points appear as short lines radial from the optical axis, and on the other they appear as tangential lines. The surface which approximately bisects the space between the two astigmatic surfaces contains images which are minimum discs of confusion and may represent the best focus compromise (Figure 6.9b and c). Astigmatism mainly affects the margins of the field, and is therefore a more serious problem with lenses that have a large angle of view.

The effects of both astigmatism and curvature of field are reduced by closing down the lens aperture. Although curvature of field can be completely corrected by the choice and distribution of the powers of individual elements, as explained earlier, astigmatism cannot, and it remained a problem in camera lenses until the 1880s, when new types of glass were made available from Schott based on work by Abbe, in which low refractive index was combined with high dispersion and vice versa. This choice made it possible to reduce astigmatism to low values without affecting the correction of chromatic and spherical aberration and coma. Such lenses were called *anastigmats*. Early anastigmat lenses were usually based on symmetrical designs, which gave a substantially flat field with limited distortion (see below).

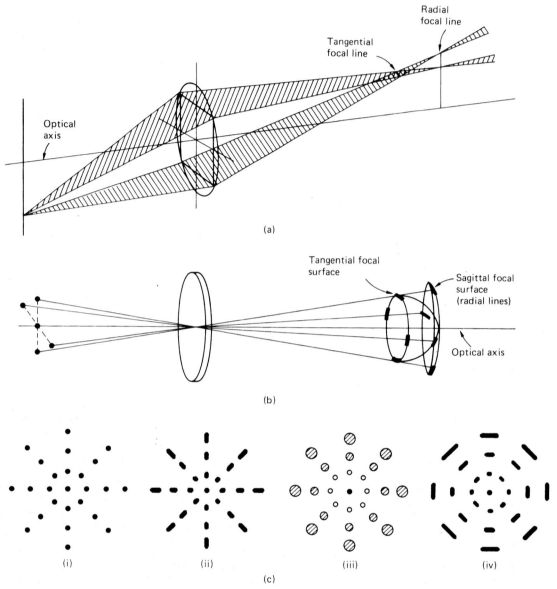

Figure 6.9 Astigmatism and its effects. (a) Geometry of an astigmatic image-forming system such as a simple lens. (b) Astigmatic surfaces for radial and tangential foci. (c) Appearance of images of point objects on the astigmatic surfaces: (i) object plane; (ii) sagittal focal surface; (iii) surface containing discs of least confusion; (iv) tangential focal surface

Curvilinear distortion

When an iris diaphragm acting as the aperture stop is used to limit the diameter of a camera lens in order to reduce aberrations, it is desirable that it should be located so that it transmits the bundle of rays that surround the primary ray (i.e. the ray that passes through the centre of the lens undeviated). Distortion occurs when a stop is used to control aberrations such as coma. If the stop is positioned for example in front of the lens or behind it, the bundle of rays selected does not pass through the centre of the lens (as is assumed in theory based on thin lenses), but through a more peripheral region, where it is deviated either inwards, for a stop on the object side of the lens ('barrel distortion'), or outwards, for a stop on the image side of the lens ('pincushion distortion') (see

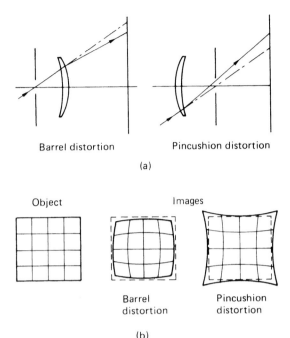

Barrel distortion Pincushion distortion

(a)

Object Images

Barrel Pincushion
distortion distortion

(b)

Figure 6.10 The effects of curvilinear distortion. (a) The selection of a geometrically incorrect ray bundle by asymmetric location of the aperture stop. (b) Image shape changes caused by barrel and pincushion distortion

Figure 6.10). These names represent the shapes into which the images of rectangles centred on the optical axis are distorted; because the aberration produces curved images of straight lines it is correctly called *curvilinear distortion*, to distinguish it from other distortions such as geometrical distortion and the perceptual distortion consequent on viewing photographs taken with a wide-angle lens from an inappropriate distance.

As distortion is a consequence of employing a stop, it cannot be reduced by stopping-down. Indeed, the fact that this action sharpens up the distorted image means that the use of a small aperture may make the distortion more noticeable. Distortion can be minimized by making the lens symmetrical in configuration, or nearly symmetrical ('quasi-symmetrical'). An early symmetrical lens, the 'Rapid Rectilinear', took its name from the fact that it produced distortion-free images and was of reasonable aperture ('rapidity'). A truly distortion-free lens is termed *orthoscopic*. The geometrical accuracy of the image given by a lens is sometimes referred to as its 'drawing'.

Some symmetrical lenses have separately removable front and rear components. Used alone, the front component of such a lens introduces pincushion distortion and the rear component barrel distortion; when the two components are used together the two

defects cancel one another. The use of a symmetrical construction eliminates not only distortion but also coma and lateral chromatic aberration. Unfortunately, residual higher orders of spherical aberration limit the maximum aperture of such lenses to about *f*/4.

Lenses of highly asymmetrical construction, such as telephoto and retrofocus lenses, are prone to residual distortions: telephoto lenses may show pincushion distortion and retrofocus lenses barrel distortion. The effect is more serious in the latter case, as retrofocus lenses are used chiefly for wide-angle work, where distortion is more noticeable. Zoom lenses tend to show pincushion distortion at long-focus settings and barrel distortion at short-focus settings, but individual performance must be determined by the user. General purpose lenses usually have about 1 per cent distortion measured as a displacement error, acceptable in practice. Wide-angle lenses for architectural work must have less than this, while lenses for aerial survey work and photogrammetry must be essentially distortion free, with residual image displacements measurable in micrometres. The use of aspheric lens surfaces may help reduce distortion.

Diffraction

Diffraction effects

Even when all primary and higher-order aberrations in a lens have been corrected and residual effects reduced to a minimum, there still remain imaging errors due to diffraction. Diffraction is an optical phenomenon characteristic of the behaviour of light at all times, and is manifest in particular by the deviation of zones of a light beam when it passes through a narrow aperture or close to the edge of an opaque obstacle. Diffraction is described by the wave model for the behaviour of light, and its effects can be quantified by fairly simple mathematics.

The most important source of diffraction is at the edges of the aperture stop of a lens. The image of a point source formed by an 'ideal' (i.e. aberration-free) lens is seen to be not a point as predicted by geometrical theory but instead to be a patch of light having a quite specific pattern. Its nature was first described by Airy in 1835, and it is referred to as the *Airy diffraction pattern*. It is seen as a bright disc (the *Airy disc*) surrounded by a set of concentric rings of much lower brightness (Figure 6.11). It can be shown that the diameter D of the Airy disc (to the first zero of luminance) is given by

$$D = \frac{2.44\lambda v}{d} \tag{1}$$

where λ is the wavelength of the light, v is the distance of the image from the lens, and d is the

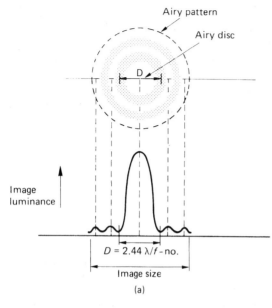

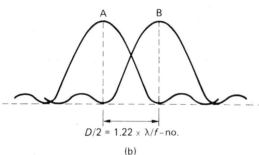

Figure 6.11 Resolution of a perfect lens. (a) A point source is imaged by a lens in the form of an Airy diffraction pattern. (b) Rayleigh criterion for resolution of a lens using the overlap of two adjacent Airy patterns, with peaks at A and B corresponding to adjacent minima or first dark ring

diameter of a circular lens aperture. For a lens focused at or near infinity, this can be rewritten as

$$D = 2.44\lambda N \qquad (2)$$

where N is the *f*-number of the lens (for close-up work, N is replaced by N', the effective aperture which is v/d).

With blue-violet light of wavelength 400 nm, the diameter of the Airy disc is approximately 0.001 N mm. Thus it is 0.008 mm for a lens at an aperture of *f*/8. This theoretical value may be compared with typical values of 0.03 mm to 0.1 mm usually taken for the diameter of the circle of confusion in aberration-limited lenses.

Note that the shorter the wavelength of light the less the diffraction, the smaller the diameter of the Airy disc and therefore the higher the resolving

power that is theoretically possible (see below). This is why ultraviolet and electron microscopy can give much higher resolution than visible light microscopy. Notice also that diffraction increases on stopping-down the lens. The practical effects of this are considered below.

Lens aperture and performance

If the aperture of a practical photographic lens is closed down progressively, starting from maximum aperture, the residual aberrations (except for lateral chromatic aberration and distortion) are reduced, but the effects of diffraction are increased. At large apertures the effects of diffraction are small, but uncorrected higher aberrations reduce the theoretical performance. The balance between the decreasing aberrations and the increasing diffraction effects on stopping down the lens means that such *aberration-limited lenses* have an *optimum aperture* for best results, often about three stops closed down from maximum aperture. Most lenses, especially those of large aperture, do not stop down very far, *f*/16 or *f*/22 being the usual minimum values, and diffraction effects may not be noticed, the only practical effect observed may be the increase in depth of field. With wide-angle lenses in particular a variation in performance at different apertures is to be expected, owing to the effect of residual oblique aberrations. Here it may be an advantage to use a small stop. Similarly for zoom lenses. For close-up photography, photomacrography and enlarging, the value of $N' = v/d$ is much greater than the *f*-number of the lens, and the effects of diffraction are correspondingly greater than when the same lens is used for distant subjects. In these circumstances the lens should therefore be used at the largest aperture that will give an overall sharp image.

Resolution and resolving power

Rayleigh criterion

The ability of a lens to image fine *detail* as a distance (d) between two adjacent points in the subject is termed its *resolution* (R), and is determined principally by the extent of residual aberrations of the lens, by diffraction at the aperture stop, and by the contrast (luminance ratio) of the subject. In photographic practice, it is more helpful to quantify imaging performance by *resolving power* (RP) where RP is the reciprocal of resolution, so

$$RP = \frac{1}{R} = \frac{1}{d} \qquad (3)$$

The relationship between diffraction and resolution was first proposed by Rayleigh in 1879 (in connec-

tion with the resolution of spectroscopic lines) as a criterion in that two image components of equal intensity should be considered to be just resolved when the principal intensity maximum of one coincides with the first intensity minimum of the other. If this criterion is adopted for two Airy diffraction patterns, the linear resolution of a lens whose performance is limited only by diffraction is one-half of the diameter of the Airy disc, so

$$R = 1.22\lambda N \tag{4}$$

The unit of millimetres (mm) is used. Accordingly, the resolving power of a diffraction-limited optical system is given by the expression

$$RP = \frac{1}{1.22\lambda N} \tag{5}$$

The unit is of reciprocal millimetres (either l/mm, or mm^{-1}), or cycles/mm, or line pairs per mm (lp mm^{-1}).

An Airy disc with a diameter of 0.008 mm thus corresponds to a resolving power of about 250 lp mm^{-1} at *f*/8 for an aberration-free lens. In practice, the presence of residual lens aberrations reduces lens performance, and so-called *spurious resolution* reduces theoretical values of resolving power to perhaps a quarter of this value. If the (arithmetic) contrast of a test subject is reduced from a value of about 1000:1 for the ratio of the reflectance or luminance of the white areas to the black, down to values more typical of those found in practical subjects, which may be as low as 5:1, then the degradation effect is even greater. A series of test subjects of differing contrasts are needed to give useful data.

Resolving power

In practical photography the concern is with the resolving power of the entire imaging system rather than just the lens, and this depends on the resolving power of the film used as well as the lens, together with other system factors such as camera shake, vibration, subject movement, air turbulence and haze. Various *test targets* have been devised in order to obtain some objective measure of lens/film resolving power, based on photographing an array of targets at a known magnification followed by a visual estimation (with the aid of a microscope) of individual target details that are just resolved in the final photographic image. While such methods have the advantage of being easily carried out, and can give useful information on a comparative basis, they do not give a full picture of the performance of the system. But such information is useful for lens design, comparison and quality control procedures.

For many purposes a practical test system for resolving power measurements consists of an array of

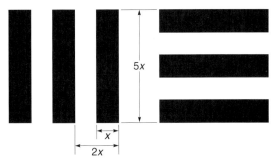

Figure 6.12 An element of a lens test target. A line of width x plus its adjacent space gives a line pair with a spatial frequency of $1/2x$

targets using a pattern of the three-bar type. Each pattern consists of two orthogonal sets of three black bars of length five times their width, separated by white spaces of equal width (Figure 6.12). If the width of a bar plus its adjacent space (known as a *line pair*) is distance $2x$ (mm), then the spatial frequency is $1/2x$ (lp mm^{-1}). Successive targets proportionally reduce in size, a usual factor being $\sqrt[6]{2}$. The resolution limit criterion is taken as the spatial frequency at which the orthogonal orientation of the bars can no longer be distinguished. A spatial frequency in the subject (RP_s) is related to that in the image (RP_i) by the image magnification (m).

$$RP_i = mRP_s \tag{6}$$

Figures for performance of a lens based on resolving power should be treated with caution and used for comparative purposes only as other measures of lens performance such as distortion, flare and contrast degradation are needed to give a fuller picture.

Modulation transfer function

Alternative electronic methods of evaluating lens performance are concerned with measurements of the *optical spread function*, which is the light-intensity profile of the optical image of a point or line subject, to derive the *optical transfer function* (OTF), which is a graph of the relative contrast in the image of a sinusoidal intensity profile test target plotted against the spatial frequency of the image of the target. The transfer function may be derived mathematically from the spread function. The OTF contains both modulation (intensity changes) and phase (spatial changes) information, and the former, the *modulation transfer function* (MTF) is of more use in practical photography.

A test object (o) or pattern, ideally with sinusoidal variation in intensity (I) or luminance (L) from maximum (L_{max}) to minimum (L_{min}) value, has a

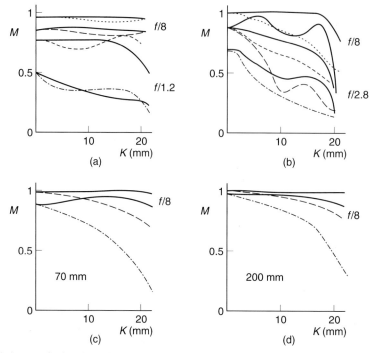

Figure 6.13 Modulation transfer functions of lenses. M, modulation transfer factor; K, semi-diagonal of 24×36 mm format. Continuous line is sagittal, broken line is meridional. Data is for 10 lp mm^{-1} and 30 lp mm^{-1} (adapted from Canon data): (a) 85 mm $f/1.2$ lens at $f/1.2$ and $f/8$; (b) 14 mm $f/2.8$ lens at $f/2.8$ and $f/8$; (c) 70–200 mm $f/2.8$ zoom lens at $f/8$ and 70 mm; (d) 70–200 mm $f/2.8$ zoom lens at $f/8$ and 200 mm

modulation (M_o) or luminance ratio or 'contrast' defined by

$$M_o = \frac{L_{max} - L_{min}}{L_{max} + L_{min}} \qquad (7)$$

A similar formula for M_i gives the corresponding contrast of the image (i).

The change of image contrast at a given spatial frequency (V) is given as the ratio of image to object modulations, termed the *modulation transfer factor* (M), where

$$M = \frac{M_i}{M_o} \qquad (8)$$

A graph of M against V gives the *modulation transfer function* (MTF) of the imaging process. By convention M is normalized to unity at zero spatial frequency. A large number of such MTF graphs produced with a range of imaging parameters are required to give a full picture of lens performance.

Abbreviated forms of MTF data are available from lens manufacturers in various forms. Typically, a graph may show the value of M for increasing distance off-axis across the image plane, plotted for two or three values of spatial frequency, but usually combinations of either 10, 20 and 40 lp mm^{-1}, or 10 and 30 lp mm^{-1} (Figure 6.13). In addition, the data show the effects of the test pattern oriented in a radial (meridional) or tangential (sagittal) direction to highlight any effects with off-axis positions. As a general rule for acceptable quality, these two curves should be close together, and the 10 lp mm^{-1} curve should not drop below 0.8 nor the 30 lp mm^{-1} curve below 0.6.

Bibliography

Freeman, M. (1990) *Optics*, 10th edn. Butterworths, London.

Hecht, E. (1998) *Optics*, 3rd edn. Addison-Wesley, Reading, MA.

Jenkins, F. and White, H. (1981) *Fundamentals of Optics*, 4th edn. McGraw-Hill, London.

Kingslake, R. (1992) *Optics in Photography*. SPIE, Bellingham.

Ray, S. (1984) *Applied Photographic Optics*, 2nd edn. Focal Press, Oxford.

7 Camera lenses

Simple lenses

A *simple lens*, i.e. a one element type with spherical surfaces, shows all of the primary aberrations. Chromatic aberrations, spherical aberration, coma, astigmatism and curvature of field all combine to give poor image quality, while distortion leads to mis-shapen images. Image quality is decidedly poor. But aberrations can be partially reduced by choice of suitable curvatures for the two surfaces and by location of an aperture stop. If, in addition, the subject field covered is restricted, it is possible to obtain image quality that is acceptable for some purposes, especially for *simple cameras* and *single use cameras*. However, a simple lens is still limited in image quality, maximum aperture and covering power. To best use the photographic process, improved performance is needed in all three categories. Given the limited sensitivity of early photographic materials, a primary requirement was an increase in relative aperture, to allow pictures, particularly portraits, to be taken without inconveniently long exposures for the subject.

A simple positive, biconvex lens is shown in Figure 7.1. Its performance can be significantly improved by modifying the lens design to give *derivatives*. Methods include alteration of curvatures, the use of other glasses and additional corrective elements. The latter are referred to as *compounding* and *splitting*, respectively, used to distribute the power and correction among more elements.

Compound lenses

The performance of a single element lens cannot be improved beyond a certain point because of the limited available number of *optical variables* or *degrees of freedom*. In particular, there are only two surfaces. By using two elements instead of one to give a *doublet lens*, the choices are increased, as there are now three or four surfaces instead of two over which to spread the total refraction. Different types of glass can be used for the elements, their spacing can be varied or they can be cemented in contact. More elements increase the possibilities. A *triplet lens* of three air-spaced elements can satisfactorily be corrected for the seven primary aberrations for a modest aperture and field of view. Six to eight elements are adequate for highly corrected, large aperture lenses. Zoom lenses require more elements to give a suitable performance, and up to a dozen or more may be used.

To design a compound lens for a specific purpose, a computer is used with an *optical design program*. The lens designer has the following degrees of freedom and variables to work with:

(1) Radii of curvature of lens surfaces.
(2) Use of aspheric surfaces.
(3) Maximum aperture as set by the stop.
(4) Position of the aperture stop.
(5) Number of separate elements.
(6) Spacings of the elements.
(7) Thicknesses of individual elements.
(8) Use of types of glasses with different refractive index and associated dispersion.
(9) Limited use of materials with a *graded refractive index* (GRIN).
(10) Limited use of crystalline materials such as fluorite and fused silica or quartz.

Compound lenses, i.e. multi-element, were progressively developed to further reduce lens aberrations to give better image quality, larger apertures and

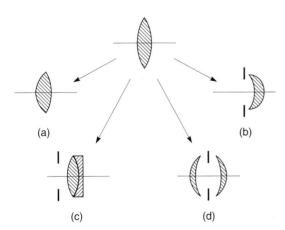

Figure 7.1 Derivatives from a simple biconvex lens to give improved performance. (a) Aspheric front surface.
(b) Changing to meniscus shape and positioning a stop in front. (c) 'Compounding' with another element of a different glass into an achromatic doublet. (d) 'Splitting' to give a doublet symmetrical lens

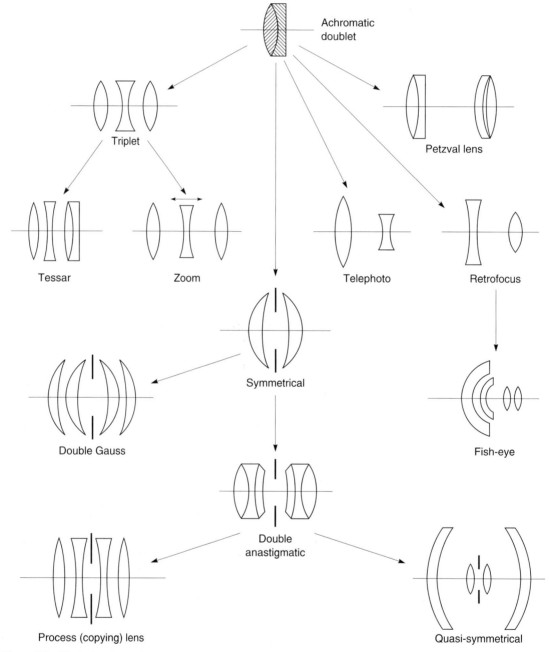

Figure 7.2 The basic achromatic doublet lens may be further split and compounded in various ways to provide the basic types of photographic lenses

greater covering power than those of simple lenses. The way in which each aberration can be controlled is detailed in Chapter 6. The general principle is to balance aberrations from one element with equal but opposite values in another element 'downstream' in the configuration. Full correction is not usually feasible, just reduction to acceptable levels in terms of the effects on image contrast and shape or size of the spread function. Compromises have to be made with a lens intended for general purpose use. If, however, maximum correction is desired in a lens designed with one particular use in mind, and which

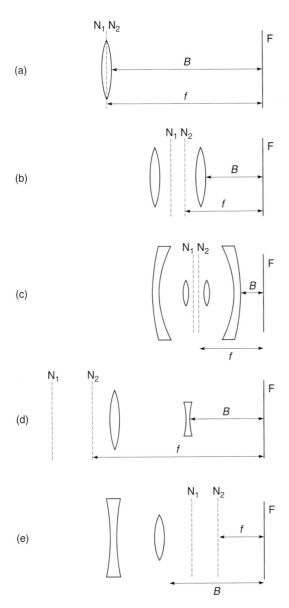

Figure 7.3 Lens configurations and nodal planes. N_1, N_2, first and second nodal planes. B, back focal distance; f, focal length; F, photoplane. (a) Simple or long focus lens, $B = f$ approximately. (b) Short focus symmetrical lens, $B < f$. (c) Quasi-symmetrical wide-angle lens, $B \ll f$. (d) Telephoto lens, $B < f$. (e) Retrofocus wide-angle lens, $B > f$

will therefore be employed only under a fixed set of conditions (say, always at full aperture, or at one magnification, or with monochromatic light) then improved performance is possible under these conditions at the expense of performance under other conditions for which the lens is not intended. Lenses of the highest correction are usually designed to give their best performance at or about one specific magnification, at a medium aperture and with light of a particular wavelength range. For example, an *apochromatic copying lens* may be suitable for reproduction ratios from 1:5 to 1:1. An enlarging lens may be designed for a similar range of magnifications, but scaling up rather than down. In general the requirements of high resolving power, large aperture, minimum distortion and extra covering power are mutually opposed. When the very highest performance in any one of these is needed, the others are reduced to some degree.

Photographic lenses use only a very few basic types in terms of *configuration* or arrangements of individual elements. The relationships of these types to each other and to the basic simple achromatic doublet lens are shown in Figure 7.2. Only the simplest form of each is shown. Practical designs usually have many more elements for the control of aberrations. The positions of the nodal planes and the relative values of focal length and back focal distance are shown in Figure 7.3.

Development of the photographic lens

Many thousands of lens designs have been produced to meet the demands of photographers for lenses of ever-larger aperture, wider field angle and extended performance. When introduced, most represented state-of-the-art designs, and ranged from the simple to very complex in configuration, the number of elements not necessarily being related to performance.

Photographic lenses can be grouped into categories related to nineteenth-century lens design. By the beginning of the twentieth century, lenses were available (albeit of modest aperture and field angle) which were virtually fully corrected for all the primary lens aberrations. Since that time, progress in lens design has largely been dependent on the availability of improved optical materials, lens-coating techniques, computer-assisted calculations, advances in lens production technology and more appropriate means of lens testing and evaluation.

It is useful to describe briefly the development of the photographic lens, the outstanding early advances of which are detailed in Table 7.1. The configurations of some of these lenses are shown in Figure 7.4. By convention in such diagrams, light enters from the left.

Simple lenses and achromats

The year 1839 marked the beginning of practical photography. The use of lenses prior to this date was

Table 7.1 Some notable steps in the development of photographic lenses

Type of lens	Degree of correction of aberrations							Maximum aperture on introduction	Approx. field covered at maximum aperture (degrees)
	Chromatic aberration	Spherical aberration	Lateral chromatic aberration	Coma	Distortion	Curvature of field	Astigmatism		
Simple lenses									
Wollaston landscape (stop in front) 1812	Poor	Satisfactory	Very poor	Satisfactory	Poor	Satisfactory	Poor	$f/14$	53
Landscape with stop behind	Poor	Satisfactory	Very poor	Satisfactory	Poor	Satisfactory (if film is curved)	Poor	$f/14$	53
Chevalier landscape (achromatized) 1828	Good	Good	Poor	Satisfactory	Poor	Satisfactory	Poor	$f/12$	28
Petzval lens 1840	Good	Good	Poor	Satisfactory	Poor	Satisfactory	Poor	$f/3.7$	20
Doublets									
Steinheil Periskop (not achromatized) 1865	Poor	Good	Very much reduced	Very much reduced	Very much reduced	Satisfactory	Poor	$f/10$	90
Rapid Rectilinear ('old' achromat) 1866	Good	Good	Good	Good	Good	Satisfactory	Poor	$f/8$	44
Anastigmats (Jena glasses)									
Ross Concentric ('new' achromat) 1888	Good	Satisfactory	Good	Good	Good	Good	Good	$f/16$	53
Zeiss Anastigmat (Protar) (= half 'old' achromat, half 'new' achromat) 1890	Good	Good	Good	Good	Good	Good	Good	$f/8$	60
Triplet									
Cooke 1893	Good	Good	Good	Good	Good	Good	Good	$f/4.5$	53
Tessar 1902	Good	Good	Good	Good	Good	Good	Good	$f/5.5$	53

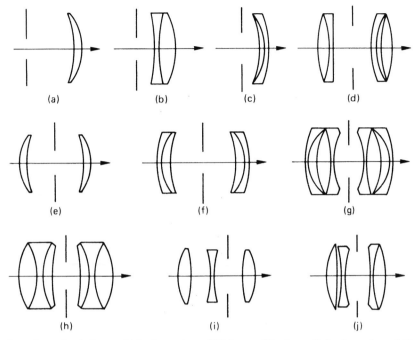

Figure 7.4 Configurations of early lenses: (a) landscape lens of Wollaston; (b) achromatic landscape lens of Chevalier; (c) Grubb's landscape lens; (d) Petzval portrait lens; (e) Steinheil's Periskop lens; (f) Rapid Rectilinear lens: (g) Zeiss Double Protar lens; (h) Goerz Dagor lens; (i) Cooke triplet lens; (j) Zeiss Tessar lens

for spectacles, telescopes, microscopes and the camera obscura. The *landscape lens* as used in the camera obscura was adapted for use in early cameras in meniscus form with a front stop. Wollaston had shown in 1812 that a flatter field plus reduced coma and astigmatism were given by this arrangement. Such lenses were used in box cameras and now in single use cameras. In 1757 Dollond produced an achromatic doublet telescope lens and this was later adopted for landscape lenses for photography. Because of uncorrected off-axis aberrations, such lenses could only be used at small apertures and fields. Maximum apertures seldom exceeded *f*/14.

The Petzval lens

Simple lenses were inconveniently slow for portraiture with the insensitive plates of the period, and active efforts were made to design a lens of large aperture; the principles were already well understood, but lack of suitable optical glasses was a problem. In 1840 J. Petzval designed a lens of aperture *f*/3.7 using two separated, dissimilar achromatic doublets. This was the first lens to be computed specifically for photography. It had about fifteen times the transmission of other contemporary designs. Some residual uncorrected aberrations, particularly astigmatism,

caused poor peripheral definition, but this was found particularly pleasing for portraiture, giving a characteristic softness and vignetting. The restricted field of good sharpness needed a longer focal length than normal to cover a given format. The consequent need for a more distant viewpoint helped improve perspective in portraiture. This design is still the basis of many long-focus large-aperture systems, especially projection lenses.

Symmetrical doublets

Landscape lenses did not improve until the 1860s, when lenses of good definition, flat field and moderate aperture became available, as in the Steinheil Periskop lens of 1865 which used two meniscus components placed symmetrically about a central stop. The significance of symmetrical or near-symmetrical construction is that it permits almost complete correction of oblique errors, particularly coma, lateral chromatic aberration and distortion. This non-achromatic lens was soon superseded in 1866 by the introduction of two independent designs: the Rapid Rectilinear by Dallmeyer and the Aplanat of Steinheil, in which the meniscus lenses were replaced by achromatic combinations. Maximum aperture was around *f*/8, but astigmatism was still uncorrected.

Anastigmats

Originally, astigmatism and field curvature could not be corrected together with other aberrations, as the dispersion of available glasses increased more or less proportionally with refractive index. However, pioneer work by Abbe and Schott in the 1880s produced new types of optical glass. Use of these resulted in the first *anastigmatic lenses*. Early examples of such lenses include the Ross Concentric (1888), Zeiss Protar (1890), Goerz Dagor (1892) and Zeiss Double Protar (1894). Lenses then became increasingly complex, symmetrical construction was used, but each component became a multiple cemented combination of old and new glass types, with maximum apertures up to about *f*/6.8. Most lenses could be used as separable components with increased focal length.

Triplets

The increasing complexity of early anastigmat lenses meant high manufacturing costs. In 1893 the Cooke Triplet lens, designed by H. Dennis Taylor and made by Taylor, Taylor and Hobson, was introduced. This differed from contemporary symmetrical designs as it used only three single separated elements, two convex ones of crown glass with high refractive index and low dispersion, separated by a biconcave lens of light flint glass of high dispersion which flattened the image surface. The advantage of a triplet design is simplicity of construction, while giving sufficient variables for full correction. The original aperture was *f*/4.5, but this was increased to *f*/2.8. Then by splitting and/or compounding the three elements a wide variety of *triplet derivatives* were produced. The Zeiss Tessar lens, designed independently in 1902 by Rudolph and in production ever since, is one of the best known of these.

Double-Gauss lenses

A major disadvantage of symmetrical construction is the inability to correct additional aberrations, particularly higher-order spherical aberration; this limits maximum apertures to about *f*/5.6. Triplet construction has a limit of about *f*/2.8. To obtain useful maximum apertures of *f*/2 or better, a derivative of a symmetrical design was adopted based on an achromatic telescope doublet due to Gauss. This doublet was air-spaced with deeply curved surfaces concave to the subject. Two such doublets both concave to a central stop, give the *double-Gauss* form of lens. Derivatives with up to seven elements have useful apertures up to *f*/1.2.

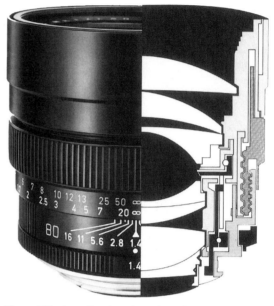

Figure 7.5 A medium long focus lens of large aperture (80 mm *f*/1.4) for the 24 × 36 mm format, showing internal configuration and construction (Leitz information)

Modern camera lenses

Camera lenses of fixed focal length in use today are usually based on triplet designs for the lower priced, moderate aperture varieties and double-Gauss designs for larger apertures. Figure 7.5 shows such a lens and the associated mechanical arrangements for focusing and diaphragm operation. Design of these mechanisms and the *lens barrel* is also a complex procedure. Symmetrical design is used for lenses for large format cameras, for copying lenses and for some types of wide-angle lens. Complex and highly asymmetric designs are used for zoom, telephoto, retrofocus and 'fish-eye' lenses.

Different in concept, and used only for long-focus lenses, the 'mirror lens' employs reflecting surfaces both as the primary means of image formation and to fold the light path for compactness. The relationship of these lenses (except for mirror systems) is shown in Figure 7.2, and Table 7.2 lists some of their features. A selection of typical configurations is shown in Figure 7.6.

The *standard lens* for a camera is one whose focal length approximates to the length of the diagonal of the image format. Such lenses are highly developed, with large usable apertures and excellent performance over their field. However, the standard lens cannot meet all needs, particularly if photographs are required of large angular fields in cramped surroundings, or long-distance shots of inaccessible subjects.

Table 7.2 Features of different types of lenses

Name or type	Basic optical construction	Exceptional for	Poor for	Special features or advantages of this design or construction	Uses	
Meniscus	*(diagram)*		A, D, F	Cheap, low flare	Simple cameras, close-up lenses	
Landscape	*(diagram)*	CA	A, F	Achromatic	Simple cameras, close-up lenses	
Soft-focus portrait	*(diagram)*			Deliberate spherical aberration	Controllable residual aberrations	Portraiture
Petzval	*(diagram)*	S	A, F	Large aperture, good correction	Portraiture, projection	
Symmetrical	*(diagram)*	D	F	Distortion-free	General	
Double anastigmat	*(diagram)*	D	S	Distortion-free, components usable separately	General	
Double Gauss	*(diagram)*	S,C	D	Large apertures possible	Low light level work	
Triplet	*(diagram)*			Good correction for all aberrations, cheap	General	
Quasi-symmetrical	*(diagram)*	D		Wide-angle lens, distortion-free	Aerial survey work, rangefinder cameras	
Process	*(diagram)*	All		Highly corrected	Copying and close-up work	
Telephoto	*(diagram)*		D	Short back focus, compact	Long-focus lens	
Retrofocus	*(diagram)*		D	Long back focus, reflex focusing	Wide-angle lens for SLR cameras	
Fish-eye	*(diagram)*		Deliberate distortion	Field angle exceeding 180 degrees, reflex focusing	Cloud studies, special distortion effects	
Zoom	*(diagram)*		D	Variable focal length with constant *f*/number	General	
Mirror	*(diagram)*	S, CA, L	A, F	Compact construction	Long focus lens	

S, spherical aberration. CA, chromatic aberration. L, lateral colour. C, coma. A, astigmatism. D, distortion. F, field curvature.

Then the use of wide-angle or long-focus lenses respectively is necessary. Also, where there is a need for a big close-up of a subject, a 'macro' lens is preferable. These alternative lenses also have a number of distinct design types, the results of intensive development work, aided by a number of interrelated advances in optical production technology. These include the following.

Lens coatings

The use of single or multiple anti-reflection coatings on lens surfaces allows more elements to be used while retaining high transmission and low flare. The contrast, colour balance and flare performance at extremes of aperture and field angle have all been improved.

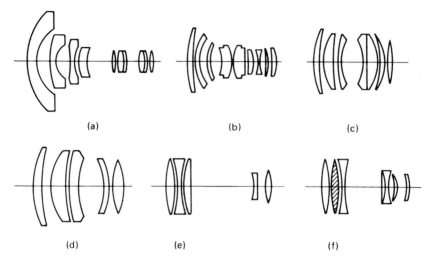

(a) (b) (c)

(d) (e) (f)

Figure 7.6 Configurations of representative lenses: (a) 8 mm fish-eye; (b) 24 mm retrofocus wide-angle; (c) 50 mm *f*/1.4 double-Gauss derivative; (d) 105 mm *f*/1.8 double-Gauss derivative; (e) 200 mm *f*/4 telephoto; (f) 400 mm *f*/2.8 super telephoto with ED glass element (hatched)

Optical materials

Alternative types of optical glass with higher refractive index and lower dispersions as well as lower weight per unit volume are available. Chemical elements such as lanthanum and tantalum are used in some special glasses, and materials such as fluorite and fused silica (quartz) are needed for some applications requiring chromatic correction extending into the ultraviolet and infrared regions.

Aspheric surfaces

The use of aspheric surfaces is made possible by advances in manufacturing techniques such as moulding and hybridization methods and allows lenses to be made with large useful apertures in both long-focus and wide-angle designs. In most designs fewer elements are needed, so that zoom lenses for compact cameras can have as few as four elements.

Floating elements

Groups of moving elements were first used in zoom lenses to change focal length, and now 'floating elements' that move axially can correct for spherical aberration, and retain performance at close object distances. This feature is particularly useful in macro lenses and wide-angle lenses of large aperture. The technique is commonly used for 'internal focusing' in a range of lenses from autofocus (AF) types to super-telephotos, giving a means of rapid focus change with little mechanical movement and allowing the lens barrel to be sealed against the environment.

Computer aided design

The original tedious task of calculating ray paths through optical systems, an essential design procedure, is greatly speeded up by the use of digital computers and optical design programs. Usually such programs will optimize a design as far as possible given practical restraints, after which human judgement determines the final configuration. The design of increasingly complex lens barrel and focusing mount assemblies is also dependent on such assistance.

Evaluation of results

Few lens users have access to equipment for the measurement of image contrast and the production of modulation transfer function figures, but such data is published by manufacturers.

Their use of complex image-evaluation techniques for the objective evaluation of lens performance has contributed to improvements in design and to the essential quality control in manufacture. A direct result was a considerable increase in the range of focal lengths available for the various formats; also larger usable apertures, closer focusing, unusual designs for specific functions and overall improved performance. The range of modern lenses offered by a manufacturer for given formats may typically be:

(1) 6.5 to 2000 mm focal length for the 24 × 36 mm (135) format.
(2) 30 to 1000 mm focal length for medium formats.
(3) 45 to 1000 mm focal length for the 4 × 5 in (102 × 127 mm) format.

An example of the improvements in just one class of lens is given by the wide-angle lens. The old problems of poor covering power, low marginal resolution, small usable apertures and flare have been overcome. Typically, for the 24 × 36 mm format, 15 mm *f*/3.5, 24 mm *f*/2, 24 mm *f*/3.5 perspective-control and 35 mm *f*/1.4 lenses are commonly available, all in retrofocus configurations. The 60 × 60 mm format has available lenses of 30 to 50 mm focal length and aperture *f*/4 to *f*/2.8. Large formats also have wide-angle lenses with usable apertures of *f*/5.6 to *f*/4 and sufficient covering power to permit limited use of camera movements. At the extreme ends of the available range of focal lengths, ultra short-focus fish-eye lenses and ultra long-focus mirror-lens designs are now common.

Another popular type of lens, the *zoom lens*, has been much improved with many interesting design variants, but has not yet reached the end of its design potential. Short range zoom lenses have largely replaced the 'standard' lens for general purpose cameras.

The *macro lens*, which is specifically designed and corrected for close-up work, now has an excellent all-round performance and a maximum aperture of *f*/2, its versatility making it a contender to the traditional standard lens.

Finally, the standard lens itself has undergone several changes. Contrast, resolution and freedom from flare have all been improved. Maximum apertures of *f*/2 or *f*/1.4 are commonplace for lenses used with the 24 × 36 mm format, and *f*/1.2 is not uncommon; *f*/2 lenses are now standard for the 60 × 60 mm format in some cases.

Wide-angle lenses

Wide-angle lenses, i.e. lenses where the focal length is less than the diagonal of the film format, originate from the earliest symmetrical versions produced in the middle of the nineteenth century. These were limited in practice by severely restricted covering power, owing to the $\cos^4 \theta$ law, fall-off in marginal resolution, and small useful apertures (typically about *f*/22).

Symmetrical-derivative lenses

Forms of quasi-symmetrical or near-symmetrical configuration give improved evenness of illumination and better image quality, as well as larger apertures up to about *f*/2.8. The symmetry means that correction for curvilinear distortion is particularly good. These symmetrical derivatives use very large negative meniscus lenses either side of the small central positive groups, giving the lens a characteristic 'wasp-waisted' appearance and increasing its bulk.

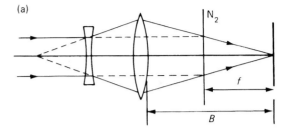

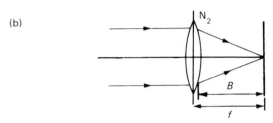

Figure 7.7 Retrofocus construction. (a) A retrofocus combination of front negative lens and rear positive lens giving back focal distance *B* much greater than focal length *f*. (b) An equivalent short-focus lens where *B* and *f* are similar

Such lenses, used on technical cameras, allow full use of the camera movements, depending on focal length and covering power. The ability to use the rising-front movement is particularly valued. Unfortunately, just like the simpler symmetrical form, such lenses have a very short back focal distance (BFD) so that the rear element is very close to the film plane. Consequently, any form of reflex viewing and focusing is impossible; when this is necessary, lenses of *retrofocus* configuration must be used instead. Note that for compact cameras, a 'telephoto wide-angle configuration' is used to give as short a BFD as possible.

Retrofocus lenses

Departing from the symmetrical form of construction by using a front divergent (negative) group with a rear convergent (positive) group of elements gives a lens that has a short focal length in relation to its back focal distance, caused by a shift in the positions of the nodal planes (Figure 7.7). As this arrangement is the opposite of the telephoto construction it is often described as a *reverse* or *inverted telephoto* configuration.

The asymmetry of the design causes some barrel distortion, especially noticeable in earlier designs. However the long back focal distance allows devices such as reflex mirrors, shutters and beamsplitters to

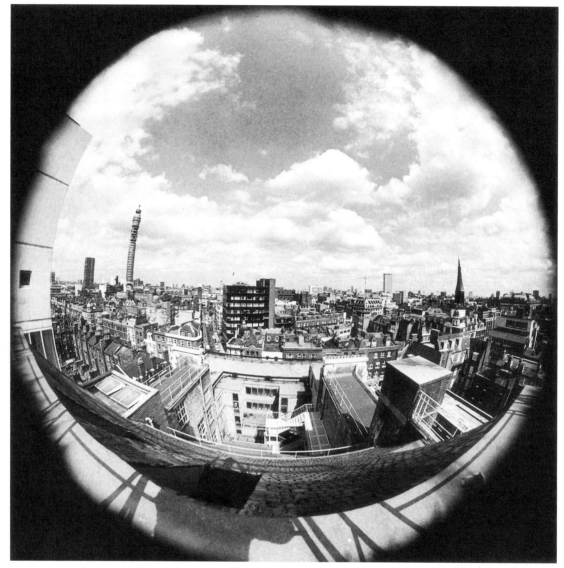

Figure 7.8 Photograph taken with an 8 mm true fish-eye lens

be located between the lens and film plane. The disadvantages are increased complexity of construction and the associated extra cost, bulk and weight.

Fish-eye lenses

The geometry of image formation and consequent illumination limit the field of view of a distortion-free lens to about 120 degrees. However, if barrel distortion is permissible, a lens covering angles of view of 180 degrees and even more is possible.

Retrofocus configuration allows use of such lens systems in single-lens reflex cameras. These lenses are called *fish-eye lenses*, and are available in two versions. The *quasi-fish-eye lens* has a circle of illumination that circumscribes the film format and gives 180 degrees angle of view across the diagonal. The *true fish-eye lens* has its circular image wholly within the film frame, thus recording more of the scene (Figure 7.8). The diameter of the image circle depends on the focal length of the lens.

A different form of image projection is used for image formation. A conventional photographic lens

of focal length f and semi-field angle θ forms images by *central projection*, where the distance (y) of an image point from the optical axis of the lens is given by the relationship $y = f \tan \theta$. Most fish-eye lenses use *equidistant projection*, where $y = f\theta$ when θ is measured in radians. Such lenses have many technical applications.

Long-focus lenses

Long focus designs

A long-focus lens is a lens whose focal length is greater than the diagonal of the format in use. As image size is proportional to focal length, an increase in focal length gives a bigger image. The usual lens configurations of achromat, Petzval, symmetrical and double-Gauss have all been used, depending on the maximum aperture and focal length required. Very-long-focus lenses of small aperture can be of simple construction, possibly just achromatic doublets. There are practical problems associated with long-focus lenses. Conventional refracting (dioptric) lens design is limited by the diameter of available glass blanks (some 150 mm) and by the degrading effects of lateral chromatic aberration as focal length increases. Also, the length and weight of such lens systems pose problems in design and handling. Internal reflections from the long lens barrel may cause flare. The use of telephoto construction and mirror optics reduces some of the problems of excessive length and lateral chromatic aberration. Refracting elements made from fluorite or special extra-low-dispersion glass can greatly improve colour correction.

Telephoto lenses

By placing a negative lens group behind a positive one, the transmitted light is made less convergent, as though it had been formed by a lens of much greater focal length; the nodal planes are now in front of the lens (Figure 7.9). The length of the lens barrel can be much less than is needed for a conventional lens of similar long focal length.

Using this idea, early *telephoto attachments*, the precursors of the modern *teleconverter*, were placed behind normal lenses to give a variety of increased focal lengths with relatively short camera extensions. The resultant combinations had small apertures, and performance was poor. Such systems were replaced by *telephoto lenses*, which are fully corrected. The ratio of the focal length of a telephoto lens to the distance from the front element to the film plane is known as the *telephoto power*.

Telephoto lenses are well corrected, and can have large apertures. There is often some residual pincushion distortion due to the asymmetric construction, but this is not usually a serious problem.

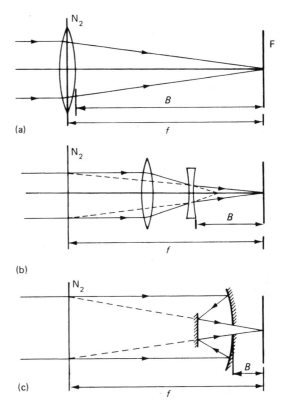

Figure 7.9 Telephoto construction. (a) A long-focus lens where the back focal distance B is similar to the focal length f as measured from the rear nodal point N_2 to film plane F. (b) An equivalent design using a front positive lens and a rear negative lens in a telephoto combination so that B is much less than f. (c) Another equivalent design using two optical reflecting surfaces to give a mirror lens, where B is very much less than f

Cameras using telephoto lenses are easier to handle, and less prone to camera shake, than those equipped with a long-focus lens of conventional design, as the camera is better balanced and lighter. The use of optical materials such as extra-low-dispersion (ED) glass and fluorite give a class of lens called *super-telephoto*. These are lenses predominantly for 24×36 mm and 45×60 mm formats, and have focal lengths of 200 to 1200 mm with the exceptionally large apertures of $f/2$ to $f/2.8$ in the shorter focal lengths and $f/4$ to $f/5.6$ in the longer focal lengths. Such lenses are state-of-the-art designs using multi-coatings, internal focusing and anti-flare construction. They are costly but are exceptionally easy to use hand-held; with applications in sport, natural history and surveillance work. Apart from the ease of focusing and the capability of using slower colour films or short exposure times, an advantage of the large aperture is that the use of suitably matched

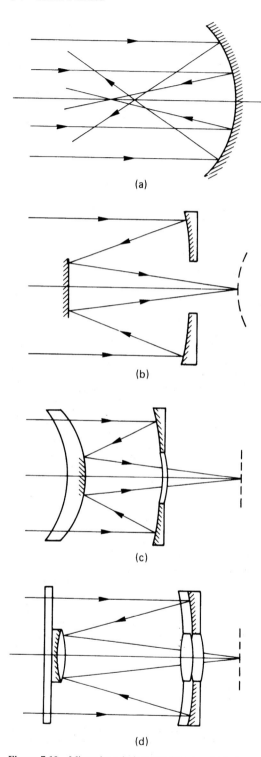

Figure 7.10 Mirror lens designs. (a) Simple spherical mirror with spherical aberration at the focus.
(b) Cassegrainian construction with secondary reflector.
(c) Bouwers–Maksutov design. (d) Mangin mirror design

teleconverters gives very long focus lenses that still have a usefully large aperture. For example, a 300 mm *f*/2.8 camera lens can be converted into a 450 mm *f*/4 or a 600 mm *f*/5.6 lens by the use of ×1.5 and ×2 teleconverters respectively.

Catadioptric lenses ('mirror lenses')

The advantage of image formation using a concave mirror rather than a convex lens is that there is no chromatic dispersion. This property was used by Newton for a reflecting telescope. Newton's telescope, however, had an eyepiece that was at right angles to the incident light. For photographic purposes there must be convenient access to the image, and the lens is best pointed at the subject, so the Cassegrainian double mirror system is preferred. This configuration uses a secondary mirror to reflect the image through a hole in the primary mirror. For astronomical telescopes a paraboloidal mirror is used, but for photographic purposes such a mirror is not suitable; not only is it expensive to produce, but it can only cope with small field angles because of off-axis aberrations. If a spherical mirror is used instead, the field angle can be larger, but the image suffers from both spherical aberration and curvature of field, both requiring correction.

Residual spherical aberration is corrected using different optical modifications (Figure 7.10). An aspheric *Schmidt corrector plate* at the centre of curvature of the spherical mirror is used for large aperture, widefield astronomical cameras, but is very expensive to manufacture. Cheaper alternatives used for photography are to use a *Mangin mirror*, which has the reflecting surface coated onto the rear surface of a thin refracting correcting element; or, alternatively, to use large thick refracting elements that are concentric with the spherical prime mirror. This latter approach was pioneered independently by Bouwers in Holland and Maksutov in Russia during the Second World War. The introduction of refracting elements constitutes a *catadioptric design*. A *dioptric system* is a system consisting of transmitting and refracting elements, i.e. lenses, whereas a *catoptric system* consists only of reflective elements, i.e. optical mirrors. A *catadioptric system* is a hybrid optical system containing both lenses and mirrors.

The refracting elements need to be achromatized; and their power chosen so as to give a flat field. They are positioned to seal the barrel and provide a support for the secondary mirror. Flare is a serious problem, so baffling and other anti-flare measures are essential.

Because of the central obstruction caused by the secondary mirror, the transmission of the lens cannot be controlled by an iris diaphragm. Instead, a turret of neutral-density filters is used; this may also contain colour filters. Mirror lenses are available with focal

Figure 7.11 Photograph taken with a catadioptric lens showing the characteristic shape of out-of-focus highlights

lengths in the range of 300 mm to more than 2000 mm and with apertures from *f*/5.6 to *f*/11. The compact design with its short length and large diameter compares favourably with equivalent long-focus or telephoto constructions. A useful feature of mirror lenses is their ability to focus close. Typically, an axial movement of a few millimetres of the secondary mirror will focus a 500 mm lens from infinity to a magnification of some 0.25. A characteristic feature of a mirror lens is the 'ring doughnut' shape of out of focus highlights due to the annular shape of the entrance pupil (Figure 7.11).

Zoom and varifocal lenses

Zoom lenses

A *zoom lens* is one whose focal length can be varied continuously between fixed limits while the image stays in acceptably sharp focus. The visual effect in the viewfinder is that of a smaller or a larger image as the focal length is decreased or increased respectively. The *zoom ratio* is the ratio of the longest to the shortest focal length: for example, a 70 to 210 mm zoom lens has a zoom ratio of 3:1. For 35 mm still photography, zoom ratios of about 2:1 up to 10:1 are available. For cinematography video and digital photography, where formats are much smaller, zoom ratios of 10:1 or 20:1 are common, further increased by digital methods to perhaps 100:1 with concomitant loss of image quality.

The optical theory of a zoom lens is simple (though the practical designs tend to be complex): the equivalent focal length of a multi-element lens depends on the focal lengths of individual elements and their axial separations. An axial movement of one element will therefore change the focal length of the combination. Such a movement coupled to a hand control would give a primitive *zoom lens* or strictly a *varifocal lens*, as is used for a slide projector. The simplest possible arrangement is a front negative lens

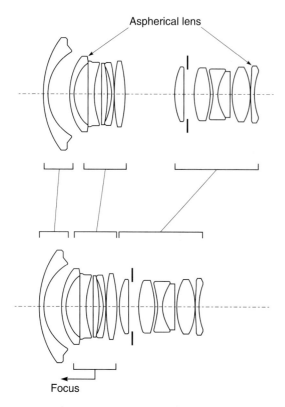

Aspherical lens

Focus

Figure 7.12 Configuration of a wide-angle zoom lens design (17–35 mm *f*/2.8–4) with mechanical compensation using three moving groups. Two aspherical elements and internal focusing are incorporated

not retain sharp focus while being 'zoomed'. Both problems require additional lens elements and in practice any number between four and twenty may be needed. A sharply focused image is retained while zooming by a process of *compensation*, provided, for example, by another element moving in conjunction with the zoom element. Two types of compensation are used; *optical*, where the moving elements or groups are coupled and move together, and *mechanical*, where the groups move independently at different rates, sometimes in different directions (Figure 7.12). Optical compensation was used originally, as the lens unit and internal controls were easier to make, but now numerically controlled machine tools produce the necessary complex control cams, and mechanical compensation is preferred as higher levels of correction are possible. The moving groups can follow non-linear paths, so that as the zoom control is operated the elements may advance and recede at different rates. Some zoom lenses use three to five moving groups, with a mixture of both optical and mechanical compensation.

The classic design of zoom lens was an arrangement of four groups of elements. Two linked movable zoom groups are located between a movable front group (used to focus the lens) and a fixed rear group which also contained the iris diaphragm. This rear group is positive and acts as a relay lens to produce an image in the film plane from the zoom groups, which behave as an afocal telescope of variable power (Figure 7.13). This system also keeps the *f*-number constant as focal length is altered, by controlling the size and location of the exit pupil of the system. This 'fixed-group' feature means that a separate mechanical control to adjust the iris according to focal length is not required. Close focusing (i.e. nearer than one to two metres) is also possible. For example, a separate *macro-zoom control* uses and rearranges the zoom groups so that for a particular focal length one group is moved to give a form of internal focusing over a

plus rear positive lens; reducing their separation increases the equivalent focal length.

A simple zoom lens suffers from two major defects: the image is severely aberrated and it does

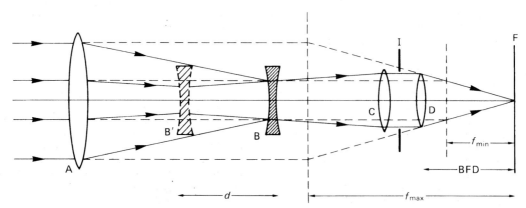

Figure 7.13 Basic zoom lens system. Elements A, B and C form the zoom variator system; D is the relay lens and I is the iris diaphragm

limited close-up range with the prime focus control set at infinity focus. (There may in practice be a gap between normal close focus and the far point of the close-up range so an achromatic close-up lens is required.) An advantage of this system is that the *f*-number stays almost constant over the close-up range, which is not the case with a conventional macro lens.

Not all 'macro' zoom lenses offer a genuine 1:1 image scale; the term 'macro' has become devalued and often just used to mean a close-focus capability. The performance of zoom lenses for close-up work was once generally poor owing to problems of spherical aberration, curvature of field and distortion, but many of the drawbacks of earlier designs have been reduced or eliminated. A *tele-zoom lens* may now be no larger than an equivalent fixed-focal-length lens of the longest focal length it replaces. The use of ED glass elements and aspheric surfaces provide even more correction and compactness.

Popular additions to the range of zoom lenses include wide-angle-to-standard lenses for 35 mm cameras such as 20–35 mm, 24–70 mm and 28–85 mm, and their equivalents for APS and digital formats. Continuous close focusing is possible with a single focus control, by movement of all or part of the lens groups, making separate macro modes obsolescent. The internal focusing may be under the control of an in-camera autofocus system, and the lens contains suitable electronics to relay data back into the central processing unit of the camera.

A penalty of mechanical compensation is that the *f*-number changes with focal length, typically giving a loss of one-half to one full stop from minimum to maximum focal length. This may be acceptable in order to keep the size of a zoom lens to within reasonable limits. Some lenses do have additional mechanical control of the iris to keep the *f*-number approximately constant while zooming. However, almost all cameras now have TTL metering, which will correct for changes in effective *f*-number. The modern zoom lens is very much a viewfinder-oriented lens in that it carries little information on its controls as to focus setting, focal length and depth of field. The distortion correction of zoom lenses is now also much improved, and image quality may approach that of a fixed-focal-length lens.

The trend is to use a zoom lens as a replacement for the once ubiquitous fixed focal length standard lens. Cameras with zoom lenses but no reflex viewing system, such as most compact cameras, use a complex coupled direct viewfinder system which is also a miniature zoom lens corrected for visual use. Only an approximate indication of the subject area is given and precision focusing is not possible, with total reliance upon an autofocus system. Digital cameras can use similar systems but also may provide useful direct viewing of focus and field of view by means of an LCD viewing screen.

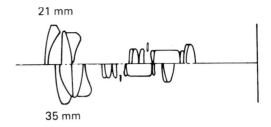

(a)

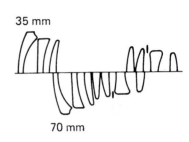

(b)

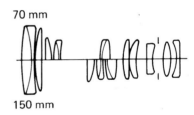

(c)

Figure 7.14 Typical zoom lens configurations; the various groups of elements alter their relative positions in various ways to change focal length. (a) All the elements in three groups move between the extremes shown to give 21–35 mm. The iris also shifts. (b) All the elements move in two groups with the iris to give 35–70 mm. (c) Two groups move to give 70–150 mm, the iris remaining static; in focusing, the whole lens is moved axially

For general purpose photography, the zoom lens is a very useful tool. One lens, say of 28–105 mm and *f*/2.8–4 specifications with close-focus capability to an image magnification of 0.25, can perform adequately for most purposes, especially if medium apertures can be used. Zoom lenses are still of modest maximum aperture, some *f*/2.8 at most, and the double-Gauss type of lens with aperture *f*/2 to *f*/1.4 is still useful for some low-light photographic tasks, as is the super telephoto lens. A selection of zoom lens configurations is shown in Figure 7.14.

Varifocal lenses

In a *varifocal lens* there is no attempt to hold the focus constant when the focal length is changed. This makes for a simpler and cheaper design especially where a constant focal plane has little or no advantage, as in slide and movie projectors. To offset the slight inconvenience of having to refocus the lens when the focal length (i.e. the projected image size) is changed, it is possible to produce very good correction with comparatively few glass elements. This type is especially useful in autofocus cameras where the focus is monitored and adjusted as necessary.

Zoom lenses for compact and digital cameras

Compact cameras use both the 135 and APS formats, while digital cameras use focal plane arrays of much smaller formats, typically from 2/3 to 1/4 inch diagonal. Apart from small formats, most of these cameras do not use reflex viewfinders but rely instead on separate optical viewfinders. Both factors influence lens design in that the rear element can be very close to the focal plane, and that a useful zoom range is possible with only a few elements, especially if the maximum aperture is modest, perhaps *f*/4 at the most. The lens must also telescope down into the camera body for storage, to help keep the size of the camera small. For the 135 format, long range zoom lenses of 38 to 200 mm are used, although the aperture reduces to some *f*/11 at the long focus setting. The lenses are non-interchangeable and the collapsible telescoping barrel may cause some optical misalignment.

The basis of such compact designs was the Zeiss Biogon wide-angle lens which has a very short *back focal distance* (BFD). From this was derived a *'telephoto wide-angle' lens* (see Figure 7.15a), a short focus lens using both telephoto configuration to reduce its physical length and internal focusing to keep its external size constant. This led to compact zoom lenses by using a moving element or group to alter focal length (Figure 7.15b) and moving the lens to give unit focusing under autofocus control. By use of technology such as plastic elements and aspheric lens surfaces, as few as four elements could be used for a satisfactory zoom or varifocal lens with a 2:1 zoom ratio. The lenses may suffer from noticeable curvilinear distortion at both ends of the zoom range and possibly some vignetting. The modest apertures available limit the useful range of an integral flash and low light level use may cause camera shake due to the slow shutter speeds needed, unless a fast film of 400 to 800 ISO is habitually used. The lenses usually lack a filter thread to take accessories such as lens hoods, filters and converters.

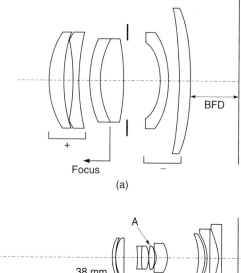

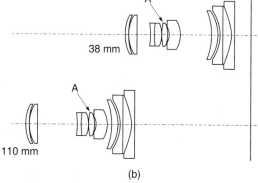

Figure 7.15 Zoom lens design for compact cameras. (a) Wide-angle telephoto configuration (35 mm *f*/2.8) as precursor to a zoom lens. (b) A 38–110 mm zoom design. Glass element A is aspherical

Many digital cameras feature a 'digital zoom' feature. This is not an optical zoom using a lens, but by a digital image processing routine to magnify the central portion of the image stored as digital data. A bigger image is given but with reduced resolution and too much 'zooming' causes unpleasant pixellation of the image.

Macro lenses

Design of a lens with good aberration correction requires the object conjugate distance to be specified. Most photography is of subjects at least 200 focal lengths away, so for convenience in design the object conjugate is taken as infinity. General purpose lenses are therefore designed to give their best performance for distant subjects. The performance of such a lens will be less satisfactory when focused on a short distance, as in close-up work or photomacrography. Design features such as floating elements and asphe-

ric surfaces may help in some cases, as can lens reversal rings, but it is preferable to use a lens optimized to produce a high-quality result when used for close-up work. Such a lens is known as a *macro lens*.

A macro lens for SLR cameras usually features an extended focusing mount using a double helicoid arrangement. This gives enough additional extension to provide a magnification of 0.5, though many do give actual-size reproduction with $m = 1$ or more. A range from infinity to half-life-size is usually sufficient in practice, at least in the 24×36 mm format, and this keeps the focusing mount to a reasonable size. For the magnification range from 0.5 to 1.0 an extension tube can be added. Such a lens has full automation of the iris, and full aperture metering. Correction is optimized for a magnification of 0.1 (not infinity as discussed above) and the corrections hold well down through the close-up range to unit magnification. Thereafter the lens is best used reversed, with possible consequent loss of the automatic features. The lens barrel may be engraved with scales of magnification and exposure correction factors: these are more useful when using manual electronic flash, as TTL metering systems automatically correct exposure at long extensions.

Macro lenses typically use a double-Gauss design computed to give a flat field and distortion-free image essential for copying work. The maximum aperture is commonly $f/2.8$. For optimum results with distant subjects it is advisable to close down about two stops from maximum. Macro lenses often have focal lengths that are longer than normal; they are typically in the range 55 to 200 mm for a 24×36 mm format. Some are obtainable as just a *lens head*, an optical unit for attachment directly to an extension bellows so as to give an extended focusing range. Others have very short focal lengths of 12.5 to 50 mm to allow greater magnification with a modest bellows extension.

Autofocus macro lenses use complex arrangements of internal adjustments of elements to provide both focus and aberration correction. The use of ED glass, aspheric surfaces and floating elements is common and a typical design may have 10 or more elements, making it a heavy lens for its size. A matched teleconverter may be used with several more elements to not only increase focal length but also to provide additional flattening of the image surface to improve results. The long focus macro lens of focal length 200 mm is a specialist lens but is favoured for the improved perspective it gives by virtue of its more distant viewpoint and the increased working distance from front element to subject. Improved chromatic correction gives 'apo' versions and apo matched teleconverters increase both focal length and magnification available. Internal focusing is convenient in a macro lens as there is then no need for a complex double helical lens barrel extension system, but the

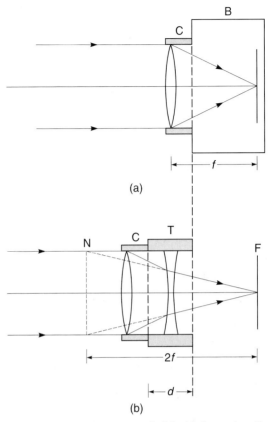

Figure 7.16 The teleconverter principle. (a) Camera lens C of focal length f in body B focuses light onto film F. (b) Addition of teleconverter T of thickness d gives rear nodal plane N and combined focal length $2f$

effective focal length also changes continuously over a short range, so an indication of magnification to help calculate depth of field is useful. Internal focusing also means that the lens barrel does not rotate during focusing, useful with direction-sensitive devices such as polarizing filters.

Teleconverters

These are optical accessories rather than photographic lenses since they do not form a real optical image on their own, only a virtual one as they are negative in refractive power. However, these optical devices are in common use with camera lenses, and a discussion of their features is appropriate here. The astronomer Barlow reported in 1834 that placing a secondary negative lens *behind* a primary positive lens would increase effective focal length; indeed, this is the principle of the telephoto lens discussed earlier. (Galileo had noted this 200 years previously.)

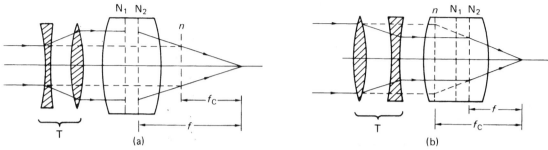

Figure 7.17 Afocal attachments. (a) Wide-angle attachment, W. (b) Telephoto attachment, T. Key: *n*, rear nodal plane of combination of focal length f_c; N_1 and N_2, nodal planes of prime lens of focal length f

Today such devices are sold as *teleconverter* or *multiplier lenses* which contain typically four to eight elements with a net negative effect, housed in a short extension tube. The teleconverter is fitted between the camera lens and body (Figure 7.16); linkages transmit the functions of automatic iris and focus and metering information. The effect of a teleconverter is typically to double or triple the focal length of the camera lens, forming a telephoto combination of short physical length. As the size of the entrance pupil is unaffected, this doubling or tripling means that the maximum aperture is reduced by two or three whole stops, turning for example a 100 mm $f/2.8$ lens into a 200 mm $f/5.6$ or a 300 mm $f/8.4$. Where these losses are unacceptable, a ×1.4 converter with only one stop loss may be preferred, especially where a long-focus lens is already in use. A highly corrected apochromatic *matched multiplier* may be supplied with the prime lens for this purpose.

The change to the marked apertures is usually automatically corrected for by the TTL metering system used in most cameras, but must be remembered for use with manual, automatic and non-OTF electronic flash. The modest cost, small size and excellent results make teleconverters useful accessories. The minimum focusing distance of the camera lens is retained, with image magnification increased. Thus a 90 mm $f/2.8$ macro lens focusing unaided to give 0.5 magnification, when used with a specially designed converter, will give a combination 180 mm $f/5.6$ lens focusing to give unit magnification. Some manufacturers produce highly corrected converters designed especially for a particular lens or range of focal lengths; in such cases the performance is excellent. In general teleconverters do not perform well with wide-angle lenses, as aberration correction may be affected adversely. Thus it is pointless to convert a 24 mm lens into a 48 mm lens of mediocre performance when a good 50 mm standard lens may be available; on the other hand it is useful to be able to convert a 200 mm lens to 400 mm to save buying a heavy and expensive lens that may seldom be needed.

Optical attachments

A variety of optical attachments can be used in front of a camera lens. Like filters, these are produced in a range of fittings and sizes, and are attached in a similar manner. Materials used range from high quality anti-reflection coated optical glass to moulded plastics. Dependent on its function, the device may be transparent and non-selective, or it may absorb some wavelengths selectivity.

Afocal converter lenses

These multiple-elements optical systems are fitted in front of the lens and are generally used with non-interchangeable lenses to alter effective focal length. The term 'afocal' indicates that they have no focal length of their own, i.e. parallel light incident on the unit emerges parallel. Optically, they are related to the Galilean telescope, used either normally or in reverse mode in front of a camera lens. However, when such a converter is used with a camera lens, the effective focal length of the combination may be greater or less than that of the camera lens alone, depending on the orientation of the converter (Figure 7.17). The *telephoto converter* increases the focal length of the camera lens by factors of from ×1.5 to ×3 or even more, and the *wide-angle converter* decreases it by a factor of about ×0.7 to even ×0.5 to give a 'fish-eye converter'. Afocal converters were originally used with twin-lens reflex cameras but are now available for any types of cameras that lack interchangeable lenses, including digital cameras.

Unless the converters are of high optical quality the results can be disappointing. Large apertures give poor resolution and small apertures produce vignetting. No change in the marked apertures of the camera lens is necessary and no exposure compensation is needed. Reflex focusing is mandatory for good results. With the telephoto converter the near focusing range is lost. Within their capabilities they are useful devices to give a modest change in focal length of a

prime lens and consequent change in field of view. They are especially useful for camcorders with fixed zoom lenses.

Another afocal device is an *anamorphic lens converter* which uses cylindrical elements rather than spherical ones in order to compress the image laterally by a factor of some 1.5 by preferentially reducing focal length of the prime lens in a horizontal meridian. The image format is unchanged. The device is then used on the projector or enlarger lens to decompress the image to produce an aspect ratio of some 2:1. This technology is adapted from wide-screen movie systems.

Close-up (supplementary) lenses

Single-element lenses added in front of a camera lens will alter its focal length, a positive supplementary lens giving a reduction in focal length and a negative lens an increase. However, the most valuable use of such *supplementary lenses* is for close focusing, especially with cameras having a limited focusing capability. Focusing on a subject at a given (close) distance is possible by using a positive supplementary lens of focal length equal to the subject distance, irrespective of the focal length of the camera lens. The camera lens is then focused for infinity and the path of the rays is shown in Figure 7.18. This is the basis of *close-up* or *portrait attachments*. The focusing movement of the prime camera lens then provides a useful close-up focusing range.

Supplementary lenses are conveniently specified according to their *power* in dioptres rather than by their focal length. The relationship between power (K) and focal length (f) is that a focal length of 1000 mm is a power of one dioptre (1 D), so

$$f = \frac{1000}{K} \qquad (1)$$

The power of a convergent supplementary lens is positive and that of a divergent lens is negative. Specification of lenses by their power is convenient because in a combination the powers of the lenses are simply added to obtain the power of the combination.

Close-up lenses are available in a range of +0.25 to +10 dioptres. The weaker powers of 0.25 and 0.5 dioptres are used chiefly with long-focus lenses to improve their close-focusing capability. They do not seriously affect the corrections of the camera lens. Supplementary lenses are usually meniscus singlets; this shape introduces only a minimal amount of oblique aberrations and thus has only a small detrimental effect on the performance of the camera lens, especially at moderate apertures. Some supplementary lenses are coated achromatic doublets, ideally designed for use with a specific camera lens,

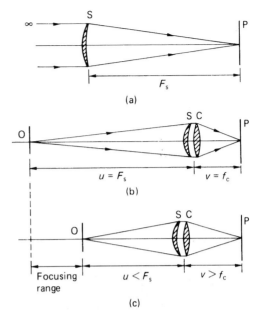

Figure 7.18 The close-up lens. (a) Positive meniscus close-up lens of focal length F_s; (b) used with a camera lens C of focal length f_c, nearest close focus is at distance F_s; (c) using the focusing extension of the camera lens to give a close-up focusing range

such as long focus and long range zoom types to provide an essential close-focus capability in the range from 0.5 to 2 metres where often there is a 'focus gap'. The reduction in effective focal length and little change to the entrance pupil diameter mean that the effective aperture of the combination conveniently compensates for any necessary exposure increase for the change in magnification.

Lens hood

Under most circumstances the use of a properly designed *lens hood* or *sunshade* with any lens will contribute significantly to image quality. The lens is shielded from light outside the subject area, and flare is reduced, especially in back-lit and side-lit conditions (Figure 7.19). The usual type of lens hood is a truncated cone or box shape, allowing maximum depth for shading without causing vignetting. The internal finish is ridged and painted matt black. The front aperture is either circular or, in more expensive models, rectangular and of the same aspect ratio as the film format. Owing to the danger of vignetting ('cut-off') by a lens hood, especially if a filter is also in use, many wide-angle lenses are not expected to be fitted with them; many such lenses are constructed with a recessed front component so that the front rim acts as vestigial type of lens hood. Alternatively a

(a) (b)

Figure 7.19 Use of a lens hood. In extreme conditions of side and back lighting, where lens flare and flare spots are a possibility, the use of a lens hood helps retain image contrast. (a) Without lens hood. (b) With lens hood

vestigial hood of cut-out 'petal' shape is used. As focal length increases the need for an efficient hood becomes greater. Many long-focus lenses are supplied with an integral retractable hood, to encourage the user to employ it. In the case of zoom lenses, the hood can only be of depth sufficient to avoid vignetting at the minimum focal length setting, even though the greatest need for a lens hood is at the maximum setting. Again, a hood can be of petal or flower shape to give some protection. Another possibility is to use a 'compendium' or bellows type of lens hood. This is unsurpassed in its efficiency, and is adjustable for a wide range of focal lengths. It can also take various filters, including vignetting and effects devices. Optimum adjustment is easy in the viewfinder of a single-lens reflex camera.

Special effects

A comprehensive range of optical attachments and devices are available for a range of effects produced in camera at the taking stage rather than by later image manipulation, although most of the optical effects can be duplicated at will by such digital image processing beginning with a 'straight' image.

Soft-focus attachments

A recurrent vogue in certain styles of photography, such as portraiture, is for a *soft-focus effect* given by the spreading of the highlights of a subject into adjacent areas. Special *portrait lenses* are available using controllable residual spherical aberration to give this effect, but these are expensive, and limited in application, although most have a 'sharp' mode also. A *soft-focus attachment* is a cheap alternative for use with any lens. Two basic types of device are available, one having a number of concentric grooves in plain glass, and the other having small regular or irregular deposits of refractive material about 1 micrometre thick, randomly scattered over a flat glass disc. The former type gives diffusion effects that depend on the aperture in use: the larger the aperture, the greater the diffusion. The latter type operates independently of lens aperture. The softening of the image results from the effects of scattering and refraction due to the presence of the attachment. Various degrees of diffusion are available and devices can be used in tandem or combination. Other devices use black or white netting of various mesh sizes encapsulated or laminated between clear plastic plates. These types give softening of the image and

controllable reduction in image contrast with no effect on colour balance. Experimentation is necessary to obtain practical familiarity with predictable effects. Also available are devices termed 'haze effect' and 'fog effect' filters, which find particular application in landscape photography. This type of 'haze' filter is not to be confused with the UV-absorbing variety.

The use of soft-focus attachments at the printing stage gives results different from those given at the camera exposure stage; in particular, the effect of diffusion at the enlarging stage of a negative is to spread the dark areas into the dark areas and shadows, whereas diffusion at the taking stage spreads the light areas.

Effects devices

Only a brief description of selected devices can be given here.

Multiple-image prisms

These are optical prismatic attachments, made of glass or moulded plastics material, which typically can give an array of repeated images of a single subject. These additional images can be typically in horizontal, vertical, slanting (echelon) or symmetrical arrangements (such as a central image with some three to seven repeat images distributed round it). The central image is, however, generally of poor quality and the remaining images may be severely degraded.

Split-field close-up device

This uses one half of a close-up lens in a semi-circular shape in front of the lower part of the camera lens, so allowing simultaneous focus on both near and far objects with an indistinct region between them. This can be useful to obtain pseudo extended depth of field provided there is no noticeable detail in the middle distance.

Centre-focus lens

This device is a glass disc with a clear central region and the outer annular region lightly ground so as to give an image with normal central definition and blurred peripheral detail.

Star-burst and twinkle devices

These effects are produced by a clear glass disc bearing closely spaced engraved lines in various patterns, which by scattering and diffraction cause the directional spreading of small intense highlights to give a 'star burst' effect to these regions, without seriously affecting overall definition. Occasionally, *diffraction gratings* are used alone or in tandem to produce small spectra from every small highlight or light source in the picture area.

Bibliography

Goldberg, N. (1992) *Camera Technology*. Academic Press, San Diego, CA.

Hirschfield, G. (1993) *Image Control*. Focal Press, Boston.

Kingslake, R. (1989) *A History of the Photographic Lens*. Academic Press, San Diego.

Kingslake, R. (1992) *Optics in Photography*. SPIE, Bellingham, WA.

Ray, S. (1992) *The Photographic Lens*, 2nd edn. Focal Press, Oxford.

Ray, S. (1994) *Applied Photographic Optics*, 2nd edn. Focal Press, Oxford.

8 Types of camera

A *camera* is essentially a light-tight box with a lens at one end to form an optical image and a fixture to hold light-sensitive material at the other to record this image. Most cameras have some means of focusing the image sharply at the *photoplane* for subjects at different distances. The duration of exposure to light is controlled by a *shutter system*, either mechanical or electronic. During the exposure the image illuminance on the film is controlled by an *iris diaphragm*, the aperture diameter of which can be varied. The optimum settings of the shutter and iris diaphragm are linked to an *exposure determination system* using light metering, that is part of the camera, possibly measuring through the lens. Finally, the camera has a *viewfinder system* by which the subject area to be included in the image may be determined. An essential feature is some means of advancing the exposed film in the gate to the next frame, and an additional feature is a *flash synchronization* device coupled to the shutter. A data display panel may be needed for camera control. Both film and digital cameras share all or most of these features.

Survey of development

A feature in the development of camera design since the primitive cameras first used in the early nineteenth century has been the progressive reduction in weight, size and shape with innovations and improvements in features. Changes were due to parallel developments in emulsion technology, optical design, construction materials and manufacturing techniques, as well as being related to the popular appeal of certain formats and the demand for versatility of function.

The *digital camera*, detailed later in this chapter, is still in a state of rapid development, progressing from early models that used analogue recording or various frame capture devices to obtain 'stills' from video cameras.

Image format

The *format* of an image as recorded in the camera is the dimensions of the *film gate* in the photoplane or the *photosensor* area. During the last decades of the nineteenth century, and continuing well into the

twentieth, most photographs were taken on glass plates. Contact printing was normal practice and plate sizes up to 305 × 381 mm (12 × 15 inches) were not uncommon. Indeed 'quarter plate' (82 × 108 mm or 3.25 × 4.25 inches) was long regarded as the minimum useful size. Apart from the standard plate sizes there were some unusual ones for specific cameras. Steady improvements in lenses, emulsions and illuminants made projection printing practicable and hence a decrease in camera image size for use with later enlargement. The use of roll film speeded this process and the 60 × 90 mm format (8 pictures on 120 size material) became very popular shortly before the Second World War, though by this time the 24 × 36 mm format on 35 mm perforated film was less of a novelty than in the late 1920s when first introduced. The 24 × 36 mm format became the most enduringly popular size, in spite of sporadic efforts on the part of manufacturers to introduce variations such as 24 × 32 mm and 28 × 40 mm. The 'half-frame' format of 18 × 24 mm proved briefly popular on account of film economy and the range of small cameras available. However, the advent of compact cameras using the larger 24 × 36 mm format but with additional features ousted the smaller format.

Truly pocket-sized cameras were introduced in the early 1970s with the 110 size format of 11 × 17 mm on film 16 mm wide in pre-loaded cartridges. Similarly, in the early 1980s another even smaller format was introduced of some 8 × 10 mm, giving 15 exposures spaced radially round a single circular piece of film (the 'disc' format). This format gave very compact cameras but required a high-technology approach in respect of lens design, emulsion quality, automation of functions and careful processing. Both formats are now defunct and have been replaced since the mid 1990s by diminutive, versatile cameras using either the Advanced Photographic System (APS) format of 16.7 × 30.2 mm on film 24 mm wide with choice of three aspect ratios, or digital cameras. The relative areas of various formats for both film and digital cameras are shown in Figure 8.1.

Roll films have been manufactured in very many sizes, most now obsolete. Available sizes are coded 110, 126, 127, 120 and 220 and APS, but the first three are now defunct. Fully or partially perforated films of width (gauge) 9.5 mm, 16 mm, 24 mm (APS), 35 mm (coded '135'), 62 mm, and 70 mm are currently used (Figure 8.2). The 110 and 126 films were

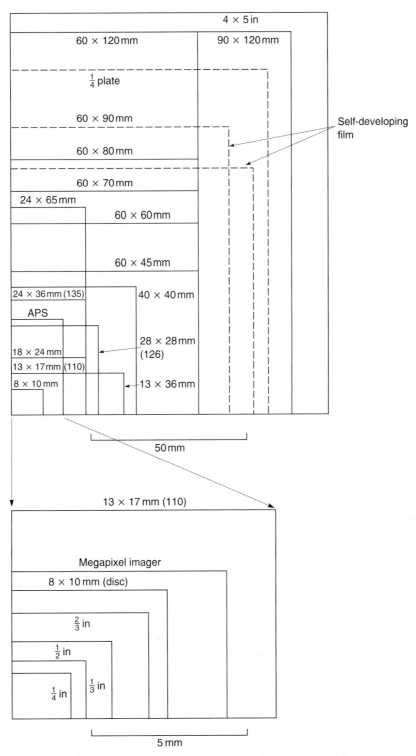

Figure 8.1 Relative areas of nominal formats for film and digital cameras. Medium and small formats are shown relative to the 4 × 5 inch large format size

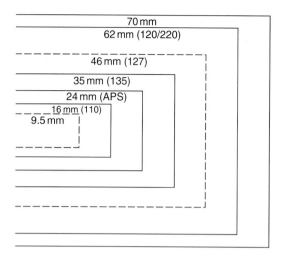

Figure 8.2 Comparison of the width (gauge) of various types of roll film. Obsolescent types are shown with dashed lines

in the form of drop-in cartridges with pre-fogged film rebates. The 126 format was 28 × 28 mm on film 35 mm wide, for use in simple or automatic cameras intended primarily for the casual user. The 127 size is obsolete, no new camera for this size having been produced for many years. Cameras with formats of 30 × 40 mm, 40 × 40 mm ('Superslide') and 40 × 65 mm were at one time available, using 127 roll film and giving 16, 12 and 8 exposures respectively per roll. The 40 × 40 mm format is still available in medium format cameras by using an alternative film back.

The dominant roll film is the 120 size, using film of 62 mm width or 'gauge', and a backing paper. This size provides a wide range of medium formats and some smaller, less common formats. Examples include 45 × 60 mm, 60 × 60 mm, 60 × 70 mm, 60 × 80 mm and 60 × 90 mm, giving 16 or 15, 12, 10, 9 and 8 exposures respectively per roll. These numbers are doubled for the 220 size, which is the same width as 120, but twice as long and supplied with leaders but no backing paper. The same formats are used with 70 mm perforated film, but the choice of emulsion types is limited. A small number of specialist cameras use 120 film to give formats of high aspect ratio or *panoramic formats* such as 60 × 120 mm, 60 × 170 mm and even 60 × 240 mm.

Sheet film was once considered an inferior alternative to plates. The introduction of polymeric base materials such as polyester, with improved dimensional stability, has meant plates are no longer used except for very specialized applications. Large format work is standardized on 102 × 127 mm (4 × 5 inch) and 203 × 254 mm (8 × 10 inch) sheet film sizes, while 60 × 90 mm is also used, possibly with an alternative digital format back. The traditional for-

mats of 'quarter-plate' (3.25 × 4.25 inch), 'half-plate' (4.75 × 6.5 inch) and 'wholeplate' (6.5 × 8.5 inch) are obsolete, and now 5 × 7 inch is rare.

A large format does not necessarily mean a bulky camera; ingenious construction methods are used to reduce size for transportation purposes. Technical cameras, even the monorail type, may be collapsed to moderate dimensions. Cameras using 35 mm film began compact, but have increased in bulk as versatility was extended. Cameras using 120 size film, on the other hand, began as bulky 'box' cameras, were superseded by compact folding models, and then became large again as modern range-finder and single-lens reflex cameras. Many cameras use adaptors to provide alternative smaller formats, e.g. roll film backs for technical cameras and 35 mm film adaptors for 120 size roll film cameras.

The true pocket-size or 'sub-miniature' camera has existed in various forms for many years and generally uses 16 mm or 9.5 mm perforated film with a format of 11 × 17 mm or less. The obsolete 110 cartridge camera supplemented these. The disc format camera could be classified as sub-miniature, but the cameras were comparatively large as they usually featured an integral electronic flash unit. Disc camera cassettes were particularly easy to load, as are the APS cartridges.

Versatility of function

On early cameras, features such as triple-extension bellows, an extensive range of camera movements and interchangeable lenses and backs were taken for granted. As designs progressed, many of these features were lost. For example, restricted focusing movements often allowed lenses to be focused no closer than 1 metre; for closer work special attachments were needed. This trend has reversed, and the standard lens on most cameras will focus continuously down to 0.5 m or less without attachments.

Large-aperture lenses require precision-built camera bodies; this usually means the loss of camera movements, though the limited covering power of such lenses would in any case not permit their use. Interchangeable lenses were uncommon until the advent of modern small-format cameras, particularly the single-lens reflex camera. The facility of interchangeable backs is still limited to a few cameras. Technical cameras retained all these useful features, and were improved by innovations such as modular and 'optical-bench' construction, 'international' backs, electronic shutters and through-the-lens exposure metering. In small-format cameras the trend is to incorporate more features such as motorized film advance and integral flash units to increase versatility; accordingly, 24 × 36 mm and medium-format camera bodies are designed and produced as the basic

unit in a 'system' of interchangeable lenses, view-finders and backs, remote control, motor drives and close-up accessories. Such a system considerably increases versatility.

The materials used for construction are important. Early plate cameras were of wood with brass fittings and leather bellows, which gave low weight and reasonable precision. Modern technical cameras use die-cast alloys with greater weight but their bulk is much the same. Bellows of square, taper or bag construction are still used. Small-format cameras need a precision given only by small manufacturing tolerances and ideally an all-metal construction. This results in a camera that can be heavy for its size. The judicious use of engineering plastics such as carbon-filled polycarbonates for many control surfaces, exteriors and less critical components, coupled with a precision diecast alloy core forming the camera body, successfully combines moderate weight with the necessary accuracy. Such plastics materials give a pleasant surface finish to the camera body and allow shaping of the body to provide anatomical grips. Camera bodies may occasionally be made from titanium metal and magnesium alloy for exceptional durability and strength with low weight.

Ergonomics are considered seriously in camera design. Cameras are especially made to be more easily operated when hand held. Improvements include positioning and legibility of scales, direction and amount of movement in focusing controls, larger and better-sited controls, large adjustable eyepieces in viewfinders, easy loading of film and the use of a comprehensive LED or LCD type display in the viewfinder, or of a large LCD type display on top of the camera body showing various pictograms and data to give a read-out of the status of the camera in its alternative modes of use. Modular design of subunits such as the shutter assembly or electronics wiring harness greatly facilitates servicing or repair. Solid-state electronic devices are very reliable, and the extensive adoption of automation in cameras has not led to any significant increase in camera malfunctions. Simple maintenance is the responsibility of the user, such as changing batteries that operate the shutter and metering systems, but long-life varieties such as lithium batteries are increasingly being used for functions and require less frequent replacement. Note that most contemporary cameras are totally or almost completely dependent on battery power for most of their functions.

Camera types

Many types of camera have been designed and produced, both for general applications and for specialized purposes in conjunction with a range of accessories. Most cameras can be categorized into one of several well-defined types, though of course there are unique exceptions. For cameras using film the types are simple, compact, rangefinder, twin-lens reflex, single-lens reflex, technical and specialized designs. A variety of types of camera is shown in Figure 8.3. Digital cameras use an opto-electronic form of imaging sensor rather than the silver-halide materials of traditional usage, but again several types are identifiable.

Simple cameras

The term 'simple camera' means one made for ease of operation, with little choice of control settings. The archetypal simple camera was the early primitive *box camera* equipped with a single meniscus or doublet lens with an aperture of about $f/14$. Smaller apertures might be selected by 'weather' symbols on an aperture control. The lens was usually fixed-focus, set at the hyperfocal distance to give reasonably sharp focus from 2 m to infinity. A 'portrait' supplementary lens, if attached, brought the focus down to about 1 metre. An alternative focusing arrangement used an elementary *three-point symbol* focusing system to indicate sharpness zones of 1–2 m (portrait), 2–8 m (group) and 3 m to infinity (landscape). A simple 'everset' shutter offered two settings of 'I' for 'instantaneous' (about 1/40 s) and 'B' for time exposures. Flash synchronization was for flashbulbs. The viewfinder was either a direct optical one or a brilliant (reflex) type without focusing function. The choice of format varied widely, from 60 × 90 mm (eight exposures on 120 film) down to 30 × 40 mm (16 on 127 film), as well as 28 × 28 mm format of the 126 cartridge, the 11 × 17 mm of the 110 cartridge, or the 8 × 10 mm of the disc film cassette.

For the user, simple cameras suffered from film loading and advance problems, overcome by the 126 format cartridge with drop-in loading technique. The later 110 cartridge was similar, with some cameras only 25 mm thick. Even with their small dimensions, some *pocket cameras* were available with comprehensive specifications and exposure automation using an electronic shutter, even if the modest lens was of fixed focus. Integral flash helped supplement small lens apertures, but the proximity of the flash tube to the optical axis, caused the 'red-eye' effect found in portraits taken with such cameras.

Improvements in sensitized materials, especially colour-negative emulsions, that made such small formats practicable and allowed useful enlargement, were later of benefit to other formats.

The *single use camera* (SUC) or 'film-with lens' camera is the current embodiment of the simple camera. The camera is intended to be used and then sent away complete for processing, when the camera components are largely recycled for reloading and further use. A basic plastic body shell with modest fixed-focus lens and a single speed shutter (1/100 s)

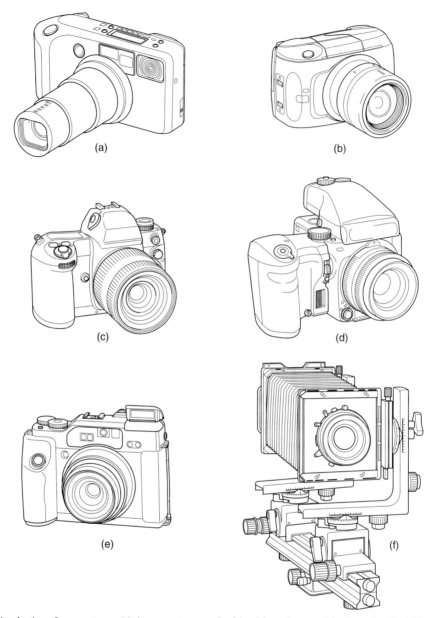

Figure 8.3 A selection of camera types. (a) A compact camera for 24 × 36 mm format with telescoping 38–135 mm zoom lens. (b) Single lens reflex camera with integral finder for APS formats. (c) Single lens reflex camera for 24 × 36 mm format. (d) 45 × 60 mm medium format SLR camera with attachable motor drive grip. (e) 45 × 60 mm medium format autofocus camera with zoom lens. (f) 4 × 5 inch large format monorail camera with L-shaped standards

contains pre-loaded film in a cassette (135 format) or cartridge (APS format). The pre-advanced film is wound back into the cassette after each exposure. The shutter is inoperative after the last exposure. Usually fast film such as ISO 400 or ISO 800 speed is loaded to allow use in a range of conditions, taking advantage of the exposure latitude of colour negative

material. Cameras are available with or without an integral flash, with output suited to the modest lens aperture. The popularity of these cameras is due to their small size, light weight, modest cost and disposability. A variety of alternatives are available, including underwater versions, long-focus and wide-angle (panoramic) types.

Compact cameras

Intermediate to simple cameras and the fully featured single-lens reflex types, the *compact camera* provides a non-interchangeable lens together with useful specifications and considerable automation, in a body of modest dimensions, using standard 135 mm type cassettes for the 24 × 36 mm format or APS cartridges for alternative formats. Early versions had a coupled rangefinder, large-aperture lens, bright-line finder and choice of shutter- or aperture-priority automation; followed by evolution into a distinct design type with comprehensive specifications. Significant developments included the incorporation of an integral electronic flash unit which added little to size but extended operating capabilities, and an 'auto-focusing' facility for the camera lens, using an active infrared ranging system or a phase detection system.

To perform well within economic operating parameters, a fixed (non-zoom) lens has a typical maximum aperture of $f/2.8$ and a focal length of 35–40 mm. A photosensor, of the silicon photodiode (SPD) type, monitors subject luminance and operates an exposure program with a between-lens shutter offering a range of some 1/20 to 1/500 s and an aperture range of $f/2.8$ to $f/16$. If the subject luminance is inadequate, the shutter release may lock until the integral flash unit is charged for use instead. Flash exposure automation is by alteration of lens aperture in accordance with distance data from the autofocus system (the flashmatic system). The film speed is usually set by the *DX coding system* on the film cassette. A *backlight control* may provide 1 to 2 stops exposure increase for high-contrast scenes. The flash can be used for fill-in purposes too, or a matrix type metering system may combine flash with the ambient light exposure.

Other features include a self-timer and a 'prefocus' system to allow focusing at a chosen distance. A separate close-focus capability may be provided. The original fixed focal length lens was replaced by more versatile systems, such as a choice of two focal lengths by the switch-operated insertion of an integral teleconverter behind the prime lens, typically giving a choice of 38 mm $f/2.8$ or 70 mm $f/5.6$. The viewfinder frame alters appropriately. More typically, a motorized zoom lens gives a range of 35 to 70 mm focal length with the viewfinder frame altering to match. Extensive zoom ranges are available such as 38 to 140 mm or even more. The penalty to keep such lenses compact enough to telescope back into the camera body is a considerable loss of maximum aperture with increase in focal length, possibly to as little as $f/11$, decreasing from some $f/4$ at the short focus end. Film of speed ISO 400 or 800 is essential for such lenses.

Additional or alternative features are a *data back* for date or time imprinting, a soft-focus device, multiple-exposure facilities and a weatherproof or waterproof body. Camera dimensions are increased accordingly. Film loading is semi-automatic with advancement to the first frame on closing the camera back. Film advance is motorized, as is rewind of the exposed film. An alternative *panoramic format* of 13 × 36 mm can be given by selecting masking blades for the film gate. The viewfinder is of complex optical design to cope with the features but must be very small to fit within the camera body. Usually *real-image* types are used, based on Kepler telescopes.

The APS type offers additional features, apart from very small camera bodies. There is a selectable choice of three alternative formats, labelled C (classic), H (HDTV) and P (Panoramic), giving aspect ratios of 1:1.5, 1:1.77 and 1:3 respectively, obtained by selective enlargement of areas of the film frame area. The film cartridge is easy to load, with film advance and rewind completely automatic. Mid-roll film interchange is possible to allow switching of film types. A range of 'intelligent' (i) features provide a range of user options, especially at the printing stage, when multiple prints or different sizes and backprinting of data may be made individually for each exposed frame. The film base is coated with an additional transparent layer of material for magnetic encoding of data.

The specifications of the compact camera ensure a very high success rate in terms of correctly exposed, sharply focused pictures made with a minimum of fuss or expertise, and with no accessories required other than perhaps a spare set of the essential batteries. Such cameras provide a very useful introduction to photography and a useful decision-free instrument for leisure pursuits.

Rangefinder cameras

This type of camera utilizes a coincidence-type rangefinder system (see Chapter 9), coupled to the focusing mechanism of the lens to ensure correct focusing at the subject distance. This method of focusing became common with the introduction of early 35 mm cameras such as the Leica and Contax, being essential for accurate focusing of large-aperture lenses. Rangefinder focusing has been used in cameras of format up to half-plate. Design improvements produced combined rangefinder-viewfinders with sets of bright-line frames. Small- and medium-format cameras with folding bellows construction used ingenious arrangements to couple the rangefinder to the lens focusing control. Interchangeable lenses are an additional problem, as the fixed baselength of the rangefinder means that focusing accuracy decreases with increase in focal length. In technical cameras, changing lenses also meant changing the focusing cam for a feeler arm coupled to the

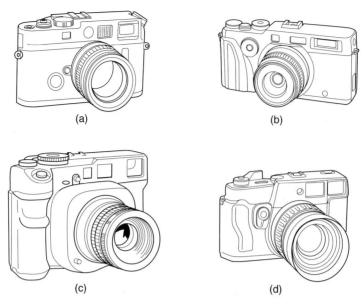

(a) (b)

(c) (d)

Figure 8.4 Rangefinder cameras: a selection of designs with coupled rangefinders: (a) 24 × 26 mm format on 35 mm film (Leica M) with interchangeable lenses and multi-frame finder. (b) Panoramic camera with choice of 24 × 36 mm or 24 × 65 mm formats. (c) 60 × 70 mm medium format camera with interchangeable lenses. (d) 60 × 90 mm medium format with fixed lens

rangefinder mechanism. Each lens required its own individually calibrated cam. In 35 mm cameras the feeler arm operated on a circular cam on the rear of the lens barrel. Close-focusing devices for rangefinder cameras were usually clumsy arrangements. The use of a rangefinder does, however, give a camera of compact design, capable of accurately focusing large aperture lenses in low light level conditions. Various designs are in production for small, medium and large format cameras. The viewfinder is complex with alternative bright-line frames, parallax correction linked to focusing and exposure metering systems by *through-the-finder* (TTF) methods. Some cameras use 35 mm film and are of either modest specification, with a non-interchangeable lens and some form of exposure automation; or of high-specification such as the Leica M types. Medium-format types may have interchangeable lenses. Large format cameras of folding construction with coupled rangefinders also have ground-glass screen focusing facilities. A selection of rangefinder cameras is shown in Figure 8.4.

Twin-lens reflex cameras

Due to simplicity in use and its versatility, this type of medium format camera was popular following the introduction of the first Rolleiflex camera. The design is essentially of two cameras mounted one above the other, the upper for viewing and focusing, the lower

for exposing the film (Figure 8.5). Both lenses have the same focal length, but the one used for focusing is of simpler construction and larger aperture, to facilitate focusing in dim light. The two lenses are mounted on the same panel, which is moved bodily to provide continuous viewing and focusing. The reflex mirror gives an upright, laterally reversed image on a ground-glass screen. The screen is shielded for focusing by a collapsible hood with a flip-up

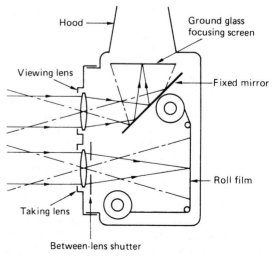

Figure 8.5 Principle of the twin-lens reflex camera

magnifier. The hood may be interchangeable with a pentaprism for eye-level viewing and focusing. The focusing screen incorporates a Fresnel lens, split-image rangefinder or microprism array to assist focusing. The viewing lens is always used at full aperture. Film transport and shutter setting is normally by means of a folding crank device. Cameras used the 60 × 60 mm format on 120/220 film. The square format meant that the camera could always be held in the same orientation for viewing and focusing, the negative being cropped later to give the final composition. Alternative formats such as 35 mm were obtained in some models by means of adaptors.

With one exception, the Mamiyaflex, twin-lens reflex cameras did not have interchangeable lenses, a considerable disadvantage. Some alternative models were fitted with fixed lenses of 55 or 135 mm focal length instead of the usual 75 or 80 mm. The Mamiyaflex used pairs of interchangeable lenses on panels, and an integral bellows coped with differing focusing extensions and close focusing.

A problem with all TLR cameras is *parallax error* in the viewfinder screen image because of the separation between viewing and taking lenses. Partial solutions included the use of a viewing screen of reduced area, a swivelling viewing lens, moving masks and moving pointers to delineate the top of the field of view. The problem is serious in close-up photography; a partial answer is a wedge-shaped prism fitted to the viewing lens when supplementary lenses are used, but for accurate work a lifting device is needed to raise the camera bodily by the distance between optical axes. Few TLR cameras are now in use.

Single-lens reflex cameras

The *single lens reflex* (SLR) camera has been popular since its introduction in the late nineteenth century, apart from a time when the TLR design was favoured. Now, following intensive development in both 35 mm and medium formats, it is the preferred design. Most innovations in camera design first appear in SLR cameras. The principle of the camera is illustrated in Figure 8.6. A plane front-surfaced mirror at 45 degrees to the optical axis is used to divert the image from the camera lens to a screen where it is focused and composed. For exposure the mirror is lifted out of the way before the camera shutter operates. After exposure the mirror can return to the viewing position. The need for speed and reliability in the mirror mechanism led to the development of electro-mechanical operations of some complexity. Details are given in Chapter 9. The great advantages of the SLR design are the ease of viewing and focusing, and the freedom from parallax error, especially important for close-up work. The depth of field at the pre-selected aperture can also be estimated.

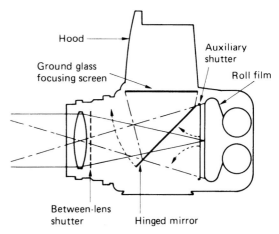

Figure 8.6 Principle of the single-lens reflex camera (Hasselblad)

The earliest designs of SLR camera used rectangular formats, and a *rotating back* was essential so that upright ('portrait') or horizontal ('landscape') pictures could be composed. Interchangeable lenses had only an iris diaphragm and were typically focused using a bellows arrangement with a rack-and-pinion drive. A counterbalanced pivoted mirror was raised by pressure on a release lever which lifted the mirror out of the way and then triggered a focal-plane shutter.

After some decline in usage due to the advent of the TLR camera, the design reappeared in 35 mm, 127 and 120 sizes, preferred because of their small size. Such cameras used focal-plane shutters with an extended range of speeds and a spring-operated mirror which returned to the viewing position upon advancing the film. The loss of the viewfinder image at the moment of exposure and afterwards was always regarded as a disadvantage of the design. The *instant return mirror*, giving uninterrupted viewing (except during the brief time the shutter was open) is now standard in most SLR cameras. For wide-angle lenses, the depth of the mirror box in the camera required the design of lenses with a long back focal distance; in particular, the retrofocus type. The reflex mirror must be sufficiently large to avoid image cut-off in the viewfinder area, and in order to retain a suitably compact camera body the mirror may need to move backwards as well as upwards on being raised.

A rectangular format is inconvenient when a vertical framing is required for a picture, as turning the camera sideways causes the image on the viewing screen to be inverted. Usually a direct-vision view-finder had to be used. A square format allows the camera to be held in the same way for all photographs, the picture shape being determined by masking off at the printing stage. Alternatively, a

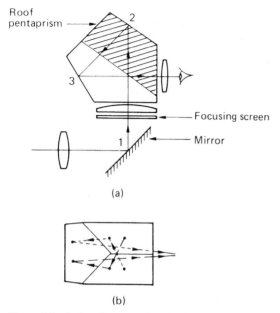

Roof pentaprism

Focusing screen

Mirror

(a)

(b)

Figure 8.7 Action of a pentaprism viewfinder. (a) Side view. (b) Top view, showing cross-over in the angled 'roof' of the prism

rotating film back is used linked to viewfinder frames.

Shortly after the Second World War, the *penta-prism viewfinder* was introduced, and this ensured the dominance of SLR cameras. Eye-level viewing and focusing are possible, with the viewfinder image erect and laterally correct for both horizontal and vertical formats. The principle of the pentaprism viewfinder is illustrated in Figure 8.7. Note that the erect but laterally reversed image on the focusing screen undergoes three reflections inside the roof prism to appear correctly oriented. The necessary precision of the angles of the prism requires it to be made of glass, so it is weighty and expensive, but hollow prism versions using mirrors reduce both. Many design improvements were introduced in the 35 mm format, but medium-format designs have been progressively developed, to match the smaller format. A significant improvement was reliable flash synchronization of focal-plane shutters, so that many cameras can now provide synchronization at speeds up to 1/250s. Following the introduction of the instant-return mirror, the operation of the iris diaphragm, which was normally stopped down manually just before expo-sure, evolved into the *fully-automatic diaphragm* mechanism (FAD). Improved viewfinder focusing screens used *passive focusing aids* in the form of microprism arrays and split-image rangefinders, usually with a choice of alternative screens for specialized purposes. Manual focusing systems have been replaced in most small and medium format SLR

cameras by autofocus systems, see Chapter 9 for operating details.

A vast range of lenses (many from independent manufacturers) is available to fit SLR cameras, ranging from fish-eye to extreme long-focus types. A feature normally available in medium-format cameras is the facility of fully *interchangeable magazine backs* for changing film type in mid-roll, or for rapid reloading Another alternative is a back equipped with a high resolution focal plane array for digital photography. A significant design advance introduced in the mid-1960's was *through-the-lens* (TTL) meter-ing. Reliable photocells of the necessary sensitivity and spectral response, coupled with the ease of showing the measurement area in the viewfinder, ensured rapid development of versatile systems (see Chapter 9).

The operational advantages of the SLR design mean that it is probably the most highly developed system camera, and the basic unit for a wide range of accessories. In particular, owing to the electronic 'enrichment' of its functions it has steadily-widening applications. The medium-format SLR camera even replaces the technical camera for many applications not requiring a large format or extensive use of camera movements.

Technical cameras

The terms *technical camera* or *view camera* cover two designs of camera. The first is the *monorail* type, based on the optical-bench principle to offer the widest possible range of camera movements (see Chapter 10). All focusing and composition is done using a ground-glass screen, and the camera can only be used on a rigid support such as a tripod or pillar stand. The second type is the *folding-baseboard* variety, and may be equipped with a coupled rangefinder and optical finder as well as a ground-glass screen. It can be used hand-held as well as mounted on a tripod.

The rationalization of the technical camera is another example of continuing improvements in design, manufacture, functional capabilities and auto-mation of operation. The early wood and brass *studio* and *field cameras* were adequate for large-format work but were very slow in operation. Improvements in lenses and a preference for smaller formats needed greater precision in manufacture. So metal was substituted for wood, giving rigidity at the expense of weight. Some standardization was achieved in the sizes of items such as lens panels, filmholders and camera backs. Technical cameras use medium for-mats such as 60×70 mm to 60×120 mm, but monorail cameras in these formats are less common. The term 'large format' covers film sizes of 102×127 mm (4×5 in) and 203×254 mm (8×10 in); intermediate sizes are obsolescent. Most cameras in

this range feature *reducing backs* and *format changing* to allow the use of smaller or larger formats with the same basic camera components when required for reasons of convenience or economy. Alternative digital backs are available which are usually linked directly ('tethered') to a computer for image display and filing.

As with other camera types, the technical camera is a 'system' camera. The basic body can be fitted with or adapted to a host of accessories, covering alternatives to almost every component. This is especially true for monorail designs produced on modular principles so that rails, front and rear standards, bellows, focusing screens, lenses and shutters are interchangeable to adapt for a range of formats or types of work.

The folding-baseboard camera may use a high-precision rangefinder with coupling to three alternative lenses. Viewing is by means of a multiple-frame, bright-line viewfinder. Sheet film, roll film, Polaroid material and even plates can be used. To offset its merit of being able to be used hand-held, it has a more limited range of movements than the monorail type. The ground-glass screen must be used for close-up work or camera movements because the rangefinder is not then operative. The bellows is usually of 'triple-extension' type, allowing a magnification of ×2 with a standard lens for the format.

Innovations in technical camera design include forms of through-the-lens exposure determination using a probe in the focal plane; preset mechanisms for shutter speeds and aperture settings; electronic shutters; extreme wide-angle lenses of large useful aperture; computer coupled and indicated camera movements, and binocular viewing and focusing aids.

Cameras for self-developing materials

A variety of cameras are available to use the range of *self-developing* (instant print) materials manufactured by the Polaroid Corporation and others. These materials are available in roll film, sheet-film and film-pack forms and the formats used include some $40 \times 60\,\text{mm}$, $60 \times 90\,\text{mm}$ and $102 \times 127\,\text{mm}$. Even larger formats are sometimes used, up to 8×10 inches and even 20×24 inches. Both colour and black-and-white materials are available, together with a range of materials usable in any 35 mm camera. The specialist cameras range from simple types with minimal control of functions to sophisticated models equipped with electronic shutters, TTL exposure metering, autofocusing and automatic ejection of the exposed film frame. The geometry of image formation, and the sequence of the layers in the particular film type, may require use of a mirror system in the camera body in order to obtain a laterally correct image in the print. This need can give a bulky, inconvenient shape or requires considerable design ingenuity to permit folding down to a compact size for carrying. Conventional types of film cannot be used in these cameras, but various adaptor backs and film holders are available to permit the use of self-developing materials in other cameras for image preview purposes. Special multi-lens versions are used for purposes such as identification pictures.

Such camera and film combinations are often very convenient to use, and find a large number of useful applications. A range of accessories is available to extend their capabilities.

Special purpose cameras

Aerial cameras

Most aerial cameras are rigid, remotely controlled fixtures in an aircraft, but for hand-held oblique aerial photography a few specialized types are used. These are simplified versions of technical cameras without movements and with rigid bodies and lenses focused permanently on infinity. A fixture for filters, a simple direct-vision metal viewfinder and ample hand-grips with incorporated shutter release complete the requirements. If roll film is used (normally 70 mm), film advance may be by lever wind or may be electrically driven. In order to obtain the short exposure durations necessary to offset vibration and subject movement, a *sector shutter* may be used. This is a form of focal-plane shutter in which an opaque wheel with a cut-out radial sector is rotated at high speed in front of the film gate to make the exposure. Various forms of data imprinting may be used to record positional and other information at the moment of exposure. These data may be taken directly from the navigational system of the aircraft.

Underwater cameras

To allow use underwater, many cameras can be housed in a pressure-resistant container with an optically flat window or a spherical 'dome port'. The housing may be an accessory for the camera. Unfortunately these casings are cumbersome. However, for underwater photography, a few cameras have been designed with a pressure-resistant, watertight body and interchangeable lenses to make them usable down to specific depths. They are also useful in adverse conditions on land where water, mud or sand would ruin an unprotected camera. These cameras usually have a simple direct-vision or optical finder and manually set focusing controls, but SLR versions have been made. The lenses are interchangeable and have suitable seals, but changing must be done out of the water. A short-focus lens may be fitted as standard to compensate for the optical

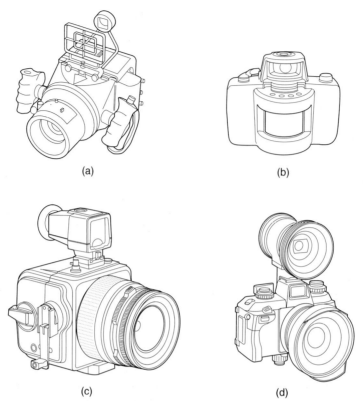

(a) (b)

(c) (d)

Figure 8.8 Special purpose cameras. (a) Electrically operated hand-held aerial camera for 4×5 inch format. (b) Rotating lens panoramic camera for a format of 24×56 mm on 35 mm film. (c) Superwide-angle camera for a 60×60 mm format, the 38 mm lens giving a picture angle of 90 degrees. (d) Underwater camera for 24×36 mm format equipped with a 15 mm fish-eye lens and accessory viewfinder

magnification effect that occurs due to the change in apparent subject distance caused by the refractive index of the water in the object space. A field of view similar to that of a standard lens on a conventional camera is then obtained. Special lenses corrected for underwater use, i.e. with water actually in contact with the front element, are also available. Such lenses are not recommended for use in air as aberrations would then not be adequately corrected. Some compact cameras are specially sealed to allow underwater use to depths such as 3 metres and will withstand adverse weather conditions.

Ultrawide-angle cameras

When a sufficiently large angle of view cannot be obtained from the usual range of lenses available for a camera, and when distortion considerations rule out the use of a fish-eye lens, then alternative types of camera may be used. The choice may be a camera body of shallow depth with a lens (usually non-interchangeable) with a large angle of view, e.g. some

110 degrees on the diagonal, as obtained by the use of a 65 mm lens with a 4×5 in format. Focusing of such a lens is usually by focusing scale, and the viewfinder may be a simple direct-vision or optical type, preferably incorporating a spirit level as an essential aid in aligning the camera. Limited shift movements may be provided such as rising front. Other features of the camera are as normal. Medium format versions find especial use as precision *shift cameras* for architectural work.

Panoramic cameras

For a wide angle of view and a print format of high aspect ratio a *panoramic camera* may be used. Typically, 140 degrees horizontally and 50 degrees vertically may be covered by rotating a normal lens design about its rear nodal point and imaging the scene through a synchronous moving slit at the focal plane which exposes the film sequentially during the exposure time. The film gate is curved with the centre of curvature at the rear nodal point of the lens.

Exposure duration is controlled by varying the width of the slit.

In other cameras a high-aspect-ratio format is used with a flat film gate and a very wide-angle lens, usually needing a spot filter to improve image illumination at the edges. Other cameras may use similar high-aspect-ratio formats. These do not give the characteristic cylindrical perspective of the true panoramic camera with rotating lens, but do show extreme geometric distortion. Formats from 60 × 120 mm to 60 × 170 mm or even 60 × 240 mm are used.

A selection of types of special-purpose camera is shown in Figure 8.8.

Automatic cameras

Most types of camera can be called 'automatic' in that there is some form of digital control using solid-state micro-electronics. Functions previously operated by mechanical, electrical or electromagnetic devices are now controlled by electronic circuitry. This replacement of gears, rods and levers varies from primitive controls, through electronic 'enrichment' to digital operation. The term 'electronic camera' is sometimes used. Strictly speaking, this term means a camera in which functions such as shutter operation and metering are controlled by a *central processing unit* (CPU) which makes logical decisions based on the *input* of digital information. The subsequent control commands or output can be carried out by the camera to give *full automation*, or with the aid of the user to change settings as appropriate, to give *semi-automatic operation*. A flow diagram showing the operational sequence of a semi-automatic camera is shown in Figure 8.9.

Analogue systems

Cameras were once all-mechanical where operation depended on the film advance mechanism to tension actuating springs and the shutter timing depended on escapement devices and gear trains.

The selenium cell light meter allowed primitive forms of semi-automation such as the manual alteration of shutter speed or aperture settings to match a movable pointer to the meter needle. This operation is still called 'match needle' even if LEDs are now used. Full automation was possible when the meter needle itself was used to set the camera exposure with the aid of trapping devices to lock it. The complex arrangements used levers, pneumatic bellows and chain drives.

The electronically controlled shutter using a resistor–capacitor circuit for exposure timing was introduced almost simultaneously with the replacement of selenium cells by smaller CdS cells which allowed

TTL metering. Total automation was possible when the photocell output was used to control the shutter timing circuitry. Electronically, the exposure-determination circuitry of the camera used the exposure equation relating shutter speed (t), aperture (N), subject luminance (L) and the film speed (S), involving the meter constant (K) for reflected light where:

$$LSt = KN^2 \qquad (1)$$

This is done by an analogue circuit such as a Wheatstone bridge arrangement (see Figure 8.10), where electrical resistance, voltage or current represent in analogue form the physical quantities involved (all of which are measured in different units). Resistance values are most commonly used.

Analogue converter devices are needed to set the appropriate resistance values into a primitive computing device such as a Wheatstone bridge. The shutter-speed setting control, film-speed setting and exposure-compensation controls all use forms of fixed and variable resistors. Aperture value setting is more difficult, as the analogue device is in the camera body and the iris diaphragm is some distance away in the lens. Some form of mechanical linkage is needed to engage a variable resistor, usually located inside the throat of the lens mount. A *maximum-aperture indicator* is needed to correct the calculations for the preset aperture when full-aperture metering is used, or to control a dedicated flashgun. Bayonet mounts are essential to ensure precise location and mating of data linkages. The aperture control setting selects resistance values according to aperture, and these values are transmitted to the CPU in the camera body by electrical contacts such as gold-plated pins (thus increasing reliability).

For shutter-priority operation, the output of the CPU was used to arrest the iris diaphragm opening at a value predetermined by the metering system. For aperture-priority operation the photocell output controlled exposure duration via the shutter. The control circuitry required only a few components such as transistors, resistors and capacitors on a printed circuit board. The silicon photodiode (SPD), with its very fast reaction time and freedom from unwanted 'memory', allowed metering to be carried out in 'real time' in the short interval between depression of the release button and the mirror rising or the shutter operating, or, better, during the shutter operation itself by metering from the actual film surface. Earlier CdS systems took a reading which was held or memorized by crude circuitry, and used to set the controls before the shutter was operated. Real-time metering with SPDs is possible with electronic flash using thyristor-operated switching circuitry. Additional forms of analogue devices were used to interface with a dedicated flashgun, such as the *hot shoe* with several electrical contacts for the purpose of data transmission and the transfer of command pulses. An SPD

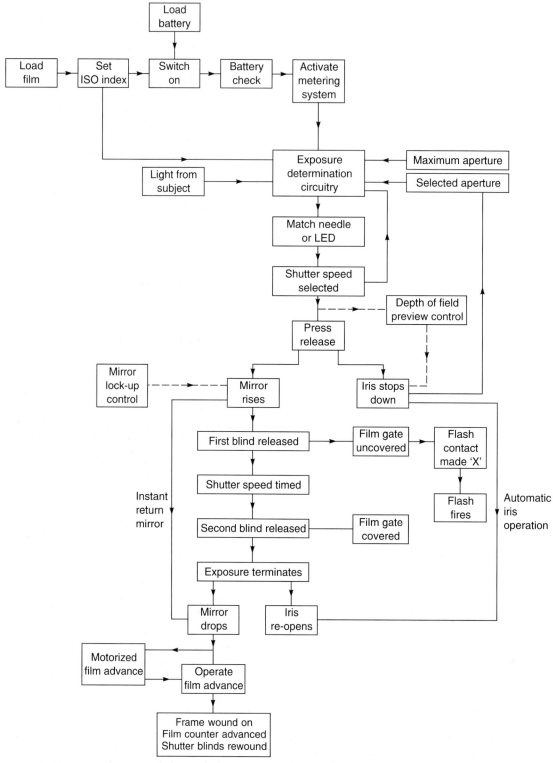

Figure 8.9 Flow diagram of exposure sequence with a semi-automatic SLR camera using analogue systems

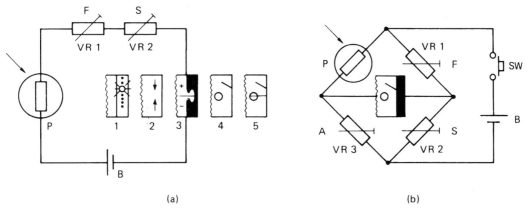

(a) (b)

Figure 8.10 Circuits and displays for semi-automatic metering in cameras. (a) Simple series circuit with the photoresistor P and battery B in series with potentiometers VR 1 and VR 2. VR 1 is coupled to the film-speed setting control F and VR 2 to the shutter-speed setting control S. Light falling on P gives a deflection of the meter needle seen in the viewfinder, or causes an LED or arrow symbols to light up. Alteration by hand of the aperture control to match a pointer to the needle or bring the needle to an index mark will set the correct exposure. Five typical viewfinder read-outs are shown: 1 by lit LED, 2 by two lit arrows, 3 by centring needle, 4 needle and index, 5 match pointer. This form of circuit is sensitive to battery voltage. (b) An improved circuit is one of the Wheatstone bridge type with the photoresistor and three potentiometers forming the arms of the bridge, which balances the meter needle when the products of resistance on opposite sides of the bridge are equal. This arrangement is independent of battery voltage. The additional potentiometer VR 3 is coupled to the aperture setting control A. The meter can be zeroed, i.e. correct aperture set, by alteration of either VR 2 or VR 3 or both together

requires additional circuitry such as operational amplifiers, and draws current from the battery which also powers the shutter and viewfinder display. The slow-acting and delicate meter needle was replaced by LED displays, still as an analogue arrangement. Apart from a choice of colours, the LED can code information in several other ways, such as being 'on' or 'off', by its intensity, by flashing at different rates, or by being lit continuously. Some very complex viewfinder data displays were devised.

A *power winder* or *motor drive* became part of every camera system and required electronic linkage to the central control to prevent any tendency for it to operate during an exposure. The interiors of cameras became packed with circuitry and wiring. Increasing demands were made on the simple analogue circuitry, especially with the advent of multi-mode metering systems and the short time available to carry out the necessary operations for each exposure especially with a motor drive operating at several frames per second. The possibility of overload became real. Most of these limitations are overcome by use of digital control.

Digital control

Digital control refers to the use of data and control commands in digital form. An early digitally controlled system was a viewfinder display using alphanumeric characters formed from seven-segment LEDs, or an LCD is called a digital display; letters and symbols can be formed as well as numbers. Power-consuming LED displays can be replaced or complemented by large LCD panels which give a comprehensive readout of the current status of the camera (such as exposure mode, film frame number, film speed in use) (see Figure 8.11). Such displays require more complex control circuitry than a simple LED display, where the LED is either lit up or not. Activation is from the CPU via devices called *decoders* and *multiplexers*. A multiplexer is a circuit which selects with the aid *of a clock circuit* one at a time from a number of inputs and outputs automatically in turn. The clock timing is provided by an oscillator circuit using quartz or lithium niobate crystals.

The CPU uses additional devices such as *analogue to digital* (A/D) converters and both *random access memory* (RAM) and *read only memory* (ROM). An external clock circuit monitors the sequence of operations and all are connected by buses for data flow.

Some systems need a 6 volt supply, others only 3 volts, determining battery needs, and space for them. Most devices are sensitive to voltage changes, so a constant-voltage supply circuit is needed. Others are sensitive to temperature, so another compensating circuit is needed.

Various types of CPU are used, depending on needs. All have large numbers of circuit elements per unit area, given by *large-scale integrated circuits*. The high

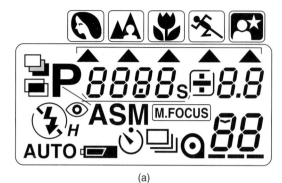

(a)

(b)

Figure 8.11 Examples of external LCD data panels on the top plate of a camera. (a) Minolta data. (b) Canon data

packing density is given by *metal oxide semiconductor* (MOS) circuitry. These are sensitive to voltage and temperature, and not easy to interface with other devices in the camera. The alternative *transistor–transistor logic* (or TTL) (not to be confused with 'TTL' metering) costs more, and uses more power, but needs less precise control. Processing speed is higher than with the simple MOS type. An intermediate choice is *integrated-injection logic* or I^2L type, which has the packing density of the MOS type but is slower than the TTL type. Operation requires a *read-only memory* or ROM device to store a fixed program of operational steps in the correct sequence to guide the CPU through its calculations in the correct order. This program may be many thousands of lines long. The ROM is static, and data does not disappear when the camera is switched off; the program cannot be added to or modified subsequently.

The whole microprocessor system depends on a clock circuit as a reference for the order of events. This can be a *quartz oscillator* giving 32 768 beats per second or hertz (Hz). These pulses are counted by appropriate circuitry, and can also be used to control shutter speeds, self-timer delays, meter 'on' timing

controls and intervalometers. An exposure of 1/1000 s is timed as 33 pulses, to an error of less than 1 per cent. The counting circuit delays travel of the second blind until sufficient pulses have elapsed. An alternative *ceramic oscillator* device gives 4 194 000 Hz for even greater accuracy and for control of complex data displays.

Digital control means that the data and calculations are handled in discrete form and not as an infinitely variable electrical quantity in their analogue form. The circuitry is basically an array of transistor switches, each of which can be in only one of two states, either 'off' or 'on', to shunt the current flow through logic gates of the 'if/then' and 'and/or' configurations. The decimal system of 10 digits from 0 to 9 is replaced by the binary system using the two digits 0 and 1, corresponding to the two alternative states of a switch. The 'number-crunching' power of a digital processing system, plus its speed and error-free operation, more than offsets the additional circuitry needed compared with analogue systems.

All input data must be coded into binary form and then the output commands decoded for implementation. The analogue data from *transducers* such as potentiometers in the film speed setting control is changed into binary data by an *analogue-to-digital* converter (A/D), and the reverse operation by a *digital-to-analogue* circuit (D/A). This conversion is doubly difficult in the case of data from the SPD photocell. This gives subject luminance data in analogue form, and covers an enormous dynamic range: a 20 EV metering range corresponds to a light level range of 1 048 576:1. This range is compressed by converting values to their logarithmic equivalents before conversion to digital form, using a *logarithmic compression circuit*. Data encoding by a *transducer* may be by movement of a wiper arm over a patterned resistor or by an optical device, the output being a string of pulses corresponding to the required 0 and 1 values. To guard against encoding inaccuracies, the strict binary code may be replaced by, for example, the *Gray Code*, which permits the checking of values by 'truth tables', so that impossible values cannot be sent to the CPU. Other components of the camera such as flash units, power drives and multifunction backs can transduce and transform their data as necessary. By means of the *DX film coding* system in binary form on a 35 mm film cassette, the film speed, exposure latitude and number of exposures may be encoded directly into the CPU by means of an array of contact pins in the cassette compartment.

The CPU performs various actions on its output. Values for the viewfinder display are 'rounded off' to conventional values or to two decimal places. The display can be updated every half second or faster and alter its intensity in accordance with the photocell output by the simple means of altering the pulsing rate of each segment (the intensity of a LED cannot be varied by other means). A 'bleeper' can operate to

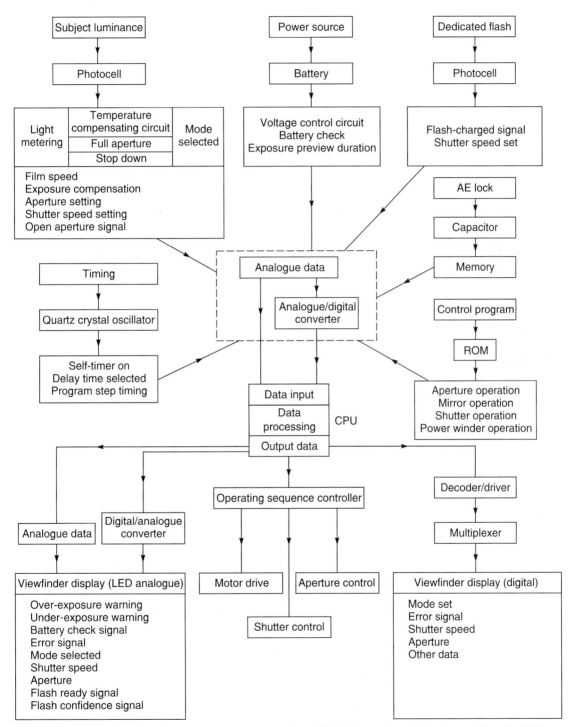

Figure 8.12 The electronic camera: generalized picture of the flow of digital data and control signals to and from the CPU

warn of camera shake or inadequate light, generate an error signal, and so on.

A separate CPU may be used for the complex *signal-processing operations* required with the data from arrays of sequentially scanned CCD devices used in autofocus systems. Accessories such as flashguns may also have complex LCD digital displays to supplement the main display on the camera body or in the viewfinder.

Other *interfaces* in the form of arrays of electrical contacts are used in the lens mount, film gate, viewfinder well and hot shoe to allow the flow of data and commands from an autofocus lens with its own ROM and transducers, with a multi-function back, an accessory automatic metering viewfinder system and various forms of dedicated flashgun respectively. A generalized picture of the flow of data and control signals in an automatic camera under digital control is shown in Figure 8.12.

The system may be further expanded or updated by means such as interchangeable ROM expansion cards or by interfacing with a personal computer, to provide a range of additional and specialist operational modes or to customize controls and functions from the default or factory settings.

Digital cameras

Introduction

While most film cameras use some form of automation involving digital control systems, they are not called 'digital cameras'. Instead this description is reserved for cameras which use a two-dimensional focal plane array (FPA) of light sensitive elements such as *charge coupled devices* (CCDs). This array responds to the optical image in an analogue manner to give an electrical output, but this is encoded as digital data giving the location of the element in the array as an (x, y) address, and the value of the response (L). By means of filtered exposures to red, green and blue light, the total (x, y, L) data is recorded for a colour image, then stored in a memory device. The signals may be processed and the data compressed to use less memory, and also used to provide a display of the image.

The term *digital photography* is currently taken to mean use of the full range of image recording, manipulation and display systems to produce images. The range of techniques and equipment used include direct use of digital cameras and hybrid methods that originate images on film and then digitize these by means of a scanner. Then follows the range of possibilities of image control by subsequent processing and manipulation, and next the numerous alternative forms of output by means of printers, display and projection systems. Only the design and functioning of digital cameras will be detailed here.

Still video cameras

The precursor of the true digital camera was the *still-video* (SV) camera introduced in the late 1980s using magnetic recording of video imagery, and meant to supplement and complement existing types of cameras. Typically, the sequential read-out of photosensor data was recorded in analogue form on an encapsulated magnetic disc of diameter 47 mm, formatted into 52 tracks. By rotating the disc at 60 or 50 rev/s for the NTSC or PAL video systems respectively, one TV field per track or one TV frame per two tracks could be recorded, giving a choice of 50 or 25 images per disc. Each track was separately recordable, accessible and erasable. Exposure data and sound could be recorded and exposure sequences of 2 to 15 fields per second were possible. The stored information was accessed either from the camera itself or by a separate player for viewing the images on a TV set or monitor. The data was transmitted via a suitable link or used in a printer to produce a 'hard-copy' print output. The system was useful until true digital cameras became available, where data was output in digital instead of analogue form.

Image resolution was modest. Initially, arrays of some 640 vertical and 480 horizontal elements were used. This gave a vertical resolution of some 500 TV lines in the *frame mode* and half this value in the *field mode* where the TV interlace (even) lines are not used, but the number of images per 50-track disc was doubled. Little visual difference was seen between the two modes at usual viewing distances. Fine detail rendering could be deliberately restricted by an optical low-pass (frequency) filter immediately in front of the sensor array chip. This selective diffuser was an etched diffraction pattern on a quartz plate, the interference effects suppressing detail so as to avoid the appearance of artefacts in the video image.

Related systems currently in use include the *still-video mode* on digital video camcorders that have a 'still frame' feature to save and output low resolution images suitable for viewing on a TV screen. A large number of such images can be stored on a single cassette of tape. Another system is that of 'frame-grabbing' where a time-based image is input to a PC and a selected frame is digitized by suitable circuitry then formatted as required for viewing and analysis.

The photosensor array

The principal component of a digital camera is the *photosensor array* in the photoplane, analogous to the emulsion surface in the gate of a film camera. By using techniques of photomicrolithography to integrate into a small area numerous circuit elements with a very high packing density, the surface of a layer of pure silicon is converted into an array of individual light sensitive devices. The associated circuitry can

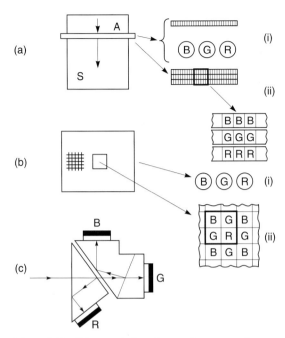

linear array uses a triple row of pixels with each row using a red, green or blue filter. If integral filters are not used then colour analysis of the scene is by three separate exposures, one for each colour, using a filter wheel in front of or behind the lens. The subject must be static, but this is no problem in applications such as still life, document copying and fine art photography. The lighting level must remain constant during the short time taken for a set of exposures to prevent colour banding in the image. Another method of colour separation giving a simultaneous exposure is by using a beamsplitter prism and three arrays. This is uncommon in digital cameras, but used in video cameras. The various alternative methods of colour separation are shown in Figure 8.13.

Signal and noise

The action of light on the silicon substrate in the photocells is to release photo-electrons. An array can use one of several alternative structures to capture and accumulate photo-electrons in the form of electrical charge. One element forms a 'well' for charge but its capacity is limited and excess electrons must be removed by a 'drain' circuit otherwise they will migrate to adjacent wells and cause degradation to the image seen as 'blooming' and noise. Figure 8.14 shows the photon transfer process as a form of characteristic curve for an array. The surface area of the element primarily determines sensitivity, usually expressed for convenience as an *ISO equivalent speed*, but because of the pixellation process, this must be traded off against resolution of detail.

Figure 8.13 Colour analysis and separation systems for digital cameras. (a) Scanning across an optical image (S) using a linear CCD array (A): (i) triple exposure using a single array with R, G, and B filters; (ii) detail of trilinear array. (b) Focal plane array: (i) triple exposure with R, G, and B filters; (ii) detail of embedded Bayer filter mosaic, 2 × 2 matrix of R + 2G + B pixels form one colour pixel. (c) Prism separation system and three filtered sensor arrays

interrogate these in a fixed sequence to transfer their exposure data to an *analogue to digital converter* (ADC) for transformation into digital data.

The array dissects a contiguous optical image formed on its surface by the lens into a set of individual *picture elements* or 'pixels'. The array can either be in single line form and used to scan across the image by a linear movement (scan mode), or be in a two dimensional rectangular form with rows and columns suited for image capture by a 'single-shot' exposure. An additional feature may be a corresponding matrix of *micro-lenses*, in the form of plano-convex condenser elements, registered with each pixel to improve sensitivity by concentrating the light from a larger capture area.

The array may also have a similar integral matrix of tricolour filters (red, green and blue) in register with the pixels so as to provide colour separation for the reproduction of colour. Otherwise, only a monochromatic (grey scale) image is given. This matrix can use several alternative arrangements of filters, depending on application, but a common Bayer pattern (named after its inventor) uses one red, one blue and two green filters in a 2 × 2 filter unit. A

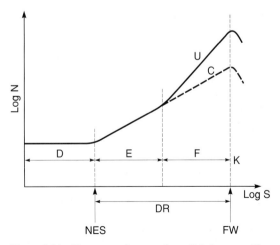

Figure 8.14 Photon transfer curve for a digital camera. The graph is of log N (noise) against log signal (S). DR, dynamic range recorded; FW, full pixel well; D, dark current; E, shot noise; F, pixel pattern noise; K, saturation; U, uncorrected noise; C, correction by gain and offset pixels

The popular *charge coupled device* (CCD) accumulates charge in a pixel well, then by command from a clock circuit that controls the ordered readout of data, this charge is transferred to an adjacent pixel for onward transfer until the end of a line of pixels is reached, when it is read out as an analogue signal identified with that particular pixel and whose 'address' is known in the *x–y* array format. The charge can be transferred via an adjacent conducting pathway, termed *inter-line transfer*. These pathways form boundaries between columns of pixels and reduce their light capture area overall. Occasionally, the data for a whole array is transferred to an adjacent identical array that is shielded from light, and then read out while the first array captures another image. This is termed *frame transfer* and has cost disadvantages. The image information may be referred to as the 'signal' and in its electronic form can be stored and processed.

The spectral sensitivity of a CCD array is that of silicon and similar to that of a silicon photodiode (SPD) as used in a light meter, with response extending to some 1000 nm, with a peak at about 750 nm in the infrared. As in a light meter, this response should be reduced by selective filtration using an infrared absorbing filter. This may be placed over the array but often it is omitted on cost grounds as the relative amount of visible light to IR in the optical image is much greater. Some cameras use an interference filter behind or in front of the lens to reject IR, a 'hot mirror' device, and if necessary to further modify the spectral response of the array. Both monochrome and infrared sensitive versions of digital cameras have been produced for specialist applications.

Other forms of circuitry are used for the photocells to give arrangements such as *charge injection devices* (CID), *complementary metal oxide semiconductors* (CMOS) and even other substrate materials are used, such as *indium tin oxide* (ITO). All have their advantages and operational limitations.

The arrays, being electronic in nature, are subject to sources of image degradation, particularly by the accumulation and influence of non-image generated electrons, generally called 'noise'. The effect can be to produce a granulated or speckled image, somewhat analogous to the grain of photographic images. Image quality can be quantified by the *signal to noise ratio* (SNR), a high value indicating good quality. If the added noise can be tolerated visually, the electronic gain in the circuitry can be increased, increasing response but also noise, and so decrease the signal to noise ratio, but the practical effect being an increase in effective speed expressed as an ISO equivalent value. The typical 'speed' of an array is some 50 to 100 ISO, but increases to 200, 400 and higher values are possible, either by a suitable control or permanently by larger pixel areas with concomitant effect on resolution.

The sources of noise are numerous and include the circuitry, the duration of exposure and local (ambient) temperatures. The electronic noise generated during a long exposure usually means that a digital camera is limited in length of exposure to some 0.25 s. Many cameras use mechanical shutters to give longer exposures, but this problem should be realized. To limit the exposure to light, the clock circuit also operates as an 'electronic shutter' in that the total readout time for the array is carried out in a chosen fixed, short time. This is also referred to as the *integration time* for the accumulation of image related charge. Exposure times as short as 1/10 000 s may be provided, with no moving mechanical parts, but as photo-electron capture is curtailed or inhibited, sensitivity is reduced, analogous to progressively reducing the lens aperture, so the actual aperture may have to be opened up in compensation, or amplifier gain increased instead with its dangers of added noise. Note that many digital cameras have only very limited aperture control features, perhaps with only a choice of two alternative values such as full aperture and *f/*8. This may done by a Waterhouse stop type of control, as it is very difficult to make a very small iris diaphragm device to fit in the lens. Given a focal length of 7 mm, the aperture diameter would only be some 0.3 mm for a *f*-number of *f/*22. An 'electronic iris' feature alters the response of the array to suit an exposure duration, and is not a mechanical device.

Necessarily, most cameras are used at ambient temperature, with higher temperatures a potential source of noise as the array becomes warmer. Arrays also generate heat in operation. Specialist types of camera with large arrays to improve resolution usually incorporate a *cooling system* for the array. This is an electronic cooler with no moving parts using the Peltier effect, where a junction of dissimilar metals drops in temperature when subjected to a voltage. This *thermo-electric cooling* may mean that the camera requires a mains power electrical supply rather than batteries.

Theoretically, each pixel of the array should have identical properties, but in practice there are dissimilarities, particularly in spectral response. Indeed, in a large array there may be a number of non-functioning pixels. Their absence is masked by suitable software in the signal processing arrangements that interpolates data from functioning adjacent pixels to provide a reasonable estimate of the missing data. This *interpolation* technique is also used to provide individual pixel data from a four element cell of colour filtered units. An associated useful technique is that of 'binning' where groups of adjacent pixels are consolidated into a single response. This greatly reduces resolution but speeds up readout time for a large array for purpose such as setting up, focusing and using a low resolution display such as a small LCD. Conversely, the accurate location of an image pixel point considerably smaller than the pixel size

(a)

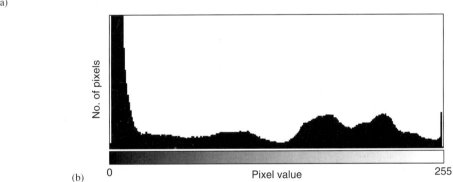

(b)

0 Pixel value 255

Figure 8.15 Histogram of the digital data from an image. (a) Original photograph. (b) Histogram of number of pixels against pixel value from 0 to 255

can be accurately located within the confines of the pixel area by use of appropriate software.

Even when not exposed to light, depending on temperature, there is a dark current noise level produced. Otherwise, each pixel has a continuously varying output linear with the level of the incident light from the optical image. This continuous analogue value must be sampled for digitizing. The sampling rate per second or frequency must be related to the spatial dimensions of the array in that it is set to the Nyquist limit of twice the spatial frequency (number of pixels per millimetre), thereby avoiding the formation of image artefacts due to 'aliasing', commonly incorrectly termed 'moiré' effects. In addition, there has to be a choice of the number of discrete values available for assigning to tonal (brightness) values in the image to record the total luminance range or 'grey scale' of the subject.

So the luminance range may be divided into 256 values, corresponding to tones, and the output from any pixel set at one of these values with 0 corresponding to black and 255 to white. For the whole array, the total data output may be displayed as a graph of number of pixels against an output value. This is the image data *histogram* and is a valuable visual representation of image properties and quality (Figure 8.15). Some cameras can display on an integral LCD screen the histogram of the photoplane image, to allow interpretation and adjustment of camera operating parameters to optimize the image when captured in digital form. The effects of image processing routines may be judged by the histogram as well as visually.

Tonal range

The number of values used for the pixel output is referred to as *bit depth* and affects matters such as image quality and the digital file size of a stored image. In the case of 256 levels representing the grey scale or tonal range, when the pixel data is sampled and one of these discrete values assigned, the digitization process converts a value into binary form. The number 256 is 2^8, with 8 binary digits or bits (b) used to give a byte (B) for storage. The index 8 is called the 'bit depth'. Usually a depth of 8 or 256 levels for a pixellated image is sufficient to give near 'photographic quality' when displayed or printed (image resolution is a separate matter, see below). Reduction of the bit depth progressively reduces tonal subtlety in the image, giving an increased appearance of 'posterization', until a bit depth of 2 gives a *binary image*, i.e. one represented only in two tones, that of black and white, as if a high contrast line film had been used. Conversely, increasing the bit depth to 10, 12 or 14 or more gives increasing quality of tone and colour rendering and a greater tonal range or contrast in the subject may be successfully recorded. This can be of use when subjects with extremes of contrast have to be recorded without loss of detail in the highlight and shadow regions. A composite value of bit depth is usually quoted for colour recording, such as 24 or 36, meaning that the three colour channels each have bit depths of 8 or 12 respectively.

The use of a greater bit depth means that a much greater volume of data must be stored in the *image file*. This file contains the 'address' or spatial location of each pixel as an (x, y) Cartesian value, the binary value of the output to a given bit depth, and, in the case of colour recording, a triple set of values for the three primary colours. Additionally, for each exposure there is an amount of associated data, such as date and time, possibly geographic location, camera mode, exposure information and so on, and possibly a digital sound file with verbal information as

dictated by the user. An image file can be several hundreds of megabytes (MB) in extent, but hundreds of kilobytes (kB) is usually preferred.

Large image files cause problems. There is the associated cost of storage, especially in RAM memory for short term use. In addition, a large file requires a longer time for downloading from the image, processing and then displaying. This time can range from a few to many seconds depending on the digital processing power available. The camera may not be usable for capture of the next subject during this delay. Transmission of large files also takes more time and there are problems with the display of such detailed images on a monitor, when most of the detail may be beyond the resolution limits of the screen image. For these good reasons and others, it is routine practice to reduce the image file size by processes of *image compression*. The 'raw' image may be stored uncompressed of course, and a compressed copy made for editing and other purposes. Note that the process of compression should be the last routine performed on an image.

A number of compression routines are in use, and are of two types, namely *lossless* and *lossy*. The former retains all the data for reclamation while the latter rejects an acceptable amount of data hopefully to retain an acceptable image that shows no visible effect on quality. The full or compressed data is stored in a variety of file formats with a range of names. Not all cameras give access to the 'raw' image data, as this is the largest file, instead, a choice is usually given of compressed files with names such as 'fine', 'standard' and 'economy' to indicate three progressive levels of compression by factors such as 4, 8 and 16. This selection process also progressively increases by similar factors the available number of exposures that can be stored on a memory 'card'. A favoured compression system is that of JPEG (Joint Photographic Experts Group).

Image resolution

So far the question of image resolution has not been discussed, but obviously segmenting an optical image into an array of pixels means that the size of individual pixels determines the subject detail retained in the primary (raw) digitized image. A measure of spatial resolution in the photosensor array is the pixel 'pitch' or centre-to-centre distance. It would seem that the smaller this is the better the resolution. However, a discrete pixel site does not consist just of light-sensitive substrate, there are areas covered by electrical connections to read out the data and to isolate the site from its adjacent neighbours. This *fill factor* may only be a quarter of the site area. Certain arrays have a full fill factor and the whole area in the photoplane is active pixel area with the connections at the rear of the sites. Ideally, the pixels

should be square to assist in image processing, but some use rectangular pixels, requiring adjustment by software routines. The use of a Bayer filter array assigns a group of four pixels to one piece of colour information so an image 'point' is effectively 2×2 pixels, theoretically reducing resolution by a factor of four, but *interpolation* gives the best estimate of the missing values. Claims about resolution values should clarify whether interpolated values are used, as numbers can be falsely elevated. The optical resolution is the critical value to consider.

It is reasonable to assume a value for the image circle of confusion based upon the pixel resolution and this can provide a basis for estimates of the depth of field in the final image, but other significant factors must be considered such as the resolution of the monitor display and print process, as well as compression effects. In general with most digital cameras that have very small arrays, the necessary focal lengths of lenses are also very short, and given the modest enlargement of the images for viewing, these factors favour an apparent extensive depth of field – indeed the practical photographic problem may be to obtain differential focusing effects so as to subdue a background.

Unlike the decades-long proliferation of film camera formats, there has been a certain amount of standardization on the dimensions of focal plane arrays, with some recognition of their precursors as vidicon tubes in video cameras, so formats such as 2/3 inch (6.6×8.8 mm), 1/2 inch (4.8×6.4 mm), 1/3 inch (3.55×4.74 mm) and even 1/4 inch (2.80×3.70 mm) are available, referring to the approximate value of the diagonal of these rectangular arrays. (The diagonal values are 11, 8, 5.9 and 4.6 mm respectively, indicating the very short focal lengths of lenses to give a standard field of view of some 50 degrees.) Within their small areas, as many photosites as possible are packed in to give better resolution of detail, with the adverse effect that smaller sites have reduced areas for photon capture and associated sensitivity. Due to the complex multi-layered planar circuitry involved for sensor 'chips', both manufacturing costs and rejection rates increase with reduction in pixel size. At present, using maximum resolution lenses, UV radiation of some 193 nm as the exposing source and the associated photoresist technology, a pixel size of some $4 \mu m \times 4 \mu m$ is available. This means that in an array of size 6.4 mm \times 4.8 mm (1/2 inch) some 1.9 megapixels are possible. Pixel count has progressively increased from some 640 \times 480 = 307 kpixels, as suited to a VGA quality monitor display, up to megapixel arrays. Currently, consumer oriented digital cameras are available at modest cost fitted with 2 to 3 megapixel arrays or 'chips'. A value of some 5 megapixels is generally regarded as needed to provide 'photographic quality' in a print of size 8 \times 10 inches. For faster operation and a greater storage capacity for the number of image files stored in memory cards, the resolution can be reduced by the user to one quarter value or less, so that a 1536 \times 1024 megapixel array can be changed to give 768 \times 512 pixels. Larger arrays, typically of size 60 \times 60 mm with a 4096 \times 4096 pixel array (some 16 Mpixels) are available for use in medium and large format cameras. These and even larger arrays are usually produced by edge butting two or more arrays with suitable software to provide image detail correlation across the joins.

While theoretical resolution is a measure of camera capability, in practice the necessary resolution is related to the subsequent print size required, or conversely, print size at acceptable quality is limited by the image pixel count. Printers suited to producing an image from the stored file typically use some form of non-impact technology involving a scanning process to assemble the output image pixel by pixel and line by line. An ink-jet printer uses either one or two black inks, or up to six ink colours in saturated and pastel shades, to output the digital image data as a 'hard copy' as distinct from the 'soft copy' displayed on a monitor. The question of image colour accuracy is dependent on colour management systems, involving calibration of a colour monitor related to a colour gamut for the printing process. Using quantities as small as 4 to 6 picolitres (pl) of ink to produce an image 'dot' on suitable print material that limits ink spread and diffusion, a dot diameter of typically 0.2 mm or less is given. Printer performance is usually quoted in *dots per inch* (dpi), so a typical performance of 600 dpi is some 24 dots per millimetre (dpm). However, unlike the halftone dot image of a printed page produced by photomechanical printing methods such as offset litho, an ink-jet dot is of fixed size. To simulate a halftone, a *dithering* technique is used where an image 'dot' of suitable tone is made up by filling up spaces in a typical 16 \times 16 matrix by printed dots, so 256 tones are possible, ranging from white (no dots) to black (all 256 dots printed). So the 24 dpm reduces to 1.5 dpm for a grey scale of 16 tones. Colour is achieved by overprinting of coloured transparent inks.

Architecture of the digital camera

Internal circuitry

The true digital camera is similar in many ways to a conventional film camera in terms of shape, functions and features (Figure 8.16). There is a lens, a shutter and a viewfinder system, means of focusing and exposure determination, automation of features and a data display. There is a light sensitive array at the photoplane and an image recording system. There is a means of frame advance and a number of interfaces such as power in, video out and connection to a

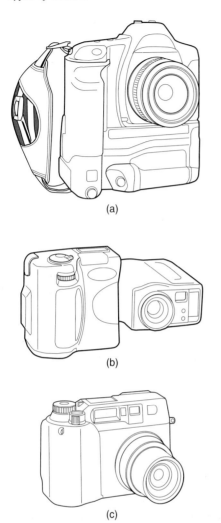

(a)

(b)

(c)

Figure 8.16 Digital cameras. (a) Using a considerably modified 35 mm SLR camera body. (b) Design using an independently rotating lens and flash unit. (c) Design using a telescoping zoom lens unit and coupled finder

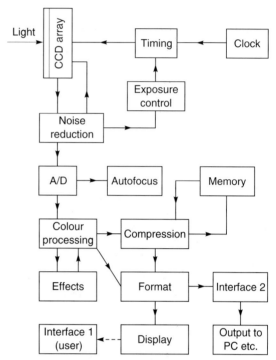

Figure 8.17 Example of a possible internal configuration or architecture of a digital camera

computer. The interior arrangements are very different. Unlike a film camera where the exposed or part-exposed film cassette, cartridge or back is removed for subsequent 'wet' processing of the material (with some time delay unless self-developing materials are used), the digital camera has various electronic circuit elements to deal with the data from the photosensor array and provide means of display, playback, editing. storage and transfer. The various alternative organizations of these elements form the *architecture* of the camera. This can be shown in outline by a basic structure such as in Figure 8.17.

The optical image formed at the photoplane by the lens is transformed into detail and colour information as *pixels*, whose small size corresponds to an image 'point' or circle of confusion in film cameras. Analysis into pixels is by a discrete number of photosensors in an array ('chip') giving an image format. The array properties are detailed above. Each photosensor (acting as an incident light meter) gives an analogue output corresponding to subject luminance (L) at that zone. A colour separation arrangement analyses incident light into its colour components. A very large amount of data is output as (x, y, L) for each pixel. This data is subjected to noise reduction processes and can also be used for exposure determination by controlling the integration time of an electronic shutter, i.e the total time the photosensors react to light and their output stored.

A clock circuit or oscillator drives a timing circuit to provide this read-out time and operate a mechanical shutter that may be linked to the electronic one. The clock also controls the read-out of the pixel data in sequential order. This analogue data is converted to digital form and the colour information processed as necessary. This data can be kept as the 'raw image' or compressed to various extents, then stored in a memory. The decompression is reversible. The colour image processing provides a format to supply the display in the camera with an image for user viewing and operational menu (interface) or via another

interface to communicate with external devices such as personal computers (PC) or printers.

A variety of different arrangements are used or alternative approaches taken to give the variety of contemporary digital camera systems, each with advantages and limitations in operational use.

Image data

The onboard memory may be fixed, now rare, but more usually removable as a *memory card* in alternative forms and storage capacities. The noise control and reduction circuitry copes with spurious data principally due to variations in the sensitivities of pixels, ambient temperature and the circuitry itself. The noise control may be variable to allow different amounts of 'gain' and hence a change in the equivalent ISO speed of the array, which is typically set at a value between 50 and 200 ISO. Higher values give reduced image quality which may be acceptable for the subject.

The 'shutter' is the length of the readout time and is an integration time for the accumulation of photo-electrons in the pixel. Noise effects due to adjacent pixels etc., increase with the uncooled arrays used. A system to chill the array is not practical on most digital cameras, so an exposure duration of more than 0.25 s may not be advisable. The noise effects do depend on the visual acceptance of image quality. A mechanical capping shutter may be used to uncover the array when switched on. A frame buffer is not needed to store the image and the scanning of the array is *progressive*, i.e. each successive line of pixels is read out, unlike the alternative *interlaced* type as used for digital video.

The ADC produces digital data by sampling at suitable discrete time intervals. The spatial frequency of detail from the lens should be limited to half the spatial frequency of the pixel elements to avoid spurious resolution in the image, termed 'aliasing' but sometimes also called 'moiré' due to its resemblance to that phenomenon. Cameras may incorporate another filter at the CCD chip level to reduce aliasing, usually by means of a thin layer of a birefringent material. This is called a *low pass filter* as it transmits the low resolution image information but rejects the high resolution spurious data.

The output digital data or 'raw' image can then be processed and manipulated for a range of purposes such as colour processing, compression, formatting for output and 'effects'. The data can also be used for an *autofocus system* of the passive phase type. Colour processing uses digital signal processing to give the best possible representation of the scene, often with the aid of a displayed histogram of numbers against scene values, given the response of the CCDs, filters and the colour gamut of the LCD display. The data

may be accessed in its raw form (as a *tagged image file format* or TIFF), but in low cost cameras more usually it is compressed to a chosen level (up to 1/20 of original size) and stored in a memory device. Formatting provides data either for display on an integral LCD screen plus the control menu or user interface for primary editing purposes (such as image saving or rejection), or into a form suitable for onwards transmission to a PC for viewing and secondary editing, then on to storage, printing or further transmission.

A variety of specialist onboard microprocessors combine many of these functions into one unit, or perhaps a suitably programmed version may be used. In the case of CMOS devices, some functions may be integrated with the photosensor array itself at chip level. The resolution from the photosensor array may be deliberately reduced by techniques such as 'binning' where the output from an adjacent cluster of pixels are combined to a single value for purposes such as speed of display, reduction of storage needs, processing time, increase number of images captured per second and to give a rapid refresh time to a viewfinder display. The format may also be subdivided into a number of smaller arrays such as 16 for a sequence of images to be captured in one or two seconds. The 'refresh' time between image capture (exposure) may be as long as several seconds, while the data is being stored. The rate depends on the onboard processing arrangements and can be very fast to allow bursts of images to be captured.

Digital backs

An alternative form of digital camera is given by adapting a conventional medium or large format camera with a *digital back* that is used instead of a roll film back or film holder (double dark slide). Invariably, the photosensor array has smaller dimensions than the film format, so the usual lenses have a reduced field of view for digital imaging use. This is a particular problem for wide-angle photography needs.

A medium format digital back uses an area or linear array of photosensors. The area array has an $x \times y$ mosaic of CCDs, usually with an integral Bayer filter matrix of RGB elements. Typical arrays are 2048×2048 (4 megapixel) of size some 31×31 mm, or 4096×4096 (16 megapixel) of size 60×60 mm. A 4 megapixel array may be increased to an effective 36 megapixel by progressive spatial shifting of the array to new positions by piezo-electric control and reading out data at each new location, This is not interpolation but true new data. A large format digital back may use arrays of 3750×5000, 6000×8000 and 8000×8000 pixels, giving in turn file sizes of some 53, 137 and 244 megabytes (MB).

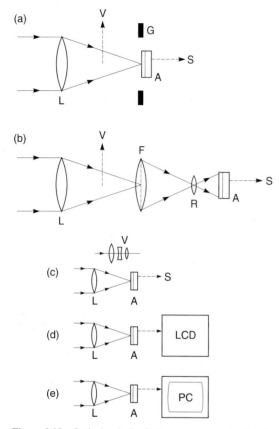

Figure 8.18 Optical and viewfinder arrangements in digital cameras. L, camera lens; V, viewfinder; G, film gate; A, array; S, signal output; F, field lens; R, relay lens; LCD, liquid crystal display; PC, personal computer. (a) Modified SLR camera with small array in film gate. (b) Use of a field and relay lens to reduce the primary image. (c) Compact design with optical finder. (d) Use of LCD as viewfinder. (e) Use of a PC as viewfinder

For exposing, an area array may use either a triple exposure technique with a filter wheel behind or in front of the lens with an RGB filter set, or a single exposure if provided with integral 'striping' of filter arrays. The subject for the triple exposure must be static and the lighting output stable during this time. Sources such as high frequency fluorescent or HMI lamps are used, the former having problems with colour fidelity, the latter being expensive.

The linear array uses a triple line of CCD pixels, each line having either a red, green or blue filter lengthwise, termed a *trilinear array*. During a short time exposure with the shutter open, this array is moved across the image area in scanning mode to record data. Again the lighting level must be accurately constant to avoid coloured scan bars. A chip cooling system can be used to improve image quality.

These digital backs can provide imagery the equal of similar film formats. They are normally used tethered to a powerful PC, whose colour calibrated monitor acts as viewfinder and the camera functions are controlled from a software menu via the keyboard. A colour proofing system is also linked to this system to preview the results on a printed page.

Viewfinder arrangements

A variety of methods are used to provide a viewfinder image, some preferable to others (Figure 8.18). Cameras using digital backs have the normal SLR or TTL viewing of the host camera, but the viewfinder area may have to be masked down to suit the smaller size of the array used. An optical relay lens system can be used to transfer the primary image to a secondary photoplane where the array is located. This restricts the maximum aperture available. Otherwise, some digital cameras have no optical viewfinder and use only a LCD screen of some 40 to 60 mm diagonal with several thousand pixels. This device is notoriously battery hungry and a timer may switch off the camera if not used for say two minutes. The screen is also used to display data and show control menus, and can often be swivelled and rotated to a convenient viewing position. A severe problem in use is low brightness in bright light and daylight conditions so the screen image is indistinct. Use of a magnifier only shows more clearly the individual pixels.

A simple reversed Galilean finder is sometimes used but the 'real image' Kepler type is preferred, especially with a zoom function. The optical path of this finder is folded to compact dimensions by use of porro mirrors and pentaprisms which also correct the

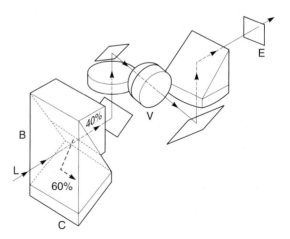

Figure 8.19 Optical viewfinder system of a digital camera (Olympus data). L, light from zoom lens; B, beamsplitter prism with a 60/40 split; C, CCD array; V, viewfinder lenses, mirrors and prisms to fold optical path; E, eyepiece

image orientation. The viewfinder coverage may be some 90 per cent. Parallax correction marks are not usually provided, instead the alternative LCD screen image is used for precise framing and focusing. A beamsplitter prism behind the lens can divert some of the light to a viewfinder system and provide an accurate viewing system (Figure 8.19).

Power supply

Digital cameras can be remarkably compact, especially scientific grade types that can be of 'lipstick' size, where only the lens and sensor array are encapsulated together, then the control signals, power supply and data output are transmitted by a tethering cable to a camera control unit (CCU) or a PC. The sensor head can be on a long cable connecting it to the body with its LCD viewfinder. Power is needed for all camera functions, including the CCD array, shutter, circuitry, displays and storage. An adequate power supply may be bulky and a battery pack take up much volume in the camera. A rechargeable battery may be recharged in the camera, and is preferably a lithium ion type with no charge memory problems. Nickel metal hydride types are an alternative. A separate battery pack may be useful and used attached to a belt. Separate digital backs for cameras are powered via a tethered connection to a PC.

Additional features

The architecture arrangements of a digital camera with an onboard CPU allows for the provision of a number of additional features to make the camera more useful or versatile. The features are selected by means such as control dials or menus accessible on LCD screens. While each make of camera may have unique special features, the following overview covers the most common ones.

A digital camera may be used in a '*burst*' mode to take a chosen number of images per second until a buffer memory is filled. This is equivalent to a motor drive feature in conventional cameras, but without the mechanical complexity and battery power they require. A variant takes a *sequence* of five images for every press of the shutter release, then image analysis software chooses the 'best' one for saving and discards the rest. This can help overcome camera shake. Another method of taking a sequence of images such as for *motion analysis* is to subdivide the array into smaller segments, typically in a 4 × 4 manner to give 16 smaller images, that are exposed sequentially in some one or two seconds.

A *time-lapse* feature allows a succession of images to be taken at pre-selected intervals, perhaps as long as one hour, for a chosen number of pictures. A *self-timer* feature gives a choice of delay time before the shutter is released and also if a single picture or short burst is required. A *remote control* using an infrared link allows many camera features to be set without touching the camera controls, which can be fiddly small buttons. An *IR link* may also be used to communicate with other cameras or a PC for downloading images or upgrading of software. An *integral timer* will switch off the camera if not used for a set length of time, often as short as one or two minutes. This *battery power saving* feature may turn out to be very inconvenient in practice, the camera reverting to 'off' just when needed or while setting up. It then needs several seconds to power up again. A '*long time exposure*' feature allows setting of exposures up to several seconds long, and the flash is automatically disabled.

Another control allows alteration of pixel response to compensate for different colour temperatures of scene illuminant, usually called 'white balance'. Typically, five choices may be provided to cope with sunlight, overcast daylight conditions, tungsten light and two varieties of fluorescent lighting. Another choice is for either colour or black-and-white images. The black-and-white image may be further converted into a sepia tone one by software in the camera.

Image files may be copied from one storage card onto another via the onboard memory in the camera, or the camera may have two card slots for identical or dissimilar cards, giving the opportunity to expand memory capability or to copy from one card format to another.

There may be a *digital zoom* facility where the image is magnified by image processing, with a concomitant loss of resolution. Coupled with a ×3 optical zoom lens range, a further ×2 digital zoom can give a total ×6 zoom range, with resolution penalties.

The image may be *annotated* in various ways apart from the data stored automatically for each one. This may be a short digital sound file using a microphone in the camera. Images carry details of date and time exposed, as well as an exposure number, either individual or cumulative, plus exposure data and file size, and perhaps camera type and lens used. Copyright information can also be added. Other choices include the addition of watermarks, logos or text.

The LCD screen serves many functions. Apart from use as a viewfinder and to display menus for control functions, it serves as a playback device for a preview of the image just captured and others in storage. It can function as a form of 'digital Polaroid' in the same way as self-developing materials to give a proof of image capture and confidence in camera functioning. The screen image may have a fast or slow refresh rate when used as a viewfinder, giving various effects when used with either the camera or subject moving. The displayed image can be zoomed

in and scanned laterally to inspect detail but the low pixel count of the screen elements does not show fine detail. An 'auto-rotate' feature senses the orientation of the camera in horizontal or vertical hold and rotates the image so that the display shows the image upright. The stored images can be displayed individually or as an array of 'thumbnails' for quicker location of an image. A variety of scrolling modes are possible, as is a 'slide-show' option when images are displayed at set intervals. A chosen image can be discarded if unsuitable or security tagged so it cannot be deleted. Images can be deleted in groups or individually. Images may be grouped and stored in separate files or 'albums'. The memory card can be reformatted as required. A secondary LCD screen may be used for readout of basic camera functions and information such as battery charge state, number of frames left, resolution selected and so on.

For convenience, the camera may be connected to a television for previewing the stored images, instead of using the integral LCD screen. A choice of image capture modes is given in terms of resolution and compression level for storage. More subtle is the choice of the amount of sharpening applied. The memory card can be removed at will, even if only part full. It can store a variable number of images based on its total capacity, say 16 MB, as a mixture of images at different resolutions.

An integral flashgun may be set to operate in a variety of alternative modes, such as fully automatic if light levels need its assistance; to give balanced fill-in light; as a full power flash, with preflashes for red-eye reduction, or off altogether. Further fine control of output is via a menu where output may be changed to suit applications such as close-up photography and avoid troublesome over-exposed highlights which totally lack detail, being outside the dynamic range of the sensor array.

The short focal length of the lenses used mean that only a very short extension of internal focusing movement is needed to permit very close focusing. An additional very close focus range may be selected by choice. Other focusing options may include a *manual focus* mode when a fixed distance is chosen, or various autofocus modes such as a single central spot or a multi-spot matrix to assess the focus related to subject distance features.

Apart from the integral flashgun, a flash connection socket or a hot shoe may be provided for use with an external flash unit or even studio flash. The choice of apertures may be limited and set by menu.

Bibliography

Davies, A. (1997) *The Digital Imaging A-Z*. Focal Press, Oxford.

Davies, A. and Fennessy, P. (1998) *Digital Imaging for Photographers*, 3rd edn. Focal Press, Oxford.

Goldberg, N. (1992) *Camera Technology*. Academic Press, San Diego.

Ray, S. (1983) *Camera Systems*. Focal Press, London.

Ray, S. (1994) *Applied Photographic Optics*, 2nd edn. Focal Press, Oxford.

Ray, S. (1999) *Scientific Photography and Applied Imaging*. Focal Press, Oxford.

9 Camera features

Advances in camera design are due to improvements in specific features of camera mechanisms, leading to the emergence of a few popular types of camera. Owing to the complexity of each of these features, many of which are interdependent, it is helpful to discuss each in detail, including systems for the shutter, viewfinder, focusing and exposure metering, as well as the iris diaphragm and flash synchronization. Camera lenses are detailed in Chapter 7.

Shutter systems

Both the type of shutter and its operational range contribute significantly to the capabilities of a camera. The function of a shutter is to open on command and expose the sensitized material to the action of light for a predetermined time, as chosen by the user or by an automatic exposure-metering system. An ideal shutter would expose each part of the film equally and simultaneously, i.e. it would allow the cone of light from the lens aperture to the focal plane to fall upon the film for the entire duration of the exposure. It should be silent in operation; cause no jarring or vibration; and require little effort to set in motion. The effective exposure duration ('shutter speed') should be accurately repeatable. The perfect shutter has yet to be achieved.

There are two main types of shutter in general use, namely the *leaf* or *between-lens shutter* and the *focal-plane shutter*; both can be purely mechanical, or more usually combine both mechanical and electronic features.

Between-lens shutters

The ideal shutter position to control the light transmitted by a lens is near the iris diaphragm, where the beam of light is at its narrowest, and so the minimum amount of shutter blade travel is required to allow light through. The film gate area is also uniformly exposed at all stages in the operation of this type of shutter.

Simple cameras may use single- or double-bladed between-lens shutters, but others use multi-bladed shutters (see Figure 9.1). Usually five blades or sectors are used, and these open somewhat like the leaves of an iris diaphragm. Sometimes an 'everset'

or 'self-setting' type of shutter mechanism is used, where a single control is depressed to compress the operating spring mechanism and then release the shutter in one movement. The speed range available may be limited to only a few settings.

Usually, between-lens shutters are of the 'preset' type where two movements are required: one for tensioning ('cocking') the operating spring and one for releasing the shutter. The tensioning operation is part of the film advance mechanism. Mechanical preset shutters of the Compur, Copal and Prontor types provide exposure times ranging from 1 s to 1/500 s plus a 'B' setting, where the shutter remains open while the release button is held depressed to give time exposures. Occasionally a 'T' setting is available, where the shutter opens when the release is pressed, and remains open until the button is pressed again to close it. To

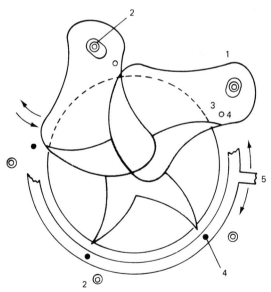

Figure 9.1 The between-lens leaf-type shutter. Principles of operation of a 5-bladed shutter, shown here in the closed position and with two adjacent blades only, for clarity. Note the considerable overlap of the blades. A specially shaped blade (1) has a slot fitting over a fixed pin (2) to give a hinge for rotary motion. Another hole (3) fits over a pin (4) in the actuating ring (5). This ring moves anti-clockwise to move the blades apart and then, after a timed delay, moves clockwise to close them again

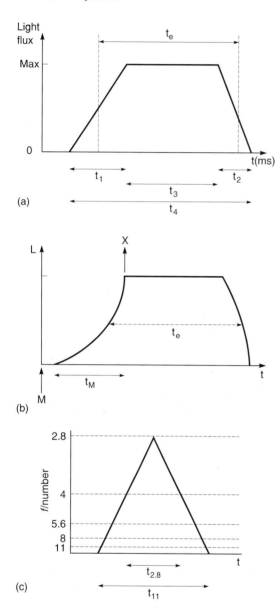

(a)

(b)

(c)

Figure 9.2 Characteristics of a leaf shutter. Leaf shutter properties are shown by a graph of light flux transmitted against time. (a) An ideal shutter: t_1, time taken for blades to open; t_2, time taken for blades to close; t_3, total open time; t_4, total operating time; t_e, effective exposure duration. (b) Typical characteristics, note blade behaviour. X-synchronization and M-synchronization are made at points shown. The value of t_M is 15–17 ms. (c) The effect of lens aperture on effective exposure time. Small apertures give more exposure than large ones due to the travel time of the blades

operate, the shutter blades pivot about their ends (or, rarely, centre) and, for all but the shortest durations, open with the same velocity and acceleration. An additional spring mechanism may increase operating velocity at the highest speeds, while the slower speeds are controlled by engaging a gear train to retard the blade closure mechanism. The characteristics of leaf shutters are shown in Figure 9.2.

On older shutters, the series of shutter speeds was 1, 1/2, 1/5, 1/10, 1/25, 1/50, 1/100, 1/250 and 1/500 second. Modern shutters provide 1, 1/2, 1/4, 1/8, 1/15, 1/30, 1/60, 1/125, 1/250 and 1/500 second, to give a progression of exposure increments similar to that provided by the standard series of lens aperture numbers, i.e. with each step double that of the previous one. This latter arrangement was originally designed to permit the introduction of an optional mechanical interlock between the aperture and shutter speed controls, in order to keep the two in reciprocal relationship with reference to an *exposure value* (EV) number. As the shutter speed was changed, the iris diaphragm was automatically opened or closed to keep exposure unchanged.

The effective exposure duration of a particular shutter-speed setting depends on variables such as the age and state of the shutter, the particular speed selected and the aperture in use. Calibration may be necessary for critical work. Shutter speeds are usually set by click stops on the selector control although the design of the shutter may in some (but not all) cases permit intermediate values to be set. For reasons of economy some shutters do not have speeds longer than 1/30 s. Large-diameter lenses as used in large-format cameras require shutters with larger, heavier blades, and the top speed may be limited to 1/250 s or longer.

Many between-lens shutters include electronic control as well as mechanical operation. Such *electronic shutters* may have the blades opened by a spring mechanism, but the closing mechanism is retarded by an electromagnet controlled by timing circuitry to give a range of shutter speeds. A typical resistor–capacitor timing circuit element is shown in Figure 9.3. Switch S is closed by the shutter blades opening, and battery B begins to charge capacitor C through a variable resistor R. The time taken to reach a critical voltage depends on the value of R, but when it is reached the capacitor discharges to operate a transistorized trigger circuit T which releases the electromagnet holding the shutter blades open. Changing the shutter speed is accomplished by switching in a different value of R. In automatic cameras the control unit may be a CdS photoresistor or silicon photodiode (SPD) arrangement which monitors the subject luminance and gives a *continuously variable* shutter speed range within the range available. More precise exposures may be given, rather than just using the marked values on the setting control. A visible or audible signal may give a

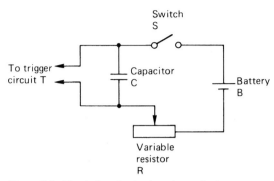

Figure 9.3 The timing circuit of an electronic shutter

warning when the required exposure time is longer than 1/30 s to indicate the need for a tripod, or change to electronic flash.

As the mechanism of an electronic shutter is still largely mechanical, there is no improvement on earlier designs in terms of performance at higher speeds or greater efficiency. It does however lend itself to automation and remote control. The camera body may carry the shutter speed control for a range of interchangeable lenses, each fitted with its own shutter and with means for interfacing with an accessory exposure-metering prism finder. In lenses for technical cameras a control box for selecting shutter speeds and apertures can be used on a long cable. Electronic shutters all require battery power for operation, but in case of failure, a single mechanical shutter speed may be available for emergency use. This is usually the lowest shutter speed that requires no electronically controlled retardation and still synchronizes with flash.

The shutter may have some further features incorporated. Besides the usual shutter speed and aperture scales, an interlocked shutter has a third scale of *exposure values* (EV). Typical EV scale values range from 2 to 18 or so, with a change from one number to the next corresponding to an alteration in the luminance of the subject by a factor of 2. The EV scale can be used with a suitably calibrated exposure meter. Also, a 'self-timer' or delayed-action device is often fitted; by means of this the release of the shutter can be delayed for some 5 to 15 s. Most shutters for technical cameras have a 'press-focus' button which opens the shutter on a time setting irrespective of the shutter speed preselected. This feature facilitates focusing on the ground-glass screen and eliminates the necessity for constant resetting of shutter speed to T or B for this operation.

A great practical advantages of between-lens shutters is the simplicity of flash synchronization at all shutter speeds. This enables the use of electronic flash for fill-in purposes, which is discussed fully in Chapter 20.

Focal-plane shutters

This type of shutter is located in the camera body and travels close to the film plane. In earlier forms, the focal-plane shutter consisted of an opaque blind with a slit of variable width, or of several fixed slits of various widths; the slit chosen was driven past the front surface of the film at a chosen velocity, progressively exposing the film as it passed across. With a focal-plane shutter the film area is exposed sequentially, unlike the action of a between-lens shutter. *The effective exposure time* (*t*) given to any portion of the film frame is given by the slit width (*W*) divided by the slit velocity (*V*).

$$t = \frac{W}{V} \qquad (1)$$

Classic shutters of this type used two opaque blinds pulled across the film gate by spring action (see Figure 9.4). The first or leading blind starts to uncover the film when the shutter release is pressed and the second or trailing blind follows to cover up the film, with a greater or a smaller gap (slit) according to the delay set and timed by the shutter speed selected. The separation between the rear edge of the first blind and the front edge of the second blind gives a slit of adjustable width which allows a range of exposure durations. The slit may also vary in width during its travel to compensate for acceleration of the slit during the exposure. The shutter is also 'self-capping' as the slit is closed by overlap of the blinds when they are reset by operation of the film advance mechanism.

Focal-plane shutters originally used rubberized cloth blinds, but materials such as aluminium, titanium and polymers can be used. Modern designs

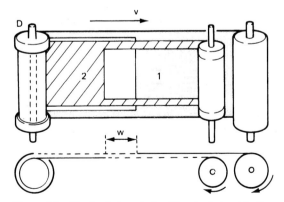

Figure 9.4 The focal-plane shutter. The classic two-blind design of a horizontally running focal plane shutter. A slit of width *W* is formed between two blinds 1 and 2 to travel at velocity *v*. The blinds travel from a common drum D to separate tensioned take-up drums of slightly different diameters

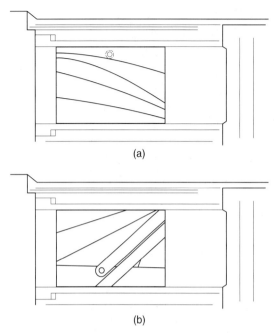

(a)

(b)

Figure 9.5 A multi-leaf, radial action focal plane shutter. (a) In cocked position, ready to operate and showing 5 of the 9 blades used (the blades may be of metal or suitable plastics. (b) In fired position, before resetting, showing more blades and the actuating arms riveted to the blades

use a slit formed by a vertically travelling fan of interlocked blades, as they can be made with the right combination of lightness and strength (Figure 9.5). The slit may travel either sideways or vertically with respect to the film gate. Vertical travel is preferred as flash synchronization speeds may be shorter due to the reduced travel time across the frame. When photographing rapidly moving subjects with a focal-plane shutter, sequential exposure to the optical image of the subject may result in distortion, depending on the direction of movement of the slit relative to that of the subject.

Factors associated with focal-plane shutter design have been those of uniform exposure across the gate, avoidance of shutter bounce, and flash synchronization. The slit width and velocity must be maintained over the whole film area, with the adjustments discussed above. For instance, an exposure of 1/2000 s demands an accurately maintained slit width of 1.5 mm between leading and trailing blinds travelling at some 3.6 metres per second, remembering the necessity for acceleration from and deceleration to rest positions. This action may be necessary up to five times or more per second during motorized operation. Figure 9.6 shows slit travel behaviour. Problems increase with format size and this, particularly with flash synchronization limitations, has

resulted in some medium-format cameras favouring between-lens shutters, as used in large format cameras. Shutter bounce is indicated by a narrow strip of over-exposure at the edge of the film frame where the trailing blind has recoiled momentarily on cessation of its forward travel.

The typical exposure time range available can be from tens of seconds to 1/8000 s (0.125 ms) or less, but the actual transit time of the shutter may be from 1/250 s to as much as 1/30 s even at its minimum effective exposure duration. Flash synchronization for flash bulbs gave problems, as special focal plane (FP) bulbs with a long burning time (now unobtainable) were needed for the higher shutter speeds. The electronic flash equivalent is a flash unit with a special 'strobed' mode which gives an effective flash duration of some 20 to 40 ms, allowing electronic flash synchronization even at shutter speeds of 1/12 000 s.

Conventional electronic flash with its negligible firing delay and short duration poses other problems. The film frame must be fully uncovered at the instant the flash fires, i.e. when the leading blind has uncovered the film gate but before the trailing blind starts its travel. The flash is normally triggered by the leading blind when it has completed its run (see Figure 9.7). Depending on the shutter design and the format, the minimum shutter speed for synchronization is at a setting (usually marked 'X') of between 1/40 and 1/250 s. Shorter exposure durations cannot be used because the frame would only be partly exposed, the shutter aperture being narrower than the film gate. At suitable synchronization speeds, subject movement may be effectively arrested by the short flash duration, but double images or over-exposure may occur at high ambient light levels. Synchro-sun techniques are therefore restricted. Between-lens shutters are therefore preferred for more sophisticated flash work. The feature of 'rear curtain synchronization' triggers the flash just before the second blind starts to cover up the film gate and is usually used at the termination of a short time exposure when a combination of subject blur and sharp image is required.

Where the travelling slit is formed by an elaborate system of pairs of blades in a guillotine action, or by end-pivoted arrays of fan-shaped blades, use of a vertically travelling slit with a 24×36 mm format can give a 50 per cent reduction in slit travel time compared with horizontal travel, so flash synchronization is possible at higher shutter speeds, currently some 1/300 s.

Focal-plane shutters allow easy interchange of lenses on a camera body; the lenses do not need individual costly between-lens shutters; and a wider range of shutter speeds is available. Cameras that use interchangeable lenses equipped with their own between-lens shutters require a separate *capping shutter* within the camera body, to act as a light-tight

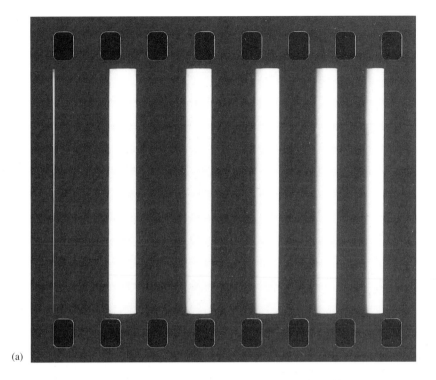

(a)

(b)

Figure 9.6 Stroboscopic photographs showing the travel of the slit of a focal plane shutter. The dark bands show the successive positions and width of the slit at intervals of some 0.002 s. Note the progressive increase in width to compensate for acceleration. (a) Horizontal travel from right to left. Shutter set at 1/2000 second. (b) Vertical travel from top to bottom. Shutter set at 1/1000 second

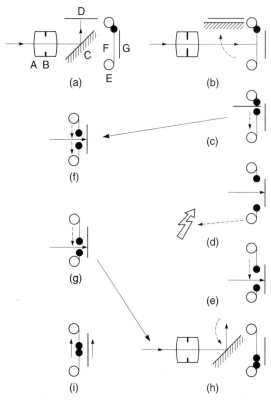

Figure 9.7 Typical operating sequence of a focal-plane shutter in an SLR camera. Key: A lens; B iris; C reflex mirror; D focusing screen; E shutter-blind mechanisms; F blinds; G film. (a) Focusing with the iris open; (b) on pressing the release, the mirror rises and the iris closes down; (c) first blind starts its travel; (d) film gate is fully open, flash will fire if connected (1/30 to 1/300 s); (e) second blind begins its travel; (f) at higher speeds both blinds operate to form a slit; (g) blinds almost fully home; (h) shutter closed, mirror drops and iris opens to restore viewing; (i) film is wound on, blinds are capped and return to 'start' position

baffle when focusing the camera or changing lenses.

Modular design of shutters allows easy replacement or repair when necessary. For many years mechanically operated shutters did not permit the automation of exposure; the user manually set the shutter speed at a pre-selected aperture in accordance with a separate or built-in (but uncoupled) light meter. The advent of electromechanically operated shutters equipped with electronic timing systems for release of the shutter blinds allowed integration of the shutter mechanism with the light-metering circuitry. Continuously variable exposure durations from many seconds to 0.25 ms could be given (though even mechanical shutters can have continuously variable exposure times). *Hybrid shutters* may use electronic

timing for speeds longer than about 1/60 s and mechanical timing for shorter times, thus allowing the shutter to be used with electronic flash and a limited range of speeds in the event of battery failure.

Camera shutters are usually operated by a *body release* situated in an ergonomically designed position that reduces the possibility of camera shake and gives fingertip operation. The body release may also operate a reflex mirror, automatic diaphragm or exposure metering system by first pressure, before the shutter is actually released. Electronic shutters are operated by a release which is simply an electrical switch. Such devices readily lend themselves to remote control by electrical or radio impulses or from special accessory camera backs which incorporate intervalometers or automatic exposure-bracketing systems.

When used in conjuction with an aperture-priority automatic exposure mode, a camera body equipped with an electronically controlled focal-plane shutter may be attached to all manner of optical imaging devices, for which the effective aperture may not be known.

The iris diaphragm

The intensity of the light transmitted by a photographic lens is controlled by the *iris diaphragm* or *stop* which is usually an approximately circular aperture. In some simple cameras the aperture is fixed in size; in others the diaphragm consists of a rotatable disc bearing several circular apertures so that any of them may be brought in line with the lens. Such fixed apertures are known as *Waterhouse stops* and are used, for example, in some fish-eye lenses. This arrangement is limited in scope. Most lenses use an iris diaphragm, the leaves of which move to form an approximately circular aperture of continuously variable diameter. When the camera shutter is of the between-lens type the diaphragm is part of the shutter assembly. It is operated by a rotating ring, usually with click settings at half-stop intervals, and calibrated in the standard series of *f*-numbers. The interval between marked values will be constant if the diaphragm blades are designed to give such a scale; in older lenses with multi-bladed diaphragms the scale may be non-linear, and the smaller apertures cramped together (Figure 9.8).

The maximum aperture of a lens may not be in the conventional *f*-number series, but can be an intermediate value, e.g. *f*/3.5. The minimum aperture of lenses for small-format cameras is seldom less than *f*/16 or *f*/22, but for lenses on large-format cameras, minimum values of *f*/32 to *f*/64 are typical. The SLR camera requires automatic stopping down to the chosen aperture immediately before exposure, in

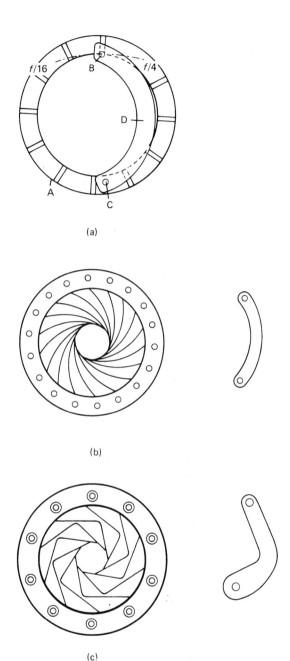

(a)

(b)

(c)

Figure 9.8 The iris diaphragm. (a) Principle of the iris diaphragm. Ring A contains a number of slots. An iris leaf D has a fixed hinge C at one end and a pin B at the other which moves in a slot in the rotating ring A. As ring A is rotated, pin B moves so that the leaf moves in an arc. The action of several overlapping leaves is to give larger or a smaller central aperture. (b) Multi-bladed iris using a simple radiused shape for each leaf. This gives a circular aperture but an unevenly spaced aperture scale. (c) Another multi-blade design, where the more complex blade shape gives an aperture scale with equidistant spacings suitable for automation or servo control

order to permit viewing and focusing at full aperture up to the moment the shutter is released.

In early SLR cameras, the lens was stopped down manually by reference to the aperture scale. The use of click-stop settings assisted this process. Next, a *pre-setting device* was introduced which, by means of a twist on the aperture ring, stopped the lens down to the preset value and no further. This arrangement is still occasionally used, for example, on perspective control (PC) lenses. The next step was to introduce a spring mechanism into this type of diaphragm, triggered by the shutter release. The sequence was thus speeded up, but the spring needed resetting after each exposure and the diaphragm then re-opened to its maximum value. This was known as the *semi-automatic diaphragm*. Finally, with the advent of the instant-return mirror came the *fully automatic diaphragm* (FAD). In this system an actuating lever or similar device in the camera, operated by the shutter release, closes the diaphragm down during the shutter operation. On completion of the exposure the diaphragm re-opens and the mirror returns to permit full-aperture viewing again (Figure 9.9). A manual override may be fitted to allow depth-of-field estimation with the lens stopped down. Some cameras with early forms of through-the-lens (TTL) metering required the lens to be stopped down to the preset aperture for exposure measurement. Cameras with a shutter-priority mode have an additional setting on the lens aperture scale, usually marked 'A', where the necessary *f*-number is determined by the camera and set just before exposure, the user having selected an appropriate shutter speed. The aperture set may be in smaller increments than the usual half-stop increments, possibly to 1/10 stop if motorized and under digital control.

In most modes the TTL metering system in a camera normally requires the maximum aperture of the lens in use to be set into the metering system to allow full-aperture metering with increased sensitivity. Various linkages between lens and body are used for data transfer.

As focal length increases, the problems of fitting a mechanically actuated automatic diaphragm increase, so electrical systems are preferred. Some ultralong-focus lenses are not connected electrically and require manual setting of the aperture. Extension tubes usually transmit the actuation for diaphragm operation via pushrods or electrical connections, but extension bellows may not do so, and manual operation, or use of a *double cable release*, may be necessary.

Lenses fitted to large-format technical cameras are usually manually operated, although some presetting devices are available, as is electronic control from film plane metering systems. Some lenses have fixed apertures such as mirror lenses and those used in simple cameras.

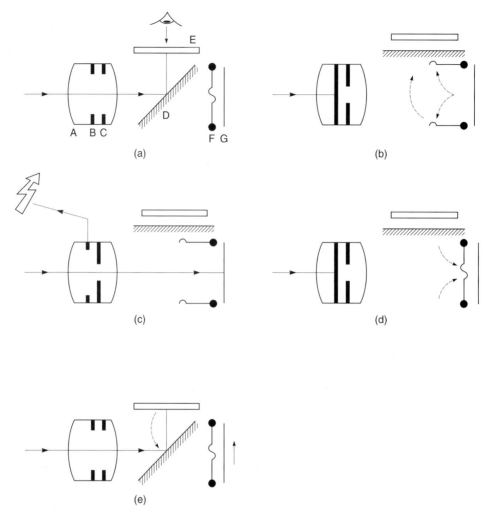

Figure 9.9 Operating sequence of a leaf shutter in a SLR camera. Key: A lens; B shutter; C iris; D reflex mirror; E focusing screen; F rear shutter or baffle flaps; G film. (a) Viewing position, shutter and iris open; (b) after pressing release, shutter closes, iris stops down, mirror rises and baffles open; (c) shutter operates, flash fires (if attached); (d) shutter closes, baffles close; (e) film is wound on, mirror drops, iris and shutter reopen. Note: operations (a) and (b) may be carried out separately by a pre-release button

Viewfinder systems

Viewfinder functions

The principal functions of the viewfinder are to indicate the limits of the field of view of the camera lens in use; to enable the user to select and compose the picture; to give a data display (Figure 9.10), and to assist in focus or exposure determination. Except for those fitted to simple cameras, viewfinders provide a method of focus indication, such as by a rangefinder, ground-glass screen or autofocus system. The type of viewfinder used often determines the shape and size of the camera, as with the TLR type, and the choice of a particular type of camera may even be related to the ease of use of the viewfinder, especially if the user wears spectacles. The viewfinder also acts as a 'control centre' and has a data display system primarily for the exposure measurement system, with a variety of indices, needles, icons, alphanumerics, lights and camera settings visible around or within the focusing screen area. There may even be either an 'eye-start' function where putting an eye to the viewfinder switches on the camera functions, or an interactive

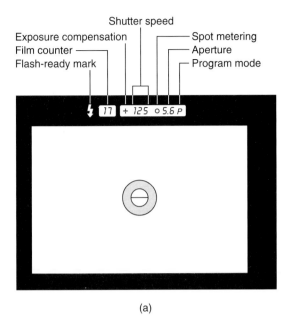

Exposure compensation
Film counter
Flash-ready mark
Shutter speed
Spot metering
Aperture
Program mode

(a)

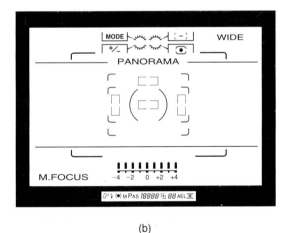

(b)

Figure 9.10 Viewfinder information displays. (a) Manual focusing camera (Contax 167MT) with central focusing aids and simple display. (b) Autofocus camera (Minolta) with complex display of alternative formats, autofocus zones and status of camera functions

viewfinder where the direction of gaze activates different autofocus zones.

Simple viewfinders

The simplest finders, as fitted to early box cameras and as supplementary finders for large-format cameras, employed a positive lens of about 25 mm focal length, a reflex mirror inclined at 45 degrees and a ground glass by which the image was viewed. This finder was used at waist level; the image illumination was poor. This early type was superseded by the 'brilliant' finder, which employed a second positive lens in place of the screen; this imaged the first lens in the plane of the viewer's eyes, giving greatly improved luminance. Such finders are still occasionally found on simple cameras, and as viewfinders on exposure meters.

A versatile simple finder for use at eye level is the *frame finder* (Figure 9.11a). A metal open frame, in the same proportions as the film format, is viewed through a small peep-sight to define the subject area. This type of finder is still available as an accessory and is compact when collapsed. Refinements to the basic design give exact delineation of the subject area and parallax compensation. Use is now mainly confined to technical, aerial and underwater cameras.

Direct-vision optical finders

Basic optics provide a *direct-vision optical finder* for use at eye level (Figure 9.11b). In the simplest type a strongly diverging negative lens is used to form an erect virtual image which is viewed through a peep-sight or weak positive eyepiece lens. This latter type, usually called a *Newtonian finder*, is in effect a reversed Galilean telescope (Figure 9.11c), the two lenses combining to produce a small bright erect virtual image.

A great improvement, the *van Albada finder*, has a mask bearing a white frame line in front of the positive lens: the negative lens has a partially reflecting rear surface. As a result, the white line is seen superimposed on the virtual image (Figure 9.12). The view through the finder extends beyond the frame line so that objects outside the scene can be seen. This is a great aid in composing, especially if the subject is moving. The eye may be moved laterally without altering the boundary of the scene. This finder is prone to flare and loss of the frame line in adverse lighting conditions; an improved version is the *suspended frame finder*, where a separate mask carrying one or several selectable frame lines for different lenses is superimposed on the field of view by a beamsplitter in the optical finder. The frame lines are separately illuminated by a frosted glass window adjacent to the finder objective lens (Figure 9.13). This type of finder has been considerably improved, and usually incorporates a central image from a coupled rangefinder (Figure 9.14). Other refinements are compensation for viewfinder parallax error by move-

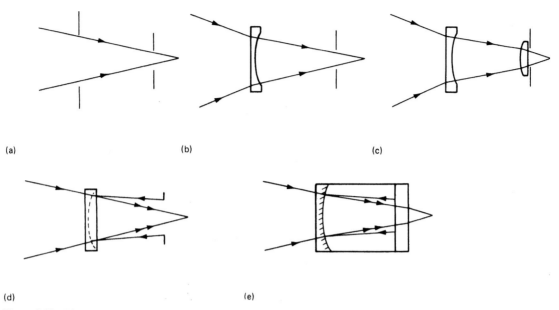

(a) (b) (c)

(d) (e)

Figure 9.11 Direct-vision optical viewfinders. (a) Simple frame finder. (b) Negative lens and peep sight. (c) Newton finder (reversed Galilean telescope). (d) Simple van Albada. (e) Galilean van Albada finder

ment of the frame line with the focusing mechanism, and a reduction in the frame area when focusing at closer distances. A through-the-viewfinder (TTF) exposure metering system can also be incorporated. As seen in such finders, the image size is usually around ×0.7 to ×0.9 life-size. Simpler cameras with non-interchangeable lenses may have a finder giving a life-size image so that both eyes may remain open, giving the impression of a frame superimposed on the scene.

For technical cameras, a zoom-type Albada finder for use with a range of lenses is available, particularly for hand-held camera applications.

Kepler type real image finder

The reversed Galilean type of finder provides a bright, upright, unreversed and virtual image. It is not easy to make this finder very compact or to provide a zoom

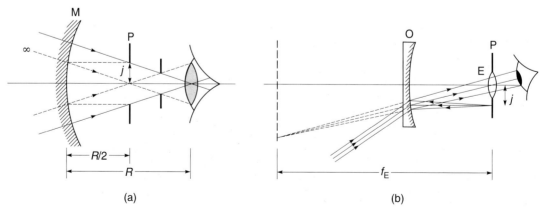

(a) (b)

Figure 9.12 The van Albada finder. A frame of semi-dimension j on plate P around eyepiece E is reflected in the metallized rear surface of objective lens O and seen at distance f_E. (a) Simple spherical semi-silvered mirror type: M, mirror. (b) Reversed Galilean type

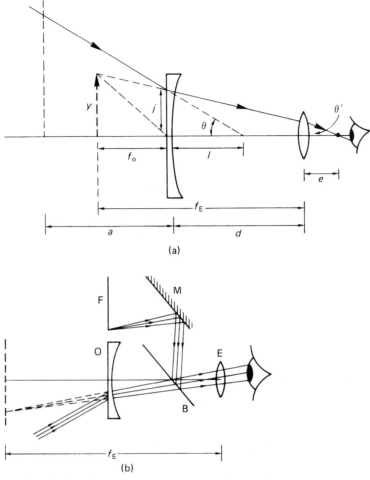

(a)

(b)

Figure 9.13 Reversed Galilean finder. (a) Distance *a* is usually zero, as the lens edge acts as the entrance window. Distance *d* corresponds to camera body thickness; *e*, eye relief. (b) Reflected mask frame version: F, separately illuminated frame; M, mirror; B, beamsplitter

mode. Instead, another type of telescope is adapted, the Kepler telescope used in reverse mode. This gives a real image but it is inverted and laterally reversed, so requires additional optics in the form of a prism erector system (like binoculars). Various prism systems are used (Figure 9.15), including pentaprism, porro and Konig types. The light path can usefully be folded optically to fit inside a compact camera body. A very bright image is given and an intermediate lens gives a zoom action coupled to a zoom lens. It is not easy to provide parallax correction or field frame lines so the field of view is usually less than that of the lens to give a margin for error. A LCD plate in the system can display alternative format lines and some data. Aspherical plastic elements can reduce distortion and a beamsplitter can sample light for through the finder exposure metering.

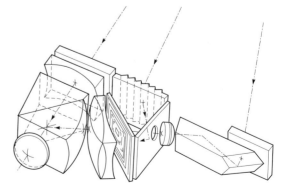

Figure 9.14 The optical configuration of a complex reversed Galilean coupled range and viewfinder with alternative frames (Leica data)

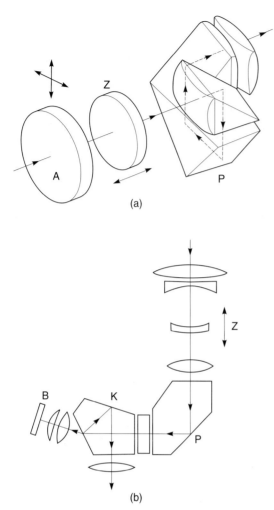

(a)

(b)

Figure 9.15 Real image finders. The optical path of the Kepler telescopic system is folded and corrected by prism systems. (a) Zoom finder: A, objective lens, movable for parallax correction; Z, zoom group; P, porroprism system with field frame. (b) Zoom finder (38–110 mm) using pentaprism P and pentagonal prism K. Light is sampled for exposure metering: Z, zoom element; B, photocell

Ground-glass screen viewfinders

Most early cameras used a plain ground-glass screen upon which the image from the lens was composed and focused, and which was then replaced by a plate-holder or film-holder in order to make the exposure. This system is still used in technical cameras. The advantages of exact assessment of the subject area covered by the lens, accurate focusing and appraisal of the effects of camera movements offset any inconvenience in viewing an image that is both inverted and reversed.

Other cameras use a reflex system, with a front-surface mirror inclined at 45 degrees to the optical axis giving an image on a ground-glass screen in an *equivalent focal plane*. The image is the same size as it will be recorded on film, and erect but laterally reversed. In the twin-lens reflex camera, viewing and taking are by separate lenses; in the single-lens reflex camera, viewing and taking are by the same lens. Focusing and viewing are done using the unaided eye or a flip-up magnifier in the viewfinder hood. Unlike the SLR camera, the TLR camera suffers from parallax error, and a mask or indicator in the viewfinder may be coupled to the focusing mechanism, to compensate for this defect.

The mirror in the viewfinder system of a SLR camera necessitated refinements in camera design. The most necessary is an *instant return mirror* (with a damping system to minimize camera shake), otherwise the viewfinder is blanked out until the mirror returns to the viewing position when the film is advanced to the next frame. The mirror may have a lock-up facility for shake-free release in telephotography and photomicrography.

Most SLR cameras have a viewfinder that is some 5 per cent pessimistic in each direction, i.e. more appears in the picture than in the viewfinder. The reason usually quoted for this is to overcome differences in aperture size in transparency mounts. Others, however, do indicate the actual area included on the negative. A plain ground-glass screen indicates whether focusing is correct, but gives a rather dim image, with a rapid fall-off in illumination towards the corners. Evenness of illumination is improved if the screen is etched on the flat base of a plano-convex lens, or if an accessory Fresnel screen is used, as a field-brightening element.

Reflex cameras without autofocus usually have a supplementary focusing aid incorporated in the centre of the screen. This is a 'passive' device, i.e. it has no moving parts. It is usually in the form of a *split-image rangefinder* or a *microprism array* (described later). Professional cameras have interchangeable viewing screens for different applications. Many screens incorporate two or more focusing methods, called *mixed screens*. With all these screens, however, if the reflex mirror is too small there will be a progressive loss of illumination towards the top of the screen with increase in focal length of the camera lens. This cut-off (viewfinder vignetting) is not seen on the film image. The reflex mirror may be multi-coated to improve reflectance and give a brighter viewfinder image. In order to transmit a portion of the incident light to a photocell for exposure metering or to a photosensor array for autofocusing, the mirror may have a partially transmitting zone or a pattern of fine perforations, and a supplementary or 'piggy-back' mirror hinged to its reverse side.

Lateral reversal of the reflex viewfinder image is troublesome, especially in action photography. For-

tunately, the addition of a *pentaprism viewfinder* gives an erect, laterally correct and magnified screen image for focusing (see Chapter 8); this is no doubt the main reason for the popularity of the SLR camera. These finders may be interchangeable with other types, and most have provision for *eyepiece correction lenses* or *dioptric adjustment* for users who would otherwise need spectacles for viewing. The viewfinder prism may incorporate a through-the-lens exposure metering system for measurements from the screen image.

Flash synchronization

In the early days of flash photography it was customary to set the camera on a tripod, open the shutter on the 'B' setting, fire the flash (which was a tray of magnesium powder) and then close the shutter. As the manufacture of flashbulbs progressed, they became sufficiently reliable to be synchronized with the opening of the camera shutter. This made it possible for flash to be used with the shutter set to give an 'instantaneous' exposure, and the camera could be hand-held for flash exposures. At first, a separate synchronizer device was attached to the camera, but now flash contacts are incorporated in the shutter mechanism for both flashbulbs and electronic flash.

Between-lens shutters

Synchronization of between-lens and focal-plane shutters presents different problems. With a between-lens shutter, the aim is to arrange for the peak of the flash to coincide with the period over which the shutter blades are fully open. There is a short delay between the moment of release and when the blades first start to open (approximately 2 to 5 ms), and a further slight delay before the blades are fully open. With flashbulbs there is also a delay after firing while the igniter wire becomes heated, before combustion occurs and light is produced. By comparison electronic flash reaches full output virtually instantaneously.

To cope with both types of flash, a between-lens shutter is provided with two types of synchronization, called respectively *X-* and *M-synchronization*. With X-synchronization, electrical contact is made at the instant the shutter blades become fully open so this type can be used with electronic flash *at all shutter speeds* (Figure 9.16). It is also suitable for use with small flashbulbs at shutter speeds up to 1/30 s. Compact cameras with an integral electronic flash unit are X-synchronized only, as are hotshoe connections. With the now obsolescent M-synchronization the shutter blades are timed to be fully open approximately 17 ms after electrical contact is made.

This was originally to allow large flashbulbs time to reach full luminous output when the shutter was fully open. This requires a delay mechanism in the shutter, and one is used similar to that used for the slower speeds in preset shutters. M-synchronization allows synchronization of type M (medium-output) flashbulbs at all shutter speeds. It is not suitable for small flashbulbs (type MF) and certainly *not* for electronic flash, which would be over before the shutter even began to open, hence no image. This form of synchronization is now rare and only X-synchronization is usually provided. The exceptions are lenses with leaf shutters intended for large-format and some medium-format cameras. Some shutters manufactured in the early days of internal flash-synchronization have a lever marked 'V-X-M'. The 'V' in this case is a delayed-action ('self-timer') setting, which is synchronized to electronic flash only.

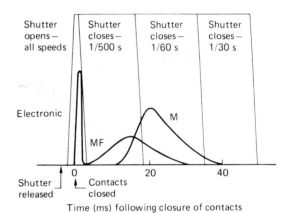

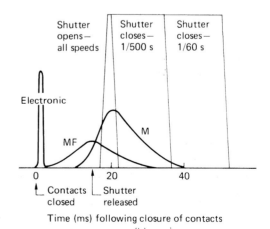

Figure 9.16 Flashbulb and electronic flash light output curves shown in relation to shutter performance curves for different types of synchronization. (a) X-synchronization. (b) M-synchronization

Focal-plane shutters

Synchronization of focal-plane shutters presents a particular problem. Exposures with electronic flash can be made only at slower shutter speeds, where the shutter slit is the same size as the film gate, so that the whole film frame area can be exposed simultaneously by the flash. When large flashbulbs had to be synchronized with fast shutter speeds up to 1/1000 s, a special slow-burning flash-bulb (class FP), now obsolete, was available. This bulb gave a near-constant output for the whole transit time of the shutter blind. The modern electronic flash counterpart has a rapidly pulsed or 'strobed' output that permits the use of flash even at 1/12 000 s.

Unlike a 'fully synchronized' between-lens shutter, which has only one flash connection and a two-position switch to select X- or M-synchronization, some focal-plane shutters had one, two or even three flash connections in the form of PC (co-axial) sockets, hot shoes and special-fitting sockets. If only one, unmarked, outlet is fitted to the camera, such as a simple hotshoe or PC cable socket, the shutter is X-synchronized only. Some older cameras have a separate control linked to this sole outlet, able to select different forms of delay, but this too is now obsolete. A pair of outlets may be X and M, or perhaps X and FP. Use of the appropriate one of these with a suitable shutter speed automatically gives correct synchronization. The extension of exposure automation to the use of electronic flash resulted in most cameras now giving automatic setting of the electronically controlled shutter to the correct X-synchronization speed, when a suitable dedicated flashgun is attached. This reverts to an alternative setting for ambient light exposure while the flash is recharging.

In X-type synchronization, the electrical contact is made when the first shutter blind has fully uncovered the film gate, and before the second blind has begun to move. Depending on the design of shutter, X-synchronization may be possible up to a shutter speed of 1/300 s. Medium-format cameras have synchronization restricted to a maximum shutter speed of typically 1/30 to 1/125 s. Due to these comparatively long shutter-open times in relation to the brief duration of an electronic flash unit, the effect of the ambient light can be a problem, and an electronic flash exposure meter which also takes into account the shutter speed in use is helpful. A comparison of shutter operation and flash source characteristics is shown in Figure 9.17.

The alternative *rear curtain synchronization* is when the flash is triggered just before the second blind starts it travel. This is useful for longer shutter speeds to give a better visual effect when there is a mix of time exposure and flash exposure.

Flash synchronization connections

The interface between the electronic flash and camera shutter is by means of an electrical connection, usually in the form of a PC socket, hotshoe (and hotfoot) or special connection (such as by a pulse of infrared radiation to allow cordless operation in off-camera use).

PC (for Prontor-Compur) is a 3 mm co-axial socket and a frequent source of connection problems. Some form of locking or screw-in version is more reliable. Flash extension cables are also a source of problems. Multiple socket outlet adapters can be used for simultaneous firing of two or more flash units.

The *hotshoe* (Figure 9.18) is a simpler and more reliable single contact outlet, utilizing the original accessory shoe as used for viewfinders, range-finders and simple flashguns. The centre contact provides X-synchronization without trailing wires. Additional contacts in the hot shoe provide additional features with dedicated flashguns. There are also non-standard special shoe fittings in use. Flashguns may be provided with an interchangeable 'hot foot' to give dedicated features with different camera systems.

Red-eye effects

The original large size of flash units meant that the flashhead was positioned above and to one side of the camera. Many cameras now have integral flash units or use small units which clip on, both of which place the flash close to the camera lens. The result is near-axial lighting along the optical axis of the lens which can give 'red-eye' where the light illuminates the retina of the eye which is red with blood vessels. The result is undesirable and unattractive. The best remedy is to remove the flash unit from near the lens, e.g. on an extension cable or by use of a slave unit. Alternative bounce or indirect flash can be used, or a flash diffuser may help. There is a loss of effective output. For direct flash, multiple preflashes may help to reduce the pupil size, or an intense beam of light may be directed from the camera to the eye, or the subject may be able to look away from the camera or the ambient light increased. Animals show similar effects but the colour effect may be green.

Focusing systems

Although lenses can be used satisfactorily as *fixed-focus* objectives, relying upon a combination of small apertures, depth of field and distant subjects to give adequate image sharpness, this simplification is not

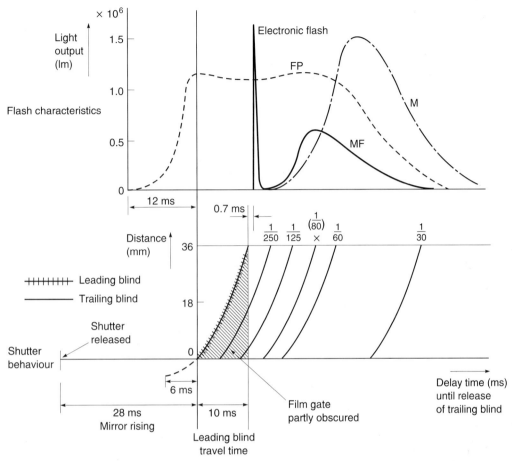

Figure 9.17 Flash synchronization of a focal-plane shutter. The lower part of the diagram shows the horizontal movement of the leading and trailing blinds across the film gate of width 36 mm. The leading blind is released some 6 ms before the end of the 28 ms taken for the reflex mirror to rise, and it takes some 10 ms to open fully. The trailing blind is released after a suitable delay time, also taking some 10 ms for its full travel. At exposure durations of less than 1/80 s (the X-synchronization value here), the film gate is still partially obscured, as the trailing blind is released before the leading blind has completed its travel. The leading blind fires the electronic flash after a delay of less than 1 ms and the flash discharge time is 1 ms or less. The full flash output of a small flashbulb of the MF type is obtained with X-synchronization and a shutter speed of 1/30 s or more, likewise for the larger 'M' type of bulb. To use the shorter shutter speeds of 1/80 to 1/2000 s, the long-burning 'FP' bulb (now obsolete) was triggered some 12 ms before the leading blind started to move. The upper part of the diagram shows the flash characteristics

usually feasible with lenses of large aperture or long focal length, nor for close-up work. To ensure that the most important part of the subject is in sharp focus it is necessary to have some form of focusing system, as well as a visual indication of the state of focus. Current focusing systems use a variety of mechanical, optical and opto-electronic arrangements (Figure 9.19). Focusing is to satisfy the conditions of the lens conjugate equation where a change in subject distance (u) requires a corresponding change in image distance (v) with focal length (f).

Unit focusing

The simplest method of focusing is by movement of the entire lens or optical unit (9.19a). This is called 'unit focusing'. The lens elements are held in a fixed configuration. Movement is achieved in various ways. Technical cameras of the baseboard type employ a rack-and-pinion or friction device to move the lens on a panel for focusing by coupled range-finder or ground-glass screen. The monorail type is focused by moving either the lens or the back of the

(a)

(b)

Figure 9.18 Flash connections. (a) Conventional hotshoe with a single central contact to fire any suitable flashgun. (b) A selection of hotshoes with additional contacts to interface the camera with specific flashguns

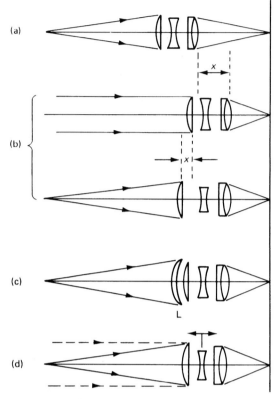

Figure 9.19 Focusing a lens. There are four principal methods of focusing: (a) by extending the whole lens by a distance x; (b) by front-cell focusing, a smaller extension is needed; (c) by adding a close-up lens L, no extension is needed; (d) by internal focusing; no extension is needed

camera; this can be useful in applications such as copying, because rear focusing alters the focus only, whereas front focusing alters the size of the image as well as the focus.

Other cameras have the lens unit installed in a lens barrel or focusing mount. Rotation of a ring on the lens barrel moves the lens in an axial direction. A *helical* focusing mount causes the lens to rotate during focusing, whereas a *rectilinear* mount does not. Rotation is generally undesirable, as the various scales may not be visible at all times and optical attachments such as polarizing filters, which are sensitive to orientation, may need continuous adjustment. A special *double helicoid* arrangement is used to provide macro lenses with the extended movement necessary to allow continuous focus to magnifications of 0.5 or more. The focusing action may be coupled to a rangefinder or to an autofocus system, or it may be viewed on a screen. The focusing distance may also be set by a scale on the baseboard.

Front-cell focusing

In simple cameras fitted with between-lens shutters, focusing is possible by varying the focal length of the lens and not by varying the lens-to-film distance. This is achieved by mounting the front element in a cell with a coarse-pitch screw thread. Rotation of this cell alters the separation of the front element from the other groups (Figure 9.19b). A slight increase in this separation causes an appreciable decrease in focal length, giving a useful focusing range. Close focusing to less than one metre is not satisfactory because the lens aberrations introduced adversely affect performance. A distance scale is engraved on the movable cell. Many zoom lenses also use a (well-corrected) movable front group for focusing. Note that rotation of the front element is a nuisance with the use of polarizing filters and other direction-sensitive attachments such as graduated filters.

Close-up lenses

A positive supplementary lens can be fitted in front of almost any lens to give a fixed close-up focusing range (Figure 9.19c). If the subject is positioned at the front focus of the supplementary lens, the camera lens receives parallel light, so it gives a sharp image at its infinity focus setting. By varying the focus setting on the camera lens, a limited close-up range is given. The design of the supplementary lens is important, as the curvatures of its surfaces determine its effect upon the aberration correction of the prime lens. Usually a positive meniscus shape is used, with its convex side to the subject. This simple lens may be perfectly adequate when used at small apertures, but an achromatic cemented doublet design with anti-reflection coatings is preferable for improved performance. A +1 dioptre lens has focal length 1000 mm, and if of diameter 50 mm has an aperture of $f/20$, which allows a doublet design to give excellent correction. Typical examples are Zeiss Proxars and Leitz Elpro ranges, which may also be matched to particular prime lenses.

Close-up lenses are calibrated in dioptres, and positive powers of +1, +2 and +3 are commonly available. Not every manufacturer uses this coding. Powers of up to +10 are available, and the lenses can be used in tandem with the more powerful one closer to the prime lens. A variable power or 'zoom' close-up lens uses a variable separation between two positive menisci to give its dioptre range. Performance is generally poor. Fractional dioptre values of +0.25 and +0.5 are useful for telephoto, zoom and long focus lenses.

The effect of the supplementary lens is to reduce slightly the focal length of the combination. No exposure correction is necessary with supplementary lenses, and the aperture scale remains unchanged. The entrance pupil diameter is virtually unchanged by the addition of the supplementary lens. Single-lens reflex cameras pose no problem for close-up focusing and framing. Other types usually require an additional prismatic device to correct the viewfinder image for parallax errors due to the proximity of the subject. Twin lens reflex and rangefinder cameras are in this category.

Internal focusing

A versatile method is *internal focusing* (Figure 9.19(d)), where the focusing control moves an internal element or group of elements along the optical axis, thereby altering focal length but not the external dimensions of the lens. The front of the lens does not rotate either. By this means an extensive focusing range is possible with only a small movement involving few mechanical parts. The lens is not extended physically, and the whole unit can be sealed against the ingress of dust and water. The focusing movement may be non-linear, and incorporate the correction for those lens aberrations which increase as the focused distance is decreased. The small masses and mechanical forces involved mean that internal focusing is particularly suitable for autofocus lenses. The drive motor can be located either in the camera body or in the lens housing. Internal focusing is used for a variety of lenses, including zoom, macro and super-telephoto types. Close-focusing is provided with retention of image quality.

Extension tubes and bellows

Many lenses can only be focused close enough to provide a magnification of about 0.1 or less. Most standard lenses have a minimum focusing distance of 0.3 to 1.0 metres. If the lens is removable, the use of *extension tubes* and *bellows extensions* between the lens and camera body provide the additional lens-to-image distance needed to give greater magnification. (Non-interchangeable lenses are limited to use of a supplementary close-up lens). An extension tube has fittings for attaching the lens to one end and the camera body to the other. Tubes of various lengths are available for use singly or in combination. Variable-length tubes are also available. For SLR cameras, automatic extension tubes have the necessary mechanical or electrical linkages to retain the operation of the iris diaphragm and TTL metering systems.

Together with the focusing movement on the lens mount, an extension tube gives a limited close-focusing range. At long extensions, a narrow-diameter tube may cause vignetting. For these reasons, an extension bellows is preferable as this permits a full and continuous focusing range, and allows lenses of long focal length to be used. Some lenses may be produced in a short-mount bellows-unit-only version. A 135 mm focal length lens for the 24 × 36 mm format with bellows may typically have a focusing range from infinity down to same-size reproduction. True macro lenses, i.e. lenses capable of full correction at magnifications greater than unity, are available specifically for bellows use.

The automatic diaphragm and other operations of a lens are retained with most designs of bellows by means of mechanical or electrical linkages, but where this is not so, a double cable release arrangement is needed to operate the iris diaphragm and shutter together (or the lens may need to be stopped down manually). Where magnification is greater than 1.0, the optical performance of a lens mounted in the usual way may be impaired, as corrections are normally computed for work at infinity, and macro settings reverse the usual proportions of conjugate

distances (i.e. $v \gg u$). A *lens reversing ring*, to mount the lens with its rear element facing the subject, avoids this problem. Extension tubes and bellows are most useful with SLR cameras, owing to the ease of focusing. A table is usually available listing increases in exposure for the various magnifications, but TTL metering avoids the necessity for this.

Focusing scales

Lenses are usually focused without reference to the distance scales engraved on the focusing control when a rangefinder, focusing screen or autofocus system is provided. These scales are useful for reference when electronic flash is being used, so that the aperture may be set according to a flash guide number, and to check if the subject is within the operating distance range of an automatic flash exposure system, as described in Chapter 3. Also, the distance values can give an estimate of the depth of field by reference to the appropriate scales on the mount, or to tables. The focusing scale may also carry a separate index for infrared use, usually denoted by a red dot or letter 'R', and the distance value first set visually or by autofocus is then transferred manually to the IR index.

As the focal length of a lens determines the amount of extension necessary for focusing on a nearby object, the closest marked distance on a focusing scale varies with the particular lens in use. The small extension required with wide-angle, short-focus lenses means that many have provision for focusing down to a few centimetres. The standard lenses used with 24×36 mm format cameras commonly focus down to approximately 0.5 m, while macro lenses have provision for magnification of 0.5 to 1.0, and additional scales of exposure increase factors and reproduction ratios. Long-focus lenses may focus no nearer than 2 to 10 m, depending on their focal length, without recourse to extension tubes, bellows or close-up lens attachments. The long bellows extension of a technical camera and the possibility of increasing the extension by adding another section, makes for a very versatile focusing system. The usual triple-extension bellows allows a magnification of 2.0 with a standard lens, but may need replacement by a flexible bag-bellows for use with short-focus lenses, as the pleated type will not compress sufficiently to allow the lens to be focused on infinity.

Focusing mechanisms vary in their ease of use. Focusing rings, knobs and levers vary in size and width. The amount of friction, ease of gripping and direction of rotation for focusing differ between lenses, and this can cause confusion when several lenses are in use. A locking control is desirable to allow focus to be preset in several positions or to prevent accidental alteration during use (such as

when copying). A zoom lens may have three raised rings on the lens barrel for the alteration of focus, aperture and focal lengths; careful design is needed to avoid confusion of function. Zoom lenses may use *one touch* operation: a control that rotates to change focus and slides to change focal length; systems using separate controls are more common. There may be a focus limiting control to restrict the focus range, to speed up autofocus and prevent 'hunting' for focus.

Ground-glass focusing screen

The traditional *ground-glass screen* or *focusing screen* is a most adaptable and versatile focusing system. It has the advantages of giving a positive indication of sharp focus and allowing the depth of field to be estimated. No linkages between lens and viewfinder are necessary, apart from a mirror (if reflex focusing is used). The screen may be used to focus any lens or optical system, but focusing accuracy depends on screen image luminance, subject contrast and the visual acuity of the user. Supplementary aids such as a screen magnifier or loupe and a focusing hood or cloth are essential, especially when trying to focus systems of small effective aperture in poor light. The plain screen has evolved into a complex optical subsystem, incorporating *passive focusing aids* (see below) and a Fresnel lens to improve screen brightness. The screen can be a plate of fused optical fibres; alternatively, the glass may have a laser-etched finish to provide a detailed, contrasty, bright image. No single type of screen is suitable for all focusing tasks and many cameras have interchangeable focusing screens with different properties. Accurate visual focusing is aided by accurate adjustment of the dioptric value of the eyepiece magnifier or loupe to suit the vision of the user.

Coincidence-type rangefinder

Coincidence-type rangefinders usually employ two windows a short distance apart, through each of which an image of the subject is seen. The two images are viewed superimposed, one directly and the other after deviation by an optical system (Figure 9.20a). For a subject at infinity the beamsplitter M_1 and rotatable mirror M_2 are parallel, and the two images coincide. For a subject at a finite distance u the two images coincide only when mirror M_2 has been rotated through an angle $x/2$. The angle x is therefore a measure of u by the geometry of the system, and may be calibrated in terms of subject distance. By coupling the mirror rotation to the focusing mount of the lens in use, the lens is automatically in focus on the subject when the

rangefinder images coincide. The accuracy of this *coupled rangefinder* system using *triangulation* is a function of subject distance u, the baselength b between the two mirrors and the angle x subtended at the subject by the base-length. Mechanical and optical limitations make this system of focusing unsuitable for lenses of more than about two-and-a-half times the standard focal length for the film format, e.g. 135 mm for the 24 × 36 mm format. The method is unsurpassed in accuracy for the focusing of wide-angle lenses, particularly with a long-base rangefinder and in poor light conditions.

As the focused distance changes from infinity to about 1 metre, the required rotation of the mirror is only some 3 degrees, so high mechanical accuracy and manufacturing skill are required to produce a reliable rangefinder. Alternative systems have been devised. One of these employs a fixed mirror and beamsplitter, obtaining the necessary deviation by a lens element which slides across the light path between them (Figure 9.20b). The rangefinder images are usually incorporated into a bright-line frame viewfinder, one of the images being in contrasting colour for differentiation. Rangefinders add little to the bulk or weight of a camera.

Split-image rangefinder

A *split-image rangefinder* is a 'passive' focusing aid in that it has no moving parts, unlike the coincidence type rangefinder. It is a small device, consisting basically of two semi-circular glass prisms inserted in opposite senses in the plane of the focusing screen. As shown in Figure 9.21, any image that is not exactly in focus on the central area of the screen appears as two displaced halves. These move together to join up as the image is brought into focus, in a similar way to the two images of the field in a coincidence-type rangefinder. The aerial image is always bright and in focus, even in poor light conditions. Because focusing accuracy by the user depends on the ability of the eye to recognize the displacement of a line, rather than on the resolving power of the eye, which is of a lower order, the device is very sensitive, especially with wide-angle lenses at larger or moderate apertures. The inherent accuracy of this rangefinder depends on the diameter of the entrance pupil of the lens in use, so large apertures improve the performance. Unfortunately, the geometry of the system is such that for effective apertures of less than about $f/5.6$ the diameter of its exit pupil is very small, and the user's eye needs to be very accurately located. Slight movements of the eye from this critical position cause one or other half of the split field to black out. Consequently, long-focus lenses or close-up photography result in a loss of function of the rangefinder facility and produce an irritating blemish in the viewfinder image. Since this obscuration is

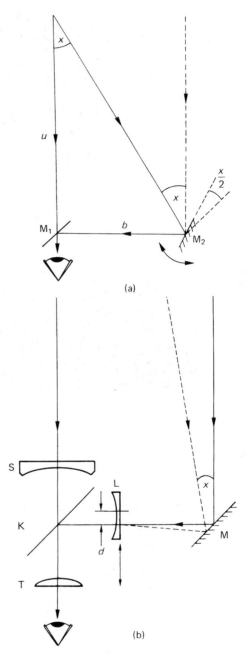

(a)

(b)

Figure 9.20 Coincidence rangefinder. (a) Rotating mirror type. (b) Sliding-lens type incorporated into a viewfinder. S and T are viewfinder elements, K a beamsplitter and L a sliding lens moving a distance d coupled to lens focusing

related to the prism angle, alternative prisms with refracting angles more suited to the lens aperture in use, or even of variable, stepped angle design, can retain useful rangefinder images even at small apertures.

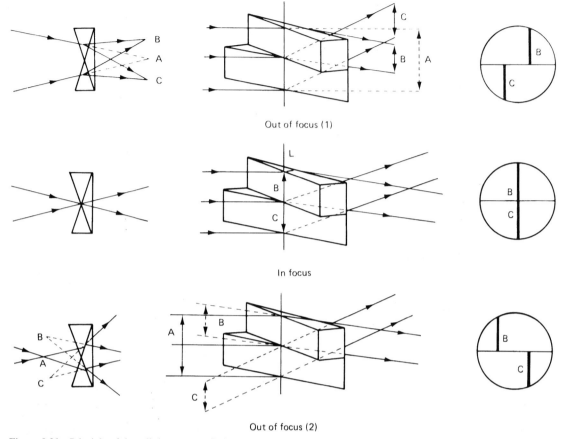

Out of focus (1)

In focus

Out of focus (2)

Figure 9.21 Principle of the split-image rangefinder

The image-splitting arrangements may be vertical, horizontal, at 45 degrees, or use a more complex arrangement to cope with subjects without definite linear structures. An additional focusing aid is often provided such as an annular fine ground-glass ring around the rangefinder prisms. The split-image rangefinder is popular with wearers of spectacles and others with refraction errors of vision, who may find it difficult to focus a screen image.

Microprism grids and screens

The principle of the split-image rangefinder is used in the *microprism grid* array, also located in the centre of the viewfinder focusing screen. A large number of small facets in the shape of triangular or square base pyramids are embossed into the focusing screen surface (Figure 9.22). An image from the camera lens that is not precisely in focus on the screen undergoes multiple refraction by these facets so that the image

appears broken up into tiny fragmentary areas with a characteristic 'shimmering' effect. At correct focus this image snaps back into its correct appearance, giving a very positive indication of the point of focus. The pyramids are small enough (<0.1 mm diameter) to be below the resolving power of the eye. This system is easy to use and very popular. Again, no moving parts are used. The disadvantage of the microprism is the same as that of the split-image rangefinder, the microprism array blacking out at effective apertures less than about $f/5.6$. Interchangeable viewfinder screens that consist entirely of microprisms are available. These give a very bright image for focusing; they can be obtained with prisms with angles suitable for lenses of a particular focal length. Microprism arrays are generally used in conjunction with one or more of the other focusing aids; thus a central split-image rangefinder may be surrounded by annular rings of microprisms and ground glass, with the rest of the screen area occupied by a Fresnel lens.

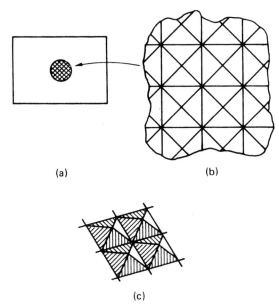

Figure 9.22 The microprism focus finder. (a) Typical location in focusing screen. (b) Enlarged plan view of prisms with square base of side of about 0.05 mm. (c) Perspective view of microprisms

Autofocus systems

Autofocus modes

For many purposes a lens that is focused visually, or even a fixed-focus lens, is adequate; the various optical aids described above simply improve accuracy of focusing. But visual focusing can be slow, inaccurate and tiring, especially if continuous adjustments are necessary. Some means of obtaining or retaining focus automatically is helpful, especially when using long-focus lenses and following subjects moving obliquely across the field of view in poor light; also for unattended cameras operated by an intervalometer. Various forms of *autofocus system* have been devised; these can operate in various modes. The autofocus system can be linked to the shutter release so this is blocked until focus is achieved, otherwise it can be overridden. The focus may then lock at this setting or it can search continuously for focus as the camera or subject move. An 'active' type of autofocus will scan a beam of infrared radiation across the scene, the reflection is measured and triangulation is used, similar to the coupled rangefinder. A 'passive' type uses no moving parts and a pair of images are compared by the output from a CCD array, similar to a split-image rangefinder. The system can be used on demand, useful as a prefocus feature as the sensor area may be much

smaller than the field of view of the lens; also, the composition may be such that an active system would give sharp focus on an area other than the main subject feature (for example, the background seen between the two heads, in a double portrait). A combination of active and passive systems may be combined to deal with a range of distances, the former being better for close distances, the latter for distant subjects.

A *focus indication mode* or *assisted focusing mode* is a form of electronic rangefinder being an analogue of an optical rangefinder or focusing screen. An LED display lights up in the viewfinder to indicate correct focus when the lens is focused manually; the direction of focusing movement required is indicated if the focus is incorrect. A *predictive autofocus mode* anticipates the position of a moving subject after the time delay due to the mirror rise time and will 'drive' the lens to this focus setting in compensation. An automatic *depth-of-field mode* is where the lens is focused automatically on the near and far points of the scene to be rendered in focus, the necessary intermediate focus is set and the automatic exposure determination system then chooses the appropriate aperture to give the correct depth of field, given an input of data from the lens as to its focal length even when using a zoom lens. Another type is a *motion-detection mode*, or *focus-trap mode* where the camera is autofocused at a suitable distance; when a moving subject enters this zone, the camera automatically fires the shutter. A *focus maintenance mode* retains sharp focus once this has been set visually; this is the system commonly used in 'autofocus' slide projectors.

Ideally, autofocus systems should be rapid-acting, should not 'hunt', should continue to function at low light levels, be economical with batteries, add little volume or weight to the camera, be reliable, and give accuracy comparable to or better than visual methods. Different systems are in use.

Active ranging systems

One autofocus method uses direct measurement of the subject distance. This ranging method using pulses of ultrasound was introduced by Polaroid for use in certain of their range of cameras for self-developing film. A *piezo-electric ceramic vibrator* (PECV) emits a 'chirp' of ultrasonic frequencies while the lens moves to focus from its near distance to infinity. The elapsed time for the return journey to the subject is proportional to subject distance. The return echo is used to stop this focusing action. Either a turret of supplementary lenses or a single elongated aspheric element may be rotated behind the main camera lens to vary the focus. This system operates even in the dark, but cannot penetrate glass.

Other 'active' opto-electronic systems involve some means of scanning across the subject area (see Figure 9.23). An *electronic distance measurement* (EDM) system uses an infrared-emitting diode moving behind an aspheric projection lens to scan a narrow beam across the scene. Reflection from a small well-defined subject area is detected by a photodiode giving a maximum response, and the scan action is halted, as is the synchronous focusing movement of the camera lens. The original Honeywell Visitronic module used a subject-scanning system, where a rotating mirror synchronized to the motorized focusing movement imaged a zone of the subject onto a photodetector array; this response is compared to the static response of the subject area as seen by a fixed mirror and second detector array. The subsequent correlation signal is a maximum when both mirrors image the same zone. This signal then locks the focusing travel. This is the electronic analogue of a coupled rangefinder. The system works best at high light levels and is dependent on specialized signal-processing circuitry. Another system (due to Canon) uses two fixed mirrors to image zones of the scene cross a linear CCD array of some 240 elements. The focused image area is compared with adjacent image areas along the array, and maximum correlation gives a 'base' or distance between the two correlated regions which relates to the subject distance and an angular subtense. This continuous self-scanning triangulation system can be adapted to operate through the lenses of video cameras.

Systems using infrared beams can operate in darkness and through glass, but can be fooled by unusual reflectances of the radiation from various materials such as dark cloth.

Phase detection focusing

This passive system uses one or more linear CCD arrays and no moving parts. The CCD array is located in the mirror chamber (Figure 9.24) beyond an equivalent focal plane and behind a pair of small lenses which act in a similar manner to a prismatic split-image rangefinder, as in Figure 9.25. Divergent pencils of rays beyond the correct focus position are refracted to refocus upon the array, and the separation (or 'phase') of these focus positions relative to a reference signal is a measure of the focus condition of the camera lens. The phase information operates a motorized focus control (Figure 9.26) in the lens, so the motor is suited to the torque requirements of individual lenses. Very rapid focusing is possible, even in continuous-focus mode. The system will even focus in the dark, using the emission of infrared radiation from a suitably filtered source in a dedicated flashgun. The autofocus zone is indicated in the viewfinder of a camera and this can be located on the important detail of the subject to be sharply in focus. The focused distance data may be used in exposure calculations or in the operation of dedicated flash systems. Accuracy of operation is dependent upon

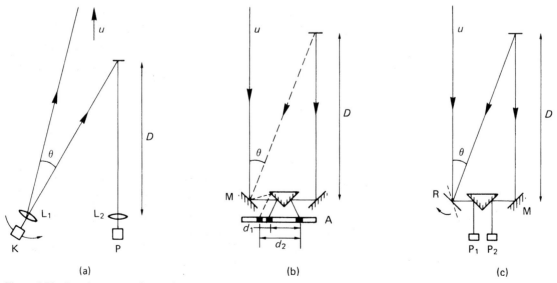

Figure 9.23 Ranging systems for autofocus cameras. (a) Scanning IR-emitting diode K with aspheric lenses L_1 and L_2 and photocell P. (b) Static system with linear CCD array A. The correlated images at separations d_1 and d_2 correspond to distances u and D respectively. (c) Scanning mirror R to correlate images on twin photocells P_1 and P_2

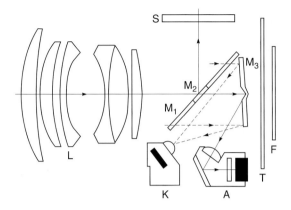

Figure 9.24 Location of autofocus and metering modules. L, camera lens; S, focusing screen; F, film in gate; M_1, reflex mirror with 30 per cent transmission; M_2, central region with 50 per cent transmission; M_3, secondary mirror with two focusing regions; A, autofocus module; K, metering module; spot or centre-weighted

using a lens aperture of *f*/5.6 or larger and also a reasonable light level. Low light performance is given by an EV scale of values, similar to that used for exposure metering systems. A dedicated flashgun fitted to the camera may emit a small preflash with a striped pattern to fall on the subject and assist autofocus in dim light. Alternatively, a continuous beam of deep red light or even infrared may be used.

One operational disadvantage is that, as the optical design of the autofocus system involves a beamsplitter mirror, the operation of which is affected by linearly polarized light, the system may not work correctly if a linear polarizing filter is used over the camera lens. A circular polarizing filter is instead required.

To deal effectively with a variety of subjects which may contain little correctly orientated detail or even none on which the autofocus system may 'lock', and to avoid the incorrect focus that may be set if the subject is not central in the frame, a variety of designs

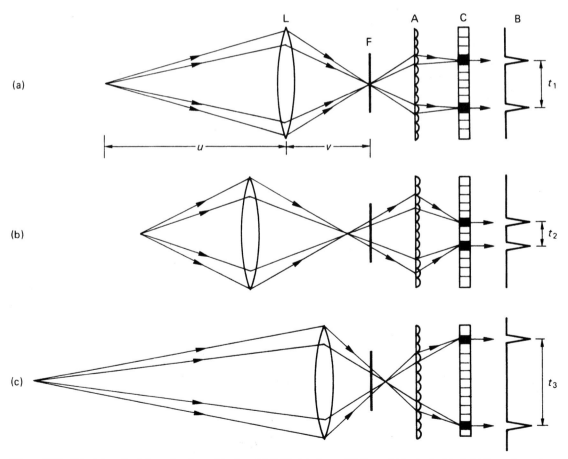

Figure 9.25 Principles of autofocus by phase detection. (a) Subject in focus. (b) Focus in front of subject. (c) Focus beyond subject. Key: L camera lens; F equivalent focal plane; A lenslet array; C CCD linear array; B output signals with time delay t_1 etc.

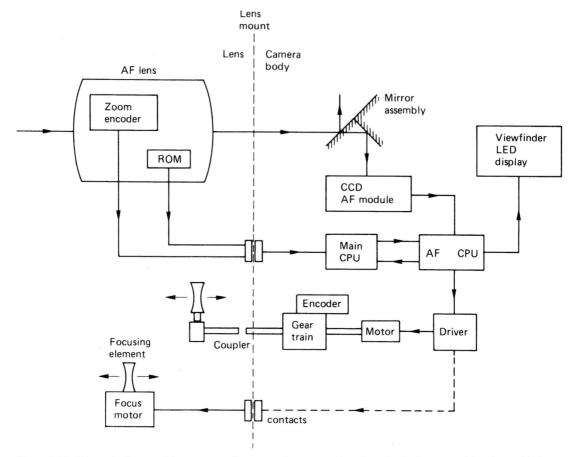

Figure 9.26 Schematic diagram of in-camera autofocus control systems with various circuit elements and interfaces with the lens

of autofocus arrays are in use in different cameras (Figure 9.27). One or more of the arrays in the field of view may be selected as suitable, sometimes by looking at the zone when an 'interactive' viewfinder will activate the selection and light a suitable indicator.

Exposure metering systems

Exposure

The topics of camera and flash exposure determination are dealt with fully in Chapter 19. An exposure meter with a calibration constant (K) measures the luminance (L) of the subject by reflected light, and given a film speed (S) the exposure equation $t = KN^2/LS$ is solved by an integral calculator to display the various combinations of shutter speed (t) and

f-number (N) required. The value of film speed may be automatically input by a DX coding system. The values of N and t may be selected automatically by a selected *program mode*. The incorporation of an exposure metering system into a camera body is more than simply a question of convenience for the user: it is a crucial element in the design. A variety of types are used, each with its own advantages and limitations. When colour materials are used, accurate exposure is particularly important. Separate exposure meters are still used, but the transfer of indicated values of shutter speed and aperture from meter to camera is time-consuming. An *integral meter* coupled to the camera controls gives more rapid operation; and there are numerous possibilities of exposure automation. The evolution of the built-in meter has gone through several stages, each of increasing complexity; but before considering these it is useful to review the properties of the various types of photocell in use in light-metering systems.

Figure 11.4 The appearance of a white building against a blue sky is enhanced in contrast by use of a red filter to darken blue (and also the green of foliage)

which, whilst having considerable colour contrast, may have little difference in luminance. A 'correct' rendering would show them as similar shades of grey with little or no contrast. A contrast filter is required to produce the necessary tone separation that is essential if the photograph is to show the distinction between the coloured areas. The fundamental property of a colour filter is that it transmits light of its own hue and absorbs light of the complementary hue (i.e. all other wavelengths). Figure 11.4 shows how the contrast of a scene may be increased by use of a red filter to darken a blue sky behind a white building.

Depending on filter density, various amounts of the 'transmission' band may also be absorbed. The basic rule for the selection of contrast filters is that to lighten a colour a filter that transmits that particular spectral region should be used; conversely, to darken a colour, a filter that has a low transmittance in that particular spectral region should be used. Colours such as reds and yellows are easily controlled in this way, but greens and browns may prove more difficult because of their low saturation. A contrast filter of the same colour as a self-coloured object is often termed

a *detail filter*, because it lowers the contrast between an object and its surroundings so that contrast in the object itself can be increased by photographic means. Detail filters are used in photomicrography, and in general photography to obtain improved rendering of texture.

A summary of the types and uses of contrast filters for photography is given in Table 11.2, and typical spectral absorption properties of contrast filters are shown in Figures 11.5, 11.6 and 11.7. Narrow-band (sometimes called 'narrow-cut') filters have a spectral transmission bandwidth less than that of standard *tricolour filters* (a set of red, green and blue filters for applications such as colour separation).

Haze penetration

Distant subjects frequently have low contrast because the light reaching the observer has become scattered by gas molecules in the air (Rayleigh scattering) and by suspended droplets of water (Mie scattering). The molecular scattering is wavelength-dependent, being inversely proportional to the fourth power of the

Table 11.1 Correction filters for black-and-white photography

Light source	Film sensitization	Rendering of colours		Correction filter needed	
		Too dark	Too light	Partial correction	Full correction
Daylight	pan	green	blue	pale yellow	yellow–green
Daylight	ortho	red	blue	pale yellow	not possible
Tungsten	pan	blue	red	pale greenish blue	blue–green
Electronic flash	pan		blue		pale yellow

Colour filters for black-and-white photography

In black-and-white photography colour filters are employed primarily as a means of controlling the tonal rendering of colours in terms of greys. There are two main groups.

Correction filters

Sensitized materials for black-and-white photography may be blue-sensitive, orthochromatic or panchromatic. The first two are used almost exclusively for special purposes such as copying and tone-separation work, and most general photography is carried out using panchromatic material. Panchromatic sensitization is not uniform throughout the spectrum, most materials being more sensitive to blue than green, while some materials have enhanced red sensitivity. Some tonal distortion of colours is thus inevitable in a monochrome reproduction. *Correction filters* help record subject colours in their true luminosity. Full or partial correction is possible, but full correction needs a greater increase in camera exposure. Note that although such procedures may be technically 'correct', the result obtained may be disappointingly dull and flat from the pictorial point of view.

A preferred rendering can be obtained by retaining the colour contrasts in the original and modifying them using *contrast filters* to produce a desired effect in each case.

Correction filters are used in various densities of yellow and yellow–green; as summarized in Table 11.1. Note that with panchromatic films, due to their non-uniform spectral sensitivity, in daylight blues are rendered too light and greens too dark, while in tungsten illumination reds are too light and blues too dark. Consequently, white clouds and blue sky may be recorded with similar densities, i.e. lacking in contrast, while the subject of a portrait in tungsten light may appear to have skin that is too pale and eyes that are too dark. Typical spectral absorption curves for correction filters are shown in Figure 11.3.

Contrast filters

Differences of colour and luminance in the subject are both represented in the printed image as differences in tone. Contrast filters are used to control the tonal range or contrast in the print arising from colour contrast in the subject. They may be used either to make a colour appear lighter or darker; or to make one colour darker and another lighter simultaneously. For example, a subject with areas of green and orange

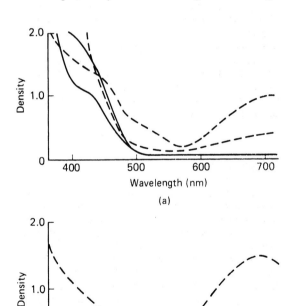

Figure 11.3 Spectral absorption curves for correction filters for black-and-white film materials. (a) Filters for partial or full correction in daylight. (b) Filters for correction in tungsten light. Solid lines denote partial correction, broken lines denote full correction

thicker and of lower optical quality than gelatin sheet, the use of such materials is limited to non-optical purposes such as colour filtration of light sources. Such filters should be non-flammable. The low cost of non-photographic filters and their availability in large sizes and rolls means that filtration of large areas such as windows may be carried out, in order to give safelight conditions or to balance exterior lighting such as daylight to a subject lit by tungsten studio lamps. By using plastics materials such as methacrylate, polycarbonate or CR 39 optical resin, which are either dyed in the mass during manufacture or coloured by imbibition of colorant, lightweight and unbreakable filters of acceptable optical quality can be made in a thickness of about 2 mm.

Gelatin filters can be of excellent optical quality, equal to that of the best optical-quality glass filters, and with virtually no effect on image location. They are available in a range of spectral absorption properties. Because of their susceptibility to surface damage and to warping under conditions of high humidity and/or temperature, gelatin filters may be cemented between two pieces of glass of appropriate optical quality.

As an element in an imaging system, a filter should ideally also be antireflection coated to reduce the possibility of flare. This is now common practice and even multi-layer coated types are available in a limited range of types. The use of filters with wide-angle lenses needs care as if too thick a filter in its mount or one of too narrow a diameter if a 'step-down' ring is used, then image cut-off is noticeable due to mechanical vignetting.

Filter sizes

Colour filters and other optical attachments are available in a variety of sizes and forms. Gelatin filters come in sizes from 50 × 50 mm upwards, and most camera systems have special filter holders for these. Acetate filters are available in sizes ranging from small squares to large rolls, suitable for covering large areas or light fittings. Cemented filters are restricted to a few square or circular sizes. Glass filters dyed in the mass are available in a range of standard mounted diameters such as 49, 52, 58, 67 and 100 mm. It is desirable to have antireflection coatings on both glass surfaces to reduce reflection losses and the possibility of lens flare. Multi-layer coatings are used on some of the more expensive filters.

Optical filters may be positioned in front of, behind or even inside a lens. Rear fitting allows filters of smaller diameter and high optical quality to be used. Lenses with filter turrets usually have the filters positioned between lens elements. A variety of fittings including push-on, screw and bayonet attach-ments are used. Often a single filter size is common to a range of lenses, allowing economy. Compendium-type lens hoods using extensible bellows allow filter discs or squares to be fitted to the rear. Other systems allow the use of several filters and attachments in tandem, each being capable of independent rotation or shifting for variation of effect.

Being part of the image-forming system, filters should be treated with care, handled as little as possible and kept scrupulously clean. Gelatin filters in particular must be kept cool and dry when not in use. Filter mounts should not stress or distort the filters when in position, otherwise image quality may suffer.

A colourless 'haze' or UV-absorbing filter is often used as an 'optical lens cap' to protect the front element of the lens from damage on the grounds that it is cheaper to replace even a high-quality filter than to pay for repair to a lens. There is, of course, little optical justification for this, as modern optical glasses are almost completely opaque to UV radiation so there is no real need for a UV filter.

Filters and focusing

When using filters in conjunction with a camera, problems may arise with respect to the accuracy of focusing the filtered image. Glass filters (especially the cemented variety) if used *behind* the lens may be thick enough to cause a significant displacement of the image plane of the lens (by approximately one-third of the filter thickness). Visual focusing on a screen with the filter in place is thus essential, at least in close-up work. If a filter is very dense or even visually opaque, as in the case of certain UV and IR transmitting filters, then substitution of a clear glass blank of identical thickness is necessary. Correction for the appropriate UV or IR focus is then applied. This problem does not arise with thin gelatin filters. For infrared photography, when a visually opaque filter is to be used, focusing may be carried out through a substitute tricolour red filter. A photographic focusing test may have to be done for critical work involving UV and IR filters to compensate for uncorrected chromatic aberration.

In colour-separation work, where exposures are to be made through dense tricolour filters, the original should be focused using the tricolour green filter, as the wavelength of peak transmission of this filter approximates to the peak sensitivity of the eye.

In the case of SLR cameras, the presence of a colour filter permanently tinting the viewfinder image may be found irksome, especially with deeper colours such as orange, green or red. There may be difficulty in visualization of the picture or in focusing the image in poor light conditions.

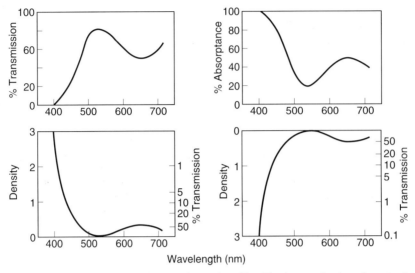

Figure 11.2 Methods of showing spectral absorption data for a colour filter. The four graphs show the same data for a pale green filter plotted in different ways to show the variations in curve shape given

exposure time such as 10 s and altering the lens aperture accordingly. Cameras incorporating through-the-lens exposure metering may give the correct compensation for certain filters such as neutral density, polarizing and pale light-balancing types, but with others anomalies may arise owing to the mismatch of spectral sensitivities of the measuring photocell and the sensitized material in use. Beamsplitter devices in the camera may cause also incorrect indication of exposure when linear polarizing filters are used, depending on the orientation of the polarizing axis to the optical axis. In such cases involving autofocus or metering systems special circular polarizing filters must be used instead of the usual linear varieties.

Filter materials

When a filter is required, it is important to use one specially designed for photographic use, with appropriate spectral and optical properties, rather than any convenient coloured piece of glass or plastics material, with unknown spectral absorption properties and inadequate optical quality.

Optical filters should be free from surface defects, and should have faces that are accurately parallel, otherwise the performance of the camera lens may be degraded. If they are to be used for photomacrography or other close-up work they should be as thin as possible to avoid possible displacement of the optical image if they are inserted after focusing. So important are the possible effects on image quality that some

lens designs such as fish-eye and mirror types are computed to be used with a suitable filter permanently in place among the lens elements. Such lenses have a selection of filters for monochrome photography in a turret as an integral part of the lens casing, usually including a colourless filter for normal colour photography.

Filters can be made of various materials such as gelatin, cellulose acetate, polyester, solid glass, gelatin cemented in glass, gelatin coated on glass, optical resin, and dielectric-coated glass for interference filters. A convenient and permanent form is a sheet of coloured glass, termed 'dyed in the mass', but only a restricted range of spectral transmittances is available. Some filters, such as heat-absorbing and ultraviolet transmitting filters, are available only in glass form. When filters of special transmission characteristics are required (as for example in technical, scientific and colour photography), dyed-gelatin filters are usually employed. These are made either by surface absorption of suitable dyes into gelatin layers or by mixing organic dyes in gelatin and coating this on glass. When dry, the coated film (which is about 0.1 mm thick) is stripped from the glass. It is supplied lacquered on both sides for protection. Light filters intended for use in an illumination system rather than in the image-forming space may be of lower optical quality and lower cost. Darkroom safelight screens may be of plastics or coated glass, protected by a cover glass.

Where constant handling is unavoidable or where high temperatures may be encountered or where large sizes are required, dyed cellulose acetate or acetate-butyrate sheet provides a useful filter material. Being

11 Optical filters

A wide range of optical filters is available for use with cameras. Filters are used to modify the transmitted spectral characteristics of the image-forming light by selective absorption. Other attachments used in front of the lens can be spectrally non-selective, but usually alter the nature of the image.

Optical filters

Spectral absorption

A *colour filter* consists of a transparent flat sheet of coloured material, usually placed in front of, within or behind a camera lens. It acts by selective absorption of the light incident upon it, as shown in Figure 11.1. A coloured opaque object such as a yellow sheet of paper reflects green and red light and absorbs blue, so a yellow transparent object transmits green and red light and absorbs blue. Such a filter is called an *absorption filter*, and achieves its effect in a different manner from an *interference filter*. Colour filters give control of tone and colour rendering with panchromatic and colour films; but with orthochromatic (blue and green sensitive) materials, only yellow filters can be usefully employed, and colour filters have no applications with materials sensitive only to blue light, other than as darkroom safelights.

Absorption data

The spectral transmission characteristics of a filter are shown by a graph in which a measure of spectral transmission (T_λ) is plotted against wave-

length (λ). *Transmittance* (or its reciprocal *absorptance*) may be normalized, or expressed as a percentage. Both arithmetic and logarithmic scales are used. Optical transmission density is usually plotted against wavelength, giving a spectral absorption curve (Figure 11.2). These curves are routinely produced by an instrument such as a recording spectrophotometer.

Filter exposure factors

To retain correctly exposed results when using a filter, an increased camera exposure must be given, to compensate for the absorption of light by the filter as appropriate. This increase may be obtained either by increasing the exposure time or by using a larger aperture. The ratio of the filtered exposure to the corresponding unfiltered exposure is termed the *exposure factor* or *filter factor*. The value of the filter factor for any given filter depends on the spectral absorption of the filter, the spectral quality of the light source used, the spectral sensitivity of the photographic material or sensor used, and the exposure duration (if reciprocity-law failure effects are significant). Often a filter may be described as '2× yellow' or '4× orange', implying filter factors of 2 and 4 respectively, regardless of the particular conditions and photographic material in use. Alternatively, the effect on exposure may be given as a negative EV (exposure value) number, e.g. –1 EV and –2 EV for the examples above. Although such general filter factors may be incorrect under some particular exposure conditions, their values do give an idea of approximate corrections, at least for filters with relatively low filter factors, when used with panchromatic film.

Filter factors are determined in a number of ways. One practical method is to photograph under the same conditions of illumination, a subject such as a neutral grey scale, first without a filter, then with the filter, giving a range of exposures in the latter case. The filtered image having the same range of densities as the unfiltered one is selected, and the exposures compared; the filter factor is the ratio of the two exposures. Dense filters (such as those used in colour separation work), which require large increases in exposure, can measured in terms of *intensity filter factors*, using a fixed

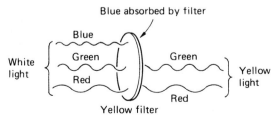

Figure 11.1 Selective spectral absorption by a colour filter, in this case a yellow filter

era. The lens used has to be of longer focal length than the standard one to permit focusing on infinity with the added extension of the bellows between lens and camera body. Wide-angle work is not usually possible. One manufacturer (Hasselblad) can supply an alternative camera body that is essentially a precision extension bellows that can take a lens, even a wide-angle type, at one end and a focusing screen or film magazine at the other.

Bibliography

Harris, M. (1998) *Professional Architectural Photography.* Focal Press, Oxford.

Harris, M. (1998) *Professional Interior Photography.* Focal Press, Oxford.

Ray, S. (1994) *Applied Photographic Optics*, 2nd edn. Focal Press, Oxford.

Stroebel, L. (1993) *View Camera Technique*, 6th edn. Focal Press, Stoneham, MA.

Figure 10.18 A perspective control lens for the 24×36 mm format. The control for the lateral shift movement is at the left and the shift is calibrated in millimetres

Figure 10.19 A shift camera. A much simplified construction is used with a shallow rigid body and helical focusing on the lens barrel. A single control sets the amount of shift

Such lenses are useful with digital cameras, especially for still-life studio subjects with full correction and control of depth of field.

PC lenses have complex retrofocus optical designs but have almost no automation of operating functions other than a simple preset aperture diaphragm. There is no autofocus and manual metering is best done stopped down to the selected aperture. PC lenses are easily adapted to a variety of other cameras for wide-angle and panoramic work. The usable image circle is some 56 mm in diameter compared with the 43 mm of other lenses for the 24×36 mm format.

Slide projectors may be fitted with *PC projection lenses* to provide a lateral shift of the projected image to coincide accurately with that of an adjacent projector with no loss of sharpness or keystone distortion to a trapezoidal shape. This accurate overlap of images is essential in multi-projector installations for multi-media presentations.

In the absence of camera movements or a PC lens, necessary corrections to inadvertent tilt effects in an image can be corrected by *digital image processing* techniques. The image is converted to digital form and then the necessary geometrical distortion is applied by trial and error to give the 'corrected' shape. This is analogous to using movements in an enlarger to change image shape, and in particular, both are frequently used to correct for converging verticals.

Shift cameras

Arguably, the camera movement most frequently used outdoors is *rising front*, and for studio work it is *drop front*, both providing correction of vertical lines from a low or a high viewpoint respectively. This movement is provided in a range of *shift cameras* (Figure 10.19) in both medium and large formats, as well as to a lesser extent in some panoramic cameras. Shift cameras are greatly simplified versions of wide-angle cameras to provide very accurate register of film plane to the lens and precisely controllable amounts of shift. Such cameras can make full and efficient use of a new generation of extreme wide-angle rectilinear lenses which have great covering power and field of view of typically 100 degrees. In use it is essential that such cameras are equipped with accurate spirit levels to ensure that the film plane is truly vertical, as only a small error can cause unwanted geometrical distortion of the image due to the very wide angle covered.

It is possible to use an extension bellows fitted with movements to provide a form of shift cam-

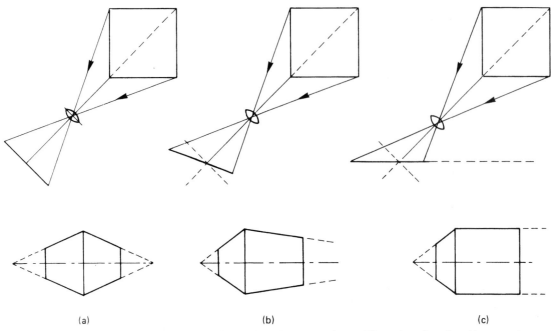

(a) (b) (c)

Figure 10.16 Perspective control by alteration of image shape. As an example, an oblique view of a cube with progressive swing of the film plane to be parallel to the front face gives image shape and vanishing points as shown from (a) to (c)

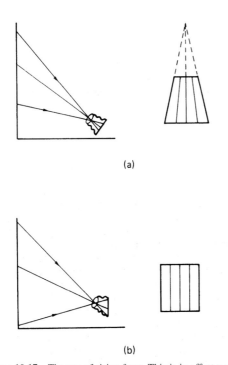

(a)

(b)

Figure 10.17 The use of rising front. This is in effect a rear tilt movement to remove the convergence of vertical lines. (a) Conventional oblique view. (b) Film back parallel to vertical subject

Perspective control lenses

Most small- and medium-format cameras lack movements other than focusing; but lenses are available as alternatives which incorporate a limited range of translational and rotational movement as part of the construction of the lens barrel and mount (Figure 10.18). They are called *perspective-control* (PC) or 'shift' lenses. They are of semi-wide-angle or wide-angle types with the necessary extra covering power to allow up to 11 mm of lateral displacement or 10 degrees of tilt relative to the 24 mm side of the 24 × 36 mm format. Usually the lens can be displaced in only one direction by mechanical movement, but by rotating the whole lens the direction of the shift axis can be changed, to allow the equivalent of rising and drop front or cross front. Even with full movement applied, hand-held exposures are possible, provided moderate apertures are used. Although such lenses cannot give a 35 mm camera the full perspective control available with a view camera equipped with an extensive range of movements, they do make it possible to produce satisfactory record photographs of (for example) architecture, under circumstances where large-format equipment would be unacceptably cumbersome. One manufacturer (Canon) offers a range of tilt and shift (TS) lenses with focal lengths of 24 mm, 45 mm and 90 mm to deal with a variety of subjects.

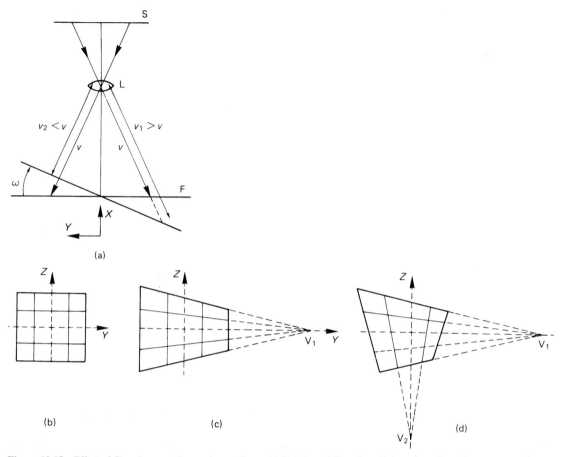

Figure 10.15 Effect of film plane rotation on image shape. (a) Rotation of film plane F through angle ω alters v to v_1 and v_2 and changes magnifications. (b) Appearance of subject with all movements neutral. (c) With rear swing about Z axis to give vanishing point V_1. (d) With combined rear swing and tilt about Z and Y axes respectively to give vanishing points V_1 and V_2

deliberate changes in perspective, for example to make lines inclined to the film plane parallel, and to make parallel lines converge towards a vanishing point. By making the film plane more parallel or less parallel to the plane of the subject, linear detail can be made to converge respectively to a lesser or greater extent. The result in turn is a 'flattening' or 'steepening' of perspective (Figure 10.16), but of course the viewpoint due to the lens position does not change. The term 'perspective control' is often used to describe this type of manipulation of the optical image.

A common application of such perspective control is in the photography of buildings, where an oblique viewpoint with a camera in neutral mode gives a true perspective rendering but with unacceptable converging verticals in the picture. The preferred 'drawing', (i.e. with the vertical lines remaining parallel) is obtained by restoring the film plane to the vertical. In

practice the photographer usually uses the rising front (Figure 10.17).

An anomalous effect may sometimes arise in such 'corrected' photographic images: it is a purely subjective keystone effect. Although the verticals in the print are indeed parallel, they nevertheless appear to be diverging, for example at the top of a building, resulting in a top-heavy appearance. The reverse effect arises when a high oblique viewpoint is used with drop front to retain parallel linear features: the subject then appears wider at the base. The best way of avoiding this is to apply somewhat less of the camera movements than would be suggested by theory. The cause of this anomalous effect is not simply an optical illusion: it is that the outermost part of the field of view actually becomes elongated because of geometrical distortion in the image when it is subjected to this type of 'correction'.

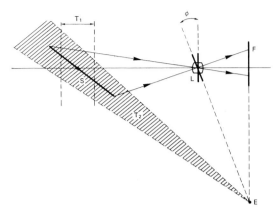

Figure 10.12 Depth of field and camera movements. The inclined subject S is not fully within the depth of field T_1 until lens is rotated through angle ϕ to satisfy Scheimpflug's rule, locating S within depth-of-field zone T_2

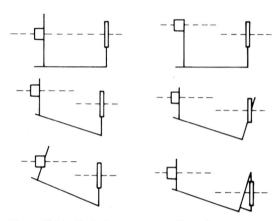

Figure 10.14 Equivalent movements. Dependent on mechanical design limitations, a particular camera movement may be given in various ways, as shown here for rising front, using base and centre tilts on front and rear

for a specific purpose. Tilts are used in conjunction with the aperture setting to obtain a volume of sharply rendered subject space of wedge shape which is judiciously positioned to encompass all of the subject matter that is required to be in focus (see Figure 10.12). Careful use of rotational movements allows minimal use of the iris diaphragm, so allowing a lens to be used at larger apertures, giving better optical performance and allowing shorter exposure times and reduced lighting levels. The main limitation on the use of combined swing and tilt movements is that of mechanical design and the fact that the image framing shifts when movements are used. Some camera designs use a 'segment tilt' or 'radial tilt' of the standards which avoids this problem by allowing the rotational axis to be positioned precisely in the film plane and to correspond to the part of the subject focused upon (Figure 10.13).

The (theoretically) simple camera movements of displacement and rotation may only be realizable in some camera designs by the simultaneous use of several movements to give the equivalent of one simple movement (Figure 10.14).

The efficient use of swing and tilt movements is hampered in practice by uncertainty concerning the exact position of the axis of rotation. Lenses mounted in a panel seldom have the rear nodal plane corresponding to the axis of rotation. In the case of telephoto lenses, the rear nodal plane is in front of the lens barrel itself and any angular movement needs to be greater than might be expected. However, such lens designs seldom have extra covering power, and do not lend themselves to use of camera movements. Centre tilt would appear to be advantageous, as little or no refocusing is required after use, in contrast to the application of base tilt, but film holders can be inserted unobstructed with the latter design. Some cameras provide both base and centre tilts.

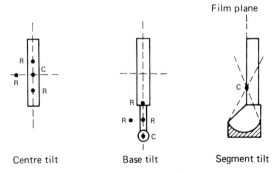

Figure 10.13 Tilts and mechanical designs. C is the centre of rotation, which does not usually coincide with the rear nodal point of the lens or the film plane. The segment or radial tilt is the exception. C may be located elsewhere, denoted by R

Control of image shape

A view camera with all movements at neutral, imaging a planar subject perpendicular to the optical axis, will give (within the usual practical limits) an undistorted image which is a true perspective rendering of the subject. If the film plane is swung (or tilted) and the lens is also swung to satisfy the Scheimpflug condition, then the image shape will also alter (Figure 10.15). Lines formerly perpendicular to the rotation axis will now converge to a 'vanishing point' of perspective. This is due to the alteration in the image conjugate v while the subject conjugate u remains constant, resulting in a change in magnification. This change in image shape can be used to produce

From similar triangles baO and bRB,

$$\frac{aO}{RB} = \frac{ab}{Rb}$$

Substituting

$$\frac{1}{u} + \frac{1}{v} = \frac{1}{f\left(\dfrac{ab}{Rb} + \dfrac{Ra}{Rb}\right)}$$

$$= \frac{1}{f\left(\dfrac{ab + Ra}{Rb}\right)}$$

but since ab + Ra = Rb, then the quantity in brackets is unity. So the relationship $1/u + 1/v = 1/f$ holds true for the condition that the three planes meet in a common line.

The Scheimpflug geometry is usually set up by eye, and fine-tuned using the focusing screen; but it is possible to arrive at optimum settings by use of special calculators or calibrations on the lens movement controls. Special enlargers called *rectifying enlargers*, which are equipped with movements, were once used to correct for the effects of 'tilt' in aerial photographs. Mechanical linkages were used to retain automatic setting of the Scheimpflug relationships as well as autofocus.

Limits to lens tilt

When camera movements, and in particular lens tilt movements, are used to control image sharpness according to the rules given above, the optical axis of the lens will not in general pass through the centre of the film frame. This means that extra covering power will almost always be needed. A lens with a useful angle of field of 70 degrees, used as a standard lens for a format giving 52 degrees FOV, allows a tilt of no more than about 15 degrees (Figure 10.10), bearing in mind the limitations imposed by $\cos^4 \theta$ fall-off. The limits are increased a little for close-up work, and with the use of small apertures.

In theory, the camera back may be swung to almost any extent, provided that the format remains within the cone of illumination from the lens. In practice there are two limitations, the variations in image illumination and in image shape. The limit to rear tilt movements, and the associated exposure variation across the format, is shown in Figure 10.11. It can be seen that a tilt of no more than 15 degrees results in an illuminance ratio of some 0.6 (approximately 0.5 EV) at the rear and far edges of the tilted film

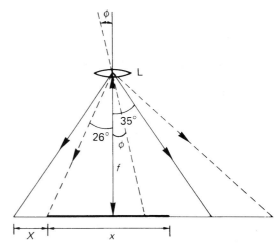

Figure 10.10 Limits to front movements. A standard lens L set at infinity focus with FOV 70 degrees covers a format with a dimension x to allow a maximum lateral displacement of X. A maximum tilt of ϕ is possible, where $\phi = (35-26) = 9$ degrees.

plane. The change in image shape with application of rear tilt is even more important. There is a change in magnification m as image conjugate v varies with tilt, while subject conjugate u is unaltered in the relationship $m = v/u$.

The choice of a lens and of a camera with an appropriate range of movements should be considered on the grounds of optical limitations.

In practice, a combination of front and rear tilts may be used to obtain the necessary sharpness, if the subject allows for some distortion. Tilt in an opposite direction may be used to *reduce* the zone of sharpness

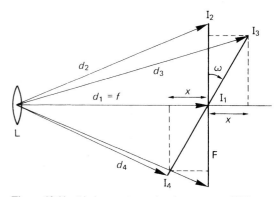

Figure 10.11 Limits to rear rotational movements. With lens L set to infinity focus, $d_1 = f$. Film plane F is swung through angle ω. To a first approximation, $d_3 = d_1 + x$ and $d_4 = d_1 - x$. For a typical value of ω of 15 degrees, $d_3 = 1.13f$ and $d_4 = 0.87f$. So image illumination ratio I_3/I_4 is $(0.87)^2/(1.13)^2 = 0.6$

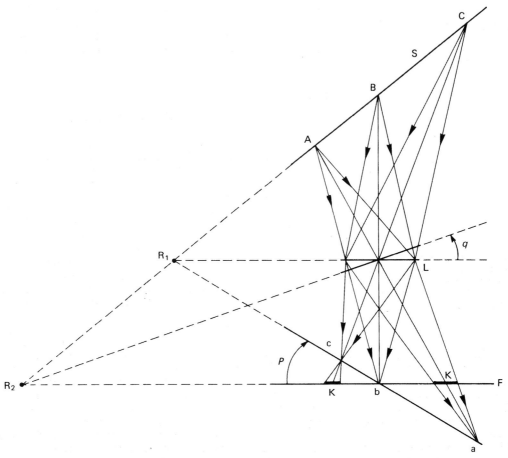

Figure 10.8 Rotational movements and Scheimpflug's rule. Points A, B and C on subject plane S give image points a, b and c and circles of confusion K on film plane F. Rotating F through angle *p* to intersect with S and lens plane L at R_1 gives sharp focus and satisfies Scheimpflug's rule. But leaving F and instead rotating L through angle *q* to give intersection at R_2 will also give overall sharp focus on S

aQ, BD and bC represent *f*, *u* and *v* in turn. Then

$$\frac{1}{u} + \frac{1}{v} = \frac{1}{Rb \sin \beta} + \frac{1}{Rb \sin \alpha}$$

$$= \frac{1}{RB\left(\dfrac{f}{aO}\right)} + \frac{1}{Rb\left(\dfrac{f}{Ra}\right)}$$

$$= \frac{1}{f\left(\dfrac{aO}{RB} + \dfrac{Ra}{Rb}\right)}$$

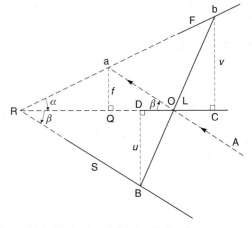

Figure 10.9 Derivation of Scheimpflug's rule

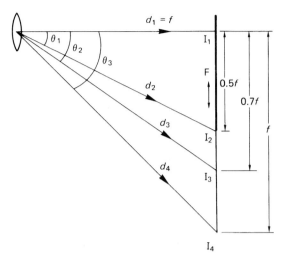

Figure 10.7 Displacement movements and image illumination. Geometry of image formation at infinity focus for a standard lens with normal (θ_1), extra (θ_2) and exceptional (θ_3) covering power. F is the film format. (See also Table 10.2)

power for that format gives exceptional covering power for the smaller format. Thus a 210 mm wide-angle lens for an 8 × 10 inch format used with a 4 × 5 inch format offers a slightly long-focus lens with a circle of good definition of diameter some 500 mm relative to the format diagonal of 164 mm.

The extent of the translational movements may be limited not only by covering power available, but also by the type of film used. This is because the exposure latitude of the film has to allow for the $\cos^4 \theta$ factor in the decrease of image illumination at the edge. At extremes, one side of the film format may be on axis, the other side at the image periphery. Figure 10.7 shows the situation with a lens of focal length f allowing a displacement of up to 0.5f within an image circle of diameter 2f. The natural vignetting gives illumination values and losses as detailed in Table 10.2. Given a change in exposure level of not more

than 0.5 EV across the format, then a FOV of 70 degrees for a standard lens, allowing a maximum displacement movement of 0.2f, is a reasonable limit for infinity focus. Individual lenses need to be tested for their capabilities.

Control of image sharpness

Image sharpness in a photographic record is usually controlled by suitable choice of focused distance, lens aperture and focal length to ensure the necessary depth of field. Large-format cameras use lenses of long focal length; and even with the increase in diameter of the acceptable circle of confusion and the small apertures available, depth of field may be inadequate, especially for an extended subject inclined to the optical axis. Figure 10.8 shows the geometry of such a situation, with the lens focused on a subject point on axis, and near and far subject points focused behind and in front of the film plane respectively, giving large circles of confusion and consequent out-of-focus images on the film. It is evident that rotation of the film plane to coincide with the other foci will give a sharp image overall. It may be less obvious that a similar effect can be produced by keeping the film plane static and instead rotating the lens. Theoretically the two solutions are equivalent, and lead to Scheimpflug's rule that an inclined subject plane is rendered sharp when the plane of the subject, the rear nodal (principal) plane of the lens and the film plane or photoplane, all extended into space as necessary, meet in a single line. As a proof of this, consider Figure 10.9, which shows the subject plane S, rear nodal plane L and film plane F extended to meet in a common line R. If the lens conjugate equation is satisfied for all points on plane S, then all of the plane will be in focus.

For a point A at infinity and a point B on S whose image points are a and b respectively, both rays Aa and Bb pass through the optical centre O. Let Aa be parallel to BR. Construct perpendiculars from B, b and a to the plane L, so that the distances

Table 10.2 Exposure variation limits to displacement movements

Lateral displacement of format in terms of lens focal length f	Necessary semi-FOV of lens (degrees) (θ)	Distance of edge detail from lens in terms of f (d)	Illumination (I)	Exposure change (EV)
		$d_1 = f$	$I_1 = 1$	0
0	26.6	$d_2 = f/0.894$	$I_2 = 0.8$	−1/5
0.2f	35	$d_3 = f/0.819$	$I_3 = 0.67$	−1/3
0.5f	45	$d_4 = f/0.707$	$I_4 = 0.5$	−1

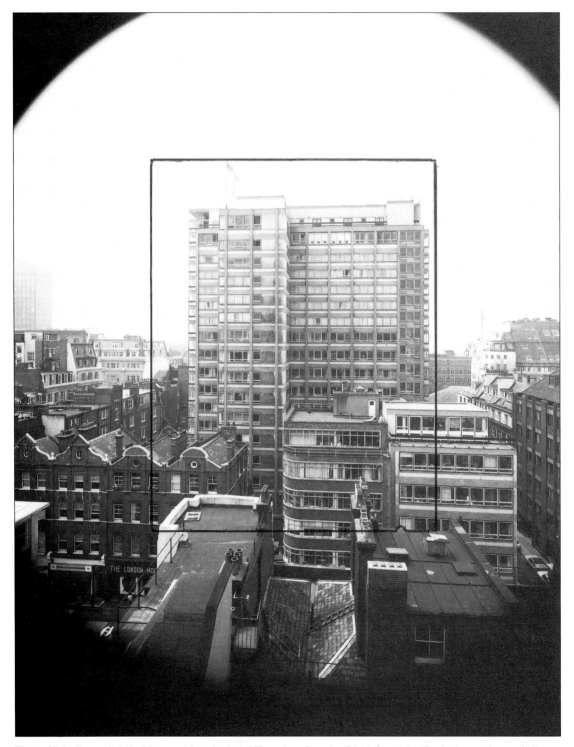

Figure 10.6 Image circle and lens covering power. A 150 mm lens for a 4 × 5 inch format (outlined) gives an image circle larger than the format, allowing extensive camera movements to be used. The lens was used on a 8 × 10 format camera to produce this image. Lack of covering power or too much movement used will result in cut-off by vignetting

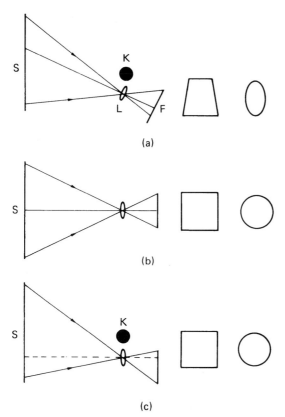

Figure 10.4 Use of translational movements. (a) An enforced oblique view of subject S, due to obstruction K. Square and circular subjects are imaged as trapezoidal and elliptical respectively. L camera lens; F film plane. (b) Ideal square-on view without movements. (c) An oblique view using cross-front movements to simulate a square-on view. All views are from above

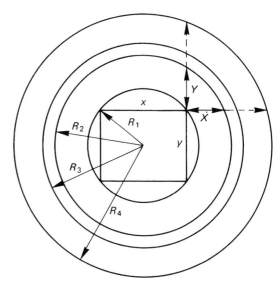

Figure 10.5 Lens covering power and camera movements: the format $x \times y$ related to image circles of various radii R. Key: R_1 format semi-diagonal, as covered by a large aperture or telephoto lens at infinity focus; R_2 lens with extra covering power of 70 degrees, infinity focus, full aperture; R_3 lens used at $f/22$; R_4 lens used at $m = 1$, Y possible vertical shift, X possible horizontal shift; $\sqrt{(X^2 + Y^2)}$ is the maximum combined displacement movement

gives X-translation and rotation combined. An eccentric lens panel allows translation movements as a rotation of the optical axis about the camera axis. The film plane may have X-rotation in the form of a *rotating back* which revolves the film-holder 90° continuously from a vertical to a horizontal position, or even through 360°. The important rotations are those about the Y and Z axes, referred to as *tilt* and *swing* respectively. Front and rear tilt and swing may be used either individually or in combination, or in conjunction with displacement movements. For some purposes, front or rear tilt or swing may be used interchangeably; but in general those of the lens are used to control the distribution of *sharpness* in the image, and those of the film holder to determine the *shape* or 'perspective' of the image (details are given below). The allowable amount of lens movement is dependent on the covering power of the lens used.

Lens covering power

The covering power of a lens is the diameter of the circle of good definition in the focal plane. This value is less than or (rarely) equal to that of the circle of illumination from the lens. Covering power is a minimum at maximum aperture and infinity focus, but increases as the lens is progressively stopped down, or focused closer (Figure 10.5).

A lens designed for use with camera movements usually has *extra covering power* to give a circle of good definition significantly larger than the format in use (Figure 10.6). The film area remains within the circle of good definition when translational movements are used or when the lens is tilted or swung. It is common practice to use as a standard lens for a given format which can accommodate some 50 degrees, one with a covering power corresponding to a field of view (FOV) of some 70 to 80 degrees, hence allowing some 10 to 15 degrees of lens rotation or tilt. Wide-angle lenses may have less additional covering power. Where the FOV on the format is not of prime concern but extensive movements are needed, then a 'long-focus wide-angle' technique may be used. This means that a wide-angle or standard lens for a larger format is used, so that the extra covering

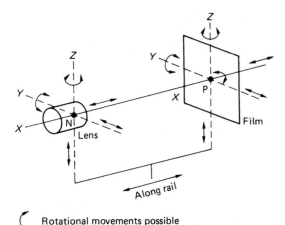

(Rotational movements possible

←—→ Translational movements possible

Figure 10.3 Monorail camera with its movements neutral. The optical axis and the camera axis are coincident in this neutral position

Translational movements

The first group of movements are those of lateral displacement or translation ('shifts') along mutually orthogonal *XYZ* axes, which are centred ideally either at the rear nodal point of the lens (so that the *X* axis is by convention the optical axis when horizontal), or at the image principal point P where the optical axis intersects the film plane orthogonally at the centre of the format (Figure 10.3). For the purpose of this chapter the rear *X* axis is called the *camera axis* and the front *X* axis the *lens axis*. Initially a view camera may be set up with both

lens and camera axes coincident, colinear and horizontal, the so-called *neutral position*, after which camera movements can be applied, including tilting the combined axes from their horizontal orientation.

Movements along the *X* axis give *front focus* or *rear focus* with reference to the lens panel and film holder respectively. The former movement alters sharp focus and magnification together, the latter alters focus at a fixed magnification. Alternatively, both standards may be moved together at a fixed separation to obtain sharp focus on the subject by moving the whole camera. Front and rear linear movements along the *Y* (transverse) and *Z* (vertical) axes are useful to centre the subject on the film format without tiresome small adjustments of the camera on its stand. These 'rising', 'falling' and 'cross' movements are also useful in retaining parallel lines or features in the image where a centralized viewpoint is not possible. The film plane needs to be kept vertical or parallel to the subject (Figure 10.4).

An important consideration is the *covering power* of the lens, which determines the permissible extent of translational movements.

Rotational movements

In theory, both the lens and the film plane may be rotated about each of the *XYZ* axes, these three rotational and three translational (displacement) movements giving a total of six degrees of freedom for each. In practice the lens is not rotated about its *X* axis (optical axis) as it is axially symmetrical. With a helical focusing mount, the focusing action

Table 10.1 A summary of camera movements using the notation of Figure 10.1

Type of movement: D displacement R rotational	Axis used: L lens C camera	Usual name of movement	Prime function or use
D	X_L	Front focusing	Focusing, with change in magnification
D	Y_L	Cross front	Position image on film
D	Z_L	Rising front	Position image on film
		Drop front	Correction of verticals
R	Y_L	Tilting front	Depth of field zone
R	Z_L	Swing front	Depth of field zone
D	X_C	Rear focusing	Focusing, no change in magnification
D	Y_C	Cross back	Position image on film
D	Z_C	Rising back	Position image on film
		Drop back	
R	X_C	Rotating back	Alter aspect ratio of image on film
R	Y_C	Tilting back	Depth of field and image shape
R	Z_C	Swing back	Depth of field and image shape

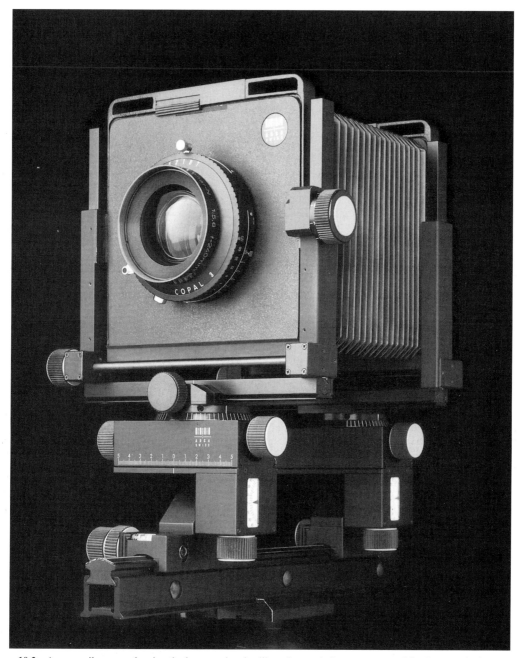

Figure 10.2 A monorail camera showing the lens panel and calibrated controls for movements of the front standard

millimetres. A rotational movement may be about an axis either through the standard, termed *centre tilt*, or about an axis located near the monorail, termed *base tilt*; or the axis may be movable to various positions. Each has advantages and limitations. Some of the various camera movements may also be found in medium format cameras and perspective control (PC) lenses.

The various possible movements in a view camera are shown in Figure 10.3, and are detailed in Table 10.1. These movements are the 'degrees of freedom' of the imaging system.

10 Camera movements

Introduction

Much professional photography is carried out using large-format cameras (Figure 10.1). These offer high image quality and versatility due to modular design and *camera movements* used for control of focus, distribution of image sharpness and the shape of the image. A direct-viewing focusing screen is essential.

Such cameras are called *view cameras* or *technical cameras*. They may be of *monorail* or *folding*

baseboard construction, the former giving unsurpassed versatility. The monorail design uses the principle of an optical bench carrying the front and rear *standards*, which in turn carry the lens panel (Figure 10.2) and film holder respectively, and which are connected by a flexible or pleated bellows. The standards may be of U or L shape, and the various movements usually have click-set 'neutral' positions and are lockable in other positions. Rotational movements are usually calibrated in degrees and translational ('shift') movements in

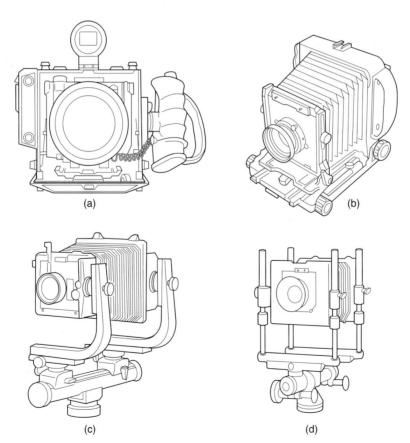

(a)

(b)

(c)

(d)

Figure 10.1 Types of large format cameras. (a) Folding baseboard camera with coupled rangefinder and optical viewfinder. (b) View camera or field camera of baseboard type. (c) Monorail camera with L-shaped standards to take the lens panel and focusing screen. (d) A monorail camera of simple construction with U-shaped standards

obscure vital information, it is better to print the data on rebates. Command backs supply a wide range of data such as shutter speed, aperture, program mode, frame number, focal length, date, time, use of flash etc. An alternative is to have the specified data for each frame encoded and stored in RAM memory in the camera or command back, to be later interrogated and downloaded into a PC for printing. Exposure data for several rolls of film can be stored in this way. One system imprints all exposure data and frame information upon rewinding the film, using the first two frames, which have been deliberately left blank for the purpose.

The Advanced Photographic System (APS) first introduced in 1996 has a variety of data recording capabilities as it features a full area transparent magnetic coating, capable of encoding some 2–8 kbytes of information per frame. This information includes that specific to user and processing needs, such as format required and simulated focal length, but potentially, frame-related sound recording and control data as well. The full film length carrying images and magnetic data is retained encapsulated in its protective cassette after processing. Comprehensive data can be printed on the front or reverse of machine prints from the *information exchange* (IX) system used. A significant amount of exposure and other information can be printed on the reverse of a print.

A digital camera can record detailed information for each exposure, available when downloaded to a computer. Interfacing is possible with a mobile Global Positioning System (GPS) unit to provide the exact location of the viewpoint of an image by imprinting the latitude, longitude and elevation of the camera at the moment of exposure. This feature is useful where location is important in an application.

Bibliography

BS ISO 516:1999. *Photography – Camera Shutters – Timing*. British Standards Institute, London.

Crompton, T. (1995) *Battery Reference Book*, 2nd edn. Newnes, Oxford.

Goldberg, N. (1992) *Camera Technology*. Academic Press, San Diego, CA.

Ray, S. (1983) *Camera Systems*. Focal Press, London.

Ray, S. (1994) *Applied Photographic Optics*, 2nd edn. Focal Press, Oxford.

Ray, S. (1999) *Scientific Photography and Applied Imaging*. Focal Press, Oxford.

may switch off the camera after a short time, varying from 30 seconds to several minutes. This switch-off can occur at the most inconvenient moment, when a picture is about to be taken. Slight pressure on the shutter release will keep power on. Other means of saving battery power include having mechanical latches on camera shutters for long exposure times using the 'B' setting. Electronic flashguns use very effective thyristor-controlled energy-saving circuitry to discharge the capacitor only as much as necessary, also the unit may switch off if not used for a few minutes. Battery drain depends on circumstances, type of circuit and type of battery. Some metering or shutter control circuits are largely independent of the state of the battery, others such as SPD circuits require a stabilized voltage, so batteries are favoured that have a near constant output during their operation and life. Heavy duty applications such as motor winders and flashguns need moderate voltage and short bursts of heavy current, supplied by clusters of alkaline-manganese or nickel-cadmium cells. Medium format cameras with integral motor drives also have heavy-duty needs.

A battery uses cells in series and each electrochemical cell uses dissimilar electrodes and a suitable conducting electrolyte, which can be liquid, gaseous, viscous or near solid. Leakage of electrolyte can be disastrous and damage equipment severely, so batteries should be removed when equipment is not needed for a time. Chemical reactions cause a gradual loss of voltage, from an initial value which is some 1.2 to 2 volts per cell. Shelf life varies for unused batteries, but can be five years or more in the case of lithium types. A battery tester may be incorporated to check voltage before use. Batteries should be changed in sets, not just one discarded when found to be discharged. Batteries are either of the throwaway or rechargeable type. The first is disposed of when exhausted and it is very dangerous to attempt to recharge it as the gases formed may cause it to explode. The rechargeable cell uses a trickle DC current of low voltage to reform the chemical cell by inducing reverse reactions. With such cells, too rapid a discharge or charge must be avoided as internal damage and heating may occur. Types of rapid recharging batteries are available such as lithium ion and nickel metal hydride types. The popular nickel-cadmium (NiCd) type may be recharged several hundreds of times in a normal lifetime of use, but does not last indefinitely. The lower internal impedance of this type can give shorter recycling times in flashguns. Batteries should be inspected for corrosion before insertion and the terminals wiped with a cloth to remove any oxide film and improve contact.

A number of battery types are in use. The *carbon–zinc cell*, the oldest type, is cheap, has a short life and cannot deliver large amounts of current. It is best used only in an emergency if other varieties are unobtainable. Zinc chloride types give improved performance.

The *alkaline cell*, or manganese-alkaline type is similar to the carbon–zinc type but with a different electrolyte and near-leakproof construction. It has about ten times the life and a wide operating temperature. The *mercury button cell* is no longer available for safety reasons and has been largely replaced by the silver-oxide cell which has a very stable output but costly so frequently substituted by alkaline or lithium cells. The *lithium cell* uses lithium instead of zinc for its positive terminal. Combined with manganese dioxide a long shelf life is given and a useful life in a camera. Low temperature operation is possible to $-20\,°$ C. The smallest voltage available is 3 volts so it can only replace two silver oxide types used in series. The *nickel–cadmium cell* delivers $1.25\,V$ that is usually adequate unless $1.5\,V$ is essential. Newer types include the lithium ion and nickel metal hydride types, both of which are rechargeable and retain no memory of previous use.

Data imprinting

It is sometimes useful to record data associated with the image for later purposes, such as unique identification, archiving and retrieval. The data may be added during the photographic or recording process. A variety of methods and systems are used. Note that the edges of photographic material already carry a large amount of latent data imprinted during manufacture, such as codings for film type, batch, frame numbers, footage etc. These can be used for filing and editing purposes, act as a simple quality control system for processing, and also allow the image to be correctly orientated. Sheet film materials carry a complex notching system for identification. Edge-printed bar codes and binary codes as perforations in the film tongue are used for automated printing purposes. The film material may also use a transparent magnetic coating to carry information in various forms. Imprinted data may possibly only be machine readable or retrieved electronically.

Data may be either imprinted during exposure, or during wind-on, or after processing, and can be located within the image or in the rebates beside or between frames, or even on the blank frames incurred during film loading. Many cameras can be fitted with accessory *data backs* or *command backs* to provide an additional range of functions. The data can be analogue (such as a watch face or dials) or in dot matrix form using LEDs and relayed optically through the film base to imprint during exposure. The exposure for the data is frequency modulated to relate to the film speed used. Exposure is synchronized to the camera shutter, sometimes via a flash socket. Options include the date in various formats, time likewise, frame number and magnification. Imprinting data within the frame is inconvenient and can

Operation of the metering system

An integral metering system is of great practical assistance, but its operation varies. Numerous steps are involved. First, the battery power must be switched on, often by first pressure on the shutter release button. This may then initiate a *battery check function* and a *timing circuit* to limit battery use and conserve life. Then the subject must be sharply focused and the appropriate area selected for measurement if applicable. In semi-automatic exposure modes either the shutter speed or lens aperture is selected first, and then the other variable set as indicated by the meter. This may be done by 'match-needle' operation, i.e. by altering the appropriate control until a moving needle in the viewfinder readout is brought into coincidence with a fixed needle or cursor. Alternatively, an LED display may indicate the necessary setting by a flashing symbol or by a simple plus, zero and minus signs which light up as the settings are changed. Stop-down metering, where the operation is done at the chosen aperture, is now rare except for instances such as close-up photography, or for use with lenses lacking a fully automatic iris diaphragm. In fully automatic cameras there is usually a choice of one or several alternative metering modes, and the user may simply have to select one setting of aperture or shutter speed or just a letter such as S, A or P on a control dial or LCD display. The autofocus system may operate at the same time.

Automatic exposure modes

In the *aperture-priority mode* the user selects a lens aperture best suited to purposes such as depth of field or optimum lens performance. Sometimes the effective aperture may not be known of the optical system in use, such as a microscope. The metering system then gives the appropriate exposure duration by control of the shutter speed. The exposure could be of many seconds duration, when reciprocity-law failure might be anticipated, but the duration also depends on metering sensitivity. An indication is given when the exposure duration necessary is out of the shutter speed range. The use of OTF metering in 'real time' compensates for fluctuations in scene luminance *during* the exposure.

In the *shutter-priority mode* the user selects the shutter speed most appropriate to avoid camera shake or to stop a moving subject or to allow the use of electronic flash fill-in lighting. The metering system then determines the appropriate aperture. The lens usually has a separate lockable 'A' setting on the aperture control ring for this mode. Various mechanisms set the aperture to the required fractional setting, possibly to 0.1 of a stop, using motorized operation within the lens.

In the *programmed mode* the camera metering system selects a suitable combination of shutter speed and lens aperture from a program of combinations related to the subject luminance. More details are given in Chapter 19. The program may be selectable from several on offer, set by the user, and may also receive an input from the lens in use to determine the appropriate shutter speed. Programs that favour small apertures for maximum depth of field are also used. The modes may be given labels such as 'depth' or 'action' or 'portrait', where, respectively, the mode selects a small aperture for depth of field, a high shutter speed to freeze a moving subject, or a large aperture to blur the background.

When using TTL flash metering, the usual arrangement is for the user to select an aperture; the flash is quenched appropriately, giving a measured exposure duration. But *programmed flash* is also possible where the subject distance, as focused first, will determine the lens aperture for a given flash output. Other alternatives are possible.

Battery power

Modern cameras, with few exceptions, are totally dependent upon battery power for all or most of their functions. Exceptions are cameras with a mechanical shutter and lacking an exposure meter or use a selenium cell meter. Battery power is used for metering, autofocus, microprocessor operation, electronic shutter control, self-timer, viewfinder displays, and motors to advance the film, rewind it and focus the lens. Accessories such as power winders, flashguns, data backs and remote controls all use batteries. Without functioning batteries the equipment is inoperative. An exception is a 'mechanical' setting of a shutter providing a single speed suitable for flash synchronization, given a failure of the battery operating the shutter timing circuitry.

For camera equipment only low direct current (DC) voltages are required, seldom more than 6 volts. Small batteries are favoured given space limitations, but have reduced capacities, especially given the number of functions to be powered. Batteries should be inserted correctly regarding polarities. A small vent hole in the battery compartment cover allows the escape of gases produced in operation. Batteries may be in a removable holder or the compartment form part of a shaped grip on the camera body. Battery performance is related to temperature and a cold weather adapter kit may be available to allow the battery pack to be kept in a warm pocket and a long cable terminates in an adapter to go into the camera compartment. A battery condition test and indication is vital. Alternative possibilities include a button and LED signal, or a warning symbol in an LCD display of status. To conserve battery power a timing circuit

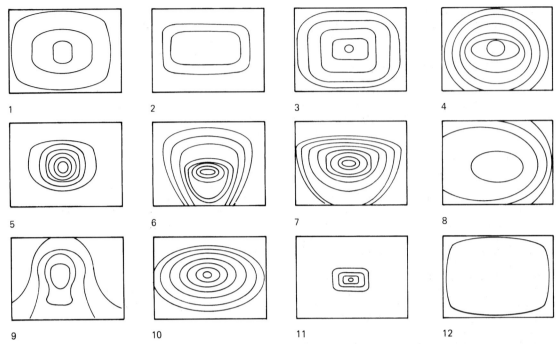

Figure 9.30 TTL metering sensitivity patterns. It is possible to plot a form of contour map of the field of view of the metering system where the lines enclose regions of decreasing sensitivity measured outwards from the centre of the format area. Twelve patterns are shown: 1 and 2, approximate integrated readings with slight central bias; 3 and 10, centre-weighted readings of differing patterns; 4, 6, 7 and 9, centre-weighted with pronounced bias to the base of the picture; 8, an asymmetric centre-weighted reading with bias to the left of the scene as is given by a reading at a medium shutter speed from a patterned blind in OTF metering; 5 and 6, pronounced centre-weighting approximating to a small area reading; 11, small area reading as given by a beamsplitter system; 12, fully integrated reading with usual slight reduction at the periphery

simultaneously from different zones of the scene, permits rapid changeover between different metering patterns or modes, and in combination with a memory programmed with a large range of optimum exposures for various scene luminance ranges and luminance distributions, the metering system may give an optimum exposure for the circumstances. The distance of the subject is also factored into the calculations (see Chapter 19). The use of fuzzy logic blurs the otherwise sharp delineation between scene categories and reduces the possibility of a sudden change in exposure with a small change in composition.

In circumstances where the metering system in use may give a wrong result due to non-typical tone distribution or luminance ratio, the use of an *exposure memory lock* control can be useful. The camera is directed at a chosen part of the scene (or at an alternative subject) and the indicated exposure settings are memorized. The camera is then pointed at the previous scene as composed and an exposure made with the predetermined values. The memory may be self-cancelling, or the data locked in until erased.

The multiplicity of methods of readings, combined with the different locations possible for the meter cell, mean that there are a number of choices of TTL-metering in cameras.

Sensitivity

The *metering sensitivity* of a TTL system is generally similar to a good selenium-cell meter for hand-held use. This is due to the loss of light by the optical and viewing system of the camera. A lens of large maximum aperture improves sensitivity, unless a stop-down measurement system is used. A SPD with amplification circuitry increases sensitivity. To compare sensitivities, it is usual to quote the sensitivity as the minimum EV number that the system can determine as an exposure when ISO 100 film is in use. For example, a sensitivity of EV 1 is typical of an SLR TTL system. A hand-held light meter, by comparison, can have an equivalent sensitivity of –4 to –6 EV, factors respectively of 32 and 128 times the TTL value.

close to the film plane, but the presence of a focal-plane shutter hinders this. A cell on a hinged or retractable arm which locates it just in front of the shutter blinds has been used, but measurements are more commonly made with the cell in an *equivalent focal plane*. This is a plane located at the same distance as the film plane from the exit pupil of the camera lens. One such plane is that of the ground-glass screen used for focusing, and this can be monitored by photocells in the viewfinder housing. A *beamsplitter* system can divert light from part of the screen to a cell located outside the screen area. The area used for measurement purposes is clearly marked on the screen.

Another equivalent focal plane is located in the base of the dark chamber or mirror housing of the camera body. A partially transparent or perforated area of the main reflex mirror transmits light via a small subsidiary mirror, termed a *piggy-back mirror*, down into the well of the dark chamber where a complex photocell arrangement is located. The cell may be a segmented type or have a supplementary aspheric lens which can be selected to give a different form of metering pattern. The autofocus system may be located here also.

A convenient but seldom-used location is to place the photocell(s) behind all or parts of the reflex mirror, with access to light by an arrangement of slits in the mirror or by making the mirror partially transparent. An additional cell reading in opposition may be needed to cancel out the error effects of light reaching the cells from the viewfinder system. Such an arrangement is unsatisfactory with interchangeable lenses if there is a change in position of the lens exit pupil. Different lenses may have exit pupils that are at different distances from the mirror along the optical axis. The measurement area of the reflex mirror then intersects the cone of light from the lens exit pupil in different positions, and samples different cross-sectional areas of the cone.

A common location is to put photocells in the housing of the pentaprism to measure the luminance of the image on the focusing screen, remembering that a change of focusing screen type may need a correction applied to the metering system, owing to changes in screen image luminance. Such arrange-ments also allow an interchangeable pentaprism housing with TTL metering to be offered as part of a camera system. This alternative is favoured for medium-format SLR cameras. The cell or cells are located either behind a pentaprism face or around the eyepiece lens. A single cell monitoring the whole of the screen area may be used, but generally two cells are employed to give a *weighted reading* to favour the central zone of the screen. This can also offset uneven illumination of the screen caused by lenses of different focal lengths. A choice of weighted or *small-area* readings may be possible. Use of a *segmented photocell* allows different

modes of use by measurement and comparison of scene luminance in different zones, sometimes termed *matrix metering*. Another ingenious solution is to position a fast-reacting SPD to respond to light reflected from the film surface itself, i.e. to the image luminance, and to terminate the exposure duration by controlling the shutter operation or by terminating an electronic flash emission. This is referred to as *off-the-film (OTF) metering*. Such an arrangement may also monitor changes in the sub-ject luminance during the exposure duration, when the mirror is raised and when other metering systems would not be operating. It has a sufficiently rapid response to monitor the output of a dedicated electronic flashgun with the necessary thyristor control circuitry. To allow for the incomplete uncov-ering of the film gate by the slit in the blinds of the focal plane shutter when giving short exposure durations, the shutter blinds may be printed with randomized arrays of light and dark patches to simulate the reflectance of the film surface and provide a form of weighted reading if required. Again, a set of segmented photocells can provide a form of matrix metering with electronic flash.

Type of reading

A TTL metering system is based on measurement of the light reflected from the subject as transmitted by the optical system in use. The meter cell does not, however, always measure all the light from the subject area covered by the lens. Several different systems are in use (Figure 9.30). A 'fully integrated' reading is a measure of all the light from the subject area, and the exposure indicated or given is liable to error caused by the tonal distribution and luminance range of the subject matter. An alternative is a 'spot' reading, where a very small area of the subject is measured; but a mid-tone grey region must be selected. There may be the choice of using a shadow or highlight spot reading and even facilities for taking several such readings from chosen parts of the scene, when the metering system will give an average reading based on these.

The 'small area' type of reading is an integrated measurement of an area of the subject too large to be considered a spot reading, but it is not a fully integrated one. This choice can give a useful compromise. The 'weighted' reading is also a com-promise where the whole image area is measured, but the central portion of the subject as viewed con-tributes most towards the result given. Various weighting patterns are in use, favouring different regions of the scene, for example to compensate for a bright sky in the upper region.

A *segmented photocell* arrangement, which takes several discrete or overlapping measurements

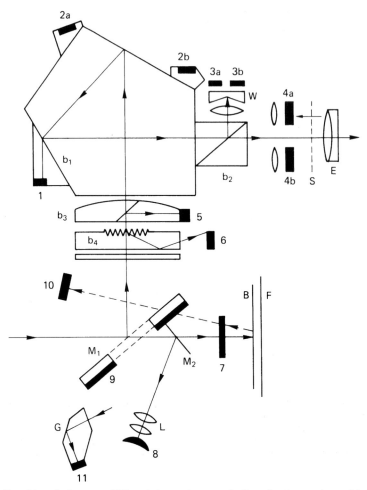

Figure 9.29 Photocell positions for in-camera TTL metering systems; a selection of systems and associated optics. (a) Screen luminance measurements: 1, integrated reading via beamsplitter b_1; 2a, 2b, photocells in series for weighted reading; 3a, 3b, segmented photocells reading via double wedge W and beamsplitter b_2; 4a, 4b, cells near eyepiece for integrated readings. Supplementary lenses give central bias. One cell may read stray light through the eyepiece for correction. E eyepiece; S eyepiece shutter. (b) Equivalent focal plane measurements: 5, small-area reading via beamsplitter b_3; 6, small-area reading via diffraction type beamsplitter b_4; 7, removable photocell on pivot; 8, photocell reading via semi-reflecting or perforated mirror M_1 and piggy-back mirror M_2, supplementary lens L added for bias; 9, photocell behind perforated mirror. (c) Measurement 'off the film' (OTF) or shutter blind B: 10, photocell for integrated reading; 11, photocell and light guide G. Cell 8 may also be used. The shutter blind may have a reflective zone

body. In theory, this should automatically compensate for the transmission losses of the lens in use, for any lens extension used, for close focusing and for the use of filters, perhaps with limitations in the last case. Measurement may be from all or only part of the subject covered by the lens in use, depending on the metering mode selected. Such a system is easily incorporated in a SLR camera and the TTL metering system is either fixed in the camera or added by means of an alternative viewfinder housing incorporating the metering system.

Many different arrangements are possible for TTL metering systems and current camera designs use most of these.

Position of the meter cell

The photocell(s) can be in various shapes or sizes without much effect on sensitivity; this allows great flexibility in the choice of location within the camera body (Figure 9.29). Ideally, the cell should be located

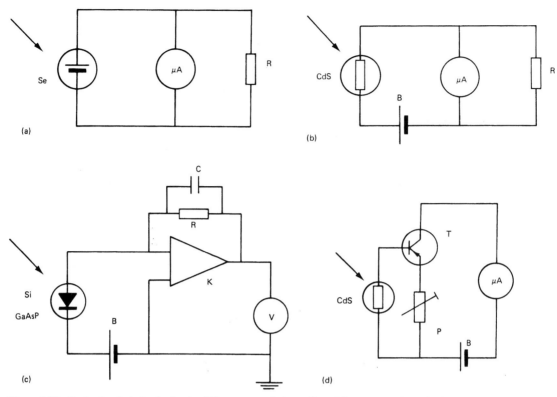

Figure 9.28 Basic electrical circuits for the different types of photocell used for exposure determination. (a) Selenium (Se) photocell with microammeter μA and resistor R. (b) Cadmium sulphide (CdS) photocell needs a d.c. power source B. (c) SPD (Si) photocell: K is an operational amplifier and R is a feedback resistor acting as a sensitivity control, C is a damping capacitor and V a voltmeter. (d) For a CdS cell a compensating-zero method circuit using a potentiometer P and an emitter-follower transistor T compensates for the non-linearity between the incident light input and photocell output

Like the CdS cell, and in contrast to the Se cell, the spectral sensitivity of the SPD cell extends from about 300 nm to about 1200 nm, with a peak around 900 nm. For photometric use in a camera or light meter, filtration to remove much of this natural IR sensitivity is necessary to give a suitable response. Such filtered varieties for use in the visible spectrum are often termed 'silicon blue' cells. Comparative electrical circuits for the operation of Se, CdS and SPD photocells are shown in Figure 9.28.

Integral metering systems

Many cameras have integral (built-in) light metering systems. The three types of photocell may be used with the cells external to the camera body, positioned in a variety of locations and ways. Because of their large size, selenium cells were generally located in the front plate of the camera or in a ring round the lens (now rare). The acceptance angle usually mat-ches that of a non-interchangeable standard lens. The smaller CdS or SPD cells have greater choice of location, but are generally positioned behind a small lens and aperture in the front plate or in the lens surround. The acceptance angle is usually smaller than that of the standard lens. Provision must be made for a battery and an on–off switch for the meter cell. Often this is by 'first pressure' on the shutter release.

Other cameras with integral meters have the photocells positioned within the camera body so that light measurement is made through the camera lens itself, and the lens can be interchangeable.

Through-the-lens measurement

The small size and high sensitivity of CdS and SPD photosensors enable the taking of reflected-light measurements from the subject through the camera lens (TTL) by a photocell installed in the camera

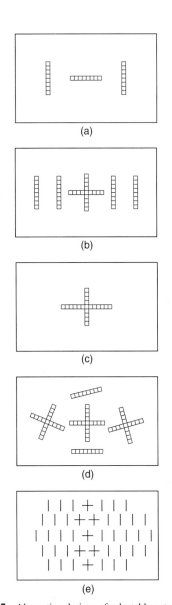

Figure 9.27 Alternative designs of selectable autofocus arrays. (a) Opposed linear CCD arrays in extended H format. (b) Cross plus vertical arrays. (c) Simple central cross format. (d) Complex linear and cross arrays with angled arrangement. (e) Complex multiple sensors usable in groups

Photocells
Selenium cells

Light-sensitive selenium (Se) is the active element in a *photovoltaic cell*. Exposure to light generates an electric potential across the cell. A sensitive galvanometer in the circuit gives a deflection proportional to the incident light incident, and the necessary

camera exposure is derived from the *light value* (LV) reading, usually via a calculator disc mounted on the meter. Sensitivity is limited, depending on the area of the cell exposed to light. A baffle limits the acceptance angle of the cell to approximately that of a camera with standard lens. Selenium cells are now rarely used as exposure automation is difficult other than by 'trap-needle' methods.

Cadmium sulphide cells

The action of light on a cadmium sulphide (CdS) photocell lowers its electrical resistance, and increases the current from a d.c. power source connected across the cell. A sensitive galvanometer in the circuit is calibrated accordingly. A small, long-life power cell of constant voltage is connected in series in the meter circuit. The CdS device is called a *photoresistor*, and is very small; but has a much greater sensitivity than a selenium cell. Its spectral response is adjusted to approximately match that of a selenium cell. The disadvantages of the CdS cell are its temperature-dependence, its 'memory' and slow speed of response. The ambient temperature can affect the response of the cell and its calibration. Response depends on the previous history of illumination so that a reading taken in a low light level after exposure of the cell to a much higher light level, tends to be an exaggerated response due to a 'memory' of the previous light level. A significant time is required before response is back to normal. Finally, the speed of response in dim light is slow, the meter needle usually taking several seconds to reach its final reading. The CdS cell has largely been replaced by the silicon photodiode.

Silicon photodiode

Light incident upon a solid-state device called a *silicon (Si) photodiode* (SPD) generates a very small current. Like the selenium cell this device is photovoltaic. But its output is too low to be used in the same way, and in cameras an amplifier is necessary to produce a useful output. An operational amplifier acts as a current-to-voltage converter, and with a suitable feedback resistance gives a high output voltage, linearly proportional to the incident light. The response is good even at very low light levels, and the linearity of response is maintained over a wide range of illuminance levels. The response time of an SPD is very short, of the order of microseconds, a useful property for switching functions. The cell area can be very small while retaining adequate sensitivity (a useful property for incorporation into a camera body). Suitable solid-state amplifier modules provide a photocell device with properties superior to those of CdS cells.

Table 11.2 Contrast filters for black and white photography

Filter	Colour	Absorbs	Lightens	Typical uses
Tricolour blue	blue	red, green	blue	copying, emphasis of haze
Tricolour green	green	blue, red	green	landscape photography
Tricolour red	red	blue, green	red	cloud photography, haze penetration
Narrow-band blue	deep blue	red, green, some blue	blue	⎫
Narrow-band green	deep green	blue, red, some green	green	⎬ copying and colour separation
Narrow-band red	deep red	blue, green, some red	red	⎭
Minus-blue	yellow	blue	yellow	cloud photography
Minus-green	magenta	green	magenta	copying
Minus-red	cyan	red	cyan	copying
Orange ('furniture red')	deep orange	blue, some green	red	emphasis of wood grain

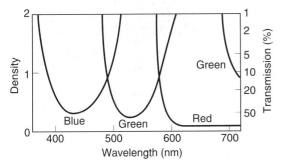

Figure 11.5 Spectral absorption curves of a standard tricolour set of red, green and blue filters

wavelength ($1/\lambda^4$). Consequently it is a maximum for ultraviolet radiation, and decreases with increase in wavelength to a minimum for infrared radiation. Thus direct light has a higher red content, while the scattered light has a correspondingly higher blue content.

In pictorial photography it may be required to retain the effects of haze, or in eliminate it tele-photography. Due to their inherent UV- and blue-sensitivity, photographic materials exposed without a filter may give a stronger impression of haze than the visual appearance. To reduce the recording of scattered radiation and hence reduce the impression of haze, thereby increasing subject contrast, a filter is required which absorbs in the blue and transmits in the red of the spectrum. A pale yellow filter is used to give a result close to the visual impression of haze. Greater penetration is achieved by using an orange or red filter. Maximum penetration is given using infrared-sensitive materials with an IR-transmitting filter. Even infrared photography, however, cannot penetrate haze caused by large droplets, such as fog or sea mist, because scattering by such particles is almost independent of wavelength.

To absorb ultraviolet radiation only without affecting the visible spectrum, a clear glass UV-absorbing filter may be used. This is often called a *haze filter* or

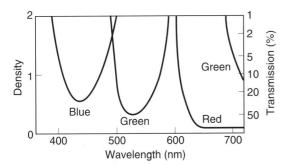

Figure 11.6 Spectral absorption curves of a set of narrow-band tricolour filters

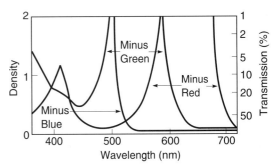

Figure 11.7 Spectral absorption curves of a set of three complementary colour filters, yellow (minus blue), magenta (minus green) and cyan (minus red)

skylight filter. This may be useful in colour photography, reducing the blue cast associated with distance or shadows in bright sunshine. Such filters require no increase in exposure. The use of UV-absorbing filters has much less effect with modern lenses than with older ones, as the glasses used in the former are almost opaque to UV radiation.

Colour filters for colour photography

Filtration needs for colour films differ from those for monochrome materials. In colour photography the main problem is to obtain an acceptable colour balance. Principal factors involved are the colour temperature of the illuminant used, (colour film is balanced for use with a specific colour temperature, usually 3200 K or 5500 K), and the exposure duration, which for correct colour balance is usually restricted to a specified range to avoid the effects of *reciprocity law failure* (RLF). Accordingly, there are many pale filters in various colours to adjust the colour balance at the camera exposure stage. In addition, colour negatives are printed with the aid of *colour print filters*, to obtain correct colour balance in a print.

Light-balancing filters

These are a form of *photometric filter* designed to raise or lower the colour temperature of the image-forming light by small amounts. They are used either over the camera lens or over individual light sources so as to bring these to a common value suitable for the colour film in use. Two series of filters are available, one bluish, to raise colour temperature, the other pale amber, to lower colour temperature. They are used with incandescent sources, which have a continuous spectrum. Their effect is quantified using the mired scale, as on this scale equal intervals corresponds to equal variations in colour of the source. The *mired shift value S* of the filter required is given by the formula

$$S = \left(\frac{1}{T_2} - \frac{1}{T_1} \right) \times 10^6 \qquad (1)$$

where T_1 is the colour temperature of the illuminant (in kelvins) and T_2 is the colour temperature balance of the material in use. The value of the shift may be positive or negative. The blue filter series, which produces an increase in effective temperature, has negative mired values, and the pale amber series, which produces a decrease in colour temperature, has positive mired values. These comparatively weak filters have low filter factors, though their effect on colour rendering is quite marked. An 18 mired (1.8 decamired) shift, for example, removes the strong blue cast due to skylight, when photographing subjects in open shade. Table 11.3 summarizes colour filters for colour films, while Figure 11.8 illustrates their spectral properties.

Table 11.3 Light-balancing and colour-conversion filters for use with colour films

Filter colour	Mired shift value	Exposure increase in stops	Typical use
Pale blue	−81	1	Type D film with aluminium flashbulbs
	−56	2/3	Type D film with zirconium flashbulbs
	−45	2/3	Type B film with GS lamps
	−32	1/3	Type B film with GS lamps
	−18	1/3	Type A film with 3200 K lighting
	−10	1/3	
Pale amber	+10	1/3	With electronic flash
	+18	1/3	Type B film with photofloods
	+27	1/3	
	+35	1/3	Type A or B film with clear flashbulbs
	+53	2/3	
Salmon pink	+112	2/3	Type A films in daylight
	+130	2/3	Type B films in daylight
Blue	−130	2	Type D films in 3200 K lighting

Type A is balanced for artificial light of 3400 K (photoflood); Type B is balanced for artificial light of 3200 K (studio lamp); Type D is balanced for daylight of 5500 K.

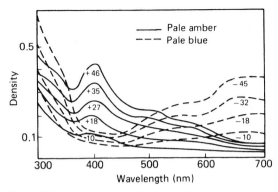

Figure 11.8 Spectral absorption curves for light-balancing filters. The number adjacent to each curve refers to its mired shift value

Colour-conversion filters

Sometimes it is not possible to avoid using colour film that is balanced for a particular colour temperature in conditions where the illuminant has a different colour temperature, for example, daylight-type film intended for 5500 K exposed in artificial light of 3200 K. To prevent the colour imbalance or cast such mismatching would cause, *colour-conversion* filters are available in two series, blue and orange in hue respectively (see Figure 11.9). The mired shift values of such filters is high, typically 130, being the difference between the mired values for 3200 K and 5500 K. The blue series for exposing

daylight-type film in artificial light have large filter factors (about ×4 or +2 EV), and with some films may give incomplete correction. The orange series, for exposing artificial-light-type film in daylight, have small filter factors (about ×1.7 or +0.7 EV), and usually give complete correction. Most films intended for motion-picture work are balanced only for artificial light. Digital cameras may also allow selection and alteration of sensor array response to the colour temperature of the illuminant without the use of filters.

Colour-compensating filters

These filters are used to adjust the overall colour balance of results obtained from colour films, especially slide films, otherwise colour casts could result. Common causes of errors in colour balance include deficiencies in the spectral quality of the illuminant used, 'bounce' light coloured by reflection from a coloured surface, variations in emulsion batch, the effects of reciprocity law failure and light absorption in underwater photography. For example, colour photography using fluorescent lighting as the sole illuminant may show colour casts in the photographs, owing to the anomalous spectral quality of such light sources. In particular a green cast is caused by the strong emission line at 546 nm in the mercury spectrum. However, by using a variety of colour-compensating filters such effects can be reduced. Two varieties of filter are available, one for film balanced for 5500 K, the other with film balanced for 3200 K. A typical coding is FL-D and FL-W indicating use with daylight type colour film with daylight types and warm white types of fluorescent tube respectively. Colour compensating filters can also be used to introduce deliberate colour casts for mood or effect. It is also possible to use them to remove colour casts in colour printing, but this is a clumsy method.

CC filters, as they are termed, are available in six hues: red, green, blue, cyan, magenta and yellow, indicated by their initial letters R, G, B, C, M and Y. The number of the filter (divided by 100) represents the density of the filter at its peak absorption wavelength. Thus a designation such as CC20R indicates a pale red filter whose optical density at its peak absorption is 0.2. A range of densities is available. Even the higher values have only moderate filter factors.

Special filters

There are other filters with special or distinct functions. Some of them may have no visible hue, because their absorption lies outside the visible spectrum, or may be visually opaque, because their transmittance lies outside the visible spectrum.

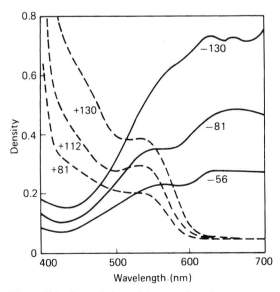

Figure 11.9 Spectral absorption curves for colour conversion filters. The numbers adjacent to the curves refer to their mired shift values

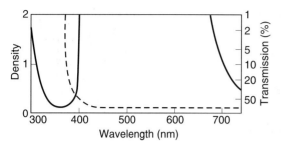

Figure 11.10 Absorption curve of an ultraviolet (UV)-transmitting filter (solid line), and of an UV-absorbing filter (broken line)

Ultraviolet (UV)-absorbing filters

The sensitivity of photographic materials to scattered UV radiation and blue light causes a loss of contrast, and a blue cast with colour materials, increasing with increasing subject distance. In addition, the spectral transmission of different lenses, especially older designs, may vary for the UV region and give different colour balances in terms of 'warmth' of image. Use of UV-absorbing or haze filters gives a better match between lenses. An additional use is as a 'skylight filter' to reduce the effect of excessive scattered light from a blue sky. Such filters are usually colourless or a very pale pink or straw colour, depending on their cut-off for short wavelengths (Figure 11.10). Often the digits in a filter code number indicates this point, e.g. 39 denotes 390 nm.

UV-transmitting filters

For some specialist applications of photography, UV radiation is used as the illuminant. However, UV sources also emit visible light. Special opaque glass filters which transmit only in the near UV region are used to block all visible radiation (Figure 11.10). Due to uncorrected 'chromatic' aberration between the UV and visible regions, a lens focus correction is usually needed unless a specially computed lens made with quartz and fluorite elements is used.

Infrared (IR)-absorbing filters

As well as visible light, all thermal sources emit much of their energy in the form of infrared radiation, which is readily converted to heat energy. In an enclosed optical system such as an enlarger or slide projector, the negative or transparency in the gate must be protected from this unwanted radiation. Colour-print materials are sensitive to IR radiation,

and its elimination from the image-forming light is therefore essential for correct colour reproduction. Colourless glass filters ('heat-absorbing glasses') which transmit visible radiation but block IR radiation, are used for these purposes (Figure 11.11). They do not need to be of optical quality if they are mounted in the illumination system of an enlarger or projector. A mounting to hold the filter loosely is necessary to avoid cracking due to thermal expansion.

Interference-type filters are also used. Usually such a filter transmits IR radiation and reflects visible light. Termed a *cold mirror*, the filter may usefully form an integral reflector of ellipsoidal shape for a tungsten–halogen light source.

IR-transmitting filters

Infrared sensitive materials have an extended spectral response to some 950 nm as well as the usual sensitivity to visible light and UV radiation. Consequently, their use needs a special filter opaque to both UV and visible radiation but transmitting in the IR region (Figure 11.11). Any filter factor must be determined empirically. These filters, which are almost opaque to visible light, are available in either gelatin or glass. Once more, due to uncorrected 'chromatic' aberration between the IR and visible regions, a lens focus correction is usually needed unless a suitably corrected lens is used. This may be an apochromatic or superachromatic lens. Usually, the focus shift correction is by means of a supplementary index mark on the focusing scale of the lens, and the visually focused distance is transferred to this IR index. The lens is seldom chromatically corrected for the infrared and the image may be characteristically 'soft' and 'hazy' due to this (Figure 11.12). Foliage appears very light in tone due to the high reflection of IR from chlorophyll in leaves.

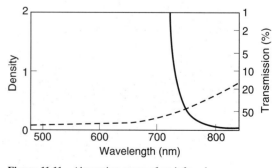

Figure 11.11 Absorption curve of an infrared (IR)-transmitting filter (solid line), and of an IR-absorbing filter or heat-absorbing filter (broken line)

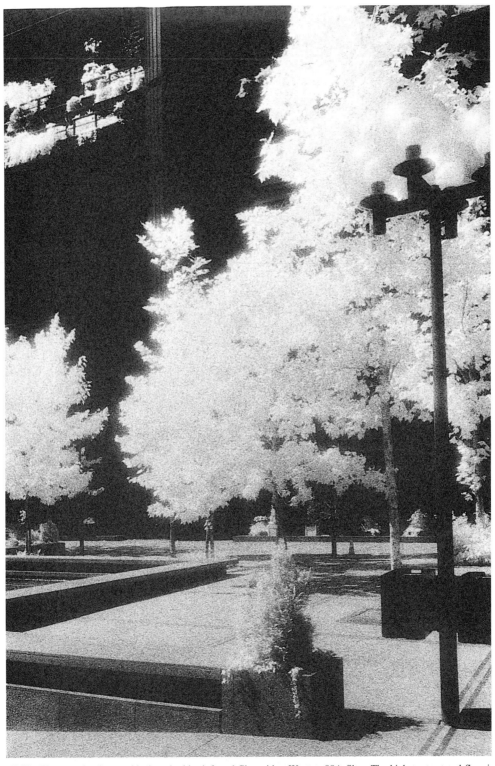

Figure 11.12 Photograph taken on black-and-white infrared film with a Wratten 88A filter. The high contrast and flare is due to the reflectance of the foliage and the IR absorption of the glass-fronted building behind

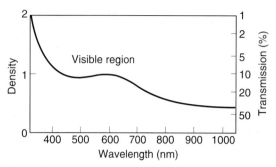

Figure 11.13 Absorption curve of a neutral density filter (non-scattering type, density 1.0)

Neutral-density filters

Neutral-density (ND) filters absorb all visible wavelength to a more or less equal extent. They may be scattering or non-scattering. A filter for use in front of the camera lens must be non-scattering, but for other applications such as the attenuation of a beam of light, the scattering type can be used. Optical quality ND filters are made by dispersing colloidal carbon in gelatin. The addition of dyes with the necessary spectral absorption properties, combined with the brown colour due to the carbon, give the necessary neutral characteristics. Note that the neutrality is confined to the visible spectrum (Figure 11.13). The use of carbon particles of a size approximating to the wavelength of light gives improved non-selective neutral density filters, but the associated scattering of light makes them unsuitable for camera use. Photographically formed silver can produce a good non-selective neutral density for the visible and infrared regions, but the scattering properties limit its use to non-image-forming beams.

The alloy *inconel*, evaporated in thin layers onto glass, gives an excellent non-selective, non-scattering, neutral-density filter, but as the attenuation is both by absorption and reflection the specular reflection may be a nuisance. Perforated metal sheets or mesh serve as excellent non-selective light attenuators, used for example in colour enlargers where they have no effect on the colour temperature of the light source. Their scattering properties do not permit use in front of a camera lens (unless they are to be used as effects filters).

Neutral-density filters are also available in graduated form, to give continuous light control over a given range of attenuation, or to give attenuation to part of the scene only, e.g. the sky region but not the foreground. A method of providing uniform controllable attenuation is by a pair of contra-rotating polarizing filters, which gave almost complete cut-off when in the crossed position.

Neutral-density filters for camera use are calibrated in terms of their optical density and filter factor, e.g. a 0.3 ND filter with filter factor ×4 (+2 EV). They can be used with both monochrome and colour films, as they have no effect on colour balance. Their uses range from a means of avoiding over-exposure with a fast film in very bright conditions to a way of using large apertures for selective focus in well-lit conditions. Mirror lenses use ND filters in lieu of aperture stops to enable selection of a different shutter speed.

Graduated filters

These optical devices are tinted over about half the filter area, with a gradual transition between the grey or coloured and the clear areas, so as to give selective filtration to parts of the subject. For example, a graduated yellow filter may be used with black-and-white film to filter the sky in a landscape picture, leaving the foreground unfiltered, the horizon approximately coinciding with the transition zone. Pairs of differently coloured graduated filters can be used in tandem in rotated opposition to give selective filtration to different zones of the scene. Filter holders to allow both sliding and rotational movement are necessary. With colour film, graduated colour filters can provide either a colour accent to part of a scene or correct the colour balance likewise, or give a strong colour effect. A graduated grey ND filter will reduce exposure to a selected area of the scene to help balance excessive luminance ratio, as in a landscape with a brilliant sky area. Similarly, with electronic flash coverage of an extended scene, the unwanted effects of light fall-off with distance and excessive exposure to the foreground can be reduced by using the filter to reduce exposure to the latter. A radially graduated ND filter or 'spot' filter is used to compensate for the loss of illumination at the edges of extreme wide-angle lenses, with need for an exposure increase of +1 EV or +2 EV.

Polarizing filters

Linear polarizing filter

As discussed in Chapter 2, light can be considered as a transverse wave motion, i.e. with vibrations orthogonal to the direction of propagation. The direction of vibration is completely randomized giving 'unpolarized' light (Figure 11.14). If the vibrations are restricted to one particular plane called the *plane of polarization*, the light is then *linearly polarized*, or *plane polarized* (or simply *polarized*). Such light can be produced, controlled and attenuated by a special type of filter termed a *polarizing filter*.

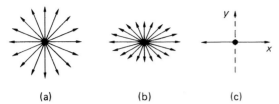

Figure 11.14 Polarized light. (a) Unpolarized. (b) Partially polarized. (c) Plane polarized (along Z-axis)

A polarizing filter is a sheet of plastics material containing a layer of transparent polymer molecules whose axes are aligned in one direction during manufacture. They are *optically active*, so that light waves vibrating is one plane are transmitted, but light waves vibrating at right-angles to this plane are blocked. Light waves vibrating in intermediate directions are partially transmitted. Such a linearly polarizing filter can be used to select light for transmission if some of it is polarized. Light coming from different parts of a scene may be in various states of complete or incomplete polarization.

Polarizing filters have several distinct applications. The light from any point in a clear blue sky in partially polarized by scattering, the direction of polarization being at right-angles to the line joining it to the sun. The polarization is strongest over the arc of the sky that is 90 degrees from the sun, and is weakest at 0 degrees (i.e. close to the sun itself) and 180 degrees (opposite the sun). Clear blue sky can thus be rendered darker by use of a polarizing filter over the camera lens; the amount being controlled by rotation of the filter. A polarizing filter does not otherwise effect colour rendering, and so is used in colour photography to control the depth of colour of a blue sky.

Unwanted surface reflections may also be reduced and even eliminated. Light that is specularly reflected from the surface of a non-metal at a certain angle is almost totally polarized in a plane perpendicular to the plane in which the incident and reflected rays lie. This is called *s-polarization*. Note that polarization at right-angles to this plane, i.e. in the plane containing the incident and reflected rays, is known as *p-polarization*. The light that is transmitted is partly p-polarized. Total s-polarization occurs when the angle of incidence is such that the reflected and refracted rays are orthogonal, i.e. the tangent of the angle of incidence is equal to the refractive index (Brewster's law). For material with a refractive index about 1.5 (i.e. most polishes, gloss paints, plastics and glass) the angle of maximum polarization (the *Brewster angle*) is about 56 degrees. For water with a refractive index of 1.33 it is about 53 degrees. Light reflected from a wide range of substances at approximately this angle is largely polarized. Polarizing filters may, therefore, be used for the control of reflections from non-metallic materials, for example glass (Figure 11.15), wood, paint, oil, polish, varnish, paper and any wet surface. Practical applications include removal of *glare spots* from painted walls, wood panelling, furniture and glass, provided a suitable viewpoint can be used. In colour photography, the presence of surface reflections reduces colour saturation, degrading the picture quality. Use of a polarizing filter to eliminate or subdue such reflections increases colour saturation and contrast and the required amount must be judged by experience.

When using a polarizing filter, the effect can be assessed by slowly rotating the filter until the optimum effect is found. For subjects that show reflection at only one surface or group of similarly placed surfaces, it is usually possible to select a suitable viewpoint for suppression. But where the reflections are at various angles, a polarizing filter over the lens cannot suppress them all at the same time, and a compromise position must be found.

In copying applications, a polarizing filter over the lens offers little control of reflections, because the unwanted light is not reflected at anything approaching the Brewster angle. Only in the case of oil paintings, where individual brush marks may cause reflections at the Brewster angle, is any control achieved, and this is very limited. However, full control is possible if the light source itself is plane polarized, the method being to place polarizing filters both over the lens and the lamps, the direction of polarization of the lens filter being orthogonal to that of the lamp filters. In this technique, the diffusely reflected light forming the image is depolarized, whereas the unwanted directly reflected light remains polarized, and does not pass through the filter on the lens. In the same way, reflections from metal objects can be controlled by placing polarizing filters over the light sources as well as over the camera lens. Large sheets of polarizing material are needed for use over light sources, and they must not be permitted to overheat.

The ideal polarizing filter works equally well for all wavelengths and has no effect on colour. In practice, polarizing filters need to be carefully selected and tested for neutral rendering for use in colour photography. Due to the absorption of both polarized light and transmitted light by the materials of the filters, the filter factor is usually about ×3.5 (+1.6 EV) rather than the theoretical ×2 (+1 EV); but a TTL metering system will usually take such variations into consideration (with the qualification below). The filter factor is independent of the sensitive material and illuminant.

(a)

(b)

Figure 11.15 The effect of a polarizing filter suitably rotated with a chosen viewpoint so as to nearly eliminate the reflections from a glass window. (a) Without filter. (b) With filter

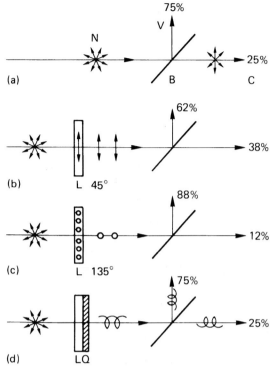

Figure 11.16 Polarized light and beamsplitters behind the camera lens. (a) With natural light N, beamsplitter B reflects light to viewfinder V and transmits to photocell or autofocus module C in ratio 3:1. (b) With linear polarizing filter L in 45 degrees position, ratio is 62:38. (c) With linear polarizing filter in 135 degrees position, ratio is 88:12. (d) With circular polarizing filter made by addition of quarter-wave plate Q, the ratio is constant at 3:1 for all positions

Circular polarizing filter

A practical problem arises when a linear polarizing filter is used with a camera that has an optical system with a beamsplitter device to sample the incoming light for exposure determination, or to direct part of the image to an array of photosensors in an autofocusing module set in the well of the camera. The beamsplitter divides the incident light into two beams that are orthogonally polarized. Consequently, when a plane polarizing filter is rotated over the camera lens, the beamsplitter does not divide this partially polarized beam in the correct proportions for viewing and light measurement, nor transmit enough light to the autofocus module for this to operate satisfactorily. The effects are dependent on the orientation of the filter over the lens (Figure 11.16). If, however, a *circularly polarizing filter* is used instead of a linear type, the properties of the beamsplitter are unaffected and light measurement errors and inoperative autofocus systems are avoided. A circularly polarizing filter

uses in its construction an additional thin layer of optically active material behind the polarizing material. This is known as a *quarter-wave plate*, and its effect is to displace the relative phases of the electric and magnetic components of the propagated wave so that the plane of polarization rotates through a complete circle with every wavecrest.

Filters for darkroom use

Safelight filters

Darkroom safelights use another type of colour filters. Their function is to transmit light in a restricted range of wavelengths, to give as high a level of illumination as possible that is consistent

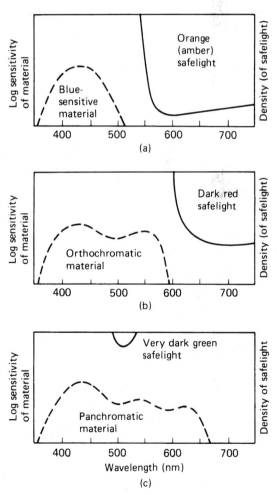

Figure 11.17 Spectral absorption curves for darkroom safelight filters. (a) Blue-sensitive materials. (b) Orthochromatic materials. (c) Panchromatic materials

with the 'safe' handling of photographic materials. Specific recommendations are given as to the wattage of the lamp to be used and the minimum safe distance of the material from the safelight, as well as the maximum duration of exposure, but the user is advised to carry out individual tests.

For blue-sensitive and orthochromatic materials the filter transmission range is chosen to fall outside the range of wavelength to which the material is sensitive. Thus a yellow, orange or yellow–green safelight may be used with the former, and a red safelight with the latter. With panchromatic materials the problem is more serious because the emulsion is sensitive to the whole of the visible spectrum. Processing should be carried out in complete darkness if possible. In emergency a very low level of illumination may be used, at a range of wavelengths to which the dark-adapted eye has its maximum sensitivity. This is in the mid-green region of the spectrum (the bluish-green appearance is an anomaly in visual perception resulting from the dark-adaptation of the eye). For colour-print materials a dim amber is preferred, corresponding to the minimum sensitivity of the material. This safelight is also suitable for panchromatic print paper (see Figure 11.17). It takes several minutes of dark-adaptation before visual assessment is possible with these safelights. Also, as the material is not totally insensitive to the wavelengths emitted by these sources they should be used with caution, and preferably only in emergency. *Light emitting diode* (LED) arrays with near monochromatic emission of light of a suitable wavelength may be used unfiltered for many darkroom purposes.

Filters for colour printing

Various sets of colour filters can be used to obtain satisfactory colour balance in the final print, depending on the printing technique in use.

A *tricolour set* of red, green and blue filters is used for the triple-exposure printing method. Alternatively, colour-compensating filters can be used in front of the enlarger lens with a single exposure, but the difficulties raised by calculations necessary to keep the number of filters to a minimum, and the need to avoid damage through handling, are such that this method is now seldom used. A preferred method for single-exposure white-light (or subtractive) colour printing is to use sturdy cellulose acetate filters or similar in the enlarger illumination system, where their optical quality is unimportant. These *CP filters* are available in yellow, magenta, cyan and red, in a range of density values. The numbering system is similar to that of CC filters, e.g. the designation CP40M denotes a magenta filter

of optical density 0.40 in its region of maximum spectral absorption.

Dichroic filters

A drawback of filters using organic dyes is that they are prone to fading. Furthermore, a mixture of dyes may not be able to provide precisely the necessary spectral absorption characteristics. A preferred alternative is to use *dichroic filters*, which have multiple thin layer coatings on a heat resistant substrate such as a quartz plate. Such filters can be used both with colour materials and variable grade papers.

A set of dichroic or *interference filters*, of complementary yellow, magenta and cyan hues, are used routinely in a 'colour head' equipped with a suitable illumination system. Such filters are calibrated either in arbitrary numbers or actual optical densities related to their effect when inserted to a greater or lesser extent into a collimated beam of light. UV- and IR-absorbing filters are also needed in a colour enlarger because of the sensitivities of print materials used.

Instead of the selective absorption of light by coloured glass or gelatin, interference filters use constructive and destructive interference of light to give a selective transmission of any hue in the visible spectrum within narrow limits of wavelength, so that spectral transmission characteristics approach very closely to the ideal, with few losses. The portions of the spectrum that are not transmitted are reflected, not absorbed. Thus such filters appear one hue (e.g. yellow) by transmitted light, and the complementary hue (blue) by reflected light, hence the alternative popular name of dichroic ('two-colour') filters. Interference filters consist of glass or quartz substrates, on which is deposited (by evaporation or electron bombardment in a high vacuum) a series of very thin layers of dielectric materials. As many as 25 individual layers are not unusual. A careful choice of refractive indexes and thickness of alternating layers restricts transmission to the desired spectral regions. Such filters should be used in a fairly well-collimated (parallel) beam of light, as spectral transmission varies with angle of incidence. Dichroic filters are usually available in small sizes only, owing to the difficulties of coating large filters uniformly. The cost is high but not unreasonable, considering the long life and reliable performance of such filters.

Bibliography

Hirschfield, G. (1993) *Image Control*. Focal Press, Boston, MA.
Ray, S. (1994) *Applied Photographic Optics*, 2nd edn. Focal Press, Oxford.

12 Sensitive materials and image sensors

Many light-sensitive substances, varying widely in their sensitivity, are known. Conventional photographic materials use *silver halides*, which are light-sensitive compounds formed by the combination of silver with members of the halogen group of the elements (bromine, chlorine and iodine).

Photographic materials are coated with suspensions of minute crystals (with diameters from $0.03\,\mu$m for high-resolution film to $1.5\,\mu$m for a fast medical X-ray film) of silver halide in a binding agent, nowadays almost invariably gelatin. These photographic suspensions are called emulsions, although they are not emulsions but solid suspensions. The crystals are commonly termed grains. In materials designed for the production of negatives, the halide is usually silver bromide, in which small quantities of iodide are also normally present. With papers and other positive materials the halide may be silver bromide or silver chloride or a mixture of the two. The use of two silver halides in one emulsion results not in two kinds of crystal but in crystals in which both halides are present, although not necessarily in the same proportion in all crystals. Photographic materials containing both silver bromide and silver iodide are referred to as iodobromide materials, and those containing both silver chloride and silver bromide as chlorobromide materials.

Silver halides are particularly useful in photography because they are developable, which means that the effect of light in producing an image can be amplified with gain in sensitivity of about one thousand million times. The image produced when photographic materials are exposed to light is normally invisible and termed the latent image.

Electronic image sensors, currently, rely almost exclusively on charge-coupled devices (CCDs), although complementary metal oxide semiconductor (CMOS) image sensors are also used. These use regular arrays of light-sensitive elements (picture elements or pixels). The CCD has the ability to convert light intensities into voltage signals. It has the three basic functions of charge: collection, transfer and conversion into a measurable voltage. The basic element of the CCD is the metal oxide semiconductor (MOS) capacitor, which is also called a *gate*. Changing the voltage at set time intervals applied to the gate allows the charge to be stored or transferred. Charges are transferred from gate to gate until they reach the sensing node where they are measured, amplified and ultimately digitized in a such a way that their spatial and temporal positions are known. CCDs were invented thirty years ago by W.S. Boyle and G.E. Smith of Bell Laboratories in the USA and were first applied in video cameras. In the early 1980s Sony produced a prototype electronic camera system for still image recording and CCD based electronic cameras are becoming increasingly popular as their resolution increases and their cost decreases.

Latent image formation in silver halides

The latent image is any exposure-induced change occurring within a silver halide crystal that increases the probability of development from a very low value to a very high value. Although all crystals will eventually be reduced to metallic silver if developed for a sufficient time, the rate of reduction is very much greater for those crystals that bear a latent image. It is generally believed that this change is the addition at a site or sites on or within the crystal of an aggregate of silver atoms. The latent image sites are probably imperfections and impurities (e.g. silver sulphide specks) existing on the surface and within the bulk of the silver halide crystal. Light quanta are absorbed, releasing photoelectrons which combine with interstitial silver ions to produce the atoms of silver. Interstitial silver ions are mobile ions displaced from their normal positions in the silver halide lattice and are present in silver halide crystals of an emulsion prior to exposure. The general reaction can be represented by the equations:

$$Br^-: \xrightarrow{h\upsilon} B\dot{r} + e^- \quad \text{and} \quad Ag^+ + e^- \longrightarrow Ag$$

where $h\upsilon$ is a light quantum, e^- is the electron and the dots represent electrons associated with atoms.

The energy levels relevant to latent image formation are shown schematically for a silver bromide crystal in Figure 12.1. Discounting thermal fluctuations, absorption of a quantum of energy greater than 2.5 eV (electron volts) is necessary in order that an electron may be raised from the valence to the conduction band. The valence band is essentially that filled band of energy in which the electrons exist. The conduction band is that empty group of energy levels, if electrons are excited to this band they are free to

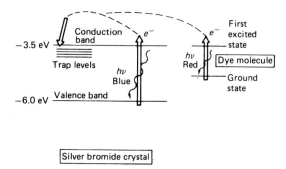

Figure 12.1 Schematic representation of the energy levels relevant in latent image formation

move and conduction can take place. Between these two levels is the band gap in which electrons cannot exist. An energy of 2.5 eV is equivalent to a wavelength of approximately 495 nm, and corresponds to the longest wavelength of the spectral sensitivity band of ordinary silver bromide. Also indicated in Figure 12.1 are the relevant energy levels of an adsorbed dye molecule suitable for sensitizing silver bromide to longer wavelengths. It can be seen that a photon of energy much less than 2.5 eV may, upon absorption by the dye, promote the molecule from its ground energy state to its first excited state. If the excited electron can pass from the dye to the crystal, latent image formation may proceed. In this way it is possible to sensitize silver halides to green and red light and even infrared radiation, although it should be noted that in the last case electron transitions arising from the thermal effects may cause crystals to become developable without exposure. Excessive fogging can result and careful storage and usage of such materials is necessary.

Although a number of different mechanisms have been suggested to account for the details of latent image formation, there is considerable experimental evidence supporting the basic principle suggested by Gurney and Mott in 1938. The essential feature of this treatment is that the latent image is formed as a result of the alternate arrival of photoelectrons and interstitial silver ions at particular sites in the crystal. Figure 12.2 shows the important steps. Here the process is considered as occurring in two stages:

(1) The nucleation of stable but sub-developable specks.
(2) Their subsequent growth to just-developable size and beyond.

The broken arrows indicate the decay of unstable species, an important characteristic of the process. The first stable species in the chain is the two-atom centre, although it is generally accepted that the size of a just developable speck is 3 to 4 atoms. This implies that a crystal must absorb at least 3 to 4 quanta in order to become developable, but throughout the sequence there are various opportunities for inefficiency, and as a general rule far more than this number will be required. During most of the nucleation stage the species are able to decay, and liberated electrons can recombine with halogen atoms formed during exposure. If this occurs, the photographic effect is lost. The halogen atoms may also attack the photolytically formed silver atoms and re-form halide ions and silver ions. Although gelatin is a halogen acceptor and should remove the species before such reactions can occur, its capacity is limited and its efficiency drops with increasing exposure.

These considerations lead to possible explanations for low-intensity and high-intensity reciprocity-law failure. During low-intensity exposures, photo-electrons are produced at a low rate and the nucleation

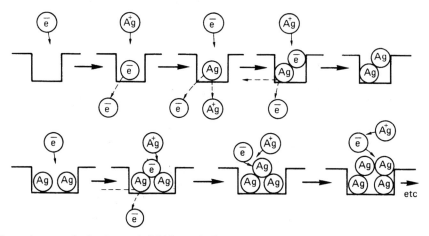

Figure 12.2 Latent image nucleation (*top row*). Initial growth (*bottom row*)

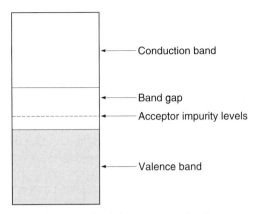

Figure 12.3 Energy levels in a p-type semiconductor

stage is prolonged. As a result the probability of decay and recombination is relatively high. During high-intensity exposures large numbers of electrons and bromine atoms are simultaneously present in the crystals. Such conditions can be expected to yield high recombination losses. Also, nucleation may occur at many sites in a single crystal, producing large numbers of very small silver specks.

Image formation by charge-coupled devices

The heart of the CCD and most electronic image sensors is the metal oxide semiconductor (MOS), which is illustrated in Figure 12.3. It comprises silicon doped with impurities, such as aluminium, so that an acceptor level of positive holes is formed in the band gap, which is able to accept electrons excited from the valence band. Since silicon has a band gap of 1.1 eV it has a sensitivity up to about 1100 nm.

Whilst this may be an advantage for recording in to the IR region of the spectrum in certain applications, it is a disadvantage for imaging within the visible region of the spectrum and would result in incorrect tone and colour reproduction. CCD cameras have a special IR absorbing filter included to restrict their spectral response to the visible region.

Figure 12.4 is a simple schematic diagram of p-type silicon MOS capacitor. The positive voltage to the gate (V_{gate}) causes mobile positive holes to migrate to the ground electrode. The region with an absence of positive charge is called the depletion region. If light of sufficient energy (greater than 1.1 eV) is absorbed in the depletion region an electron-hole pair is produced. The electron remains in the depletion region (see Figure 12.4) whilst the positive holes migrate to the ground electrode. The number of electrons that can be retained in the depletion region is the *well capacity*, which depends upon the physical sizes of the oxide layer and the gate electrode area as well as the applied voltage.

In order to record images the sensor contains a large number of elements (pixels) in the form of a two-dimensional array for most CCD based cameras and a linear array for many scanning devices and some types of studio based cameras. The sensor size, number of picture elements and the number of grey levels are all becoming larger as the technology matures. At the time of writing, full frame (36 × 24 mm) 35 mm camera format size sensors are becoming available with 6 million pixels, although at relatively high cost.

The CCD array consists of a series of gates. Adjustments of the gate voltages allows transfer of electrons from well to well. This is a function of time. Figure 12.5 shows the way in which charges are transferred between neighbouring wells (1). After exposure to light, the charge in well 1 is shown in (2). If a voltage is applied to gate 2, electrons flow from well 1 to well 2 (3), and (4) shows the situation when equilibrium is reached. If the voltage to gate 1 is

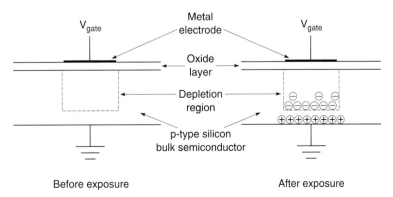

Figure 12.4 The basic element of an electronic image sensor: p-type silicon metal oxide semiconductor

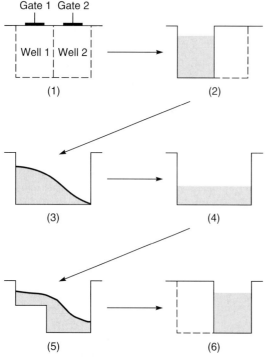

Figure 12.5 Transfer of charge between neighbouring pixels in a CCD sensor (after Holst). The potential in the well increases towards the bottom of the well

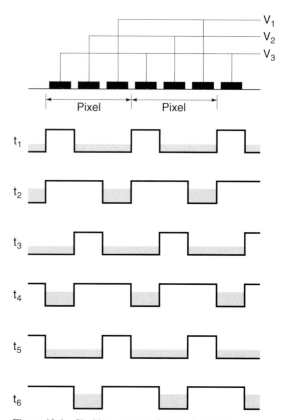

Figure 12.6 Clocking sequence for a typical CCD three-phase device (after Holst). The black areas represent the gates and the shaded areas the stored charges. Different times are given by t_1 etc.

reduced electrons begin to be completely transferred to well 2 (5), and in (6) complete transfer is shown.

Thus the charges forming the image are transferred in a time-dependent way if one considers a complete array of image elements and their gates. The clocking sequence for a three-phase device is shown in Figure 12.6. In the diagram it can be seen that only one-third of the pixel area is available (a *fill factor* of 33 per cent) as the well capacity (three gates).

There are a number of different ways in which CCDs can be configured for different readout modes. Some different array architectures are given in Figure 12.7 and include linear arrays, full-frame transfer, interline transfer and frame interline transfer. These are provided for various applications. For example, linear arrays are used in scanners and some studio based still cameras; full-frame transfers are used mainly for scientific applications; interline transfer and frame transfer arrays tend to be used in professional television systems and consumer products.

The storage and transfer areas are shielded from the light. From Figure 12.7 it can be seen that the full frame transfer architecture consists of two almost identical arrays, one for imaging and one for storage, which makes them costly to produce. Interline

transfer arrays, however, have shielded strips which decreases the light sensor size and may occupy only 20 per cent of the array, i.e. have a low *fill factor*. Like many commercial products, CCD detectors are a compromise between cost, efficiency and suitability for purpose. For example, interline transfer arrays have low fill factors but the transfer of charge is rapid. Manufacturers improve the fill factors of these devices by the inclusion of microlens arrays over the CCD, which increase the effective size of the sensor element.

So far we have only considered arrays that respond to light intensity and in order for CCD based devices to record colour three methods are used. One is to successively record each image through red, green and blue filters to additively record colour (see Chapter 14). This method is used for scanning colour originals and in some studio cameras where only static subjects are being recorded. The second method, which is commonly used in digital cameras, is to place a colour filter array (CFA) over the CCD. Although many filter arrays are used in digital

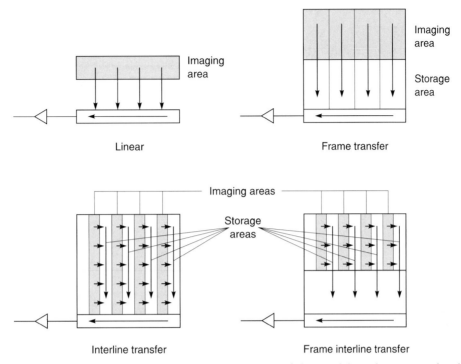

Figure 12.7 CCD architectures in which the arrows indicate the movement of charge and the readout output register is shown as the horizontal box at the bottom of each diagram

cameras, a typical Bayer colour filter array is illustrated in Figure 12.8.

The third method involves the use of a beam-splitter behind the lens which divides the input into three separate channels which separately record the red, green and blue signals (or other appropriate combinations) on three filtered CCD detectors. Whilst this is an expensive solution to the recording of colour it allows higher resolution than is possible with CFAs. With CFAs a single CCD is used which reduces the effective resolution and data has to be interpolated to provide the missing information. If a red area is being recorded, it can be seen from Figure 12.8 that there will be pixels which will not have been activated and the missing data has to be added.

CCDs are very complicated and sophisticated detectors and possess a number of characteristics by which they can be judged and compared. Some fundamental characteristics of CCDs are summarized in Table 12.1.

Production of light-sensitive materials and sensors

The principal materials used in the preparation of a photographic emulsion which is coated on a base to form the sensitive layer are silver nitrate, alkali-metal halides and gelatin, and all these must satisfy stringent purity tests. The gelatin must be carefully chosen, since it is a complex mixture of substances obtained from the hides and bones of animals, and, although silver salts form the light-sensitive material, gelatin plays a very important part both physically and chemically.

Gelatin is a protein derived from collagen, the major protein component of the skin and bones of animals. It is a *lyophilic* or *hydrophilic colloid*

G	R	G	R	G	R	G	R	G
B	G	B	G	B	G	B	G	B
G	R	G	R	G	R	G	R	G
B	G	B	G	B	G	B	G	B
G	R	G	R	G	R	G	R	G
B	G	B	G	B	G	B	G	B
G	R	G	R	G	R	G	R	G
B	G	B	G	B	G	B	G	B
G	R	G	R	G	R	G	R	G

Figure 12.8 The Bayer colour filter array (CFA)

Table 12.1 Performance characteristics of CCD sensors

Characteristic	Comment
Detector size	dimensions of sensor area (mm × mm)
Pixel size	physical dimensions of pixels expressed as μm × μm for each pixel, or as numbers of vertical and horizontal pixels for whole sensor area
Fill factor	fraction of pixel area which is sensitive to light (%)
Full well capacity	maximum charge (or signal) which the sensor element can hold (J/cm^2, or number of electrons)
Noise	many sources: *shot* noise accompanies generation of photoelectrons and *dark current* electrons; *pattern* noise due to pixel to pixel variations; *reset* noise when reading the charge and added to by the amplifier; *quantization* noise arising from analogue to digital conversions. Expressed as rms electrons or rms volts
Dark current	due to thermal generation of current (number of electrons or nA/cm^2)
Dynamic range	ratio of full well capacity to noise (dB)
Scanning mode	interlaced or progressive
Resolution	relates to detector size, pixel size and fill factor (see Chapter 24) expressed as lines/mm, dpi, cycles/mm. Often expressed as numbers of pixels or file size. Applies to the imaging system output
Quantum efficiency	ratio of number of electron-hole pairs produced to number of photons absorbed (maximum value unity)
Spectral response	plots of quantum efficiency against wavelength
Architecture	structure and readout modes of detector arrays

made up of long chain molecules which are soluble in water. It possesses a number of unique properties that make it particularly suitable as a binder for silver halide microcrystals. The combination of many different physical and chemical properties in one type of chemical compound explains why it has not so far been possible to replace gelatin by a synthetic polymer as a binder for silver halides. Certain synthetic polymers may be used in conjunction with gelatin as gelatin extenders but not as a substitute. Gelatin has remarkable properties as a binding agent which are summarized as follows.

(1) Dispersed with water, it forms a convenient medium in which solutions of silver nitrate and alkali halides can be brought together to form crystals of insoluble silver halides. These crystals remain suspended in the gelatin in a fine state of division, i.e. it acts as a protective colloid.

(2) Warmed in water, it forms a solution which will flow, and, by cooling an aqueous solution of gelatin it sets to a firm gel. Thus it is possible to cause an emulsion to set firmly almost immediately after it has been coated on the base, aided by cooling. The water is removed in a current of warm air to form a coated layer that is reasonably strong and resistant to abrasion.

(3) When wetted, gelatin swells and allows processing solutions to penetrate.

(4) Gelatin is an active binding agent, containing traces of sodium thiosulphate sensitizers and nucleic acid degradation products (restrainers) that influence the speed of emulsions.

(5) It acts as a halogen acceptor, as described earlier.

(6) The properties of gelatin can be modified, by chemical reactions such as hardening or cross-linking of the gelatin chains, to make it tougher, and reduce its tendency to swell.

(7) It enables developer solutions to distinguish between exposed and unexposed silver halide crystals. In the absence of gelatin, silver halides are reduced to metallic silver by a developer solution regardless of whether they bear a latent image.

(8) Gelatin confers stability on the latent image.

Gelatins vary greatly in their photographic properties. The 'blending' of gelatins originating from different sources helps in producing a binder with the required properties and in obtaining consistency. Modern photographic emulsion technology tends to use 'inert' gelatin, i.e. gelatin containing less than five parts per million of sulphur sensitizers and nucleic-acid-type restrainers. A more recent development by gelatin manufacturers is to provide gelatins which are substantially free of all sensitizers and

restrainers ('empty' gelatin). These gelatins may then be doped to the required degree by the addition of very small amounts of the appropriate chemicals by the emulsion manufacturer.

The essential steps involved in the preparation of photographic emulsions consist of the following:

(1) Solutions of silver nitrate and soluble halides are mixed in the presence of gelatin under carefully controlled conditions, where they react to form silver halide and a soluble nitrate. This stage is called *emulsification*.

(2) This emulsion is subjected to a heat treatment in the presence of the gelatin in a solution in which the silver halide is slightly soluble. During this stage the crystals of silver halide grow to the size and distribution which will determine the characteristics of the final material, particularly in terms of speed, contrast and graininess. This stage is known as the *first (physical or Ostwald) ripening*.

(3) The emulsion is then washed to remove the by-products of emulsification. In the earliest method of doing this the emulsion was chilled and set to a jelly, shredded or cut to a small size and then washed in water. In modern practice, washing is achieved by causing the emulsion to settle to the bottom of the vessel by the addition of a coagulant to the warm solution. The liquid can then be removed by decanting etc.

(4) The emulsion is subjected to a second heat treatment in the presence of a sulphur sensitizer. No grain growth occurs (or should occur) during this stage, but sensitivity specks of silver sulphide are formed on the grain surface and maximum sensitivity (speed) is reached. This stage is known as the *second ripening, digestion* or *chemical sensitization*.

(5) Sensitizing dyes, stabilizing reagents, hardeners, wetting agents, etc., are now added.

All these operations are capable of wide variation and it is in the modification of these steps that much progress has been made in recent years, so that emulsions of extremely diverse characteristics have been produced. In a given photographic emulsion the silver halide crystals vary both in size and in the distribution of their sizes. They are said to be polydisperse unless special conditions are used in their preparation such that they are all of the same size (monodisperse). Not only does the crystal size and distribution of crystal sizes affect the photographic emulsion, but the shape of the crystals, the nature of the halides used, their relative amounts and even the distribution of the halides within a single crystal have pronounced effects.

Manufacturers of sensitive materials are able to control all these and many other factors, and to tailor-make emulsions so that the material is optimized with

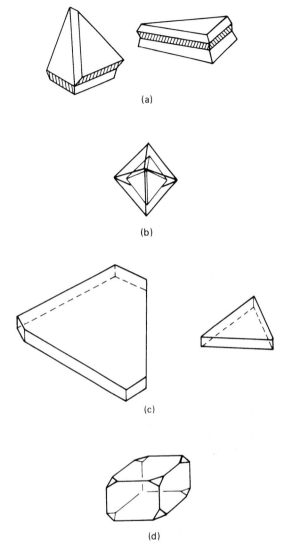

Figure 12.9 Examples of types of emulsion grains (crystals).(a) Twin grains (Agfa). (b) Double structure (Fuji). (c) Tabular or T-grains (Kodak). (d) Cubic (Konica)

respect to speed and granularity for a specific application, as well as having the appropriate characteristics of tone and colour reproduction. In the past ten years much of the research and development work has led to the manufacture of colour negative films and papers of high sensitivity, low granularity and high image quality. For optimizing the sensitivity, resolution and granularity of colour negative films the individual manufacturers adopt their own individual methods.

Some examples of the various sophisticated ways of employing specific types of silver halide crystal in colour negative films are illustrated in Figure 12.9.

T-grains (flat tabular crystals) allow maximum sensitizing dye to be adsorbed to the grain surface, and encourage very efficient absorption of light, as well as possessing other useful optical and chemical properties that give higher resolution and lower graininess than might be expected from crystals of large surface area. Double-structure crystals optimize both absorption of light and graininess. Monodisperse crystals of appropriate size minimize light scatter within the layer, and so improve image resolution. Much of this sophisticated emulsion technology, originally devised for colour materials, has also been applied to the modern generation of black-and-white materials. Examples include Ilford's XP-2, a monochrome film that yields a dye image and is processed in colour-processing chemicals, Kodak's 'T max' films using Kodak's 'T-grain' technology, and Fuji's Neopan films which use their 'high-efficiency' light-absorption grain technology.

The support

The finished emulsion is coated on to a support, usually referred to as the base, most commonly film or paper. The base used in the manufacture of films is usually a cellulose ester, commonly triacetate or acetate-butyrate, although manufacturers also use newer synthetic polymers which offer important advantages in properties, particularly dimensional stability. This makes them of special value in the fields of graphic arts and aerial survey. The first of these newer materials to be used widely was polystyrene; but the most outstanding dimensionally stable base material to date is polyethyleneterepthalate, a polyester and the raw material of Terylene fabric. As a film, polyethylene terephthalate has exceptionally high strength, much less sensitivity to moisture than cellulose-derivative films, and an unusually small variation in size with temperature (see Table 12.2). Being insoluble in all common solvents, it cannot be fabricated by the traditional method of 'casting' (spreading a thick solution of the film-former on a moving polished band or drum, evaporating off the

solvent and stripping off the dry skin). Instead, the melted resin is extruded, i.e. forced through a die, to form a ribbon which is then stretched while heated to several times its initial length and width. A heat-setting treatment locks the structure in the stretched condition, and the film is then stable throughout the range of temperatures encountered by photographic film. Polystyrene is extruded in a somewhat similar manner.

Film base differs in thickness according to the particular product and type of base, most bases in general use coming within the range of 0.08 mm to 0.25 mm. Roll films are generally coated on 0.08 mm base, miniature films on 0.13 mm base, and sheet films on 0.10 mm to 0.25 mm base. Polyethylene terephthalate base can usually be somewhat thinner than the corresponding cellulosic base because of its higher strength.

Glass plates have now almost entirely been replaced by films but they are still used occasionally in a few specialized branches such as astronomy, holography and spectroscopy, because of their dimensional stability and rigidity, although the dimensional stability of modern safety film bases and the application of electronic sensors is such that the use of glass plates is now rarely essential. An additional advantage of using plates is that they lay flat in the camera; however, these advantages are outweighed by their disadvantages of high cost, fragility, weight, storage space requirements and loading difficulties.

The paper used for the base of photographic and digital hard copy must be particularly pure. Photographic base paper is, therefore, manufactured at special mills where the greatest care is taken to ensure its purity. Before photographic paper is coated with emulsion, the base is usually coated with a paste of gelatin and a white pigment known as baryta (barium sulphate), to provide a pure white foundation for the emulsion, giving maximum reflection. However, most modern paper bases are not coated with baryta but are coated on both sides with a layer of polyethylene and are known as PE or RC – polyethylene or resin-coated papers respectively (Figure 12.10). The upper polyethylene layer contains titanium dioxide as the white pigment and optical

Table 12.2 Properties of supports

	Glass	Paper	Cellulose triacetate	Polyethylene terephthalate
Thermal coefficient of expansion (per °C)	0.001%		0.0055%	<0.002%
Humidity coefficient of expansion (per % RH)	0.000	0.003 to 0.014%	0.005 to 0.010%	0.002 to 0.004%
Water absorbed (at 50% RH, 21 °C)	0.0%	7.0%	1.5%	0.5%
Processing size change	0.00%	−0.2 to −0.8%	<−0.1%	+0.03%
Tensile strength at break (N cm⁻²)	13 730	690	9650	17 240

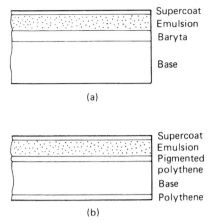

Figure 12.10 Construction of photographic papers.
(a) Baryta paper. (b) Polyethylene or resin-coated paper

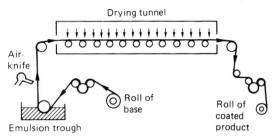

Figure 12.11 Schematic diagram of a coating machine

whiteners. They are impermeable to water, which prevents the paper base from absorbing water and processing chemicals. This results in substantially shorter washing and drying times than are required by traditional baryta-coated fibre-based papers.

Different papers are required for the hard copy output of digital images, particularly if 'photographic quality' is a requirement. In addition to the use of heavyweight bases of $264\,g/m^2$, papers for ink-jet printing require special surface coatings which guarantee homogeneous surface penetration, minimum image spread, high gloss and brightness. Coated paper surfaces may use relatively thick coatings ($20\,\mu$m) of silica in a starch binder. Dye diffusion thermal transfer (D2T2) papers also have special surface coatings to optimize dye uptake, stability, gloss and brightness and the ability to withstand the high temperatures required for the dye transfer.

Coating the photographic emulsion

The coating of modern materials is a complex task and the coating methods in current use are the subject of commercial secrecy. One of the earliest forms of coating flexible supports was 'dip' or 'trough' coating (see Figure 12.11), but this method has been replaced by one or other of the coating techniques outlined below. Dip coating is a slow method because the faster coating results in thicker emulsion layers which are difficult to dry, and may have undesirable photographic properties.

In order to increase the coating speed this method has been modified by the use of an air-knife, which is an accurately machined slot directing a flow of air downwards onto the coated layer and increases the amount of emulsion running back into the coating trough. Coating by this method results in the use of more concentrated emulsions, faster coating speed and thinner coated layers. Other more modern coating methods employ accurately machined slots through which emulsion is pumped directly onto the support (slot applicator or extrusions coating) or after flowing down a slab or over a weir onto the support (cascade coating) (Figure 12.12). Such coating methods allow coating speeds to be far higher than were possible

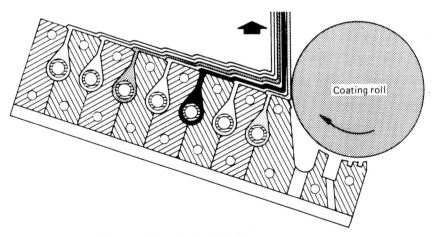

Figure 12.12 Cross-section of a multiple cascade coating head (Agfa)

with the more traditional methods. This allows very high coating speeds to coat base material approximately 1.4 metres wide. Modern monochrome materials have more than one layer coated; colour materials may have as many as fourteen layers, while instant self-developing colour-print films have an even more complex structure. In modern coating technology, many layers are coated in a single pass of the base through the coating machine, either by using multiple slots or by using a number of coating stations, or by a combination of both. The coated material is chilled to set the emulsion, after which (with films and papers) a protective layer, termed a non-stress superheat, is applied to reduce the effects of abrasion. The emulsion is then dried.

With fast negative materials it is usually impossible to obtain the desired properties in any single emulsion. Two emulsions may then be prepared which together exhibit the desired characteristics. These may be mixed and coated as a single emulsion, or they may be applied as two separate layers, an undercoat and a top coat. For the highest speeds the top coat consists of the fastest component emulsion while the undercoat comprises a slower layer. This arrangement gives the required combination of speed, contrast and exposure latitude.

Charge-coupled devices (CCDs)

Photographic sensors are complex to manufacture and require a number of stages and components of high purity. They can be produced in large lengths and widths to provide homogeneous sensors of large area which are subsequently cut to appropriate sizes. CCD sensors, however, are far more difficult to produce and are batch multi-stage processes based on

Table 12.3 Some common sizes of sheet film and papers

Size (cm)	Size (inches)
10.2 × 12.7	4 × 5
10.5 × 14.8 (A6)	4 × 5.5
14.8 × 21.0 (A5)	5.8 × 8.3
16.5 × 21.6	6.5 × 8.5
20.3 × 25.0	8 × 10
21.0 × 29.7 (A4)	8 × 11.5
25.4 × 30.5	10 × 12
29.7 × 42.0 (A3)	11.7 × 16.5
40.6 × 50.8	16 × 20

MOS techniques. Their fabrication involves deposition of many layers of silicon compounds, implantation of specific ions and a metallization layer on ultra-pure silicon wafers. Theuwissen (1996) gives details of 29 stages involved in the production of a typical CCD sensor. This explains their relatively high cost and difficulty in mass producing a 24 × 36 mm, or larger, full frame imager because of the increase in defects as the sensor size increases and the high wastage rate.

Sizes and formats of photographic and electronic sensors and media

Sheet films and papers are supplied in a great many sizes. The nominal sizes in most common use are given in Table 12.3.

Roll and films are made in several sizes, identified by code numbers. A number of sizes are given in Table 12.4. Where more than one format is given in

Table 12.4 Roll film sizes

Size coding	Film width (mm)	Nominal image size (mm)	Number of images	Notes
110	16	13 × 17	12/20	Single perforations, cartridge loaded
APS	24	17 × 30	15/25/40	Advanced Photo System, different aspect ratios possible, data recorded on magnetic strip, processed film remains in cartridge
126	35	26 × 26	12/20	Single perforations, cartridge loaded
135	35	24 × 36	12–36	Double perforations, cassette loaded
120	62	45 × 60 60 × 60 60 × 70 60 × 90	16/15 12 10 8	Unperforated, rolled in backing paper
220	62	As for 120 but double number of images		Unperforated film with leader and trailer
70 mm	70			Double perforations, cassette loaded

Table 12.5 Sizes and resolutions of typical CCD sensors

Approximate size (H × V) (mm × mm)	No of pixels (H × V)	File size* (mB)
5.3 × 4(8 mm, 1/3 in)	320 × 240	0.2
	640 × 480	0.9
	756 × 504	1.1
	1024 × 768	2.2
8.8 × 6.6 (2/3 in)	1280 × 960	3.7
14 × 9.3	1524 × 1012	4.4
24 × 36 (35 mm)	3072 × 2048	18

*Assumes no data compression, 8 bits/colour and 3 channels.

Table 12.4, the size achieved in any given instance depends upon the design of the camera used. In addition, with modern cameras and encoding of films different image sizes, selected by the choice of camera or camera settings, are now becoming more popular.

In 1996 a new format was introduced known as the Advanced Photo System (APS). This was defined jointly by Eastman Kodak Company, Fuji Photo Film Co. Ltd., Canon Inc., Minolta Co. Ltd. and Nikon Corporation. In comparison with previous cartridge systems, APS has the unusual features of storing the processed film in the cassette and incorporating a magnetic coating for recording information about the photographer's choice of formats. The film format and the cassette is smaller than 35 mm, which has allowed the design of more compact cameras with a very much simpler loading system (see Figure 12.14).

Generally, for image sensors size is related to quality; the larger the area the better the quality. Manufactures of photographic sensitive materials have improved the quality of their products over a long period of time such that smaller format materials can be introduced which are of acceptable quality to the consumer, the most recent one being the APS technology mentioned above. Electronic sensors are a much more recent innovation and have had a shorter period of evolution of less than 30 years compared with 150 years for photographic materials, but are advancing rapidly. Table 12.5 lists some typical CCD sensor sizes, their number of pixels and file sizes. Because of the complex multi-stage manufacturing process and structure of CCDs it is very difficult to mass produce large area CCDs. The failure rate is high, which makes them expensive and the larger the area and the greater the number of pixels the higher is the chance of defects which also makes the production of high resolution (large numbers of pixels in a given area) costly.

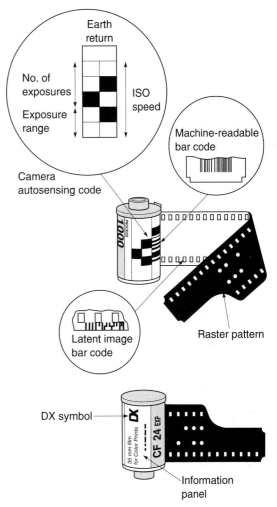

Figure 12.13 DX coding of 35 mm film

Film coding

DX coding was introduced more than a decade ago for 35 mm films which provides information for the photographer and the processing laboratory. This system of coding is shown in Figure 12.13. The cassette has printed on it an auto-sensing code which enables certain cameras to set the film speed on the camera to that of the film automatically by making appropriate electrical contact with the pattern on the cassette. Also printed on the cassette is a machine-readable bar code. A raster pattern punched into the film leader and a bar code along the edge of the film provide data about the film for the processing laboratory. More recently, APS was introduced (see Table 12.4 and Figure 12.14) and provides a magnetic recording coding system for the photographer and for the processing laboratory. In addition to the magnetic

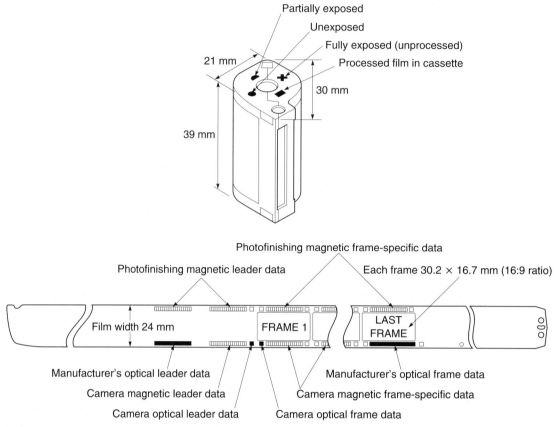

Figure 12.14 The Advanced Photo System (APS)

data for recording information at the time of exposure, the end of the cartridge has visual indicators of the exposure status of the film to show if the film is unexposed, partially exposed, fully exposed but not processed, or exposed and processed (see Figure 12.14).

File formats

There are a vast number of different file formats which are used for handling, manipulating and storing digital images, many of which arose from the requirements of computer graphics, driven by manufacturers of hardware and software. Virtually all graphics programs save files in their own proprietary or native format but most modern programs are able to read a variety of different formats. This is now being driven by the end-users who demand inter-system compatibility, the gradual emergence of standards and manufacturers joining together to provide file formats that are more universal and more appropriate to the requirements of photorealistic imaging.

There are two basic overall types of files for storing image data – these are vector graphics and bitmap (raster) image structures. Vector graphics files comprise data in the form of vectors that mathematically define lines and curves by their geometrical formulae but cannot be used for photorealistic imagery. This format has the advantage that it can be re-sized or re-scaled without distortion, the images are of good quality on any output device and is most suitable for bold sharp graphics rather than for continuous tone photographic types of imaging. Also it results in smaller file sizes with less need for data compression. Examples of vector graphics formats include: CDR (CorelDRAW), CGM (Computer Graphics Metaphile) and WMF (Microsoft Windows Metafile). A more complete listing is given in Table 12.6. Bitmap or raster images divide the image in to a grid of equally sized squares (pixels). Each pixel is defined by a specific location and colour (see Figures 1.1 and 1.2). This file format is especially suitable for photographic types of imagery, which involve continuous tone with subtleties of colour and tone but suffer from the disadvantage of being resolution

Table 12.6 Image file formats

Format	Name/origin	Windows file extension	Comments
BMP	Bitmap, Microsoft Windows	.bmp	B, different sub-formats
CDR	CorelDRAW	.cdr	V
CGM	Computer Graphics Metaphile	.cgm	V
CLP	Clipboard, Microsoft Windows	.clp	B
DRW	Micrografx Draw	.drw	V
EPS	Encapsulated PostScript, Adobe	.eps	B, standard format for storing high resolution PostScript illustrations
FlashPix	Hewlett-Packard Company, Eastman Kodak Company, Live Picture Inc., Microsoft Corporation	.fpx	B, multi-resolution, developed for rapidity and ease of use by consumers and small office users, uses JPEG compression
GIF	Graphics Interchange Format, CompuServe	.gif	B
HGL	Hewlett Packard Graphics Language	.hgl	V
JPEG	Joint Photographic Experts Group	.jpg	B, standard lossy compression system
PCX	Zsoft Paintbrush	.pcx	B, subformats
Photo-CD	Kodak Photo-CD	.pcd	B, up to 6 different resolutions from 'thumbnail' to high resolution (2000 dpi) for hard copy output, uses Photo YCC for colour encoding, widely used for storing 100 images on CD-ROMS
Picture CD	Kodak	.jpg	B, uses JPEG compression for storing images on CD-ROM, 1 film high resolution (1000 dpi)
Picture Disc	Kodak	.jpg	B, uses JPEG compression for storing 28 low resolution (300 dpi) images on a PC floppy disc
PICT	Macintosh PICT format, Apple	.pct	B,V, used by many applications, originally developed for MacDraw software
PNG	Portable Network Graphics	.png	B
TIFF	Tag Image File Format, Aldus	.tif	B, different sub-formats, very widely used and supported
WMF	Microsoft Windows Metafile	.wmf	V

B, bitmap; V, vector.

dependent. When magnified on the screen or printed at high resolution the images can show rough or jagged edges (jaggies). There are many examples of this type of format, such as BMP (Microsoft Bitmap), EPS (Encapsulated PostScript), GIF (Graphics Interchange Format, CompuServe) and TIFF (Tag Image File Format, Aldus). For a summary of file formats see Table 12.6. However, it is not possible to transfer bitmap formats into vector formats and the situation is further complicated by the fact that vector formatted files can contain text and bitmap information (meta data) as well as vector data.

Unfortunately, the situation is even more complicated than indicated by the few selected examples given above. For example there are a number of variations, or sub-formats of the TIFF format, which may lead to difficulties when transferring images from one platform to another. Because file sizes for high quality photographic images can be very large a need has arisen for data compression. Needs of photographic users have led to the introduction of specific file formats for transfer and storage of photographically recorded data. Examples of these include Kodak's Photo CD

Table 12.7 Kodak Digital Science Photo CD image formats

Name	Resolution (pixels)	Comments
Base 16	128 × 192	Small thumbnail for rapid viewing of all images
Base 4	256 × 384	Thumbnail, low resolution for rapid viewing of individual images full-screen
Base	512 × 768	TV resolution. Highest screen resolution viewing for multimedia applications
4 × Base	1024 × 1536	HDTV resolution for DTP proof prints
16 × Base	2048 × 3072	High resolution for hard copy output up to 5 × 7 in from 35 mm originals
64 × Base	6144 × 4096	Additional higher resolution on Pro Photo CD

(PCD) which was released in 1992, their more recently introduced Picture Disk and FlashPix (FPX), a new format introduced in 1996 by a partnership between Hewlett-Packard Company, Eastman Kodak Company, Live Picture Inc. and Microsoft Corporation.

The Kodak Photo CD is a revolutionary and far-sighted approach to handling digital images which was introduced at a very early phase in the evolution of digital imaging. The initial idea was for images digitized from 35 mm films to be viewed on television screens and so required TV resolution but higher resolution images were included for hard copy output and for potential future higher definition TV systems. Also two low resolution images were included for rapid viewing of thumbnails of all the images on the disc and rapid viewing of thumbnails of individual images. At a later date an additional higher resolution was added to cope with the needs of professional photographers for storage of 2 1/4 inch square and 4 × 5 inch larger format originals, This is the Kodak Pro Photo CD. The available formats at which the images are stored are given in Table 12.7.

Details of other more recently introduced formats for viewing, using and storing digitized photographic images, such as FlashPix, Picture CD and Picture Disc are given in Table 12.6. These formats are evolving as digital imaging matures and the needs of end-users become clearer. Because image files are large there is a need for data compression and the emerging formats make use of data compression techniques to keep file sizes down to sensible sizes to allow for more efficient storage and rapid transfer of data.

Data compression

The two overall type of compression techniques are lossless and lossy. Lossless coding results in the decompressed image being identical with the original digital image which may be a significant requirement in applications such as medical and forensic imaging where the integrity of the data is paramount and may be a legal requirement for the unaltered storing of images. Lossy techniques, however, discard data and the decompressed image will not be identical to the original image. Lossy techniques allow a much higher level of compression with some sacrifices in image quality. Generally lossy techniques discard information that is not visually apparent or too objectionable, such as high frequency information, or by reducing the bit level. Various compression techniques are part of the sub-formats mentioned in Table 12.6 and appear in applications programs as an option when saving files in a particular format. Generally lossless techniques, such as Huffman encoding and entropy coding (Lempel/Ziv/Welch, LZW), only allow compression ratios of around 1:2.5, whereas lossy techniques such as JPEG and Fractal transform of Barnsley of Iterated Systems Inc., allow compression ratios of up to 1:100 and higher. JPEG is an agreed international standard for image compression and is widely used and adopted in many computer applications.

Bibliography

Davies, A. and Fennessy, P. (1998) *An Introduction to Electronic Imaging for Photographers,* 2nd edn. Focal Press, Oxford.

Diamond, A.S. (ed.) (1991). *Handbook of Imaging Materials.* Marcel Dekker, New York.

Holst, G.C. (1996) *CCD Arrays, Cameras and Displays.* SPIE Optical Engineering Press, Bellingham, WA.

Kay, D.C. and Levine, J.R. (1995) *Graphics File Formats.* Windcrest Books/McGraw-Hill, New York.

Proudfoot, C.N. (ed.) (1997) *Handbook of Photographic Science and Engineering,* 2nd edn. IS&T, Springfield, VA.

Tani, T. (1995) *Photographic Sensitivity.* Oxford University Press, Oxford.

Theuwissen, A.J.P. (1996) *Solid-State Imaging with Charge-coupled Devices.* Kluwer Academic, Dordrecht, The Netherlands.

13 Spectral sensitivity of photographic materials

The inherent sensitivity to light of the silver halides is confined to the limited range of wavelengths absorbed by them. This range includes the blue and violet regions of the visible spectrum, the ultraviolet region and shorter wavelengths extending to the limit of the known spectrum, including X-radiation and gamma-radiation. This applies, in general terms, to all types of emulsion – chloride, bromide, iodobromide, etc. – though the position of the long-wave cut-off of sensitivity varies with the type of emulsion, as shown in Figure 13.1. The amount of light absorbed in the inherent sensitive region, and hence the useful speed of an emulsion, depends on the volumes of the individual silver halide crystals present in the emulsion. Fast emulsions therefore usually give coarser-grained images than slower emulsions.

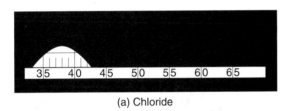

(a) Chloride

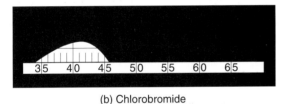

(b) Chlorobromide

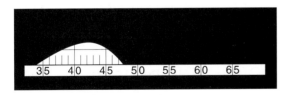

(c) Bromide

(d) Iodobromide

Figure 13.1 Wedge spectrograms of unsensitized chloride, chlorobromide and iodobromide emulsions (to tungsten light at 2856 K)

Response of photographic materials to short-wave radiation

Despite the fact that the silver halides have an inherent sensitivity to all radiation of shorter wavelengths than the visible, the recording of such radiation involves special problems. In the first place, the crystals of silver halide in the emulsion significantly absorb radiation of wavelength shorter than about 400 nm. The result is that images produced by *ultraviolet* (UV) radiation lie near the surface of the emulsion, because the radiation is unable to penetrate very far. Also, at wavelengths shorter than about 330 nm, the radiation is absorbed by glass. To record beyond this region, quartz, or fluorite optics have to be employed. At about 230 nm, absorption of radiation by the gelatin of the emulsion becomes serious. To record beyond this region, special emulsions have been employed: *Schumann* emulsions have an extremely low gelatin content, and in some other special emulsions, by the adoption of a particular manufacturing technique, the concentration of the silver halide grains is much higher at the surface than deeper in the emulsion layer. Particular care must be taken not to abrade the surface of either type of emulsion or stress marks will result. As an alternative to the use of such special emulsions, fluorescence can be employed to obtain records in this region. Ordinary photographic films can be used, the emulsion being coated with petroleum jelly or mineral oil, which fluoresces during the exposure to form a visible image to which the emulsion is sensitive. The jelly is removed before processing, by bathing the film in a suitable solvent.

The region 230–360 nm, sometimes referred to as the *quartz UV region*, is of particular importance in spectrography, because many elements display characteristic lines here. By a fortunate coincidence the gamma of many emulsion, which in general varies considerably with wavelength, is comparatively

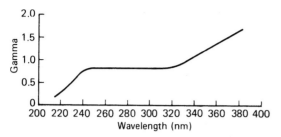

Figure 13.2 Relationship between gamma and wavelength in the ultraviolet for a typical emulsion

constant throughout this region. This is illustrated in Figure 13.2.

Below about 180 nm, UV radiation is absorbed by air, and recording has to be carried out in a vacuum. At about the same wavelength, absorption of radiation by quartz becomes serious and fluorite optics or reflection gratings have to be employed. Below 120 nm, fluorite absorbs the radiation and reflection gratings only can be employed. Using special emulsions in vacuum with a reflection grating, records may be made down to wavelengths of a few nanometres, where the ultraviolet region merges with the soft X-ray region. This technique is known as *vacuum spectrography*.

No problem of absorption by gelatin or by the equipment arises in the X-ray or gamma-ray regions. In fact, the radiation in this region is absorbed very little by anything, including the emulsion, and it is therefore necessary to employ a very thick emulsion layer containing a large amount of silver halide to obtain an image. For manufacturing and other reasons, this is normally applied in two layers, one on each side of the film base. Another way of getting round the difficulty arising from the transparency of emulsions to X-rays is to make use of fluorescent intensifying screens. Such screens, placed in contact with each side of the X-ray film emit, under X-ray excitation, blue or green light to which the film is constructed to be very sensitive, and thus greatly increase the effective film speed. Heavy metal salt and, especially, rare earth salt intensifying screens considerably reduce the radiation dosage to patients receiving diagnostic X-ray exposures. For very short-wave X-rays and gamma-rays, such as are used in industrial radiography, metal screens can similarly be used. When exposed to X-rays or gamma-rays these screens eject electrons which are absorbed by the photographic material forming a latent image. The metal employed for such screens is usually lead. There are thus two major types of intensification of the effect of X-ray exposure, depending on the wavelength: *salt screens* and *lead screens*.

Although invisible to the eye, ultraviolet radiation is present in daylight, and, to a much lesser extent, in

tungsten light. Ultraviolet radiation from about 330 to 400 nm, sometimes referred to as the *near-UV region*, may under some circumstances affect the results obtained in ordinary photographs, giving increased haze in distant landscapes and blue results in colour photographs of distant, high altitude or sea scenes. Shorter wavelengths than about 330 nm are sure to be absorbed by the lens although most modern camera lenses absorb substantial amounts of radiation nearer to the visible limit at approximately 400 nm.

Response of photographic materials to visible radiation

Photographic materials that rely on the unmodified sensitivity of the silver halides have been referred to variously as *blue-sensitive, non-colour-sensitive, ordinary* or *colour-blind* materials. The most commonly used term is probably the description 'ordinary'. The materials used by the early photographers were of this type. Because such materials lack sensitivity to the green and red regions of the spectrum, they are incapable of recording colours correctly; in particular, reds and greens appear too dark (even black) and blues too light, the effect being most marked with saturated colours.

For some types of work this is of no consequence. Thus, blue sensitive or blue-and-green sensitive emulsions are still in general use today for printing papers, and for negative materials used with black-and-white subjects in graphic arts applications. Even coloured subjects such as landscapes, architectural subjects and portraits can be recorded with a fair degree of success on blue-sensitive materials, as witness the many acceptable photographs that have survived from the days when these were the only materials available. One of the reasons for success in these cases is that the colours of many natural objects are not saturated, but are whites and greys that are merely tinged with a colour or group of colours. Photographs on blue-sensitive materials are thus records of the blue content of the colours, and, as the blue content may often be closely proportional to the total luminosity of the various parts of the objects, a reasonably good picture may be obtained. When the colours are more saturated, blue-sensitive materials show their deficiencies markedly, and photographs in which many objects appear far darker than the observer sees them cannot be regarded as entirely satisfactory. Such photographs were in fact regarded as satisfactory for many decades because many viewers were accustomed to the incorrect rendering as a convention of photography. They regarded a blue sky being reproduced as white and red reproduced as black as being entirely normal. But such tonal distortions cannot really be satisfactory and it is therefore desirable to find some means of conferring

on emulsions a sensitivity to the green and red regions of the spectrum, while leaving the blue sensitivity substantially unchanged.

Spectral sensitization

It was discovered by Vogel in 1873 that a silver halide emulsion can be rendered sensitive to green light as well as to blue by adding a suitable dye to the emulsion. Later, dyes capable of extending the sensitivity into the red and even the infrared region of the spectrum were discovered. This use of dyes is termed *dye sensitization, colour sensitization*, or *spectral sensitization*. The dyes, termed *spectral sensitizers*, may be added to the emulsion at the time of its manufacture, or the coated film may be bathed in a solution of the dye. In all commercial emulsions today the former procedure is adopted, although when *colour-sensitive materials* were first introduced it was not uncommon for the users to bathe their own materials. In either case sensitization follows from the

dye becoming adsorbed to the emulsion grain surfaces. Dye that is not adsorbed to the silver halide crystals does not confer any spectral sensitization. The amount of dye required is extremely small, usually sufficient to provide a layer only one molecule thick over only a fraction of the surface of the crystals. The quantity of dye added, and hence the sensitivity of the emulsion in the sensitized region, depends to a certain extent on the surface area of the silver halide crystals.

The sensitivity conferred by dyes is always additional to the sensitivity band of the undyed emulsion, and is always added on the long wavelength side. The extent to which an emulsion has been dye-sensitized necessarily makes a very considerable difference to the amount and quality of light which is permissible during manufacture and in processing.

For practical purposes, colour-sensitive black-and-white materials may be divided into four main classes:

(1) Orthochromatic
(2) Panchromatic

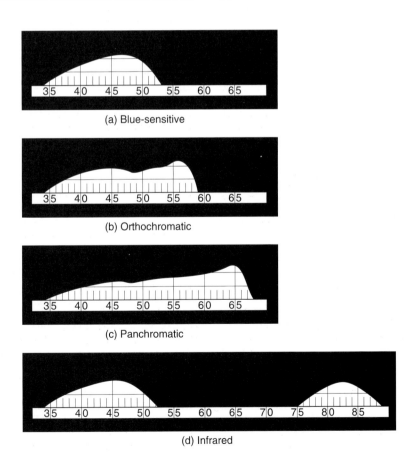

(a) Blue-sensitive

(b) Orthochromatic

(c) Panchromatic

(d) Infrared

Figure 13.3 Wedge spectrograms of typical materials of each of the principal classes of spectral sensitivity (to tungsten light at 2856 K)

(3) Extended sensitivity
(4) Infrared-sensitive

The spectral sensitivities of three of these classes are illustrated in Figure 13.3.

Some classes of sensitizing dyes are found to lower the natural sensitivity of emulsions to blue light, while conferring sensitivity elsewhere in the spectrum. This may not be desirable in black-and-white emulsions but is sometimes useful, especially in colour materials.

Orthochromatic materials

In the first dye-sensitized materials, the sensitivity was extended from the blue region of the spectrum into the green. The spectral sensitivity of the resulting materials thus included ultraviolet, violet, blue and green radiation. In the first commercial plates of this type, introduced in 1882, the dye eosin was used and the plates were described as isochromatic, denoting equal response to all colours. This claim was exaggerated, because the plates were not sensitive to red at all, and the response to the remaining colours was by no means uniform. In 1884, dry plates employing erythrosin as the sensitizing dye were introduced. In these, the relation between the rendering of blue and green was improved, and the plates were termed orthochromatic, indicating correct colour rendering. Again, the description was an exaggeration. The term orthochromatic is now applied generally to all green-sensitive materials. Most modern green-sensitive materials have the improved type of sensitization of which the use of erythrosin was the first example. Although orthochromatic materials do not, in fact, give correct colour rendering, they do give results that are acceptable for many purposes, provided the dominant colours of the subject do not contain much red. Orthochromatic materials are, in fact, no longer widely used for general purpose photography although spectral sensitization of the orthochromatic type is used in a few special-purpose monochrome materials.

Panchromatic materials

Materials sensitized to the red region of the spectrum as well as to green, and thus sensitive to the whole of the visible spectrum, are termed panchromatic, i.e. sensitive to all colours. Although red-sensitizing dyes appeared within a few years of Vogel's original discovery, the sensitivity conferred by the red sensitizing dyes at first available was quite small, and it was not until 1906 that the first commercial panchromatic plates were marketed.

There are many different types of panchromatic sensitization, the differences between some of them being only slight. The main variations lie in the position of the long-wave cut-off of the red sensitivity, and in the ratio of the red sensitivity to the total sensitivity. Usually, the red sensitivity is made to extend up to 660–670 nm. Panchromatic materials have two main advantages over the earlier types of material. In the first place, they yield improved rendering of coloured objects, skies, etc. without the use of filters. In the second place, they make possible the control of the rendering of colours by means of colour filters. Where the production of a negative is concerned, and the aim is the production of a correct representation in monochrome of a coloured subject, panchromatic emulsions must be used. Again, when it is necessary to modify the tone relationships between differently coloured parts of the subject, full control can be obtained only by the use of panchromatic materials in conjunction with filters.

Extended sensitivity materials

The sensitivity of the human eye is extremely low beyond 670 nm and an emulsion with considerable sensitivity beyond this region gives an infrared effect, that is, subjects that appear visually quite dark may reflect far-red and infrared radiation that is barely, if at all, visible but which leads to a fairly light reproduction when recorded by such a film. A comparison between typical panchromatic and extended sensitivity films is shown in Figure 13.4.

Panchromatic emulsions with spectral sensitivity extended to the near infrared, up to about 750 nm, are available for general camera use and can be useful for haze penetration in landscapes, coupled with a light

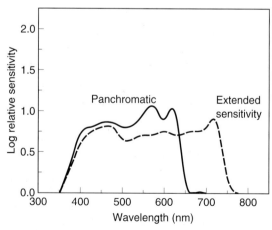

Figure 13.4 The spectral sensitivities of typical panchromatic and extended sensitivity films

rendering of green foliage and, typically a rather dark rendering of blue skies which may be enhanced by use of appropriate filters over the camera lens. The monochrome reproductions obtained can be quite striking and account for the use of such materials which do, after all, distort the tonal rendering of the subject away from our perceptions of subject brightness.

Infrared materials

The classes of colour-sensitized materials so far described meet most of the requirements of conventional photography. For special purposes, however, emulsions sensitive to yet longer wavelengths can be made; these are termed infrared materials. Infrared sensitizing dyes were discovered early in this century, but infrared materials were not widely used until the 1930s. As the result of successive discoveries, the sensitivity given by infrared sensitizing dyes has been extended in stages to the region of 1200 nm. The absorption of radiation, around 1400 nm, by water would make recording at longer wavelengths difficult, even if dyes sensitizing in the region were available. Infrared monochrome materials are normally used with a filter over the camera lens or light source, to prevent visible or ultraviolet radiation entering the camera.

Infrared materials find use in aerial photography for the penetration of haze and for distinguishing between healthy and unhealthy vegetation, in medicine for the penetration of tissue, in scientific and technical photography for the differentiation of inks, fabrics etc. which appear identical to the eye, and in general photography for the pictorial effects they produce. The first of these applications, namely the penetration of haze, depends on the reduced scattering exhibited by radiation of long wavelength. The other applications depend on the different reflecting powers and transparencies of objects to infrared and visible radiation. Lenses are not usually corrected for infrared, so that when focusing with infrared emulsions it is necessary to increase the camera extension slightly. This is because the focal length of an ordinary lens for infrared is greater than the focal length for visible radiation. This applies even when an achromatic or an apochromatic lens is used. In an achromat the foci for green and blue-violet are (usually) made to coincide, and the other wavelengths in the visible spectrum then come to a focus very near to the common focus of green and blue-violet. Similar considerations apply to an apochromatic lens. Infrared radiation, however, is of appreciably longer wavelength, and does not come to the same focus as the visible radiation. Lenses can be specially corrected for infrared, but are not generally available for camera use. Some modern cameras have a special infrared focusing index for this purpose. With others,

the increase necessary must be found by trial. It is usually of the order of 0.3 to 0.4 per cent of the focal length.

Other uses of dye sensitization

Sensitizing dyes have other uses besides the improvement of the colour response of an emulsion. In particular, when a material is to be exposed to a light source that is rich in green or red and deficient in blue (such as a tungsten lamp), its speed may be increased by dye sensitization. Thus, some photographic papers are dye sensitized to obtain increased speed without affecting other characteristics of the material. Many modern monochrome printing papers use differences in spectral sensitization to define high and low contrast emulsion responses within the same material. Modification of the spectral quality of the enlarger illuminant by suitable filters then makes possible the

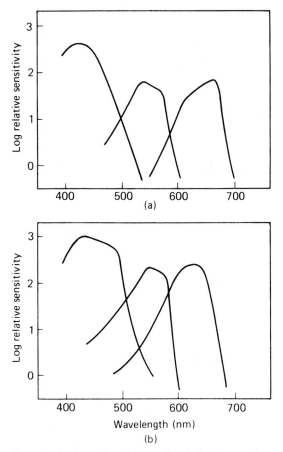

Figure 13.5 Spectral sensitivities of typical colour negative films exposed to daylight: (a) Daylight-balanced film. (b) A faster film, suitable for a range of illuminants, but optimally exposed to daylight (type G film)

control of contrast in the print. In most cases this can eliminate the need for the several contrast 'grades' of paper that were commonplace before the introduction of modern variable contrast printing papers.

The most critical use of dye sensitization occurs in tripack colour materials in which distinct green and red spectral sensitivity bands are required in addition to the blue band. This has required quite narrow sensitization peaks, precisely positioned in the spectrum. Spectral sensitivities of typical modern colour films are shown in Figure 13.5.

A particularly interesting and useful balance of sensitivity is provided by dye-sensitized tabular crystals of the type used in modern 'T-grain' emulsions. These crystals are of large surface area but are very thin, contain little silver halide, do not absorb very much blue light, and hence have a low sensitivity in that spectral region. On the other hand, they have a large surface area and relatively large quantities of sensitizing dyes can be adsorbed to them. This means that such emulsions can be selectively very sensitive to spectral bands outside the region of natural sensitivity, but have only minor natural sensitivity. They are thus well suited to use in colour materials and may eliminate the need for a yellow filter layer to restrict the inherent blue sensitivity of red and green sensitive emulsions.

Determination of the colour sensitivity of an unknown material

The colour sensitivity of an unknown material can be most readily investigated in the studio by photographing a colour chart consisting of coloured patches with a reference scale of greys. In one such chart it has been arranged that the different steps of the neutral half have the same luminosities as the corresponding parts of the coloured half when viewed in daylight. If a photograph is taken of the chart, the colour sensitivity of the emulsion being tested, relative to that of the human eye, is readily determined by comparing the densities of the image of the coloured half with the densities of the image of the neutral half. The value of the test is increased if a second exposure is made on a material of known colour sensitivity, to serve as a basis for comparison. In the absence of a suitable test chart it is possible to assemble a collage of suitably multicoloured material from magazines or other sources. Ideally the colour areas selected should appear comparably light to the observer. The collage can then be copied as required. Unexpectedly dark monochrome records of colours will indicate a low sensitivity in the spectral region concerned.

A more precise, yet still quite practical, method of assessing the colour sensitivity of a material is to determine the exposure factors of a selection of filters. A selection of three filters, tricolour blue, green and red, may be used. An unexpectedly large filter factor will reveal a spectral region, that passed by the filter concerned, to which the film is relatively insensitive.

In the laboratory, the spectral sensitivity of a material is usually illustrated by means of a graph of spectral sensitivity against wavelength, determined as a wedge spectrogram. This usually yields a plot of \log_{10} relative sensitivity against wavelength in nanometres.

Wedge spectrograms

The spectral response of a photographic material is most completely illustrated graphically by means of a curve known as a wedge spectrogram, and manufacturers usually supply such curves for their various materials. A wedge spectrogram, which indicates the relative sensitivity of an emulsion at different wavelengths through the spectrum, is obtained by exposing the material through a photographic wedge in an instrument known as a wedge spectrograph. The spectrograph produces an image in the form of a spectrum on the material, the wedge being placed between the light source and the emulsion. A typical optical arrangement is shown in Figure 13.6.

Examples of the results obtained in a wedge spectrograph are shown in Figure 13.3, which shows wedge spectrograms of typical materials of each of the principal classes of colour sensitivity. We have already seen other examples of wedge spectrograms in Figure 13.1. The outline of a wedge spectrogram forms a curve showing the relative log sensitivity of the material at any wavelength. Sensitivity is indicated on a logarithmic scale, the magnitude of which depends on the gradient of the wedge employed. All the spectrograms illustrated here were made using a continuous wedge, but step wedges are sometimes used.

In Figure 13.3 the short-wave cut-off at the left of each curve is characteristic not of the material, but of the apparatus in which the spectrograms were produced, and arises because of the ultraviolet absorption by glass (to which reference was made earlier).

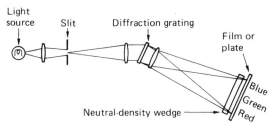

Figure 13.6 Optical arrangement of wedge spectrograph

Secondly, the curves of the spectrally sensitized materials are seen to consist of a number of peaks; these correspond to the summed absorption bands of the dyes employed.

The shape of each curve depends not only on the sensitivity of the material but also on the quality of the light employed. All the spectrograms shown in Figure 13.3 were made with a tungsten light source with a colour temperature of approximately 2856 K. Wedge spectrograms of the same materials, made to daylight, would show higher peaks in the blue region and lower peaks in the red.

The wedge spectrogram of the infrared material in Figure 13.3 shows a gap in the green region of the spectrum. This permits the handling of the material by a green safelight. Infrared-sensitive materials do not necessarily have this green gap and furthermore may receive infrared radiation transmitted by materials which appear opaque to light. Some black plastics and fabrics, such as camera bellows, may transmit infrared radiation, as may the sheaths in dark slides used for the exposure of sheet film in technical cameras. Unexpected fogging of extended sensitivity emulsions or infrared materials may occur and constructional materials may be implicated if this is found.

The colour material whose spectral sensitivity is shown in Figure 13.5(a) was designed for daylight exposure and was therefore exposed using a tungsten source of 2856 K and a suitable filter to convert the illumination to the quality of daylight. The omission of the conversion filter would have resulted in a relatively higher red sensitivity peak, at about 640 nm, and a lower blue peak, at about 450 nm.

The necessity to balance the exposing illuminant and the film sensitivity by the use of correction filters can be inconvenient, although generally accepted by professional photographers. The ill-effects of omitting correction filters can be substantially reduced by using a negative film specially designed for the purpose, termed *type G* or, sometimes, *universal* film. An example is shown in Figure 13.5(b), which should be compared with 13.5(a). It will be seen that the sensitivity bands of the type G film are broad and less separated than those of the conventional film. The sensitivity characteristics of type G materials give an acceptable colour reproduction over a wide range of colour temperatures, though the optimum is still obtained with daylight exposure. This tolerance to lighting conditions is gained at the expense of some loss in colour saturation and other mechanisms may have to be used by the manufacturer to restore this to an appropriate level. Alternatively very fast blue-sensitive emulsions of extra-large latitude may be used to provide a suitable image over a wide range of illuminant quality. Such a film will yield negatives of unusually high blue density when used in daylight and these may prove awkward to print in automatic printers.

Uses of wedge spectrograms

Although they are not suitable for accurate measurements, wedge spectrograms do provide a ready way of presenting information. They are commonly used:

(1) To show the way in which the response of an emulsion is distributed through the spectrum.
(2) To compare different emulsions. In this case, the same light source must be used for the two exposures. It is normal practice to employ as a source a filtered tungsten lamp giving light equivalent in quality to daylight (approx. 5500 K) or an unfiltered tungsten lamp operating at 2856 K, whichever is the more appropriate.
(3) To compare the quality of light emitted by different sources. For this type of test, all exposures must be made on the same emulsion.

Spectral sensitivity of digital cameras

The fundamental spectral sensitivity of charge coupled device (CCD) sensors used in digital cameras is that of the silicon itself, modified by interference effects within thin overlying layers forming part of the chip construction. The spectral sensitivity of a typical monochrome CCD is shown in Figure 13.7, from which it will be seen that there is rather a low blue sensitivity but considerable sensitivity extending into the infrared region. In most CCD cameras the infrared sensitivity is restricted by an infrared absorbing filter on the face of the CCD, but in special purpose cameras a separate filter may be fitted to the camera lens.

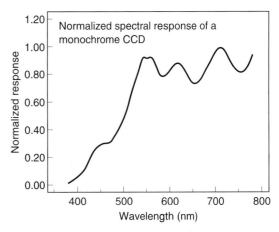

Figure 13.7 The spectral sensitivity distribution of a typical unfiltered monochrome CCD

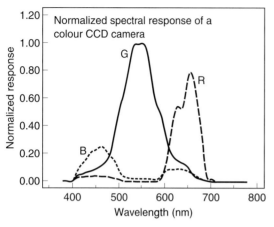

Figure 13.8 The spectral sensitivity of a colour CCD camera showing red, green and blue channel separation

construction, severely reduces the amount of light available and various approaches have been made to compensate for this. The use of complementary filters can approximately double the illumination at the chip and a simple inversion of the signal from each sensitive cell can convert, for example, yellow to blue response. There are some drawbacks in such systems, commonly including a loss of colour quality and increased 'noise' or graininess in the image. The spectral sensitivity of a colour CCD camera is illustrated in Figure 13.8, showing the separation of red, green and blue signals made possible by the application of red, green and blue filters to a single CCD chip. An additional infrared-cutting filter is usually incorporated at the surface of the CCD and is responsible for the long wavelength cut off shown by the colour CCD camera illustrated.

Colour separation in a CCD is achieved by filtration of the light incident on the device. The most compact method is to coat a 'checker board' of red, green and blue filters on the face of the CCD so that each sensitive cell is exposed through a single filter element. An alternative method is to use three CCDs together with a beam splitting device to select separate red, green and blue beams, directing one to each of the three CCDs. The use of such filters, in either

Bibliography

James, T.H. (ed.) (1977) *The Theory of the Photographic Process*, 4th edn. Macmillan, New York.

Walls, H.J. and Attridge, G.G. (1977) *Basic Photo Science*. Focal Press, London.

For sensitivity data for specific photographic products and CCD cameras, the reader is recommended to consult the Websites of the manufacturers.

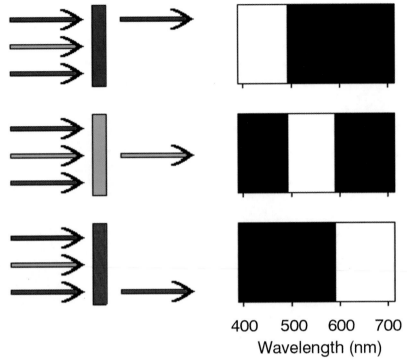

Plate 1 The action of ideal blue, green and red filters, and the corresponding spectral density distributions

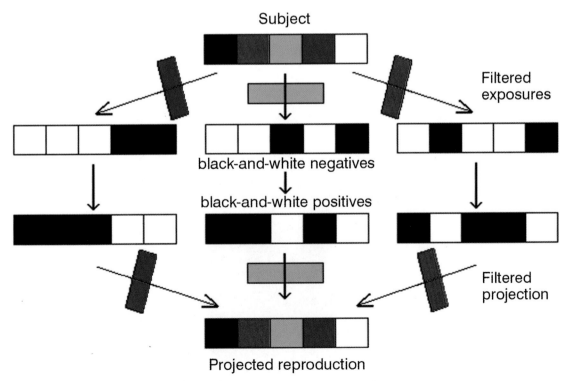

Plate 2 Maxwell's method of colour photography

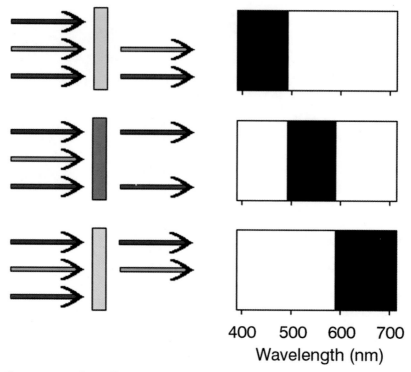

Plate 3 Ideal yellow, magenta and cyan filters

Plate 4 Combinations of complementary colour filters

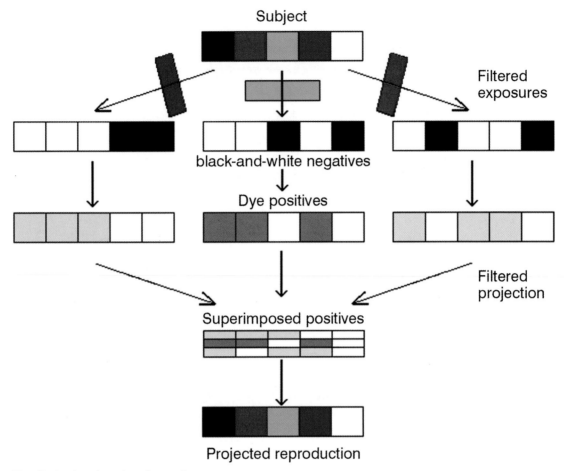

Plate 5 A subtractive colour photograph

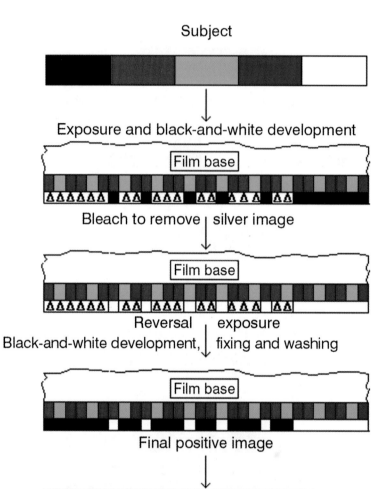

Subject

Exposure and black-and-white development

Film base

Bleach to remove silver image

Film base

Reversal exposure

Black-and-white development, fixing and washing

Film base

Final positive image

Projected reproduction

Plate 6 The Dufaycolor system, an additive colour film

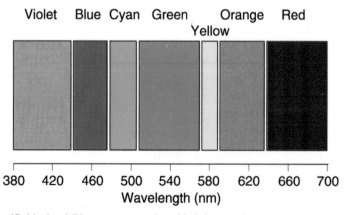

Violet Blue Cyan Green Orange Red

Yellow

380 420 460 500 540 580 620 660 700

Wavelength (nm)

Plate 7 Seven hues identified in the visible spectrum, together with their approximate wavelength ranges

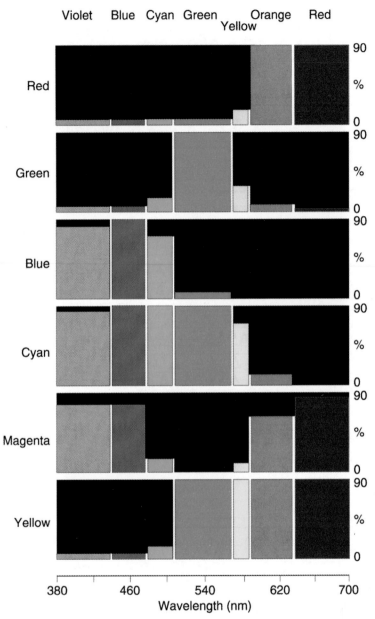

Plate 8 The selective spectral absorptions of some coloured surfaces length ranges

Supercoat
Blue-sensitive emulsion
Yellow filter layer
Green-sensitive emulsion
Interlayer
Red-sensitive emulsion

Plate 9 Cross-section of integral tripack film of camera speed

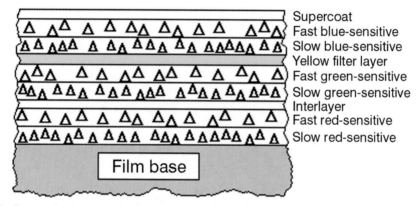

Supercoat
Fast blue-sensitive
Slow blue-sensitive
Yellow filter layer
Fast green-sensitive
Slow green-sensitive
Interlayer
Fast red-sensitive
Slow red-sensitive

Plate 10 Cross-section (not to scale) of a modern colour-negative film. Note the double-coated emulsion layers with fast components coated above the slow. The symbol Δ represents silver halide crystals

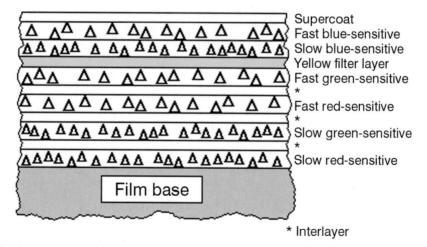

Supercoat
Fast blue-sensitive
Slow blue-sensitive
Yellow filter layer
Fast green-sensitive
*
Fast red-sensitive
*
Slow green-sensitive
*
Slow red-sensitive

* Interlayer

Plate 11 Cross-section (not to scale) of a modern high-speed colour-negative film. The structure is such that it gives the maximum access to exposure to the fast-emulsion components. The use of tabular-grain, 'T-grain', emulsions in the green- and red-sensitive layers allows the omission of the customary yellow filter layer below the blue-sensitive emulsions

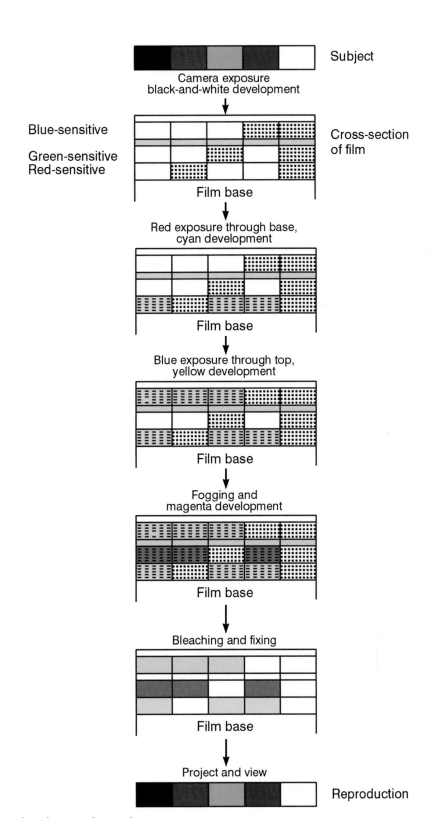

Subject

Camera exposure
black-and-white development

Blue-sensitive

Green-sensitive
Red-sensitive

Cross-section
of film

Film base

Red exposure through base,
cyan development

Film base

Blue exposure through top,
yellow development

Film base

Fogging and
magenta development

Film base

Bleaching and fixing

Film base

Project and view

Reproduction

Plate 12 Non-substantive reversal processing

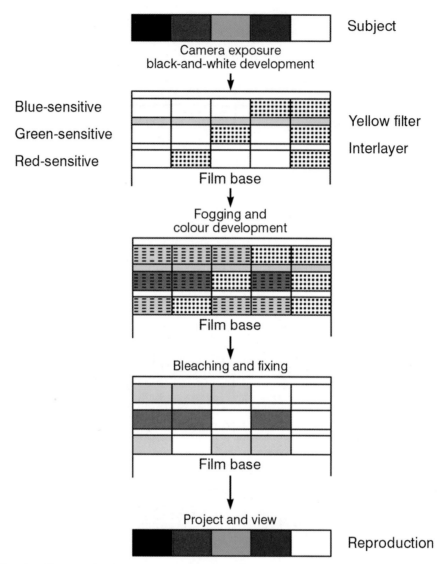

Subject

Camera exposure
black-and-white development

Blue-sensitive

Green-sensitive

Red-sensitive

Yellow filter

Interlayer

Film base

Fogging and
colour development

Film base

Bleaching and fixing

Film base

Project and view

Reproduction

Plate 13 The substantive reversal process

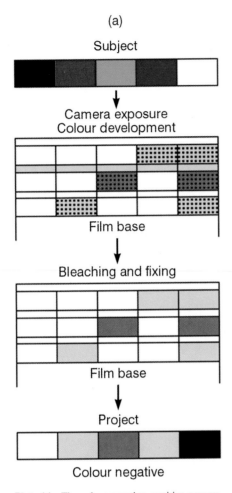

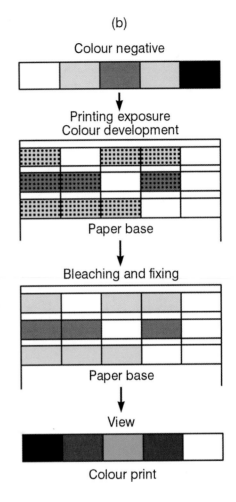

(a)

Subject

↓

Camera exposure
Colour development

Film base

↓

Bleaching and fixing

Film base

↓

Project

Colour negative

(b)

Colour negative

↓

Printing exposure
Colour development

Paper base

↓

Bleaching and fixing

Paper base

↓

View

Colour print

Plate 14 The colour negative–positive process

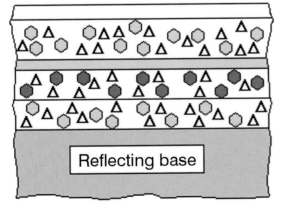

Supercoat

Blue-sensitive emulsion + yellow dye

Yellow filter layer

Green-sensitive emulsion + magenta dye

Red-sensitive emulsion + cyan dye

Reflecting base

Plate 15 Cross-section of silver-dye-bleach material

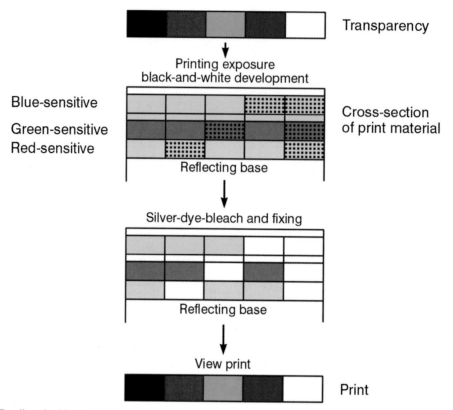

Transparency

Printing exposure
black-and-white development

Blue-sensitive

Green-sensitive
Red-sensitive

Cross-section
of print material

Reflecting base

Silver-dye-bleach and fixing

Reflecting base

View print

Print

Plate 16 The silver-dye-bleach process

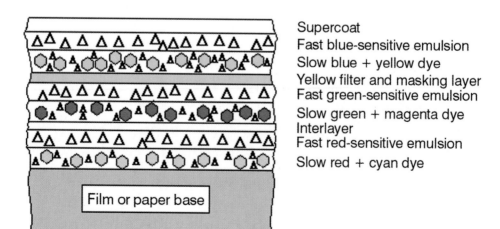

Supercoat
Fast blue-sensitive emulsion
Slow blue + yellow dye
Yellow filter and masking layer
Fast green-sensitive emulsion
Slow green + magenta dye
Interlayer
Fast red-sensitive emulsion
Slow red + cyan dye

Film or paper base

Plate 17 Cross-section of a recent silver-dye-bleach print material (not to scale)

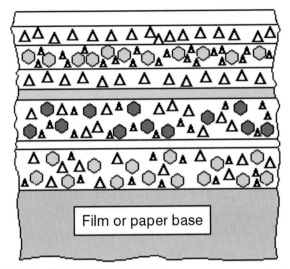

Supercoat
Blue-sensitive emulsion
Blue + yellow dye
Masking emulsion layer
Yellow filter layer
Green-sensitive emulsion
+ magenta dye
Interlayer
Red-sensitive emulsion
+ cyan dye

Film or paper base

Plate 18 Cross-section of Ilfochrome Rapid Low Contrast material, showing the presence of the masking layer

Spacer
Red-sensitive emulsion
Cyan dye-developer

Base

Plate 19 Polacolor emulsion and dye-developer layer combination

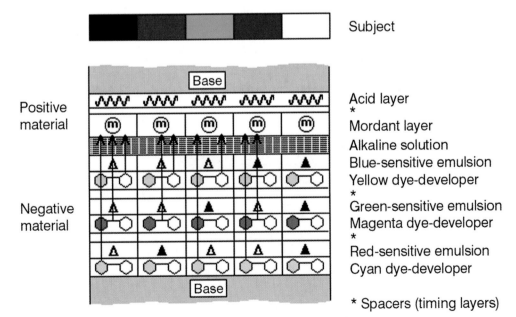

Subject

Positive
material

Acid layer
*
Mordant layer
Alkaline solution
Blue-sensitive emulsion
Yellow dye-developer
*
Green-sensitive emulsion
Magenta dye-developer
*
Red-sensitive emulsion
Cyan dye-developer

Negative
material

* Spacers (timing layers)

Plate 20 Polacolor – the processing stage

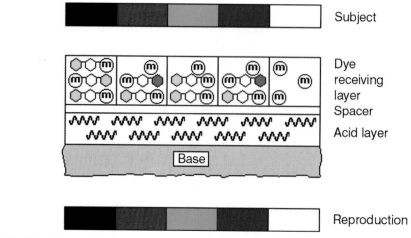

Subject

Dye
receiving
layer
Spacer

Acid layer

Base

Reproduction

Plate 21 The Polacolor record

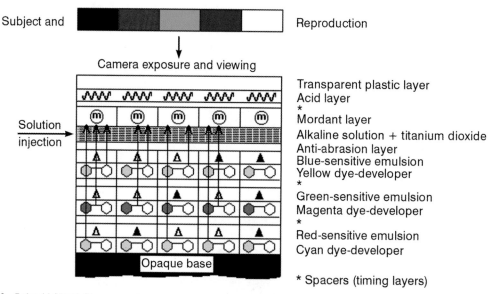

Subject and

Reproduction

Camera exposure and viewing

Transparent plastic layer
Acid layer
*
Mordant layer
Alkaline solution + titanium dioxide
Anti-abrasion layer
Blue-sensitive emulsion
Yellow dye-developer
*
Green-sensitive emulsion
Magenta dye-developer
*
Red-sensitive emulsion
Cyan dye-developer

* Spacers (timing layers)

Solution
injection

Opaque base

Plate 22 Polaroid SX-70 film, processing

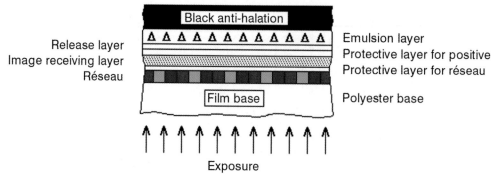

Black anti-halation

Release layer
Image receiving layer
Réseau

Emulsion layer
Protective layer for positive
Protective layer for réseau

Film base

Polyester base

Exposure

Plate 23 The structure of Polachrome instant-colour-slide film

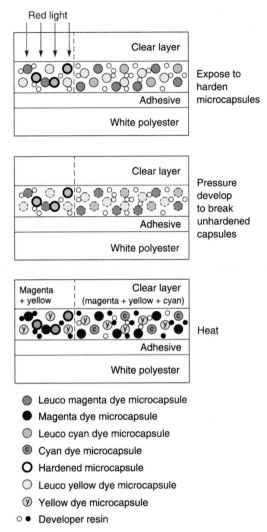

Plate 24 The principles of Cylithographic materials

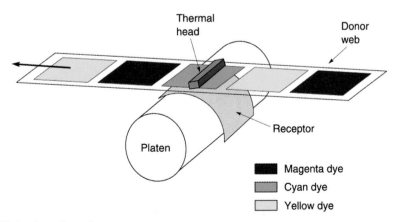

Plate 25 Dye diffusion thermal transfer process

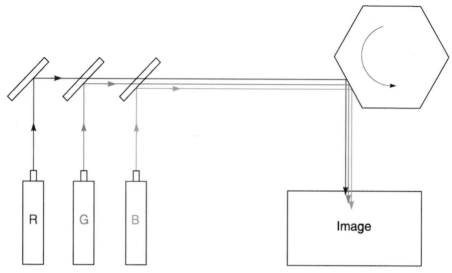

Plate 26 Single-beam RGB laser imaging system (Durst)

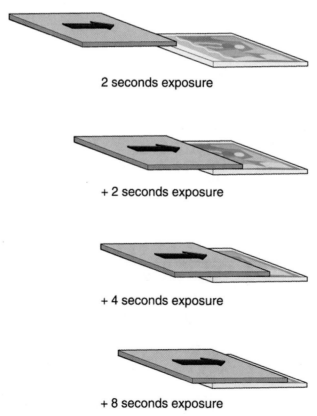

2 seconds exposure

+ 2 seconds exposure

+ 4 seconds exposure

+ 8 seconds exposure

Plate 27 A processed test strip for determining the required exposure

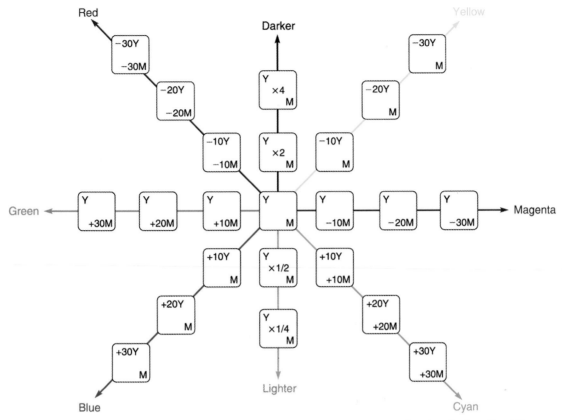

Plate 28 A ring-around series with units of 10 in filtration, centred on yellow and magenta filtration of values, Y and M

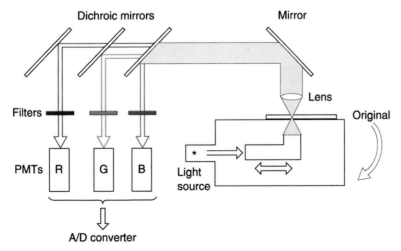

Plate 29 Cross-section of a typical drum scanner

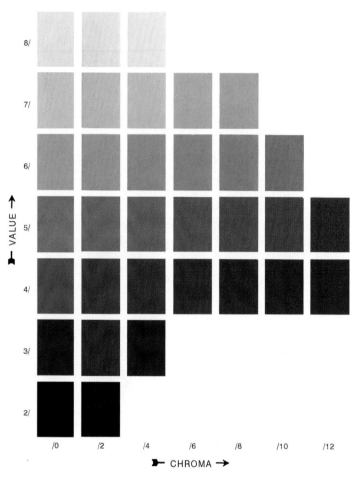

HUE

5.0 R

VALUE →

8/
7/
6/
5/
4/
3/
2/

/0 /2 /4 /6 /8 /10 /12

➤ CHROMA ➤

Plate 30 Specification of colour by sample: a representation of a page from the Munsell Book of Colour, of Hue 5R. Figure provided by, and reproduced by kind permission of, Munsell, a Division of Gretag Macbeth, LLC

Plate 31 Mixing primary colours selected from the visible spectrum

14 Principles of colour photography

Materials that reflect light uniformly through the visible spectrum appear neutral, that is white, grey or black depending on the reflectance. A reflectance of 1 indicates that 100 per cent of the light is reflected, and the object appears perfectly white. Conversely, a zero reflectance indicates a perfect black. A reflectance of 0.20 corresponds to a mid-grey tone reflecting 20 per cent of the incident light. However, equal visual steps between black and white are not represented by equal steps in reflectance.

The sensation of colour arises from the selective absorption of certain wavelengths of light. Thus a coloured object reflects or transmits light unequally at different wavelengths. Reflectance varies with wavelength and the object, illuminated with white light, appears coloured. Colour may be described objectively by a graph of reflectance against wavelength; typical coloured surfaces described in this way are shown in Figure 14.1. It is possible to describe the appearance of materials that transmit light, such as stained glass or photographic filters, similarly. In such cases the term used is *transmittance*. An alternative way of describing a colour is in terms of the variation of *reflection* or *transmission density* with wavelength. Equal density differences are visually approximately equal, so that in some instances the use of reflection or transmission density is preferable to reflectance or transmittance.

Colour matching

The colours of most objects around us are due to a multitude of dyes and pigments. No photographic process can form an image from these original colourants, but colour photography can produce an acceptable reproduction of colours in the original scene. Such a reproduction reflects or transmits mixtures of light that appear to match the original colours, although in general they do not have the same spectral energy distributions. Different spectral energy distributions that give rise to an identical visual sensation are termed *metamers*, or *metameric pairs*. A metameric match is described in Figure 14.2.

Because of this phenomenon of metamerism it is only required that a colour photograph should be capable of giving appropriate mixtures of the three primaries. We shall now consider the methods by which blue, green and red spectral bands are selected and controlled by colour photographs.

A convenient way of selecting bands of blue, green and red light from the spectrum for photography is to

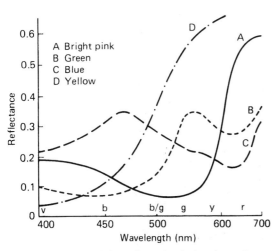

Figure 14.1 Spectral absorptions of typical surface colours

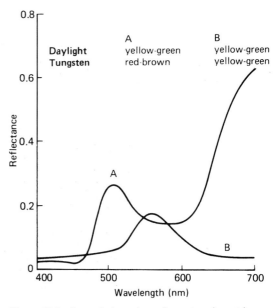

Figure 14.2 Spectral absorptions of a metameric match

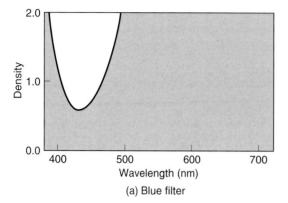

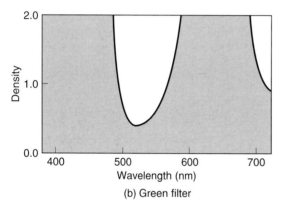

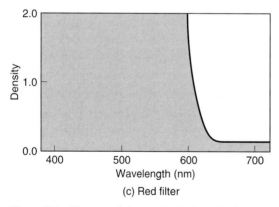

Figure 14.3 The spectral density distributions of primary colour filters used in practice

use suitable colour filters. We may select bands in the blue, green and red regions of the spectrum. This selective use of colour filters is illustrated in Plate 1, which shows the action of 'ideal' primary colour filters, and their spectral density distributions.

The spectral density distributions of primary colour filters available in practice differ from the ideal, and the distribution curves of a typical set of such filters are shown in Figure 14.3. It will be noticed that the

filters shown transmit less light than the ideal filters, although the spectral bands transmitted correspond quite well with the ideal filters previously illustrated. The blue, green and red filters available for photography are thus able to give three separate records of the original scene, and such filters were in fact used in making the first colour photograph.

The first colour photograph

James Clerk Maxwell prepared the first three-colour photograph in 1861 as an illustration to support the three-colour theory of colour vision. (The demonstration was only partially successful owing to the limited spectral sensitivity of the material available at the time.) He took separate photographs of some tartan ribbon through a blue, a green and a red filter, and then developed the three separate negatives. Positive lantern slides were then produced by printing the negatives, and the slides were projected in register. When the positive corresponding to a particular taking filter was projected through a filter of similar colour, the three registered images together formed a successful colour reproduction and a wide range of colours was perceived. Maxwell's process is shown diagrammatically in Plate 2.

Methods of colour photography that involve the use of filters of primary hues at the viewing stage, in similar fashion to Maxwell's process, are called *additive* methods. In the context of colour photography the hues blue, green and red are sometimes referred to as the *additive primaries*.

Additive colour photography

In Maxwell's process (Plate 2) the selection of spectral bands at the viewing stage was made by the original primary-colour filters used for making the negatives. The amount of each primary colour projected on to the screen was controlled by the density of the silver image developed in the positive slide.

An alternative approach to the selection of spectral bands for colour reproduction is to utilize dyes of the complementary hues yellow, magenta and cyan to absorb, respectively, light of the three primary hues, blue, green and red. The action of ideal complementary filters listed in Table 14.1 is shown in Plate 3.

Subtractive colour photography

Whereas the ideal primary colour filters illustrated in Plate 1 may transmit up to one-third of the visible spectrum, complementary colour filters transmit up to two-thirds of the visible spectrum; they *subtract* only one-third of the spectrum.

Table 14.1 Primary and complementary colours

Primary (or additive primary)	Complementary (or subtractive primary)
Red	Cyan (blue–green)
Green	Magenta (red–purple)
Yellow	Blue

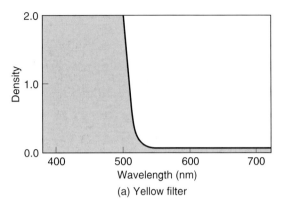

(a) Yellow filter

As with primary filters, the complementary filters available in practice do not possess ideal spectral density distributions, and examples of such non-ideal filters are shown in Figure 14.4.

Combinations of any two primary filters appear black because they have no common bands of transmission, so such combinations cannot be used together to control the colour of transmitted light. With complementary filters the situation is quite different. Despite the imperfections of practical complementary filters, it remains substantially true that each absorbs only about one-third of the visible spectrum. Consequently such filters may be used in combination to control the colour of transmitted light. The effect of combining complementary filters is shown in Plate 4.

In principle, the positive lantern slides used in Maxwell's additive method of colour photography can be made as positive dye images. If we make the hue of each positive complementary to that of the taking filter – the positive record derived from the negative made using a blue filter being formed by a yellow dye and so on – then the three positives can be superimposed in register and projected using only one projector. Such methods, which involve the use at the viewing stage of dyes which *subtract* blue, green and red light from the spectrum, are called *subtractive* processes. The preparation of a subtractive colour reproduction from blue, green and red light records is illustrated in Plate 5.

We have examined the principles of operation of the additive and the subtractive methods of colour photography, and will now consider the operation of some practical examples of each type of process.

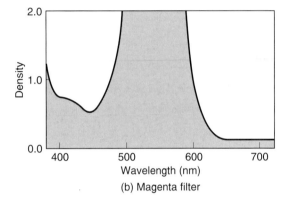

(b) Magenta filter

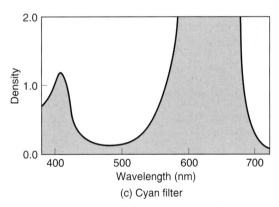

(c) Cyan filter

Figure 14.4 Typical yellow, magenta and cyan filters

Additive processes

As we have seen, the first three-colour photograph was made in 1861 by an additive process. The viewing system required the use of three projectors, and the entire process was too unwieldy for general photography. By the first decade of the twentieth century, however, an ingenious application of the additive system had made possible the production of plates yielding colour photographs by a single exposure in a conventional camera.

In order to achieve analysis of the camera image in terms of blue, green and red light, the exposure was made through a mosaic, or *réseau*, comprising a large number of tiny blue, green and red filter elements. Depending on the manufacturer, the réseau was either integral with the photographic material, or, in some cases, was placed in contact with it. Materials which employed an integral réseau were then reversal-processed, while those using a separate réseau could be negative-processed and then contact-printed to

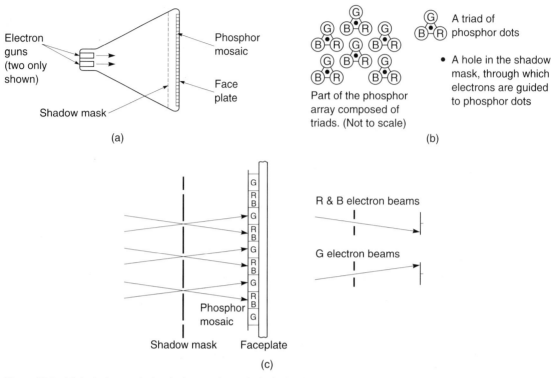

Figure 14.5 (a) A shadow-masked cathode ray tube, typical of television or computer monitors. (b) The phosphor dot pattern. (c) Electron beam paths through the shadow mask to the phosphor dots, with angles exaggerated for clarity

yield a positive which was subsequently registered with a colour réseau screen.

In each case, projection yielded a colour reproduction of the original scene, the method being exemplified by the Dufaycolor process in which the réseau was integral with the film. The system is shown in Plate 6.

Exposure was made through the film base, the réseau being printed on the base beneath the emulsion. After first development the negative silver image was completely removed using an acid potassium permanganate bleach solution, and the residual silver halide was fogged and developed to a positive metallic silver image. After fixing, washing and drying, the resulting positive reproduction could be viewed.

The complexity of early additive processes is avoided by the current additive slide process *Polachrome*. The 35 mm camera film is constructed similarly to the Dufaycolor product; the integral réseau, however, does not consist of squares but of very fine parallel lines of red, green and blue dye. Exposure is made through the film base and the integral réseau. The exposed emulsion is processed in a very small lightweight machine to give a positive image, formed close to the réseau, by diffusion transfer

from the emulsion, which contains the negative image. The emulsion and the unwanted negative image are stripped away after processing and discarded, leaving the additive-colour transparency.

In such additive processes, whether employing an integral or separate réseau, the colour mosaic is present at the viewing as well as the taking stage. This means that the brightness of reproduction of white is limited by the light absorption of the réseau. Less than one-third of the light striking the film is transmitted. Such methods therefore waste about 70 per cent of the available light and generally give a dim picture.

Additive methods employing three separate analysis negatives and the corresponding positives can give very good colour reproduction and a bright image owing to the use of three separate light sources. Such methods are cumbersome in operation and suffer from registration difficulties. The more convenient methods employing réseaux have suffered from the loss of light at the projection stage and definition difficulties due to the presence of the réseau. Even if the réseau employed is so fine as to be unobjectionable in the reproduction, further generations of reproduction, such as reflection prints, tend to be unsatisfactory.

The registration and light-loss problems inherent in additive methods of colour photography have largely led to the adoption of methods based on the subtractive system for most practical colour photography. The mosaic method of additive colour reproduction has, nevertheless, survived in rapid-process slide film and, most importantly, in cathode ray tubes (CRTs) in colour television and computer monitors. The mosaic incorporated in the face of the television tube consists of dots of red, green and blue *phosphors*, light-emitting substances that are stimulated by electron impact. Registration of images is ensured by careful manufacture and setting-up procedures, and there is no filtering action to cause loss of brightness. The dot structure is very fine; each dot is smaller than a typical *pixel,* and is usually much less noticeable than the line pattern, or *raster*, present. The structure of a colour CRT is illustrated in Figure 14.5. The tube has three electron guns corresponding to red-, green- and blue-emitting phosphor dots respectively. Electrons are emitted towards the faceplate of the CRT and are prevented from exciting phosphors emitting inappropriate colours by the presence of the shadow mask with precisely positioned apertures. The phosphor dots illustrated are arranged in RGB triads, each of which corresponds to one hole in the shadow mask, through which three electron beams pass, at slightly differing angles, to excite the appropriate phosphors.

Polachrome slides suffer from the inherent difficulties of light loss, and from visibility of the réseau at large magnifications. The réseau is, however, very fine (some $25\,\mu$m per triplet of filters), and prints enlarged to five times magnification are, in fact not objectionable, when viewed at conventional distances.

Subtractive processes

Subtractive systems use yellow, magenta and cyan image dyes in appropriate concentrations to control the amounts of blue, green and red light, respectively, transmitted or reflected by the reproduction. Thus white is reproduced by the virtual absence of image dyes, grey by balanced moderate quantities of the three dyes, and black by a high concentration of all three dyes. Colours are reproduced by superimposed dye images of various concentrations. The effects of superimposing pairs of subtractive dyes are identical to the combination of filters of the same hues and have been illustrated in Plate 4.

The possibility of preparing subtractive dye positives from blue, green and red separation negatives has already been referred to. If such dye positives are used then it is possible to superimpose the yellow, magenta and cyan images to obtain a reproduction that may be projected using one projector only, or viewed against a reflecting base.

Although such a separation system suffers from registration difficulties when the positives are superimposed, two important commercial processes have operated in this manner. In each case separation positives are made which are able to absorb dye in an amount depending upon the amount of image. Each positive then carries the dye and is made to deposit it on a receiving material which retains the transferred dye. The three dye images are laid down in sequence to build up the required combination. The positive transmission or reflection prints made in this way can be of very high quality provided accurate image registration is maintained. Two major processes which operate by this method are the Kodak Dye Transfer method of making reflection colour prints, and the Technicolor method of preparing motion-picture release colour prints.

Integral tripacks

While it is possible, as we have seen, to produce subtractive dye images separately, and to superimpose them to form a colour reproduction, this method finds limited application. Most colour photographs are made using a type of material that makes blue, green and red records in discrete emulsion layers within one assembly. This specially designed emulsion assembly is called an *integral tripack*. The latent-image records within the emulsion layers are processed in such a way that the appropriate dye images are generated, in register, within the emulsion layers by colour development. The processing chemistry is such that the blue, green and red records are made to generate complementary yellow, magenta and cyan images respectively.

Bibliography

Coe, B. (1978) *Colour Photography.* Ash & Grant, London.
Coote, J.H. (1993) *The Illustrated History of Colour Photography.* Fountain Press, Kingston-upon-Thames.
Hunt, R.W.G. (1995) *The Reproduction of Colour*, 5th edn. Fountain Press, Kingston-upon-Thames.

15 Sensitometry

The objective study of the response of photographic materials or other imaging systems to light or other radiation is called *sensitometry*. It is concerned with the measurement of the exposure that a material has received and the amount of the resultant image. In conventional silver-based photography this is assessed by the amount of blackening, silver-image formation, which takes place. It is possible to produce photographs without any knowledge of sensitometry, but to obtain the best performance out of photographic systems, under all conditions, an understanding of the principles governing the response of imaging systems is invaluable. A knowledge of at least an outline of sensitometry is therefore highly desirable for anyone wishing to make use of any of the specialized applications of photography in science and industry.

As sensitometry is concerned with the measurement of the performance of photographic materials and other light-sensitive systems, it is necessary to use precise terminology in defining the quantities that are measured. The impression that a photograph makes on us depends on physiological and psychological as well as physical factors, and for this reason the success of such an image cannot be determined from a mere series of measurements. This does not mean that we can learn nothing from a study of the factors that *are* amenable to measurement; it simply means that there are limitations to the help that sensitometry can give us.

dark, depending on the angular relationship between source, surface and eye) and to variation in the illumination that the subject receives. The ratio of the maximum to the minimum luminance in a subject is defined as the *subject luminance range*.

It may surprise us at first to realise that an effect such as a sunset, or the rippling of wind over water, can be reduced to areas of varying luminance. Yet it is so in the camera, and in the eye viewing a black-and-white print too, with the difference that the mind draws not only on the eyes for its impression, but on past experience. Thus, when we look at a picture of an apple, for example, we see more than just light and shade. Our past experience of apples – their size, their weight, their taste – comes to the aid of the eyes in presenting to the mind a picture of an apple.

Our final goal in sensitometry is to relate the luminances of the subject to the luminances of the print. This involves the study first of the response of the negative material, then of the response of the positive material, and finally of the relation between the two. We shall consider each of these in turn, beginning with the negative material.

It is customary to refer to the light areas of a subject as the highlights and the dark areas as the shadows. To avoid confusion, it is desirable that the same terms should be applied to corresponding areas both in the negative and in the print, even though in the negative the highlights are dense and the shadows clear.

The subject

As far as the camera is concerned, a subject consists of a number of areas of varying luminance and colour. This holds good whether the subject is a portrait or a landscape, a pictorial or a record shot. In the same way, a photographic print consists of areas of varying luminance and sometimes colour. Luminance is measured in candelas per square metre.

The variations in luminance in a subject are due to the reflection characteristics exhibited by different areas of it and to the differing angles at which they are viewed (a surface that diffuses light fairly completely, such as blotting paper, looks equally bright no matter from which direction it is viewed, but a polished surface may look very bright or very

Exposure

When a photograph is taken, light from the various areas of the subject falls on corresponding areas of the film for a set time. The effect produced on the emulsion is, within limits, proportional to the product of the illuminance E and the exposure time t. We express this by the equation

$H = Et$

Before international standardization of symbols, the equation was $E = It$ (E was exposure, I was illuminance) and this usage is sometimes still found.

The SI unit for illuminance is the *lux* (lx). Hence the exposure is measured in lux seconds (lx s). It

should be noted that the lux is defined in terms of the human observer, who cannot see radiation in either the ultraviolet or infrared regions of the electro-magnetic spectrum. The inclusion of either of these spectral bands in the desired imaging exposure may therefore yield erroneous results with some films or other imaging systems.

As the luminance of the subject varies from area to area, it follows that the illuminance on the emulsion varies similarly, so that the film receives not one exposure over the entire surface but a varying amount of light energy, i.e. a range of exposures. As a general rule the exposure duration is constant for all areas of the film, variation in exposure over the film being due solely to variation in the illumination that it receives.

It should be noted that the use of the word 'exposure' in the sense in which we are using it here is quite different from its everyday use in such phrases as, 'I gave an exposure of 1/60 second at f/8'. We can avoid confusion by designating the latter *camera exposure,* as we have already been doing in previous chapters.

Density

When a film has been processed, areas of the image that have received different values of illumination are seen to have differing degrees of darkening, corre-sponding to the amount of developed silver, or image dye, which has been formed. The blackness of a negative, i.e. its light-stopping power, can be expressed numerically in several different ways. The following three ways are of interest in photography.

Transmittance

The transmittance τ of an area of a negative is defined as the ratio of the light transmitted I_t to the light incident upon the negative I_i. This is expressed mathematically as:

$$\tau = \frac{I_t}{I_i}$$

Transmittance is always less than 1, and is often expressed as a percentage. Thus, if 10 units of light fall on a negative and 5 are transmitted, the negative is said to have a transmittance of $5/10 = 0.5$, or 50 per cent. Although transmittance is a useful concept in certain fields, in sensitometry it is not the most expressive of units because it decreases as blackness increases, and equal changes in transmittance do not appear as equal changes in blackness.

Opacity

Opacity, O, is defined as the ratio of the light incident on the negative, I_i, to the light transmitted, I_t. That is:

$$O = \frac{I_i}{I_t}$$

Opacity is the reciprocal of transmittance i.e.:

$$O = \frac{1}{\tau}$$

Opacity is always greater than 1 and increases with increasing blackness. From this point of view, it is a more logical unit to use in sensitometry than transmittance, but equal changes in opacity still do not represent equal changes in perceived blackness.

Density

Transmission density, D_T, is defined as the logarithm to base ten of the opacity. That is:

$$D_T = \log_{10}\left(\frac{1}{\tau}\right) = \log_{10}\left(\frac{I_i}{I_t}\right)$$

Density is the unit of blackening employed almost exclusively in sensitometry. Like opacity it increases with increasing blackness, but has the following practical advantages:

(1) The numerical value of density bears an approx-imately linear relationship to the amount of silver or image dye present. For example, if the amount present in an image of density 1.0 is doubled, the density is increased to 2.0, i.e. it is also doubled. The opacity, however, increases from 10 to 100, i.e. tenfold.

(2) The final aim in sensitometry is to relate the tones of the print to those of the subject. Blackness in the print depends on the way the eye assesses it, and is therefore essentially physiological. The law governing the effect produced in the eye when stimulated is not a simple one, but over a wide range of viewing conditions the response of the eye is approx-imately logarithmic. Thus, if we examine a number of patches of a print in which the density increases by equal steps, the eye accepts the steps as of an equal increase in blackness. From this point of view, therefore, a logarithmic unit is the most satisfactory measure of black-ening. Table 15.1 gives a conversion between density, opacity and transmittance.

Where it is desired to distinguish between densities of images on a transparent base and those of images

Table 15.1 Density, opacity and transmittance

Density	Opacity	Transmittance	Density	Opacity	Transmittance (per cent)
0.0	1.0	100	1.6	40	2.50
0.1	1.3	79	1.7	50	2.00
0.2	1.6	63	1.8	63	1.60
0.3	2.0	50	1.9	79	1.25
0.4	2.5	40	2.0	100	1.00
0.5	3.2	32	2.1	126	0.80
0.6	4.0	25	2.2	158	0.60
0.7	5.0	20	2.3	200	0.50
0.8	6.3	16	2.4	251	0.40
0.9	8.0	12.5	2.5	316	0.30
1.0	10	10	2.6	398	0.25
1.1	13	7.9	2.7	501	0.20
1.2	16	6.3	2.8	631	0.16
1.3	20	5	2.9	794	0.12
1.4	25	4	3.0	1 000	0.10
1.5	32	3.2	4.0	10 000	0.01

on an opaque base, the former are referred to as transmission densities and the latter as reflection densities.

Effect of light scatter in a negative

When light passes through a photographic image it is partially scattered. One result of this is that the numerical value of density depends on the spatial distribution of the incident light, and on the method adopted for the measurement of both this and the transmitted light. Three types of density have been defined according to the geometry of illumination and light collection; these are illustrated in Figure 15.1.

(1) *Direct or specular density.* This is determined by using *parallel* illumination and measuring only *normal* emergence, the straight-through rays.
(2) *Diffuse density.* This is sometimes termed *totally diffuse* density. It may be determined in either of two ways:
 (a) by using parallel illumination and measuring *total* emergence (whether normal or scattered), or
 (b) by using *diffuse* illumination and measuring only *normal* emergence.
 The numerical value of diffuse density is the same with either method of measurement.
(3) *Doubly diffuse density.* This is determined by using *diffuse* illumination and measuring *total* emergence.

Practical measurements of any of these types of density are based on the ratio of a reading made by a photocell when the sample is not in place (taken as I_i) to the reading on the same photocell when the sample is in place (I_t). The difference between diffuse density and doubly diffuse density is usually quite small, but specular density is always greater than either.

Callier coefficient

The ratio of specular density to diffuse density is termed the *Callier coefficient*, or *Callier Q factor*, and can be expressed as:

$$Q = \frac{\text{specular density}}{\text{diffuse density}}$$

This ratio, which is never less than 1.0, varies with grain size, the form of the developed silver and the amount of the deposit. As far as the grain is concerned, the finer it is, the lower the resultant scattering and the nearer to unity is the Callier coefficient.

The factors above which influence the value of Q vary quite markedly with the degree and type of development used. Consequently, the Callier coefficient varies with density and contrast in a complicated way, even when a combination of only one film and one developer is investigated. An example of such behaviour is illustrated in Figure 15.2, where the value of γ for each curve indicates the degree of development received by the film. At low degrees of development, with this particular combination of film and developer, the value of Q is approximately

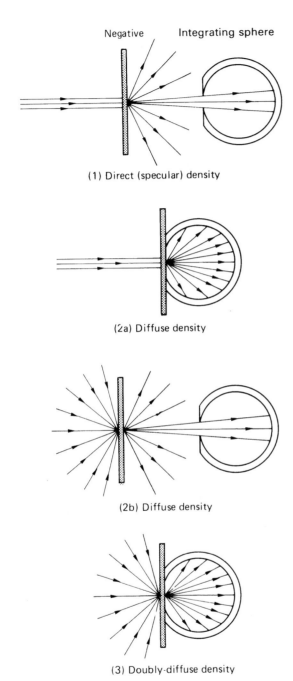

Figure 15.1 Optical systems for measuring different types of density

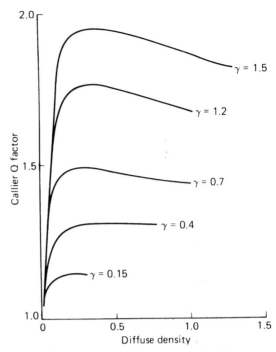

Figure 15.2 Variation of Callier Q factor with image density and degree of development

One result of the variation of the Callier coefficient with density is that the tone distribution in the shadow areas of a print produced with a condenser enlarger is likely to be different from that which appears in a print produced using a diffuser enlarger. Colour photographic images, however, are essentially non-scattering, so that they possess Callier coefficients close to unity, and consequently may be measured by a variety of optical arrangements. Thus in printing colour negatives there is seldom any measurable difference between the results from diffuser or condenser enlargers.

Density in practice

The types of density related to photographic practice are shown in Table 15.2.

Some kinds of illumination present an intermediate type of density, as, for example, when an opal bulb or a diffusing screen is used in a condenser enlarger.

Apart from the true condenser enlarger and projectors, the effective density in all the examples quoted is either diffuse or doubly diffuse. As already stated, the difference between the latter two forms of density is slight. For normal photographic purposes, therefore, densities of negatives are expressed simply as diffuse densities, which give particularly reliable and repeatable measurements.

constant at densities above about 0.3; for more complete development, however, there is no single value of Q that can be adopted; consequently no simple correction for specularity can be applied to densitometer readings.

Table 15.2 Effective density in different photographic practice

Type of work	Effective density
Contact printing:	
(a) In a box, with diffused source	Doubly diffuse
(b) In a frame, using a clear bulb or an enlarger as illuminant	Diffuse (parallel illumination, total emergence)
Enlarging:	
(a) Condenser enlarger (point source, no diffuser)	Specular
(b) Diffuser enlarger (particularly *cold cathode* types)	Diffuse (diffuse illumination, normal emergence)
Still or motion-picture projection:	
All types	Specular

If the image in a negative or print is not neutral in tone, its measured density will depend not only on the optics employed to measure it, but also on the *colour* of the light employed and the response to colour of the device employed to measure it. Considering these last two factors, we may consider density as being of four main kinds according to the spectral specifications involved:

(1) *Density at any wavelength, spectral density.* Determined by illuminating the specimen with monochromatic radiation.
(2) *Visual density.* Determined by measuring the illuminated specimen with a receiver having a spectral response similar to that of the normal photopic human eye.
(3) *Printing density.* Determined by illuminating the specimen with tungsten light and employing a receiver with a spectral response similar to that of photographic papers.
(4) *Arbitrary density.* Determined by illuminating the specimen with tungsten light and employing an unfiltered or even filtered commercial photosensor as the detector, the combination possessing arbitrary sensitivity spectral sensitivity.

This classification applies equally to all three main types of density: specular, diffuse and doubly diffuse. For most monochrome photographic purposes *diffuse visual density* is employed.

Colour densities are also usually measured using diffuse densitometers. Colour images are composed of three dyes, each controlling one of the primary colours of light: red, green and blue. In practice, therefore, colour images are described in terms of their densities to red, green and blue light, the densitometer being equipped with filters to select each primary colour in turn.

The colour filters chosen for a densitometer may simply select red, green and blue spectral bands and measure the integrated effects of all three dye absorptions within those bands. The densities measured this way are called *arbitrary integral densities* and are most commonly used in quality control measurements. For more useful results the densitometer filters and cell sensitivities are carefully chosen so that the densities measured represent the effect of the image either on the eye or on colour printing paper. Such measurements correspond to density categories (2) and (3) for black-and-white images, and are referred to as *colorimetric* and *printing densities* respectively. In practice, colorimetric densities are seldom measured because suitably measured arbitrary densities can usefully describe the response of the eye to visual neutral and near-neutral tones. This is all that is usually required. Printing densities are, however, widely applied in the assessment of colour negatives for printing purposes, although measurements of this type can usually refer only to some defined 'typical' system.

The characteristic (H and D) curve

If density is plotted as ordinate against exposure as abscissa, a response curve for a film or plate of the general shape shown in Figure 15.3 is obtained.

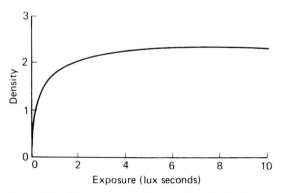

Figure 15.3 Response curve of an emulsion obtained by plotting density against exposure

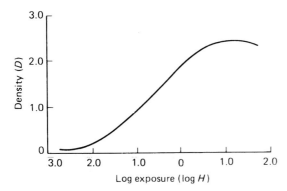

Figure 15.4 A characteristic curve – the response curve obtained by plotting density against log exposure

Although a curve of this type may occasionally be of value, a far more useful curve for most purposes is obtained by plotting density against the common logarithm (logarithm to base 10) of the exposure. This gives a curve of the shape shown in Figure 15.4, the type of response curve employed in ordinary photography. It is referred to as a *characteristic curve* or *H and D curve*, after F. Hurter and V.C. Driffield, who were the first to publish curves of this type. The H and D curve is simply a diagram which shows the effect on the emulsion of every degree of exposure from gross under-exposure to gross over-exposure for any one development time and any particular developer. These variables have to be specified because the characteristic curve varies with processing conditions and even, to a smaller extent, exposure intensity and duration.

The use of $\log_{10} H$ instead of H as the unit for the horizontal axis of the response curve of a photographic material offers several advantages:

(1) In practice, we consider changes in camera exposure in terms of the factor by which it is altered; the natural progression of exposure is geometrical, not arithmetical. (When increasing an exposure time from 1/60 to 1/30 second, for example, we speak of doubling the exposure, not of increasing it by 1/60 second.) A logarithmic curve therefore gives the most reasonable representation of the way in which density increases when exposure is changed. The series of camera exposure times 1/500, 1/250, 1/125 etc. is a logarithmic series, as is that of printing exposure times 2, 4, 8, 16 seconds etc.

(2) A D vs $\log H$ curve shows, on a far larger scale than a density-exposure curve, the portion of the curve corresponding with just-perceptible blackening, i.e. with small values of exposure. The speed of a film is usually judged in terms of the exposure needed to produce quite small values of density.

(3) The use of logarithmic units for both horizontal and vertical axes enables values of density in the photographic negative to be transferred readily to the log-exposure axis of the characteristic curve of the print. This simplifies the task of relating the brightnesses of the original scene, the transmission densities of the negative and the reflection densities of the print.

Main regions of the negative characteristic curve

The characteristic curve of a negative material may be divided into four main regions: the toe or foot, an approximately linear (straight-line) portion, the shoulder and the region of solarization, as shown in Figure 15.5.

It is only on the linear portion of the curve that density differences in the negative are directly proportional to visual differences in the original scene. For this reason the linear portion was at one time referred to as the region of correct exposure, the toe as the region of under-exposure and the shoulder as the region of over-exposure. As we shall see later in this chapter, however, such descriptions are misleading. The value of density reached at the top of the shoulder of the curve is referred to as D_{max}, the maximum density obtainable under the given conditions of exposure and development.

Provided the horizontal and vertical axes are equally scaled, the numerical value of the tangent of the angle c which the linear portion of the curve makes with the log H axis is termed gamma (γ).

When $c = 45^{0}$, $\gamma = 1$.

Gamma may be defined less ambiguously in terms of the values of density and log exposure corresponding to any two points lying on the straight-line portion of the curve. Referring to Figure 15.6:

$$\gamma = \tan c = \frac{BC}{AC} = \frac{D_2 - D_1}{\log H_2 - \log H_1}$$

or, more mathematically

$$\gamma = \frac{\Delta D}{\Delta \log H}$$

where the symbol Δ, the Greek capital letter *delta*, means 'change in'. This last definition of γ does not depend on a characteristic curve at all, merely on the quantities: log exposure, which is known, and density, which is measured. The data required must, however, correspond to points on the linear part of the characteristic curve.

Gamma serves to measure *sensitometric contrast*, i.e. the rate at which density increases as log exposure

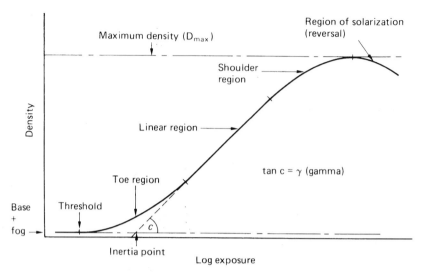

Figure 15.5 The 'geography' of the characteristic curve of a negative material

increases in the linear portion of the curve. It should be noted, however, that gamma gives information only about the linear portion of the curve; it tells us nothing about the other portions. Further, as will be seen later, the contrast of a negative is not determined by gamma alone: other factors play an important part, and with modern emulsions no portion of the curve may be strictly linear. In the case where there is no linear portion, the value of γ collapses to the maximum value of the gradient, technically at the point of inflexion.

Sensitometric contrast is an important aspect of performance, and, with experience, is readily appreciated from a superficial examination of the H and D curve (provided the abscissa and ordinate axes have been equally scaled). The region of *solarization*, or reversal (though not of use in ordinary photography), is of interest. In this region an increase in exposure actually results in a *decrease* in density. The exposure necessary to produce solarization is commonly of the order of one thousand times greater than normal exposure, and is seldom encountered. Materials do,

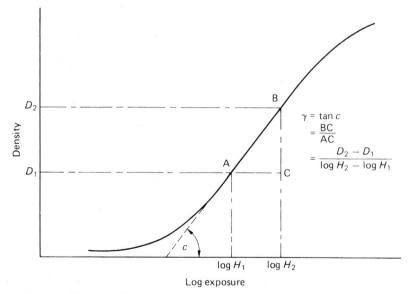

Figure 15.6 Gamma in terms of density and log exposure

however, vary widely in the degree of solarization which they show. In general, the more efficient a material is at forming a latent image the less likely is solarization to occur.

Below the toe, the curve becomes parallel to the log H axis, a little way above it at a *minimum density* or D_{min}. The value of density in this region is the sum of densities due to the film or paper base supporting the emulsion, the gelatin of the emulsion, any silver developed from unexposed emulsion grains and any residual chemical stain present after manufacture or formed during processing of the film. This, usually small density, is sometimes misleadingly termed *base density*. The most generally used description is *fog level*. As we have seen, this is not totally precise but is good enough for many applications. It is the minimum density obtainable with the process employed. Base density refers to the density of the film or paper support while fog results from the development of unexposed silver halide grains. The point on the curve corresponding to the first perceptible density above fog is called the *threshold*.

The intersection of the extrapolated straight-line portion of the curve with the D_{min} produced is referred to as the *inertia point*, and the value of exposure at this point as the *inertia*. On published characteristic curves the log exposure axis may be marked 'Relative log exposure', often abbreviated to 'Rel log *H*' or more properly, 'Log relative exposure', similarly abbreviated to 'Log rel *H*'. Use of a relative instead of an absolute scale of exposure does not affect the shape of the curve, though it does mean that absolute values of emulsion speed cannot be determined from the curve.

Variation of the characteristic curve with the material

The characteristic curves of individual materials differ from one another in their shapes and in their positions relative to the log *H* axis. The position of the curve in relation to the log *H* axis depends upon the sensitivity or *speed* of the material. The faster the material, the farther to the left of the scale is the curve situated. The threshold density is achieved at the lowest exposures with fast emulsions. Film speed is dealt with in detail elsewhere. The main variations in the shape of the characteristic curve are:

(1) Slope of linear portion (gamma).
(2) Length of linear portion.

The length of the linear portion is usually expressed in terms of the density range from the point at which the toe merges with the straight line, to the point at which the straight line merges with the shoulder.

Photographic materials differ both in the maximum slope that can be achieved and in the rate at which the value of the slope increases. Modern negative materials are usually made to yield a gamma of 0.7 or so at normal development times. They commonly have a long toe, which may extend up to a density of as high as 0.7, and the straight line may be short or even non-existent. Some modern ultrafast materials have a so-called bent-leg or dog-leg curve, which has in effect two straight-line portions of different slopes. The lower part of the curve is fairly steep, but at a higher density the slope changes to a lower value. A curve of this shape may have certain advantages in the photography of subjects that contain relatively intense highlights, e.g. night scenes.

Materials intended for copying are usually designed to have a short toe (i.e. one which merges into the linear portion at a low density), and a long linear portion, the slope of which depends on the nature of the work for which the material is intended. Materials for copying capable of yielding gammas ranging from below 1 up to 10 or more are available.

In the duplication of negatives it is necessary to use a material possessing a long linear portion, the slope of which can readily be controlled in processing. The exposure should be confined to the linear portion, and it is advantageous to develop to a gamma of unity. Curves for specific materials are published by film manufacturers.

Variation of the characteristic curve with development

The H and D characteristic curve is not a fixed function of an emulsion, but alters in shape with the conditions of exposure, e.g., the colour and intensity of the light source, and with the conditions of processing; in particular, the curve is markedly affected by the degree of development.

If the development time is varied, other conditions being kept constant, a series of H and D characteristic curves is obtained, which, in the absence of soluble bromide (or other anti-foggant) in the emulsion or developer, is of the type shown in Figure 15.7 in which density above 'fog' is plotted against log exposure. It will be seen from this figure that whereas a single characteristic curve tells us a certain amount about the behaviour of a material, a family of curves made with varying development time gives a much more complete picture. The most obvious change in the curve with increasing development is the increase in the slope of the linear portion (gamma). For any given emulsion, then, gamma is a measure of the degree of development, and has for this reason sometimes been termed the *development factor*. Another point that may be noted is that the linear

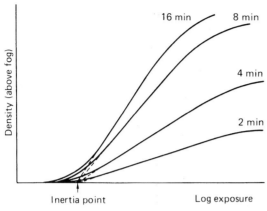

Figure 15.7 Effect of development time on characteristic curve of older sensitive materials

inertia and corresponds to an increase in speed with increased development.

It is important to notice that throughout any consideration of the inertia and confluence points all densities must be recorded as values above D_{min} for each sample of film. (D_{min} itself, as well as speed and contrast, varies with development time.)

Gamma-time curve

By plotting gamma as ordinate against development time as abscissa we obtain a curve, the general shape of which is illustrated in Figure 15.9.

Gamma increases very rapidly as development begins, and then increases at a more gradual rate until a point is reached where increased development produces no further increase in gamma. The value of gamma at this point is termed *gamma infinity* (γ_∞). Gamma infinity varies from emulsion to emulsion and depends to some extent on the developing solution used. A material capable of yielding a high gamma infinity is said to be a *high contrast material*. With most materials it is rarely desirable to develop to gamma infinity, as prolonged development is accompanied by an increase in fog and graininess, either or both of which may reach an unacceptable level before gamma infinity is achieved. Owing to *chemical fog,* caused by the development of unexposed emulsion grains, gamma will actually fall off with very prolonged development, as the effect of the additional density due to fog is greater on low densities than on high. This fall-off is illustrated by the broken portion of the curve shown in Figure 15.9.

A gamma-time curve shows the value of gamma infinity obtainable with a given material and developer. It also shows the development time required to reach this or any lower value of gamma. We have seen that it is rarely desirable to employ the very top part of the gamma-time curve owing to the growth of fog and graininess. It is also usually unwise to employ the very

portions of all the four curves shown in the figure meet, when produced, at a common *inertia point,* at zero density above the fog level.

In the early days of sensitometry, a family of characteristic curves of the type shown in Figure 15.7 was fairly readily obtainable with the sensitive materials of the time, by using a developer free from bromide ion. This is not typical of materials used today, which commonly contain anti-foggants; also most modern developers now contain bromide ion in solution, and the curves obtained are usually of the general pattern shown in Figure 15.8. The straight lines are still seen to meet at a *confluence point* (although this is not invariably the case), but this point is depressed, i.e. is now below the log H axis. As a result, not only does the slope increase but the curve as a whole moves to the left as development time is increased, the inertia shifting towards a limiting value. This shift is termed the *regression of*

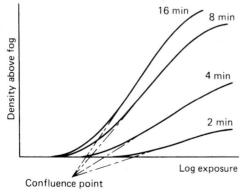

Figure 15.8 Effect of development time on characteristic curve of current sensitive materials

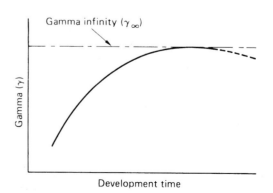

Figure 15.9 Gamma-time curve

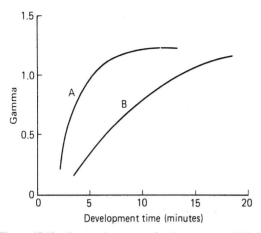

Figure 15.10 Gamma-time curves for the same material in two different developers

Variation of gamma with wavelength

Besides being dependent on development, gamma also depends to some extent on the colour of the exposing light. The variation within the visible spectrum is not great, but it becomes considerable in the ultraviolet region. The general tendency is for gamma to be lower as wavelength decreases. This variation of gamma can be ignored in ordinary photography, but must be taken into account in three-colour work and spectrography.

In the visible region the gamma of an emulsion can be controlled in manufacture by the addition of dyes. It has been possible, for three-colour work, to make available special emulsions in which the gammas achieved in the three main regions of the spectrum, *blue, green and red*, are very nearly equal.

Placing of the subject on the characteristic curve

As we have already noted, a characteristic curve shows the response of a material under a wide range of exposures. Only a part of this curve is used in any single negative. The extent of the portion used depends on the subject luminance ratio; its position depends on the actual luminances in the scene and on the exposure time and lens aperture employed. Strictly, it is the illuminance ratio of the image on the film with which we are concerned here, and, if flare is present, this will be less than the subject luminance ratio. In the present context we shall assume that flare is absent.

We have already noted that the characteristic curves of most modern negative materials are characterised by a long toe. The part of the curve used by a

bottom part, where a small increase in development time gives a large increase in gamma, because in this region any slight inequalities in the degree of development across the film will be accentuated, with the likelihood of uneven density or mottle.

Figure 15.10 shows gamma-time curves for a film in two differing developer formulae. Curve A was produced in an MQ-carbonate developer, curve B in an MQ-borax developer. Comparison of such curves assists in the choice of a suitable developer when the desired gamma is known. For example, if a gamma of 0.5 were desired the MQ-borax developer would be preferable to the MQ-carbonate developer, since, with the latter, contrast is changing rapidly with development time at the gamma required. On the other hand, to achieve a gamma of 1.1 the MQ-carbonate developer would be the more suitable, the MQ-borax developer requiring an excessively long development time to reach this value.

Gamma-time curves for individual materials under stated conditions of development are published by film manufacturers. Such curves give a good indication of the general behaviour of a material, and can be of considerable assistance in the selection of a material and developer for a given task. Because, however, working conditions may vary from those specified and because of variations in materials in manufacture and during storage, in order to be of greatest value gamma-time curves for any given material should be determined by the user under the particular working conditions.

When plotting sensitometric results such as fog, emulsion speed or contrast against development time, it is often useful to adopt a logarithmic scale for time. This compresses the region of long development times and sometimes enables the more interesting results to approximate a straight-line graph. This is easier to draw and to use than a curve.

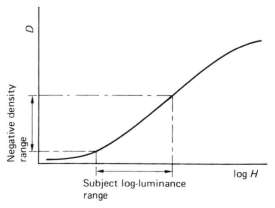

Figure 15.11 Portion of the characteristic curve employed by a 'correctly exposed' negative

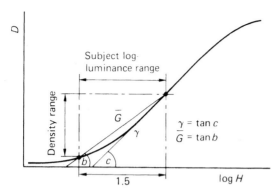

Figure 15.12 Average gradient

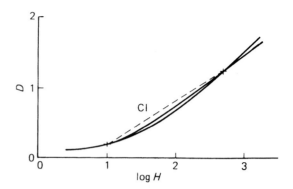

Figure 15.13 Two negative characteristic curves with different values of gamma (γ) but identical contrast index (CI).

'correctly-exposed' negative includes part of this toe and the lower part of the straight-line portion. This is illustrated in Figure 15.11.

Average gradient and \bar{G}

It follows from the fact that a negative usually occupies part of the toe of the curve as well as part of the straight line that gamma alone gives an incomplete picture of the contrast of an emulsion. Frequently, a better measure of contrast is obtained by taking the slope of the line joining the two limiting points of the portion of the characteristic curve employed (Figure 15.12). This is referred to as the *average gradient*. It is always lower than gamma. Several limiting points on the curve are specified in standards concerning special photographic materials. For normal negative films the quantity \bar{G} has been defined by Ilford Ltd as the slope of a line joining the point at a density of 0.1 above D_{min} with a second point on the characteristic curve 1.5 units log rel H in the direction of greater exposure.

Contrast index

A measure of contrast devised by Kodak is the *contrast index* which, like \bar{G}, takes into account the toe of the negative characteristic curve. The method of determination involves the use of a rather complicated transparent scale overlaid on the characteristic curve, although an approximate method is to draw an arc of 2.0 units cutting the characteristic curve and centred on a point 0.1 units above D_{min}. The slope of the straight line joining these two points is the contrast index.

A fuller and more rigorous description of contrast index determination is to be found in Kodak Data Booklet SE-1. Two curves of different gamma but identical contrast index are illustrated in Figure

15.13. Negatives of identical contrast index produce acceptable prints using the same grade of printing paper. Gamma is clearly a poor guide to the density scale of a processed negative exposed partly on the foot of the characteristic curve.

Effect of variation in development on the negative

Let us assume that the negative represented by the curve in Figure 15.11 was given normal development. If we make two other identical exposures of the same subject, and give more development to one and less development to the other, we shall obtain two further curves, such as those which are shown, together with the 'normally developed' curve, in Figure 15.14. Because the camera exposure is the same in all three cases, the limiting points of the parts of the curves used, measured against the log H axis, are the same for all three curves.

A study of these curves shows that over-development increases the density of the negative in the

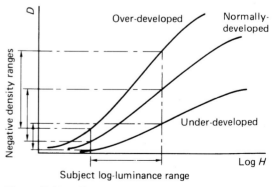

Figure 15.14 Effect on negative of variations in development

Figure 15.15 Subject tones

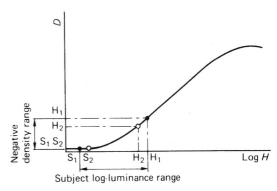

Figure 15.17 Densities on under-exposure and normal development

shadows to a small extent and in the highlights to a large extent. As a result, the negative as a whole is denser and, more important, its *density range,* the difference between the maximum and minimum densities, is increased. Under-development has the reverse effect. It decreases density in both shadows and highlights, in the highlights to a greater extent than in the shadows, and thus the density range of the negative is reduced and its overall density is less. Thus the major effect of variation in the degree of development is on the density range, known as the *contrast* (strictly, the *logarithmic contrast*) of the negative.

Effect of variation in exposure on the negative

Let us suppose that we are photographing the cube shown in Figure 15.15 and that S_1 is the darkest area in the subject, S_2 the next darkest, H_1 the highest highlight and H_2 the next highest. Then on a normally exposed, normally developed negative the exposures and densities corresponding to these areas will be approximately as shown in Figure 15.16. In an under-exposed negative of the same subject, given the same development, the location of these points will be as shown in Figure 15.17.

Compared with the normally exposed negative, the density range of the under-exposed negative is compressed. More important, the two shadow areas

S_1 and S_2, although having different luminances and thus yielding different exposures on the film, yield the same density on the negative; they are thus no longer separated in any print. Some shadow detail is therefore completely lost, and the shadow detail that remains will be degraded. This is a case of gross under-exposure. Moderate under-exposure results in shadow detail being degraded but not completely lost.

In a moderately over-exposed negative given the same development, the four selected areas of the subject will be placed on the curve as shown in Figure 15.18. The average density of the negative is now greater than that of the normally exposed negative, and the density range is expanded. In particular, tone separation in the shadows is increased.

In the case of a grossly over-exposed negative, however, the shoulder of the curve may be reached (Figure 15.19). In these circumstances the density range of the negative will be compressed, and highlight detail degraded if not completely lost. With modern negative films the latitude to over-exposure is very great and over-exposure sufficient to degrade highlight detail seriously is fairly unusual; it is far more common to encounter under-exposure.

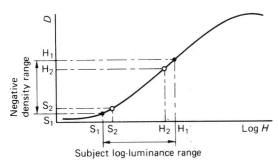

Figure 15.16 Densities on normal exposure and normal development

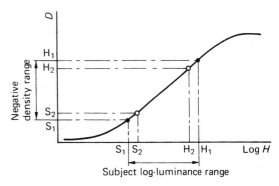

Figure 15.18 Densities on over-exposure and normal development

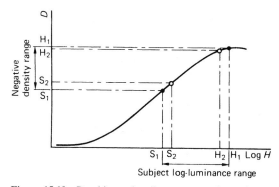

Figure 15.19 Densities on heavily over-exposed negative

Exposure latitude

We define *exposure latitude* as the factor by which the minimum camera exposure required to give a negative with adequate shadow detail may be multiplied without loss of highlight detail. Exposure latitude is illustrated in Figure 15.20.

We may call the distance along the log *H* axis between the lowest and highest usable points on the curve the *useful exposure range*. This depends principally upon the emulsion and the degree of development. These two factors also govern latitude, but this is also dependent upon the subject contrast, i.e. the log-luminance range of the subject. This is illustrated in Figure 15.21.

In practice, loss of highlight detail (which sets the upper limit to exposure) often results from loss of resolution due to graininess and irradiation, before the shoulder of the curve is reached. As the required level of resolution usually depends upon the negative size employed and the consequent degree of enlargement

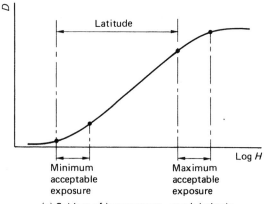

(a) Subject of low contrast — much latitude

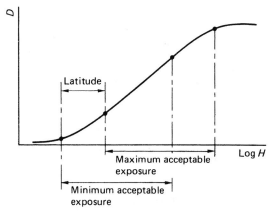

(b) Subject of high contrast — little latitude

Figure 15.21 Effect of subject contrast (log luminance range) on latitude

necessary in making the final print, we may add 'size of negative' to the factors above governing useful exposure range and latitude. Thus in general there is less exposure latitude with a small format than with a large one.

The log-luminance range of the average subject is less than the useful log-exposure range of the film, and there is usually considerable latitude in exposure. If, however, we have a subject with log luminance range equal to the useful log exposure range of the film there is no latitude, i.e. only one exposure is permissible. With the exceptional subject having a luminance range *greater* than the useful exposure range of the film no exposure will yield a perfect result; we must lose either shadow detail or highlight detail or both. All that we can do is to decide which end of the tone range we can best sacrifice. This is more likely to arise with high contrast materials such as colour and monochrome reversal (slide) films.

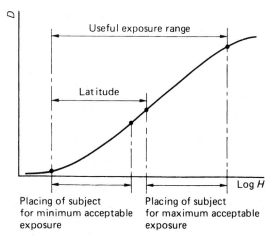

Figure 15.20 Exposure latitude

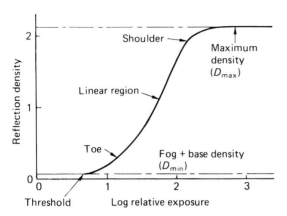

Figure 15.22 The 'geography' of the characteristic curve of a photographic printing paper

becoming parallel to the log H axis at a value of D_{max} which rarely exceeds a value of 2.1.

(2) The toe extends to a fairly high density.
(3) The straight-line portion is short and, in some papers, non-existent.
(4) The slope of the linear portion is generally quite steep compared with a film emulsion.
(5) Fog (under normal development conditions with correct safe-light) is almost absent, although the minimum density may slightly exceed the density of the paper base material alone owing to stain acquired in processing.

Differences (2) and (4) arise from the fact that when a silver image on an opaque diffusing base is viewed by reflected (as opposed to transmitted) light its effective density is increased, because light must pass through the image at least twice.

Maximum black

The practical consequence of (1) above is that the maximum density obtainable on any paper is limited, however long the exposure or the development. The highest value of density which can be obtained for a particular paper with full exposure and development is called the *maximum black* of the paper. The maximum density obtained on any given paper depends principally on the type of surface. It can be seen from Figure 15.23 that light incident on the surface of a print undergoes three types of reflection:

(1) Part is reflected by the surface of the gelatin layer in which the silver grains are embedded.
(2) Part is reflected by the silver grains themselves.
(3) The remainder is reflected by the surface of the paper base itself (or the baryta coating on the base).

It is the sum of these three reflections that determines the reflectance and hence the density of the print.

By increasing the exposure received by a paper, and thus the amount of silver in the developed image, we can eliminate entirely the reflection from the paper base, but reflections from the gelatin surface of the emulsion and from the individual grains themselves cannot be reduced in this way. It is these reflections that set a limit to the maximum black obtainable.

The reflection from the surface of the emulsion depends upon the nature of this surface. A print will normally be viewed in such a way that direct, *specular*, reflection from its surface does not enter the eye. We are therefore concerned only with diffuse reflection. Now, the reflection from the surface of a glossy paper is almost entirely direct, so that the

If the subject range is below average we have extra latitude. In practice, however, this is limited on the under-exposure side by the fact that an exposure too near the minimum will be located entirely on the toe and may result in an unprintably soft negative. It is usually preferable to locate the subject on the characteristic curve in such a position that part at least of it is on the linear portion. In this way better negative contrast and more satisfactory print quality are achieved.

The response curve of a photographic paper

The characteristic curve of a paper is obtained in the same way as that of a film or plate, by plotting density against log exposure. Density in this case is *reflection density* and is defined by the equation:

$$D_R = \log_{10}\left(\frac{1}{R}\right)$$

where R, the *reflectance*, is the ratio of the light reflected by the image to the light reflected by the base or some specified 'standard' white. This definition of reflection density is analogous to that of transmission density above.

Figure 15.22 illustrates the general shape of the characteristic curve of a paper. This curve, like that of a negative material, can be divided into four main regions: toe, straight line (or linear region), shoulder and region of solarization, though the latter is seldom encountered.

The main differences between the curve of a paper and that of a film or plate are:

(1) The shoulder is reached at a relatively low density and turns over sharply, the curve

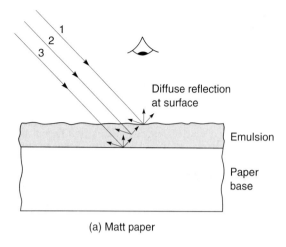

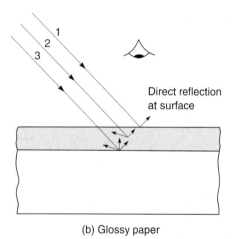

Figure 15.23 Diagrammatic representation of the reflection of light striking two papers of differing surface characteristics

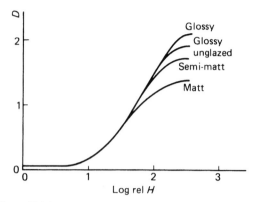

Figure 15.24 Characteristics of papers of different surfaces

amount of light reflected from the surface of such a paper which enters the eye when viewing a print is very small indeed. In these circumstances, the limit to the maximum density of the print is governed principally by the light reflected by the silver image itself. This is usually a little less than 1 per cent, corresponding to a maximum black of just over 2.0. The reflection from the surface of a matt paper, on the other hand, is almost completely diffuse, so that an appreciable amount of light (say 4 per cent) from the surface of the paper reaches the eye, in addition to the light from the silver image. (There may also be light reflected from particulate material, included in the emulsion of many matt papers.) The maximum black of matt papers is therefore relatively low. Semi-matt and 'stipple' papers have values of maximum black intermediate between those of matt and glossy papers. The following figures are typical of the values of

maximum black obtainable on papers of three main types of surface:

Surface	Reflection density (maximum)
Glossy, glazed	2.10
Glossy, unglazed	1.85
Semi-matt	1.65
Matt	1.30

Modern resin-coated printing papers are not glazed after processing but possess a high natural gloss and thus may achieve a D_{max} of over 2.0 without glazing. Glossy colour prints possess little reflecting material other than the paper base, and values as high as 2.5 are not uncommon.

The effect of variation in maximum black on the characteristic curve is confined largely to the shoulder of the curve, as shown in Figure 15.24.

Exposure range of a paper

The ratio of the exposures corresponding to the highest and lowest points on the curve employed in a normal print is termed the exposure range of the paper (Figure 15.25). This may be expressed either in exposure units or in log exposure units. It represents the usable exposure range of the paper and hence corresponds to the greatest negative density range that can be fully accommodated on the printing paper.

Variation of the print curve with the type of emulsion

Photographic papers employ emulsions which contain various proportions of silver chloride and silver bromide. Slow emulsions intended for contact printing have usually contained a high proportion of silver

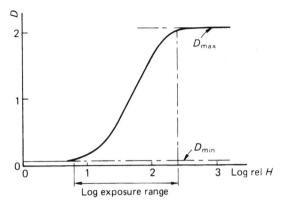

Figure 15.25 Exposure range of a printing paper

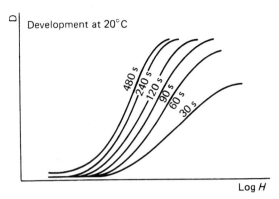

Figure 15.27 Characteristic curves of a traditional bromide printing paper for different development times

chloride, while enlarging papers have a much greater proportion of silver bromide. The names 'chloro-bromide' and 'bromide' papers indicate different proportions of silver bromide present and the characteristic curves of these papers differ somewhat in shape. To illustrate these differences, characteristic curves of two widely differing papers of the same exposure range are shown in Figure 15.26. The practical effect of differing curve shapes is to alter the tonal relationships within the print, a matter of some subjective importance. Such subtle differences give additional control at printing.

It will be seen that although in the examples selected both papers give the same range of tones, i.e. have the same density range, and both have the same exposure range, the relation of density to log exposure is not the same in the two cases. With paper A the density increases evenly with the increase in log exposure, but with paper B the relation of density to log exposure is markedly S-shaped, i.e. highly non-linear. In practice, paper A would be expected to give more even tone separation in the shadows and

highlights than paper B. Curve A is typical of high-chloride papers and curve B of bromide papers; a chlorobromide paper curve would be intermediate between the two.

Variation of the print curve with development

With papers the characteristic curve varies with development, but rather differently from that of negative film. Figure 15.27 shows a family of curves for a bromide paper. The normally recommended development time for this paper (in the developer employed) is 2 minutes at 20C.

With more modern printing papers, development normally requires a minimum of about 1 minute. At longer development times the curve may be displaced to lower exposure levels, but, unlike the curve of a chloride paper, the slope may increase slightly. In other words, both speed and contrast of a bromide paper may increase on prolonged development. The increase in contrast is usually not very great, but it is sometimes sufficient to be of practical value. The major effect of variation of development time on papers of all types is on the effective speed of the paper.

The situation may be complicated by the composition of 'bromide' paper, which may contain a significant proportion of silver chloride. This modifies the development behaviour so that there is no detectable contrast increase once maximum black has been reached.

With papers of all types, there is *development latitude* between the two extremes of under-and over-development. With the bromide paper shown in Figure 15.27, this extends from about $1\frac{1}{2}$ minutes to 4 minutes. Between these times the maximum black is achieved but with no increase in fog. The ratio of the

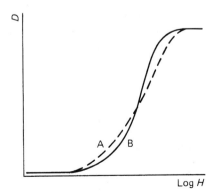

Figure 15.26 Characteristic curves of two different printing papers

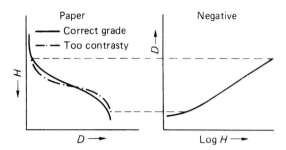

Figure 15.28 Negative and paper characteristics

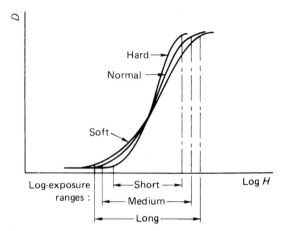

Figure 15.29 Paper contrast

exposure times required at the shortest and longest acceptable times of development is referred to as the *printing exposure latitude*. Development latitude and exposure latitude are interrelated; both cannot be used at the same time. Thus, when once an exposure has been made there is only one development time that will give a print of the required density. In dish processing the development latitude may be reduced in modern printing papers by extended green sensitivity which may make the emulsions liable to *actinic exposure,* exposure generating latent image, by yellow or orange safelights. The effect may be visible, at low levels, as a reduction in tonal contrast of the prints made. There may be no increase in fog level, but a noticeable reduction of contrast.

Requirements in a print

It is generally agreed that, in a print:

(1) All the important negative tones should appear in the print.
(2) The print should show the full range of tones between black and white that is capable of being produced on the paper used. (Even in high-key and low-key photographs it is usually desirable that the print should show *some* white and *some* black, however small these areas may be.)

In printing, the actual exposure of the paper in any given area is governed by the density of the negative in the corresponding area; the greater the density of any negative area, the less the exposure, and vice versa. In order, then, to meet both requirements (1) and (2) above, the exposure through the highlight areas of the negative must correspond with the toe of the curve of the printing paper, and the exposure through the shadow areas of the negative must correspond with the shoulder of this curve. Expressed sensitometrically, this means that the log exposure range of the paper must equal the density range of the negative. This correspondence is illustrated in Figure 15.28, which shows the negative characteristic curve

together with that of an appropriate and an inappropriate printing paper (too contrasty).

Now, not all negatives have the same density range, which varies with the log luminance range of the subject, the emulsion used, the exposure and the degree of development. Obviously, therefore, no single paper will suit all negatives, because, as we have seen, the log exposure range of a paper is a more or less fixed characteristic, affected only slightly (if at all) by development. A single paper with a sufficiently long log exposure range would enable requirements (1) to be met in all cases, but not requirement (2). Printing papers are therefore produced in a series of differing *contrast grades* or *usable exposure ranges*. Figure 15.28 shows two such *contrast grades* and relates them to the negative density range.

Paper contrast

In Figure 15.29 are shown the characteristic curves of a series of bromide papers. These papers all have the same surface and differ only in their contrasts or usable exposure ranges, which are described as soft, normal and hard respectively. These have usually been designated by grade designations ranging from 0 at very low contrast to 5 at very high contrast. Recent changes in international standards may, however, lead to such numbers going out of use. All three papers in Figure 15.29 have been developed for the same time. It will be noted that the three curves show the same maximum black, but that the steepness of the curve increases and the exposure range decreases as we progress from the 'soft' to the 'hard' paper. From this we see that the descriptions 'soft', 'normal' and 'hard' apply to the inherent contrasts of the papers themselves, and not to the negatives with which they are to be used. The soft paper with long log exposure

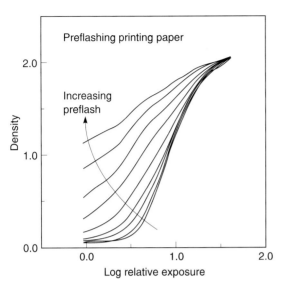

Figure 15.30 Control of print contrast by preflashing the printing paper

highlights, the shadow areas of the print will be under-exposed and the result will appear 'flat'.

The softer the grade of paper, i.e. the longer its log exposure range, the greater is the exposure latitude (as defined earlier) in printing. It is, however, generally unwise to aim at producing negatives suited to the softest available paper because there is then nothing to fall back upon if for some reason a negative proves to be exceptionally contrasty. It is therefore generally best to aim at the production of negatives suitable for printing on a middle grade of paper.

A simple, if only approximate, check on the (arithmetic) exposure range of a paper can be made by giving to a strip of it a series of progressively increasing exposures. The exposure ratio is the ratio of the exposure time required to yield the deepest black that the paper will give to that required to produce a just perceptible density.

Some skilled monochrome printers use an interesting method for the control of tone reproduction. What is done is to use a brief uniform, non-image, pre-exposure or *preflash* to modify the characteristic curve shape of the printing paper in use. Generally speaking, the higher the intensity of the uniform preflash the lower the contrast obtained. There is usually some increase in the minimum density, although this can be acceptable if it is not too high. Results obtained with a series of preflashes of increasing intensity are shown in Figure 15.30, which shows a large increase in useful exposure range, extending outside the range of exposures available in the experiment. This method of controlling print contrast has, in fact, been used in the large scale production of monochrome prints using a type of automatic printer and is currently discussed in the context of high quality black-and-white printing by specialists in the field.

range, is, in fact, intended for use with 'hard' negatives, with high density range. Conversely, the 'hard' paper, with short log exposure range, is intended for use with 'soft' negatives, with low density range.

Modern *variable contrast* papers comprise two emulsions of differing contrasts and possessing differing spectral sensitivities. The contrast is varied by suitably filtering the enlarger at exposure; typically the highest grades are achieved using a grade 5 filter, which is magenta, and the lowest by using a grade 0 filter, which is yellow. Intermediate contrasts are achieved using either a set of appropriately designed colour filters, or by the use of a special enlarger head to vary the spectral distribution of the printing illuminant. The sensitometry of such papers will require similar filtration plus, usually, a correction filter to raise the colour temperature to that of a typical enlarger if 2856 K is used in the sensitometer. The characteristic curves corresponding to contrast grades will approximate those found for equivalent traditionally graded papers.

If negatives of the same subject, differing only in contrast, are each printed on papers of the appropriate exposure range, the prints will be practically identical. If, however, an attempt is made to print a negative on a paper with too short a log exposure range (i.e. too hard a paper), and exposure is adjusted to give correct density in, say, the highlights, then the shadows will be over-exposed, shadow detail will be lost in areas of maximum black, and the result will appear too hard. If, on the other hand, a paper of too long a log exposure range is used (i.e. too soft a grade) and exposure is again adjusted for the

The problem of the subject of high contrast

Meeting the formal requirements (1) and (2) does not necessarily imply that the resulting print will be aesthetically pleasing. In practice, the print will usually be satisfactory if the subject luminance range is not high; but with a subject of high contrast the result will often appear 'flat' and visually uninteresting, even though both the formal requirements have been met. This is because the log luminance range of a high-contrast subject is far greater than the maximum density range that can be obtained on a paper.

Two remedies are possible. The simplest is to print the negative on a harder grade of paper and to sacrifice detail at either the shadow or the highlight end of the scale. This, in effect, means abandoning

requirement (1) but is often satisfactory. A preferred remedy is to use a 'harder' printing paper but to isolate the various tone-bands within the picture, and treat them individually by *printing in*. In this way we can obtain the contrast we require within the various tone-bands of the picture without sacrificing detail at either end of the scale. For aesthetic reasons it may be considered appropriate to produce a considerable measure of distortion in the tones of the final print.

Tone reproduction

The relation of the reflectances of the various areas of a print (or luminances when the print is suitably illuminated) to the corresponding luminances of the subject is referred to as *tone reproduction*. Our goal in photography is normally to obtain an acceptable reproduction of the various luminances of the original scene, thus keeping each tone in approximately the same relative position in the tone scale. We cannot always do this, but the very least we should strive for is to retain *tone separation* throughout the whole range of tones.

The optimum objective result to be aimed at is *proportionality* between print luminances and subject luminances throughout the whole range of the subject; *equality* can rarely be hoped for, because the range of luminances possible on a printing paper or other reflective medium is less than the luminance range of the average subject. These considerations can be expected to apply to all hard copy images, whether produced on a photographic printing paper, or on a computer output medium such as a dye sublimation material or an ink-jet print.

Hurter and Driffield were the first to study the problem of tone reproduction from the sensitometric point of view. Their work extended over the period 1874–1915, their classic paper being published in 1890. At this time, the popular negative and printing materials all yielded characteristic curves with a long straight line. Hurter and Driffield took the view that perfect tone rendering in the print could only be achieved by first obtaining a negative in which all the values of opacity were proportional to the luminances of the subject. They stated that, for correct reproduction, exposure should be judged so that all the tones of the subject are recorded on the linear portion of the characteristic curve, and the negative should be developed to a gamma of 1.0. This state of affairs is illustrated in Figure 15.31, where it is apparent that if the log exposure differences, A_1, A_2 and A_3 are all equal, then the corresponding density differences B_1, B_2 and B_3 will also be equal to one another and to A_1, A_2 and A_3.

From their 'correct' negative Hurter and Driffield made prints on carbon, platinum or gold-toned

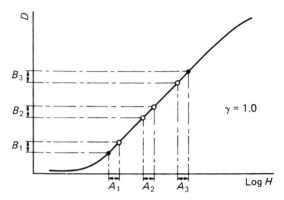

Figure 15.31 Using the straight-line portion of the characteristic curve

printing-out-papers (POP) using only the linear portion of each paper curve. All these papers had characteristic curves with a short toe and short shoulder, so that, assuming the papers to be capable of yielding a gamma of 1.0, it was quite a simple matter to obtain technically correct reproduction of many types of subject. If the gamma of the paper selected was not 1.0 (it was usually greater), correct reproduction could be obtained by developing the negative to a gamma equal to the reciprocal of the print gamma, so that the product of the gammas of negative and positive remained unity. Hurter and Driffield's approach, although not generally applicable to modern materials, is the basis of the methods used for the preparation of duplicate negatives.

The introduction of chloride and bromide papers early in the present century altered the situation, because these papers have a short linear portion and a long toe. It is impracticable when printing on these materials to use only the linear portion of the curve, and, therefore, with such papers, a negative made to Hurter and Driffield's specification does not give correct tone reproduction. Some distortion is in fact inevitable at the printing operation; our aim must be to introduce the appropriate distortion in the negative to counteract this.

Now, fast modern negative materials also have a long toe, use of which does in fact introduce some distortion, fortunately in the right direction. If, therefore, as is usual, we place our shadow tones on the toe of the curve of such a negative material and the highlights on the straight line, the contrast in the shadows of the negative is lower than in the highlights. In printing, however, the contrast of the paper curve in the shadows (located on the upper half of the curve) is greater than the contrast in the highlights, which are on the toe. The overall effect in the final print, therefore, is to yield roughly proportional contrast throughout the whole tone range. This is illustrated in Figure 15.32.

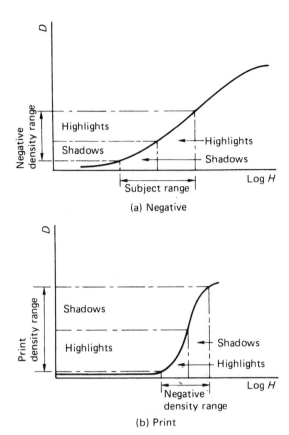

Figure 15.32 Obtaining proportional contrast in prints

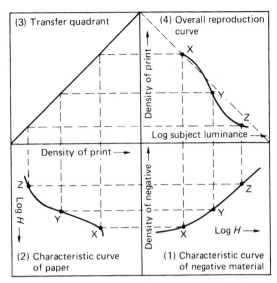

Figure 15.33 A quadrant diagram

The quadrant diagram

It has been found valuable to employ graphical methods to study the problems of tone reproduction, one very useful method being the so-called *quadrant diagram* originated by L.A. Jones. This enables practical problems in tone reproduction to be studied, and solved scientifically.

The simplest form of quadrant diagram is illustrated in Figure 15.33. This employs four quadrants, representing respectively the negative, the print and the overall reproduction, the remaining quadrant being a transfer quadrant. For a more complete solution of the problem, other quadrants may be added as desired, to illustrate the effects of flare, viewing conditions, intensification or reduction, etc.

In quadrant 1 of Figure 15.33, the densities of the negative have been plotted against the log luminances of the original subject. If the camera is free from flare, this curve will be identical to the characteristic curve of the material, in which density is plotted against the log of the exposure received by the film. The characteristic curve of the printing paper appears in quadrant 2. This is turned through 90 degrees in a

clockwise direction from its normal position, as in Figure 15.28, to enable density values on the negative to be transferred directly to the log exposure scale of the positive.

To relate print densities to subject log luminances we draw lines parallel to the axes to link corresponding points on the negative and positive curves, turning the lines proceeding from the positive curve through 90 degrees in the transfer quadrant to intersect the lines from the negative curve in quadrant 4. By linking corresponding points, such as *x*, *y* and *z*, for every part of the negative and positive curves we obtain an *overall reproduction curve* as shown. For exact reproduction this curve should take the form of a straight line at 45 degrees to the axes. In practice it is always more-or-less S-shaped, owing to the non-linearities in the negative and positive characteristic curves. Flattening at the top of the reproduction curve indicates tone compression in the shadows, arising from the non-linearity of the toe of the negative characteristic curve and the non-linearity of the shoulder of the paper characteristic curve. Flattening at the bottom of the curve indicates tone compression in the highlights arising from the non-linearity of the toe of the print characteristic curve.

The quadrant diagram may also be used to examine the requirements for negative duplication (Figure 15.34). A duplicate negative is defined as a negative which possesses density relations identical with those of the original negative, and produces an identical print when printed on the same grade of printing paper. It should be noted that there is no requirement for the duplicate to have the same *densities* as the original negative, merely the same *density range*: it may be lighter or darker overall than the original. It is

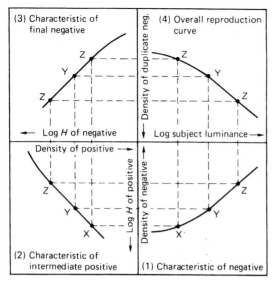

Figure 15.34 Use of a quadrant diagram to illustrate duplication of a negative

usually darker. The first step in duplication is to produce an intermediate positive record on a film possessing a linear characteristic, the exposure being such as to locate the image entirely on that linear region, and the development controlled to give a gamma of unity. The intermediate positive is then printed on the same film material using identical exposure and development criteria to obtain a negative once more. Provided the gamma has been correctly controlled, with all exposures made on the linear portion of the intermediate film characteristic, the final negative will have the same tone reproduction properties as the original negative. It may well, however, have a higher minimum density, owing to the necessity of using only the linear region of the intermediate film characteristic. If the intermediate positive is not made at a gamma of unity, then (in order to maintain the overall tone reproduction) the gamma of the next stage must be the reciprocal of the gamma of the intermediate positive.

Reciprocity law failure

The reciprocity law, enunciated by Bunsen and Roscoe in 1862, states that for any given photosensitive material, the photochemical effects are directly proportional to the incident light energy, i.e. the product of the illuminance and the duration of the exposure. For a photographic emulsion this means that the same density will be obtained if either illuminance or exposure duration is varied, provided

that the other factor is varied in such a way as to keep the product H in the equation

$$H = Et$$

(encountered earlier) constant.

Abney first drew attention to the fact that the photographic effect depends on the actual values of H and t, and not solely on their product. This so-called *reciprocity failure* arises because the effect of exposure on a photographic material depends on the *rate* at which the energy is supplied. All emulsions exhibit reciprocity failure to some extent, but it is usually serious only at very high or low levels of illumination, and for much general photography the reciprocity law can be considered to hold. In the sensitometric laboratory, however, the effects of reciprocity failure cannot be ignored, nor in certain practical applications of photography.

Practical effects of reciprocity failure

Reciprocity failure is encountered in practice as a loss of speed and increase in contrast at low levels of illumination, i.e. at long exposure times. The degree of the falling-off in speed and the region at which maximum speed is obtained varies from material to material. The effects of reciprocity failure are illustrated in Figures 15.35 to 15.37.

Figure 15.36 shows that the variation in speed with exposure time and illumination level is quite different for two types of emulsion. In manufacture, emulsions are designed so that the optimum intensity is close to the intensity normally employed. Thus, the fast negative film is intended for use at high intensities, with exposure of a fraction of a second, and the astronomical plate is intended for use at low intensities, with exposures of minutes or hours.

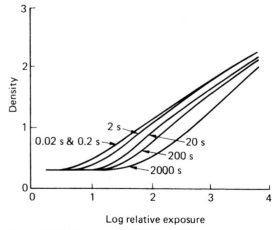

Figure 15.35 Characteristic curves of a fast negative film for different exposure times

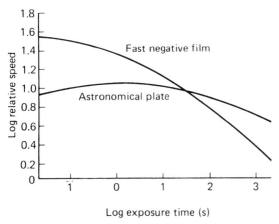

Figure 15.36 Reciprocity failure effect on speed

'time-scale' factors. (An explanation of the terms intensity-scale and time-scale is given later in this chapter.) Because of reciprocity failure, exposure times for the making of giant enlargements are sometimes unexpectedly long.

The variation of speed and contrast with differing exposure duration is usually different for each of the three emulsion layers present in colour materials. Consequently, departures from recommended exposing conditions may lead to unacceptable changes in colour balance for which no compensation may be possible.

It should be noted that although the mechanisms underlying the anomalous reciprocity effects are dependent on the illuminance on the emulsion and can be adequately explained only on that basis, it is the *duration of the exposure* that is critical in determining the importance of reciprocity failure to the practical photographer.

The loss of speed and contrast at short exposure times assumes practical importance with high-voltage electronic flash, which may give very short exposures. It may then be necessary to increase development times to compensate for these effects.

As the result of reciprocity failure, a series of graded exposures made using a time scale yields a result different from a set made using an intensity scale. Consequently, in sensitometry, a scale appropriate to the conditions in use must be chosen if the resulting curves are to bear a true relation to practice. For the same reason, filter factors depend on whether the increase in exposure of the filtered negative is obtained by increasing the intensity of exposure (by varying the light intensity or the lens aperture) or by varying the exposure duration. In the former case the filter factor is independent of the time of exposure, but in the latter case it depends largely on the exposure time required by the unfiltered negative. Two types of filter factor are therefore quoted for some types of work: 'intensity-scale' factors and

Intermittency effect

An exposure given in a series of instalments does not usually lead to the same result as a continuous exposure of the same total duration. This variation is known as the *intermittency effect*. It is associated with reciprocity failure, and its magnitude varies with the material. In practical photography the intermittency effect is not usually important except, possibly, in the making of test strips on printing paper for determining correct printing exposures. If an enlarging timer is used to make a series of separate exposures to build up a test strip the suggested time may not be appropriate if a single continuous printing exposure is used. In sensitometry, the effect cannot be ignored, as some sensitometers give intermittent exposures. It is found, however, that a continuous exposure and an intermittent exposure of the same average intensity produce similar effects when the frequency of the flash exceeds a certain critical value, which varies with the intensity level. It is important, therefore, that intermittent exposures given in a sensitometer should be made at a rate above a critical frequency, which has to be determined by experiment for each emulsion studied.

Sensitometric practice

It would be possible to construct the characteristic curve of an emulsion, or at least part of the curve, from the negative of a pictorial subject, by measuring the log luminances of the various parts of the subject and plotting against them the densities of the corresponding areas of the negative, illustrated in Figure 15.38. This would, however, be an exceedingly laborious method if many curves were required, and it is not normally adopted. Instead, a standard 'negative' is produced by giving a known range of

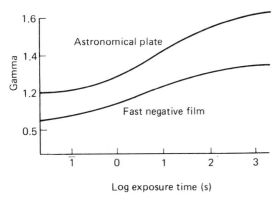

Figure 15.37 Reciprocity failure effect on contrast

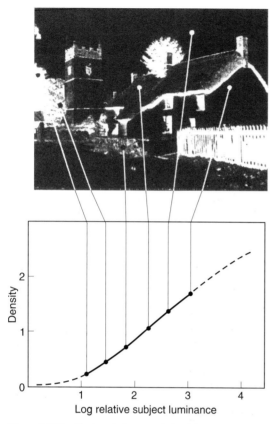

Figure 15.38 Characteristic curve derived from a negative

exposures to the material under test. The production of characteristic curves by this method involves:

(1) Exposure of a strip of the material in a graded series of exposures; this is carried out in a sensitometer.
(2) Processing of the exposed material under controlled conditions.
(3) Measurement of the densities obtained; this is carried out using a densitometer.
(4) Plotting of the results as a graph of density against log relative exposure.

Sensitometry requires careful work and, to be of full value, the use of special apparatus. In manufacturers' laboratories, where the production of characteristic curves is a routine, elaborate apparatus (often designed by the manufacturer's own research staff) is employed.

Sensitometers

A *sensitometer* is an instrument for exposing a photographic material in a graded series of steps, the values of which are accurately known. The essentials of a sensitometer are:

(1) *A light source of known, standard intensity and colour quality.* Many sources have been proposed and used at various times. The light source adopted as standard in recent years has been a gas-filled tungsten lamp operating at a colour temperature of 2856 K. The lamp is used with a selectively absorbing filter to yield the spectral distribution that corresponds to daylight of 5500 K modified by a typical camera lens. The filter used may be made of a suitable glass or employ specified solutions made up by the user. The colour temperature of 5500 K corresponds to daylight with the sun at a height typical of temperate zones during the hours recommended for colour photography and is therefore suitable for the exposure of colour and monochrome films designed for daylight use. Any sensitometric light source must be stabilized in terms of both luminous intensity and, particularly when used for colour materials, colour temperature. Fluctuations in mains voltage can alter both quantities, and are generally compensated by sophisticated voltage stabilizers. Alternatively, batteries may sometimes be used to avoid power fluctuations. In most cases a DC supply to the lamp is used to avoid AC modulation of the exposure, which may be significant at short exposure times.

(2) *A means of modulating the light intensity.* To produce the graded series of exposures, it is possible to alter either the illuminance or the time during which the exposure lasts. As already stated, because of reciprocity failure the two methods will not necessarily give the same results, and, to obtain sensitometric data which will correctly indicate the behaviour of the material under the conditions of use, the exposure times and intensities should be comparable with those which the material is designed to receive in practice.

A series of exposures in which the scale is obtained by varying the intensity – referred to as an *intensity scale* – can conveniently be achieved by use of a neutral 'step wedge' or 'step tablet'. A series of exposures in which the scale is obtained by varying the time – referred to as a *time scale* – may be achieved by use of a sector wheel rotating at constant speed (Figure 15.39a), a plate falling at constant velocity (Figure 15.39b) or, in some cases, a sectored cylindrical drum. Whichever system of modulation is chosen, a sensitometer is designed so that the exposures increase logarithmically along the length of the strip. The log exposure steps are usually 0.3, 0.2, 0.15 or 0.1. If for any reason it is desired to interrupt the exposure, this must be done in such a way that the intermittency effect does not affect the

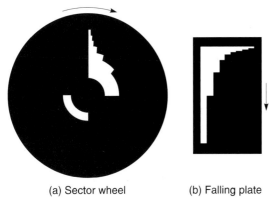

(a) Sector wheel (b) Falling plate

Figure 15.39 Two types of time-scale sensitometer shutter

sity measurements in quantity are nowadays invariably carried out on electronic instruments, visual instruments are still of value when only a few readings are required and eyestrain is unlikely to be a problem.

Electronic densitometers are of many different types, ranging from simple direct-reading instruments to instruments with highly sophisticated circuits employing a null system, with, in some instances, automatic plotting of the results.

The light detectors used in electronic densitometers may be devices using vacuum-tube technology such as photoemissive cells and photomultipliers, or solid-state devices such as photodiodes and phototransistors. Although the former devices are still widely used there is a trend towards the universal use of solid-state detectors.

results. Figure 15.40 shows a typical sensitometric strip. This particular example was produced in an intensity-scale sensitometer, being exposed through a step wedge.

As actual exposure in the camera is best represented by an intensity scale of exposures, sensitometers used for process control are of the intensity-scale type. Early commercial sensitometers were usually time-scale instruments, because the design problems are fewer, but this was not at the time a serious drawback. On occasion, however, it did cause confusion, and modern commercial sensitometers are nearly always intensity-scale instruments.

Densitometers

The name *densitometer* is given to special forms of photometer designed to measure photographic densities. Instruments designed to measure the densities of films and plates are described as *transmission densitometers*, while those designed to measure papers are termed *reflection densitometers*. Some densitometers are designed to enable both transmission and reflection densities to be measured on the one instrument, usually employing separate sensor heads for the two tasks.

Densitometers can be broadly classified into two types: visual and electronic. The earliest densitometers were visual instruments and, although den-

Single-beam instruments, direct reading

The commonest type of transmission densitometer uses a light-sensitive detector illuminated by a beam of light in which the sample to be measured is placed. The response of the detector is displayed on a meter calibrated in units of density. The design is illustrated in Figure 15.41(a), a single-beam direct-reading densitometer. Such instruments are usually set up for measurement by adjusting the density reading to zero when no sample is present in the beam. This operation may be followed by a high-density setting using some calibration standard, or even an opaque shutter for zero illumination. Once set up, the instrument is used for direct measurements of the density of samples placed in the beam.

Stability of light output, of any electronics used (not shown in Figure 15.41) and of performance by the detector are required for accurate density determination. In practice fairly frequent checks of the instrument zero may be required to eliminate drift. A further requirement of the direct-reading instrument is linearity of response to changes of illuminance.

Single-beam instruments, null reading

In order to avoid difficulties due to non-linearity of response it is possible to arrange for the illumination to remain constant no matter what density is to be

Figure 15.40 A sensitometric strip

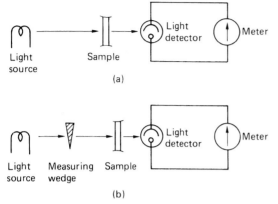

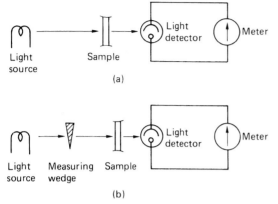

Figure 15.41 Single-beam instruments. (a) Direct-reading. (b) Substitution or null-reading

measured. The design of the instrument is shown in Figure 15.41(b). In this, a substitution method is used.

The *measuring wedge* inserted into the measuring beam is a continuous neutral-density wedge calibrated so that its density is known at any point inserted in the beam. The instrument zero is established by moving the wedge so that its maximum density lies in the beam and arranging that the meter needle is at a single calibration position. The sample to be measured is placed in the beam and the meter restored to its null position by withdrawal of the measuring wedge. The density of the sample is given by the extent of withdrawal.

The consistency of density measurement thus depends on the same factors as for direct-reading

instruments with the exception that cell non-linearity is eliminated as a source of error. On the other hand the measuring wedge calibration is introduced, but this is a less serious source of potential error.

Twin-beam instruments

Many of the sources of error inherent in single-beam instruments can be eliminated if two beams are taken from the same source, as shown in Figure 15.42. One beam, A in the diagram, has a path identical with that of a null-reading single-beam instrument, while the other beam, B, passes through an uncalibrated compensating wedge before illuminating a second photocell. The outputs of the two cells are compared electronically and the difference between them is indicated on the meter. Normally only one gradation is shown on the meter, all readings being of the null type.

To zero the instrument the measuring wedge is inserted into the measuring beam, A, to its maximum density. In general the meter will not then be at its null position. The uncalibrated wedge is then inserted in the compensating beam and adjusted so that the meter registers no deflection from the null position. Measurements are then made by placing samples in the measuring beam and withdrawing the measuring wedge until the null reading is restored, the extent of withdrawal indicating the density of the sample. Fluctuations in lamp output affect both beams equally and are thus compensated in instruments of this type. The detectors are maintained under constant conditions of illumination and no assumptions of linearity of response are required. The accuracy of the instrument depends on the calibration of the measur-

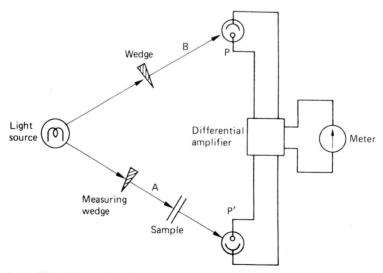

Figure 15.42 Twin-beam differential or null-reading instrument

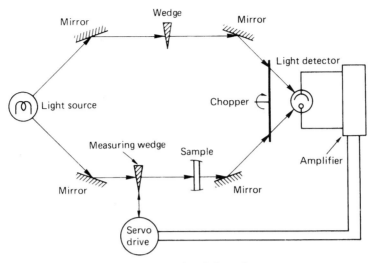

Figure 15.43 Automatic plotting densitometer (twin-beam split and chopped)

ing wedge, sources of short-term errors in density being eliminated by this design.

Visual densitometers are differential twin-beam instruments. Although unreliable as an absolute judge of density, the human eye is very sensitive to small differences between two compared densities. Visual densitometers compare the unknown density with that of a calibrated wedge displayed side-by-side in the visual field. The illumination may not be maintained constant in a visual instrument.

Automatic plotting

Densitometers used for the measurement of large numbers of sensitometric strips are often arranged so that the characteristic curve is automatically plotted by the instrument. To achieve this a pen is moved across appropriately scaled graph paper at a rate corresponding to the movement of a sensitometric strip past the measuring aperture. This requires the strip to have been exposed through a *continuous* sensitometric wedge, the density of which varies directly with distance. The density detected by the instrument is revealed as a signal which makes a servo-motor drive the plotting pen to an appropriate position relative to the density scale on the graph paper. Usually the servo-motor drives the measuring wedge to a null position using a mechanical link to which the pen is attached.

One type of automatic-plotting densitometer is illustrated in Figure 15.43. It is called a *twin-beam split and chopped* instrument. The desirable features of twin-beam operation are retained but the two beams are used to illuminate a single photocell. The *chopper* is a rotating shutter which allows the beams

to reach the cell alternately. Any difference between the beam intensities appears as a variation of the output current from the photocell. The variation can be amplified electronically and used to drive the servo-motor and measuring wedge to the null position.

Microdensitometers

These instruments are used to examine density changes over very small areas of the image. Such microstructural details are measured for the assessment of granularity, acutance and modulation transfer function, as described elsewhere in this text.

To measure the density of a very small area it is usual to adapt a microscope system, replacing the human eye by a photo-multiplier tube. The sample is driven slowly across the microscope stage in synchronism with graph paper moving past a pen, which registers density in a manner similar to that of the automatic-plotting densitometers already considered. Microdensitometers are commonly twin-beam instruments, and the ratio of graph paper movement to sample movement may be as great as 1000:1.

Colour densitometers

In addition to monochrome silver images, it is often necessary to make sensitometric measurements of colour images. These are composed of just three dyes absorbing red, green and blue light respectively. It is therefore possible to assess colour images by making density measurements in these three spectral regions. Colour densitometers are similar to monochrome

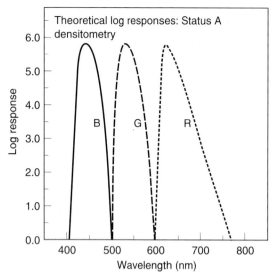

Figure 15.44 Blue, green and red response bands for ISO Status A colour densitometry

instruments but are equipped with three primary colour filters. These red, green and blue filters combine with the sensor characteristics to give three separate response bands, in the red, green and blue spectral regions respectively.

The behaviour of a dye image can be assessed most effectively when the densitometer measures only within the spectral absorption band of the dye.

So, colour densitometers are usually equipped with narrow-band filters, a typical set of instrument responses being shown in Figure 15.44. In view of the unwanted spectral absorptions of image dyes it will be appreciated that a colour-density measurement (red, green or blue) represents the sum of contributions from all the dyes present. Such measured densities are described as *integral densities*.

For most purposes no further information is required, but sometimes a single image dye is required to be measured in the presence of the other two. In such cases *analytical densities*, which represent the individual dye concentrations, have to be calculated from the measured integral densities. Procedures for doing this are beyond the scope of this work; it is sufficient to note that, outside a research laboratory, there are no simple methods of measuring analytical densities, although they may be calculated from integral densities.

An important choice of densitometer filters arises when the response of the instrument is to be matched to that of a colour print paper. The purpose of this exercise is to use a densitometer to assess colour negatives and hence to predict the printing conditions required to yield a good colour print. Instruments set up according to an ISO Standard for the measurement

of masked negatives are said to give *Status M densitometry*. When set up in a manner specified as an ISO Standard so that visual neutrals formed of the three image dyes of a reversal film give red, green and blue densities which are identical and equal to those of a matching non-selective neutral (such as silver), the system is described as *Status A densitometry*. These designated types of colour density are internationally recognized ISO standards.

The spectral responses of instruments for Status densitometry are tightly specified. It may not, however, be necessary to establish a system meeting such specifications because arbitrary integral densities are often satisfactory for such purposes as quality control. As with black-and-white densitometers the commonest type is the direct-reading single-beam instrument. Instruments of this type include Gretag, MacBeth and X-rite transmission and reflection densitometers.

Elementary sensitometry

An elementary form of sensitometry, which (although not of a high degree of precision) can be of real practical value in testing the performance of sensitized materials or photographic solutions, can be carried out with nothing more elaborate than a step wedge and a simple visual densitometer. If a commercial step wedge is not available, a suitable substitute can be made by giving a stepped series of exposures to an ordinary film. Useful step increases in a wedge used for this purpose are density values of 0.15 for the testing of films and 0.1 for testing papers.

A strip of the material under test is exposed through the wedge by contact, or the wedge may be illuminated from the rear and photographed with a camera. If the latter procedure is adopted, care must be taken to eliminate possible causes of flare and the wedge should be diffusely illuminated. The densities obtained on the strip are then plotted against the densities of the step wedge which govern the exposure. The step wedge densities are plotted to increase from right to left, this corresponding with log exposure of the strip increasing from left to right in the usual way. Simple sensitometry of this type may be used for various purposes, e.g.:

(1) To study the effect of increasing development on the speed and contrast of an emulsion.
(2) To compare the emulsion speeds and contrasts yielded by two developers.
(3) To compare the speeds of two emulsions.
(4) To compare the contrasts of two emulsions.
(5) To determine filter factors.
(6) To measure the exposure range of a printing paper.

The luminous intensity, distance etc. of the lamp used are needed only if we wish to find the absolute

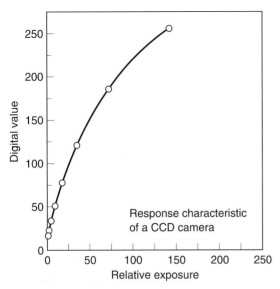

Figure 15.45 The transfer characteristic of a monochrome CCD camera obtained by plotting the output of the CCD as digital values against the relative exposure

speed of a material. All the characteristics listed above can be studied without this information, provided the luminous intensity, distance and colour temperature of the lamp remain constant and that identical exposure times are given.

Sensitometry of a digital camera

At the time of writing there is no standard method for characterizing digital cameras, but useful results can be obtained by the adaptation of sensitometric methods developed for the examination of silver-based photographic systems.

The light-sensitive element of a digital camera, usually a *charge coupled device* (CCD), unlike a photographic film, is not something that can be taken away and examined. Any investigation of its sensitometric properties has to be carried out *in situ*, within the camera. The elementary methods discussed above have to be used but if acceptable accuracy is to be achieved it is usually necessary to have calibrated grey scales or sensitometric wedges. Alternatively the need for a wedge can be avoided if the shutter of the camera can be controlled and, preferably, the lens removed. The camera can then be set up so that a suitably controlled light source is allowed to illuminate the shutter and a series of exposures can then be made over as wide a range of exposure times as possible.

Calibrated reflection grey scales are available commercially at reasonable cost and should have as

large a density range as possible, certainly at least 2.0. A transmission neutral wedge of density range 3.0 would be better in determining the *dynamic range*, or *useful exposure range* of the camera. The grey scale should be evenly illuminated and photographed using the digital camera under study. The evenness of illumination can be tested by superimposing a sheet of white card and repeating the exposure. The camera will then act as a photometer and characterize any unevenness due to illumination of the grey scale, or within the camera itself.

The output of the CCD is customarily stored within the camera and can be accessed by a suitable computer equipped with appropriate software, sometimes, but not always, including a driver for the camera. What is required is the output in pixel values from 0 (darkest black) to 255 (lightest white) for each step of the grey scale. A graph of pixel value against relative luminance of grey scale is shown in Fig.15.45. Because most calibrated grey scales possess fairly constant tonal increments, the steps are normally calibrated in reflection density. In order to calculate the relative luminance scale we use the equation shown earlier in the chapter which defines density, but modified for reflection density

$$D_R = \log_{10}\left(\frac{I_i}{I_r}\right)$$

and rearrange it to calculate I_r/I_i as a measure of relative luminance

$$\left(\frac{I_r}{I_i}\right) = \frac{1}{10^{D_R}}$$

where values of 10^{D_R} may be conveniently looked up in Antilogarithm tables or directly evaluated using a hand calculator.

The transfer function obtained illustrates the response of the CCD camera to exposure level and has been fitted in the diagram by a convenient mathematical function, giving a smooth curve. It shows a reduction of gradient as the limiting white reproduction is achieved, but it is difficult to interpret in the light of existing knowledge and habits of thought about photographic characteristic curves. If, on the other hand, we plot log digital value against exposing wedge density (a logarithmic measure) we obtain, from the same experiment, the result shown in Figure 15.46.

This is a transfer function resembling a low contrast reversal photographic characteristic curve and can be interpreted in a similar way. First, the data are more evenly distributed than in the linear scales of Figure 15.45, and closely fit the linear regression drawn through them. The equation of the straight line appears on the graph. The linear response effectively runs up to the maximum possible, at 255, from a minimum at 30. This minimum persisted at higher

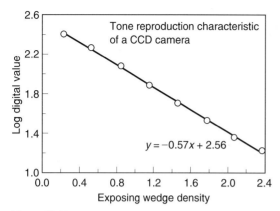

Figure 15.46 The characteristic curve of a CCD camera plotted as log digital value against exposing wedge density

wedge densities, representing the minimum output possible with the camera in its normal configuration, with lens in place and essentially photographing a suitably illuminated sensitometric step wedge. Some of the minimum digital value probably originates as flare and some as detector noise. The former can be largely avoided by removing the lens and using time-scale sensitometry. The latter will remain under these circumstances. The linear response in Figure 15.46 gives a useful exposure scale of approximately 2.2 log units, equivalent to 7 stops.

The mean gradient of −0.57 evaluated from the straight line shown in Figure 15.46 is approximately equivalent to that of photographic negative films, when conventionally developed, but takes no account of contrast modifications which arise in later stages of the digital imaging chain. The output device for example, commonly a computer monitor, will increase the effective contrast considerably, and visual inspection usually reveals sufficient contrast in the final reproduction under normal viewing conditions.

This study of a digital camera shows the power of quite simple sensitometry. The test subject was a transmission step wedge. The camera output was evaluated with computer software commonly used in digital imaging.

In many applications the nominal calibration of the neutral step wedge is adequate. If greater accuracy is required then it is necessary to calibrate the grey scale separately using equipment not commonly available outside a laboratory, and to determine the spectral properties of the illuminants used. This also requires expensive laboratory equipment. In fact the full resources of photographic sensitometry are required for the precise characterization of both silver-based and digital photographic systems.

Bibliography

Eggleston, J. (1984) *Sensitometry for Photographers.* Focal Press, London.

James, T.H. (1977) *The Theory of the Photographic Process*, 4th edn. Macmillan, New York.

SMPTE (1963) *Principles of Colour Sensitometry.* Society of Motion Picture and Television Engineers, New York.

Thomas, W. (ed.) (1973) *SPSE Handbook of Photographic Science and Engineering.* Wiley, New York.

Todd, H.N. and Zakia, R.D. *Photographic Sensitometry.* Morgan & Morgan, Hastings-on-Hudson (latest edition).

16 The reproduction of colour

In photography two alternative approaches to the reproduction of colour are open to us: all objects, of any colour, can be reproduced as shades of grey, varying from black to white, or may be reproduced in colours that are acceptably close to those of the original. Black-and-white photography existed for nearly a century before colour photography became common, and it was found very early on that the human visual system would accept a monochrome picture as a true record of coloured objects provided the greys of the reproduction were related to the brightnesses of the original colours. To understand how this is achieved we need to know something about the responses of the eye and of photographic emulsions to different colours. We shall then go on to consider the reproduction of colour by colour films – a rather more complicated story.

Colours of the rainbow

We have already seen that white light can be separated by means of a prism into light of different hues: violet, indigo, blue, green, yellow, orange and red: 'all the colours of the rainbow'. We also saw that these correspond to different wavelengths. White light is a mixture of light of different wavelengths. Light consisting of a single wavelength, or narrow band of wavelengths, is highly saturated in colour. Colours of this type are referred to as *spectral colours*, or more properly, *spectral hues*. This is an opportunity for us to note that 'hue' and 'colour' are not the same thing. Hue is that characteristic of colour (the other two are *lightness*, or *luminosity*, and *saturation*, or *purity*) to which we give names such as red, green, blue or yellow and which is related to the wavelength composition of the colour. The terms 'hue' and 'colour' are thus not interchangeable, although in general parlance the term 'colour' is frequently used where 'hue' would be more appropriate. In this chapter the correct terminology is adhered to as far as is possible without being unnecessarily pedantic.

While Newton identified the seven spectral hues listed above, his terminology was not that most readily understood today. In particular he seems to have described what we would call 'blue' as 'indigo' and a blue–green, which we shall call 'cyan', as blue.

A revised set of names is shown in Plate 7, which indicates the spectral hues and the corresponding wavelength bands.

Colours of natural objects

The pure colours of the spectrum are rarely to be found in the objects which we see around us; instead we see somewhat less vivid versions of them together with many colours, such as purple or *magenta*, which are not to be found in the spectrum. This does not mean that light of a different nature is emitted by these objects. Objects are visible because of the light that they reflect or transmit to our eyes, most objects deriving this light from some outside source of illumination. Coloured objects appear coloured because they absorb some wavelengths and reflect or transmit others. Light sources possess colour because of the spectral composition of their emitted radiation. Low pressure sodium vapour street lights, for example, appear yellow because most of the light emitted has a wavelength of approximately 589 nm, corresponding to a spectral yellow.

Suppose we examine a number of pieces of coloured paper. Now, although we can discern six or more hues in the spectrum of white light, for many purposes we may consider it as a mixture of just three colours, blue, green and red. Suppose the first piece of paper reflects only the blue part of the light falling on it, the green and red portions being absorbed. Then, when illuminated by white light, it will look blue, and we say simply that it is a piece of blue paper. Similarly a piece of green paper will reflect green and absorb blue and red, and a piece of red paper will reflect red and absorb blue and green. Sometimes, an object reflects more than one of the three groups. For example, one of the pieces of paper might reflect green and red, absorbing only the blue; this paper would look yellow. In the same way, a paper reflecting both blue and red would look purple or magenta, while a paper reflecting both blue and green would look blue–green or cyan. In general, any common object assumes a colour which is a mixture of the spectral colours that are present in the illuminant and not absorbed by the object. The selective absorption of a range of coloured surfaces is illustrated in Plate 8.

Table 16.1 Typical reflectances of natural objects in the three main regions of the spectrum

Colours of natural objects	Reflectance (%)		
	Blue	Green	Red
Red	5	5	45
Orange	6	15	50
Yellow	7	50	70
Brown	4	8	12
Flesh	25	30	40
Blue	30	15	5
Green	6	10	7

The colours described in the example above were a result of the complete absorption of one or more of the main colour groupings of white light. Such colours are called *pure*, or *saturated colours*. The pigments of most commonly occurring objects absorb and reflect more generally throughout the spectrum. The colours of natural objects (sometimes referred to as pigmentary colours) therefore contain all wavelengths to some extent, with certain wavelengths predominating. They are of much lower saturation than the colours of the papers supposed in our example. Thus, a red roof, for example, appears red not because it reflects red light only, but because it reflects red light better than it reflects blue and green. The spectral properties of some common surface colours are illustrated in Plate 8, in terms of the percentage reflectance of each of the seven spectral hues.

Table 16.1 shows the percentage reflectance in the three principal regions of the spectrum of some of the main colours in the world around us. It will be seen that the general rules connecting the kind of absorption with the resulting impression are the same as with the pure colours of the papers considered in the example above. The figures quoted in the table, which are approximate only, are percentages of the amount of incident light in the spectral region concerned, not of the total incident light.

We see from Figure 14.1 and Plate 8 that the spectral absorption bands of commonly encountered coloured objects are broad.

Effect of the light source on the appearance of colours

We noted above that the colour assumed by an object depends both upon the object itself and on the illuminant. This is strikingly illustrated by a red bus, which, by the light of sodium street lamps, appears

brown. In this context 'brown' means, strictly, 'dark yellow'. (This is a combination of words that does not normally occur in English, for cultural reasons that do not concern us here.) If the illuminant is pure yellow, then the *hue* of the reflected light cannot be other than yellow, even though the object may (as in this case) reflect very little. A deep red rose reflects no yellow light at all, and when seen under a (low-pressure) sodium street lamp it appears black. We are accustomed to viewing most objects by daylight, and therefore take this as our reference. Thus, although, by the light of sodium lamps, the bus appears brown, we still regard it as a red bus. The change from daylight to light from a sodium lamp represents an extreme change in the quality of the illuminant, from a continuous spectrum to a line spectrum. The change from daylight to tungsten light – i.e. from one continuous source to another of different of different energy distribution – has much less effect on the visual appearance of colours. In fact, over a wide range of energy distributions the change in colour is not perceived by the eye. This is because of its property of *chromatic adaptation*, as a result of which the eye continues to visualize the objects as though they were in daylight.

If we are to obtain a faithful record of the appearance of coloured objects, our aim in photography must be to reproduce them as the eye sees them in daylight. Unlike the eye, however, photographic materials do not adapt themselves to changes in the light source, but faithfully record the effects of any such changes: if a photograph is not being taken by daylight, the difference in colour quality between daylight and the source employed must be taken into account if technically correct colour rendering is to be obtained, and it will be necessary to use colour-compensating filters.

In practice, a technically correct rendering is rarely required in black-and-white photography, and changes in the colour quality of the illuminant can usually be ignored. In colour photography, however, very small changes in the colour quality of the illuminant may produce significant changes in the result, and accurate control of the quality of the lighting is essential if good results are to be obtained.

Response of the eye to colours

Our sensation of colour is due to a mechanism of visual perception which is complicated, and which operates in a different way at high and low levels of illumination. In considering the reproduction of colours in a photograph we are concerned with the *photopic* mechanism, i.e. the one operating at fairly high light levels. For the purposes of photographic theory, it is convenient to consider this as using three types of receptor. A consideration of the way in which these receptors work is known as the *trichromatic*

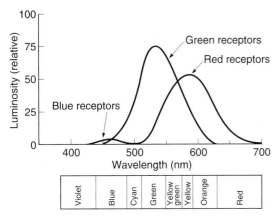

Figure 16.1 The three fundamental sensation curves of the trichromatic theory of colour vision

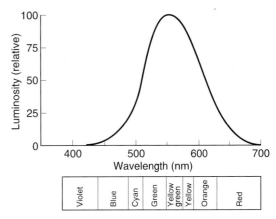

Figure 16.2 Visual luminosity curve

theory of colour vision. This theory, associated with the names of *Young* and *Helmholtz*, postulates receptors in the retina of the eye which differ in their sensitivity and in the regions of the spectrum to which they respond. The first set of receptors is considered to respond to light in the region of 400–500 nm, the second to light in the region of 450–630 nm and the third to light in the region of 500–700 nm. Considered on this basis, the behaviour of the eye is probably best grasped from a study of curves in which the apparent response of the hypothetical receptors (in terms of luminosity) is plotted against wavelength, as in Figure 16.1.

The perceived luminosity of blues is lower than that of either greens or reds. As a result, spectral blues look darker than reds, and reds look darker than greens. It must be clearly understood, however, that luminosity (or *lightness*) has little to do with the vividness or *saturation* of colours. Thus a dark blue may look as fully saturated as a green that appears inherently much lighter; and a differently balanced set of curves is obtained if colour-sensitivity is substituted for luminosity as the vertical scale (as shown in Figure 16.17).

The validity of the three-colour theory was for a long time a subject of controversy, but it is now supported by experimental evidence indicating that there are indeed three types of colour-sensitive receptor in the retina of the eye. The justification of the use of the theory for our purposes is that a person with normal colour vision can match the hue of almost any given colour by mixing appropriate amounts of blue, green and red light. Colour photography itself relies on this phenomenon. By adding together the ordinates of the three curves shown in Figure 16.1, we obtain a curve showing the sensitivity to different wavelengths of the eye as a whole. Such a curve is shown in Figure 16.2. This visual luminosity curve shows the relative luminous efficiency of radiant energy. It shows how the human eye responds to the series of spectral colours obtained by splitting up a beam of pure white light of uniform spectral composition throughout the visible spectrum – referred to as an *equal energy spectrum* – to which sunlight roughly approximates. It is useful to notice by how many times the luminosity of the brightest colour, yellow–green, exceeds that of colours nearer the ends of the spectrum.

Primary and complementary colours

When any one of the three sets of colour-sensitive receptors of the eye is stimulated on its own, the eye sees blue, green, or red light respectively. These three colours are known to the photographer as the *primary colours*, already mentioned. The sensations obtained by mixing the primaries, are called *secondary* or *complementary* colours and are obtained when just two sets of receptors are stimulated (Table 16.2). If all three sets of receptors are stimulated in equal proportions the colour perceived is neutral.

Table 16.2 Primary and complementary colours

Primary colour	Complementary colour	Additive mixture
Red	Cyan	= Blue + green
Green	Magenta	= Blue + red
Blue	Yellow	= Green + red

It should be pointed out that in painting the theory of colour is treated somewhat differently. As a painter is concerned with mixtures of colorants rather than lights it is customary in painting to describe as 'primaries' the pigments blue, red and yellow. These can be the basic set of Prussian Blue, Crimson Lake and Chrome Yellow, equivalent to the photographer's cyan, magenta and yellow. By mixing these pigments in various combinations it is possible to obtain almost any hue.

Complementary pairs of colours

Any two coloured lights which when added together produce white, are said to be of *complementary colours*. Thus, the secondary colours (cyan, magenta and yellow) are complementary to the primary colours (red, green and blue), respectively. Some colour theorists in the field of aesthetics refer to such complementary pairs of colour as 'harmonious colours'.

Low light levels

At low light levels a different and much more sensitive mechanism of vision operates. The dark-adapted, or *scotopic*, eye has a spectral sensitivity differing from the normal, or *photopic*, eye. The maximum sensitivity, which, in the normal eye, is in the yellow–green at about 555 nm, moves to about 510 nm, near the blue–green region. This change in sensitivity is referred to as the *Purkinje shift* (Figure 16.3). It is because of this shift that the most efficient dark-green safelight for panchromatic materials has a peak transmittance at about 515 nm rather than at 555 nm.

It is also found that the eye, which can distinguish a large number of colours under bright lighting conditions, becomes much less colour-sensitive at lower levels of illumination. Under very dim conditions only monochrome vision is possible. This property is not shared by colour films, so that under dim conditions the correct exposure will nevertheless reveal the colours of the subject and often surprises the photographer, whose recollection is of a far more drab original. It is of interest that the brightness of television screens and computer monitors is considerably less than sunlit scenes, and may be inadequate for the eye to operate in its fully photopic mode, but much too bright for scotopic vision to predominate. In this case the eye is said to be operating in a *mesopic* mode, which entails a lowered sensation of colourfulness compared with that from photopic vision. This is true despite the apparent success of television in giving vivid colour reproduction.

Black-and-white processes

A monochrome photographic emulsion is considered as reproducing colours faithfully when the relative luminosities of the greys produced are in agreement with those of the colours as seen by the eye. So far as a response to light and shade is concerned – and this, of course, has a very large part to play in the photographic rendering of the form and structure of a subject – it is clear that a light-sensitive material of almost any spectral sensitivity will do. If, however, our photograph is to reproduce at the same time the colours of the subject in a scale of tones corresponding with their true luminosities, then it is essential that the film employed shall have a spectral response corresponding reasonably closely to that of the human eye.

We have seen that, although the ordinary silver halide emulsion is sensitive only to ultraviolet and blue radiation, it is possible by dye-sensitization to render an emulsion sensitive to all the visible spectrum. To assist us in evaluating the performance of the various materials in common use, Figure 16.4 shows the sensitivity of the eye and the sensitivity to

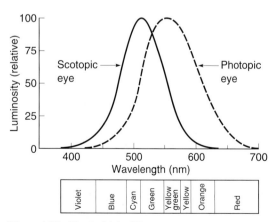

Figure 16.3　The Purkinje shift

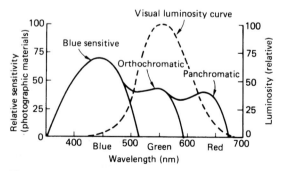

Figure 16.4　Response of photographic materials to daylight

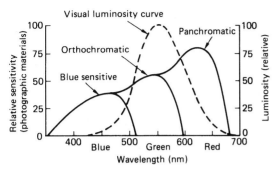

Figure 16.5 Response of photographic materials to tungsten light

daylight of typical examples of the three main classes of photographic materials. Figure 16.5 contains curves for the same materials when exposed to tungsten light, the visual response curve being repeated.

Table 16.3, which lists the primary and secondary hues and indicates how each is recorded in monochrome by the three main classes of emulsion, illustrates the practical effects of the differences shown between the visual luminosity curve and the emulsion spectral sensitivity curves in Figures 16.4 and 16.5. The descriptions given in the table are relative to the visual appearance of the colours.

Less saturated colours than the primaries and secondaries follow the general pattern shown in Table 16.3 but to a lesser extent. Thus, brown can be regarded as a desaturated and dark yellow, and pink as a desaturated and light magenta.

It is clear from the curves in Figures 16.2 and 16.3 and from Table 16.3 that:

(1) No class of monochrome material has exactly the same sensitivity distribution as the human eye, either to daylight or to tungsten light. In the

first place, the characteristic peak of visibility in the yellow–green is not matched by the photographic response, even with panchromatic materials. On the other hand, the relative sensitivity of panchromatic materials to violet, blue and red greatly exceeds that of the human eye.

(2) The closest approximation to the sensitivity of the eye is given by panchromatic materials.

(3) Of the three groups of light-sensitive materials listed, only panchromatic materials can be employed with complete success for the photography of multicoloured objects as only these respond to nearly the whole of the visible spectrum.

(4) Even with panchromatic materials, control of the reproduction of colour may be needed when a faithful rendering is required, as no type of panchromatic material responds to the different wavelengths in the visible spectrum in exactly the same manner as the human eye. Control of colour rendering is also sometimes needed to achieve special effects.

The control referred to under (4) above is achieved by means of *colour filters*. These are sheets of coloured material which absorb certain wavelengths either partially or completely, while transmitting others. By correct choice of filter it is possible to reduce the intensity of light at wavelengths to which the emulsion is too sensitive. The use of colour filters is considered in detail elsewhere in this book.

Colour processes

The principles of the two major types of photographic colour reproduction have been described in Chapter 14. The processes considered there illustrate the ways in which *additive and subtractive colour syntheses* can be carried out following an initial *analysis* by means of blue, green and red separation filters. It was

Table 16.3 Recording of primary and complementary colours by the main types of photographic emulsion

	Blue-sensitive (daylight)	*Orthochromatic (daylight)*	*Panchromatic (daylight)*	*Panchromatic (tungsten)*
Primaries				
Blue	Very light	Light	Rather light	Correct
Green	Dark	Rather dark	Slightly dark	Slightly dark
Red	Very dark	Very dark	Slightly light	Light
Secondaries				
Yellow	Very dark	Slightly dark	Correct	Rather light
Cyan	Light	Very light	Slightly light	Slightly dark
Magenta	Slightly light	Correct	Rather light	Rather light

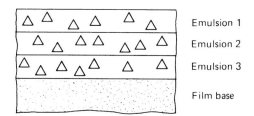

Figure 16.6 Simplified cross-section of an elementary integral tripack film

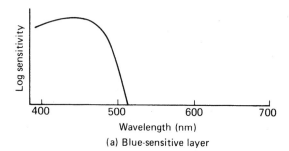

(a) Blue-sensitive layer

stated that most colour photographs are made using the emulsion assembly known as the integral tripack and the procedure of colour development in which yellow, magenta and cyan image dyes are formed to control the transmission of blue, green and red light

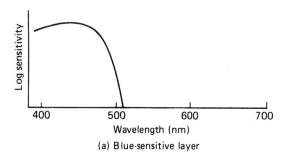

(a) Blue-sensitive layer

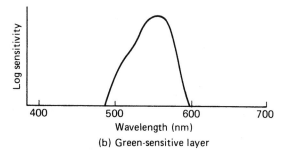

(b) Green-sensitive layer

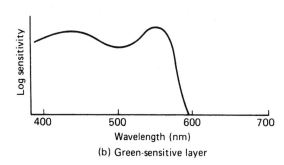

(b) Green-sensitive layer

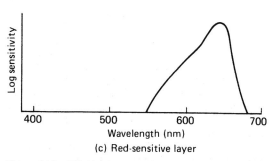

(c) Red-sensitive layer

Figure 16.8 Effective layer sensitivities of a typical tripack film

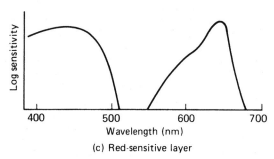

(c) Red-sensitive layer

Figure 16.7 Layer sensitivities of an elementary tripack film

respectively by the final colour reproduction. As shown in Figure 16.6, three emulsions are coated as separate layers on a suitable film or paper base and these emulsions are used independently to record the blue, green and red components of light from the subject. The analysis is primarily carried out by limiting the emulsion layer sensitivities to the spectral bands required.

The sensitivities of typical camera-speed emulsions are illustrated in Figure 16.7. All three layers possess blue sensitivity. Blue light must be therefore be prevented from reaching the green- and red-recording layers.

In practice the film is coated as shown in Plate 9, with the blue-recording layer on top of the other two layers, and a yellow filter layer between the blue-recording and green-recording layers. The supercoat is added to protect the emulsions from

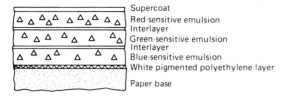

Figure 16.9 Cross-section of a typical tripack colour-printing paper. Note the different order of emulsion layers when compared with Plate 9

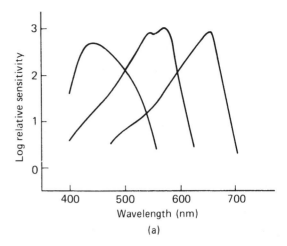

(a)

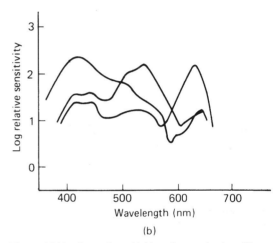

(b)

Figure 16.10 Spectral sensitivities of reversal colour films exposed to daylight. (a) A subtractive tripack film. (b) An additive film with integral réseau

damage. The filter layer absorbs blue light sufficiently to suppress the blue sensitivities of the underlying emulsions, and an interlayer is usually positioned between the lower emulsion layers. The resulting (effective) emulsion layer sensitivities are shown in Figure 16.8.

A more elegant solution to the problem of inherent blue-sensitivity of the green- and red-recording layers is to suppress it within the emulsion layers themselves. This may be achieved in materials for camera use by, for example, the use in those layers of tabular emulsion crystals of very high surface area:volume ratio. The blue response depends on the amount of silver halide in each crystal, a volume effect; but the dye-sensitized response depends on the quantity of adsorbed dye, a surface-area effect. A high area:volume ratio therefore increases the sensitivity in the sensitized region compared with the inherent blue sensitivity, and with modern sensitization techniques this may be so low as to require no yellow-filter layer in the coated film.

In print materials it is often possible to reduce and confine the inherent sensitivity of red- and green-sensitized emulsions to the far blue and ultraviolet spectral regions, and to exclude these by a suitable filter during printing; no yellow filter layer is then required in the print material and the order of layers may be changed to suit other needs. A commonly employed order of layers in colour-printing materials is illustrated in Figure 16.9. The most important images for the visual impression of sharpness are magenta and cyan, the latter being particularly important. The red- and green-sensitive layers are therefore coated on top of the blue-sensitive emulsion so that the red and green optical images reach the appropriate layers without suffering any prior blurring due to scatter in the blue-sensitive layer.

The sensitivity distributions of two colour-negative tripack films are shown in Figure 13.5; they illustrate how the sensitivities of the individual layers contribute to the overall sensitivity balance of the film. There is little need for any particular speed balance in a colour negative, so the actual sensitivity balance is arranged to suit printing rather than visual criteria. This is not the case for positive images, which are generally designed to be viewed directly or by projection, and must therefore possess at least a satisfactory neutral reproduction. Wedge spectrograms of reversal colour films may thus be considerably different from those of negative films. Two such reversal films are illustrated in Figure 16.10, which compares typical subtractive and additive film sensitivity distributions. The differences in speed separations of the three records in the two films may be of little practical significance as the useful exposure range of the additive film in particular is rather short, i.e. it has a restricted latitude, and all practical images may therefore possess adequate colour separation.

Formation of subtractive image dyes

Having analysed the camera image into blue, green and red components by means of the tripack film construction it is then necessary to form the appropriate image dye in each layer. Conventionally this is achieved by the reaction of the by-products of silver development with special chemicals called *colour couplers* or *colour formers*. Developing agents of the p-phenylene diamine type yield oxidation products, which will achieve this:

(1) Exposed silver bromide + developing agent → metallic silver + oxidized developer + bromide ions

(2) Oxidized developer + coupler → dye

Thus to form a dye image alongside the developed silver image a special type of developer is required and a suitable colour coupler must be provided either by coating it in the emulsion or by including it in the developer solution.

The dyes formed in subtractive processes would ideally possess spectral absorptions similar to those illustrated in Chapter 14. However, they are not in fact ideal, and possess spectral deficiencies similar to those also shown in Chapter 14. The consequences of these dye imperfections can be seen when the sensitometric performance of colour films is studied.

Colour sensitometry

Using the sensitometric methods examined in Chapter 15, it is possible to illustrate important features of colour films in terms of both tone and colour reproduction. Tone-reproduction properties are shown by neutral exposure, that is exposure to light of the colour quality for which the film is designed, typically 5500 or 3200 K. This exposure also gives information about the overall colour appearance of the photographic image. Colour exposures are used to show further colour reproduction properties not revealed by neutral exposure.

Negative–positive colour

Colour negative films and printing papers have tone reproduction properties not unlike those of black-and-white materials (see Figure 16.24), except that colour-negative emulsions are designed for exposure on the linear portion of the characteristic curve. The materials are integral tripacks and generate a dye image of the complementary hue in each of the three emulsion layers: yellow in the blue recording,

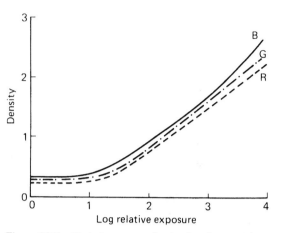

Figure 16.11 Neutral exposure of a simple colour-negative film

magenta in the green recording and cyan in the red recording layer.

The densities of colour images are measured using a densitometer equipped with blue, green and red filters, and all three colour characteristic curves are drawn on one set of axes. Typical simple negative characteristics obtained from neutral exposure are shown in Figure 16.11, which shows that the three curves are of similar contrast although of slightly different speeds and density levels. The unequal negative densities have no adverse effect on the colour balance of the final print because colour correction is carried out at the printing stage.

Neutral-exposure characteristic curves are not very informative about colour reproduction, but characteristic curves obtained from exposures to the primary colours are better. Saturated primary-colour exposures could be expected to reveal the characteristics of individual emulsion layers. The results of such exposures of a simple colour-negative film are shown in Figure 16.12. The characteristic curves show a number of departures from the ideal in which only one colour density would change with colour exposure. Two main effects are seen to accompany the expected increase of one density with log exposure: the first is the low-contrast increase of an unwanted density with similar threshold to the expected curve; the second is a high-contrast increase (similar to that of the neutral curves) of an unwanted density with a threshold at a considerably higher log exposure than the expected curve. The former effect is due to secondary, unwanted, density of the image dye: thus the cyan image formed on red exposure shows low-contrast blue and green secondary absorptions. The second effect is due to the exposing primary colour filter passing a significant amount of radiation to which one or both of the other two layers are sensitive. The blue exposure has

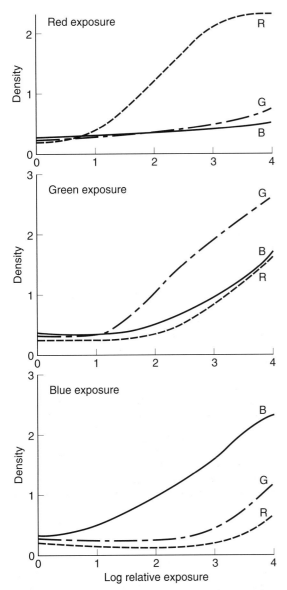

Figure 16.12 Colour exposures of a simple colour-negative film

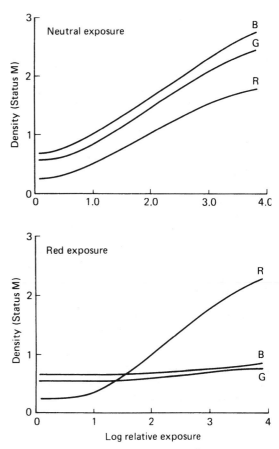

Figure 16.13 Neutral and red exposures of a masked-negative film

clearly affected both green- and red-sensitive layers. In this case of blue exposure the separation of layer responses is largely determined by the blue density of the yellow filter layer in the tripack at exposure as all emulsion layers of the negative are blue-sensitive. The results of green exposure show a combination of the two effects, revealing secondary blue and red absorptions of the magenta dye and the overlap of the green radiation band passed by the filter with the spectral sensitivity bands of the red- and blue-sensitive emulsions.

Modern colour negative films yield characteristic curves different from those shown in Figures 16.11 and 16.12 owing to various methods adopted to improve colour reproduction. Sensitometrically the most obvious of these is *colour masking*, which is designed to eliminate the printing effect of unwanted dye absorptions by making them constant throughout the exposure range of the negative. The important characteristics of a masked colour-negative film are shown in Figure 16.13. The most obvious visual difference between masked and unmasked colour negatives is the overall orange appearance of the former, and this appears as high blue and green densities, even at D_{min}. The mechanism of colour masking is described later, but its results can clearly be seen in the case of the red exposure illustrated in Figure 16.13. The unwanted blue and green absorptions of the cyan image are corrected by this masking. Ideal masking would result in blue and green characteristic curves of zero gradient, indicating completely constant blue and green densities at all

exposure levels. In practice it can be seen that the blue and green absorptions are slightly under-corrected so that both blue and green densities do rise a little with increased exposure.

A second method of colour correction is to make image development in one layer inhibit development in the other emulsion layers. If an emulsion has an appreciable developed density this may be reduced by development of another layer, giving a corrective effect similar to that of colour masking. Such *inter-image effects* are not always simply detected by measuring integral colour densities but they are sometimes easy to see. Inter-image effects, for example, would appear to be operating in the negative film illustrated in Figure 16.12. Blue exposure results in development of the yellow image in the top layer of the tripack and this, in turn, inhibits development of the green- and red-sensitive layers so that the green and red fog levels fall while the blue density increases. Such unexpectedly low image densities are usually the only clue to the existence of inter-image effects to be found using integral densitometry.

Most recent colour-negative films (Figure 16.13) use a combination of colour masking with inter-image effects, and this allows excellent colour correction with much lower mask densities than were previously used. The mask density and its colour, however, remain far too high for such a colour correction method to be used in materials such as reversal films and colour print materials, designed for viewing rather than printing. The consequences of dye deficiencies in such systems are, however, less important than in negative–positive systems where two reproduction stages are involved with a consequent reinforcement of colour degradation.

Reversal colour

Colour-reversal films are constructed similarly to integral tripack negative films. The positive nature of the image springs from a major difference in the processing carried out, not from the emulsions used in the film. As in the negative, the dye image generated in each layer is complementary to the sensitivity of the emulsion: a yellow dye is generated in the blue-sensitive layer etc.

Sensitometry is carried out as for the negative film and characteristic curves plotted. The results of neutral exposure are illustrated in Figure 16.14 and show typical positive characteristic curves. Unlike the colour-negative material it is important that the results of a neutral exposure on reversal film appear neutral; no simple correction can be carried out once the image has been developed. In the case illustrated the curves show sufficiently similar densities for the result to be visually satisfactory. The major difference is at so high a density as to be imperceptible – there is rarely any perceivable colour in regions of deep shadow.

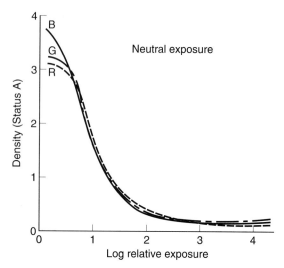

Figure 16.14 Neutral exposure of a colour-reversal film

Colour exposures (Figure 16.15) show various departures from the ideal and are sometimes quite difficult to interpret. The two main effects are, however, as easily characterized as they were for colour negatives; the unexpected decrease of density with log exposure at low-contrast and the decrease in a colour density other than that of the exposure at high contrast. The former effect is generally caused by the secondary absorption of an image dye, and the latter shows the overlap between the spectral region passed by the exposing filter and the sensitivity band of the emulsion concerned. Red exposure yields characteristic curves showing the effects of secondary absorptions and inter-image effects. The expected result of red exposure is a decrease in red density with increasing exposure. This is seen in Figure 16.15; but other results are also observed. The initial large decrease in the density of the cyan dye image with increased exposure is accompanied by a small decrease in the green density, caused by the correspondingly reduced unwanted secondary green absorption of the cyan-image dye. A considerable increase in blue density takes place over the same exposure range, and this indicates the existence of an inter-image effect in which the development of an image in the red-sensitive layer inhibits the development of an image in the blue-sensitive layer. This effect may take place at the first (non-colour) development stage, but is more likely during colour development, and represents a colour-correction effect akin to masking. The apparently high minimum density to red in the case of red exposure is due to unwanted red absorptions of the yellow and magenta image dyes present in maximum concentration. At high exposure levels, when the blue- and green-

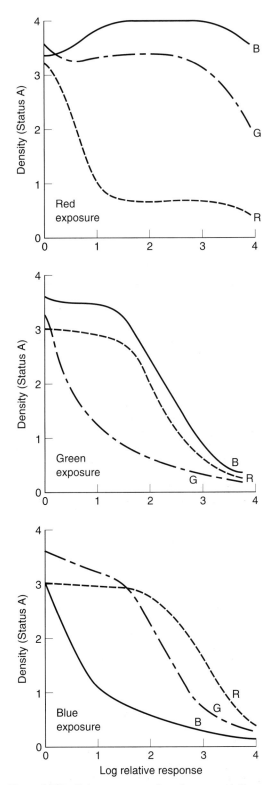

Figure 16.15 Colour exposures of a colour-reversal film

sensitive layers respond and the yellow and magenta dye concentrations fall, the red density is also reduced.

The response of the blue- and green-sensitive layers to exposure through a red filter is due to the small but appreciable transmission of the red filter in the green and blue regions of the spectrum.

Green exposure causes the expected reduction in green density giving a green characteristic curve with a long low-contrast foot. This is not due to a low-contrast reduction of magenta image at the foot, as there is probably no magenta dye present. It is due to a fall in the total secondary green absorptions of the yellow and cyan dyes as they decrease in concentration at high exposure levels. This is caused by a significant overlap between the pass-band of the green exposing filter and the spectral responses of the red- and blue-sensitive layers. It will also be noticed that the initial fall in magenta dye concentration at low exposure levels is accompanied by reduced red and blue densities. This is due to the unwanted secondary red and blue absorptions of the magenta image dye; as the concentration of magenta dye decreases so do its absorptions, both wanted and unwanted. In the case of blue exposure all three layers show the effects of actinic exposure, the speed separation of the emulsions being mostly due to the yellow-filter layer present at exposure. As with colour-negative material, all the emulsion layers are sensitive to blue. The low-contrast shoulder of the green characteristic curve shows the reduced green absorption associated with decreasing yellow dye concentration. The yellow image clearly has a green secondary absorption. The long low-contrast foot of the blue characteristic curve is due, not to the yellow image dye which is probably present at minimum concentration, but to the blue secondary densities of the magenta and cyan dyes which are decreasing in concentration with increased exposure.

In essence, each of the colour-exposed results may be analysed in terms of three main regions. The first, at low exposure levels, shows one dye decreasing in concentration; its secondary densities are revealed by low-contrast decreases in the other two densities. The second region, at intermediate exposure, shows no change in any of the three curves, but the level of the lowest is well above the minimum found on neutral exposure, owing to the unwanted absorptions of the two image dyes present. This is exemplified by the red exposure (Figure 16.13) at a log relative exposure of 2.0. Lastly we find, at high exposures, the region where sufficient *actinic* exposure, that is exposure to which the emulsion is sensitive, of the remaining two emulsions leads to a decrease in the concentration of the corresponding image dyes. The secondary absorptions of these two dyes are shown by a low-contrast decrease in the third curve – for example the blue density at log relative exposures of 1.5 or more. For reversal film, departures from this scheme are caused

by inter-image effects which appear as unexpected increases in density with increased exposure, or by overlap of filter pass bands with sensitivity bands of the emulsions. This last departure from the ideal results in a compression of the three regions with the possible loss of the middle one and overlap of the other two. In the examples shown, the middle region is not evident on green or blue exposure owing to the sensitivity separations of the three emulsions being only as much as is needed for adequate colour reproduction. Only the red exposure has sensitivity separation to spare. Indeed the extensive range of exposures over which no change is seen in the image may be the cause of poor reproduction of form and texture of vivid red subjects. Red tulips or roses, for example, may simply appear as red blobs with no visible tonal quality or texture.

Inter-image effects are extremely common in colour processes, either by design or accident. They are not usually detectable by integral densitometry, although there are a number illustrated in Figures 16.12 and 16.15.

Additive systems

The neutral characteristics of a typical additive colour-reversal film are shown in Figure 16.16. A number of the limitations of such processes are immediately obvious. The useful upper limit of density in images designed for projection is approx-

imately 3.0, so an upper limit is therefore set on the density scale of a reversal film. The necessarily high minimum density caused by the integral réseau of additive colour filters imposes a downward limit on the density of highlights that is considerably higher than that of subtractive reversal films. Transparencies made using additive films tend therefore to appear rather dark and to have a shorter tonal scale than subtractive materials. Not only does this short tone-scale limit the latitude of the film, but it may also limit the range of colours available.

Imperfections of colour processes

Additive system

Typical spectral sensitivity curves of the eye are shown in Figure 16.17(a); the sensitivities of the three colour receptors overlap considerably. While the red receptor alone is stimulated by light of a wavelength of 650 nm or greater, there are no wavelengths at

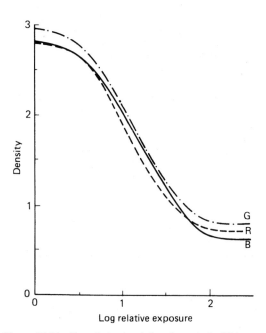

Figure 16.16 Neutral characteristics of a typical additive colour-reversal film

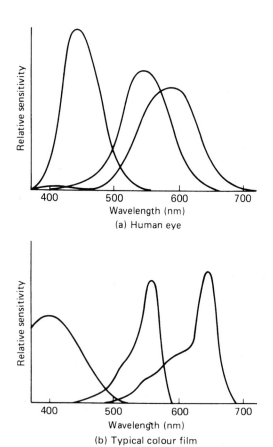

Figure 16.17 Spectral sensitivities of the human eye and a colour tripack film

which unique stimulation of the blue or green receptors is possible. A good approximation to the ideal can be achieved by using a wavelength of about 450 nm for the blue stimulus, but the best that can be done for the green is to select light of a wavelength of about 510 nm. Even at this wavelength there is still considerable red- and blue-sensitivity in addition to green. In practical systems of additive colour photography shortage of light usually dictates the use of fairly wide-band filtration. The green record will thus elicit a significant response from the blue- and red-sensitive receptors of the retina as well as from the green receptors. The green light appears to be mixed with some blue and red light, and in consequence appears a paler green. Reproductions of greens thus appear paler than the originals. Similar, but less severe, desaturation of blues and reds is also encountered owing to the broad spectral bands used in practice. The overall effect is to desaturate colours by the addition of white light.

The impossibility of achieving separate blue, green and red stimulation of the retina is common to both additive and subtractive three-colour systems of colour reproduction.

Subtractive system

The subtractive system not only shares the limitations of the additive system in the reproduction of colour, but also suffers from defects introduced by the use of subtractive image dyes. Ideally, each subtractive dye controls one-third, and only one-third, of the visible spectrum. If the regions controlled were made narrower than this, it would not be possible to reproduce black, or saturated colours, owing to uncontrolled transmission in one or two bands of the spectrum.

The subtractive system thus uses blue, green and red spectral bands that may be somewhat broader than those used in the additive system, and the reproductions of vivid colours are accordingly more desaturated. This would result in reproduced colours appearing markedly paler than the originals, if certain steps (detailed later) were not taken to improve matters.

In addition to the inherent inferiority of the subtractive system when compared with the additive system, a further difficulty arises from the imperfections of the image dyes. In particular, magenta and cyan image dyes have additional absorptions in regions of the spectrum other than those required. Thus the blue secondary absorptions of the magenta dye result in dark blues, bluish greens, poorly saturated yellows and reddish magentas. The blue and green secondary absorptions of the cyan dye cause dark blues, dark greens, poorly saturated reds, yellows and magentas, and dark cyans of poor saturation. It is clearly important to correct such deficiencies where possible.

Correction of deficiencies of the subtractive system

Various means are adopted to minimize the deficiencies of the subtractive system. One common procedure is to construct the photographic emulsions so that the blue, green and red sensitivities have steeper peaks, which are also more widely separated than the peak sensitivities of the retinal receptors. A comparison between typical colour film sensitivities and those of the eye is shown in Figure 16.17. This expedient improves the saturation of many colours, but may introduce errors, either because the emulsion sensitivities extend beyond those of the eye, or because of a gap in the film sensitivities such as that shown at a wavelength of about 480 nm in the illustration.

The extension of emulsion sensitivity farther into the short-wave region than that of the eye may result in blue skies being reproduced incorrectly, and distant views appearing pale and blue. If these faults are encountered, the remedy is usually to employ an ultraviolet-absorbing filter over the camera lens. At the long-wave end of the spectrum, the extended sensitivity of the colour film compared with that of the eye leads to an interesting effect. Flowers that reflect blue light, particularly bluebells and 'Morning Glory', often also possess a high reflectance close to the long-wave limit of retinal sensitivity. The result is that in colour photographs it is frequently found that these flowers appear pink or pale magenta instead of blue. There is no simple remedy for this fault, as filters which cut off the extended sensitivity region adversely affect colour reproduction within the visible region.

It is found that the desaturation of colour reproductions described above is reduced by adopting a higher emulsion contrast than would be ideal in theory. The reproduction thus possesses a higher contrast than the original and this results in an increase in saturation of vivid colours together with a decrease in saturation of pastel colours and a departure from objectively correct tone reproduction. In most cases faults due to the increased tone contrast are outweighed by the superior colour saturation. It is, however, often advisable to keep the lighting ratio of the subject low in colour photography, if the increased tone contrast of the reproduction is not to be objectionable.

In the processing of colour materials it is often found that development of the record of one colour inhibits the development of an adjacent emulsion layer. This *inter-image effect* is in many ways a vertical analogue of the, lateral, Eberhard effect encountered in black-and-white processing; the products of development of the colour record diffuse into

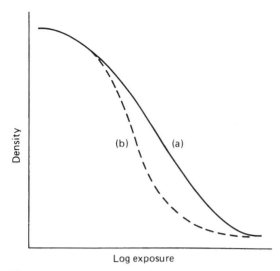

Figure 16.18 The characteristic curve of the red-sensitive layer of a colour-reversal film: (a) in the case of a neutral exposure; (b) in the case of a red exposure

adjacent emulsion layers and inhibit development. An important difference lies in the fact that whereas the action of the Eberhard effects extends parallel to the film base, the colour inter-image effects act in a direction perpendicular to the film base.

The useful inter-image effects found in colour processes may be promoted by design of the system, and harnessed to improve colour reproduction. The development of the record of any colour is made to inhibit the development of other colour records. Thus the neutral scale reproduction may possess a contrast which is much exceeded by the contrast of the reproduction of colours, such a situation being illustrated in Figure 16.18. Successful use of inter-image effects gives increased colour saturation with little distortion of tone reproduction, and can lead to very acceptable results.

Compensation for deficiencies of the subtractive system achieved by these means may be successful in a first generation reproduction. This category embraces colour transparencies produced by reversal processing of the original camera film. In many cases further generations of reproduction are required. Such further reproductions include reflection prints made from colour negatives or reversal transparencies, and duplicate positive transparencies. It is generally true that further reproduction stages accentuate the departures from ideality of the first generation. Saturated colours become darker and may change hue, pale colours become paler and lose saturation, and tone contrast increases so that highlight detail is lost, while the shadow areas become totally black. From the point of view of colour reproduction, therefore, it is usually preferable to make the camera record on

negative film which can be made relatively free from deficiencies of colour and tone reproduction. The method used to achieve this freedom from deficiencies of colour reproduction is called *colour masking.*

Masking of colour materials

The spectral density distribution of a typical magenta image dye is shown in Figure 16.19(a). The characteristic curve of the green-sensitive emulsion which generates the dye is shown alongside and represents the green, blue and red densities of the dye image. It will be seen that the density to green light increases with exposure as would be expected, and that the unwanted blue absorption of the dye is shown by the increase in blue density over the same exposure range.

At the printing stage an unmasked negative record employing this dye will convey spurious information to the printing paper about the distribution of blue light in the camera image. This is undesirable and results, for instance, in bluish greens in the print reproduction, among other shortcomings.

In order to compensate for the variation of blue density with the magenta dye content of the negative, it is merely necessary to prepare a corresponding positive yellow dye record, as shown in Figure 16.19(c) and (d). The yellow positive is then superimposed in register with the negative, as shown in (e). Provided the blue-density characteristic curve of the positive is equal to the contrast of the negative, but in the opposite sense, the combined effect of the mask and the unwanted secondary density of the image dye is as shown in (f). The printing effect of the unwanted absorption of the magenta image dye has been entirely compensated at the expense of an overall increase in blue density.

Making separate coloured masks is usually inconvenient and modern colour masking systems rely on the formation of masks within the negative colour film. This is called *integral masking*, and is widely used in colour-negative films. The overall orange appearance of such negative films results from the yellow mask of the magenta dye together with the reddish mask required by the cyan image dye. The yellow image dye is usually sufficiently free from unwanted absorptions for masking to be unnecessary.

Integrally masked colour images cannot be used for projection purposes, as the colour cast is too great. If a colour negative (say of a poster) is required for direct projection it is necessary to use a slide film developed by a colour-negative processing method. It is worth noting that although integral colour masking cannot be used for materials intended for viewing (directly or via a projector), the use of inter-image

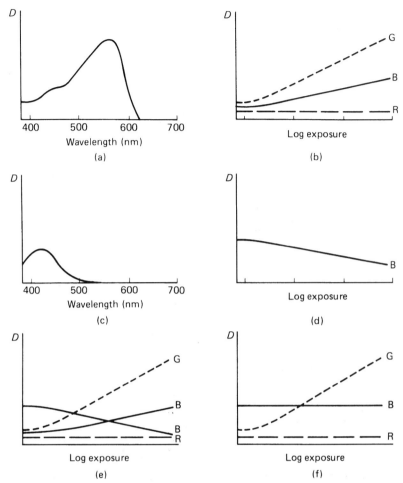

Figure 16.19 Elements of masking the blue absorption of a magenta image dye. (a) Spectral density distribution and (b) characteristic curves of the magenta dye image. (c) Spectral density distribution and (d) characteristic curve of the yellow mask. (e) Image and mask characteristic curves. (f) Integral characteristic curves of the masked green-sensitive layer

effects is analogous to masking, and can be used to achieve a useful degree of colour correction.

Problems of duplication

So far we have considered the reproduction of colour by reversal colour film to prepare transparencies and the use of negative film designed for the production of prints. Satisfactory though they may be for viewing, the use of transparencies for the production of further generations of reproduction involves a number of rather awkward problems. An important case is the requirement for the production of a duplicate of a transparency. Clearly, if the original transparency is satisfactory, the duplicate should resemble it as closely as possible. This is difficult to

achieve without taking special steps. Although it is possible simply to photograph the transparency on a film similar to that used for the original, this is rarely satisfactory, as can be shown by a simple quadrant diagram (Figure 16.20).

In quadrant 1 the characteristic curve of the original reversal film is shown together with three representative tones X, Y and Z. The record of tones within the range XYZ represents the image to be duplicated, and the shape of the curve indicates what is desired in the final reproduction following duplication. The original transparency is copied using a system possessing linear tone transfer characteristics as shown in quadrant 2; this system could be a contact printer or a flare-free copy camera. In quadrant 3 the solid curve XYZ represents the characteristic of the duplicating film when the original camera film stock

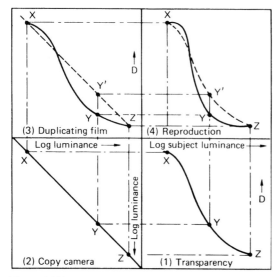

Figure 16.20 Tone reproduction of duplicate transparencies. (a) XYZ in quadrant 4 represents the result of duplication on to the original camera film stock. (b) XY'Z is the result of duplication on a film with linear characteristics of gradient 1.0

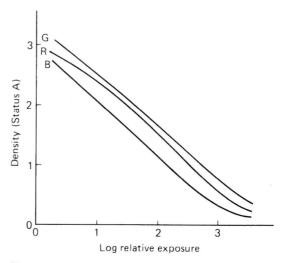

Figure 16.21 Characteristics of a typical slide-duplicating film with curves displaced with respect to the log exposure axis for clarity. In normal use correction filters are used to give optimal neutral reproduction

is used for that purpose. The resulting tone reproduction in the duplicate transparency is shown as the curve XYZ in quadrant 4, and can be seen to have a very much higher mid-tone gradient than the original transparency as well as severely compressed highlight and shadow detail. The consequences for colour reproduction are that pastel colours tend to appear as white in the duplicate, while more saturated colours appear at maximum saturation, but may also be very dark.

The same quadrant diagram may be used to find the optimum shape for the characteristic curve of the duplicating film if the original transparency is assumed to have the tone reproduction required of the final duplicate. What is done is to plot that curve, XYZ in quadrant 1, as XY'Z in quadrant 4 and then to work back to quadrant 3 to find the characteristic curve required of the duplicating film. This is shown as XY'Z in quadrant 3: a duplicating reversal film with a linear characteristic curve of gradient 1.0 is required. Special reversal films are, in fact, made especially for duplicating colour transparencies, and they have characteristics similar to those predicted from the quadrant diagram. The films are balanced for use with *either* tungsten *or* electronic-flash illumination, and optimum colour-balance correction can be achieved by the use of filters similar to those used in colour printing. The characteristic curves of a typical slide duplicating film are shown in Figure 16.21, the curves being displaced from the optimal neutral for clarity. It will be seen that the characteristics obtained are very close to the ideal, with long

linear regions and short toes. Duplicate transparencies made on such films can be highly successful, and if correctly exposed they exhibit minimal compression of highlight and shadow detail. The colour reproduction can also be correspondingly successful if the correct filtration is determined.

An important problem arises in the preparation of prints from positive transparencies. Prints made directly on reversal colour paper tend to be inferior to those made from camera negatives using the negative–positive system, particularly with respect to the rendering of highlight detail and colour reproduction. The former difficulty arises from the printing of the low contrast toe of the transparency on the low contrast toe of the reversal print material; colour reproduction is limited by the lack of masking to correct for dye deficiencies in the camera record and the print. Although a number of complicated masking procedures using specially prepared silver masks may be adopted to correct these deficiencies, the most practical solution is to make an intermediate negative, using a film specially made for the purpose, and then to print the negative on conventional colour-negative printing paper. The internegative film is masked to correct for dye deficiencies, and in addition possesses tone reproduction properties designed to retain the important highlight contrast which would otherwise be lost. The sensitometric characteristics of such an internegative film are shown in Figure 16.22.

The internegative film illustrated is exposed so that the highlights of the transparency to be printed are recorded on the high-contrast portion of the characteristic curves whereas the higher contrast mid-tones of the transparency are recorded on the lower contrast

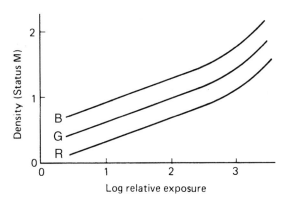

Figure 16.22 Characteristics of an internegative film

region. Shadow detail is also recorded at low contrast, but this is not usually a serious matter. The enhanced highlight contrast enables prints to be made on conventional negative–positive paper, retaining the highlight detail of the original transparency. The internegative is also integrally colour-masked to correct for dye deficiencies, and this results in enhanced colour reproduction in the final print. The use of a correctly exposed internegative can thus improve both tone and colour reproduction in the printing of colour transparencies.

The chemistry of colour image formation

We saw in Chapter 14 that the image of a subject may be analysed in terms of blue, green and red light content. It is usual in colour photography to control these portions of the visible spectrum by means of yellow, magenta and cyan dyes respectively. In this section we shall be concerned with three important methods of producing the dye images commonly encountered in colour photography. The methods rely on the generation of dyes, the destruction of dyes, and the migration of dyes respectively. We shall consider each of them in turn.

Chromogenic processes

Generation of dyes

Most commercial colour processes and a number of monochrome processes employ a processing step in which the generation of image dyes takes place. This dye-forming development gives the name *chromogenic* (colour-forming) to such processes. Such a dye-forming solution is called a *colour developer* and in this solution image dyes are generated alongside the development of metallic silver. Two important chemical reactions take place in a colour developer:

(1) Silver halide grains which have been rendered developable by exposure to light, or otherwise, are *reduced* to metallic silver and the developing agent is correspondingly *oxidized*:

> Developing agent + silver bromide → developer oxidation products + metallic silver + bromide ion

(2) Developer oxidation products react with chemicals called *colour formers* or *colour couplers* to form dyes. Colour developing agents of the substituted p-phenylenediamine type are used in practice, and the colour of the developed dye depends mainly on the nature of the colour former:

> Developer oxidation products + colour former → dye

Colour photographic materials

The dye-forming development reaction allows us to generate dyes of the required colours, yellow, magenta, and cyan, to control blue, green and red light respectively. To take advantage of colour development it has been necessary to make special integral tripack photographic materials as already described. This means that light-sensitive emulsions are coated in three layers on a suitable support; the basic construction is shown in Figure 16.6. The records of blue, green and red light are made independently in the three emulsion layers. The resulting layer sensitivities are illustrated in Figure 16.7. The demand for high film speeds and improved quality led to important developments in the technology of colour film assembly. Some of these changes are revealed by obvious but microscopic structural changes, and one such departure from the conventional tripack is shown in Plate 10. In order to obtain the required latitude it is customary to include two separate emulsions, a fast and a slow component of similar spectral sensitization, in each layer of a tripack colour film. This arrangement gives the highest sensitivity when the fast component is coated above the slow and therefore has the greatest possible access to the incoming radiation. Each sensitive layer of the elementary tripack construction is then coated as a double layer and the colour-former:silver ratio in each component may be manipulated independently to optimize sensitometric and micro-image properties.

A further improvement in film speed has accompanied the structural change illustrated in Plate 11. In this cross-sectional diagram it will be seen that the logic which positions the fast component above the slow in the emulsion double layers in Plate 10 has

been pursued to the point where the fast green- and red-sensitive components both lie above the two slow components, resulting in a partial inversion of layer order, with the fast red-sensitive layer above the slow green-sensitive layer. This structure is considerably more complex than that shown in Plate 10, but has been used to meet very stringent targets for speed and quality. The adoption of tabular-grain emulsions in the green- and red-sensitive layers has made possible the omission of the customary yellow-filter layer from the structure shown in Plate 10. This change, in itself, tends to reduce both the overall thickness of the coating and the scattering of input light, thus improving image sharpness.

We have examined the method used to obtain separate blue, green and red latent-image records in an integral tripack. Now we shall consider the methods by which the colour-developer oxidation products evolved in an emulsion layer are arranged to react with a colour former to yield the appropriate image dye. As the colour developing agents are mobile in solution and diffuse rapidly through the swollen emulsion we shall be concerned especially with the location of colour formers in chromogenic development.

Location of colour formers

It is required that the records of blue, green and red light shall be composed of yellow, magenta and cyan dyes respectively. This distribution of dyes is achieved by presenting colour formers to developer oxidation products in a selective manner. Thus the oxidation products of development of the blue-recording emulsion are allowed to react only with a yellow-forming coupler. This coupler may be in solution in the colour developer, or it may be introduced into the emulsion during manufacture of the film.

Developer-soluble couplers can only be used when a single dye is to be formed in a colour development stage. Three colour developers are needed for a tripack and only one emulsion must be rendered developable before each colour development if separation of the colour records is to be achieved. These conditions can be satisfied only in certain reversal processes which we shall consider later.

Couplers incorporated in the emulsions are used to form all three image dyes in one colour-development step. In this case only the appropriate dye-forming couplers may be permitted in an emulsion layer, if separation of the colour records is to be adequate. The colour formers therefore have to be immobilized to prevent diffusion of the couplers from layer to layer during manufacture or later and specially formulated interlayers incorporated to prevent migration of oxidized colour-developing agent from layer to layer.

Two main methods of immobilizing couplers have been used. The method adopted by Agfa-Gevaert was to link the otherwise mobile coupler to a long chemically inert chain. This chain interacts with gelatin in such a way that the molecule is effectively anchored in the layer. Such a coupler is described as being *substantive* to gelatin. Processes employing this type of immobilized coupler are referred to as *substantive processes*. Processes employing developer-soluble couplers are termed *non-substantive processes*.

The second immobilizing method is due to Eastman Kodak and employs shorter chemically inert chains linked to the otherwise mobile coupler. The inert chains are selected for oil solubility and render the

Table 16.4 The primary functions of solutions commonly used in colour processes

Solution	Function
Black-and-white developer	Develops a metallic silver image
Pre-bleach	Hardens the gelatin before entering the bleach
Bleach	Bleaches a metallic silver image, usually by oxidation and rehalogenation to silver halide
Bleach-fix	Bleaches the metallic silver image and fixes the silver salts formed. Leaves only the dye image required
Colour developer	Develops dye images together with metallic silver
Fix	Dissolves silver halide present after required development and/or bleaching has taken place
Fogging bath	Replaces fogging exposure in modern reversal processes
Hardener	Hardens the gelatin to resist damage in subsequent processing stages
Stabilizer	Improves the stability of dye images, may also contain wetting agent and hardener
Stop-fix	Stops development as well as removing silver halide

entire molecule soluble only in oily solvents. A solution of such a coupler is made in an oily solvent and that solution dispersed as minute droplets in the emulsion, before coating. The coupler is very insoluble in water and the oily droplets are immobile in gelatin, so that the coupler is unable to diffuse out of the emulsion layer in which it is coated. Processes of the *oil-dispersed coupler* type are also sometimes loosely called 'substantive processes', although the couplers are not, themselves, anchored to the gelatin.

Colour processing

We have already encountered a number of processing steps which are used in colour processing. Before examining the applications of such steps we will summarize the functions of colour processing solutions commonly encountered in colour processes (Table 16.4).

The major differences between the processing of conventional black-and-white and of colour tripack films arise because of the need in the latter case to generate precisely the required amounts of the image dyes in all three layers. If this is not achieved, objectionable colour effects can occur: they may be largely independent of density level, resulting in a uniform colour cast over most of the tone scale, or density-dependent, showing a change in colour balance with density level. The former case corresponds to a speed imbalance of the three layers and is illustrated in Figure 16.23(b), while the latter corresponds to a contrast mismatch and is illustrated in Figure 16.23(c).

The processing conditions under which a colour film will give correct values of speed and contrast for all the emulsion layers are very limited and are generally specified closely by the film manufacturer. The specifications usually include processing times and temperatures, as well as the method and timing of agitation in processing solutions. In addition, such factors as rate of flow of wash water may also be specified. It is important to realize that any departure from the exact processing specifications laid down by the film manufacturer is likely to lead to a lower-quality result.

Where manufacturers suggest process variations in order to modify a property (speed for instance) there is often a penalty in terms of some other property such as graininess.

We will now consider how solutions of the types shown in Table 16.4 are used in colour processes. We shall start by examining colour-reversal processing.

Reversal process

As already described, there are two main types of chromogenic colour reversal process, the

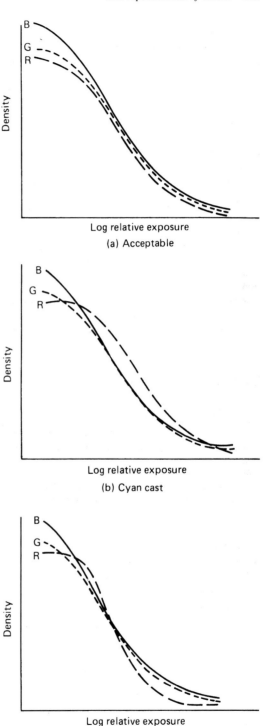

Figure 16.23 Characteristic curves of colour-reversal films

developer-soluble coupler type and the type with couplers incorporated in the emulsions. The Kodachrome process is of the former (non-substantive) type, the couplers being present in the colour developer solutions. It is illustrated schematically in Plate 12. The first step is black-and-white development in which silver halide crystals bearing a latent image are developed to metallic silver – a black-and-white negative image. It is then necessary to form the required dye images by colour development of the residual silver halide crystals.

In order to develop cyan dye where red-sensitive crystals were *not* rendered developable by the camera exposure, all that is needed is to expose the film fully to red light, and to develop the fogged red-sensitive grains in a cyan-forming developer. The exposure is most efficient when unscreened by developed silver, and is therefore made through the back of the film to avoid screening by the upper two emulsion layers. The blue-sensitive layer is then exposed to blue light through the front of the film and developed in a yellow-forming developer. The green-sensitive layer may then be fogged by an intense white or green exposure, but in practice it is often preferable to use a chemical fogging agent in the magenta colour developer. In either case the remaining silver halide crystals are developed to yield a magenta dye.

At this stage in the process there are three positive dye images together with silver resulting from the complete development of the silver halide emulsions. The developed silver is quite dense and would make viewing of the dye images impractical. The silver has to be removed by a bleach bath followed by a fix. A bleach solution forms silver salts from the developed metallic silver. Any yellow filter layer is also usually discharged during bleaching. The silver salts formed are then removed by a fixing stage, leaving only the required dye images present in the gelatin.

In addition to the processing steps outlined there are likely to be intermediate rinses and washes and other baths for special purposes. The apparent simplicity of putting soluble couplers in colour developers is thus offset by the complexity of such a non-substantive process, which effectively prohibits user-processing.

Reversal films incorporating couplers in the emulsion are simpler to process, and in many cases may be processed by the user. Such a reversal process is shown in Plate 13, and commences with black-and-white development. After the first development the film is fogged with white light before colour development, or chemically before (or in) the colour developer. The fogged silver halide grains are colour-developed to yield positive dye images together with metallic silver. The appropriate dye colours are ensured by the location of the yellow-forming coupler only within the blue-recording layer, the magenta-forming coupler only within the green-recording

Table 16.5 A variant of the Kodak E-6 process for colour-reversal film

Step	Temp. (°C)	Time (min)	Total time (min)
1 Developer	38 ± 0.3	6–7	6–7
2 Wash in running water	38 ± 1.0	2	8–9
3 Reversal bath	38 ± 1.0	2	10–11
4 Colour developer	38 ± 1.0	4	14–15
5 Pre Bleach	35–40	2	16–17
6 Bleach	35–40	6	22–23
7 Fix	35–40	4	26–27
8 Wash in running water	35–40	4	30–31
9 Rinse	ambient	1.0	31–32
10 Dry	20–60		

layer, and the cyan-forming coupler only within the red-recording layer. Bleaching and fixing are then carried out in order to leave only the image dyes in the gelatin layers.

An example of a Kodak reversal processing procedure, the industry standard E6 process, is included as an illustration (Table 16.5). The colour couplers are present as oil dispersions within the emulsions of most modern reversal films.

The processing details given in Table 16.5 are for the standard E-6 process designed for correctly exposed reversal film. It is possible to make a limited correction for non-standard exposure by adjusting the first development time. Recommendations for the first development time of many films are:

2 stops under-exposed	11.5 min at 38°C ± 0.3°C
1 stop under-exposed	8 min
1 stop over-exposed	4 min

Steps 1 to 3 take place in total darkness, the remaining steps in normal room light. Recommendations for timings vary according to the type of processing equipment employed.

Manipulations of first development usually involve the sacrifice of some quality and should be used only as an emergency measure, unless the known sacrifice of quality is tolerable.

Negative–positive process

The negative–positive process is analogous to the conventional black-and-white process in that a negative record is made by camera exposure followed by processing. This record is not generally intended for viewing but is used to produce a usable positive by contact or projection printing on a colour-print material. Since information about the blue, green and red light content of the camera image is to be available at the printing stage it is customary to use

the blue-, green- and red-sensitive layers of the colour-negative film to generate yellow, magenta and cyan image dyes respectively. Metallic silver is of course generated at the same time, and is removed by subsequent bleaching and fixing operations. The remaining dye images form the colour-negative record, the colours formed being complementary to those of the subject of the photograph. The production of a colour-negative record is illustrated in Plate 14(a). If integral masking is employed in the colour negative, then low-contrast positive masks are formed at the development stage if coloured couplers are used.

The colour negative is then the subject of the printing stage. In principle, the negative is printed on to a second integral tripack which is processed in similar fashion to a colour negative. The production of a positive print is shown in Plate 14(b) as the preparation of a reproduction of the subject of the negative exposure. Certain differences of construction are shown in the positive. Printing papers and some print films employ red- and green-sensitive emulsions whose natural blue sensitivity is low and largely confined to wavelengths shorter than about 420 nm, a region normally filtered out in colour printing. Consequently no yellow filter layer is required to suppress unwanted blue sensitivity and the order of layers can be selected on the basis of other criteria. It is found to be advantageous to form the image that is the most critical in determining print sharpness in the topmost layer. In most cases the cyan and magenta images are crucial for sharpness and the red-sensitive emulsion is coated uppermost, so that the red image is least affected by emulsion turbidity at exposure.

Colour-print materials have characteristic curves similar to those of black-and-white print materials, as the tone-reproduction requirements are quite similar. Thus, the colour-negative film may have characteristic curves similar to those shown in Figure 16.24(a). Curves for a motion-picture release positive film are shown in Figure 16.24(b) and for a typical printing paper in Figure 16.24(c). The negative illustrated is masked giving an overall colour cast, and this results in vertical displacements of the blue- and green-filter density curves, compared with the red curve.

The higher blue and green densities of colour negatives are compensated by manufacturing colour print materials with blue and green sensitivities correspondingly higher than the red sensitivity. The printing operation allows manipulation of the overall colour of the reproduction by modification of the quantities of blue, green and red light allowed to reach the print material from the negative. This may be achieved by separate additive exposures through blue, green and red filters ('tricolour printing'), or by making a single exposure through appropriate dilute subtractive filters, yellow, magenta or cyan ('white-light printing'). This control of colour balance being

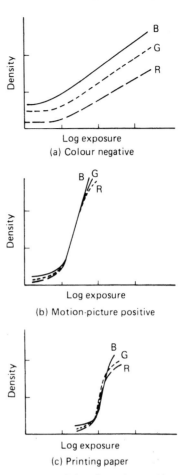

Figure 16.24 Characteristics of negative–positive colour materials

easy to achieve, it is not so important that negative and print materials should possess standard speed balances as that reversal materials should. Little or no colour correction of a reversal transparency is usually possible after the taking stage, whereas in the negative–positive process adjustment of colour balance at the printing stage is a usual procedure.

Typical colour-negative and colour-paper processes are shown in Tables 16.6 and 16.7.

Colour paper processes normally require only two or three solutions with the necessary washes. It is quick and simple, using a bleach-fix, or *blix*, solution and operating at a comparatively high temperature.

In Table 16.6, steps 1 and 2 take place in the dark, the remainder in the light. Agitation procedures suitable for the process are specified in instructions packed with the processing chemicals. Unlike the E-6 reversal process, recommendations are not normally made for modification of development time to compensate for exposure errors.

Table 16.6 A current version of the Kodak C-41 process for colour negative

Step	Temp. (°C)	Time (min)	Total time (min)
1 Developer	37.8 ± 0.15	3¼	3¼
2 Bleach III	24–41	6½	9¾
3 Wash in running water	24–41	3¼	13
4 Fixer	24–41	6½	19½
5 Wash in running water	24–41	3¼	22¾
6 Stabilizer III	24–41	1½	24¼
7 Dry	24–43	10–20	

In Table 16.7, steps 1 and 2 take place in the dark or specified safelighting, the remaining steps in normal room light.

Silver-dye-bleach process

The processes considered so far have relied on the formation of image dyes by colour development within the emulsions. There are, however, alternative approaches: one of these is to destroy dyes introduced into the emulsions at manufacture. In such processes the red exposure is arranged to lead to the destruction of cyan dye; the green exposure leads to the destruction of a magenta dye; and blue exposure leads to the destruction of a yellow dye.

Commercial processes of this type have used the silver photographic image to bring about the chemical decomposition of dyes present in the emulsion layers. A current process which uses this mechanism is *Ilfochrome,* a process for the production of positive prints from positive transparencies. In systems of this type, the print material is an integral tripack and is constructed as shown in Plate 15. The uppermost, blue-sensitive emulsion contains a yellow dye; the green-sensitive layer contains a magenta dye; and the red-sensitive layer contains a cyan dye.

Because of the high optical density of the dyes present in the emulsions, together with emulsion desensitization by some of the dyes, it is necessary to use high-speed emulsions in order to achieve short printing exposures.

The processing of modern silver-dye-bleach materials follows the scheme illustrated in Plate 16. The initial step is the black-and-white development of silver halide crystals rendered developable by the printing exposure. The silver image is then used to reduce the dyes present in the emulsions. This reaction may be summarized:

Dye + acid + metallic silver →
reduced dye fragments + silver salts

It is arranged that the fragments resulting from the reduction of the dyes are colourless and/or soluble. Thus in the silver-dye-bleach bath we have image-wise reduction of the dyes by metallic silver, and corresponding oxidation of the silver. The reaction is extremely slow (owing mostly to the immobility of the reacting species), and a catalyst is necessary to obtain a satisfactory rate of bleaching. The catalyst is usually incorporated in the silver-dye bleach, or it may be carried over from solution in the black-and-white developer, within the emulsion layers.

In Table 16.8, steps 1 and 2 take place in darkness, the remainder can be in normal lighting.

Following the silver dye-bleach, unwanted silver salts are removed in a fixing bath. In some processes this fixer may be preceded by a silver bleach to rehalogenize silver image not oxidized by the dye-bleach. In the process listed in Table 16.8 this second bleach does not appear and there are no intermediate washes, but at least two cascade washes

Table 16.7 The Kodak RA4 process for negative colour papers

Step	Temp. (°C)	Time (sec)	Total time (min)
1 Developer	35.0	45	¾
2 Bleach-fix	35 ± 3.0	45	1½
3 Wash in running water	30–40	90	3
4 Dry	not above 96		

Table 16.8 A silver-dye-bleach process for Ilfochrome Rapid papers, Process P4

Step	Temp. (°C)	Time (sec)	Total time (sec)
1 Developer	39 ± 0.5	35	35
2 Bleach	39 ± 0.5	35	70
3 Fixer	39 ± 0.5	35	105
4 Wash 1	36 ± 3	35	140
5 Wash 2	36 ± 3	35	175
6 Drying	50 ± 1		

are recommended to follow the fixing stage. The final result is the positive dye record retained within the gelatine, as shown in Plate 16.

Major advantages claimed for the silver-dye-bleach process follow from the freedom to use compounds classed as *azo dyes*. These can possess better spectral properties than the dyes formed by chromogenic development, and are markedly less fugitive to light. The better spectral properties improve the saturation and lightness of image colours, while the improved light-fastness gives a much greater life for displayed prints. A further advantage is that the presence of the image dyes at exposure results in a decreased path length of light scattered within the emulsions. This improves the sharpness of the image to such an extent that it is higher than for any comparable chromogenic reflection print material. The sharpness is also improved by the use of low silver halide coating weights, made possible by the very high spectral absorptions of the azo dyes. Very little dye therefore has to be bleached, and thus very little developed silver is required.

The basic structure described above for silver-dye-bleach materials has been improved over time. It has in fact been common practice to use an inerlayer between red- and green-sensitive emulsions in order to prevent the bleaching of an image dye due to the presence of developed silver in an adjacent emulsion layer. In addition, each emulsion layer can be a double-coated assembly comprising a fast component containing little or no image dye and a slow component which contains all the necessary image dye complementary in hue to the sensitivity of the layer. There is no need for an interlayer between the two component emulsion layers, as the silver image in the fast emulsion is to bleach the dye in the adjacent slow emulsion. This structure has been found to lead to a number of advantages in terms of emulsion speed, contrast and image sharpness. The structure is illustrated in Plate 17, and shows a yellow filter layer.

In addition, silver-dye-bleach materials have been 'masked' in various ways. Clearly, silver-dye-bleach print materials, whether viewed by transmission or reflection, cannot be masked in a similar way to colour negatives: whites have to be as light and neutral as possible. On the other hand, some form of inter-image effect can be used without adding to the minimum density, and this, in essence, is what has been done in silver-dye-bleach materials.

In one such masking system the filter layer contains colloidal silver, i.e. very finely divided silver particles which are yellow in hue, and is an active player in promoting a favourable inter-image effect. The material is so formulated that, in correct processing conditions, *physical* development takes place *in the filter layer* due to the presence of the colloidal silver, but not in the vicinity of images developed in the green- or red-sensitive emulsions.

The physically developed silver is bleached by the silver-dye-bleach and this gives rise to bleaching of the adjacent yellow image dye in the blue-sensitive layer. Hence, wherever there is a significant amount of magenta or cyan dye in the image, there will be a corresponding reduction in the amount of yellow dye present. The yellow dye image will be at a maximum where there is no magenta or cyan present. The similarity between this and the masking of a negative film gives rise to 'masking' being used to describe the mechanism. A substantial degree of colour correction can be achieved, but without an increase in minimum density.

More recent silver-dye-bleach materials include a direct positive masking emulsion layer which possesses sensitivity to red and green light. A recent structure, published for Ilfochrome Rapid low-contrast products, is shown in Plate 18. The masking layer is shown between the yellow filter layer and the lower of the double coated blue-sensitive emulsion layers. The masking layer gives a positive record in the black-and-white developer which will yield a negative yellow image by bleaching the adjacent yellow dye in the lower of the blue-sensitive emulsions during the bleach stage. This means that the yellow image so formed will run counter to the unwanted blue absorptions of magenta and cyan images, with a substantial degree of colour correction being achieved and no inevitable increase in minimum density.

Instant colour processes

Polacolor

A number of systems using chemical processes initiated within the camera have been designed to give 'instant pictures'. Although the chemical reactions yielding the colour images usually progress to completion in a few minutes in the hand of the photographer, such systems are often called *in-camera processes*. The first instant-picture colour process was the Polacolor system, introduced in 1963. Polacolor prints were obtained by pressing the shutter release and pulling a film and print sandwich from the camera. About one minute later the film and print were peeled apart, and the unwanted film was discarded. A later development, SX-70 film and its associated special camera, were revealed in 1972, and in this system no discard was required, as the entire process used only a single integral sheet of material for both exposure and subsequent colour image formation. Both 'peel apart' and 'integral' variants of the Polacolor process have continued but with separate applications. The apparently less convenient 'peel apart' variant is, for example, suitable for and widely applied in professional studio use.

Both of the Polacolor processes rely on the development of a silver image to modify the mobility of suitable image dyes which are released to diffuse into an image-receiving layer.

In the 1963 Polacolor process, a negative film of three light-sensitive assemblies is coated in the conventional order with the red-sensitive emulsion next to the base, and the blue-sensitive emulsion farthest from the support. Each light-sensitive assembly consists of two layers, one of which contains a silver-halide emulsion of appropriate sensitivity while the other, nearer the film base, contains a compound called by Polaroid a *dye-developer*, which has a molecular structure comprising a black-and-white developing agent chemically linked by an inert chain-like structure to a dye. There is a large choice of dye structures offering potential advantages in colour reproduction compared with chromogenic processes. The construction of a Polacolor red-sensitive assembly is shown in Plate 19.

After exposure, the Polacolor film is processed to yield a positive colour reflection record. To achieve this, the film is pulled, together with a receiving material, between pressure rollers. The pressure rollers rupture a pod attached to the receiving layer, and this releases a viscous alkali solution which is spread between the negative film and the positive receiving layer.

The alkali solution penetrates the negative emulsions and activates the dye-developer molecules, rendering them soluble and thus mobile. The dye-developer molecules are very active developing agents in alkaline solution, and on development taking place are once more rendered immobile. Dye-developer molecules which diffuse out of an emulsion-developer layer combination have to pass through a spacer, or timing, layer. They are thus delayed so that by the time they reach another emulsion layer, development of that layer has taken place and they are unlikely to encounter developable silver halide. Under these circumstances the dye-developer molecules are free to diffuse out of the negative material and into the receiving material. The structure of the dye-developer molecules does not in fact allow them to diffuse very quickly through the emulsion layers. In order to speed up development, much smaller and more mobile molecules of a 'messenger' developing agent may be used. These diffuse rapidly and develop the exposed silver halide crystals. Dye-developer then regenerates the oxidized messenger developing agent, becoming oxidized itself in the process. The receiving material acts as a sink for dye-developer molecules and this encourages diffusion into the receiving layer. The structure of the receiving layer is shown in Figure 16.25 and the diffusion stage is shown in Plate 20.

Dye-developer molecules entering the receiving layer encounter a mordant which immobilizes the dye part of the molecule and thus anchors the entire

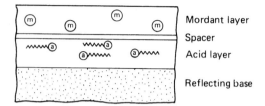

Figure 16.25 Polacolor receiving material

molecule. The alkali present in the processing solution diffuses slowly through the spacer layer in the receiving material and reaches the layer which contains large immobile organic acid molecules. The alkali is neutralized by the acid with the evolution of water, which swells the spacer layer and assists further penetration by alkali to the acid layer and consequent neutralization. After about one minute the reactions are completed, the reflection positive is peeled off the residual negative and is suitable for viewing. The positive image is illustrated in Plate 21.

The elegance and ingenuity of the process lie in the carrying out of the processing within the material, and in leaving behind in the discarded negative unwanted silver and dye-developer. Note that any emulsion fog results in a lowering of the dye density in the positive; the stain is not increased.

The Polacolor SX-70 process, introduced in 1972, used the mechanisms on which the original process was based. The image-receiving material was, however, part of the same assembly as the light-sensitive emulsions and the associated dye-developer layers.

Processing of such materials is initiated, as in the earlier material, by the rupture of a pod. The contents of the pod are injected into the composite assembly between the emulsion and image-receiving layers. The structure of the material and the solution injection are shown diagrammatically in Plate 22, which is not drawn to scale.

It will be seen that the material consists of a large number of layers comprising the dye-releasing light-sensitive elements and an image-receiving assembly. These components are not unlike those of the earlier Polacolor materials, though certain improvements in detail have been made. The major structural difference is that the entire stack of layers is contained between two relatively thick outer layers. One of these is transparent; the exposure is made, and the image viewed, through this layer. The other is the opaque backing to the material. The processing solution is contained within a wide margin to the picture area and is injected into the picture area when the film is expelled from the camera after exposure.

The processing solution consists primarily of a strong alkali containing a dispersion of the white pigment titanium dioxide and certain dyes which are

highly coloured in alkaline solution. The alkali present activates and mobilizes the dye-developers in the dye-releasing assembly and a messenger developing agent coated in the anti-abrasion layer of the negative. The titanium dioxide remains at the site of injection, between the blue-sensitive emulsion and the image-receiving layer, forming a white background to the received image viewed through the transparent plastic front sheet. The protecting dyes present absorb so much light that effectively none penetrates to the emulsion layers; this gives rise to the figurative description of the dyes as a 'chemical darkroom'.

As the process continues, the dye image is released from the emulsion assembly, diffuses through the white titanium dioxide and is immobilized in the image-receiving layer just as in the original Polacolor process. This continues until the alkaline solution penetrates the spacer or *timing layer* between the dye-receiving and polymeric acid layers present immediately beneath the transparent outer sheet. As in the earlier material, penetration of the timing layer leads to a rapid neutralization of the alkali present but this, in the SX-70 film, additionally causes decoloration of the protective dyes present and, ultimately, the colour image is seen against the white titanium dioxide background.

The dye-developers incorporated in the SX-70 material are of an improved type, using complex compounds of dyes with certain metals, notably copper and chromium. Such metal complexes have greater stability than similar uncomplexed dyes and yield images that possess good light-fastness. The complexes used are termed 'metallized dyes' by Polaroid. A number of improvements have been made to both the peel apart and integral types of Polaroid materials since their introduction. Among other changes, the technical literature has suggested that metallized image dyes are used in both variants and that an alternative dye releasing technology may have been adopted for at least one of the image dyes.

Alternative method for instant photography

An alternative approach to instant picture production was adopted by Eastman Kodak, who combined a number of novel features in a process unveiled in the spring of 1976. New immobile compounds were devised, which were derivatives of developing agents which, on oxidation, undergo a reaction that releases a chemically bound image dye. The image dyes themselves were selected from the class of *azo dyes*, potentially giving better colour reproduction than conventional photographic image dyes. The final major innovation was the use of emulsions, which, on

development, yielded positive silver images as opposed to the customary negative images. A similar mechanism is used in the Ilfochrome Rapid masking system described briefly above.

On exposure the direct-positive emulsions develop in areas unaffected by light and, in so doing, release image dyes that diffuse to the image-receiving layer, where there is a mordant to immobilize them. The dye image is located between a white opaque layer and a transparent film through which it is viewed. In the meantime the alkaline activator penetrates a timing layer to reach a polymeric acid which neutralizes the alkali and terminates the processing stage.

As with Polacolor, neutralization of the alkaline solution is achieved by the eventual penetration of the solution through a timing layer to an acid. Kodak termed the principle underlying these processes *redox dye release*, indicating that dye release follows an oxidation/reduction reaction. Systems of dye release by oxidation have also been used in Fuji instant camera films and in the photothermographic Pictrography process. Dye release by reduction has been employed by Agfa-Gevaert in processes designed for the production of enlarged prints from transparencies. Fuji has also used reactions of this type in colour-print processes. Polaroid themselves have also made use of a different dye release system, compatible with the dye-developer environment, so that dye release is used in the yellow-releasing layer in a number of Polaroid instant print films, while typical magenta and cyan dye-developers provide the other two image dyes.

The final instant process we shall consider is that used by Polaroid in instant additive-colour transparency products. These include Polavision instant motion-picture film and Polachrome 35 mm instant colour-slide film. We shall confine our attention to the latter product, which utilizes the structure shown in Plate 23. The polyester film base carries the réseau described in Chapter 14; above this is a layer to protect it from damage. The next layer above contains nuclei for physical development, and receives the positive image during processing. Above the image-receiving layer is a further protective layer, and a separable release layer to enable the upper layers, i.e. the emulsion and anti-halation layers, to be stripped off after processing.

Exposure is made through the base, and the red, green and blue contents of the input light are analysed by the réseau and the panchromatic emulsion. As an example, exposure to green light results in a negative silver record only behind the green filter, and this is achieved by development in a solvent developer in a simple processing machine. Where this image is not developed, silver-halide solvents present in the processing solution dissolve the undeveloped crystals forming a physical developer. Physical development then deposits silver on nuclei in the image-receiving

layer, forming a positive image of high covering power. This image is confined to the areas behind filters that did not transmit the incoming light, and is thus a positive. In this case, with heavy green exposure, the receiving layer has no developed image corresponding to the green filter elements.

After one minute has passed, development is complete and the film is rewound into its original cassette and the unwanted negative emulsion assembly and antihalation layers are peeled away and discarded. The transparencies are then ready for viewing.

Bibliography

Evans, R.M., Hanson, W.T. and Brewer (1953) *Principles of Colour Photography.* Wiley, New York.

Hunt, R.W.G. (1995) *The Reproduction of Colour*, 5th edn. Fountain Press, Kingston-upon-Thames.

James, T.H. (ed.) (1977) *The Theory of the Photographic Process*, 4th edn. Macmillan, New York.

Proudfoot, C.N. (1997) *Handbook of Photographic Science and Engineering,* 2nd edn. IS&T, Springfield, VA

17 Photographic processing

Developers and development

The purpose of development is to form a visible image corresponding to the invisible latent image. It continues the effect of light on the silver halide grain by converting exposed grains to black metallic silver (see Figure 1.1).

> Exposed silver halide + reducing agent → metallic silver + oxidized reducing agent + halide ion

In this process of chemical development each crystal of the emulsion acts as a unit, it is either developable as a whole or is not developable. There is a second type of development in which the silver forming the developed image is derived from a soluble silver salt contained in the developing solution itself. This is called physical development but is not normally used with modern photographic materials. However, some physical development does occur in nearly all developers, because they contain complexing substances which dissolve some of the silver halide and so provide soluble silver compounds in the developer solution. On exposure to light, photographic emulsions form latent images which are mainly on the surfaces of the crystals, as was shown in Chapter 12. With sufficient exposure latent images of a developable size are formed which are called development centres. When a photographic emulsion is immersed in a developing solution the crystals are attacked at these points by the developing agent, and each crystal which has received more than a minimum exposure is rapidly reduced to metallic silver.

Developing agents are members of the class of chemical compounds known as reducing agents. Not all reducing agents may be used as developing agents; only a few are selective and able to distinguish between silver halide crystals that have a latent image and those that do not. For those reducing agents that have been found suitable as developers, the action of the agent on exposed and unexposed (or insufficiently exposed) crystals is distinguished by its rate. It is not that unexposed silver halide crystals do not develop at all, but that exposed crystals develop very much more quickly than unexposed crystals. The latent image acts as a catalyst that accelerates the rate of development, but cannot initiate a reaction that would not occur in its absence. Under normal conditions, the proportion of unexposed crystals developed is quite small, but with very prolonged development practically all the crystals in an emulsion, both exposed and unexposed, will develop. Density resulting from the development of unexposed crystals is called chemical fog.

Composition of a developing solution

Developing agents are not used alone; a developing solution, usually referred to simply as a developer, almost always contains certain other constituents whose presence is essential for the proper functioning of the solution. A developing solution usually comprises the following ingredients.

- *Developing agent (or agents)* to convert the silver halide grains in the emulsion to metallic silver.
- *Preservative* (a) to prevent wasteful oxidation of the developing agent, (b) to prevent discoloration of the used developing solution with consequent risk of staining of negatives and prints and (c) to act as a silver halide solvent in certain fine-grain developer formulae.
- *Alkali* (sometimes termed the *accelerator*) to activate the developing agent and to act as a buffer to maintain the pH or alkalinity at a constant value.
- *Restrainer* to increase the selectivity of the development reaction, i.e. to minimize fog formation by decreasing the rate of development of unexposed grains to a greater extent than that of exposed grains.
- *Miscellaneous additions*: these include wetting agents, water softening agents, solvents for silver halides, anti-swelling agents for tropical processing, development accelerators etc. In addition, there must be a solvent for these ingredients; this is nearly always water.

We shall consider each of these constituents in turn, in detail.

Developing agents

A large number of different substances have been used from time to time as photographic developing agents. Almost all of those in use today are organic compounds. Not all developing agents behave in

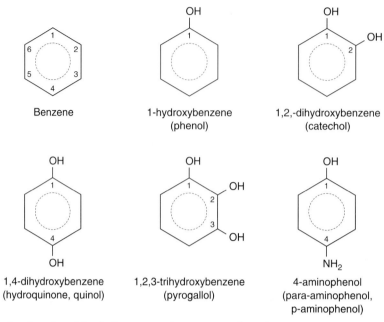

Figure 17.1 Examples of naming of developing agents and some commonly used names

exactly the same way and for certain purposes one agent may be preferred to another. Consequently, a number of different agents are in use for one purpose or another, the characteristics of the more important ones being described below in alphabetical order by their most commonly used name. The naming of organic chemicals follows internationally agreed rules but chemical catalogues and common usage means that there are a number of different names used for the same compound. The naming of the developing agents is indicated in Figure 17.1, which is based on benzene which, when substituted by an –OH group is termed phenol.

Amidol

Amidol (2,4-diaminophenol dihydrochloride), discovered by Andresen in 1891, is a fine white or bluish-white crystalline powder, readily soluble in water. An amidol developer can be made simply by dissolving amidol in a solution of sodium sulphite, without other alkali. Amidol developers should be made up when required, as they have poor keeping qualities. A solution of amidol and sulphite, while not becoming discoloured to any extent, loses much of its developing power within two or three days, though it keeps well if slightly acidified with sodium or potassium metabisulphite. In the dry state, amidol is slowly affected by air and light; it should therefore be kept in dark-brown, well-stoppered bottles. Amidol

developers develop rapidly. They were at one time widely used with papers but are now rarely used.

L-Ascorbic acid

Ascorbic acid, also known as vitamin C, was first patented by Ohle in 1932 as a reducing agent for silver ions. Like hydroquinone, it becomes more active at higher alkalinities. It forms very active superadditive developing solutions in combination with phenidone or metol.

Catechol

Catechol (pyrocatechin pyrocatechol, 1,2-dihydroxybenzene) discovered by Eder and Toth in 1880, is sometimes used to provide tanning developers and warm-tone developers for certain papers. With caustic alkalis it gives rapid development with high contrast, in a similar manner to hydroquinone.

Glycin

Glycin (4-hydroxyphenylaminoacetic acid) is a white crystalline powder, discovered by Bogisch in 1891. It is only slightly soluble in water but freely soluble in alkaline solutions. Glycin developers are non-staining and have exceptionally good keeping properties, but,

unfortunately, they are too slow in action for general use. To obtain as much activity as possible, potassium carbonate is the preferred alkali for glycin developers because it can be used at a greater concentration than sodium carbonate. It is used, in conjunction with other developing agents, in some fine-grain developer formulae of low energy. The action of glycin is considerably restrained by bromide. The non-staining properties of glycin and its very slow oxidation in air make it very suitable for any process in which the sensitive material is exposed to the air during development.

Hydroquinone

Hydroquinone (quinol, 1,4-dihydroxybenzene), whose developing properties were discovered by Abney in 1880, takes the form of fine white crystals, fairly soluble in water. The dry substance should be kept well-stoppered, because it has a tendency to become discoloured. Hydroquinone is used mainly in combination with metol or phenidone, with which it forms superadditive mixtures, or as the single developing agent in traditional lithographic developers.

Metol

Metol (4-methylaminophenol sulphate), introduced by Hauff in 1891, is a white crystalline powder readily soluble in water. Metol developers are characterized by high emulsion speed, low contrast and fine grain. They are valuable when maximum shadow detail is required. Useful low-contrast developers may be made up, using metol, sodium sulphite and sodium carbonate, or simply metol and sodium sulphite alone. In general, however, metol is used in conjunction with a second developing agent, hydroquinone, as a superadditive combination, developers containing the mixture having certain advantages over developers based on either developing agent alone. Metol-hydroquinone developers are usually referred to simply as MQ developers, the letter Q being derived from the name quinol, a synonym for hydroquinone.

Para-aminophenol

Para-aminophenol (4-aminophenol) is a developing substance, first used by Andresen in 1888, which has been widely used for compounding highly concentrated developers. The active agent in these is an alkali salt of 4-aminophenol, produced by the action of sodium hydroxide. The solution is diluted with from 10 to 30 times its volume of water to form the working developer.

Paraphenylenediamine

At one time, many popular fine-grain developers were based on paraphenylenediamine (p-phenylenediamine, 4-aminoaniline, 1,4-diaminobenzene) as the developing agent. Paraphenylenediamine, also discovered by Andresen in 1888, when used alone requires very long development times. To obtain convenient developing times, most paraphenylenediamine developers contain another developing agent, e.g. glycin or metol. Derivatives of 4-aminoaniline form the basis of modern colour developing agents.

Phenidone

Phenidone (1-phenyl-3-pyrazolidone), the developing properties of which were discovered in the Ilford laboratories in 1940, possesses most of the photographic properties of metol together with some unique advantages. It shares with metol the property of activating hydroquinone so that a phenidone–hydroquinone (PQ) mixture forms a useful and very active developer. Used alone, phenidone gives high emulsion speed but low contrast, and has a tendency to fog. Mixed with hydroquinone, however, and with varying concentrations of alkali, phenidone produces a wide range of developers of differing types. The activation of hydroquinone requires a much lower concentration of phenidone than of metol. A detailed comparison of the relative merits of PQ and MQ developers is given later in this chapter.

More stable derivatives of phenidone have been proposed, especially for use in concentrated liquid developers. These include Phenidone Z (1-phenyl-4-methyl-3-pyrazolidone) and dimezone (1-phenyl-4,4-dimethyl-3-pyrazolidone).

Pyrogallol

One of the earliest developing agents first used by Frederick Archer in 1850, pyrogallol (pyro, pyrogallic acid, 1,2,3-trihydroxybenzene) is poisonous and is very soluble in water. The image formed by a pyrogallol developer consists not only of silver but also of brownish developer oxidation products which stain and cross-link (tan) the gelatin. Pyrogallol was formerly used in combination with metol in a developing solution without sulphite, for processing negatives known to be severely under-exposed. It is now seldom if ever used for photographic negatives, but has found an important niche as a developer for reflection holograms, where its staining properties reduce scatter and its cross-linking effect on gelatin minimizes emulsion shrinkage.

Of all the developing agents described above, only phenidone, metol and hydroquinone are in

wide-spread use today for the development of monochrome materials, while analogues of p-phenylenediamine (4-aminoaniline) are widely used for the development of colour materials. All developing agents should be regarded as being potentially hazardous by skin absorption, and rubber gloves should always be worn when preparing or using developing solutions.

Preservatives

Sodium sulphite is commonly used as the preservative in developing solutions, although potassium (or sodium) metabisulphite is sometimes used as an alternative, either by itself or in addition to sulphite. It is available in both crystalline and anhydrous forms. Anhydrous sodium sulphite is a white powder which dissolves readily in water. Sodium sulphite crystals dissolve most easily in water at about 40 °C, giving a weakly alkaline solution (pH approximately 8.5). The pH of a solution is an internationally agreed measure of its acidity or alkalinity, defined as follows:

Every aqueous solution contains hydrogen (H^+) and hydroxyl (OH^-) ions (charged atoms or groups of atoms). In a neutral solution, such as pure water, the two types of ions are present in equal concentrations of 10^{-7} mole per litre. In an acid solution there is an excess of hydrogen ions over hydroxyl ions, and in an alkaline solution an excess of hydroxyl ions over hydrogen ions, but the product of the two concentrations remains at 10^{-14}, as in pure water. The degree of acidity or alkalinity of a solution is related to the relative concentrations of the two ions, and for this purpose the pH scale is used.

$$pH = \log_{10} (1/\text{hydrogen-ion concentration})$$

On this scale, pure water (a neutral solution) has a pH of 7. An acid solution has a pH below 7, and an alkaline solution a pH above 7. The greater the amount by which the pH of a solution differs from 7, the greater is its acidity or alkalinity. It will be appreciated that, since the pH scale is logarithmic, quite small changes in pH may indicate significant changes in the activity of a solution.

One advantage in using potassium metabisulphite in preference to sodium sulphite is that it forms a slightly acidic solution (pH 4–5) which helps to decrease the rate of aerial oxidation in concentrated two-solution developers, i.e. one solution containing the developing agent and preservative and the other containing the alkali. Sodium metabisulphite may be used instead of potassium metabisulphite, the quantity required being 85 per cent of the weight given for the potassium salt.

As mentioned earlier, one of the main functions of the preservative is to prevent wasteful oxidation of the developing agent by air. It is convenient to think of the sulphite as removing the oxygen from the air

dissolved in the solution or at the surface of the solution, before it has time to oxidize the developing agent. This, however, is an over-simplification. The action of the preservative is not simply a matter of preferential reaction between sulphite ions and oxygen; the rate of uptake of oxygen by a solution of sodium sulphite and hydroquinone, for example, is many times smaller than the rate of uptake by either the sulphite or hydroquinone alone.

Sulphite ion also reacts with developer oxidation products and prevents staining of the image by forming soluble and often colourless sulphonates:

> Silver halide + developing agent → oxidized developing agent + metallic silver + halide ion + hydrogen ion (acid)

> Oxidized developing agent + sulphite ion + water → developing agent sulphonate + hydroxyl ion (alkali)

In addition to its function as a preservative and prevention from staining, sulphite ions have a third function. It acts as a solvent for silver halides and so promotes some physical development, which leads to finer-grained images provided that its concentration is sufficiently high.

Alkalis

Almost all developing solutions require an alkali to activate the developing agent. By suitable choice of alkali, the pH of a developing solution can be adjusted to almost any required level, and in this way a range of developers of varying activity can be prepared. One alkali commonly used is sodium carbonate, of which there are three forms available commercially: crystalline or decahydrate, containing 37 per cent of the salt; monohydrate, containing 85 per cent of the salt; and anhydrous or desiccated, containing practically 100 per cent of the salt. The monohydrate has the advantages of being more stable and more easily dissolved than the other forms. One part of the anhydrous may be replaced in formulae by 2.7 parts of the crystalline form or by 1.17 parts of the monohydrate.

In some developer formulae, potassium carbonate is used as the alkali. It is supplied in its anhydrous form and should be kept tightly sealed; if left exposed to the air, it rapidly absorbs water vapour and becomes damp or even semi-liquid. Potassium salts have the advantage of increased solubility, which allows them to be used at a higher concentration.

In the high-sulphite, low-energy class of fine-grain developers, borax (sodium tetraborate) is a common alkali. The use of sodium metaborate as an alkali has been advocated in certain formulae, although identical results are obtained by employing equal parts of sodium hydroxide and borax.

Table 17.1 Some buffering agents and their useful pH ranges

Buffer	pH range
Sodium or potassium hydroxide	above 12.5
Trisodium phosphate/sodium hydroxide	12.0–13.0
Trisodium phosphate/disodium hydrogen phosphate	9.5–12.6
Sodium carbonate/sodium hydroxide, or potassium carbonate/potassium hydroxide	10.5–12.0
Sodium carbonate/sodium bicarbonate, or potassium carbonate/potassium bicarbonate	9.0–11.0
Borax/boric acid	8.0–9.2
Sodium sulphite/sodium metabisulphite, or potassium sulphite/potassium metabisulphite	6.5–8.0

Certain alkaline salts also act as buffers to maintain the pH value constant during the development reaction and on storage or standing of the developer in a processing machine. A solution is said to be buffered when it shows little or no change in pH on the addition of acid or alkali. Water is unbuffered and its pH is greatly affected when only a little acid or alkali is added. Buffering of photographic solutions is commonly achieved by the use of relatively large amounts of a weak acid, e.g. boric acid, and the sodium salt of that acid, e.g. borax (see Table 17.1).

The relative amounts of the buffer components determine the pH value of the solution and their concentrations determine the buffering capacity. For example, a solution containing 21.2 grams per litre of anhydrous sodium carbonate has a pH value of 11.6. So has a solution containing 0.13 grams per litre of sodium hydroxide, but the latter would rapidly become neutralized.

Restrainers (anti-foggants)

Two main types of restrainer are employed, inorganic and organic. The function of a restrainer is to check the development of unexposed silver halide crystals, i.e., to prevent fog. Restrainers also slow down the development of the exposed crystals to a greater or lesser extent and so affect film speed. The effectiveness of a restrainer in minimizing fog, and its effect on film speed, varies from one developing agent to another and also depends on the material being developed and the pH of the developing solution.

Potassium bromide is the most widely used restrainer. Soluble bromide is produced as a by-product of the development process and affects the activity of the developer. Inclusion of bromide in the original developing solution therefore helps to minimize the effect of this release of bromide. For this reason most developer formulae employ bromide as a restrainer, including those that also contain organic restrainers. Developers for papers always include bromide because the smallest amount of fog is objectionable.

Of the several organic substances that have been found suitable for use as restrainers, benzotriazole is widely employed. Organic restrainers are especially valuable in phenidone developers, the activity of most phenidone formulae being such that to prevent fog with high-speed materials the amount of bromide required as restrainer would be so great that there would be a risk of stain, because bromide when present in excess is a mild silver halide solvent. Use of an organic restrainer avoids this risk. A certain amount of bromide is, however, usually included in phenidone formulae to help to keep the activity of the solution constant with use, for the reason already explained.

Organic restrainers are capable of restraining fog without affecting film speed, to a greater extent than inorganic restrainers. For this reason they have come to be widely used as anti-foggants for addition to standard developer formulae whenever there is particular danger of chemical fog or staining. In this role, organic restrainers are commonly used:

- To minimize the risk of fog and staining on material subjected to prolonged development or to development at high temperatures.
- To help to prevent fog or veiling on materials that have been stored under unfavourable conditions or which are of doubtful age.

The use of anti-foggants is particularly valuable with prints, because fog is more objectionable than with negatives. Organic anti-foggants are very potent and must be used with care. Their use in excess may lead to a loss of effective emulsion speed and a reduction in the rate of development.

Miscellaneous additions to developers

Besides the main ingredients – i.e. developing agent(s), alkali, preservative, restrainer – a developing solution sometimes contains other components for specific purposes. These may include wetting

agents, silver halide solvents, anti-swelling agents for high temperature processing, calcium-sequestering agents (water softening agents) and development accelerators.

The presence of calcium salts in tap water causes a calcium sludge to be precipitated by the sulphite and carbonate in the developer. This may cause a chalky deposit to appear on films and plates on drying. This scum is most likely with developers with a high sulphite content and low pH, e.g. MQ-borax formulae, especially if hard water is used. Calcium scum may be removed by bathing negatives in a 2 per cent acetic acid solution after washing, and then briefly rinsing them.

Calcium sequestering agents are often included in developers to prevent scum from forming by converting the calcium salts into soluble complexes which cannot be precipitated by the sulphite and carbonate in the developer. Sodium hexametaphosphate (Calgon) is commonly used for this purpose. A suitable concentration in most circumstances is about 3 grams per litre. This should be added to the water before the other developer constituents. EDTA (ethylenediaminetetra-acetic acid) is used also as a sequestering agent in developers but suffers from some disadvantages, although it is an efficient sequestering or complexing agent for calcium ions. In the presence of trace amounts of copper or iron ions it catalyses or speeds up the rate of aerial oxidation of developing agents. Also EDTA is able to form complexes with silver ions that may cause dichroic fog due to physical development.

Some developers also contain development accelerators, which increase the rate of development independently of the alkali (which is also sometimes called an 'accelerator'). Examples of these compounds include cationic (positively charged) wetting agents such as cetyl pyridinium bromide, organic amines, e.g. ethylenediamine, non-ionic polymers, e.g. polyethylene glycols, and urea in extremely small quantities).

Superadditivity (synergesis)

Many combinations of two developing agents have been found to have a far greater effect than the sum of their individual effects. This phenomenon is called superadditivity or synergesis. Figure 17.2 illustrates this phenomenon for metol and hydroquinone developing agents.

If a film is developed in an MQ-carbonate developer for the recommended time an image of normal contrast showing both highlight and shadow detail is obtained. If, however, the film is developed in the same basic developer formulation for the same time but omitting metol, only a trace of the brightest highlights are recorded. If the film is developed for

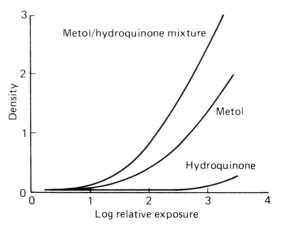

Figure 17.2 Superadditivity in a metol-hydroquinone developer

the same time in the developer, omitting hydroquinone, an image is obtained that contains both highlight and shadow detail but is somewhat lacking in contrast. It is clear from these experiments that a developer containing both metol and hydroquinone produces a photographic effect that is greater than would be expected from a mere addition of the effects of metol and hydroquinone.

The mechanism of superadditivity may be explained as follows. Metol, or the primary developing agent, is adsorbed to the silver-halide crystal surface, where it reduces a silver ion to metallic silver. In doing so it becomes oxidized and the oxidation product remains adsorbed to the developing grain. Hydroquinone, or the secondary developing agent, then reduces the primary developing agent oxidation product and so regenerates the primary developing agent at the grain surface. The secondary developing agent is oxidized and its oxidation product is removed by reaction with sulphite. This cycle repeats itself until that grain is fully developed. Thus superadditivity involves a regeneration mechanism in which a constant supply of active primary developing agent is maintained at the surface of the developing grain. The efficiency of the development reaction is far greater in superadditive developers than in developers containing single developing agents where fresh developing agent has to diffuse to the grain surface and the oxidation product has to diffuse away, react with sulphite and be replaced by the diffusion of more developing agent. By varying the ratio of hydroquinone to metol it is possible to formulate developers that give any desired contrast.

Phenidone also forms a superadditive system with hydroquinone as metol does, but it is much more efficient than metol. Whereas a given weight of hydroquinone requires about one quarter of its weight of metol to activate it, it needs only a fortieth part of

its weight of phenidone. This means that a PQ developer is cheaper than its MQ equivalent, and highly concentrated liquids can be produced with a PQ system with less risk of the developing agents precipitating out. For a given pH, a PQ developer is slightly more active than its MQ equivalent. Therefore, to obtain the same activity as its MQ counterpart, a PQ developer can work at a slightly lower pH, giving better keeping properties in use and a longer shelf life.

With the MQ system the hydroquinone regenerates the metol. This process, however, has a low efficiency because some of the metol is lost by conversion to an inactive monosulphonate. In PQ developers, the regeneration of the primary oxidation product of phenidone appears to be much more efficient and is not accompanied by any phenidone sulphonation. This results in a longer working life. It also simplifies the control of replenished PQ developers, since only a small fixed allowance need be made for the loss of phenidone. Bromide ion has less of a restraining action on PQ developers than on MQ ones, especially at a low pH. Metol, particularly at high pH, tends to become hydrolysed to form methylamine, giving rise to an unpleasant fishy odour, whereas phenidone does not.

Monochrome developer formulae in general use

Many thousands of different developer formulae have been published and a great number of different formulae are still in general use. Nevertheless, the basic types of formulae in use today are relatively few in number. Unfortunately, there is no generally agreed method of classifying developer formulae. At one time developers were classified according to the developing agents they contained; this terminology persists to a limited extent. Thus, developers are still termed MQ and PQ for metol-hydroquinone and phenidone-hydroquinone respectively.

Developers are also classified according to their action (fine-grain, low-contrast, high-contrast, acutance etc.) or according to the materials for which they have been formulated (print, colour-negative, X-ray, lithographic, etc). In addition to this confusing and overlapping terminology, developers are also known by a number of trade names or code numbers. Kodak: D-76, HC-110, Microdol-X, Technidol LC; Ilford: ID-11, Ilfotec HL, Ilfosol-S, Microphen, Perceptol; Agfa: Atomal FF, Refinal, Rodinal, Studional Liquid; Fuji: Fujidol. All are trade names of some representative developers from manufacturers of sensitized products. There are also many other named developers from specialist manufacturers of processing chemicals who provide developers for processing a wide variety of films.

For convenience, developer formulae may be classified into various types which combine the type of developer, its action and the material for which it has been designed, thus avoiding the use of uninformative trade names.

- *Universal:* Suitable for developing all types of materials such as roll film, sheet film, 35 mm film, papers. However, although such developers are very convenient because of their universality, it is better to select a developer that is specially formulated for the material concerned.
- *Fine-grain:* For yielding negatives such that graininess is optimized in the prints. These are particularly suited for the development of 35 mm films which may require a high degree of enlargement.
- *Low-contrast:* Designed to give negatives of very low contrast, either for recording scenes of exceptionally high contrast, or for developing films which are inherently high in contrast to give negatives that can be printed with a full range of tones.
- *High-contrast:* For developing line, X-ray, aerial films, i.e. where it is necessary to produce a contrast that is higher than normal.
- *Extreme-contrast:* Also termed 'lithographic'. Developers formulated for use with lithographic films, to give the extreme contrast as required in the production of line and half-tone screen images for photomechanical work.
- *Acutance (high-definition):* Specially formulated for maximizing edge effects for increased image definition.
- *Paper or print:* Specially formulated for developing prints in dishes or for machine-processing of prints.
- *Colour (chromogenic):* Colour-negative developers used for the development of monochrome films that have dye images rather than images of metallic silver (Ilford XP-2).
- *Concentrated:* For one-shot use. The highly concentrated developer is diluted by a large amount, used once only and then discarded.

The most widely used developers are based on mixtures of metol and hydroquinone (MQ), and phenidone and hydroquinone (PQ). Although other combinations of developing agents are used, for general photography nothing has been found to equal MQ and PQ mixtures in all-round efficiency and flexibility.

Fine-grain developers

All photographic images have a granular structure. Although this structure is not normally visible to the unaided eye it may become so on enlargement, especially at high magnifications. The tendency to use smaller negative sizes aroused early interest in the

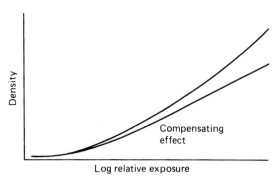

Figure 17.3 Hypothetical example of compensation in development

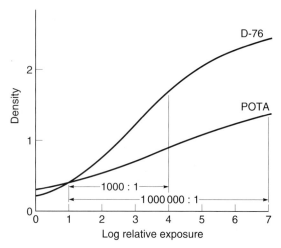

Figure 17.4 Low-contrast development

possibility of obtaining a less grainy image than normally provided by conventional developers. As a result, special fine-grain and extra-fine-grain developers have evolved. These developers achieve the desired result in several ways. First of all, they are usually low-contrast, as this minimizes clumping of the silver grains: with active development silver filaments formed from an exposed grain may come into contact with neighbouring grains and make them developable. Some formulae actually produce smaller individual grains, though this tends to result in reduced emulsion speed.

Most fine-grain developers yield negatives of comparatively low contrast due in part to a compensating effect in which developer in the highlight areas of the negative becomes exhausted and effectively gives less development in the more dense areas of the negative than would be obtained in the absence of any compensating effect (see Figure 17.3).

Although a reduction in contrast serves to minimize the graininess of the negative, it is doubtful whether it contributes significantly to a reduction in the graininess of the final print. Any reduction in graininess achieved by lowering the contrast of the negative is likely to be offset to a large extent by the increased contrast of a higher contrast paper required to print it. Fine-grain developers act to some extent by processes involving physical development. This has the effect of inhibiting the filamentary growth of silver that occurs in normal chemical development, and thus minimizes clumping. The penalty is the total loss into solution of a proportion of the silver halide, and a corresponding fall in effective emulsion speed. However, the most important condition for obtaining negatives of low granularity is to select a material of inherently small grain size

Low-contrast developers

The original application of low-contrast developers was for recording scenes of exceptionally high contrast. More recently these developers were revived for developing films such as Kodak Technical Pan Film which is an ultra fine-grain film of inherently high contrast. Low-contrast developers are based on solutions of single developing agents and are very simple formulae. For example, the developer POTA, recommended for the above material, is a solution of phenidone (1.5 g) and sodium sulphite (30 g) in one litre of water. No other chemicals are used. An earlier low-contrast developer is Kodak D-23, which consists of metol (7.5 g) and sodium sulphite (100 g) in one litre of water. An advantage of POTA is that it gives low contrast without loss in film speed. This is shown in Figure 17.4, in which the action of POTA is compared for the same film with that of a conventional fine-grain developer (D-76). POTA is able to record scenes with an arithmetical contrast of 1 000 000:1, whereas with D-76 the curve begins to level off at much lower log relative exposure values and so is unable to record adequate detail beyond a ratio of about 1000:1.

High definition developers

High definition or high acutance developers are solutions that enhance the contrast of edges and fine detail in the negative to give increased definition to photographic images, although the resolving power of the emulsion may not be any higher than normal. This is achieved by the use of a formula containing low concentrations of developing agent, sulphite and bromide and a high pH. This promotes the production of adjacency effects shown in Figure 17.5.

Development results in the production of soluble bromide and oxidation products which are liberated in proportion to the amount of silver developed.

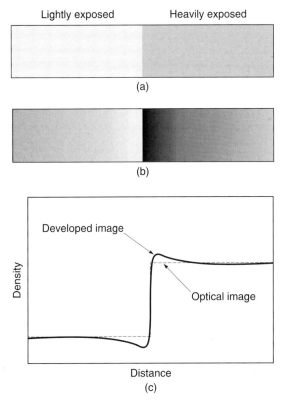

Lightly exposed Heavily exposed

(a)

(b)

(c)

Figure 17.5 Adjacency (edge) effect: (a) exposed photographic layer, (b) developed image, (c) microdensitometer trace across boundary of developed edge

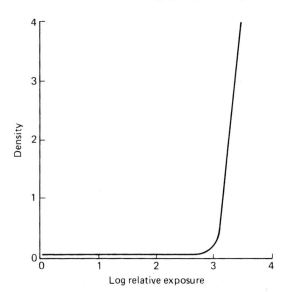

Figure 17.6 Lithographic development

These diffuse across the boundary between heavily exposed areas to the adjacent lightly exposed areas where they inhibit development and a reduction in density takes place. Whilst in the immediately adjacent heavily exposed areas fresh active developer diffuses in, due to the concentration gradient created, and the density is enhanced.

This increase in microcontrast across the boundary between the two areas can sometimes be seen as a dark line within the edge of the heavily exposed area and light line within the lightly exposed area. These are known as *Mackie lines*. Other manifestations of edge effects include the *Eberhard* and *Kostinsky* effects, which affect the density and position of small dots or lines in images which can be a problem in applications such as astronomy.

High definition developers may increase emulsion speed by a factor of one stop or more, but they also increase graininess. They are, therefore, generally recommended for use only with fine-grain (i.e. slow- or medium-speed) emulsions. Because of their low concentration of developing agents, most high-definition developers should be made up only when

required for use and used once only. Enhanced adjacency effects may be obtained in MQ-borax and other soft-working fine-grain developers by using them at greater dilutions, e.g. by diluting the stock solution 1 + 1 or 1 + 3, and increasing the developing time by the appropriate amount.

Extreme-contrast (lithographic) developers

Lithographic development has a characteristic curve showing very low fog, very high contrast and a very sharp toe (see Figure 17.6). It results from a combination of special lithographic emulsions and developers. This lith effect (Figure 17.6) is not given by developing normal negative emulsions in a lithographic developer nor by developing a lithographic emulsion in a high-contrast developer.

Traditional lithographic developers contain hydroquinone as the developing agent and depend for their effect on infectious development, i.e. the acceleration of the development of low densities adjacent to high densities. Although these developers give extreme contrast with the appropriate emulsions they are usually much less alkaline than developers normally associated with high contrast. A very low concentration of sulphite is maintained in the developer, either by the addition of paraformaldehyde, which forms formaldehyde-bisulphitein in the developer on reaction with sulphite. The aldehyde–bisulphite compound dissociates slightly into its component chemicals, thus supplying a constant and small amount of

sulphite, sufficient to protect the developer from aerial oxidation but not enough to interfere with infectious development. The pH value for infectious development is critical and must be maintained within very small tolerances by the inclusion of an appropriate buffering compound.

Colour (chromogenic) developers

Colour developer solutions have many similarities with monochrome developers. They contain the same types of constituents with some modifications, i.e. a developing agent based on p-phenylenediamine, a preservative such as sodium sulphite, an alkali and a restrainer or anti-foggant such as potassium bromide or potassium iodide in very small quantity. Apart from the developing agent, a major difference between a colour developer and a typical monochrome developer is that in a colour developer preservative is present at a much lower level (generally less than 2 grams per litre). The reason for this is that in the colour development reaction the developer oxidation products are required to form the dye image by reaction with a colour coupler. As developer oxidation products also react with sulphite ions a significant amount of sodium sulphite in the developer would compete with the colour coupler and the yield of dye image would be reduced according to the following simplified equations:

> Silver halide + colour developing agent →
> metallic silver + halide ion + oxidized colour
> developing agent
>
> oxidized colour developing agent + colour
> coupler → dye

Or,

> oxidized colour developing agent + sulphite
> ion → sulphonate

Colour developer solutions may also contain an antioxidant or anti-stain agent such as hydroxylamine or ascorbic acid, which provides some protection from the effects of aerial oxidation which promotes colour coupling and hence dye formation or staining in unexposed areas. Other constituents of colour developing solutions include competing couplers, e.g. citrazinic acid or a competing black-and-white developing agent to control colour contrast. In colour-reversal processing the developer often contains a chemical fogging agent to avoid the inconvenience of the reversal exposure. Chromogenic developers are used for the development of almost all colour camera materials and are also used in the processing of certain types of monochrome dye materials such as Ilford XP-2. This film uses the emulsion technology associated with modern colour-negative films, but produces a monochrome dye image.

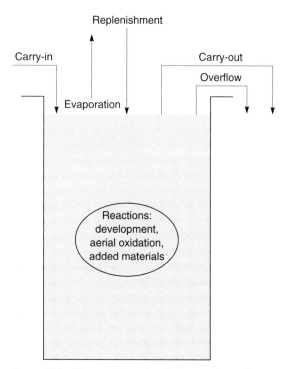

Figure 17.7 Changes taking place in a processing tank

Changes in a developer with use

As the function of a developer is to cause a chemical change in the exposed material, the composition of the developing solution must change with use. Because developers are used continuously, particularly in processing machines, it is important to know what changes to expect, how these changes affect the function of the solution, and what can be done to prevent or compensate for them (see Figure 17.7).

The first change occurs because some developer solution is carried out of the tank with the film, both on its surfaces and in the swollen emulsion layer. This removes some of each ingredient from the solution. The amount removed depends upon the size of the film, the type of clip or holder employed and the time during which developer is drained back from the film into the tank. The second change occurs because the developing agents are used up by reducing the silver halide in the negative to silver and by aerial oxidation. When the developing agents are used up by reducing silver halide, the products of the reaction tend to cause a fall in pH. When, however, it is used up by aerial oxidation, the pH tends to rise. The reactions involved, expressed in simple form, are as follows:

(a) Exhaustion through use
Developing agents + silver bromide →
oxidized developing agents + metallic silver
+ bromide ions + hydrogen ions (acid)

(b) Exhaustion on standing
Developing agents + oxygen → oxidized
developing agents + hydroxyl ions (alkali)

With the less alkaline developers, e.g. MQ-borax and PQ-borax developers, changes in pH have a very marked effect on the activity of the solution. These changes may be countered by incorporating in the developer a buffer system in place of the normal alkali.

The third change occurs because the preservative is used up.

The fourth change occurs because the bromide content of the developer is increased, as bromide ions are liberated from the emulsion.

The main effects of these changes on the working of the developer are:

● The development time required to reach a given contrast increases, due to exhaustion of the developing agents and increase in the bromide content. If a developer is to be used repeatedly, the development time must be increased as more and more material is put through the bath; alternatively, the developer must be replenished.
● The effective emulsion speed decreases due to the increase in bromide. This speed loss may be partially offset by the increased development time required to maintain contrast.

Exhaustion of the developing agents is bound up with exhaustion of the sulphite, since, if the sulphite is completely oxidized before the developing agents are used up, the developing agents, lacking a preservative, will rapidly oxidize. The shelf life of a developer is largely determined by the sulphite content and its working life may be governed either by exhaustion of the developing agents or by exhaustion of the sulphite. For small-scale use it is best to discard a developer after it has been used once, or after the amount of material recommended by the originator of the formula has been passed through. For large quantities of material, a more economical and environmentally sensible use of solutions can be achieved by use of a replenishment technique which discards the minimum amounts of solutions when carried out properly.

Replenishment

Replenishment ideally involves a continuous replacement of part of the used developer by a solution that has been formulated so that the mixture maintains photographic characteristics in the material being developed constant. Two methods of replenishment are commonly employed. The first is known as 'topping up' and the second as the 'bleed' method. In the former, which is used extensively in small-scale processing systems, the developing solution is maintained at a constant level by a feed system, so that the volume added is equal to the volume of developer carried over by absorption in the gelatin and on the surface of the material being developed. This is an ideal method of replenishment.

In the 'bleed' system, which is commonly employed for machine processing of film with a circulating developer system, used developer is run off and replenisher fed in continuously, so that the level of the developer and its characteristics remain constant. The bled-off developer, after modifications, may be used for other purposes. The bleed system of replenishment is the only one in which it is possible to maintain absolute constancy in the bromide concentration. In certain circumstances, this offers practical advantages. Although many processing machines have a fully automated replenishment system, adjustments to the replenishment rate may have to be made to keep the process within the limits set by the manufacturer. To assist in the setting-up of automatic processing equipment, suppliers of chemicals provide tables or graphs that relate the volume of replenisher to the area or number of films being processed.

Formulation of replenishers

For any developer, the formulation of a satisfactory replenisher depends largely upon the processing conditions employed and the photographic material being developed. Storage conditions, and the frequency with which the developer is used and its surface agitated during passage of the photographic material, affect the allowance which must be made for atmospheric oxidation. The coating weight and the average amount of developable silver per unit area of material developed, determined by the exposure and the degree of development, are also factors that must be considered. The carry-over, which depends largely on the type of holder employed and the draining time, has a considerable bearing on the formulation of a replenisher. Therefore, only for standard conditions is it possible to recommend a single replenisher, which can be formulated from the data obtained by quantitative study of the chemical changes in the developer solution under working conditions. This procedure is normally followed by the manufacturers of packed developers in devising replenishers for use under standard conditions of processing.

If facilities for chemical analysis of developer solutions are available, addition of individual ingredients may be made as required, even under varying conditions of work, and the life of the solution

maintained indefinitely. This procedure is adopted in motion-picture and very large-scale processing laboratories where very large volumes of solution are employed and constant performance of the bath is of utmost importance.

Preparing developers

Safety precautions

All processing solutions should be regarded as potentially harmful, and safety precautions are largely a matter of common sense and good house-keeping. In the workplace they are governed by current regulations and recommendations in the UK, such as COSHH (Control of Substances Hazardous to Health). Before using any chemicals a risk assessment must be carried out and health and safety or hazard data information should be obtained from the supplier. The four main types of possible exposure to chemicals are: contact with skin and eyes, inhalation, swallowing and injection via accidental cuts. Direct contact with all photographic chemicals must be avoided by the use of rubber or plastic gloves when preparing and using solutions. Where dish or tank processing is being undertaken, fingers should not be immersed in the solutions but protective gloves employed, or print tweezers when developing photographic papers.

Some of the components of developers are toxic or are known irritants, which cause allergenic reactions, contact dermatitis or skin sensitization. For example, metol, amines, black-and-white developers, colour developers and colour developing agents are known irritants. Specific warning notices are usually given on the label on the bottle or packet of the chemicals being used.

If chemicals are accidentally splashed into the eyes, wash at once with running water and seek medical advice. Also if processing chemicals come into contact with the skin, wash immediately in water. If any sort of rash or skin irritation occurs seek medical advice. Always wear an apron or laboratory coat when dealing with chemicals to avoid accidental splashes to clothing. Always store solutions in properly labelled and dated bottles which cannot be mistaken for drink bottles. Never store solutions near food or take food or drink into the mixing or working areas. Large-scale users of processing solutions should ensure that their mode of use conforms with the current health and safety regulations or codes of practice.

Individual chemicals

In general, developers should be made up using warm water to speed up the dissolving of the chemicals.

With developers containing metol it is recommended that this water should be at a temperature of not more than 50 °C otherwise the metol may decompose. Developers containing phenidone can, however, be made up at about 50 °C. When making up a developer, only about three-quarters of the required final volume of water should be taken to start with, so that by adding the remainder after the various chemicals are dissolved the volume can be made up to exactly the required quantity. This final addition should be of cold water. The order in which the constituents of a developing solution are dissolved is important. In general, the best order is:

(1) Preservative
(2) Developing agent(s)
(3) Alkali
(4) Other components.

This order is governed principally by the need to guard the developing agents from oxidation. Dissolving the preservative first will prevent oxidation of the developing agents while the solution is being made up. The rate of oxidation of the developing agents is very much accelerated by the presence of alkali. It is, therefore, usually best for addition of the alkali to be left until both preservative and developing agents have dissolved completely. The other components have little influence on the rate of oxidation of the developing agents and can be left until last.

There are important exceptions to the above general rules for developers containing metol, phenidone and colour developers. Metol is relatively insoluble in concentrated solutions of sodium sulphite, so that with metol and MQ developers only a small quantity of sulphite should be added first as a preservative, then the developing agent and then the balance of the sulphite. Phenidone is not as readily soluble as some developing agents, but its solubility is assisted by the presence of alkali. It is, therefore, best added after both sulphite and alkali. (Phenidone does not share with metol the difficulty of dissolving in strong solutions of sulphite.) To prolong the life of a colour developer prepared from individual chemicals, all the ingredients except the developing agents should be dissolved in the order given in the formula, and the developing agent added immediately before use.

Pre-packed developers

To avoid the inconvenience of preparing developers and replenishers from their constituent chemicals, compounded developers and replenishers are available. The two main types are powdered chemicals and liquid concentrates. For ease of use liquid concentrates are often preferred because they require only

dilution before use which is much simpler to carry out than the more lengthy procedure involved in dissolving powders. The modern trend is toward the use of liquid concentrates, and many developers are available only in this form. However, liquid concentrates are more bulky, more expensive and have a more limited shelf life than powdered chemicals. Packaging of processing chemicals in tablet form is carried out and this form of packaging makes handling far simpler, especially for automated processing systems used in mini-labs.

Powdered chemicals

Powdered chemicals are usually dissolved in warm water (approximately 40 ° C) to make up the working strength solution directly; but in some cases, they are used to prepare a stock solution which is then diluted as required. The main problems encountered in packaging developers in a powdered form are the stability of the mixture and the selection of appropriate chemicals such that the powders dissolve rapidly. Generally anhydrous powdered chemicals are used. They must not absorb moisture to any great extent or they may form a hard cake that is difficult to dissolve. To increase the stability of the powdered chemicals it is usual to pack the developing agent and alkali separately. The packet that contains the developing agent may also contain some sodium or potassium metabisulphite as a preservative. The remainder of the developer components, preservative, restrainer and alkali are packed in the second packet or container. In some cases a third packet is included. This contains a sequestering agent (e.g. EDTA) and should be dissolved first. For ease of use much modern packaging now allows powdered chemicals to be packed as single powder mixtures, each chemical component being kept from interacting by spray-drying, coating or encapsulation.

Powdered chemical packs generally should not be divided into smaller quantities for making up less than the recommended solution volume. The chemicals may not be perfectly mixed in their packets and taking less than the complete packet may result in the preparation of developers with the wrong proportions of the various constituents. Shaking the packets may not produce uniform mixing and could increase the non-uniformity of the mixture.

Liquid concentrates

Liquid concentrates are widely available for processing most types of photographic material. However, single-solution liquid concentrates are inherently less stable than their powder counterparts and therefore may have a more limited shelf-life. They have the advantage, however, that large quantities can be purchased and divided for storage into smaller airtight containers, before diluting to the required volume. For economic considerations they are made as concentrated as possible. Some liquid concentrates for one-shot processing may be diluted by as much as one hundred times, but more usually the required dilution to prepare the working strength solution is within the range of 1:3 to 1:50. Because they are diluted with large volumes of (tap) water, liquid concentrates often contain EDTA to prevent the precipitation of calcium salts. In compounding liquid concentrates one of the major problems is that of the limited solubilities of the chemicals and the tendency of some to crystallize from solution, especially when subjected to storage or transport at low temperatures.

Normally potassium salts are used in preference to sodium salts because of their greater solubility. In some formulae organic amines or amine–sulphur dioxide compounds may be used to provide an alkali and preservative that are more soluble than their inorganic equivalents. In addition to the usual developer chemicals, liquid concentrates may contain a water-miscible solvent such as ethylene glycol or methylcellulose to keep the developing agents in solution. Because of the high pH of the concentrate, an additional problem is that of stability of the developing agents. For example, phenidone decomposes in aqueous solution at high temperatures. Accordingly, more stable derivatives of phenidone such as phenidone-Z or dimezone may be used in liquid concentrates. To increase the stability and shelf life of liquid concentrates, some are packed in the form of two solutions, one containing the developing agent and preservative, the other containing the remainder of the developer chemicals. This is important for colour developers and various special-purpose developers such as lithographic and high-contrast developers.

For simplicity and versatility in packaging developers and replenishers for large-scale processing a 'starter' solution is included in a separate and smaller bottle. This contains the restrainer together with possibly a small amount of developing agent oxidation product which, when added to the remainder, forms the actual developer solution. The 'developer' when diluted appropriately, forms the replenisher.

Techniques of development

The manipulation of the sensitive material during development depends largely upon the nature of the material. Sheet and roll films each require different methods of handling. Details of the procedures recommended with each of these classes of materials are given in the following pages.

Manual development of sheet films

Although it is more usual to process sheet films in automatic processing machines, manual processing is still being undertaken in special applications where limited amounts of material are being processed. Sheet films may be developed in a dish, lying flat, emulsion upwards, or more usually in a tank, suspended vertically in hangers of special design.

For dish development, the film is placed in the empty dish and flooded with developer. The surface must be wetted quickly and evenly, otherwise developing marks will result. During development, the dish must be rocked continuously to provide agitation. Care must be taken to ensure that the rocking is not too rapid and that it is varied at intervals, e.g., first to and fro, then from side to side, to avoid patterns of uneven density caused by standing waves. In tank development, agitation should be intermittent, and achieved by lifting the films (in their hangers) from the tank, allowing them to drain to one corner, and replacing them in the bath, once every two minutes. At the beginning of development, films should be agitated vigorously for about 30 seconds to dislodge any airbells and ensure even wetting. Vigorous agitation throughout the whole of the development process is, however, to be avoided, as it may lead to uneven development due to the variation in the degree of agitation at the edges of films.

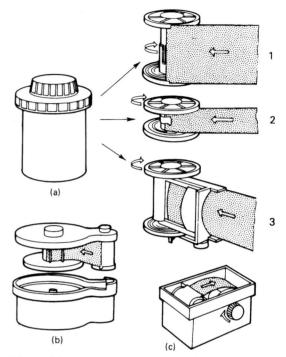

Figure 17.8 Developing tanks and spirals. Developing tank, which may be used with (1) self-loading spiral, (2) centre-loading spiral or (3) automatic loading spiral

Manual development of roll films

Many different types of tank have been designed for the small-scale manual processing of roll films (35 mm, 120 etc.). Some allow daylight loading, although the majority involve darkroom loading. All are suitably light-trapped to make it possible to carry out the developing process in the light. The film is wound into a special holder comprising a spool having wide flanges, the inner surfaces of which bear spiral grooves. In some tanks of this type, the distance between the flanges can be adjusted to accommodate various widths.

There are two basic types of spiral available for developing tanks: self-loading and centre-loading types (see Figure 17.8). In self-loading spirals, which are usually made from plastics materials, the film is loaded from the outside of the spiral flanges towards the central core. The flanges of the spirals are free to rotate by a limited amount, and the outermost grooves of the flanges have gripping devices which allow the film to pass in one direction only. Loading the film on the spiral is accomplished by pushing the film into the grooves just past the gripping mechanisms and then rotating the flanges backward and forward by small amounts to cause the film to be drawn into the spiral.

Centre-loading spirals, which are usually made from stainless steel, have fixed flanges, and loading is accomplished by clipping the film to the central core and then rotating the entire spiral in one direction whilst holding the film in a curved position so that it clears the outermost grooves and is loaded from the centre towards the outside. These spirals are sometimes provided with a device which maintains the film in a curved position and aids the loading operation. Stainless-steel spirals are robust, and can be dried rapidly by heat.

Once the film has been loaded into the tank in a darkroom, all processing operations, as well as the removal of the film, may be carried out in full daylight. Processing solutions are introduced into the tank through a central light-tight opening in the lid. During development, agitation is obtained by periodic inversion of the complete tank. Alternatively, the spool carrying the film may be rotated in the tank. Rotary action is usually by a rod which is inserted through the central opening to engage the film-holder spindle; it is usually recommended that the film should be agitated intermittently. Agitation should be in both directions since continuous rotation of the film holder in one direction might cause the film to come out of the spiral. After development is complete, the solution is poured from the tank and

replaced by the subsequent processing solutions in turn for the recommended times. The final washing stage should be continued for at least 20 minutes in running water. If running water is not available, the tank should be filled and emptied with clean water at least six times, allowing five minutes to elapse between each filling and emptying.

After washing, the tank should be opened, a drop of wetting agent added and the film removed as carefully as possible. The film should then have a clip attached to each end and be hung by one of these clips in a warm, clean atmosphere and allowed to dry. The tank should be thoroughly washed, wiped, and placed to dry. It is important that this drying should be thorough and that the wiping should not leave traces of fibrous material in the spiral grooves. Only moderate heat should be used to speed up the drying of a tank made of plastics material because it may warp with excessive heat.

Tank lines

For larger-scale processing, tank lines are a useful form of equipment. There is still a place for these in the modern darkroom, despite their having to be manually operated in total darkness. They are inexpensive and versatile, capable of accommodating virtually any format or process. They comprise a series of rectangular tanks of 7–15 litres capacity, surrounded by a water or air jacket which maintains the temperature of the processing solutions at the correct value. Photographic material is held in baskets (see Figure 17.9). Agitation is effected by raising and lowering the baskets in the tanks, and the operator transfers them from tank to tank at the times appropriate for the process.

Tank lines are usually operated as replenished systems, and with care can be maintained over long periods. When not in use the tanks are covered with lids that float on the surface of the solution, to minimize atmospheric oxidation; they also have a cover over the top. To overcome the limitation of the manual nature of tank lines, many types of automatic processing devices are used, even for relatively small scale processing which are described in the following section.

Machine processing

For processing large quantities of film or print materials neither simple tank processing of films nor dish processing of papers is appropriate. A number of processing machines with various capacities suitable for all scales of operation from the amateur photographer to the large-scale photofinishing laboratory are available. Table 17.2 gives approximate capacities of

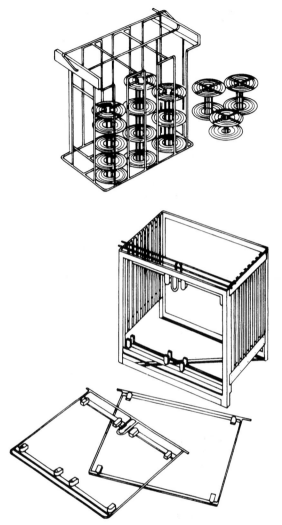

Figure 17.9 Tank line film holders, showing spirals and baskets for roll and 35 mm films and sheet film holders

various types of processing device. The various approaches to machine processing of photographic materials are shown in Figure 17.10.

Figure 17.10 includes a variety of tube or drum processors (a) to (d), which are relatively small-scale batch processors and have the advantage of versatility. Many examples of these processors may be used for processing almost any photographic material provided that the appropriate roll film, sheet film or paper holders are available. Many tube or drum processors use one-shot processing, in which fresh processing chemicals are used for each batch of material being processed and are discarded after their use. The more sophisticated types re-use the solutions and require replenishment.

Table 17.2 Approximate capacities of processors

Processor	Approximate rate or capacity
Multispiral developing tank (manual)	Up to five 135 36-exposure films
Tank line(13.5 litres) spirals loaded in processing racks (manual)	Up to 30, 135 36-exposure films; 30, 8 × 10 prints/batch
Tube or drum (machine)	Up to 50, 135 36-exposure films/batch; 60 A4 prints/batch
Self-threading roller	1 m/min; 1000, 9 × 13 cm prints/hour
Continuous roller (machine)	Up to 20 m/min (film), 10 m/min (prints)
Dunking (machine)	400 films/h

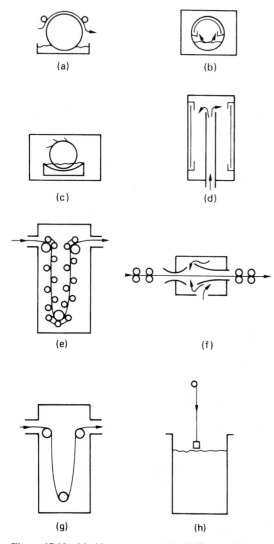

Figure 17.10 Machine processors. (a)–(d) Types of drum processor. (e) Self-threading roller processor. (f) 'Transflo' processor. (g) Continuous roller processor. (h) Dunking

The simpler versions are non-automatic and require the operator to pour in the processing chemicals and to drain the drum at the end of each processing cycle. However, once loaded these machines may be operated in the light as the tube or drum is itself light-tight or is contained in a light-tight box. These processors have the disadvantage of an intricate loading procedure. For higher through-put of films or papers and ease of loading, self-threading roller processors (Figure 17.10e) are commonly used, especially for RC black-and-white and colour papers, X-ray films and graphic arts materials, provided that the scale of operation justifies their use. As the name implies, the material film lengths, sheet films or papers is fed in at one end of the machine, is guided in and out of the processing tanks by a number of closely spaced rollers, and emerges from the machine dry. These machines are fully automatic and use replenishment systems to maintain solution activity. Another example of this type of processing machine is shown in Figure 17.10(f). This is an in-line or straight-through processing machine in which the material travels horizontally through the machine, guided by rollers, through applicators into which solutions are pumped from reservoirs contained in the machine.

To avoid carry-over of solution from one tank to another, which would affect the replenishment rate, these machines are fitted with squeegee rollers between the tanks, as shown in Figure 17.11. The rollers in these machines are a critical feature: some manufacturers use hard rollers, others use soft rollers; the rollers may be either in a staggered configuration (as in Figure 17.11) or in pairs directly opposite one another. Most modern materials are designed to be processed in machines of this type, with emulsions that are thinly coated and hardened so as to be able to withstand the pressure of the rollers. These machines are a rapid and convenient method of fully-automated processing, and are available as small-scale table-top processors which lend themselves to the processing of prints, but they require careful maintenance and regular cleaning. They are available in various sizes and configuration as to suit many different applica-

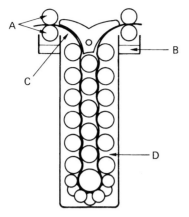

Figure 17.11 Rack system in the *Colenta* self-threading roller transport processor: A, squeegee rollers; B, water; C, material path; D, staggered rollers

processing chemicals. Continuous roller processors contain relatively few rollers compared with self-threading roller processors, but require a leader to be used for attaching the roll of material to be processed. Both types of processor lack the versatility of tube or drum processors, as they are normally designed for a film or paper. Dunking machines are used for processing films in individual lengths, which obviates the need for splicing films together before processing. A typical machine of this type is shown in Figure 17.12. Films are placed in clips and hung on bars or frames that are automatically raised and lowered into the processing tanks by a chain-driven hoist mechanism. The bars or frames are moved forward in each tank by serrated tracks along the sides of the processing tanks. To move the film forward the outer tracks move upward past the inner stationary tracks and move the ends of the rods supporting the films over and into the next serration. When the bars reach the last serration in the tank the hooks on the lifting mechanism pick them up and transfer them to the next tank.

Obtaining the required degree of development

Development of any material is the most critical step in determining the optimum image quality. Whilst there is no absolute and universally accepted definition of image quality, the following criteria are normally adopted for negative processing.

● Processed materials should be free from uneven development, streaks or airbells.

tions, from the advanced amateur to the professional processing laboratory. They are available as complete systems for use by mini-labs. For this application there is a trend to waterless systems and daylight operation. These systems use conventional wet-processing solutions, but have a self-contained water reservoir for washing. This requires changing regularly, but does not need to be plumbed in to a mains water supply.

For very large-scale processing, in photofinishing laboratories, either continuous-roller processors (Figure 17.10g) or dunking machines (Figure 17.10h) are used. These machines have a high throughput, and employ replenishment to maintain the activity of

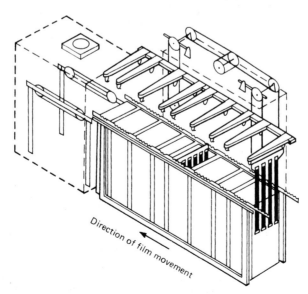

Figure 17.12 Dunking processing machine

- Negatives should not have densities that require very long printing times.
- Highlight and shadow detail should be acceptable.
- Negatives should have the appropriate contrast for printing on a normal or average contrast grade of paper.

Development of negatives is performed almost entirely by the time/temperature method. Standard developer formulae are used and a development time is given which will produce a known degree of contrast. The time of development is based either on the recommendations of the manufacturer for the emulsion employed, or on the user's experience. This method of development does not allow compensation for variation in subject range or for errors in exposure, but, provided reasonable care is taken in determining exposure, the latitude of the photographic process is such that satisfactory results are usually achieved. The development time required to obtain a given contrast with a given material depends principally on:

- Film used.
- Nature, dilution and state of exhaustion of developer.
- Temperature of the developer.
- Type and amount of agitation.

Materials differ appreciably in the rate at which they develop. The effects of variations in the composition of a developer on the development time required to reach a given contrast have been referred to earlier. Rate of development is dependent on the temperature of the developing solution, the rate of reaction increasing with temperature. For photographic processing it is usually best to work at a temperature in the region of 18–24 °C. This has traditionally represented a compromise between low temperatures, which lead to inconveniently long development times, and high temperatures, which lead to uncontrollably short development times, fog, stain, frilling, reticulation, etc. Published development times are usually related to a standard temperature of 20 °C, a temperature selected as easily maintainable (in temperate climates) all the year round.

However, with modern colour materials and some monochrome emulsions, far higher temperatures are now used. For example, many current black-and-white films have a standard recommended processing temperature of 24 °C, and 38 °C is used for colour materials. It is recommended that where possible the temperature of the developing solution should be maintained at the recommended temperature. If this is not possible, for black-and-white materials manufacturers supply charts or tables from which development times for other temperatures can be determined, provided they are not too different from the recommended temperature. Colour processing requires very accurate control of the temperature (to within ± 0.25 °C) in order to maintain contrast and speed balance between the layers. These times and temperatures are fixed and should not be varied from those recommended unless the speed rating of the film is being increased. The amount of agitation affects the development time required; the more vigorous the agitation, within limits, the shorter the development time required. Thus, the continuous form of agitation recommended in dish development permits the use of development times about 20 per cent less than those required when developing in a tank with intermittent agitation.

In automatic processing devices agitation is carried out by a number of methods to ensure evenness of development and freedom from unwanted development effects. Agitation is by one or more of the following methods:

- Solution recirculation by pumps, used in some continuous-processing machines.
- Film travel: the motion of the film through the solution provides a form of agitation, and is used in a number of uncritical processes, usually in combination with solution recirculation.
- Gas-burst agitation, providing a uniform and reproducible form of agitation by means of the release of gas bubbles through small holes in a distributor at the bottom of the tank at precise time intervals. Nitrogen is used for developers, and air can be used for other solutions such as bleaches.
- Spray application, generally restricted to the washing stage; but if the spray device is below the surface of the solution it can be used for processing solutions.

The importance of correct agitation cannot be overemphasized, not only for uniform development across wide areas but also for processes which depend upon edge effects and may have their image quality adversely affected by over-agitation. When processing photographic materials there is an almost stationary layer of liquid close to the film surface, the laminar layer, which arises from frictional forces between the microscopically rough emulsion surface and the solution. This layer decreases the rate at which chemicals can diffuse in and out of the emulsion. Most agitation methods are designed to minimize the thickness of the laminar layer by creating turbulent flow in the solution, close to the emulsion surface.

For a given material and developer, the degree of development required by an ordinary (continuous-tone) negative depends principally upon the nature and lighting of the subject (subject luminance ratio) and, to a lesser extent, on the printing conditions to be employed. Published development times assume a subject of average log luminance range and are

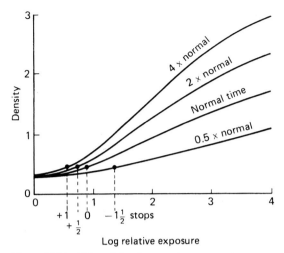

Figure 17.13 Effect of development time on speed

designed to give negatives suitable for printing on a medium grade of paper with a typical enlarger. This usually corresponds to a gamma of 0.65–0.80 or an average gradient (\bar{G}) of 0.55–0.70. With subjects of below-average or above-average log luminance range, published development times will usually yield negatives that require to be printed on harder or softer grades of paper respectively. For sheet films separate development times are usually published for dish and tank use. The difference between the two sets of times takes into account the differing forms of agitation employed in the two cases. If the recommended tank dilution of the developer differs from the dish dilution, the change in dilution is also allowed for.

Variation of development time and effective film speed

Although the main effect of variation of development time is on contrast, there is also an effect on effective emulsion speed. Shorter development times decrease the effective speed and longer development time increase it (see Figure 17.13). The limit to the control of speed possible by varying development time is set largely by the accompanying variation in contrast; development must not be such that negatives are too low or too high in contrast to be printed on the papers available. The maximum development time may also be limited by granularity and fog, both of which increase with increasing development time. The practice of continuing development to obtain maximum speed is sometimes referred to as forced development or push-processing. Because this technique yields a high contrast, it is generally suitable

only for negatives of subjects of short log luminance range. Figure 17.13 shows the effect of changes in development time on speed, where speed has been defined as the log relative exposure required to reach a density of 0.1 above base-plus-fog. It can be seen that changes in effective speed have been obtained at the expense of alteration of contrast. However, dilution of the developer and extension of the development time gives a compensating effect that slows down the rate of increase in contrast while giving a small speed increase.

Certain active developers give the maximum speed that the material is capable of, normally at the expense of high contrast and increased granularity. However, many manufacturers supply specially formulated developers that yield optimum negatives with respect to speed gain, contrast and granularity. The gains in speed with such developers may be of the order of one-third to two-thirds of a stop. It must be stressed that film speed is fixed by the development of the film under standard conditions defined in the appropriate American, British or other national or international standard (see Chapter 18) and as such cannot be varied. Film speeds for general photography are based on a camera exposure slightly greater than the minimum required to yield a negative that will give an 'excellent' print. A safety factor of one-third of a stop is included in their determination. Thus by extending development only a very little extra shadow detail may be recorded.

The majority of claims for vast speed increases are based to a very great extent on the exposure latitude of the film when used for recording scenes of low contrast or low subject luminance ratio which contain virtually no shadow detail. In such cases the film is effectively being underexposed and the scene is recorded further down the characteristic curve (see Chapter 18). In practice it is possible to up-rate certain films by as much as two to three stops depending on the scene contrast and the individual criteria for acceptability of prints that contain little or no shadow detail. Techniques of forced development or push-processing give only marginal improvements in image quality for underexposed negatives of low-contrast subjects.

Real and significant speed increases are possible with reversal films. These are achieved by increasing the time spent in the first developer. Speed increases of two to three stops are common for certain colour-reversal materials. In reversal processing the situation is quite different from that for negative materials. Shadow detail is recorded even if the film is underexposed, but remains unrevealed in the dense areas of the transparency when subjected to standard conditions of processing. Increasing the time in the first developer leads to less silver halide being available for the second development, and hence a less dense positive image, which reveals underexposed shadow detail.

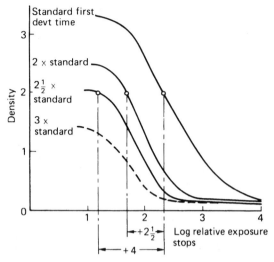

Figure 17.14 Effect of first development time on speed for a reversal process

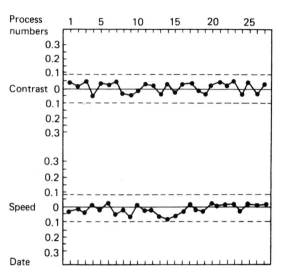

Figure 17.15 Typical process control chart for a black-and-white process

Figure 17.14 shows the effect of increasing the time in the first developer for a typical colour reversal film. Speed changes have been arbitrarily defined as log relative exposures required to give a density of 2.0. However, there is a limit to speed increases with reversal films. For example, the lowest curve in Figure 17.14 shows that the maximum density is far too low for acceptability and that the curve is too short to record both highlight and shadow detail, even for scenes of moderate subject log luminance range. Another limitation that is not shown by the plotting of visual densities from a material that has been exposed to a neutral light source is that the three sensitive layers may be affected differently by modifying the processes, which affects the colour balance as well as the tone reproduction.

Increasing the speed rating of colour-reversal films by increasing the time of the first development also reduces image quality to some extent. Maximum density is reduced, graininess and contrast increase, and there is some change in colour rendering and a reduction in the ability of the film to record scenes of moderate to high contrast. However, up-rating reversal films is a very useful (and much-practised) undertaking for recording poorly lit scenes, or for recording action where short exposure times are essential.

Quality control

To ensure consistency of processing from day to day or from batch to batch, adequate quality control procedures are essential, especially in large-scale processing systems involving replenishment. This is commonly carried out sensitometrically, using pre-exposed control strips processed with the batch of films or at regular intervals in a continuous processor. Control strips comprise a step tablet pre-exposed under strictly controlled conditions by the film or paper manufacturer. After processing, the steps are read using a densitometer together with a master strip, which is a processed control strip provided by the manufacturer along with the pre-exposed but unprocessed strips. From the density readings, fog, speed and contrast are derived and the differences between the values for the user-processed strip and the master control strip are plotted on a quality-control chart against the date or process number. Specified control limits appear on the chart as horizontal lines above and below the central line (see Figure 17.15). The process must be maintained within these limits. The intelligent use of control charts enables this to be done and consistent results to be obtained. Thus if the control limits are exceeded action has to be taken to bring the process back into control. This may involve an adjustment in the replenishment rate after checking that processing times, temperatures and agitation are correct for the process. For colour processes the same principles apply, but the charts are more complicated: they involve three lines for each parameter, relating to the behaviour of each layer (i.e. the red, green and blue records).

A useful form of presentation of colour balance is by the use of trilinear plots, which can give a direct indication of the shifts in colour balance of a standard patch for different materials, batches, processes or colour printing conditions. Figure 17.16 shows a typical plot comprising three main axes at 120 degrees (the full lines labelled respectively yellow,

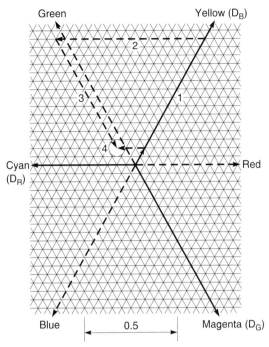

Figure 17.16 Trilinear plot (for explanation of 1 to 4, see text)

magenta and cyan) and three additional axes also at 120 degrees to each other but opposite to the main axes. These are shown as broken lines labelled respectively blue, green and red. If, for example, a 'neutral' patch has measured density values D_B (yellow), D_R (cyan) and D_G (magenta) of 0.80, 0.85 and 0.75 respectively, its position on the trilinear plot can be determined as follows:

1 Plot a 'yellow' vector 0.80 units along the 'yellow' axis.
2 From this point plot a 'cyan' vector 0.85 units parallel with the 'cyan' axis (the dotted line 2).
3 From this point plot a 'magenta' vector 0.75 units parallel with the 'magenta' axis (the dotted line 3).
4 Mark the end of the final vector with a cross or circle.

This is the plot of the colour balance of this patch. From its position it can be seen that it is greenish cyan in hue. The same point is reached regardless of the order used in plotting the vectors. A true neutral, i.e. all density values equal, would plot at the centre of the diagram.

Alternatively, these plots can be carried out by first subtracting the lowest density value from the other two (i.e. subtracting a neutral) and then plotting the remaining two vectors as before. For the above example, subtracting 0.75 from the other values gives values of 0.05 and 0.10 for D_B and D_R respectively (and 0 for D_G). This plot is also shown in Figure 17.16 (the arrowheads and dotted line close to the centre). The same point is reached on the diagram; it is a matter of personal choice which procedure is adopted.

Processing following development

Immediately after a photographic material has been developed it contains a visible silver image, and for colour materials also a dye image. It is not in a condition to be brought into the daylight or be used in the further operation of making prints. The silver halide crystals that were not affected by exposure and have not undergone development remain in the emulsion, making it difficult to print from the negative. Also, the silver halide is still sensitive to light and will gradually print out, changing colour and masking the image to a greater and greater extent as time goes on. The gelatin is in a swollen condition and has absorbed a considerable amount of the developer solution. Immediately following development of conventional black-and-white materials they are immersed in a rinse or stop bath before fixation. The purpose of fixation is to remove the unwanted silver halide without damaging the silver image. The fixing operation also may be used to harden the gelatin, to prevent further swelling.

Rinse and stop baths

A plain rinse is very often used between development and fixation to slow the progress of development by removing all the developing solution clinging to the surface of the film. A rinse, however, does not completely stop development, as developer remains in the emulsion layer, but it does remove much of the gross contamination of the film by the developing solution. Rinsing is carried out by immersing the material in clean water. To ensure that this does not become loaded with developer, running water should be employed, if possible. Rinsing in plain water must be followed by fixation in an acid fixing solution to stop development. The rinse then serves not only to slow development, but also to lessen the work that has to be done by the acid in such a fixing solution. Rinsing thus protects the fixer.

Although a plain rinse can be used between development and fixation, a better technique is to use an acid stop solution. This not only removes the developer clinging to the surface of the film, but also neutralizes the alkaline developer carried over in the emulsion layer and so stops development because developing agents are not active in acid conditions.

In selecting an acid it must be remembered that some of the solution will be carried into the fixer as

films pass through it. This rules out use of strong acids such as sulphuric acid which cause precipitation of sulphur in the fixing solution. Solutions of potassium or sodium metabisulphite (2.5%) or acetic acid (1%) are commonly used.

Fixers

Although, a fixing solution may perform several functions, its primary action is the removal of unexposed silver halide from the emulsion.

Silver halide + fixing agent → silver/fixing agent complex (soluble) + halide ion

Fixing solutions always contain a solvent for silver halide. For use in photographic processing, the solvent must form a complex with silver which can be washed out, must not damage the gelatin of the emulsion and must not attack the silver image. Only thiosulphates are in general use because all other solvents for silver halides have disadvantages.

The most widely used silver-halide solvents are ammonium and sodium thiosulphate. Sodium thiosulphate ('hypo'), when in acid solution, however, has a weak solvent action on the silver image. Although this action is negligible during the time required for fixation, prolonged immersion in a fixing solution may reduce the density of the image. This effect is most marked with fine-grain negative emulsions and printing papers in which the image colour may be affected as well as the density.

The fixing solution removes the residual silver halide by transforming it into complex sodium argentothiosulphates. These substances are not particularly stable and, after fixation, must be removed from the emulsion by washing. If left in the emulsion, they will in time break down to form yellowish-brown silver sulphide.

In the presence of a high concentration of soluble silver, or low concentration of free thiosulphate, when the fixing solution is nearing exhaustion, the complex sodium argentothiosulphates may become adsorbed, or 'mordanted', to the image. These are difficult to remove by washing. Fixation in an exhausted solution therefore has a risk of subsequent staining due to the breakdown of the silver complexes remaining in the emulsion, however efficient the washing process.

A fixing solution for negatives usually contains 20–40 per cent of crystalline sodium thiosulphate. For papers, a solution stronger than 20 per cent increases the risk of bleaching the image on prolonged fixation, and may aggravate the problem of removing sodium thiosulphate from the paper on washing. Because the average coating weight of papers is only about one-quarter of that of negative materials, fixing times for papers are shorter than those required by negative materials, and the times required in the weaker solution are not excessive.

Ammonium thiosulphate is now commonly used as a fixing agent, at a concentration of around 10–20 per cent. Ammonium thiosulphate fixes much more rapidly than sodium thiosulphate. This is due to the presence of the ammonium ion, and the rate of fixation of ammonium thiosulphate is between two and four times that for an equivalent concentration of sodium thiosulphate. However, ammonium thiosulphate does have some limitations as a fixing agent. It is less stable than the sodium compound and attacks the silver image more readily. Exhausted ammonium thiosulphate fixers cause staining, owing to the more rapid breakdown of the silver complexes. Despite these limitations, ammonium thiosulphate is the basis of most rapid fixers.

Acid and acid hardening fixers

The addition of a weak acid to a fixing solution ensures that development stops immediately on immersion, irrespective of whether an intermediate stop bath was used. Strong acids cause thiosulphate to decompose with the formation of colloidal sulphur. Acid fixers are therefore usually made up either by the addition of potassium or sodium metabisulphite to the solution of sodium thiosulphate or, alternatively, by the addition of a weak acid such as acetic acid, together with sodium sulphite.

Hardening of gelatin layers has a number of advantages and is carried out in the manufacture of most photographic materials but is also carried out as part of the fixing process. Gelatin molecules consist of long chains of atoms, and these chains are bound to each other only loosely, so that water molecules are taken up freely. Cross-linking binds the chains closely together and so inhibits swelling. The advantages of hardened layers may be summarized as follows:

- A hardened film is less easily damaged in subsequent processing operations.
- Less water is taken up by a hardened emulsion, which provides rapid drying.
- A higher temperature is used for drying, which further speeds up the drying.

Hardened emulsions are an essential feature of modern high temperature machine processing which allow rapid processing, less solution carryover and hence more efficient replenishment and quality control. Most modern emulsions are thin, and are hardened during manufacture, thus minimizing both swelling during processing and carry-over of processing solutions.

A typical inorganic hardening agent is aluminium potassium sulphate (potash alum), which causes hardening in which aluminium or chromium ions combine with the gelatin to form cross-links and make it more resistant to water, heat and abrasion.

A fairly careful control of pH is required in acid hardening–fixing solutions. If the pH is too low there is a danger of sulphurization; if too high, of precipitation. A safe range is 4–6.5. For optimum hardening, the pH should be at about the middle of this range. Hardening–fixing solutions are therefore made to contain ingredients which ensure good buffering properties which prevents carry-over of developer from affecting the pH adversely.

Preparing fixers

Crystalline sodium thiosulphate should be dissolved in hot water, as it has a negative heat of solution. Anhydrous sodium thiosulphate, however, has a positive heat of solution and should be dissolved in cold water with vigorous stirring to prevent caking. In both cases the metabisulphite should be added to the solution only when it has returned to room temperature, otherwise sulphur dioxide gas may be given off and the thiosulphate may become partially decomposed. The formulae of acid hardening–fixing solutions are more complicated than those of ordinary acid fixing solutions, and greater care is therefore needed in making them up. The procedure to be followed in making up a hardening fixer will depend on the particular formula employed, and detailed instructions are given with each formula and packing. One general rule that may be noted in making up potassium alum hardening fixers supplied as single-powder mixtures is that the water used should not be above 27°C; if hot water is used the fixer may decompose. Most proprietary fixers are based on ammonium thiosulphate, and are supplied as concentrated liquids which only require dilution before use.

Time required for fixation

Rate of fixation depends principally upon the following factors.

● *Type of emulsion and thickness of coating*

Other things being equal, fine grain emulsions fix more rapidly than coarse ones, and thin emulsions more rapidly than thick ones. Silver chloride emulsions fix more rapidly than silver bromide emulsions.

● *Type and degree of exhaustion of the fixing solution*

The rate of fixation depends on the concentration of the fixing agent up to about 15 per cent for both sodium and ammonium thiosulphate, but increasing the concentration above 15 per cent hardly alters the rate. As stated earlier, the concentration of sodium thiosulphate usually employed in practice is between 20 and 40 per cent. A partially exhausted solution fixes more slowly than a fresh solution, not only on account of reduction in concentration of thiosulphate, but also, if used for fixing negatives, because of the accumulation of soluble silver and of iodide. For special work, fixing agents which clear more rapidly than sodium thiosulphate may be employed.

● *Temperature of the solution*

Increase in temperature gives increased rate of fixation.

● *Degree of agitation*

The rate of fixation is controlled by a diffusion process, so that agitation materially reduces the time required.

● *Degree of exposure*

The greater the exposure, the less the amount of unused silver halide remains to be removed by the fixing solution, and hence the more rapid the rate of fixation. Hardening takes place slowly, and usually requires longer than clearing. To be efficient, hardening is therefore assisted by allowing materials to remain in the fixer for twice as long as they take to clear.

The temperature of the fixer is by no means as critical as that of the developing solution, but for films it should normally lie within a few degrees of the temperature of the developer, to avoid the danger of damage to the gelatin.

Changes in fixers with use

The composition of a fixer, like that of a developer, changes with use. We can best understand the reasons for these changes by considering the sequence of events following development, assuming that an acid-hardening fixing solution is used, preceded by a plain rinse.

- The rinse removes much of the gross contamination of the film by the developing solution and slows development.
- The film is transferred to the fixer where the acid neutralizes the alkali of the developing solution in the emulsion layer and stops development.
- The thiosulphate converts the silver halide in the emulsion to soluble complex sodium argentothiosulphates and halide ions. Thus the concentration of silver complexes and halide ions increases.

- The hardening agent diffuses into the gelatin and begins its hardening action.

As the solution continues to be used, more and more of the alkaline developer is carried over and the acid becomes exhausted. A good guide to the degree of acid exhaustion is provided by its pH value. The pH of the solution should preferably not be allowed to rise above about 6.0. If the solution becomes alkaline, it will not stop development and there will be risk of staining. If the solution is a hardening–fixing solution there will also be a serious reduction of hardening power. If a hardening fixer becomes very alkaline, a precipitate may be formed from the interaction of the hardening agent and the alkali. This will tend to deposit on negatives in the form of a scum, which may be difficult to remove.

Not only does the acidity of the solution decrease as it is used, but the fixing action becomes slower. This is partly due to exhaustion of the thiosulphate, but with negative materials it is also due to a concentration of iodide derived from the emulsion, which builds up in the solution. Silver iodide, present in many negative emulsions, is extremely difficult to dissolve in a solution of sodium thiosulphate, and has the effect of depressing the solubility of silver bromide and so retarding the clearing process as a whole. We thus have a symptom of apparent exhaustion which is brought about by the accumulation of an antagonistic end-product. Among other important products which build up in the solution are the complex sodium argentothiosulphates. These also retard clearing but their most important effect is upon the permanence of the negatives and prints. Silver indicator test papers are available; these change colour on immersion in a fixer containing silver. These papers are calibrated so that the intensity of the coloration may be read from a chart which relates the colour to the silver content.

A further cause of exhaustion of a hardening fixer can be exhaustion of sulphite, but the quantity employed is usually sufficiently large to ensure that trouble from this source is rare. Lastly, since a small volume of water from the rinse is carried into the fixer on each film and a small volume of the fixing solution is carried out, the fixer becomes progressively diluted with use. This also leads to an increase in clearing time.

For large-scale use fixers, like developers and all other processing solutions, are replenished (see Figure 17.7). The first property of a fixer to decrease with use is its acidity, then its hardening properties. The life of a fixer may, therefore, be usefully increased by the addition of a suitable acid mixture. If this is made to contain a hardener, both acidity and hardening power can be restored to a certain extent. This process cannot, however, be continued indefinitely because of the accumulation of iodide and silver in the fixer. It is therefore, not worthwhile to

Figure 17.17 A small-scale electrolytic silver recovery unit: A, tank; B, rotation and control unit; C, rotating cathode

attempt to replenish a fixer by the addition of thiosulphate unless some means of removing the silver is available, as, for example, by electrolytic silver recovery (see below).

Silver recovery

The recovery of silver from a fixing solution is attractive both from environmental and economic considerations, quite apart from the possibility of replenishing the fixer. In black-and-white materials only a relatively small amount of the silver halide is reduced to silver by the developer to form the image. The remainder is dissolved from the sensitive layer and ends up as silver complexes in the fixer solution. In colour materials all the silver halides are removed from the material by the bleach or bleach-fixing solutions. Thus if sufficient material is processed, recovery of silver becomes worthwhile. Table 17.3 gives the approximate recoverable silver from various types of photographic materials.

The various methods of silver recovery commonly practised at the present time may be divided into three main groups:

- Electrolytic
- Metallic replacement
- Chemical

Table 17.3 Amounts of potentially recoverable silver in photographic materials

Photographic material	Recoverable silver (grams/100 units processed)
B and W negative (1–120, 1–135–36, roll)	10–16
B and W print (20.3 × 24.5 cm)	3–6
Colour negative (1–120, 1–135–36, roll)	24–28
Colour print (20.3 × 25.4 cm)	1–2
Lithographic film (20.3 × 25.4 cm)	10–17
Industrial X-ray (35 × 43 cm)	155–249
Medical X-ray (35 × 43 cm)	46–93

Electrolytic

Electrolytic silver-recovery units (see Figure 17.17) operate by passing a direct current through the silver-laden fixer between two electrodes, usually a carbon anode and a stainless steel cathode, onto which almost pure silver is deposited (by cathodic reduction of silver ions). At the cathode the following reaction occurs:

Silver thiosulphate complex + electron →
silver + thiosulphate

The silver is periodically stripped from the cathode and sent to a silver refiner. There are many electrolytic units commercially available. Some types employ a high current density, which requires efficient agitation by re-circulation of the fixer solution, and use rotating cathodes to prevent the formation of silver sulphide. Low current density units make use of a large area cathode and do not need agitation.

With all types of electrolytic silver recovery unit, careful control of the current density is required. If it is too low silver recovery is slow and inefficient, and if it is too high silver sulphide is formed. Fixer solutions that have been electrolytically de-silvered may be re-used after replenishment. During electrolysis both sulphite and thiosulphate ions are oxidized at the anode by the following reaction:

Sulphite + water → sulphate + hydrogen ions
+ electrons

Thiosulphate → tetrathionate + electrons

Thus before re-use thiosulphate and sulphite must be added. During the recovery of silver by electrolysis the pH must be maintained below 5; there must be sufficient sulphite present, also a small amount of gelatin is desirable as an aid to the even plating of silver. Electrolytic methods may be used for recovering silver from fixers based on sodium and ammonium thiosulphates and from bleach-fix solutions used

Figure 17.18 A small-scale metallic replacement cartridge capable of recovering 2.5 kg of silver

in some colour processes. The solution may be re-used and the silver is recovered in a pure form (92–99 per cent).

The main limitations of this method are the expense of the units, the consumption of electricity and the degree of control that has to be exercised by the operator.

Metallic replacement

These methods, although simpler, result in a fixer solution that is contaminated by other metal ions after recovery of silver. The fixer solution cannot be re-used, and the recovered silver is in a less pure form than that obtained by the electrolytic methods described above. Metallic replacement depends on the principle that if a metal that is higher on the electrochemical scale than silver (e.g. copper, zinc, iron) is added to a solution containing silver ions, it will displace silver metal from the solution.

Silver thiosulphate complex + iron metal →
silver + iron ions + thiosulphate

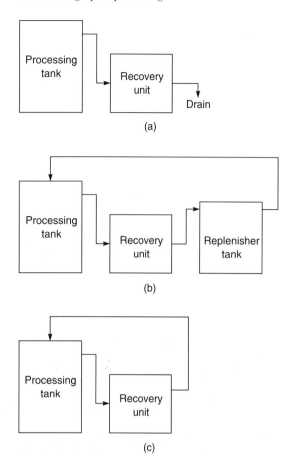

Figure 17.19 Modes of silver recovery in machine processing. (a) Terminal. (b) Regeneration/replenishment. (c) Recirculation

The modern application of this method is to pass the silver-laden fixer through a cartridge (see Figure 7.18) of steel wool in which the metallic displacement takes place. When silver is detected in the effluent from the cartridge, the cartridge is replaced by a fresh one and the exhausted cartridge is sent away for silver refining. For efficient recovery the pH of the fixer should be between 4.5 and 6.5. Below pH 4.5 the steel wool dissolves; above pH 6.5 replacement is slow. This is a simple, efficient, inexpensive and non-electrical method, but has the limitation that the fixer solution cannot be re-used. Bleach-fix solutions so treated can, however, be re-used after appropriate replenishment and adjustment of concentration. A number of firms supply cartridges, and on return of the exhausted cartridge pay the processing laboratory for the silver recovered (less a charge for refining, etc).

Figure 17.19 shows three modes of silver recovery. In all these, electrolytic units may be used for both fixer and bleach-fix solutions. For fixer solutions the 'terminal' mode must be used with the metallic-displacement method of silver recovery. Silver recovery may also be carried out as a batch process.

Chemical methods (precipitation or sludging)

These methods involve the addition of certain compounds to the silver-laden fixer which precipitate either an insoluble silver compound or metallic silver. For example, when a solution of sodium sulphide is added to an exhausted fixer, silver sulphide is precipitated. The solution must be alkaline, or toxic hydrogen sulphide is produced. Alternatively, sodium dithionite (hydrosulphite) precipitates metallic silver from a used fixer solution. Although these methods are efficient, they are potentially hazardous, and the chemicals can contaminate photographic materials and solutions. The de-silvered solution is not re-usable, and this method is not recommended for use in or near a processing laboratory.

Bleaching of silver images

The removal of silver images is necessary in a number of processes. For example, in black-and-white reversal processes the negative silver image is removed after the first development stage, leaving the originally unexposed silver halide unaffected. In chromogenic processes (see Chapter 24) it is necessary to remove the unwanted silver image that is formed together with the dye image, leaving the dye image alone; in various methods of after-treatment such as intensification and reduction, bleaching of silver is also involved. Holograms made for display purposes are also bleached rather than fixed.

Bleaching of silver images involves the oxidation of metallic silver to silver ions which combine with other ions to form either soluble or insoluble silver compounds. In black-and-white reversal processing the negative silver image is removed by immersing the material in an acidic solution of an oxidizing agent such as potassium dichromate or permanganate:

> Metallic silver + oxidizing agent + sulphuric acid → silver sulphate (soluble) + reduced oxidizing agent

With the exception of silver sulphate the products of the reaction tend to remain in the emulsion and may cause staining. The bleaching reaction is therefore followed by a clearing solution of sodium or potassium metabisulphite which removes these products.

Different bleach solutions are used in chromogenic processes. To remove metallic silver in these processes two basic methods are used. The first is the

conversion of metallic silver to silver bromide by the use of an oxidizing agent in the presence of bromide ions (rehalogenating bleach):

> Metallic silver + oxidizing agent + bromide ions → silver bromide + reduced oxidizing agent

The silver bromide so formed may then be removed in a conventional fixing solution. Potassium ferricyanide (hexacyanoferrate) has now been replaced by ferric EDTA (see below) as the oxidizing agent because the latter is not harmful when discharged into streams, whereas ferricyanide decomposes under the influence of air and sunlight to give toxic cyanide.

The second is a combined bleaching and fixing solution (bleach-fix or blix):

> Metallic silver + oxidizing agent + thiosulphate → silver-thiosulphate complexes (soluble) + reduced oxidizing agent

The choice of the particular oxidizing agent for use in combination with thiosulphate in a bleach-fix solution is critical. Strong oxidizing agents such as potassium permanganate, dichromate or ferricyanide cannot be used because they would oxidize thiosulphate.

The most commonly used oxidizing agent is ferric EDTA (iron (III) ethylenediaminetet-ra-acetic acid). This oxidizing agent is strong enough to convert metallic silver to silver ions, but does not decompose thiosulphate. The earliest bleach-fix solution to be used was Farmer's reducer, which is an unstable solution based on ferricyanide and thiosulphate and is normally prepared immediately before use and then discarded. It did find use in some colour processes in which the material was first immersed in a solution of ferricyanide and then transferred to a second solution of fixer without an intermediate rinse. The ferricyanide carried over into the fixer formed an unstable bleach-fix but this approach could only be used in one-shot processing methods.

Washing

The purpose of the washing operation is to remove all the soluble salts left in the emulsion layer after fixing. The important salts to be removed are sodium (or ammonium) thiosulphate and the complex silver salts. If thiosulphate is allowed to remain, it can cause the silver image to discolour and fade, the sulphur in the residual thiosulphate combining with the silver image to form yellowish-brown silver sulphide. If the complex silver salts are allowed to remain they also may decompose to form silver sulphide, which will be especially noticeable in the highlights and in unexposed areas.

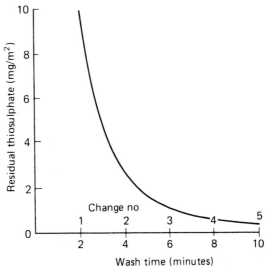

Figure 17.20 Washing in changes of water

For efficient washing of films or papers, running water is recommended as this ensures that fresh water is continuously brought to the gelatin surface. In practice, this method is very wasteful of water, and satisfactory washing can be obtained by using several changes of water. The removal of thiosulphate from an emulsion layer is a simple process of diffusion of soluble salt from the layer to the water, the rate increasing with the difference between the concentrations of salt in the layer and in the adjacent water. If the concentration of salt in the water becomes equal to that in the emulsion layer no further diffusion of salt from the emulsion can be expected. From this, the advantage to be gained by frequent changes is easily seen. Agitation during washing is very advantageous, because it displaces water heavily loaded with soluble salt from the emulsion surface and replaces it with fresh water. For quick and efficient washing of films, six changes, each lasting for two minutes with agitation, will usually prove satisfactory. With extreme agitation, three changes of half-a-minute will provide adequate washing for many purposes. Without agitation, five changes of two minutes each may be given (see Figure 17.20).

Washing is even more important with prints than with films, because paper emulsions are of finer grain than film emulsions and consequently fade much more readily in the presence of thiosulphate. Whereas in the fixation of films only the gelatin layer becomes impregnated with sodium thiosulphate, with prints sodium thiosulphate permeates the base and becomes held in the paper fibres and baryta coating, from which it is very difficult to wash out. For normal purposes, washing times of

30 minutes for single-weight papers and 1 hour for double-weight papers are adequate. However, even with these times of washing, traces of sodium thiosulphate are retained in prints and are sufficient to cause fading in time under storage conditions of high temperature and high humidity. If archival permanence is required, use of a so-called hypo eliminator is necessary (see below). Modern resin-coated papers do not suffer from these problems and a washing time of only 2 minutes is necessary.

As the effects of faulty washing (and faulty fixation) appear only after the image has been stored for some considerable time, there is a tendency for the dangers inherent in such faulty processing to be overlooked. It is, however, important that these stages of processing should be treated seriously; all the work that goes into the making of a photograph is wasted if they are ignored.

When permanence is more than usually important, the last trace of thiosulphate may be destroyed by a hypo eliminator, essentially an oxidizing agent which converts thiosulphate to sulphate, which is inert and soluble in water. Various hypo eliminators have been suggested, such as potassium permanganate and perborate, sodium hypochlorite and persulphate, and iodine in potassium iodide solution; all of these have serious drawbacks; probably the best method is to immerse the well-washed material in an ammoniacal solution of hydrogen peroxide for 5 minutes, following this with 10 minutes' further washing.

The use of a hypo eliminator appears to be justified only when it is impossible to remove the hypo by washing, a situation that normally arises only with prints. Hypo elimination is not intended as a short cut to do away with washing. There are, however, occasions when it is desired to shorten the washing time, and this can be achieved by the use of washing aids. These are based on an observation that the constitution of processing solutions can greatly influence the rate of removal of hypo from a photographic material during the final wash. One recommended technique is to rinse the material being processed briefly after fixation and then immerse it for two minutes in a 2 per cent solution of anhydrous sodium sulphite. By the use of this technique, the subsequent washing time can be reduced to one-sixth of that normally required.

Tests for permanence

It is sometimes desirable to test the completeness of the fixing and washing of negatives and prints. Two tests are required: one for the presence of unwanted silver salts, the other for the presence of thiosulphate. If either of these tests is positive the permanence of the negative or print cannot be assured.

Test for residual silver

A simple test for the presence of injurious residual silver compounds is to apply a drop of 0.2 per cent sodium sulphide solution to the clear margin of the negative or print after washing and drying. After 2 or 3 minutes the spot should be carefully blotted. If silver salts are present, silver sulphide will be formed. Any coloration in excess of a just-visible cream indicates the presence of unwanted silver salts. For control, a comparison standard may be made by processing an unexposed sample of material through two fixing baths and making a spot test on this sample. The presence of unwanted silver salts may be due to too short an immersion in the fixing solution, use of an exhausted fixer, or insufficient washing.

This operation must be carried out in a well-ventilated space, preferably in the open air, and well away from sensitive materials or processing solutions. In contact with acid, sodium sulphide gives off toxic hydrogen sulphide gas which also fogs photographic material. Keep the solution away from skin, eyes and clothing.

Test for residual sodium thiosulphate

Tests for residual thiosulphate are of many kinds; some are intended to be applied to the wash water, others to the photographic material itself. A test applied to the wash water gives an indication of the readily diffusible thiosulphate in the emulsion layer, but no indication of the amount of thiosulphate held by upper fibres or baryta coating. Such tests may therefore be useful with films but are of no value with papers. With all materials, a test of the residual thiosulphate in the photographic material itself is to be preferred.

One of the usual solutions for detecting the presence of thiosulphate in the wash water is an alkaline permanganate solution. The procedure for the use of this is as follows. Dissolve 1 gram of potassium permanganate and 1 gram of sodium carbonate (anhydrous) in 1 litre of distilled water. Add one drop of this solution to each of two vessels, one containing drops of water from the washed film and the other an equal quantity of water straight from the tap. If the colour persists for the same time in both, then washing has been satisfactory. If, however, the colour of the water drained from the washed material clears first, washing is incomplete. (The tap water control is required because tap water itself may contain substances which decolorize permanganate.) The detection of thiosulphate in the processed photographic material may be carried out quite simply by applying one spot of a 1 per cent silver nitrate solution to the clear margin of the negative or print after washing and drying. After 2 or 3 minutes the material must be thoroughly rinsed to remove excess reagent, which if not removed will darken on

exposure to light. If thiosulphate is present, silver sulphide will be formed where the spot was applied. Any coloration in excess of a pale cream indicates the presence of an unsafe amount of hypo.

Drying

After washing small batches of film, they should preferably be given a final rinse for a minute or two in a bath containing a few drops of wetting agent. This will improve draining and so help to prevent the formation of drying marks. The materials should then be taken straight from this bath and placed to dry. Surplus moisture from the surface of the material may be wiped off with a clean, film wiper, a soft chamois leather or a cellulose sponge dipped in water and wrung dry. For satisfactory drying, care should be taken to avoid placing films close together, as this will prevent effective access and circulation of air, with the result that negatives will dry slowly from the edges, the centre being the last to dry, which may result in variations in density. This effect is probably due to variation with drying rate of the packing or orientation of the silver grains in the emulsion.

Rapid drying by heat is not recommended except in properly designed drying cabinets; even if the films have been hardened, quick drying involves risk. Good circulation of clean air is much more expeditious than drying by heat. The air stream must not, however, be too violent; a steady current is all that is required. Under normal conditions, a roll film hung to dry about 5 feet from an electric fan will dry in 20–30 minutes. Care must be taken to maintain the flow of air until drying is complete, for the reason explained above. Where rapid drying of a large number of films is required, the use of heated drying cabinets is essential. When such cabinets are employed, it is desirable that ducting to the outside of the building should be installed. It is extremely important that no drops of water remain on either surface of a film before drying begins, as these will give rise to drying marks. Use of hard water for washing aggravates this risk, and in hard-water areas it is advisable to give a final rinse in distilled water, with or without wetting agent. In large-scale processing systems, drying is normally carried out within the processing machine. For high output and more rapid processing more efficient drying techniques are required. Jet-impingement dryers which direct air onto the film surface by slots or holes perpendicular to the surface are one such example. Other drying techniques include infra-red and microwave radiation. Also, in processing equipment drying is speeded up by the use of efficient squeegees to remove excess surface water. These range from flexible wiper blades to more sophisticated rollers and air squeegees.

Bibliography

Coote, J.H. (1982) *Monochrome Darkroom Practice*. Focal Press, London.

Haist, G. (1979) *Modern Photographic Processing*, Volume 1. Wiley, New York.

Jacobson, R.E. and Jacobson, K.I. (1980) *Developing*, 18th edn. Focal Press, London.

Jacobson, R.E. (1991) Photographic processes – 1890 to the present day, *Journal of Photographic Science*, **39**, 70–6.

Proudfoot, C.N. (ed.) (1997) *Handbook of Photographic Science and Engineering*, 2nd edn. IS&T, Springfield, VA.

18 Speed of materials, sensors and systems

Speed of photographic media

Two films are said to differ in speed if the exposure required to produce a negative on one differs from the exposure required to produce a negative of similar quality on the other, the material requiring the lower exposure being said to have the higher speed. The speed of a material thus varies inversely with the exposure required, and we can therefore express speed numerically by selecting a number related to exposure. The response of the photographic emulsion is complex, and speed depends on many factors, of which the following are the most important:

● Exposure
 The colour of the exposing light, e.g. whether daylight or tungsten light.
 The intensity of the exposing light. This is because of reciprocity law failure (Chapter 15).
● Development
 The composition of the developing solution.
 The degree of development, e.g. as measured by the contrast achieved. This depends principally upon the development time, the temperature and the degree of agitation.

Strictly it is not possible to define the speed of a material completely by a single value. Nevertheless, a speed number can provide a very useful guide to the performance that may be expected from a material and a single speed number can be determined for photographic materials provided that all the conditions are defined.

Methods of expressing speed

From some points of view, the problem of allotting a speed number appears simple. It would seem, for instance, that if we wish to compare the speeds of two materials, all we have to do is to make exposures on each to yield comparable negatives, and the ratio of the exposures will give us the ratio of the speeds. It is true that we can usefully compare speeds in this way, but the comparison may not be typical of the relation between the two materials under other conditions. Furthermore it will tell us nothing about the absolute speed of the materials. It is in trying to obtain absolute speed numbers for general application that difficulties arise.

One of the first problems in allotting speed numbers is connected with the variation in the speed of photographic materials with the conditions of use. This problem is generally overcome by agreeing upon standard conditions of exposure and processing for the speed determination. A further problem is concerned with the criterion of exposure to be used as the basis for the measurement of speed, i.e. the particular concept of speed which is to be adopted.

This problem arises from the fact that a negative consists not of a single density but of a range of densities. Consequently, it is not immediately apparent which density value or other negative attribute should be adopted. The characteristic curve is a help here, and several different points related to this curve have been suggested as speed criteria. Most of these points are related to the toe of the curve, i.e. to the shadow areas of the negative. These criteria can be divided into five main types, as follows:

● Threshold
● Fixed density
● Inertia
● Minimum useful gradient
● Fractional gradient

Each of these criteria will be assessed in turn.

Threshold systems

The threshold is the point on the characteristic curve corresponding to just perceptible density above fog, i.e. the point where the toe begins. Under the heading 'threshold systems' are those systems in which speed is based on the exposure required to give such a density (Figure 18.1).

The disadvantages of the threshold as a criterion of speed are that it is difficult to locate exactly and that it is not closely related to the part of the characteristic curve used in practice.

Fixed density

Another method of comparing film speeds is in terms of the exposure required to produce a given density above fog. For general-purpose films, a (diffuse visual) density of 0.1 or 0.2 above fog is frequently selected (Figure 18.2), which corresponds approx-

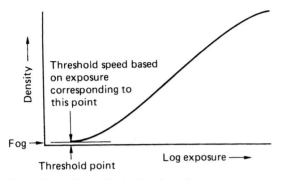

Figure 18.1 Threshold criterion of speed

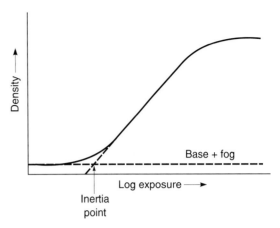

Figure 18.3 Inertia criterion

imately to the density of the deepest shadow of an average negative. With high-contrast materials in which a dense background is required, a density of 1 to 2 is a more useful basis for speed determination, while for materials used in astronomy, a density of 0.6 has been suggested. It will be apparent that the exposure corresponding to a specified density can be more precisely located than the threshold.

A fixed density criterion (D = 0.1 + fog) was adopted in the first National Standard speed system, the DIN system, in 1934, and is now employed in all current systems.

Inertia

This was the basis selected by Hurter and Driffield for their pioneering work on quantifying the photographic process. The inertia point is the point where an extension of the line representing portion crosses the line representing the base + fog level (Figure 18.3). Under the processing conditions which were prevalent in Hurter and Driffield's time, inertia was independent of development and so offers a fixed point of reference. Further, the inertia point is related to the linear portion of the

characteristic curve, i.e. the part of the curve in which objectively-correct reproduction in the negative is obtained. With short-toe materials, as used by Hurter and Driffield, this would be an advantage. With modern materials which have a long toe often with no linear region, the linear portion of the curve has little relevance.

Minimum useful gradient

Threshold speed systems work at the very bottom of the toe of the characteristic curve, while systems based on inertia ignore the toe completely. Neither system approximates very closely to actual practice, where a part (but only a part) of the toe is used. It was at one time suggested that a criterion more closely related to practice could be obtained from that point on the toe of the characteristic curve at which a certain minimum gradient is reached. A value of 0.2 for tan a in Figure 18.4 was proposed.

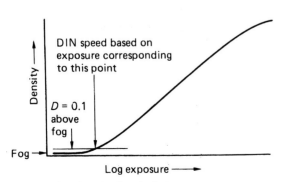

Figure 18.2 Fixed density criterion

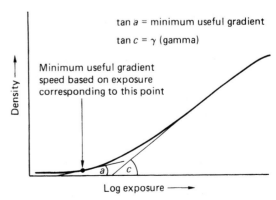

Figure 18.4 Minimum useful gradient criterion

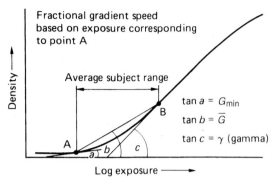

Figure 18.5 Fractional gradient criterion

The minimum useful gradient criterion was based on the idea that loss of tone separation in the shadows (shadow detail) is the first sign of under-exposure, and that this in turn is due to unacceptably low contrast in the portion of the characteristic curve occupied by the shadows. The minimum useful gradient criterion did not come into general use but is of interest because it led to the more fundamental fractional gradient criterion.

Fractional gradient

The main argument against the minimum useful gradient criterion is that the minimum value of contrast acceptable in the shadows is not a constant but depends upon the contrast grade of the paper on which the negative is to be printed. If the overall contrast of the negative is such that it needs a hard paper, the contrast of the negative in the shadows can be lower than with a negative requiring a soft paper. In other words, the minimum contrast acceptable in the toe depends upon the contrast of the negative as a whole. Realization of this fact led to the conception of the fractional gradient criterion. The point chosen for this criterion is the point A in Figure 18.5, where the slope of the tangent to the curve at A equals a given fraction of the slope of AB, the line joining the points marking the ends of the portion of the curve employed. This is usually expressed by the equation:

$$G_{min} = K \times \bar{G}$$

where G_{min} = tan a and \bar{G} = tan b (provided the density and log exposure axes are equally scaled), and K is a constant determined empirically.

Practical tests by L.A. Jones showed that a value for K of 0.3 gave results corresponding very well with the minimum exposure required to give a negative from which an 'excellent' (as opposed to merely 'acceptable') print could be made. In Jones's work, the fractional gradient point A was located by the equation:

$$G_{min} = 0.3 \times \bar{G}(1.5)$$

where $\bar{G}(1.5)$ means the average gradient over a log-exposure range of 1.5, a value which has been shown to be fairly typical for exterior scenes in daylight. When located in this way, point A is sometimes referred to as the 'Jones point'.

Table 18.1 The principal methods of expressing film speed of negative monochrome materials adopted in early standards

System	Date of introduction	Type of unit	Speed criterion	Development
H and D	1890	Arithmetic	Inertia	Developer to be bromide-free; development time not important
Scheiner	1894	Logarithmic	Threshold	Not specified
DIN*	1934	Logarithmic	Fixed density (0.1 + fog)	To be continued until maximum speed is obtained (optimal development)
BS*	1941	Logarithmic	Fixed density (0.1 + fog)	To be under carefully controlled conditions giving a degree of development comparable with average photofinishing. See Figure 18.6 and accompanying text
ASA*	1943	Arithmetic	Fractional gradient	
BS and ASA	1947	Arithmetic and logarithmic	Fractional gradient	
DIN	1957	Logarithmic	Fixed density (0.1 + fog)	
ASA	1960, 1972	Arithmetic	Fixed density (0.1 + fog)	
DIN	1961	Logarithmic	Fixed density (0.1 + fog)	
BS	1962, 1973	Arithmetic	Fixed density (0.1 + fog)	
ISO	1956, 1962		Fixed density (0.1 + fog)	

*DIN, ASA and BS stand respectively for Deutsche Industrie Normen, American Standards Association (now American National Standards Institution or ANSI), and British Standard. ISO stands for International Standards Organization.

This criterion was employed first by Eastman Kodak in 1939, and was later adopted by the then American Standards Association (in 1943) and the British Standards Institution (in 1947) as the basis for national standards.

Speed systems and standards

Table 18.1 outlines standards which were adopted by the various national standards organizations. In 1960–2, the American, British and German Standard speed systems were brought into line in all respects except for the type of speed rating employed, the American and British Standards specifying arithmetic numbers and the German Standard logarithmic ones. This agreement was made possible by work which showed that good correlation exists between speeds based on a fixed density of 0.1 above fog and the fractional gradient criterion, for a wide variety of materials when developed to normal contrast. Speed in all three systems is therefore now determined with reference to the exposure required to produce a density of 0.1 above fog density, this criterion being much simpler to use in practice than the fractional gradient criterion.

The American and British standards were further modified in 1972 and 1973 respectively. Both use the same speed criterion mentioned below but the developer solution and the illuminant specified are slightly different from those specified in the earlier standards. The common method adopted for determining speed in the three Standards is illustrated in Figure 18.6. This procedure is used in the current International Organization for Standardization (ISO) standard.

The International Organization for Standardization (ISO) is an international federation of national standard (member) bodies. Its work is undertaken by various technical committees on which interested member bodies have representatives. Draft international standards are adopted when at least 75 per cent of the member bodies have cast supporting votes. It is important to note that where ISO speed values are to be measured, reference must be made to all the specifications, and definitions which can only be found by direct reference to the standard.

Figure 18.6 shows the basic principles now used for the determination of ISO speed. The characteristic curve of a photographic material is plotted for the specified developing conditions. Two points are shown on the curve at M and N. Point N lies 1.3 log exposure units from point M in the direction of increasing exposure. The development time of the negative material is so chosen that point N has a density 0.80 greater than the density at point M. When this condition is satisfied, the exposure corresponding to point M represents the criterion from which speed is calculated. It is for the degree of

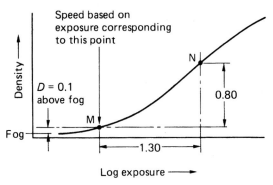

Figure 18.6 Principles of the method adopted for determining speed in current ISO standard

development thus obtained that the correlation between the fixed density criterion and the fraction gradient criterion that was referred to above holds good. In the current standards speeds are determined from the following formulae:

$$\text{Arithmetic speed, } S = \frac{0.80}{H_m}$$

$$\text{Logarithmic speed, } S^O = 1 + 10 \log_{10} \frac{0.80}{H_m}$$

where H_m is the exposure in lux seconds corresponding to the point M in Figure 18.6 and distinctions between arithmetic and logarithmic speeds are provided in the next section. Table 18.2 shows the equivalent arithmetic and logarithmic speed numbers. The range of exposure values for rounding to the particular speed value are provided in tables of the ISO Standard.

In Table 18.1 and elsewhere in the text reference has been made to arithmetic and logarithmic speed ratings. With arithmetic scales a doubling of film speed is represented by a doubling of speed number. With logarithmic speed scales, distinguished by a degree (°) sign, the progression is based on the common logarithm (base 10 scale). The common logarithm of 2 is almost exactly 0.3, and logarithmic film speeds are scaled so that a doubling of film speed is represented by an increase of 3 in the speed index.

The ISO speed ratings printed on the boxes of films are daylight ratings represented in the following ways:

- ISO 100, as arithmetic speed
- ISO 21°, as logarithmic speed
- ISO 100/21°, as both arithmetic and logarithmic speeds.

Speed ratings are not published for high-contrast materials, such as those used in the graphic arts or for

Table 18.2 Conversion table between ISO speed ratings

ISO speed rating	
arithmetic (S)	logarithmic (S°)
3200	36
2500	35
2000	34
1600	33
1250	32
1000	31
800	30
650	29
500	28
400	27
320	26
250	25
200	24
160	23
125	22
100	21
80	20
64	19
50	18
40	17
32	16
25	15
20	14
16	13
12	12
10	11
8	10
6	9
5	8
4	7

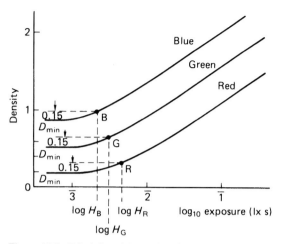

Figure 18.7 Principles of the method for determining speed of colour negative films (BS 1380: Part 3: 1980, and used currently in ISO 5800: 1987)

ISO speed ratings for colour materials

Colour-negative film

The principles of speed determination for colour-negative (print) films follow those previously described for monochrome materials. However, speed determination is complicated by the fact that colour materials contain layers sensitive to blue, green and red light and the standards involve averaging the speeds of the three sensitive layers. The currently adopted ISO standard (ISO 5800: 1987) uses fixed-density criteria for locating the speed points of the three layers, exposed in a defined manner and processed according to the manufacturer's recommendations after storage at $23 \pm 2\,°C$ for between 5 and 10 days, for general purpose films. Blue, green and red densities are measured according to defined ISO measurement standards and the characteristic curves shown in Figure 18.7 are plotted.

The points B, G and R are located at densities of 0.15 above the minimum densities for the blue, green and red sensitive layers. The log-exposure values corresponding to these points are log H_B, log H_G and log H_R respectively. The mean exposure, H_m, is then calculated from two of these values (H_G and the slowest layer, usually the red-sensitive layer H_R) according to the following formula:

$$\log_{10} H_m = \frac{\log_{10} H_G + \log_{10} H_R}{2}$$

Or,

$$H_m = \sqrt{H_G \times H_R}$$

microcopying, nor for special materials such as astronomical plates, holographic materials and recording films. As we have already seen, any system for expressing the speed of a photographic material must take into account exposure and development conditions, and must be related to some particular criterion of correct exposure. The systems in general use for ordinary photographic materials cannot be applied to high-contrast or special materials since the conditions of exposure and development are quite different. For these applications speed points are often measured at fixed densities greater than 0.1.

ISO speed ratings should not be confused with manufacturers' exposure indexes, which are suggested values for use with exposure meters calibrated for ISO speeds and have been arrived at by manufacturers' testing procedures for determining camera settings. A speed rating preceded by the letters 'ISO' implies that this rating was obtained by exposing, processing and evaluating exactly in accordance with the ISO standard.

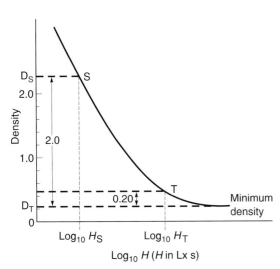

Figure 18.8 Principles of the method for determining the speed of colour-reversal (slide) films used in ISO standard (ISO 2240: 1994(E))

The logarithmic speed is calculated as follows:

$$\text{Logarithmic speed, } S^O = 1 + 10 \log_{10} \frac{\sqrt{2}}{H_m}$$

where all exposure values are in lux seconds. The speed values are then determined from a table of $\log_{10} H_m$ provided in the standard.

The arithmetic speed may be calculated from the value of H_m by the formula:

$$\text{Arithmetic speed, } S = \frac{\sqrt{2}}{H_m}$$

Colour-reversal film

Unlike the previously described standard for colour-negative films, that for colour-reversal films involves measurement of diffuse visual density and the plotting of a single characteristic curve, shown in Figure 18.8. Films are exposed in a defined manner and processed according to the manufacturer's recommendations. For the determination of speed two points (T and S) are located on the characteristic curve of Figure 18.8. Point T is 0.20 above the minimum density. Point S is that point on the curve at which the density is 2.0 above the minimum density. The log exposure values (log H_S and log H_T) corresponding to points S and T are read from the curve and their mean value (H_m) calculated:

$$\log_{10} H_m = \frac{\log_{10} H_S + \log_{10} H_T}{2},$$

$$\text{or } H_m = \sqrt{H_S \times H_T}$$

from which the speeds may be calculated by analogous procedures to those used for the previously described ISO standards:

$$\text{Arithmetic speed, } S = \frac{10}{H_m}$$

and

$$\text{Logarithmic speed, } S^O = 1 + 10 \log_{10} \frac{10}{H_m}$$

All exposure values are in lux seconds.

Speed of digital systems

The ISO standards now becoming adopted for digital systems arise from the activities of a technical committee PIMA/IT10. PIMA is the acronym for the Photographic and Imaging Manufacturers Association which is accredited by the American Standards Institute (ANSI) and sponsors PIMA/IT10. Members of PIMA/IT10 are representatives of users which include: other standards organizations, government agencies, manufacturers of digital cameras, scanners, printers, memory cards or components and imaging software developers. The purpose of PIMA/IT10 is to establish standards for electronic still-picture imaging.

The specification of speed for an electronic still-picture camera poses similar but different problems to those described earlier for photographic media. Digital cameras may involve substantial amounts of on-board data processing, such as data compression, analogue to digital conversion and the ability to alter speed settings electronically by increasing the electrical gain. Also most cameras include an IR-absorbing or blocking filter. The standard (ISO 12232:1998) takes many of these factors into account. Like the standards for photographic media, those for digital systems specify conditions of illumination, temperature, relative humidity and exposure time. In addition there are those variables specific to digital systems which require specification. These include:

- Adjustment of white balance for the illumination used, as equal RGB signals according to ISO 14524.
- Exposure time (photosite integration time) not longer than 1/30 s.
- IR-absorbing (blocking) filter should be used if required (ISO 14524).
- If the device uses any form of lossy compression this must be disabled.
- If lossy compression systems cannot be disabled then noise-based values for ISO speed determination should not be reported.

The standard (ISO 12232) provides two methods for the determination of speed and has as one of its aims a correlation between the ISO speed rating of an electronic camera and that for conventional photographic media. This means that a setting of ISO 200 on an electronic camera requires the same exposure time and aperture to that of a photographic film with an ISO speed of 200.

The two methods for determination of ISO speed are speed based on saturation and speed based on noise, which is the preferred method.

Speed based on saturation (S_{sat})

This is based on the user setting the camera exposure such that the highlights of the image are just below the maximum value (saturation) for the signal value, i.e. before they become clipped.

For focal plane measurement of exposure this is defined as:

$$S_{sat} = \frac{78}{H_{sat}}$$

where H_{sat} is the minimum exposure level (lx s) that produces the maximum output signal with no clipping.

If exposure cannot be measured in the focal plane, S_{sat} is calculated as follows:

$$S_{sat} = \frac{120A^2}{L_{sat}t}$$

where A is the effective f-number of the lens, L_{sat} is minimum luminance (cd m^2) of a uniform reflecting medium, and t is the exposure time (s).

Speed based on noise (S_{noise})

This is based on the minimum exposure value before the onset of noise becomes objectionable. This depends on subjective assessments of judgements and their correlations with noise to decide on the acceptability of noise. Two noise-based speeds are used ($S_{noise\ 10}$ and $S_{noise\ 40}$). Where 10 corresponds to the 'first acceptable' image and 40 the 'first excellent' image, determined from psychophysical experiments.

For focal plane measurement of exposure this is defined as:

$$S_{noisex} = \frac{10}{H_{S/Nx}}$$

In the above equation $H_{S/Nx}$, the exposure providing the camera signal-to-noise ratio which must satisfy a number of criteria specified in the standard, x has the value of 10 or 40. The signal-to-noise ratio may in general terms be defined as:

$$\frac{S}{N} = \frac{exposure\ (or\ luminace) \times gain}{standard\ deviation}$$

Exposure is the input photometric exposure (lx s), *luminance* is the luminance (cd m^2), *gain* is the incremental signal gain (ratio of rate of output level to that for the in input level of the monochrome or luminance channels), *standard deviation* is that for monochrome output level or weighted colour output (for colour cameras) for a 64 × 64 pixel area.

The standard also provides for the situation in which the focal plane exposure cannot be measured. The ISO standard (12232) also includes weighting factors for summing luminances in single exposure colour cameras in which the weighting factors are not known, from the individual channels according to ITU-R BT.709:

$$Y = \frac{2125}{10\,000}R + \frac{7154}{10\,000}G + \frac{721}{10\,000}B.$$

This standard provides the complete procedures to be adopted, together with tables from which ISO speed values can be read in relation to the determined values of noise S_{noise} or S_{sat}.

Speed ratings in practice

The only useful speed number in practice is one that adequately represents the speed of a material, or system, under the conditions in which it is likely to be used. Published speed values aim at providing exposures that will secure a printable negative, or an excellent result from a digital system under a wide range of conditions. The published rating for a given material or system cannot therefore be the best to use under all conditions of use. For critical use it is always best for the user to determine the appropriate exposure index to suit the particular equipment and conditions. Published exposure indexes provide a valuable starting point, although if you have selected an exposure index that suits your needs you should remember that it is no more 'correct' than the published figure, except for your own conditions of working.

Bibliography

Allbright, G.S. (1991) Emulsion speed rating systems, *Journal of Photographic Science*, **39**, 95–9.

Egglestone, J. (1984) *Sensitometry for Photographers*. Focal Press, London.

ISO 6: 1993 *Photography – Black-and-White Pictorial Still Camera Negative Films/Process Systems– Determination of ISO Speed.*

ISO 2240: 1994 *Photography – Colour Reversal Camera Films – Determination of ISO Speed.*

ISO 2721: 1982 *Photography – Cameras–- Automatic Controls of Exposure.*

ISO 5800: 1987 *Photography – Colour Negative Films for Still Photography – Determination of ISO Speed.*

ISO 6846: 1992 *Photography – Black-and-White Continuous Tone Papers – Determination of ISO Speed and ISO Range for Printing.*

ISO 7589: 1984 *Photography – Illuminants for Sensitometry – Specifications for Daylight and Incandescent Tungsten.*

ISO 12232: 1998 *Photography – Electronic Still-picture Cameras – Determination of ISO Speed.*

ISO 14524: 1999 *Photography – Electronic Still-picture Cameras – Methods for Measuring Opto-electronic Conversion Functions (OECFs).*

ITU-R BT.709: 1993 *Basic Parameter Values for the HDTV Standard for the Studio and for International Programme Exchange.*

Kriss, M.A. (1998) *A Model for Equivalency ISO CCD Camera Speeds.* Proceedings ICPS '98, Antwerp, Belgium, Volume 2, pp. 341–7.

Todd, H.N. and Zakia, R.D. (1974) *Photographic Sensitometry.* Morgan and Morgan, New York.

19 Camera exposure determination

Camera exposure

Other chapters have explained image formation by a lens and the response to light of various photosensors such as film. After due consideration of subject composition, perspective and sharpness, the photographer judges the best moment to make the exposure. An optical image of appropriate intensity is transmitted by the lens and reaches the photoplane for an appropriate length of time. This *camera exposure* is controlled by the combination of lens aperture (N) and shutter speed (t). More generally, the photographic result of exposure (H) is the product of image illuminance (E) and exposure duration (t), so that

$$H = Et \tag{1}$$

Determination of the optimum camera exposure is important for any photographic situation in terms of the resulting quality of the photographic image. Any subject contains areas of different luminances giving the overall *subject luminance ratio* (or range), so that image capture in turn gives a range of exposures at the photoplane, which on processing produces a range of monochrome or colour densities or values that form the image. With photographic materials, the range of image densities produced is predicted by the characteristic curve of the film, which depends on the type of film and the development conditions used, given the positioning of the range of log exposures on the curve, which depends on camera exposure.

Apart from exposure duration, the components of camera exposure are given by equation (13) in Chapter 5, including subject luminance, lens aperture and image magnification, with others such as lens transmittance (including the necessary exposure factor for any filter used) and vignetting, both optical and mechanical. Camera exposure may be determined by practical trial, e.g. by an estimate based on previous experience, followed by assessment of the resultant image after processing, especially if using a self-developing material. However, scene measurement using a lightmeter is preferable. Essentially this may be done by measurement of the *luminance* of selected areas (*zones*) of the subject, which is the resultant of the *illuminance* on the subject and its *reflectance*. Allowance is then made for other factors affecting camera exposure, including the *effective film speed*, which depends on film type and treatment, the chosen lens aperture or shutter speed, and any filter factor. These are all known values.

The four principal variables determining camera exposure are subject luminance, film speed, lens

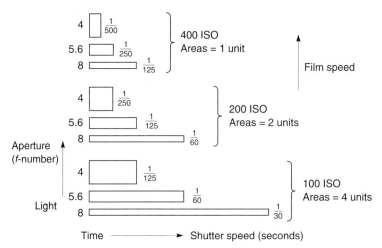

Figure 19.1 Exposure relationships. The diagram shows the relationships between film speed, exposure duration and aperture setting to give equivalent exposures (shown here as the areas of rectangles). A long exposure duration implies a reduced aperture and a slow film a larger rectangle, for a subject of given luminance

aperture and shutter speed. As shown in Figure 19.1, for any particular camera exposure there is a range of combinations of shutter speed and lens aperture usable with a given film speed. The selection of a suitable combination is a primary creative control in photography and will be dictated by the subject itself or the treatment required. For example, a moving subject may require a certain minimum shutter speed to give a sharp image. Alternatively, the focal length of lens used or possible camera shake may also dictate shutter speed as the important factor. In such cases the aperture must be chosen to suit this exposure duration. But for subjects requiring specific depth of field or the optimum performance from a lens, the choice of aperture is important and the shutter speed is secondary. The ability to change the illumination on the subject allows more choice of both of these variables. The use of tungsten illumination or electronic flash allows such variations in practice.

Optimum exposure criteria

Before considering methods of measuring subject luminance or illumination to estimate camera exposure, it is useful to consider the criteria by which the correctness of exposure is judged. For black-and-white or colour negatives, judgement rests finally on printing quality. So a *correctly exposed negative* is defined as a negative that will give an excellent print with least difficulty. Colour reversal material will be considered later. The visual judgement of black-and-white negative quality requires considerable experience due to related printing circumstances such as the print material used and the illumination system of the enlarger, together with personal preferences for the overall density level of a negative. A long-standing empirical quality guide is that a correctly exposed and processed negative made on pictorial film will usually have some detail in the shadows (low-density regions) and the highlights (high-density regions) will just permit text to be read through them if the negative is laid on a page in good light. For images on line film the correct exposure is judged from the appearance of the low-density fine line detail, which should be completely transparent and sharp-edged, without any filling-in, and the highlights should be totally opaque.

Colour negatives are more difficult to judge visually because of the presence of coloured dye masks. Again, the presence of shadow detail is a useful clue, but these regions are heavily masked. A colour densitometer can provide a quantitative guide to optimum exposure. For example, with a red filter, readings of 0.7–0.9, 1.15–1.35 and 1.10–1.30 in regions of mid grey tone, highlight and diffuse highlight respectively can indicate correct exposure.

Other quantitative criteria for optimum exposure of negative materials relate to the systems used for determining film speed. In the case of black-and-white pictorial materials, the sensitivity may be determined from the minimum exposure necessary to give a density of 0.1 (above base + fog density), which 'pegs' this density to the image detail of lowest luminance, i.e. the deepest shadow for which detail is to be recorded. In the case of colour-negative material, this minimum density level may be 0.15 or greater. With colour transparency materials, correct exposure gives a result that retains details in the highlights (low-density regions) so that there are no totally blank ('burnt-out') areas. Note that even with subjects having white highlight areas, the minimum density above base + fog level, and the shape of the characteristic curve, are such that a minimum density value of some 0.2–0.3 is necessary to avoid the highlight appearing as a 'hole in the transparency'. Correct exposure locates the important highlights at this point on the characteristic curve (which is also used for speed determination).

Exposure latitude

From the characteristic curve of a material, the separation on the log exposure axis between the maximum and minimum useful density points is termed the *useful log exposure range*. As stated above, the subject luminance ratio to be recorded determines the *log exposure range* given to the material. This may be less than, equal to or greater than the useful log exposure range the material can accommodate, related to its intrinsic contrast properties and processing treatment. If the log exposure range is less than the useful log exposure range of the material, as may often be the case, then the *exposure latitude* of the material is the factor by which the minimum camera exposure necessary to give adequate shadow detail in the case of negatives (or highlight detail in the case of reversal materials) may be multiplied, without corresponding loss of highlight detail (or shadow detail) (see Figure 19.2). Detail may be defined as discernible density differences in adjacent tones corresponding to resolved regions of the subject.

In the case of colour-negative materials, exposure latitude also depends on use with an illuminant of suitable colour temperature. For example, an excess (or deficiency) of the blue component of the illuminant will give the blue-record layer more (or less) exposure relative to the green- and red-record layers, and place the blue exposure range on a different region of the characteristic curve relative to the other two. This reduces exposure latitude, as any exposure outside the region that is linear for all three emulsions simultaneously will result in coloured highlights or shadows.

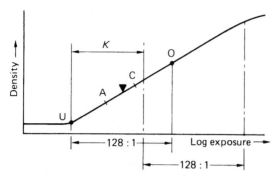

Figure 19.2 Latitude to over-exposure for negative materials. The index, U, O, A and C markings of the Weston Master exposure meter are shown relative to an average subject luminance range. The exposure latitude *K* is a multiple of the minimum useful exposure

The high contrast of colour reversal material, typically equivalent to a gamma value of some 1.4, causes a reduced exposure latitude, even with a subject whose luminance range is 30:1 or less. The lower inherent contrast of negative materials gives more exposure latitude, and the ability to record subjects of greater luminance range. Conventionally, exposure latitude is expressed as tolerance in stops or *exposure values (EV)* relative to the optimum exposure. Colour reversal materials usually have a latitude of ± 0.5 EV or less, where ± 1 EV indicates a permissible error of double or half the optimum exposure. Note that natural vignetting across an image field from a wide-angle lens may give an illumination level that varies as much as this, so a *centre spot filter* may be needed. Ideally, reversal material should be exposed to within 0.3 EV of optimum.

The DX film speed coding system used on 35 mm film cassettes can input the metering system with film exposure latitude value. Depending on film type, four alternative ranges of ± 0.5, ±1, +2, −1 and +3, or

−1 EV may be used. The primary use is for automatic exposure metering; for example, if the camera is set on aperture-priority mode, and the overall subject luminance is so high that the aperture chosen requires an exposure duration shorter than that available from the shutter speed range, then if the resultant over-exposure does not exceed the latitude of the material, the shutter will be released; otherwise it could be set to lock.

Most colour-negative materials have a useful exposure latitude of up to +3 EV (factor ×8) to over-exposure, and −1 EV (factor ×0.5) to under-exposure, and give acceptable prints. Because of the fixed development conditions of colour-negative material and the non-scattering properties of the dye images (so that print contrast is unaffected by the type of illumination in the enlarger) most colour-print paper materials are available in only one or two contrast grades. Alteration of print contrast to suit particular subjects or negatives is possible by the use of contrast-altering silver masks. Black-and-white negative material has similar (or greater) exposure latitude than colour-negative material, but with the possibility of altering processing conditions to cope with extremes of subject luminance ratio, plus a range of paper grades for printing.

Subject luminance ratio

To assist exposure determination a subject can be classified by its *luminance ratio*, or (incorrectly) the 'subject luminance range'. This is numerically equal to the product of the *subject reflectance ratio* and the *lighting ratio*. For example, a subject whose lightest and darkest zones have reflectances of 0.9 and 0.09 respectively, i.e. a reflectance ratio of 10:1, when illuminated such that there is a lighting ratio of 5:1 between maximum and minimum illumination levels, has a subject luminance range of (10 × 5):1, i.e. 50:1. A high luminance ratio denotes a subject of high contrast. Luminance ratios range from as low as 2:1

Table 19.1 Subject classification by luminance range or ratio

Subject luminance ratio classification	Luminance ratio	EV range	Average luminance as percentage of illumination	Weston Master series exposure meter index	Approximate exposure correction factor
Very high	2048:1 (2^{11}:1)	11	11	C	+1 EV
High	512:1 (2^{9}:1)	9	14		+0.5 EV
Average	128:1 (2^{7}:1)	7	18	arrow	0
Low	32:1 (2^{5}:1)	5	25		−0.5 EV
Very low	8:1 (2:1)	3	41	A	−1 EV

to 1 000 000:1 (10^6:1). Integration of individual luminance levels gives a value for the *average reflectance* of a scene, which depends on the subject luminance ratio. Based upon appropriate scene measurements, it is usually assumed that an average outdoor subject has a luminance ratio of 128:1 or 2^7:1, corresponding to a seven-stop (or 7 EV) range.

As well as luminance ratio, the integrated luminance of all tones in a scene may be used for exposure determination purposes. The value for an 'average' outdoor scene is taken to be some 12–18 per cent and the range of colours also integrate to a mid-grey tone, usually called 'integration to grey'. Indoor studio subjects may be closer to 18 per cent reflectance. Neutral grey cards of 18 per cent reflectance are often used as substitute 'average' subjects for exposure determination using reflected light measurement. For meter calibration purposes, a subject with a reflectance ratio of 2048:1 (2^{11}:1) has a mean reflectance of some 11 per cent; with 8:1 (2^3:1) a reflectance of some 40 per cent (see Table 19.1). If the exposure meter is calibrated (as it usually is) for a mean reflectance of 18 per cent, this could result in exposure errors respectively of +80 per cent and –60 per cent. It is usually necessary with a subject matter of excessively high or low contrast to apply a *subject correction factor*.

If excessive, the subject luminance ratio may be reduced by the use of additional illumination, such as by *fill-in flash* or *synchro-sunlight* techniques. In many cameras with automatic exposure metering, a *segmented photocell* monitors the average luminance and luminance ratio of zones in the scene, such as by measuring the central area and the background separately. Supplementary fill-in light from an integral flash unit (to reduce subject contrast) may be provided automatically over a limited range of flash-to-subject distances. The required amount of flash is monitored by off-the-film measurement.

Development variations

For a given set of processing conditions, a variation in development time can be used to control the contrast of black-and-white negatives, as measured by the *negative density range* corresponding to the *log exposure range*. A change in development time alters density range (contrast) of a negative, whereas a change in camera exposure determines the position of the density range on the characteristic curve. The effects of exposure and development are summarized by the graphs in Figure 19.3. By giving normal, reduced or increased development and exposure in various combinations, some nine varieties of negative are possible. Not all of these have ideal printing characteristics, of course: some cannot adequately be matched to the available grades of printing paper, and others do not have a suitable overall density level.

For example, an under-exposed and under-developed negative is of low average density and low density range, and requires a hard grade of paper (which has a low exposure latitude and emphasizes graininess). Also, areas of low density show marks and scuffs to a greater extent than areas of higher density. On the other hand, an over-exposed, over-developed negative is grainy, and requires a long printing exposure on a soft grade of paper, which does not in general record shadows and highlights well owing to the shape of its characteristic curve. Variation in development time changes effective film speed, too; in particular, prolonged development results in a higher effective exposure index for the material, producing what amounts to an over-exposed result if the exposure was based on a normal speed rating. Reduced development, however, can match the useful log exposure range of a material to a high subject log luminance range, to yield a negative of density range printable on a normal grade of paper. A side effect of under-development is a loss of effective film speed, so the material must have its camera exposure adjusted accordingly. This technique of increased exposure (or down-rating of speed) and reduced development to deal with high-contrast scenes works best with materials of nominal speed ISO 400.

The possibilities of individual development of exposed material to suit scenes whose luminance ratios have been measured using a spot metering system, form the basis of the *Zone System* of exposure determination.

Colour-negative material cannot be treated in this way, but colour-reversal film may have its effective exposure index varied, (usually increased) by alteration of first development time, contrast is also affected, though the exact nature of the variation depends on the material.

Exposure determination

Early experience of development by inspection led to an empirical rule of exposure: 'expose for the shadows and develop for the highlights'. At a later stage, development by time-and-temperature methods, and use of printing paper with a variety of contrast grades, meant subjects could be exposed and negatives processed to a similar contrast to give acceptable prints. So the rule was modified to 'expose for the shadows and let the highlights take care of themselves', and this advice is still useful for black-and-white negatives.

Colour negatives can be exposed for shadow detail, but the minimum exposure should locate shadows on the linear portion of the characteristic curves and not on the toe regions. This gives correct reproduction of tone and colour. Provided the highlights are also on the linear portion, tone and colour reproduction are

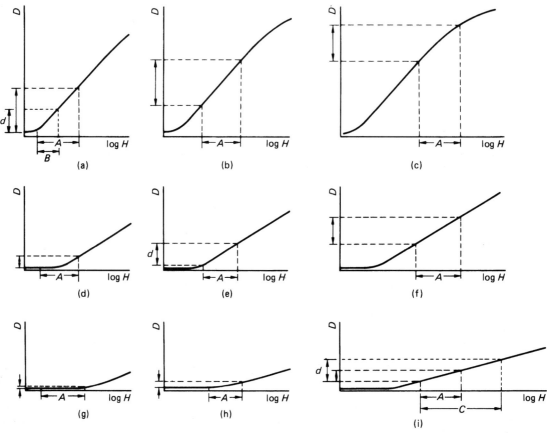

Figure 19.3 Summary of the effects of exposure and development variations on negative density range and density values. (a) Under-exposure and prolonged development. (b) Correct exposure and prolonged development. (c) Over-exposure and prolonged development. (d) Under-exposure and normal development. (e) Correct exposure and normal development. (f) Over-exposure and normal development. (g) Under-exposure and curtailed development. (h) Correct exposure and curtailed development. (i) Over-exposure and curtailed development. Key: A, normal subject log luminance range; d, negative density range, to print on normal grade paper; B, low subject log luminance range; C, high subject log luminance range

acceptable throughout the range of densities. A colour print cannot reproduce the large tone range shown in a black-and-white print, as tonal distortions acceptable in the latter are unacceptable in colour prints due to the colour-balance errors in the deepest shadows, and the low tolerance of most viewers to such 'skewed' colour balance. Such local colour imbalances are not correctable at the printing stage, as corrective filtration is only effective for *overall* colour casts.

With reversal materials, the method of camera exposure determination by measurement of both shadow and highlight luminances is equally valid, the shadows and highlights being suitably located on the characteristic curve. This time the highlights are recorded as *low* densities, as described above. So it is best to base exposure on subject *highlights*, and let the shadows 'take care of themselves'. This arrange-

ment works for most subjects, but for high-key subjects (i.e. with no important dark areas), exposure is best increased by $+\frac{1}{2}$ to $+1$ EV to avoid a 'washed-out' appearance. Likewise, a low-key subject (i.e. with minimal highlight detail) needs a reduction in exposure of $-\frac{1}{2}$ to -1 EV.

It may not be convenient or easy to measure directly the highlight luminance of a subject, but an incident-light measurement gives a good approximation, since the highlights of most subjects are white or near-white, with a high reflectance, so an illumination measurement is similar to a highlight luminance measurement.

An *artificial highlight* may be provided in a scene for easy measurement of reflectance by making the exposure measurement on a matt white card. If the assumed reflectance of this is 90 per cent, i.e. 5 times more than an assumed average scene reflectance of

18 per cent, and the meter used is calibrated in the normal way, for 18 per cent reflectance, the indicated exposure should be multiplied by 5 to provide correct exposure. The artificial highlight method is useful in copying work, and is particularly worthwhile when colour slides are being exposed of subjects with unusual reflectance properties (snow scene, dark forest glades).

Practical exposure tests

If the material has no film speed rating, optimum exposure can be determined by practical tests, as for materials intended for copying, photolithography and similar tasks. The instruction sheet supplied with the material may suggest starting points for exposure level with particular illuminants, filters, development and subjects. Such techniques are suited to the studio and photographic laboratory, as processing and evaluation are carried out immediately after exposure. When using a large-format studio camera, for example, the dark-slide of the filmholder may be progressively inserted to allow a doubling sequence of timed exposures to be given. Thus a sequence of 1, 2, 4, 8 and 16 seconds exposure is given by consecutive additive exposures of 1, 1, 2, 4 and 8 seconds respectively. The camera must remain stationary during the tests, of course. For small- and medium-format cameras a similar test series is given by exposing a sequence of individual frames. Either the shutter speed can be varied while the aperture is held constant or vice versa. Of these choices, the shutter-speed variation gives a constant image luminance but may cause reciprocity-failure effects, and the depth of field is constant. If aperture variation is used, two series of exposures should be made, one with increasing and one with decreasing aperture size. This is because many iris diaphragm systems have up to a quarter of a stop backlash. Aperture variation is mandatory if flash illumination is being used.

Many cameras with integral power-wind offer an 'automatic bracketing' feature in some automatic exposure modes, so that on setting a choice of up to $\pm 3\,\mathrm{EV}$ in $\frac{1}{3}\,\mathrm{EV}$ increments, a range of exposures is given with exposure variations to bracket the exposure in cases of doubt or where the necessity for a good result overrides the cost of the film. Either shutter speed or aperture may be varied in such a series.

The use of self-developing materials, usually known as a 'Polaroid test', with material of a known exposure index, gives a means of determining or verifying exposure, and may be used on location. A suitable back is used on the camera, and the results examined after exposure. Differences in exposure indexes between the self-developing film and the (colour) material can be allowed for by simple calculation or the use of a neutral density filter.

Composition, positioning of subject and props, lighting balance and the presence of any undesirable reflections may also be checked.

Light measurement

Optimum exposure may be determined by measurement of the luminance of the subject (or zones of it), or, alternatively, by measuring the illumination on the subject (incident light), followed by location of the log luminance ratio in a suitable position on the characteristic curve of the material. Ideally, the luminance ratio itself should be determined; but this requires experience in locating suitable zones, and is by no means easy to measure accurately. This method is usually too complicated for everyday use. Simpler methods are preferred in practice, even though they may, in theory, be less accurate.

Measurement of luminance of darkest shadow

This method locates this tone at a fixed point on the toe of the characteristic curve, giving the correct density to the deepest shadow that is to be recorded. Practical difficulties include the necessary metering sensitivity, the effects of flare light on measurements and the effect of highlights in the field of view of the meter. Some meters have an indicator for this measurement; for example, Weston exposure meters had a 'U' mark which was set to the darkest-shadow reading.

Measurement of luminance of lightest highlight

This locates the highlight at a fixed point with the highlight detail and other tones as differing densities. Shadow detail is usually adequately recorded, but a subject of average contrast may receive more exposure than necessary. The original Weston exposure meter had an 'O' setting for this method; otherwise with other meters the indicated exposure should be divided by 5. This method is similar to the *artificial highlight* method, which works well for colour-slide material. Note that when using this method, measurements must not be made on specular highlights.

Measurement of a key tone

A subject zone of intermediate luminance, i.e. a midtone, is selected and located at a fixed point on the characteristic curve. Typically an exposure 10 to 16 times more than that for the shadow or speed point is given. This *key tone* may be a Caucasian flesh tone

(about 25 per cent reflectance). Control of scene illumination allows the shadows and highlights to be suitably located too. A substitution method may also be used: a medium grey card (18 per cent reflectance) is held so as to receive the same illumination as the subject it is replacing. The light meter is used close up so that the card fills the acceptance angle of the photocell. The 'arrow' setting of the original Weston meter was calibrated for such a mid-tone, as are most metering systems.

Cameras with automatic exposure control may offer an 'exposure memory lock' feature to allow the metering system to measure and set an exposure for a key or substitute tone, after which the picture is recomposed and the stored exposure given. This memory may be self-cancelling after exposure, or may require manual cancellation.

Measurement of total scene luminance

This 'integration' method accepts all the light flux from the chosen area of the subject to be photographed. Such a *reflected light measurement* is widely used, as it is simple to carry out and requires little selective judgement. It is used in hand-held meters, in flash meters and for in-camera metering systems for both ambient and flash illumination. Its high success rate is largely because the useful log exposure range of negative materials is greater than the log luminance range of the average subject.

A correction is usually necessary to the indicated values of exposure settings for subjects of very high or very low contrast, or for a subject of non-typical tone distribution, such as a high-key or low-key subject. Typical corrections necessary are a doubling of indicated exposure for high-contrast or high-key subject matter, and a halving of indicated exposure for low-contrast or low-key subject matter. The original Weston exposure meter had two exposure index marks denoted 'C' and 'A' to cope with high- and low-contrast (or high- and low-key) subjects. These settings give corrective alterations of +1 EV and −1 EV respectively.

Most cameras with an automatic-exposure mode have an associated *exposure compensation control* which offers manually-set increases or decreases of up to ±3 EV or more in increments of $\frac{1}{2}$ or $\frac{1}{3}$ EV to cope with atypical subjects or luminance distributions.

Measurement of incident light

The *incident light method* measures the light incident on the subject rather than the light reflected from it. It is an easy measurement to make with a hand-held light meter, but is not suitable for an in-camera metering system. It positions the highlights

(rather than the mid-tones) on the characteristic curve, and is thus particularly suitable for use with colour-reversal materials. No information is given with regard to the shadows, and exposure corrections may have to be made if the subject is very dark or back-lit.

Exposure meter calibration

A hand-held *light meter*, commonly called an *exposure meter*, may be used to measure either subject luminance or subject illumination. It is a form of photometer not dissimilar to those used by lighting engineers, with its light value readings convertible into camera exposure settings. The usual form of meter calibration and its relationship to subject, camera and film speed parameters are shown in Figure 19.4, where a reflected light reading is being taken.

Consider a small off-axis area of the subject of luminance L that is imaged in the focal plane of the camera with image illuminance E_F. The values of L and E_F are related by equation (16) in Chapter 5, so that if the lens has a transmittance T, and f-number N, and the region is at an angle θ from the optical axis,

$$E_F = \frac{L\pi T \cos^4 \theta}{4N^2} \qquad (2)$$

Equation (2) may be rewritten as

$$E_F = \frac{qL}{N^2} \qquad (3)$$

where q is a constant derived from known (or assumed) values of the quantities above.

So from equation (1), the exposure H_F at the focal plane is given by

$$H_F = \frac{qLt}{N^2} \qquad (4)$$

H_F can be replaced by a sensitometrically determined speed number S for the film used where

$$S = \frac{H_O}{H_m} \qquad (5)$$

where H_O is a constant and H_m is the *speed point* or *minimum useful exposure*. Now,

$$H_F = kH_m \qquad (6)$$

where k is constant and a multiple of H_m therefore,

$$H_F = \frac{kH_O}{S} \qquad (7)$$

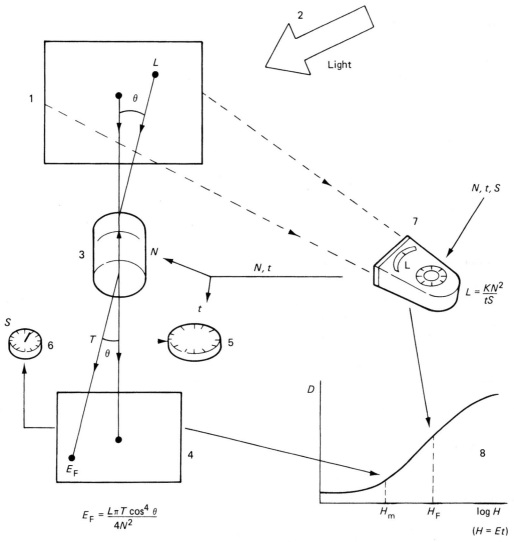

$$E_F = \frac{L\pi T \cos^4 \theta}{4N^2}$$

$$L = \frac{KN^2}{tS}$$

$$(H = Et)$$

Figure 19.4 The calibration of a light meter. The subject (1) is illuminated by light (2) and imaged by the lens (3) onto the film plane (4). The camera has a shutter speed setting dial (5) and film speed setting control (6). The luminance of the scene is measured by a light meter (7). The film speed and exposure are related by the characteristic curve (8) of the film. (The other values are referred to in the text.) Film speed is determined from the value H_m and the exposure meter indicated an exposure corresponding to H_F

So, by substituting for H_F in equation (4) and rearranging, we have

$$t = \frac{kH_O N^2}{qLS} \tag{8}$$

Choosing a new constant K, usually called the *calibration constant* for luminance, gives

$$K = \frac{LtS}{N^2} \tag{9}$$

Similarly, for an incident light reading when the illuminance E_S of the subject is measured,

$$C = \frac{E_S tS}{N^2} \tag{10}$$

where C is the calibration constant for illuminance. The calibration procedures are detailed in a number of national and international standards such as those formerly published by ANSI, BS, DIN and currently by ISO.

For black-and-white materials, the exposure for a mid-tone of some 18 per cent reflectance is located at approximately 16 times that required for the speed point, to distribute the subject tones along the characteristic curve. The value of k in equation (6) would be 16 in this case. Typical values of the constants K and C for a mid-grey (18 per cent) tone are 3.33 and 20.83 respectively; more precise values may be given in the instruction manual for a particular exposure meter. For a subject of 18 per cent reflectance $L = 0.18E_S$. From equations (9) and (10), t is proportional to N^2, so that

$$\frac{t_1}{t_2} = \frac{N_1{}^2}{N_2{}^2} \tag{11}$$

Given an appropriate film speed and scene luminance or illumination value, the *calculator dials* of an exposure meter will solve equation (11) for a wide range of *equivalent pairs* of shutter speed (t) and lens aperture (N). The pair most appropriate to subject treatment may then be chosen, e.g. either to provide sufficient depth of field or to stop action. A digital readout on an LCD screen can give a comprehensive display of exposure data.

For various forms of in-camera metering, if shutter speed or aperture is pre-selected then the appropriate value of the remaining variable will be given. If *program exposure mode* is set, a combination of both t and N will be set. This mode of use is best explained in terms of *exposure values*.

Exposure values

The term *exposure value* (EV) must not be confused with *light value* (LV), which is simply a number on an arbitrary scale on an exposure meter as a measure of subject luminance or illuminance. The exposure value (EV) system originated in Germany in the 1950s and was intended as an easily mastered substitute for the shutter speed/aperture combination, giving a single small number instead of two (one of which was fractional). The EV system is based on a geometric progression of common ratio 2, and is thus related to the doubling sequence of shutter and aperture scales. The relationship used is

$$2^{EV} = \frac{N^2}{t} \tag{12}$$

Taking logarithms and rearranging

$$EV = \left(\frac{1}{\log 2}\right) \log \left(\frac{N^2}{t}\right) \tag{13}$$

or

$$EV = 3.32 \log \left(\frac{N^2}{t}\right) \tag{14}$$

For example, a combination of 1/125 second at $f/11$, from equation (14), gives an EV of 14. Similarly, all exposures equivalent to this pair will give an EV of 14. Some cameras made in the 1950s and 1960s have shutter speed and aperture setting controls linked together and to an EV scale, but this feature is now rare.

Although no longer used for such purposes, the idea of the EV scale is useful in exposure measurement practice, remembering that an increment of 1 in the EV scale indicates a factor of 2 in exposure. A primary use is to give a quantitative measure of the *sensitivity* of a metering system by quoting the minimum EV that can be measured for a film speed of ISO 100. For example, a hand-held exposure meter using a silicon cell has a typical measuring sensitivity of between EV –2 and EV –8, with a range of 16 EV. A sensitivity of EV –2 can allow metering in moonlight. The use of various attachments such as spot meter arrangements or fibre-optic probes reduce the sensitivity considerably; a high initial value is therefore needed for meters intended for such accessories.

In-camera meters are limited in their sensitivity by the light losses involved in their optical systems, and by the maximum aperture of the lens for full-aperture TTL metering. For comparisons this aperture must be quoted: for an $f/1.4$ lens a sensitivity of EV 1 at ISO 100 is typical. The operating limit of an in-camera autofocus system is quoted similarly. Another use of the EV system is the *EV graph* (Figure 19.5), where the scales on the rectangular axes are shutter speed and aperture. A series of diagonal lines connecting pairs of values of equivalent exposures represent the EV numbers. These EV loci may be extended to an adjacent graph of film speed and subject luminance. On such a graph it is possible to show the behaviour of a particular camera, for example in terms of the envelope of performance with the range of settings available. Additionally in the case of an automatic camera the different exposure modes and forms of programmed exposure can be compared.

Finally, EV 'plus' and 'minus' scales are commonly used on the exposure compensation and auto-bracketing controls of automatic cameras, and to indicate filter factors and exposure compensation for interchangeable focusing screens.

Incident light measurements

Measurements of scene reflectance or luminance are not always ideal, as some subjects have either a non-typical tone distribution, or extremes of luminance, or

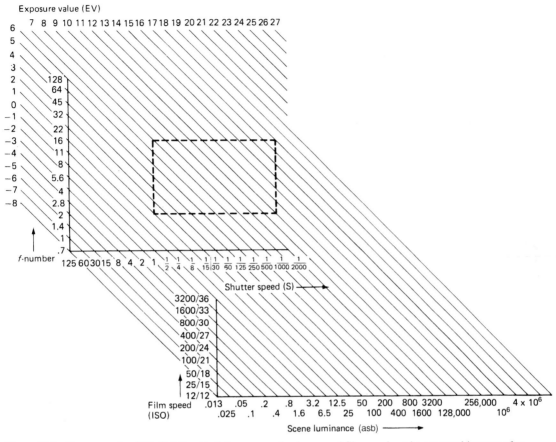

Figure 19.5 Exposure value (EV). Relationship between scene luminance and film speed can be expressed in terms of an exposure value which is a combination of aperture and shutter speed. The rectangle indicates the typical operating range of a camera fitted with an *f*/2 lens

both. Assuming that for an average scene both incident- and reflected-light measurements give the same correct camera exposure, then equations (9) and (10) are equal, so that

$$\frac{L}{E_S} = \frac{K}{C} \tag{15}$$

But as $L = RE_S$, then

$$R = \frac{K}{C} \tag{16}$$

Subject reflectance is thus assumed to be equal to the ratio of the exposure constants K and C. For example, a meter may be calibrated for a midtone so that $K = 3.64$ and $C = 25.6$, so that R is approximately 0.14 or 14 per cent. Other values such as the 18 per cent reflectance of a neutral grey test card are used as a

substitute 'average subject'. The reasoning for use of an incident light reading of subject illuminance E_S is that by definition no subject can have a reflectance greater than 1.0, and exposure may be adjusted so that the brightest highlight renders an acceptable maximum or minimum density in a negative or transparency respectively. But since in equation (10) the illumination E_S is not precisely defined as to source size or direction, the light meter must integrate the incident light over a large acceptance angle to account for all contributing sources. For this purpose a translucent diffuser is placed over the photocell for incident light readings. The diffuser also reduces the response of the photocell, and different transmittance values or masks may be used to limit the reading with intense light sources such as studio flash units.

The diffuser may be flat or dome-shaped to give different forms of response. For a *flat diffuser*, if the angle between the normal to the photocell surface and

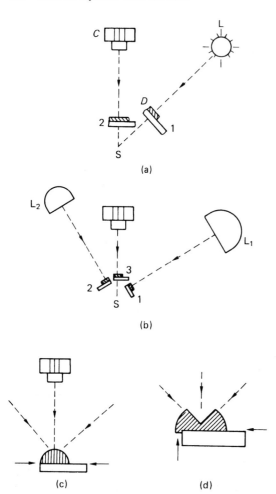

Figure 19.6 Techniques of incident light metering. (a) Flat diffuser Duplex method: C, camera; S, subject; L, brightest source; D, diffuser. (b) Flat diffuser and measurement of lighting ratio: (c) Domed diffuser taking a single reading. (d) Invercone diffuser includes backlighting

The flat *cosine receptor* is directional and necessary when illuminance measurements are to be made taking into account Lambert's Cosine Law. However, when a flat diffuser is used for making measurements of illuminance for a photographic exposure, the meter is pointed in turn at the camera position from the subject, then at the brightest source of illumination from the subject (Figure 19.6). The log arithmetic mean of the two readings is then taken. This average is the mid-point of the readings on the (logarithmic) scale of the meter. This technique is called the *Duplex method*. Alternative methods include either pointing the meter towards the camera, or, pointing midway between the camera and a single illuminant, or taking averages of readings towards the camera and each illuminant in turn.

The *lighting ratio*, based upon the measurement at the subject with the meter pointed at each illuminant in turn, requires the much more directional response of a flat diffuser. For this reason many flash exposure meters are fitted with a flat diffuser. When an exposure meter is converted for use as a photometer to measure illuminance on a surface, again a flat diffuser is essential.

A more convenient method of incident-light metering is to use a diffuser of hemispherical shape; in this case the meter is simply directed from the subject towards the camera position for a single measurement. Its shape effectively presents a surface that is equally oriented in all directions relative to the subject–camera axis and its projected area relative to a beam of light at any angle of incidence is the same.

The compact *invercone* design of diffuser as used on the Weston series of exposure meters was a truncated hemisphere with an inverted cone inside it. It overhung the meter body and picked up any significant backlighting on the subject. The term 'invercone' is often generally applied to diffusers for meters.

a ray of light from the primary illuminant is denoted by θ, then the response (r) is given by

$$r = k_a \cos \theta \tag{17}$$

and of a *hemispherical diffuser* by

$$r = \frac{k_b (1 + \cos \theta)}{2} \tag{18}$$

From the mathematical forms of equations (17) and (18) the flat and dome diffusers are said to have *cosine response* and *cardioid response* respectively. The constants k_a and k_b are not necessarily identical and may be the value of r when θ is zero.

Exposure meters in practice

The photocell

Although the majority of cameras now have some form of in-camera exposure determination system, the hand-held *light meter* or *photometer*, usually called an *exposure meter*, is still widely used. It can be used with cameras that do not have their own metering system; as a check on in-camera systems or for difficult subjects or extremely low-light conditions; for incident-light measurement; and as the basis of a system of specialized accessories for a range of light measurement tasks. It also has a role in the measurement of ambient light and electronic flash illumination.

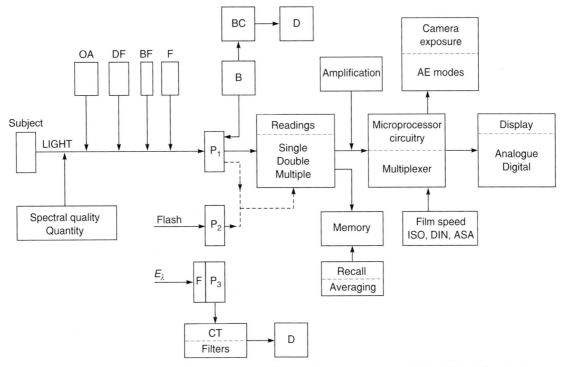

Figure 19.7 Block diagram of the principal components and features of an exposure meter. Ambient light, flash and colour temperature may all be measured. OA, optical attachments; DF, diffusers; BF, baffle; F, filter; B, battery; BC, battery check; D, display; P_1, P_2, P_3, photocells; CT, colour temperature; E_λ spectral illumination

An *exposure meter* consists basically of a light-sensitive electronic device, some means of limiting its acceptance angle, an on–off switch and a range-change switch, a power source (as necessary), a scale in light values, a set of calculator dials or readout of exposure data, and a diffuser for incident-light readings (see Figure 19.7). A variety of types of photocell are in use, including selenium 'barrier-layer' photovoltaic cells, cadmium sulphide (CdS) photoresistors, and silicon photodiodes (SPD). Their relevant properties are listed in Table 19.2; suitable circuitry is described in Chapter 9. The spectral sensitivity of the various types differs markedly (see Figure 19.8). The CdS and SPD types have high infrared sensitivity. The SPD is usually encapsulated with a blue filter to absorb IR to reduce this

Table 19.2 Properties of photocells used in exposure determination systems

Photocell type	Se	CdS	SPD
Battery needed	No	Yes	Yes
Amplifier needed	No	No	Yes
Speed of response	Slow	Slow	Fast
Memory effects	Eventually	Yes	No
Sensitivity	Low	Medium to high	High to very high
Linear response	Approximately	Poor	Yes
Spectral (colour) sensitivity	Matches eye	Red bias	Needs blue filter
Size	Large	Small	Small
Range change device needed	Yes	Yes	No
Electrical property	Photovoltaic	Photoconductor or photoresistor	Photovoltaic
Cost of unit	Medium	Low	High

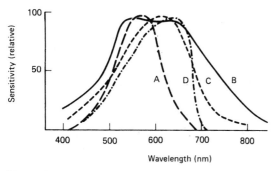

Figure 19.8 Spectral sensitivity of photocells. The graphs of relative spectral sensitivity against wavelength show the approximate spectral response or sensitivity of different photocells used in exposure metering systems. A, Visual spectral sensitivity and a filtered selenium cell. B, CdS photoresistor. C, Silicon photodiode (SPD) fitted with a blue filter ('silicon blue' cell). D, Gallium arsenide phosphide photodiode (GPD)

sensitivity and is referred to as a 'silicon blue' cell. A selenium cell is also usually filtered to match its spectral response to that of the standard CIE photopic visual response curve.

The response of the selenium cell to light is dependent upon cell area, limiting sensitivity unless the cell area is large. A plug-in booster cell can increase sensitivity by some 2 EV. The Weston series of exposure meters used a hinged perforated baffle arrangement over the large photocell to limit response at medium to high light levels. For low light levels the baffle was swung back to uncover the full cell area for greater response. This action also changed the light-value scale from high to low range.

A CdS photocell meter may have a resistor network to change its response range; alternatively it may use a neutral-density filter or a small aperture in front of the cell. The SPD gives a near-linear response over a range of some 15–20 EV and does not require a range changeover switch. Its response is unaffected by its previous exposure to light, unlike the CdS photocell.

Acceptance angle

Both the CdS and SPD photocells are small devices with a response that is independent of cell area; but require special optical arrangements when used in exposure meters. All photocells are non-imaging devices, which integrate the incident light flux. The response is restricted to the subject area covered by the camera lens, or a smaller area. Alternative techniques of integrated, small-area and spot readings are used.

Traditionally, the selenium cell meter was limited to have an acceptance angle of some 50 degrees, corresponding to the field of view of the standard lens of a camera format, but with a much more rectangular aspect ratio, to reduce the effect of a bright sky area. The removal of the baffle increases the acceptance angle to some 75 degrees, to assist sensitivity. The acceptance angle is determined by a field angle limiter of honeycomb grid type, or by a refraction type using a transparent lenticular screen with a grid in front of the selenium cell. The much smaller CdS and SPD cells may simply be located at the bottom of a cylindrical black-lined well or have a positive lens bonded to the receptor surface. These arrangements give acceptance angles of some 30 degrees, allowing more selective readings of zones of the subject area. A small viewfinder may help to aim the meter cell at the desired area. Accessory devices may reduce this angle even further to 15 degrees or even 7 degrees, with a reduction in sensitivity due to light losses in the optical system used. The *spot meter* or *exposure photometer* is a specialist meter of acceptance angle 1 degree or less (see below). Such spot metering is often available in SLR cameras as one of two or three alternative means of selective image measurement.

Optical attachments

An exposure meter is the basis of a 'system' of accessories and attachments for conversion to alternative measurements or purposes. The use of acceptance-angle reducing devices and viewfinders has been described above. Other devices may allow small-area readings of incident light to be made in the plane of the projected image on the easel of an enlarger or at the copyboard of a copying set-up. These *enlarging* and *repro attachments* may incorporate a diffuser and a plastic or fibre-optics *light guide* to enable the meter to be used flat upon the easel or copyboard. The enlarging attachment is used for techniques of printing exposure determination by comparative image photometry using a calibration obtained from an 'excellent' black-and-white print made by trial-and-error methods. Other accessories may include a small dome diffuser on a rod and flying lead to permit readings from within a table-top set-up or an *eyepiece adapter* for attachment to the viewfinder of a camera to monitor the screen image. A flexible *fibre-optics probe* attached to the photocell may act as an angle limiter or allow *ground-glass screen measurements* to be made. The meter then requires an additional calibration mark to allow for the effect of the transmission of the screen (or a comparative method may be used). A *micro-scope attachment* allows the meter to be fixed to the

eyepiece end of a microscope tube with the eyepiece lens removed, so as to measure the luminance of the intermediate aerial image from the objective lens and indicate exposure time by comparative image photometry from known exposure parameters. An accessory photocell probe on a flying lead can be inserted via a special dark-slide into the focal plane of a large-format camera and make small-area readings in the plane of the focused optical image. This could be considered as possibly the ideal metering arrangement. Other attachments may convert the meter into a colour-temperature meter, for measurement of electronic flash, or with a reduced acceptance angle, as a spot meter.

Most meters no longer use a moving-coil arrangement to move a pointer over a light value scale. Instead, solid-state devices give a digital read-out, and a LED or LCD panel gives the values, operational status and mode of the meter. The meter may also have a flash-metering mode, offering the same range of incident and reflected light readings and use of most of the accessories. Some exposure meters may also be used in a photometer mode where the light values are converted into luminance or illuminance readings in SI units. Alternatively, digital light meters may give a direct digital readout of the values in various chosen units.

Photometry units

The SI unit of luminance is the candela per square metre ($cd\,m^{-2}$), formerly called the *nit*. The SI unit of illuminance is the lux (lx), which represents an illuminance of 1 lumen per square metre. These units and their use in photometry are discussed in Chapters 3 and 5. Most meters that are adapted for incident-light measurements can be used for direct measurements of illuminance, using conversion tables, often supplied with the meter. Table 19.3 shows the relationships between EV numbers (for ISO 100) and illuminance values in luxes. Also shown is the relationship between EV numbers and luminance in candelas per square metre, as measured by a reflected-light meter. The relation between luminance and illuminance is that a perfectly diffuse reflector illuminated by 1 candela per square metre has an illuminance of 1 lux, so that for the same EV reading, luminance ($cd\,m^{-2}$) = $1/\pi \times$ illuminance (lx).

Unfortunately, the situation is complicated by a number of units left over from the obsolete FPS and CGS systems. These can be found in descriptions of lighting units and in the instruction booklets for older types of exposure meter. As conversion tables for these units are becoming scarce, they are included in Table 19.3. The foot-lambert (ft L) is still often

Table 19.3 Photometric units and camera exposure. Approximate corresponding values of various units of luminance and illuminance related to exposure value (EV) for camera exposure determination with a film of speed ISO 100

EV (for 100 ISO)	Subject luminance (brightness)					Illuminance (illumination on subject)				EV (for 100 ISO and R = 1)
	$cd\,m^{-2}$ (nit)	stilb $cd\,cm^{-2}$ (sb)	apostilb $lm\,m^{-2}$ (asb)	$cd\,ft^{-2}$	lambert (L)	foot-lambert (ft L)	lux $lm\,m^{-2}$ (lx)	phot $lm\,cm^{-2}$	$lm\,ft^{-2}$	
−2	0.03		0.1			0.01	0.1		0.01	−2
−1	0.06		0.2			0.02	0.2		0.02	−1
0	0.13		0.4	0.01		0.04	0.4		0.04	0
1	0.25		0.8	0.02		0.07	0.8		0.07	1
2	0.5		1.6	0.05		0.15	1.6		0.15	2
3	1		3.14	0.09		0.29	3.1		0.29	3
4	2		6.28	0.2		0.58	6.3		0.58	4
5	4		12.57	0.4		1.17	12.6		1.2	5
6	8	0.001	25.1	0.8		2.34	25		2.3	6
7	16	0.002	50.3	1.5		4.67	50		4.7	7
8	32	0.003	100.5	3	0.01	9.34	100	0.01	9	8
9	64	0.006	201	6	0.02	18.7	201	0.02	19	9
10	128	0.01	402	12	0.04	37.5	402	0.04	37	10
11	256	0.03	804	24	0.08	75	804	0.08	75	11
12	512	0.05	1609	48	0.16	150	1609	0.16	150	12
13	1024	0.1	3217	96	0.32	299	3217	0.32	299	13
14	2048	0.21	6434	190	0.64	598	6434	0.64	598	14
15	4096	0.41	12868	381	1.29	1196	12868	1.29	1196	15
16	8192	0.82	25736	761	2.57	2392	25736	2.57	2392	16
17	1684	1.68	51472	1522	5.15	4784	51472	5.15	4784	17
18	32768	3.28	102944	3044	10.29	9568	102944	10.29	9568	18

encountered in connection with screen luminance of a projected image. The stilb (sb) was (and still is) used for the luminance of light sources and the apostilb (asb) for the luminance of non-self-luminous sources. It will be noticed from Table 19.3 that the apostilb is numerically equal to the lux; but it is a unit of luminance, not illuminance.

Spot meters

A photometer or exposure meter with an acceptance angle of 1 degree or less is usually referred to as a *spot meter*. Its applications are for precise measurement of the luminance of small areas of a large subject, for example when a long-focus lens is to be used, or if the subject matter is inaccessible or if the area of interest is itself small. A complex optical system is needed. Such a meter will typically show a field of view of some 5–20 degrees horizontally, in a viewfinder with focusing capabilities. The much smaller measuring spot area is shown in the field together with a light value scale which may be in digital form. A measuring accuracy of ± 0.1 EV is possible. The classic design of visual spot photometer used a Kepler telescope configuration and a split cube carrying a 'spot mirror' to image an internal reference light source in the measurement area. The spot was matched to the subject tone by attenuation using sliding density wedges (Figure 19.9). The principle was essentially that of the Bunsen grease-spot photometer. Two calibration indices were provided for use of either highlight or shadow readings of

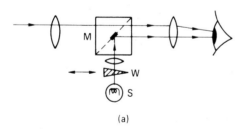

(a)

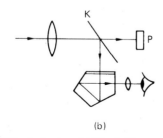

(b)

Figure 19.9 Spotmeters. (a) Visual: M, spot mirror; W, optical density wedge; S, reference source. (b) Photo electric: P, photocell; K, aperture mirror or beamsplitter

luminance. The image was inverted (a minor inconvenience) and could be focused for close distances.

Modern designs use an SPD, with a pentaprism to give an upright, unreversed image in the viewfinder. A flare-free arrangement uses an *aperture mirror* containing a small aperture in front of the photocell; this avoids the necessity for a beamsplitter which could otherwise affect the polarization of the emergent light. Most instruments are calibrated for a mid-grey tone, but shadow and highlight readings may also be used as well as an averaging arrangement. A digital display gives comprehensive summaries of relevant exposures for various camera modes, scene luminance range and other data. Several separate readings may be stored, displayed on recall and averaged as required. Both ambient-light and flash-metering modes are available, but incident-light readings are not possible.

SLR cameras with TTL metering systems may offer the alternative of a true *spot mode* reading. The acceptance angle of the spot field varies with the focal length of the camera lens in use, and with long-focus lenses this can be very small. A number of spot readings may be taken in the subject area, stored, averaged and the calculated exposure then given automatically by the camera in the appropriate exposure mode. This form of TTL metering should not be confused with *small-area readings*, where an acceptance angle of some 5–20 degrees is used (5–10 per cent of the viewfinder area), and calibration is for a mid-tone.

In-camera metering systems

Automatic exposure

A light metering system built into a camera body is directly coupled to the camera controls either for manual operation and setting or for use of one of several alternative *automatic exposure* (AE) modes. The necessary photocell(s) may be located in various positions, requiring different optical systems for each variant. Non-SLR cameras usually have the metering system located to read directly from the subject, possibly with a choice of reflected- or incident-light measurements. A selenium photocell may be placed as an annulus round the lens, using lenticular baffles to determine the acceptance angle.

The more compact CdS or SPD cells can be placed behind an aperture fitted with a small lens located either on the camera body or near the camera lens. The latter is preferable, as such positioning makes it possible to compensate for the effects of lens attachments such as filters. Metering sensitivity is high as light losses are low compared with TTL metering. A frame line in the viewfinder may indicate the measurement area. To provide simple allowance for film speed, a metal plate with a series of graded

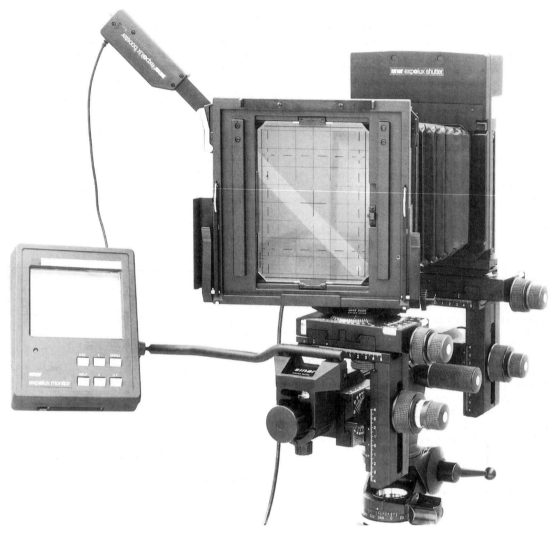

Figure 19.10 A photocell on a probe inserted into a large format camera to take small area readings at the photoplane

apertures, or a tapered slit, is located in front of the photocell and is linked to the film speed setting control, using a change in the incident light, rather than electronic circuitry to provide variation of the cell output.

TTL measurements have advantages in that only the imaged area is used, regardless of the lens fitted, and compensation of exposure is usually automatic for bellows extension and optical attachments. Exceptions include infrared and linear type polarizing filters.

Such exposure compensation is particularly important when zoom lenses are being used, as the *f*-number usually changes as focal length is altered. In such cases some means of constantly monitoring image illuminance is essential.

The best location for a photocell is in the true photoplane of the camera, as realized in some insertable metering systems for large-format cameras (Figure 19.10), but an *equivalent focal plane* can be used instead. Full details of photocell locations and optics are given in Chapter 9. Such TTL systems are normally limited to simple measurements of subject luminance, and the uncertainties of exposure determination with non-average scenes using a simple integrated measurement led to the use of alternative sensitivity patterns for meters, also described in Chapter 9, to improve the proportion of acceptable exposures. The usual patterns are those of approximate full-area integration with central bias, of centre-weighted measurement (possibly with directional bias) and of small-area measurement. More

sophisticated systems may use true spot metering of very small areas, or zone measurements by multiple zone or *segmented photocells* to provide scene categorization information (matrix metering). A desired sensitivity pattern is obtained by positioning the planar photocell behind spherical or aspherical lenses, or by use of patterned Fresnel mirrors. Pairs of photocells with overlapping fields of view may also be used.

A particularly accurate form of TTL metering is that of *off-the-film* (OTF) metering, in which image luminance measurements are made using the light reflected from patterned shutter blinds or from the film surface itself during exposure; off-the-film monitoring is possible even with rapidly fluctuating light levels. For short exposure times, the patterned shutter blind simulates average image luminance over the obscured area of the film gate during travel of the slit. Flash metering uses the open gate full frame area.

In-camera metering is normally used in semi-automatic or automatic mode. In the former, either shutter speed or aperture or both together are varied manually, until a readout indicates that correct exposure has been set. The camera can be used to scan and sample the scene in chosen areas, and a modified exposure given as judged necessary. Automatic exposure offers a choice of shutter priority, aperture priority and various program modes. Additionally, *metering pattern* may be altered, an *exposure compensation control* may be used or an *exposure memory lock* employed to improve the proportion of acceptable pictures from non-average scenes.

Metering sensitivity is dependent upon the effective maximum aperture of the lens in use. Measurement may have to be carried out in a *stopped-down mode* if a lens without automatic iris diaphragm operation or maximum-aperture indexing is used. Metering is of the reflected light from a subject as the incident-light mode is not available to TTL metering systems. Metering sensitivity with an $f/1.4$ lens and ISO100 film is generally of the order of 1 EV, significantly less than that of a hand-held meter.

Programmed exposure modes

An automatic camera with choice of exposure modes includes at least one *programmed exposure mode*; this is the 'snapshot' form of setting for such a camera. This was the original form of automatic exposure as pioneered in early cameras of the point-and-shoot variety with no alternative exposure modes other than one for flash that gave a fixed shutter speed and allowed the aperture to be set manually. More recently, multi-mode cameras may offer choice of user-selectable or calculated programs as well as one set by the lens in use.

The main advantage of a programmed AE mode is that photography is speeded up when rapid response

is vital to capture fugitive subject matter. Seconds can be lost in the preselection of aperture or shutter speed or the taking of a meter reading, whereas the programmed-mode camera gives a usable result almost every time on pressing the release. Even the time taken to focus can be crucial, but the combination of autofocus with programmed AE gives a swift response. Programmed exposure is also convenient at times when the user wishes to be relaxed and not to have to concentrate on decisions about exposure, as well as being a safety-net for inexperienced photographers. The principles of programmed AE, often designated on a camera as the *'P' mode*, are simple. As previously explained, the photocell output and the set film speed will determine the necessary exposure for a scene in terms of exposure value (EV), which represents a wide range of equivalent combinations of lens aperture and shutter speed. The electronic circuitry in the metering system is programmed to give one particular combination according to the EV data fed in. Examples of such programs are shown in Figure 19.11, in which a program is given as a straight line with a chosen slope and one or more changes in direction to span the EV measuring range of the camera.

A horizontal or vertical line shows that one variable is kept constant while the other changes continuously; for example, shutter speed may change continuously over the range 8 s to 1/8 s while the aperture is held constant at $f/1.4$. A sloping line shows that both variables change continuously. A steeply sloping line shows that priority is given to the maintenance of short exposure durations, to minimize the risk of camera shake or to stop subject motion, while relying upon lens performance and accurate focusing at the corresponding large aperture. A required EV of (say) 12 for correct exposure is interpreted in various ways by programmed cameras. It could mean settings of 1/30 s at $f/11$ for one camera or 1/80 s at $f/7$, 1/125 s at $f/5.6$ or even 1/500 s at $f/2.8$ for other cameras. An electronically controlled shutter and fractional control of lens aperture setting allows non-standard exposure settings. Note that a viewfinder readout of the analogue type usually indicates rounded-off values for shutter speeds and apertures; for an analogue display the values of 1/80 s at $f/7$ in the example above may be shown rounded off to the nearest conventional values of 1/60 s and $f/8$ (the actual camera exposure will be the true value). A digital display will usually show the true values.

Some decision should be left to the user as to whether shutter or aperture priority might be appropriate under different circumstances, such as moving subject matter, depth-of-field requirements, low light levels or long-focus lenses. So there is a choice of 'normal', 'action' and 'depth' AE programs. Additionally, the insertion of an alternative lens of different focal length may automatically select one of three shutter-biased program modes usually referred

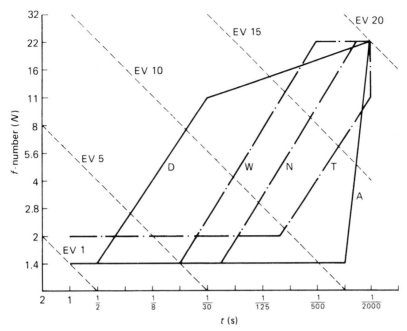

Figure 19.11 Programmed exposure modes. The EV graph shows five possible program profiles over an exposure range from EV 1 to 20. These are D (depth), W (wide), N (normal), T (telephoto) and A (action). Both D and A may be selected manually while W, N and T are usually set by the focal length of the lens in use

to as 'wide', 'standard' and 'tele', with the turning point of the program line on the EV graph at the point where the minimum hand-held shutter speed may be used. The slope of the program line may increase progressively from 'wide' to 'tele'. A zoom lens may alter the program selected continuously as focal length is altered. It may even be possible for the user to designate a non-standard program profile for the camera.

The use of any programmed AE mode requires that the lens aperture control is locked at a minimum value *AE setting* as for shutter-priority exposure mode; the aperture value is then selected by the camera in increments that may be as small as 0.1 EV. When used with a metering-pattern system capable of some analysis of tonal distribution of the subject matter, for example centre-weighted or segmented-photocell types, then programmed exposure modes are capable of producing a high proportion of acceptably exposed, sharp results. This form of 'decision-free photography' may be less acceptable in situations requiring critical creative control of focus and subject sharpness.

Segmented photocell systems

Accurate determination of camera exposure, especially by in-camera TTL AE systems, is limited by

variations in subject luminance ratio and non-typical subject tone distributions, which necessitate their recognition and classification by the user. The use of spot metering, small-area and various weighted integrated readings can help, with intelligent use. An overall improvement in the percentage of successful results is possible using a *segmented photocell* or *matrix metering* arrangement for scene classification (Figure 19.12). The viewfinder image is measured,

Figure 19.12 Simple arrangements of segmented photocell arrays

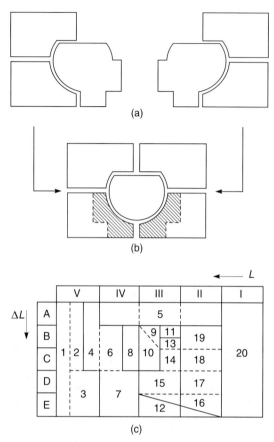

(a)

(b)

(c)

Figure 19.13 Metering with segmented photocells (Nikon AMP system). (a) Twin overlapping pairs of three segments; (b) format zones; (c) scene classification by luminance L and luminance ratio ΔL value from zones

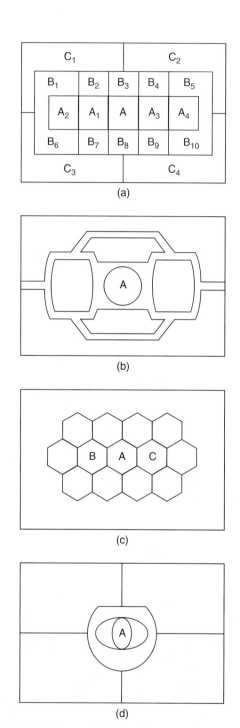

(a)

(b)

(c)

(d)

Figure 19.14 Segmented photocell arrangements. (a) Canon, 16 segments: A, spot metering. A_1 to A_4, movable spot metering and focus zones. Evaluative metering uses all segments. (b) Pentax, eight segments: A, spot metering. Other zones give centre-weighted and averaged metering. (c) Minolta, 13 segments. A simpler seven-segment inner group is also used. A, spot metering. A, B, C, centre-weighted. (d) Nikon, eight segments: A, spot metering

assessed, compared to stored data on a large number of scene patterns and categorized for subject type. Adjustments are then made automatically to the basic camera exposure. The idea was introduced in 1983 in the Nikon FA camera; and other systems soon followed. For example, the screen area may be measured as five or six separate zones (with some overlap) by means of two symmetrically opposed segmented photodetector arrays, both with three independent measurement areas (Figure 19.13a and b). Numerous alternative arrays of cells are used, some of which can provide spot, small area and weighted readings as well (Figure 19.14). The weighted response data from the separate segments is classified by signal-processing techniques, using an onboard microprocessor. Analysis of zonal luminance difference values and the total subject luminance value, plus the metering pattern, allows classification into a number of computer-simulated subject types (Figure 19.13c). The basic exposure is then modified

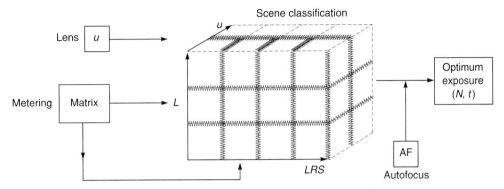

Figure 19.15 Matrix metering and fuzzy logic. Scene classification uses subject distance (*u*) from the lens, scene luminance (*L*) and luminance range of the subject (*LRS*) or contrast. Fuzzy logic blurs the sharp demarcation of scene types. Defocus information about the zones of the scene comes from the autofocus (AF) module. The output is the optimum exposure as an *f*-number (*N*) and shutter speed (*t*).

using stored data for several hundred subject types as determined from practical tests or evaluation of photographs.

The *tone distribution* may be determined, often just as a comparison of central foreground to background luminance, and if a chosen difference value in EV is exceeded, then an integral flash unit may be charged automatically and used for fill-in purposes. The lens aperture and shutter speed are optimized separately for subject distance (using autofocus data) and flash synchronization. Additionally, separate segments may be switched out or used in different configurations to provide various alternative forms of metering sensitivity patterns (spot, small-area, centre-weighted). Larger numbers of zones and segments are used in some cameras.

Scene classification

A further improvement in scene classification for automatic exposure methods is to provide subject distance (*u*) information from the autofocus module and focus setting on the lens. This latter requires that the focusing control has a suitable transducer and data link with the microprocessor in the camera. From the *matrix* array of photocells used to divide the scene into segments, the scene can be classified using the three pieces of data, overall scene luminance (*L*), luminance range of the subject (*LRS*) and the subject distance (*u*) (see Figure 19.15). The scene classification box is subdivided into a series of scenes for which optimum exposure data is stored, based on extensive practical tests, especially for non-typical scenes. The scene is matched to one of these and the optimum exposure given. The defocus data from the AF system helps determine whether the subject is central or off-centre in the frame as this can give emphasis to different segments of the matrix. By the additional use of 'fuzzy

logic' procedures, the scene type boundaries are not sharply defined but overlap to some extent to avoid sudden changes in exposure, e.g. when using a motor drive, when small variations in an essentially constant scene may cause a noticeable change in exposure as the scene is inadvertently reclassified and exposure altered. The same principle can be applied in a simpler way to the use of fill-in flash to give a balanced exposure to subjects, especially of excessive contrast. A simplified flow diagram of matrix metering is given in Figure 19.16.

A matrix array of CCD photocells filtered to blue, green and red light, together with scene classification data can also be used in-camera to assess the colour temperature of a scene.

Electronic flash exposure metering

Flash properties

Electronic flash may be used as the main light source for a picture or in combination with ambient light to provide a means of reducing the subject luminance ratio. The properties of electronic flash, including production, spectral and temporal properties and the control of output, are detailed in Chapter 3; but it is useful here to emphasize its widespread use as an illuminant either in the form of a studio flash unit, or as a unit that can be attached to the camera, or as a 'dedicated' unit with secondary roles such as autofocus assistance, or as an integral unit within the camera body. The useful properties of flash are a controllable luminous output, a constant colour temperature close to that of daylight, motion-stopping abilities, low heat emission and, in some cases, strobing capability. Its only drawback is the difficulty of synchronization with a focal plane shutter at high shutter speeds. The illumination on a subject is a combination of direct and indirect light, the reflective properties of the

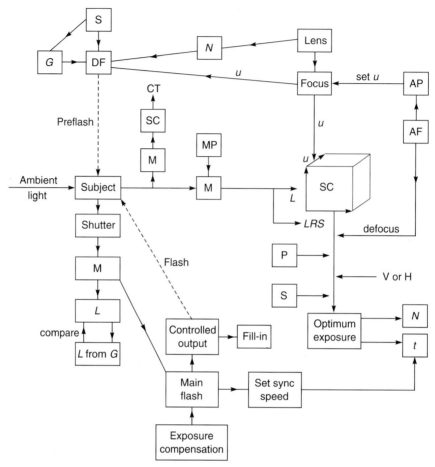

Figure 19.16 Matrix metering. A much simplified flow diagram for data and control of exposure using matrix arrays for ambient light, flash and colour temperature: S, film speed; DF, dedicated flashgun; *G*, guide number; *N*, *f*-number; *u*, subject distance; CT, colour temperature; M, matrix measurement; MP, matrix pattern; SC, scene classification; *L*, subject luminance; *LRS*, luminance range of the subject; *t*, shutter speed; P, chosen AF program; AF, autofocus module; AP, autofocus pattern; V, vertical format; H, horizontal format

surroundings of a subject often having a pronounced effect on the illumination. In the absence of any flash modelling lights, it can be difficult to allow for such effects. Also, as the flash duration is short, any visual judgement as to illumination level and the necessary exposure is not possible, so some means of flash exposure determination is desirable. Various methods are used, but in general, flash exposure control is either by use of lens aperture or alteration of flash output, due to the necessity of synchronizing the flash output with the camera shutter.

Self-developing materials

The use of these materials allows a test exposure with flash and also gives a positive confirmation of

correct flash synchronization, and of ensuring, at the very least, that the 'M' setting has not been used by mistake. Flash synchronization can be checked visually by opening the camera back, placing the eye about 30 cm behind the focal plane, opening the lens aperture fully and operating the camera shutter with the camera pointed at a white wall. A bright disc indicates correct functioning. If either a star, or a segment of a disc or nothing at all, is seen, the shutter is out of synchronization.

Modelling lights

Most studio flash units have modelling (guide) lights integral with the flashtube. These lights may indicate lighting distribution and balance and can be either

turned off or left on when the flash operates. They may be tungsten or tungsten–halogen and the light output is altered in proportion to the flash output if this is variable. Studio flash units usually offer a variety of power increments, some allowing increments as small as 0.1 EV.

A conventional exposure meter may be used in conjunction with these modelling lights to provide a measure of the related flash output. The technique is simple. Using an approved lighting arrangement, a bracketed series of test exposures is made using the flash illumination and then the correct *f*-number is determined by visual inspection of the results. The subject is then metered using an incident-light technique, and from the calculator dials, a shutter speed is found that corresponds to the *f*-number determined by tests for the same film speed setting. This shutter speed marking now acts as the flash calibration index; if the lighting arrangement or subject is changed, the meter will indicate the new *f*-number required for flash exposure opposite the shutter speed marking found.

Flash exposure guide numbers

The light output and the required camera exposure for a given flash unit can conveniently be expressed by an *exposure guide number* or *flash factor* (as explained in Chapter 3). For a film of speed ISO 100 and a subject distance *d* (in metres), the necessary *f*-number *N* is given from the guide number (*G*) by the relationship $G = Nd$.

This guide number is often included in the alphanumeric code designation of a flash unit. For example, inclusion of the number 45 would usually indicate a basic guide number of 45 in metres for ISO 100 film material. The guide numbers *are* only guides, and practical tests are needed to establish their correctness, which depends to some extent on the effects of the surroundings, ambient light level and the shutter speed used. The guide number also changes with *fractional power output* selection as offered by many units, some of which are able to select full, half, one-quarter, one-eighth and one-sixteenth power or less, or, when a camera motor-drive setting is selected, giving reduced power and rapid recycling. Likewise an alteration in *flash covering power* to suit different lenses will also affect the guide number.

To assist the determination of the necessary *f*-number for correct exposure given the variables concerned, most flashguns incorporate some form of calculator in the form of annular dials, or as a comprehensive LED or LCD display. Additional useful data shown are the *subject distance range* covered and especially the *maximum subject distance* possible for correct exposure at the indicated *f*-number. Guide numbers are devised on the assumption of a

near-point source and are based on the Inverse Square Law. A doubling of flash output or doubling of film speed used increases the guide number by a factor of 1.4. A quadrupling of output or film speed doubles the guide number. Doubling the distance between the flash source and the subject distance needs a change of +2 EV in exposure (factor ×4).

While such calculations are reasonably simple to make for one flash source, it becomes increasingly difficult to do so for two or more sources, especially if they are at different distances and of differing powers. The positioning of flash-heads without the assistance of modelling lights is a task requiring experience and skill. But as a guide to simple twin-head flash, using one flash off-camera as the main (modelling) light and the other on-camera as fill-in light, the fill-in light should provide approximately one-quarter to one-half the output of the main light.

The guide number system has been replaced in automatic flash units by the use of *variable flash output* and hence duration as a means of controlling exposure, but it is still applicable in situations such as the use of *ring flash* units or in lenses where a guide number may be set and linked to the focusing control to give a readout of the *f*-number necessary for a given subject distance. Similarly it is used in autofocus cameras where the flash output is fixed, and the appropriate *f*-number set by the distance setting from the autofocus system.

Synchro-sunlight

The use of guide numbers with fractional flash output settings of one-half, one-quarter etc. of full power is useful with *synchro-sunlight* techniques where the flash output is selected given the camera settings for the ambient-light exposure. For example, a subject at a distance of 4 metres from the camera, and in bright direct sunlight, requires 1/125 s at *f*/11 with ISO 100 film, and the fill-in flash on the camera has guide numbers of 44, 22 and 11 (in metres for ISO 100) for full, one-quarter and one-sixteenth power respectively. Using the flash at full power for a flash-only exposure would also need *f*/11. Hence at quarter power, leaving the aperture at *f*/11 provides one-quarter of the exposure; but this is suitable as the necessary fill-in for the ambient-light exposure. The use of a between-lens shutter with flash synchronization at every setting gives greater choice of *f*-number to suit the power and distance of the flash fill-in unit, although the typical shortest flash synchronization speed of a focal plane shutter at some 1/250 s is also useful.

Flash meter

The usual types of exposure meter (light meter) used for ambient light measurements cannot be used with

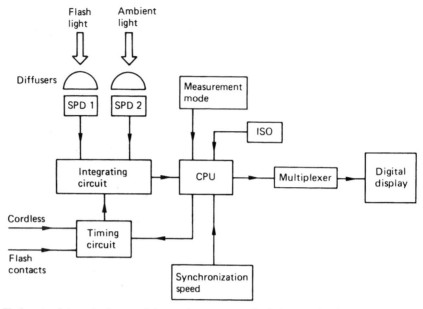

Figure 19.17 Flash meter. Schematic diagram of the usual components of a flash meter for shutter-synchronized or cordless use. Twin photocells measure both ambient light and flash light

flash owing to their slow response to changing light conditions, and their lack of synchronization with the flashgun. A *flash meter* (Figure 19.17) uses different circuitry and an SPD with a response time of 10 microseconds or less, so as to measure both the intensity and duration of the flash output from the light reflected from the subject. An integrating circuit measures the total response during a selected 'gate' time (corresponding to the shutter speed selected), and the output is usually displayed either directly as an *f*-number or as a light value for conversion into an *f*-number for use.

There are other significant differences compared with a conventional exposure meter. The meter circuitry is cleared, reset and activated on receipt of the flash output and so requires some form of synchronization with the flash unit. This may be done by a conventional flash lead from the unit and a PC socket in the flash meter. Alternatively, *cordless control* may be offered. With this system there is no electrical connection between meter and flash unit. Instead, a control switches on the meter circuitry to stand-by mode and the flash unit is operated using the 'test flash' control, or fired from the camera shutter. The photocell then responds to the momentary change in subject illumination and measures flash output. Another cordless alternative is for the flash meter to emit a pulse of infrared radiation when triggered manually; this operates suitable slave photocells on each flash unit and causes them to fire and hence be measured. A useful feature is that of

'accumulative flash' where a single flash is insufficient so the necessary illumination level is built up by multiple flashes, with a static subject of course, and the camera shutter set on 'B' for a short time exposure. In this mode the flash meter is activated, then measures and integrates several successive flashes ('pops') until the required *f*-number is indicated. No account is taken of any intermittency effects in the photographic material used.

Most flash meters take account of the ambient light as well as the flash output. This is important in the case of (for example) a slow flash synchronization speed and powerful modelling lights. The shutter speed to be used for synchronization is set into the meter, and this will determine the measurement time gate of operation, for example 1/60 s. When activated, the meter simultaneously measures both flash output and ambient light for this 1/60 s chosen and calculates the necessary aperture for the mixed lighting. Often the ambient light has little effect, especially at short exposure durations and small apertures. It may be measured by a separate photocell in the flash meter. The ratio of both sources may be indicated. Often a flash meter can also be used for ambient-light measurements alone.

Most flash meters are used principally for incident-light readings using a domed diffuser, but others use a flat diffuser particularly for balancing lighting by the ratio of outputs, and in such cases the more directional response must be taken into account. Reflected-light measurements may also be made,

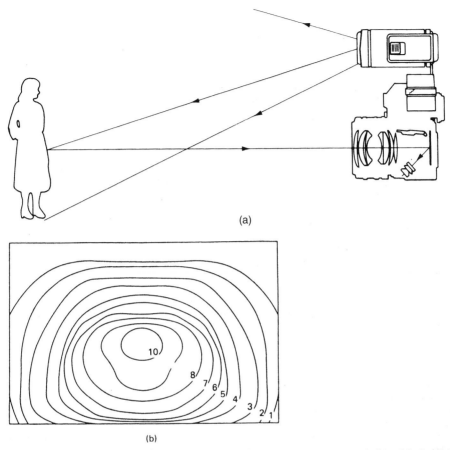

(a)

(b)

Figure 19.18 Automatic off-the-film (OTF) flash metering. (a) Principles: light emitted by the dedicated flash unit is reflected by the subject and the image luminance on the film surface is monitored by a photocell. (b) The metering sensitivity pattern may be centre-weighted and biased to the bottom of the field of view

together with the range of system accessories available, so that spot readings are also possible.

Comprehensive digital displays give a full readout of metering mode, the average of several readings and cumulative flash exposure, usually indicating *f*-number to one-tenth of a stop. Metering sensitivity is again usually assessed in terms of the minimum EV indicated for ISO 100 material. A sensitivity of 1 EV is typical.

A *chronotron* measures flash duration, the colour temperature of the flash, any colour correction filters necessary and the scene illumination in lux as well as being able to balance two sources.

Automatic electronic flash

Flash features

A great convenience is automatic exposure using an attachable electronic flash, where a fast-reacting SPD photocell operates a thyristor switch to quench the flash discharge. Full details are given in Chapter 3. The photocell monitors subject luminance (brightness during the flash emission), and calibration usually assumes a scene of average tonal distribution. Exposure errors are possible due to non-typical subject matter or measurement of luminance. For example, a small close subject with a large distant background will tend to be heavily over-exposed as the flash output endeavours to light the background to a suitable level. The photocell usually has a modest acceptance angle of some 30 degress or less, to help overcome such problems by reading from the centre of the subject area only, though some means of aiming is helpful. Since only reflected-light readings are used, the photocell must be maintained in a 'look-ahead' position, i.e. directed at the subject. *Bounce flash*, or indirect flash, requires a tilting flash reflector assembly; alternatively the photocell can be equipped with a flying lead to enable it to be used in the

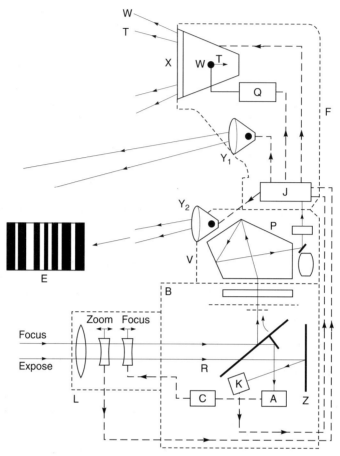

Figure 19.19 Flash metering and autofocus systems. Solid lines, light paths; dotted lines, data paths. L, lens; B, camera body; V, viewfinder; F, dedicated flashgun; P, pentaprism; A, autofocus module; K, flash metering module; C, camera CPU; J, flashgun CPU; X, flash assembly; Y_1, supplementary flash; Y_2, LED projector for focus assist; E, projected deep red pattern; R, reflex mirror assembly; Z, film surface

hotshoe of the camera. Parallax errors arise for close-up work, where the integral photocell may not be pointing directly at the subject area. In such cases a fibre-optics light guide is useful to transmit light from the subject to the photocell.

An automatic flash unit usually has an integral calculator system and display which indicates a choice of one, two or more alternative apertures or a limited continuous variation of *f*-number. At the chosen aperture, the variable flash output then gives a range of subject distances over which correct exposure is possible. The user may choose either a large aperture to extend the range of subject distance or a small aperture in order to give maximum depth of field. With nearby subjects, a large aperture also means reduced flash recycling time and more flashes per set of batteries. Manual allowance has to be made for filter factors and for image magnification in close-

up work. As well as a far limit, there is a near limit to subject distance; below this over-exposure results, as the flash cannot be quenched quickly enough. Automatic flash can be used successfully for synchro-sunlight by the subterfuge of either setting a film speed some four times greater than that in use, or using an aperture two stops more than actually set on the camera. Multiple-flash set-ups, each using thyristor control, are less easy to control for correct exposure.

Off-the-film (OTF) flash measurement

Most of the limitations of attachable automatic flashguns are avoided if *in-camera flash metering* is available. This operates by means of off-the-film (OTF) measurement of image luminance. The mon-

itoring photocell operates the quench circuit of a dedicated flashgun. A special lead is required for off-camera flash. Variables such as lens aperture, filters, magnification and lens transmittance are all allowed for, and indication is given if the controlled flash duration has given over or under-exposure, to allow manual correction for a repeat photograph. A simple table or indicator on the flashgun shows the useful subject distance range with the chosen aperture and film speed. In operation, a reflected-light measurement is made of the actual image on the film surface when the film gate is fully uncovered by the shutter at a fully synchronized setting. The metering pattern is usually of weighted form and asymmetrical due to the position of the photocell optics in the base or side of the camera dark chamber (Figure 19.18).

Figure 19.19 shows the integration of photocell arrays in the camera for autofocus, autofocus assist and flash metering. The difference in reflectance of the sensitive surfaces of different emulsions does not seem to be significant, with the exception of self-developing colour-reversal material which is exposed through its base plus integral filter mosaic and so presents a dark surface to the meter.

OTF systems in general give a high proportion of correct exposures, and are especially useful for photomacrography or the use of ring flash where the subject may be close to the lens, making conventional forms of exposure measurement difficult.

Large-format cameras can use a probe-mounted photocell located in the rear of the lens panel to measure the illuminance on the film surface during the flash exposure. An alternative related system is to position a probe in the film plane, then to fire a test flash at the subject; a readout of correctness of exposure at a chosen aperture will be given.

A *programmed automatic flash mode* is available in some cameras. In this system the shutter speed is fixed at the usual synchronization setting, and the camera sets the lens aperture to an appropriate value, which is obtained from the focused distance data and the flash guide number.

Matrix flash metering

This versatile system uses a form of scene classification using a segmented photocell array or *matrix* and a series of weak preflashes emitted in the time between the reflex mirror rising and the shutter opening. Using the lens focus data and the luminance of each segment of the scene compared with the theoretical value from the guide number, the most significant segment is chosen for the automatic flash output and then this is balanced to the ambient illumination from the main meter reading and the correct amount of fill-in flash emitted. This automatic fill-in feature is invaluable using a controlled flash mixed with ambient-light exposure, if scene contrast measurements by the matrix metering system indicate that it will be necessary. No complex calculations need be done by the user.

Bibliography

Davis, P. (1998) *Beyond the Zone System*, 4th edn. Focal Press, Oxford.

Dunn, J. and Wakefield, G. (1981) *Exposure Manual*, 4th edn. Fountain Press, London.

Goldberg, N. (1992) *Camera Technology*. Academic Press, London.

Graves, C. (1997) *The Zone System for 35 mm Photographers*, 2nd edn. Focal Press, Oxford.

Ray, S. (1983) *Camera Systems*. Focal Press, London.

Ray, S. (1994) *Applied Photographic Optics*, 2nd edn. Focal Press, Oxford.

Stimson, A. (1974) *Radiometry for Engineers*. John Wiley, New York.

20 Hard copy output media

Hard copy output

At the end of the imaging chain (see Figure 1.3), image data, however it was captured, has to be output in such a way that the image can be viewed. In this chapter we will consider output principally in the form of hard copy (images that are tangible, usually as reflection or transmission print media, rather than transient images on a screen or display). In conventional analogue systems this is achieved mainly by the negative–positive process by photographic printing. In hybrid systems output may be laser or LED writing of digital data to photographic paper or other material. In digital systems hard copy output may be by direct output to photographic paper, to plain or special papers via electrophotographic or ink-jet printing, or using special thermal transfer and other materials (see Figure 21.1). The processes and media for hard copy output from digital systems are in a stage of continuing development and systems are being improved and evolving at a very high rate.

Photographic papers

For producing hard copy output by conventional photographic means, photographic printing papers behave in exactly the same way as negative materials, using a similar light-sensitive material, i.e. a suspension of silver halides in gelatin. Many different types of printing paper are made for applications from conventional photographic printing to computer output via laser or LED printing devices. They may be classified into two overall types: monochrome papers and colour papers. For convenience we may classify the characteristics of photographic monochrome papers under the following headings:

- Type of silver halide emulsion.
- Contrast of the emulsion.
- Nature of the paper surface.
- Nature of the paper base.

In addition to these monochrome negative–positive photographic papers, colour print materials are widely used and are available for different applications, such as:

- Papers for printing from colour negatives.
- Reversal papers for printing from colour positives or transparencies.

- Dye-bleach print materials also for printing from colour transparencies.
- Dye-diffusion materials for printing from colour negatives or transparencies.
- Papers for direct writing (laser, LED).

Type of silver halide emulsion

Monochrome papers vary in terms of the type of the silver halides used in the sensitive layer. These are chloride, bromide and chlorobromide emulsions, chlorobromide emulsions being a mixture of silver chloride and silver bromide in which the individual crystals comprise silver, bromide and chloride ions. Bromide and chlorobromide emulsions may also contain a small percentage of silver iodide. Most emulsions for papers contain varying ratios of silver chloride to silver bromide, from 1:3 to 3:1. The nature of the silver halide employed in a paper emulsion largely determines its speed, rates of development and fixation, image colour and tone reproduction qualities.

Papers differ widely in their speed, chloride papers being the slowest and bromide the fastest, with chlorobromide papers in between. Similarly, silver chloride, although less sensitive than silver bromide, develops faster. Generally speaking chlorobromide papers are of greater speed and softer in contrast as their bromide content increases. The fastest of them are in the same speed range as bromide papers. These attributes are made use of in the manufacture of modern monochrome and colour papers to provide materials that not only have the optimum photographic attributes of image colour, speed and contrast but also develop and fix as rapidly as possible.

The speed of photographic papers is defined according to the standard ISO 6846, and like other current standards for speed (see Chapter 18) is based on a fixed density criterion of 0.6 above the minimum density. Details of the conditions under which the determination is made are given in ISO 6846 but the principle of the method is shown in Figure 20.1.

In Figure 20.1 the value of $\log_{10} H_m$ is the exposure required to produce a density of 0.60 above D_{min} read from the graph. The ISO speed values are obtained from a table of $\log_{10} H_m$ and corresponding values. The speed values are derived from the formula:

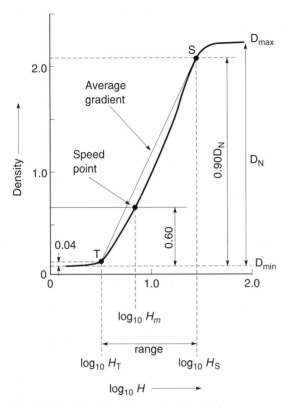

Figure 20.1 Principles of the method adopted for determining speed of a photographic paper according to current ISO standard

$$S = \frac{1000}{H_m}$$

where H_m is the exposure (lx s) that gives a density of 0.60 above D_{min}. ISO speed numbers for photographic papers are prefixed by the letter P.

Spectral sensitivity of emulsions for photographic papers is also affected by their halide content. As the bromide content increases the spectral sensitivity extends to longer wavelengths. Whereas monochrome negative materials are spectrally sensitized to enable the reproduction of colours to be controlled, printing papers that are used only to print from monochrome negatives have no need of spectral sensitization other than as a means of increasing their sensitivity to tungsten light or as means of obtaining differing spectral sensitivities for variable contrast papers. However, some monochrome papers are spectrally sensitized so that they can be used for producing black-and-white prints with correct tones from colour negatives. Such papers are therefore sensitive to light of all wavelengths and require handling in total darkness or by a dark amber safelight. Also papers spectrally sensitized for laser and LED printing devices are available.

The colour or tone of the image on a photographic paper (untoned) depends primarily on the state of division of the developed image, i.e. on its developed grain size, although it is also affected by the tint of the base. The grain size of the image depends on the nature and size of the silver halide crystals in the original emulsion, or any special additions which may be made to the emulsion and on development.

The size of silver halide crystals in paper emulsions is very small, so that no question of visible graininess due to the paper ever arises, even with the fastest papers. As grains become progressively smaller, the image, which with large grains is black (colder tones), becomes first brown, then reddish and then yellow, finally becoming practically colourless in extreme circumstances. When a paper is developed, the grains are small at first but grow as development proceeds; it is, therefore, only on full development that the image gets its full colour. The finer the original crystals of the emulsion, the greater the possibility of controlling the image colour, both in manufacture and by control during development. Bromide papers yield relatively coarse grains and, when developed normally, yield images of a neutral-black image colour. Chloride emulsions are of finer grain. Some papers are designed to yield blue-black images by direct development, others to yield warm-black images by direct development, the colour depending on the treatment the emulsion has received in manufacture. For example some paper emulsions contain toning agents that change the image colour on development, probably by modifying the structure of the developed silver image so that it appears bluer in colour. Chlorobromide emulsions are intermediate in grain size between chloride and bromide papers. Some chlorobromide papers are designed to give only a single warm-black image colour; others can be made to yield a range of tones from warm-black and warm-brown to sepia.

Paper contrast

Most monochrome printing papers are available in a range of contrast grades, to suit negatives of different density ranges. With any given negative, therefore, it is usually possible to make a good print on any type of paper, provided that the appropriate contrast grade is chosen. There will, however, be certain differences in tone reproduction between prints on different types of paper. The differences arise because the characteristic curves of different papers have subtle variations in shape.

Although the type and ratios of silver halides present in the emulsions of photographic papers are of considerable importance, the amount of silver per unit area (coating weight) and the ratio of silver to

gelatin also have important effects on their properties. Emulsions for papers have a much lower silver-to-gelatin ratio than negative emulsions because of the surface characteristics required in prints.

Most manufacturers offer high-quality papers of the traditional type, i.e. fibre-based papers of high coating weight. These are designed for fine-art or exhibition work, where extremely high image quality and archival permanence are required. Because of their high coating weight they are capable of achieving high densities (about 2.4) and give rich blacks and excellent tonal gradation on double-weight papers with results of exhibition quality.

To print satisfactorily from negatives of different density ranges, papers are required in a range of contrast grades. Glossy-surfaced papers, the most widely used variety, are usually available in five or six grades, although some other surfaces are available only in two or three grades. The selection of a suitable grade of paper for a given negative is a matter for personal judgement based on experience, or for practical trial. If a trial is considered necessary, it is important that development should be standardized at the recommended time and temperature. If the correct grade of paper has been selected, and exposure adjusted so that the middle tones of the picture have the required density, then the lightest highlights in the picture will be almost white (though with just a trace of detail) and the deepest shadows black. If the highlights show appreciable greying, and the shadows are not black, the paper selected is of too soft a contrast grade for the negative; a harder paper should be tried. If the highlights are completely white with no detail at all, and not only the shadows but the darker middle tones are black, the paper selected is of too hard a contrast grade for the negative; a softer paper should be tried.

Different contrast grades of photographic papers are now expressed in terms of log exposure ranges, according to ISO 6846. In Figure 20.1 it can be seen that the log exposure range is defined by $\log_{10} H_S - \log_{10} H_T$ which are determined from the points S and T on the characteristic curve and expressed as values from ISO R40 to ISO R190. To avoid decimal points in expressing ISO ranges the differences in log exposure values are multiplied by 100:

$$R = 100(\log_{10} H_S - \log_{10} H_T)$$

The lower the number the higher the contrast of the paper. From Figure 20.1 it can also be seen that the average gradient or contrast of a paper is given by:

$$\bar{G} = \frac{D_S - D_T}{\log_{10} H_S - \log_{10} H_T}$$

This is the slope of the line joining points S and T on the characteristic curve.

Variable-contrast papers

In addition to the conventional printing papers so far described, special types of paper are manufactured (e.g. *Agfa Multicontrast, Ilford Multigrade, Kodak Polycontrast*) in which the effective contrast can be changed by varying the colour of the printing light. With these variable-contrast papers it is possible to produce good prints from negatives of any degree of contrast on one paper which thus does the work of the entire range of grades in which other printing papers are supplied, and makes it unnecessary to keep stocks in a variety of grades.

A variable-contrast paper depends upon the use of two emulsions with differing spectral sensitivities and contrasts, mixed together in the coated layer. For example, one emulsion may be blue-sensitive and high in contrast and the other green-sensitive and low in contrast. Thus exposing the paper to blue light will give a high-contrast image and exposing it to green light a low-contrast image. Varying the proportions of blue and green light in the enlarger will give intermediate grades. The colour of the exposing light is controlled by the use of specially calibrated filters, by the use of a colour enlarger or by the use of a purpose-made enlarger head with an appropriately filtered light source. Variable contrast papers have the advantage of needing only one box of paper rather than a number of boxes, one for each paper contrast. It is also possible to fine-tune the range of the paper by appropriate selection of filters. Filters are usually numbered from 0 to 5 to cover various specified ISO ranges from low to high contrast.

Paper surface

The surface finish of a paper depends on the texture, or mechanical finish of the paper, and its sheen. The texture of a paper depends on the treatment that the paper base receives in manufacture. Glossy papers, for example, are calendered, to produce a very smooth surface, while grained papers are usually embossed by an embossing roller. Rough papers receive their finish from the felt on the paper-making machine.

Surface texture governs the amount of detail in the print. Where maximum detail is required, a smooth surface is desirable, whereas a rough surface may be employed to hide graininess or slight lack of definition. A smooth surface is also desirable for prints that are required for reproduction and have to be copied using a camera and various textures are available for special effects. Paper surfaces therefore may be specified according to texture and surface and appear in manufacturers catalogues under names such as: Smooth/Glossy; Smooth/Semi-Matt; Fine-Grain/Lustre.

Surface finish arises largely from the super-coating, the thin layer of gelatin that is applied over the emulsion of many papers in manufacture, to provide protection against abrasion. This layer gives added brilliance to the print, by increasing the direct (specular) reflecting power of the paper surface. Glossy papers are smooth with a high sheen; a higher maximum black is obtainable on glossy papers than on others. Matt papers are smooth but have no sheen; starch or powdered silica is included in the emulsion to subdue direct reflection. At one time a large variety of surfaces was available, but rationalization in the photographic industry has greatly reduced the number. Papers with a fine irregular patterned surface are called variously 'lustre', 'stipple', etc., and those with a regular pattern are called 'silk' or a similar name. There are also semi-matt surfaces which are smooth but not glossy.

Paper base

The colour, or tint, of the base paper used for photographic papers may be white or one of a variety of shades of cream or blue. In general, cream papers tend to give an impression of warmth and friendliness; they are very suitable for prints of warm image colour. A white base may be used to simulate coldness and delicacy. Many white-base papers contain optical whiteners which fluoresce when irradiated with blue or UV, thus increasing their apparent whiteness. Two thicknesses of base are commonly available, designated single-weight ($150–200 \, g/m^2$, thickness approximately $150 \mu m$) and double-weight ($250–300 \, g/m^2$, thickness approximately $260 \mu m$) respectively. Both double-weight and single-weight papers are used for enlargements; single-weight is often sufficient if the print is to be mounted, but in the larger sizes double-weight paper is to be preferred because with thinner papers there is a danger of creasing in a wet state.

Resin-coated papers

Most printing papers now consist of a paper base coated or laminated on both sides with an impervious layer of a synthetic organic polymer such as polyethylene (polythene). Such papers are termed RC (resin coated) or PE (polyethylene) papers. They offer a number of advantages for the user. Because the base on which the emulsion is coated is impervious to water and most processing chemicals, washing and drying times are considerably shorter than with conventional papers. For example, washing times are reduced from 30–45 minutes for fibre based papers to about 2 minutes for RC papers, which saves both time and water. RC papers cannot be heat-glazed, but the glossy-surface variety dries to a gloss finish, and the papers lend themselves very readily to rapid machine processing. They also dry almost completely flat. Processing can be considerably quicker than with fibre based papers if the chemicals devised specifically for RC papers are used. However, they also have their limitations: processing a number of sheets at one time in a processing dish may lead to damage of the emulsion surface by the sharp edges; different retouching techniques and materials are required; and there is a tendency for papers to 'frill' or de-laminate at the edges, especially if dried too rapidly. Dry mounting of RC type papers generally requires the use of special low-melting-point mountants. RC papers are available in a limited number of surfaces. These include glossy, 'silk' and 'pearl'. Only one weight of RC paper, intermediate between single-weight and double-weight, is usually available. Figure 12.5 shows the layer structure of a typical photographic paper. A modern polythene-coated paper has a thickness of around $250 \mu m$ and a weight of approximately $270 \, g/m^2$.

Colour photographic papers

Colour papers are provided for direct printing of colour-negative (print) and colour-slide materials as well as for output from hybrid systems via laser or LED printing devices. All colour-print papers are polythene-coated and, unlike monochrome papers, are available only in one or at most two contrast grades. For negative–positive colour printing two contrast grades are provided by some manufacturers. The higher contrast grade gives increased colour saturation with some sacrifice in latitude; the lower contrast grade is more appropriate for negatives of high-contrast subject matter.

All colour photographic papers, whatever their chemical principles of image formation, depend on the subtractive principle of colour reproduction (see Chapter 2), and have individual emulsion layers that are sensitive respectively to red, green and blue light. Chromogenic materials comprise layers containing cyan, magenta and yellow colour couplers which form dyes after colour development. Silver-dye-bleach materials – *Ilfochrome Classic* (formerly *Cibachrome*) – contain cyan, magenta and yellow dyes that are bleached in correspondence with the image. Dye-diffusion materials, such as *Fujifilm Pictrography*, contain dyes which upon activation and release diffuse, in correspondence with the image, into a receiving layer. Table 20.1 summarizes the various colour hard copy output photographic materials.

In the case of the most widely used chromogenic systems for printing from colour negatives there has been standardization amongst the manufacturers, who all provide compatible materials and processing solutions. There are also many independent suppliers

Table 20.1 Summary of processes (excluding drying) for photographic hard copy colour print materials

*Chromogenic negative–positive laser/LED output (RA-4)**	*Chromogenic positive–positive (Ektachrome R-3)*	*Silver-dye-bleach positive–positive (Ilfochrome Classic P-30)*	*Dye-diffusion positive–positive negative–positive laser/LED output (Fujifilm Pictrostat and Pictrography)*
1 Colour develop	1 B and W develop	1 B and W develop	1 Activate (thermal + moisture develop)
2a Optional stop bath	2 Wash	2 Rinse	2 Peel apart
2b Optional wash	3 Colour develop	3 Bleach (dye and silver)	
3 Bleach-fix	4 Wash	4 Fix	
4 Wash	5 Bleach-fix	5 Wash	
	6 Wash		

*Tube or drum process. Machine process is carried out at higher temperature for shorter time, omitting 2a and 2b.

of processing chemicals. All chromogenic negative–positive papers are processed by the Kodak RA process or equivalent system of other manufacturer.

Processing photographic paper

The developers used today for monochrome papers of all types are commonly MQ or PQ formulae. We saw earlier that the colour of the image is influenced by development. The three components of the developer that have the most important influence on image colour are the developing agent, bromide restrainer and organic anti-foggant. For example, developing agents such as glycin or chlorohydroquinone (chlorquinol) give a warm image tone in the absence of organic anti-foggants but are little used now in print developers. Organic anti-foggants such as benzotriazole tend to give a cold or bluish image. Thus PQ developers will give a bluish image because they usually contain an organic anti-foggant. As the bromide content is increased the image becomes warmer in tone, so MQ developers tend to give warmer images than PQ developers. Chromogenic colour development depends upon colour couplers in the paper reacting with oxidized developing agent to form the image dyes, whereas silver dye-bleach

materials involve the bleaching of dyes already present, and dye-diffusion materials involve the diffusion of dyes to a receptor layer and require special processing equipment.

Resin-coated (PE or RC) papers generally have shorter process times than their fibre-based equivalents, and lend themselves to machine processing where speed of access and throughput warrant the expense of a processing machine. Table 20.2 summarizes the approximate processing times for fibre-based and resin-coated papers.

Most colour-print materials require the temperature to be kept within ± 0.3 °C whilst the silver dye-bleach process is more tolerant and allows variation of ± 1 1/2 °C. The process times for colour photographic papers have been reduced considerably since they were first used, as shown in Figure 20.2. These changes have been brought about by changes in the materials, processing solutions and by the use of higher processing temperatures.

Table 20.2 Process times for monochrome papers (dish processed at 20 °C)

Process	*Fibre-based (baryta-coated)*	*Resin-coated (PE or RC)*
1 Development	90–120 s	60 s
2 Stop bath	10–30 s	5–10 s
3 Fixation	1–5 min	30 s – 2 min
4 Wash	30–60 min	2–4 min

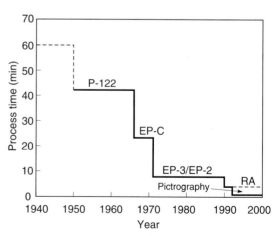

Figure 20.2 Colour paper access times for representative Kodak processes and Fujifilm Pictrography

Development techniques

For dish processing, the exposed print should be immersed in the developer by sliding it face upwards under the solution. Development of papers is a straightforward operation, but prints must be kept on the move and properly covered with solution. The busy printer will find it convenient to develop prints in pairs, back to back, feeding them into the solution at regular intervals, keeping the pairs in sequence and removing them in order when fully developed. Several prints may be developed at one time in the same dish provided there is sufficient depth of developer and that the prints are interleaved throughout. The action of interleaving the prints, i.e. withdrawing pairs sequentially from the bottom of the pile and placing them on the top, will help to dislodge any airbells which may have formed on the prints.

When making enlargements of very large size, the provision of large dishes or trays sets a problem. Where very big enlargements are made only occasionally, the dishes need be only a few inches larger than the narrow side of the enlargement, because development can be carried out by rolling and unrolling the paper in the processing baths, or by drawing it up and down through the solution. In exceptional cases, development can be carried out by placing the enlargement face up on a flat surface and rapidly applying the developer all over the print with a large sponge or swab. Previous wetting with water will assist in obtaining rapid and even coverage of the print by developer. Fixing can be done in the same way. Alternatively, makeshift dishes can be made from large pieces of cardboard by turning up the edges, clipping the corners (which should overlap), and lining them with polythene sheet.

For processing prints, especially colour prints, many small-scale tanks and machines are available and are becoming increasingly popular. These may be operated in the light once they have been loaded with the paper in the darkroom. They range from the simple and relatively inexpensive tube or drum processors which are capable of processing both films and prints, to the more costly and somewhat larger roller transport processors (see Figures 20.3 and 20.4).

These are all small-scale processing devices used by both amateurs and professionals. Larger-scale machines are described in Chapter 17. The simple drum processor is the print analogy of the daylight film developing tank, and is available in a number of sizes ranging from one suitable for processing a single sheet of paper 20.3 cm × 25.4 cm (8 inches × 10 inches) to one large enough to process a single sheet of paper 40.6 cm × 50.8 cm (16 inches × 20 inches). An appropriate number of smaller sheets can also be accommodated in this larger drum. The exposed paper is loaded into the tank in total darkness with its emulsion surface facing inwards and its other

Figure 20.3 A small-scale Jobo drum (rotary discard) processor with automatic agitation and constant-temperature bath

side in contact with the inner surface of the drum. All subsequent processing operations are then carried out in the light. Temperature control is achieved by two main methods: either by rotating the drum in a bowl

(a)

(b)

Figure 20.4 Examples of table-top roller transport print processors. (a) Fujimoto CP51/CP31 with the main processing module on the right and the wash/dry module on the left. (b) Durst Printo in the Ilfochrome configuration with the dryer module attached on the right

of water at the appropriate temperature, or by a pre-rinsing technique in which water is poured into the drum at a temperature above that of the surroundings and the final processing temperature.

Details of the required temperature of this pre-rinse are provided by the drum manufacturers in the form of a nomogram or calculator. These simple processing drums use very small quantities of solutions for processing each print but suffer from the disadvantage that they have to be washed thoroughly after each use to prevent contamination. Washing of prints is carried out outside the drum. An alternative approach to the simplification of print processing is by using a table-top self-threading roller transport processor. This finds application in the processing of both monochrome resin-coated papers and colour-print materials. Machines of varying degrees of sophistication are available. The more advanced versions are microcomputer-controlled, with built-in sensors and automatic replenishment systems, solution recirculation and agitation by pumps, together with variable speed, adaptable to the processing of monochrome or various types of colour papers. The majority of machines require separate washing and drying of the prints, but they may be provided with additional modules so that dry-to-dry processing can be carried out. Two examples of table-top roller transport processors are given in Figure 20.4. Machines of this type are capable of processing up to approximately 200 8 × 10 inch prints per hour, and no plumbing in is required.

Fixation

Prints are fixed in much the same way as negatives and acid fixing baths are invariably used. The thiosulphate concentration of print fixing baths does not normally exceed 20 per cent, compared with a concentration of up to 40 per cent for films and plates. A fixing time of up to about 5 minutes is used for fibre-based papers, and only around 30 seconds is needed for resin-coated papers (see Table 20.2). To avoid the risk of staining, prints should be moved about in the fixing bath, especially for the first few seconds after immersion. Prolonged immersion of prints in the fixing bath beyond the recommended time must be avoided. It may result in loss of detail, especially in the highlights, because the fixer eventually attacks the image itself.

The print is the consummation of all the efforts of the photographer; thus everything should be done to ensure its permanence, and proper fixation is essential. Improper fixation may lead not only to tarnishing and fading of prints, but also to impure whites on sulphide toning. For the most effective fixation of papers, it is probably better practice to use a single fairly fresh bath, than to use two fixing baths in succession. With the latter method, the first bath contains a relatively high silver concentration. Silver salts are taken up by the paper base in this bath, and tend to be retained in the paper even after passing through the second, relatively fresh, bath. This, of course, does not apply to RC papers.

Where processing temperatures are unavoidably high, a hardening–fixing bath should be employed. Several proprietary liquid hardeners are available for addition to paper fixing baths. Use of a hardener is often an advantage even in temperate climates if prints are to be hot glazed or dried by heat. Never use a fixing bath for papers if it has previously been used for fixing negatives. The iodide in the solution may produce a stain.

Bleach-fixing

In chromogenic colour-print processing the removal of the unwanted silver image and unexposed silver halides is usually carried out in a single bleach-fix solution (see Table 20.1). Bleach-fix solutions contain an oxidizing agent that converts metallic silver to silver ions, together with a complexing agent (thiosulphate) that forms soluble silver complexes with the oxidized silver and with any unexposed silver halide remaining in the emulsion.

Bleach-fixing is carried out for the recommended time at the recommended temperature, and in small-scale processing is discarded when the specified number of prints has been passed through the solution or when its storage life has been exceeded. In larger scale processing it is normal practice to recover silver from the solution and reuse the bleach-fix after aeration and replenishment. Electrolytic or metallic displacement techniques of silver recovery are the preferred methods. In the case of the latter method the presence of iron salts in the solution after silver recovery does not have the disadvantage it has when this method is used to recover silver from fixer solutions, because the oxidizing agent is ferric EDTA, which can be formed by the addition of EDTA (ethylene diaminetetra-acetic acid) to the de-silvered solution. Thus the recovery and replenishment operation forms extra oxidizing agent. It is important to bleach-fix the print material for the specified time and temperature because incomplete removal of silver and silver halide results in a degraded print, especially noticeable in the highlight areas. Bleach-fixing is a less critical stage than development and a larger amount of temperature variation is permitted (usually ±1 °C).

Washing

The purpose of washing prints is to remove all the soluble salts (fixer, complex silver salts) carried on and in the print from the fixing bath. Where only a

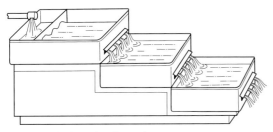

Figure 20.5 Cascade print washer

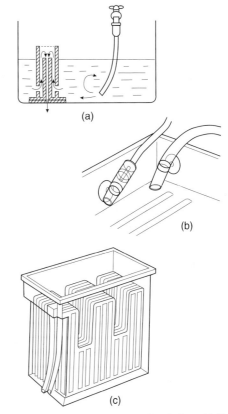

Figure 20.6 Examples of print washing devices. (a) Simple sink syphon. (b) Syphon attached to a processing dish. (c) 'Toast-rack' print washer

few prints are being made they may be washed satisfactorily by placing them one by one in a large dish of clean water, letting them soak there for five minutes, removing them singly to a second dish of clean water, and repeating this process six or eight times in all. A method that is equally efficient and much less laborious, though requiring a larger consumption of water, consists of the use of three trays, arranged as in Figure 20.5, through which water flows from the tap. Prints are placed to wash in the bottom tray of this cascade washer. When others are ready for washing, the first prints are transferred to the middle tray and their place taken by the new ones. When a further batch is ready, the first prints are put in the upper tray and the second batch in the middle one, leaving the bottom tray for the latest comers. In this way, prints are transferred from tray to tray against the stream of water, receiving cleaner water as they proceed. For washing large quantities of prints, this type of washer is made with fine jets for the delivery of water to each tray. These afford a more active circulation of water and dispense with the occasional attention required with the simpler pattern.

Other examples of efficient arrangements for washing prints are shown in Figure 20.6. One method consists of a sink fitted with an adjustable overflow; water is led in by a pipe which is turned at right angles to the sink and terminates in a fine jet nozzle. The effect of this is to give a circular and also a lifting motion to the water and the prints which overcomes the tendency of the prints to bunch together. The overflow is a double pipe which is perforated at the base. This extracts the contaminated water (which has a higher density than fresh water) from the bottom of the sink and prevents it from accumulating. If the top of the outer pipe is closed off, the overflow becomes a siphon which periodically empties the water away, down to the level of the perforations. It is possible to buy siphons that convert processing dishes into washing tanks (Figure 20.6b).

A form of print-washer which solves the problem of prints sticking together is by holding them in a rocking cradle like a toast-rack (Figure 20.6c). The in-flow of water causes the rack or prints to rock backwards and forwards so ensuring that the prints

are in constant motion and that there is an efficient flow of water around them. Numerous mechanical print washers are sold which are designed to keep prints moving while water passes over them. In purchasing any print washer it is necessary to be satisfied that prints cannot come together in a mass so that water cannot get at their surfaces, nor be torn or kinked by projections in the washing tank. Commercial print washers are in general suited only to prints of relatively small size. Washing in automatic print processors is more efficient than that for manual or batch processing. The reasons for this may be summarized as follows:

- Efficient removal of fixer from the print surface by the use of squeegees or air-knives.
- Control of the temperature of the water.
- Uniform time of immersion in the processing solutions.
- Control of exhaustion of the fixer by replenishment and possibly by silver recovery.
- Efficient separation of the prints, allowing free access of the wash water.

- Reduction of carry-over of chemicals from one solution to another by the use of squeegees between the solutions.

All the above features of automatic print processors result in a shorter wash time than is required in manual or batch processing in order to yield prints of comparable permanence. However, some of these features can be incorporated in manual processing. For example, tempered wash water can be used, fixers can be replenished at the proper intervals, and wash tanks can be designed to give efficient washing. The efficiency of washing can be increased by introducing a solution of 1 per cent sodium carbonate between the fixer and final wash. This is recommended for fibre-base papers and improves their life expectancy.

Drying

Once they have been thoroughly washed, prints intended to be dried naturally can be placed face upwards in a pile on a piece of thick glass. The excess of water should then be squeezed out and the surface of each print wiped gently with a soft linen cloth or chamois leather. The prints can be laid out on blotters or attached to a line with print clips. Where a large volume of work is being handled, fibre-based prints may be dried by heat using flat-bed or rotary glazing machines, or special rotary dryers. It is usually an advantage to use a hardening–fixing bath when prints are to be dried by heat. The drying of matt and semi-matt papers by heat gives a higher sheen than natural drying, because raising the temperatures of the paper causes bursting of starch grains included in the emulsion to provide the surface texture. With semi-matt papers the higher sheen may in some instance be preferred, but with matt papers it will usually be considered a disadvantage, in which case natural drying should be employed.

Resin-coated papers may be dried by hanging up the prints in the air or in a drying cupboard in the same way as films or by the use of one of the many commercially available purpose-made dryers for RC papers. They dry rapidly without curling. They may also be dried on glazing machines provided that the following precautions are observed:

- All surface moisture is removed.
- The base is towards the heated 'glazing' surface.
- The temperature of the glazing surface is below 90 °C.

RC papers are impervious to water so that it is essential that the emulsion is not placed in contact with the heated surface and that surface moisture is thoroughly removed by squeegeeing.

Glazing of fibre-base papers

The appearance of prints on glossy fibre-base papers is considerably enhanced by glazing, a process that imparts a very high gloss. Glazing is effected by squeegeeing the washed prints on a polished surface. When dry, the prints are stripped off with a gloss equal to that of the surface onto which they were squeegeed. Glazing is best carried out immediately after washing, before prints are dried. If it is desired to glaze prints that have been dried, they should first be soaked in water for an hour or more. Glass is usually considered to give the finest gloss, although some other surfaces are also suitable. Chromium-plated metal sheets and drums, however, are far more widely used, as is polished stainless steel. Before prints are squeegeed on to the glazing sheet, the surface of the sheet must first be thoroughly cleaned, and then prepared by treating it with a suitable glazing solution to facilitate stripping of the prints. Where a considerable volume of work is handled it is usual to employ glazing machines, on which prints are dried by heat, to speed up the operation. These machines are of two types, flat-bed and rotary. Glazing can be completed in a few minutes. Flat-bed glazers accommodate flexible chromium-plated sheets on to which prints are squeegeed. The glazing sheet is placed on the heated bed of the glazer and assumes a slightly convex form when held in place by a cloth apron which serves to keep the prints in close contact with the glazing sheet. In rotary machines, prints are carried on a rotary heated chromium-plated (or stainless steel) drum on which they are held in place by an apron.

Pictrography and Pictrostat

Fujifilm have introduced a novel system which combines rapid access to dry images but takes full advantage of the high image quality associated with photographic silver-halide-based media without the use of processing chemicals. One system has been devised for high quality output from a digital printer. It enables direct printing from scanned images Photo CDs etc., by exposure via laser diodes (Pictrography). An essentially similar system has also been devised for printing negatives and slides (Pictrostat) using a conventional light source. The process is shown in Figure 20.7 and involves thermal development and transfer of dyes from a donor layer to the receiving sheet. All the necessary image forming chemicals are contained in the donor layer and processing is activated by a combination of moisture and heat. In exposed areas a latent image is formed which on development releases a dye which diffuses from the donor layer to the receptor layer. The layers are peeled apart and the process takes less than one minute for an A4-sized print. It is a complete system

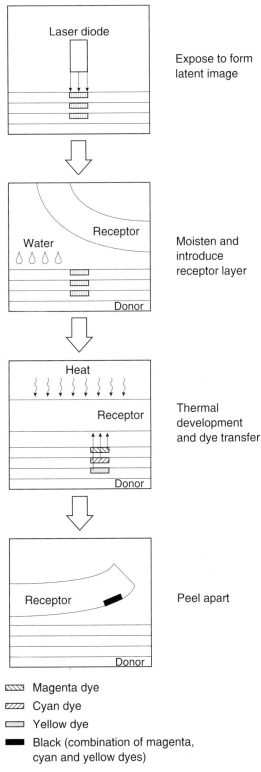

Expose to form latent image

Moisten and introduce receptor layer

Thermal development and dye transfer

Peel apart

▨▨▨ Magenta dye

▨▨ Cyan dye

▭ Yellow dye

■ Black (combination of magenta, cyan and yellow dyes)

Figure 20.7 Principles of Fujifilm Pictrography

which has to be carried out in the manufacturer's hardware using the appropriate rolls of donor and receptor materials.

Dry Silver materials

Dry Silver materials were originally developed by the 3M Company more than 35 years ago and combine the advantages of the high sensitivity and image quality of silver halides as sensors with a totally dry thermal development process. Unlike the previously described pictrographic system, the Dry Silver process does not involve image transfer initiated by moisture and heat but is carried out by heat alone in a single layer. The Dry Silver system is shown in Figure 20.8.

The Dry Silver layer is around $10\,\mu$m thick and contains silver halide and spectral sensitizing dye, a supply of silver in the form of an organic silver salt (silver behenate), a developing agent dispersed in an organic polymer. The application of heat induces development in those areas where a latent image has been formed. The supply of silver to form the image

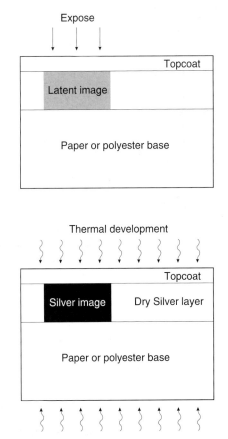

Figure 20.8 Principles of the Dry Silver process

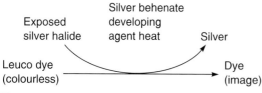

Figure 20.9 The Dry Silver colour system

comes from the organic silver salt present in the layer and is a form of solid state physical development. The developing agents used in this system are not like those normally used in conventional wet photographic systems. They have to withstand the high temperatures of around 130–140 °C used for thermal development which takes place in a few seconds. Despite having all the image forming components present in the thermally developed layer they are claimed to have a life expectancy of more than 20 years.

A colour Dry Silver process has also been devised by the 3M Company. This process depends upon the formation of dyes from leuco dyes (colourless dye precursors) resulting from the reaction between silver behenate and the leuco dye catalysed by the latent image. This reaction takes place in less than 6 seconds at around 135 °C. The amount of silver generated is insignificant and does not affect the appearance of the dye image. The mechanism of the Dry Silver colour process is shown in Figure 20.9.

These materials are suitable for many applications, which include continuous tone photographic printing and computer hard copy output using lasers, laser diodes or LEDs. They form the output in a number of medical imaging applications.

Cylithographic materials/Cycolor

A dry colour process originally developed by the Mead Corporation, USA., in the early 1980s, *Cylithography* is a light-sensitive material which, when exposed, releases dyes when developed by pressure followed by heat. It is a single layer material like Dry Silver, but depends upon photoploymerization of organic chemicals, rather than the light sensitivity of silver halides.

The sensitive layer consists of microencapsulated leuco cyan, magenta and yellow dyes sensitive to red, green and blue light respectively. The walls of the microcapsules are around $0.1\,\mu m$ thick and are relatively easily broken by pressure. On exposure, the microcapsules become hardened via photopolymerization and resistant to rupture by the subsequent pressure development brought about by passing through rollers. The sequence of operations and the structure of this material is shown in simplified form in Plate 24.

Plate 24 shows the formation of a red image in these materials. Exposure to red light hardens the red sensitive microcapsule containing the cyan leuco dye, leaving the green and blue sensitive microcapsules unaffected. On applying pressure the unhardened blue and green sensitive microcapsules containing yellow and magenta leuco dyes are broken and the leuco dyes released. The application of heat in the presence of a 'developer' completes the formation of yellow and magenta dyes to form a red image.

This system is claimed to be less expensive than other systems, requiring only inexpensive hardware, no ink cartridges and no expensive receiving sheets. It is single layer material, containing all the necessary image forming components (like Dry Silver), which only requires the application of pressure and heat to form the image.

Thermal imaging materials

A variety of systems that involve differing thermal technologies have been devised for application to imaging. They all involve the application of external thermal energy, which induces image formation by chemical or physical means or a combination. Their names and abbreviations are summarized in Table 20.3.

A number of other imaging materials also involve the application of heat but those previously described use heat to reveal an image that was originally formed by light (see Figures 20.7, 20.8, 20.9 and Plate 24) whereas thermal imaging materials use a heated printing head to write to the material. They have been used for many years in applications such as faxes, printing of tickets and receipts and in medical imaging.

Direct thermal imaging (D1T1) involves the use of a heat-sensitive paper but until recently has not found application for photographic quality output, neither has direct thermal transfer (D1T2), which is an on–off process, unable to produce continuous tone without the additional complexity of screening. An example of D1T1 technology is Fujifilm's *Thermo-Autochrome* (TA) system, which contains thermally sensitive layers that produce yellow, magenta and

Table 20.3 Thermal imaging materials

Principal employed	Abbreviation
Direct	D1T1
Transfer	
Direct thermal transfer	D1T2
Dye diffusion thermal transfer	D2T2
Reactive thermal transfer	R1T2
Resistive ribbon thermal transfer	R2T2

cyan dyes with a resolution of around 200 dpi. Dye diffusion thermal transfer (D2T2) can produce continually varying amounts of dye and hence continuous tone. This material finds extensive application in hard copy output of photographic quality. The application of heat causes transfer of dyes from a donor web to the receptor (see Plate 25). These materials are often called dye sublimation, although this terminology is incorrect since direct contact between donor and receiver is an essential requirement for dyes to migrate and with any air gap the process does not work. It seems unlikely that sublimation is involved in the transfer. Receptor materials for dye diffusion thermal transfer papers have special surface coatings to optimize dye uptake, stability, gloss and brightness and the ability to withstand the high temperatures required for the dye transfer.

These materials are capable of 8-bit reproduction and have an optical density range similar to that of conventional colour photographic paper. Their quality is high and virtually indistinguishable from a conventional photographic colour print, but at the time of writing the equipment is expensive. The printing speed like many digital output devices is slow because in this case it requires three (or more) successive transfers of cyan, magenta and yellow dyes, together with the time needed for data handling and transformations.

Materials for ink-jet printing

Papers and films for ink-jet printing must have an appropriate spread factor of the ink droplet since high image quality is obtained from circular dots of high contrast with well-defined edges. When the ink droplet hits the paper surface it has a diameter equal to that when it is in-flight. The final diameter is reached after the solvent has evaporated and the ink has spread in to the paper surface. Thus the paper surface is very important in controlling image quality. The final diameter is reached when all the solvent has evaporated to leave the ink absorbed by the paper. Also a delicate balance has to be achieved between adhesion and diffusion so that the ink droplet sticks to the paper surface and does not spread excessively. Figure 20.10 shows the cross-section of an ink droplet and receptor layer with varying amounts of diffusion and adhesion.

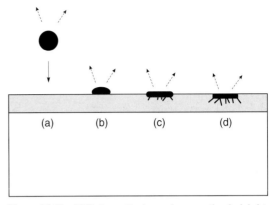

Figure 20.10 Diffusion, adhesion and evaporation in ink-jet printing using a coated paper receptor. (a) In-flight droplet. (b) Poor diffusion and adhesion. (c) Good diffusion and adhesion. (d) Excessive diffusion but good adhesion. The dashed arrows represent evaporation

For photographic quality output the receptor layers are coated on resin-coated heavy-weight papers like photographic papers. The receptor layer may comprise two layers, a top image-forming layer and immediately below an ink-fixing layer which contains inorganic micro-pore particles in a starch binder. Subtle improvements are being made in these papers to achieve resolutions of 600 dpi or greater by modifications to the receptor layers and their compositions to control adhesion, diffusion and other properties such as water and fade resistance.

Bibliography

Diamond, A.S. (ed.) (1991) *Handbook of Imaging Materials*. Marcel Dekker, New York.

Gregory, P.L. (ed.) (1995) *Chemistry and Technology of Printing and Imaging Systems*. Chapman and Hall, London.

ISO 6846: 1992 *Photography – Black-and-white Continuous Tone Papers – Determination of ISO Speed and ISO Range for Printing*.

Proudfoot, C.N. (ed.) (1997) *Handbook of Photographic Science and Engineering*, 2nd edn. IS&T, Springfield, VA.

Tani, T. (1995) *Photographic Sensitivity*. Oxford University Press, Oxford.

21 Production of hard copy

In the previous chapter we considered the characteristics and mechanisms involved in a variety of differing hard copy output media. In this chapter we shall deal with the means of production of hard copy both by conventional photographic printing and by the newer technologies. Today there is a bewildering array of available means and media for producing hard copy. Figure 21.1 gives an extended version of the section of the imaging chain which deals with these aspects, previously given in Figure 1.3 in a more generalized form.

The right hand side of Figure 21.1 shows the conventional route to obtaining hard copy from photographic negatives or slides via optical printing

on to light sensitive paper which is subsequently developed to reveal the image. Whilst this form of conventional photographic optical printing requires an enlarger, or similar device for printing, all the other systems require their own specialized form of hardware for converting computer output data into electrical signals that are converted into energy required at thermal printheads, impulses for ink-jets, light intensities etc. in other devices that produce the image. Most of these printing devices are available in compact forms for desktop operation although many are large commercial units for use in printshops. The same is true of photographic printers and processors, which are available as small compact units and very

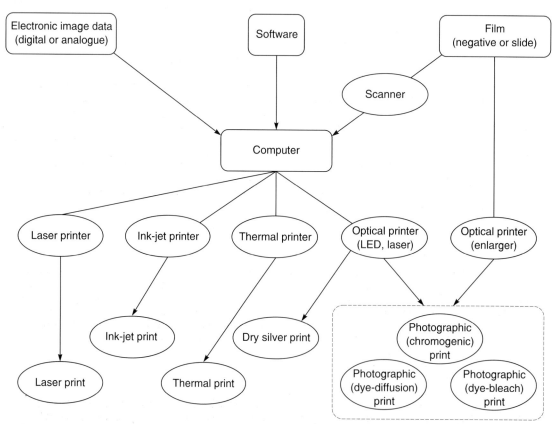

Figure 21.1　An imaging chain showing various routes to hard copy output

much larger installations for use in printshops, mini-labs and large processing laboratories. Figure 21.1 also shows that photographic originals, whether slides, negatives or prints, can be printed via the computer and a variety of printing devices. This requires the intervention of a scanner in order to digitize the photographic image. Scanners also will be considered in this chapter as an integral part of the current hybrid approach to obtaining hard copy.

Photographic printing and enlarging

There are two main ways of making prints from photographic material: contact printing and projection printing. In contact printing the sensitized paper is placed in contact with the negative, while in projection printing the paper is remote from the negative, the negative image being projected on to the paper by optical means.

Contact printing requires only the minimum of apparatus and equipment but because of the trend to smaller format materials is only carried out as a means of proofing for conveniently identifying and selecting images for subsequent enlarging. The modern equivalents of contact sheets from 35 mm films are the thumbnail images provided with Kodak Photo CDs and with the more recently introduce APS format films. Apart from the application for producing contact sheets, contact printing is now only carried out in a few specialist applications where large format materials are used, such as astronomy, photogrammetry and some survey applications. In the past contact prints were made using either a printing frame or box to ensure as perfect a contact as possible between the negative and the print paper during printing. More commonly, however, contact printing is used to provide proofing sheets from 120 or 35 mm films. Then the paper may be placed on the enlarger baseboard with the negatives on top, emulsion to emulsion. A glass plate or a plastic holder keeps them in close contact and the enlarger beam is used as a light source. A sheet of paper 20.3×25.4 cm (8×10 inches) can accommodate twelve negatives 6×6 cm in three strips of four or 36 negatives 24×36 mm in six strips of six. Special printing frames which hold strips of negatives in the way shown above are available. If the negatives are reasonably uniform in density and contrast they can be printed with a single exposure. If not, such a sheet may be used as a guide for selection of a more appropriate paper grade and/or exposure for particular negatives.

Projection printing is the process of making positive prints by optical projection of the negative image on to print paper. The image may be enlarged, the same size as the negative or reduced. As projection printing is usually employed for the production of enlarged prints, projection printers are

usually referred to as enlargers, and the term 'enlarging' is loosely used to cover all forms of projection printing, whether the image is actually enlarged or not. Enlarging allows control in various directions to be introduced during printing, by, for example:

- Selection of the main area of interest in the negative, and enlargement of this area to any suitable size. This enables unwanted and possibly distracting areas around the edges of the picture to be eliminated, thus concentrating interest on the main subject.
- Dodging and shading This enables detail in highlights or shadows, which would otherwise be lost, to be revealed.
- Local fogging by a small external light can be used where dark areas are required, e.g. around a portrait, to concentrate attention on the face.
- Modification of the appearance of the image by use of diffusers, etc. between lens and paper.
- Correction or introduction of perspective distortion by tilting the enlarger easel and/or negative carrier.

All these manipulations, and many others, can be carried out with digitized images and the appropriate software, such as Adobe Photoshop.

Types of enlargers

Early enlargers resembled large slide projectors, with the optical axis horizontal. To save bench space, later enlargers were designed with the axis vertical and most are of this type. Not only do vertical enlargers save space, but they are much quicker in use. In some of them, operation is speeded up further by means of automatic focusing devices. Horizontal enlargers are, however, still used for very large prints.

The optical systems of most enlargers are of three main types:

- Condenser
- Diffuser
- Condenser–diffuser

The condenser type, based on the slide projector, was the earliest form of optical system used in enlargers. Later, diffuse or semi-diffuse illumination tended to displace the straightforward condenser type. Today, diffuser enlargers or condenser–diffuser are the most common types of enlarger.

Condenser enlargers

Figure 21.2 illustrates the arrangement of a condenser enlarger. The purpose of the condenser (C) is to illuminate the negative evenly and to use the light

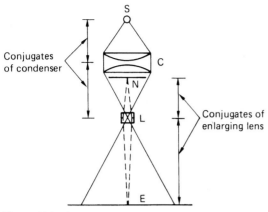

Figure 21.2 Optics of condenser enlarger

output of the lamp as efficiently as possible. These aims are achieved if the condenser forms an image of the light source (S), within the enlarging lens (L). The latter is employed to form an image of the negative (N), in the plane of the easel (E). The negative causes some scattering of the light, so that a cone of light spreads out from each image point, as indicated by the broken lines in the figure. This cone fills the lens

(L), but very unequally, the intensity of the part of the beam that passes through the central area of the lens being much greater than that of the part that passes through its outer zone. One result of this is that stopping down the lens of a true condenser enlarger does not increase exposure times by as much as might be expected but tends to increase contrast, as it cuts down the light scattered by the negative.

The required diameter and focal length of a condenser enlarger depend on the size of the largest negative to be used. The diameter must be at least equal to the diagonal of the negative and the focal length should be about three-quarters of this value. The choice of focal length for the enlarging lens is restricted by a number of practical considerations. If it is too short in relation to the negative size, it will not cover the negative at high degrees of enlargement. If it is too short in relation to the focal length of the condenser, the light source must be a long way from the latter in order to form an image of the source within the lens. This necessitates a big lamphouse. It also means that the area of negative illuminated by the condenser is reduced. If, on the other hand, the focal length of the enlarging lens is too great, the distance from lens to baseboard is inconveniently long when big enlargements are required. The best compromise is usually achieved by choosing a lens

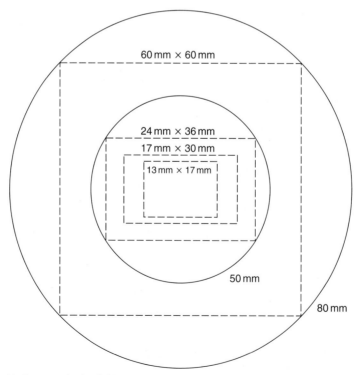

Figure 21.3 Relationship between circular fields covered by enlarging lenses of focal lengths of 50 mm and 80 mm and the negative size

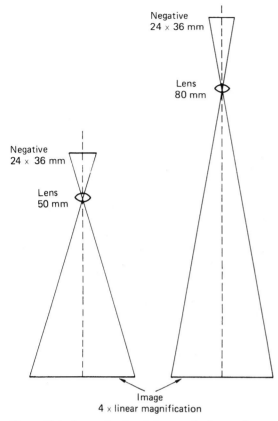

Figure 21.4 Lens-to-baseboard distances for lenses of different focal length and the same degree of magnification

Negative
24 × 36 mm

Lens
80 mm

Negative
24 × 36 mm

Lens
50 mm

Image
4 × linear magnification

Table 21.1 Negative contrast and type of enlarger

	Condenser enlarger	*Diffuser enlarger*
Contrast index	0.45	0.56
\bar{G}	0.55	0.70

with a focal length at least equal to that of the condenser but not exceeding it by more than one-third. This results in a lens of focal length equal to or slightly longer than that of the 'normal' camera lens for the negative size covered (Figure 21.3).

Figure 21.3 indicates that any negative size which fits into or is smaller than the circular image field of the lens can be enlarged with that lens. Although this choice of focal length ensures even illumination, and a 24 × 36 mm negative could be enlarged with an 80 mm focal length enlarging lens, this would result in the enlarger head being raised higher than if a 50 mm lens were to be used (see Figure 21.4). This may be inconvenient, and it may be impossible to obtain a sufficiently high degree of enlargement. In Chapter 4 we saw that the simple lens equation could be written in the form:

$$v = f(1 + m)$$

where v is the lens-to-baseboard distance, f is the focal length of the lens and m is the magnification.

Thus in Figure 21.4, if the degree of enlargement is ×4 (i.e. $m = 4$), we can see that the lens-to-baseboard

distance is 25 cm for the 50 mm lens and 40 cm for the 80 mm lens. Although at this magnification these distances are unlikely to cause problems, with higher magnifications v could become unacceptably large.

To achieve optimum illumination in a condenser enlarger, the various parts of the optical system must be so located that the light beam from the condenser converges to its narrowest cross-section within the enlarging lens. Now, when the degree of enlargement is altered, the distance of the enlarging lens from the negative is altered to obtain sharp focus. As the negative and condenser are fixed in relation to one another, it is obvious that some adjustment of the light source in relation to the condenser must be made if the image of the source formed by the condenser is to be kept within the enlarging lens. This involves setting up the enlarger each time the degree of enlargement is changed. Most modern enlargers are of the diffuser or condenser–diffuser type, which avoids the necessity for these tedious adjustments.

The advantages of condenser enlargers may be summarized as follows:

- Give maximum tone-separation, especially in highlights.
- High optical efficiency making them most suitable for high degrees of enlargement.

However, for most applications their limitations outweigh their advantages:

- Accentuate blemishes and grain.
- Require readjustment of the lamp position whenever the degree of enlargement is altered appreciably, or
- Require different condensers for different focal length lenses.

Condenser enlargers are therefore restricted to the production of large prints.

Also, as neither an advantage nor a limitation, image contrast is higher than when using a diffuser enlarger, thus requiring the negatives to be developed to a lower contrast (see Table 21.1) or, alternatively, a lower contrast paper to be used.

Diffuser enlargers

Diffuse illumination may be obtained by direct or by indirect lighting of the negative, the different methods

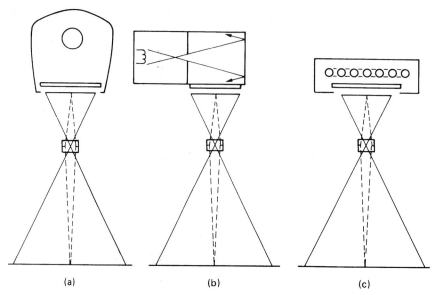

Figure 21.5 Optics of three types of diffuser enlargers. (a) Direct (illumination through opal diffuser. (b) Indirect illumination. (c) Cold-cathode illumination

being illustrated in Figure 21.5. For small negatives, an opal or frosted tungsten lamp with a diffusing screen (opal or ground glass) between lamp and lens is all that is required (Figure 21.5a). This method can be extended to somewhat larger negatives by using a bulb silvered at the tip, or a diffuser specially treated to that the transmission of the central part is reduced, to assist in obtaining uniform illumination of the negative. To illuminate a really large negative directly, an assembly of small bulbs may be employed behind the diffuser.

The indirect method of illumination, shown in Figure 21.5(b), is another commonly used method for obtaining diffuse illumination which is suitable for large negatives. A tungsten–halogen lamp is placed at right-angles to an integrating or diffusing box, i.e. a box with an inside surface that acts as an efficient diffuse reflector. A method of obtaining diffuse illumination by means of a cold-cathode lamp is illustrated in Figure 21.5(c). Lamps of this type, in the form of a grid or helix, provide a large intense source of uniform illumination.

Diffuser enlargers do not suffer from the limitation of changing condensers or positioning of light sources and subdue scratches, blemishes, retouching and grain. However, they are less efficient than condenser enlargers and less suitable for high degrees of enlargement, although modern high efficiency light sources overcome this problem to some extent.

Image contrast is lower than when using a condenser enlarger, requiring negatives to be developed to a higher contrast (see Table 21.1), or a higher contrast grade of paper to be used.

Because of the variation of the Callier coefficient with density, the tone distribution in the shadows of a print produced with a condenser enlarger may be different from that in a print produced in a diffuser enlarger. Table 21.1 relates the required negative contrast to the enlarger type. This contrast is usually quoted in manufacturer's data sheets as 'normal' or 'high' contrast for condenser and diffuser enlargers, respectively. When developing negatives to differing contrasts the following considerations are important:

- Some increase in camera exposure (up to 1 stop) may be required when developing to the lower contrast.
- The required contrast refers to average subjects.
- The contrasts quoted in the table are those recommended by film manufacturers for printing average negatives on a normal grade of paper.

Condenser–diffuser enlargers

Most current popular enlargers employ an optical system which includes both condenser and diffuser. For many purposes such a system offers a very practical compromise between condenser and diffuser enlargers. It allows shorter exposure times than a true diffuser enlarger, yet avoids the necessity for adjusting the position of the lamp for each variation in the degree of enlargement as is necessary in a condenser enlarger. Grain and blemishes on the negatives are subdued to a useful extent, even though not as much

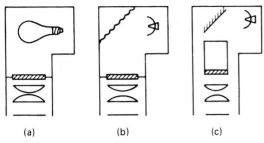

Figure 21.6 Condenser–diffuser illumination systems.
(a) Opal lamp, diffuser and condenser. (b) Tungsten–halogen lamp, integrating box, diffuser and condenser.
(c) Tungsten–halogen lamp, light-pipe and condenser

as in a diffuser enlarger. In most of these condenser–diffuser enlargers, diffusion is achieved simply by using an opal or frosted bulb as light source, instead of the point source required in a true condenser enlarger. Figure 21.6 illustrates three ways of obtaining partially diffuse illumination in condenser–diffuser enlargers.

Some condenser enlargers are fitted with a removable diffusing screen, usually a sheet of ground glass, between the condenser and the negative carrier. This avoids the necessity for frequent readjustment of the position of the lamp, but exposures are longer. The ground glass is uniformly illuminated by the condenser and its scatter is predominately towards the lens. An alternative approach is to use a light-integrating box lined with reflective material, with a diffuser at the exit face. These are widely used in colour enlargers. This action, and the consequent increase in the amount of light passing through the

lens (as compared with use of a diffuser alone), is the sole advantage of using the condenser in this case. To achieve even illumination to the corners of the negative when a diffusing screen is used in a condenser enlarger, the diameter of the condenser must be a little larger than usual, i.e. a little greater than the diagonal of the negative.

Figure 21.7 compares the integrating-box approach with a novel 'dioptic' light pipe which achieves uniform diffuse illumination with little light loss. A light pipe constructed from acrylic material conveys the illumination to the diffusion screen directly from the tungsten–halogen lamp, and at the same time absorbs any UV radiation.

Light sources for enlarging and printing

Details of a variety of light sources have been given earlier in Chapter 3, but light sources for enlarging and digital printing devices include the following:

- Tungsten lamps
- Tungsten–halogen lamps
- Cold-cathode lamps
- High intensity filtered (RGB) light sources
- Lasers (RGB and diodes)

A single tungsten lamp provides a convenient and efficient source of light for enlarging, and most smaller enlargers uses this type of source. A tungsten lamp may be used in conjunction with a condenser or with a diffusing system. An opal lamp used with a condenser provides a convenient condenser–diffuser system. Some tungsten lamps are specially designed for use in enlargers. These are usually slightly overrun, to give high efficiency, and specially treated to provide uniform diffuse illumination with minimum absorption by the envelope of the lamp. Do not use an ordinary 'pearl' lamp or an opal lamp with the maker's name on the envelope, where it may be focused by the condenser. (This is less important where the lamphouse is designed for indirect illumination.)

Tungsten–halogen lamps are also used in many modern enlargers. Their spectral output differs from conventional incandescent lamps owing to some spectral absorption by iodine vapour, and they have a greater output of ultraviolet radiation because the quartz envelope of the lamp transmits this region of the spectrum (see Chapter 3).

Cold-cathode lamps are obtainable in various forms. For use in enlarging they are usually made in the form of a grid or spiral, which provides a large intense source of uniform illumination. All cold-cathode light sources for enlarging are of the diffuser type. As their name implies these sources produce very little heat, their emission is mainly in the blue

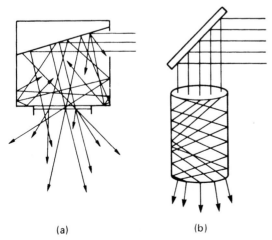

Figure 21.7 Comparison of integrating box and light-pipe diffuser. (a) Integrating box showing light losses due to scatter. (b) Light-pipe showing minimal light loss

region of the spectrum to which monochrome papers are particularly sensitive which has advantages in the production of large prints with relatively short exposures.

Sources such as RGB filtered high intensity lamps (Xenon) and various types of lasers are now used in modern hard copy output devices for 'writing' to photographic colour paper or to special materials (see Chapter 20). Laser diodes are now being produced with their lasing wavelength moving to shorter wavelengths in the visible spectrum. Currently they lase in the red/IR regions at 635 nm to 870 nm with outputs ranging from 3 to 150 mW. Other types of lasers are required for imaging in the green and blue regions of the visible spectrum. For example helium–neon lasers are inexpensive with outputs in green (543 nm) as well as the red (633 nm), whilst for the blue region argon–ion lasers provide their most intense outputs at 488 nm (blue) and 514 nm (green). Lasers provide an intense narrow beam of collimated and coherent radiation which is especially suitable for use in the output from digital imaging devices for 'writing' to photosensitive media by a scanning system. An example of a scanning RGB laser system is given in Plate 26. In this example, used in *Durst* large format digital laser imagers, scanning is achieved by a rotating polygon mirror and a single beam produced by combining the three RGB laser outputs.

Lenses for enlargers

Lenses especially designed for use in enlargers are usually of the symmetrical type. Apertures are often marked not with *f*-numbers but with figures such as 1 (maximum aperture), 2, 4, 8 etc., to indicate the relative exposure times required. For ease in operation in the darkroom, click stops are frequently fitted. Because of the danger of overheating, the elements of an enlarger lens are sometimes not cemented.

We saw earlier, for a condenser enlarger, the focal length of the enlarging lens should be similar to or slightly longer than that of the normal camera lens for the negative size concerned This rule holds good for diffuser enlargers too. If the focal length of a lens used with a diffuser enlarger is too short, it is difficult to obtain uniform illumination at the edges of the field; if it is too long, the required throw becomes inconveniently long, just as with a condenser enlarger. An exception to the general rule for determining the focal length of an enlarger lens applies when working at or near same-size, or when reducing, e.g., when making slides for projection. The angle subtended by the lens at the negative is then much smaller, and it is possible to use a lens of shorter focal length than normal without risking uneven illumination or inadequate covering power. In

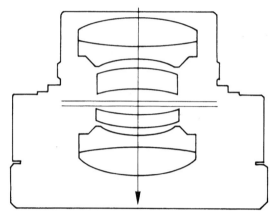

Figure 21.8 A typical high quality enlarging lenses (Schneider Componon)

fact, use of a lens of shorter focal length is often essential when reducing if the enlarger has a limited bellows extension. Incorporation of a heat filter in an enlarger fitted with a tungsten lamp is always recommended for protecting both negative and lens from overheating.

When selecting an enlarging lens the following should be considered:

- *Focal length:* Is this suitable in relation to the size of negative, focal length of condenser (if employed) and range of extension? The suitability of the focal length of the lens in relation to the negative is a question of covering power. This should be tested when the angle subtended by the lens at the negative is at its greatest. This occurs at large magnifications, when the lens is nearest to the negative. Zoom enlarging lenses are now available.
- *Resolution:* This should be tested both in the centre and at the edges of the field, at the greatest degree of enlargement likely to be employed in practice, the test being repeated at several apertures.
- *Range of stops:* Can the markings be read easily or are click-stops fitted? Is the smallest stop small enough to permit sufficiently long exposures for dodging to be done at same-size reproduction? Can the lens be pre-set to stop down to the required aperture after focusing at full aperture?
- *If an autofocus enlarger is employed.* A check should be made that the focusing device operates satisfactorily with the lens concerned at all magnifications.

Many manufacturers of lenses offer enlarging lenses ranging from budget-priced three-element lenses to expensive high-quality lenses of six or more elements (see Figure 21.8). The additional optical elements are to correct for various lens aberrations

(see Chapter 6). The simpler lens are designed for moderate degrees of enlargement (around 4× or 5×) whereas the more complex and expensive lenses are designed for giving optimum image quality in both monochrome and colour at virtually any degree of enlargement from 1× to 20×. Lens design is a compromise between cost and performance, and there seems little point in buying high-quality camera lenses and printing the resulting negatives with an enlarging lens of inferior quality. A typical high-quality enlarging lens which has been available for a number of years is the *Schneider Componon*, illustrated in Figure 21.8.

Ancillary equipment

Negative carriers

The most important feature of any carrier is that is should hold the film flat. This is often achieved by sandwiching the negative between two pieces of glass of good quality, which must be kept scrupulously clean. With very small negatives, e.g. of the 24 × 36 mm size, the glass can be dispensed with and the negative held between two open frames, which lessens the chance of dust marks on prints. When such glassless carriers are used, there is, however, a tendency for negatives to 'pop' or jump from one plane to another under the influence of heat; if this happens between focusing and exposing, the print may be out of focus. Stopping down to increase depth of focus helps to minimize the effect but can itself cause loss of definition.

In order to prevent non-image firming light from reaching the paper from the margins of the negative, most enlargers incorporate adjustable masking blades either in the enlarger or in the negative carrier. This minimizes flare and consequent loss of contrast.

Heat filters

To protect negatives from damage due to overheating, enlargers are fitted with a heat filter, i.e. a filter which passes light but absorbs infrared radiation. The provision of a heat filter is particularly important when a tungsten lamp is employed as the illuminant and exposure times are long, e.g. when big enlargements are being made, or when using colour materials. A heat filter will also protect an enlarger lens from possible danger from overheating.

Easels and paper holders

When using a horizontal enlarger, the sensitive paper is commonly pinned to a vertical easel, which is usually parallel to the negative. For enlargements with white borders, it is necessary to fit some form of masking device to the easel. For vertical enlargers, special paper-holding and masking frames are available. The easels of some vertical enlargers themselves incorporate built-in masking devices. Easels for borderless prints are also available. One type makes use of a flat board that has a tacky surface which grips the back of the paper to hold it flat, and is readily released after exposure. The tacky surface can be reapplied from an aerosol spray when it ceases to be effective. Another method for obtaining borderless prints is by the use of spring-loaded magnetic corners that grip the edges of the paper without obscuring the surface, and so hold the paper flat on a metal base. More sophisticated easels use a vacuum to hold the paper flat.

For professional enlarging where a large number of prints are required, a roll paper holder with motorized transport may be used. This enables many enlargements to be made on a long roll of paper and the motorized paper-transport mechanism can be coupled to the exposure timer for automatic paper advance after each exposure. For enlargements with black borders, prints are first made in the usual way, with or without a white border. A sheet of card, measuring, say, 10 mm less each way than the print, is laid centrally on it and the edges, which are not covered by the card, are fogged to white light (such as an open-film gate) for one or two seconds.

Exposure determination

The following factors which affect exposure times in enlarging are very significant:

- Light source and illuminating system.
- Aperture of enlarging lens.
- Density of negative.
- Degree of enlargement.
- Paper speed.

The exposure required will also be influenced by the effect desired in the final print. The most reliable way of determining the exposure is by means of a test strip. A piece of the paper on which the print is to be made is exposed in progressive steps, say 2, 4, 8 and 16 seconds. This is done by exposing the whole strip for 2 seconds, then covering one-quarter of the paper with a piece of opaque card while a further exposure of 2 seconds is made. The card is then moved over to cover half the strip and a further 4 seconds exposure is given. Finally, the card is moved to cover three-quarters of the strip and an exposure of 8 seconds is given. The results of this technique are shown in Plate 27. If care is taken to move the card quickly and precisely, it may be moved while exposure proceeds, which avoids the need for switching the light off and on. The exposed strip is then given standard development, and the correct exposure is assessed on the

basis of a visual examination of the four steps in white light.

If the correct exposure appears to lie between two steps, the exposure required can usually be estimated with sufficient accuracy, but if desired a further test strip may be made. If, for example, the correct exposure appears to lie between 8 and 16 seconds, a second strip exposed in steps of 10, 12 and 14 seconds will give a good indication of the exact time required.

Once the exposure time for one negative has been found by test, other negatives of similar density and contrast may be given the same exposure. Further test prints will at first be required for negatives of widely differing density, but with experience it is possible to estimate the exposure required for almost any negative, without resort to test exposure. Such trial-and-error methods are also used when an electronic assessing device is used as a means of calibrating the instrument using a standard or representative negative.

Effect on exposure of variation of aperture

With a diffuser or condenser–diffuser enlarger, the effect of stopping down on exposure is similar to that experienced in the camera, i.e. the exposure time required varies directly with the square of the *f*-number, in contrast to a condenser enlarger, where the light reaching the lens from each point on the negative is not distributed evenly in the lens but is concentrated on the axis.

Modern enlarging lenses are anastigmats with a flat field and excellent definition at full aperture. Defini-tion may be slightly improved by stopping down one or two stops, but there should not be any necessity to stop down further simply on account of definition. In fact definition in enlarging may sometimes be harmed by excessive stopping down. Considerable stopping down is required only if:

- A glassless negative carrier is employed and there is risk of the film buckling. Stopping down then assists by increasing the depth of field.
- The easel has to be tilted to correct or introduce perspective distortion. Stopping down then increases the depth of focus.
- Exposure times at larger apertures are too short to enable exposures to be timed accurately or to permit dodging. Stopping down the lens of a condenser enlarger tends to increase contrast.

Effect of variation of degree of enlargement on exposure

It might at first be expected that the exposure required when enlarging would vary directly with the area of the image, i.e. with m^2, where m is the degree of enlargement (image size/object size). This applies approximately to fully diffuse enlargers. However, for semi-diffuse enlargers and condenser enlargers a better approximation is to exposure variation with $(1 + m)^2$. When the exposure at one particular degree of enlargement has been determined, the exposures for prints at other degrees of enlargement, from the same negative, can conveniently be calculated from Table 21.2, which applies to the more commonly used diffuse enlargers and is based on the m^2 formula. The required exposure is found from the table by

Table 21.2 Approximate exposure factors and degree of enlargement

Degree of enlargement for which exposure is known	New degree of enlargement										
	1	*2*	*3*	*4*	*5*	*6*	*8*	*10*	*12*	*14*	*16*
1	1	4	9	16	25	36	64	100	144	196	256
2	0.25	1	2.3	4.0	6	9	16	25	36	49	64
3	0.11	0.44	1	1.8	2.8	4	7	11	16	22	28
4	0.06	0.25	0.56	1	1.6	2.3	4.0	6.3	9	12	16
5	0.04	0.16	0.36	0.64	1	1.4	2.6	4	6	8	10
6	0.03	0.11	0.25	0.44	0.69	1	1.8	2.8	4	5	7
8	0.02	0.06	0.14	0.25	0.39	0.56	1	1.6	2.3	3	4
10	0.01	0.04	0.09	0.16	0.25	0.36	0.64	1	1.4	2.0	2.6
12		0.03	0.06	0.11	0.17	0.25	0.44	0.69	1	1.4	1.8
14			0.05	0.08	0.13	0.18	0.33	0.51	0.73	1	1.3
16				0.06	0.10	0.14	0.25	0.39	0.56	0.77	1

Notes

This table applies to diffuser enlargers.

At very long exposure times, reciprocity law failure may assume significant proportions. The higher factors in this table should therefore be used as a guide only. The actual exposure time required when a high factor is indicated may be much longer than that derived from the table.

multiplying the known exposure by the factor in the column under the new degree of enlargement on the line corresponding to the known exposure for the original degree of enlargement.

Exposure meters and timers

Various types of exposure meters have been devised to assist in the determination of exposures in enlarging. The general procedure when using these devices is to read the luminance of the image on the easel at the desired magnification, with the lens stopped down as required. The reading may be made in either the shadow or highlight areas of the image, provided that the instrument is suitably calibrated. A reading of the luminance of the shadows, i.e. the lightest part of the (negative) image, is usually the easiest to take, and is probably the best guide to the exposure required. These meters require calibration and setting up by initially determining the correct exposure by practical test and judgement when printing a representative negative.

Use of an exposure meter, however, does not completely solve the problem of print exposure. With subjects of unusual luminance range or unusual tone distribution, the exposure indicated by the meter will not always be the best. In these cases, the exact exposure must be found by trial, although use of a meter may assist by giving a first approximation to the exposure required. Some assistance in estimating exposure can be obtained by reading the density of the negative shadows or highlights with a densitometer (off-easel assessment).

Whilst the use of meters is a significant help, allowance must still be made for other variables such as degree of enlargement, aperture, light source, type of optical system employed, etc. Electronic assessing and timing devices are used extensively in colour printing and are described more fully at the end of this chapter. In order to assess the exposure required for printing a negative use is made of the fact that the light transmitted by the majority of negatives integrates to a more or less constant density, or spot readings of a small critical area such as a mid-tone (flesh tone or a grey card included in the original scene) are taken with a suitable measuring instrument. Determination of exposures by either of these methods with the negative in the enlarger and the probe of the measuring instrument on the baseboard is given the name on-easel assessment. In both cases the meter requires calibration by printing a 'master' or 'standard' negative by a non-instrumental method involving practical tests and judgements.

Once a satisfactory print has been made, the measuring probe is placed on the baseboard and the instrument is zeroed, employing either a spot or integrated measurement of the light transmitted by the master negative. Any other negative that does not

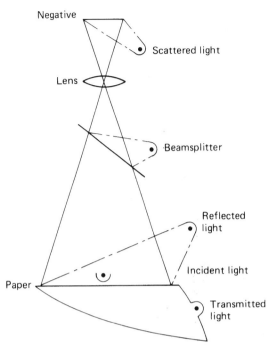

Figure 21.9 Various positions of detectors for assessing exposure

depart markedly from the master should give a satisfactory print after taking a reading with the meter and adjusting the exposure by the amount indicated by the measuring device being used.

Many exposure-assessing devices also have an electronic timer incorporated, and lend themselves to automated printing by assessing the exposure during the printing operation and turning the enlarger lamp off after the required time. In this method of automatic exposure determination the total or integrated light transmitted by the negative is measured by placing the detector or probe in one of a variety of positions shown in Figure 21.9 which are summarized below:

- Measuring light scattered by the negative before passing through the enlarger lens.
- By deflecting a portion of the transmitted light to the detector by means of a beamsplitter after it has passed through the enlarger lens.
- By measuring light reflected from the paper.
- By measuring light incident on the paper after it has been diffused.
- By collecting and measuring light after it has been transmitted by the paper.

The first two methods are widely used in automatic printers and measuring light incident on the paper is a procedure commonly used in professional enlargers

for both colour and black-and-white printing. Masking frames, complete with photocell or photo-multiplier tube on an arm, which collect light reflected from the surface are used in the printing of both black-and-white and colour negatives. Collecting light transmitted by the paper is a very inefficient means of monitoring exposure and is only used in some forms of special purpose contact printers. It is also possible to use a simple photographic exposure meter for assessing exposures for printing negatives. One such technique involves placing the exposure meter against the enlarger lens to measure the integrated light from the master negative after having first obtained a satisfactory print. Then with the new negative in the enlarger the aperture is adjusted to obtain the same reading as before and a print made using the same exposure time. Although seemingly crude, this technique does work and has even been used in colour printing.

Variation in illuminant in enlarger

The output of a tungsten lamp falls off with age. In determining exposures, allowance must be made for this, especially when a new lamp is fitted. If the new lamp is of a different type or make from the previous one, even if it is of the same wattage, its output may differ because not all lamps of the same wattage have equal luminous efficacies.

Voltage fluctuations in the mains supply can make it difficult to achieve accurate exposures in enlarging. For example, a 5 per cent reduction in voltage lowers the light output by about 20 per cent and at the same time alters the colour temperature considerably. Normal supply variations do not usually cause trouble, but, if for any reason the variation is excessive, it may be worthwhile in critical work to fit a voltage regulator to the supply.

Conventional image manipulation

Dodging and shading

One of the advantages of enlarging is that it gives the photographer the opportunity of controlling the picture by intercepting the projected image between the lens and the easel. A straight enlargement from any negative seldom gives the best image that can be obtained, and with the great majority of subjects such as landscapes, portraits, architecture or technical, a little local shielding of parts which print too dark, or the printing-in of detail in some especially dense part of the negative, often results in a considerable improvement. Control of this kind may be used to compensate for uneven lighting of the subject, or to give added prominence to a selected part of the composition.

To bring out detail in a highlight, use a piece of card with a hole in it that is slightly smaller than the part to be treated. After exposing the whole picture in the usual way, use the card to shield all parts except that which is to be exposed further. Hold the card fairly close to the paper, and keep it on the move slightly to avoid the edge being recorded, for the time that a trial enlargement shows to be necessary.

To hold back shadows, e.g. a portrait in which the shadow side of the face becomes too dark before the full details of the other parts are out, use a 'dodger'. These can be made from thin card cut to a variety of shapes and sizes with wire threaded through holes in the card. They may be made double-ended, with a twist in the middle of the wire for hanging on a hook in the darkroom. The shape and size of the shadow cast by a dodger can be varied by tilting it, and by using it at different angles and at different distances from the easel. Many people find it convenient to use their hands as a dodging device.

Correction or introduction of perspective distortion

In Chapter 10 on camera movements we saw that if we tilt a camera in order to include the whole of a building in a photograph, we will produce a negative with converging verticals. Without camera movements these results are inevitable. The effect can be balanced out to some extent by tilting the enlarging easel. In this way the convergence can be cancelled, though as this operation elongates the image, only a small degree of convergence can be corrected. Some enlargers allow tilting of the negative holder and this can reduce the distortion provided the negative is properly centred. If the tilt of the negative holder and the baseboard satisfy the *Scheimpflug* requirement, defined in Chapter 10, the image will be sharp overall at full aperture. The positioning of the negative is not easy, as its precise position depends on the solution of a complicated equations and a satisfactory result will depend on trial-and-error methods.

Minimizing graininess

As all photographic images are made up of grains of silver of finite size, enlargements may appear grainy. The grainy appearance of a print is primarily a function of the granularity of the negative and the degree of enlargement. It may, however, be minimized at the printing stage by:

● Choice of a suitable enlarger. Where graininess is serious, condenser enlargers should be avoided as they accentuate the effect; diffuser enlargers are a better choice.

- Using a printing paper with a textured surface.
- Using a diffuser between enlarger lens and printing paper. See below under 'Soft-focus enlargements'.
- Setting the enlarger slightly out of focus. This is seldom effective, as the grains are sharper than the recorded detail. As a result the detail disappears before the graininess disappears.

The graininess permissible in a print depends very much on the conditions of viewing. The graininess acceptable in a large print to be hung on an exhibition wall is much greater than can be tolerated in a small print intended for viewing in the hand. When preparing 'giant' enlargements, critical judgement should not be given until the prints are finally spotted, and viewed at the appropriate distance. Giant enlargements can appear extremely coarse and full of imperfections when they are examined at short viewing distances before mounting and finishing.

Soft-focus enlargements

Some types of subject are often greatly improved by diffusing the image to blur its aggressively sharp definition a little. This may be achieved by the interposition of a suitable material between the lens and the image. A piece of black chiffon, bolting silk, fine-mesh wire or crumpled cellulose sheet may be fitted to a rim which is slipped on to the enlarging lens for part or all of the exposure. Alternatively, an optical soft-focus attachment can be employed. The result is to give the image a soft appearance with a slight overlapping of the edges of the shadows in to highlight areas. In addition to giving softer definition, the enlargement also shows slight reduction in contrast and graininess is minimized. Net-like material or cellulose sheet stretched over a card cut-out

may also be used close to the enlarging paper. The texture effect is then usually more pronounced. Whatever form of diffusing medium is used, at least 50 per cent of the exposure should generally be made without the diffuser. The effect produced when diffusion is obtained in the enlarger is not the same as when a soft-focus lens is used on the camera. In printing from a negative there is slight 'bleeding' of shadows in to highlight areas whilst in capturing the image with a camera the opposite effect occurs.

Colour printing

The basic techniques of black-and-white printing are also applicable to colour printing. Contact, projection and automatic printing methods are all used, but with some practical restrictions owing to the nature and properties of the colour materials. In addition, more sophisticated equipment is needed to ensure consistency and predictability of results. The principles of colour photography are discussed fully in Chapter 14, and the technology of colour reproduction by subtractive synthesis methods using yellow, magenta and cyan dye images only, is described for both reversal and negative–positive processes in Chapter 24.

Colour printing materials, of which there are a wide variety of general- and special-purpose types, all utilize such dye images, though there is a wide diversity of order of layer sensitization, emulsion contrast, method of dye formation and type of base used, depending on the manufacturer and the purpose of the material.

The basic aim of colour printing is to produce a colour print of an original subject having acceptable density and colour balance. There are various forms of colour printing, depending on the materials employed; these may be subdivided into the two

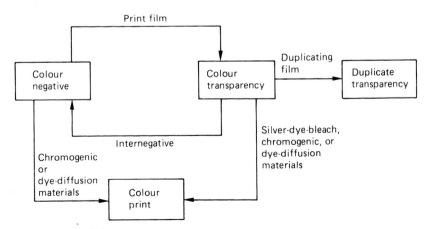

Figure 21.10 Routes in colour printing

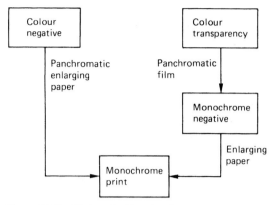

Figure 21.11 Black-and-white prints from colour negatives

classes of negative–positive printing and positive–positive printing. In the former, a colour negative is printed on to colour-print material which is subsequently colour-developed to give the final positive result. In the latter, a colour transparency is printed onto colour material which is reversal-processed, using either chromogenic development, dye-destruction or dye-diffusion techniques (see Figure 21.10). These processes may be further extended if devices such as colour intermediates or masking techniques are required.

Other forms of printing from colour originals (negative or reversal) include the making of monochrome prints, colour separation matrices for dye imbibition printing, and the production of colour inter-negatives. Figure 21.10 outlines the most common pathways to various end-products, starting with a colour negative or transparency. Colour-print materials have an opaque white reflecting base that may be of paper, resin-coated paper or plastics to give colour prints for viewing by reflected light. Alternatively, a transparent base may be used to give a transparency for viewing by transmitted light. The production of black-and-white prints from colour negatives or transparencies can be carried out via the routes indicated in Figure 21.11.

Variables in colour photography and printing

The accuracy or acceptability of the final colour reproduction, in particular when colour printing by negative–positive techniques, depends on a large number of variables in the reproduction chain. Some are under the direct control of the user, others are not. An abbreviated lists of variables includes:

● Nature of the subject and subjective colour effects.

● Properties of the light source used (intensity, hue etc.).
● Camera and lens used.
● Exposure duration.
● Film batch characteristics, including latent image stability.
● Film processing.
● Colour enlarger characteristics, e.g. intensity and hue of light source and filter spectral properties.
● Print exposure conditions.
● Colour paper batch characteristics.
● Colour paper processing.
● Viewing conditions for the colour print.

It might seem that colour printing is a formidable task and that the possible sources of error would make acceptable colour reproduction a difficult achievement. Fortunately, with some care, foresight and methodical operating techniques, it is possible to control most of the variables concerned with the mechanics of print production so that full attention can be given to the problems of print assessment. Much of the necessary information regarding the use and practice of colour printing is available from the manufacturers of sensitized materials, albeit with the emphasis on their own range of products. There is now almost full compatibility between one manufacturer's products and those of another so that colour negatives taken on one product may be printed on print material from another source. In addition, paper and processing solutions from independent suppliers are also available.

Colour filtration

Some of the inconsistencies at the camera stage, such as incorrect colour temperature of the source and reciprocity law failure effects, may be wholly or partially correctable either overall or locally on the print by corrective colour filtration of the enlarger light source. Such colour filtration is the prime control of colour reproduction in the print. By altering the relative proportions of exposures to the red, green and blue sensitive layers of the print material, which respectively yield cyan, magenta and yellow dyes, colour reproduction may be varied at will. The peak sensitivities of the individual layers of colour-print materials are matched to correspond more or less with the peak spectral absorptions of the three subtractive dyes used in colour negative materials for any one range of products. However, the individual sensitivities of the three layers of the colour-print material vary greatly, to compensate for the particular position of one layer in the coating order and to give adequate separation of spectral sensitivities of the layers without the need for an additional yellow filter layer

Table 21.3 Corrective adjustments when colour printing by the additive method

	Negative–positive printing		Positive–positive printing	
	Remedy		Remedy	
	Either	Or	Either	Or
Appearance of test print on assessment	Increase exposure through this filter	Decrease exposure through this filter	Increase exposure through this filter	Decrease exposure through this filter
Too dark		All three	All three	
Too light	All three			All three
Yellow	Green and red	Blue	Blue	Green and red
Magenta	Blue and red	Green	Green	Blue and red
Cyan	Blue and green	Red	Red	Blue and green
Blue	Blue	Green and Red	Green and red	Blue
Green	Green	Blue and red	Blue and red	Green
Red	Red	Blue and green	Blue and green	Red

used in conjunction with the blue-sensitive layer. Also, compensation for the density of the masking layers in masked colour negative materials may also be given by this means. Difficulties in manufacture mean that each batch of colour-print material may have layer sensitivities similar to but not identical with other batches. Modern manufacturing methods now provide materials that are very consistent in sensitivity and reciprocity law behaviour. Finally, the overall response of the colour-print material depends on the spectral energy distribution of the light source in the enlarger and any selective absorption by the optical system.

The major role of colour filtration in colour printing is to compensate for any batch differences of materials, for variations in the illumination of the subject, processing variations and changes due to keeping films before and after exposure. Secondary functions include compensation for differences between printers in terms of the quality of light output and the correction of colour casts due to reciprocity-law failure effects. This latter are caused by the unequal response of the three image-forming layers as the image luminance decreases. Colour-filtration is, of course, also a creative tool in the hands of the user, permitting mood and effect to be introduced into prints, for 'correct' colour reproduction is not always the aim.

The necessity of controlling the relative exposures of the three layers of different spectral sensitivity of colour-print materials is a fundamental aspect of the design of equipment for colour printing. Two basic methods are used: sequential (or simultaneous) selective exposure of each layer (additive printing) or a filtered single exposure, exposing all three layers simultaneously (subtractive printing). The two methods involve different sets of colour filters.

Additive (triple-exposure) printing

The colour-print material may be exposed to the colour negative (or transparency) by three consecutive exposures using tricolour red, green and blue separation filters. The blue-sensitive layer of the paper emulsion is exposed only to the yellow dye image of the negative, carrying 'blue' information about the subject, the green-sensitive layer only to the magenta dye image and so on. The exposure level for each layer is adjusted by varying the exposure time given, though it is possible to alter the lens aperture instead and retain a constant exposure time. Because of the filters and method used, this printing method is usually referred to as additive colour printing. Overall print density is controlled by the aggregate magnitude of the three exposures. Print colour balance is determined by the ratio of the three exposures. From subtractive theory we can derive tables for the effect of corrective adjustments to final colour balance. Table 21.3 refers to conventional negative–positive printing and positive–positive printing by this method.

The advantages of the additive method are that only three filters are needed, obviating the need for an expensive colour enlarger, and that it lends itself to use in colour printers for mass production. The disadvantages are formidable. Foremost is that of registration problems, if the enlarger or masking frame should be moved accidentally between exposures. There is also the possibility of widely differing exposure times for the individual layers. Some users find difficulty in assessment of colour prints and subsequent corrective action for colour and density changes. Finally, local control of density and colour by selective filtration and exposure is not easy to perform, even for skilled operators. However, some colour printing devices use simultaneous additive

printing in which three light sources can be separately varied (time or intensity) and so avoid registration problems.

Subtractive or white-light printing

The preferred alternative for manual colour printing is to give a single exposure of filtered white light instead of three exposures of coloured light. Selective exposure of the three layers with a constant exposure time and lens aperture is made by altering the proportions of red, green and blue light from the source by subtracting the excess amounts using weak colour printing filters of cyan, magenta and yellow respectively.

From the subtractive theory of colour reproduction, it is again possible to derive tables to suggest filtration changes to improve colour reproduction when a test print is assessed. Table 21.4 lists such corrections for negative–positive printing using conventional colour materials. It is worth pointing out that most colour-print materials require the use of only yellow and magenta colour printing filters for all corrections. The following principles, on which Tables 21.4 is based, are summarized below for negative–positive printing.

- A colour cast is removed by a filter of the same colour.
- Colours not included in the filter set are obtained by the combination of two appropriate filters.
- Filters of all three colours should never be used together because they produce a neutral grey which increases the exposure. Thus a filter selection of 10Y, 20M and 10C is the same as 10M + 10 grey. In such a case 10Y, 10M and 10C should be removed, leaving 0Y, 10M, 0C.
- The more intense the colour of the cast the higher the filter value or density is required.

- Filters increase the required exposure depending on their density.

For obtaining acceptable colour prints three major assessments have to be made by the printer. These are the exposure time, the colour, and the intensity of the colour cast. Of these the last two are the most difficult to assess, and are discussed later under 'Colour print evaluation'. Even with the most modern automatic printing equipment it is necessary to obtain a correctly balanced colour print by a series of tests and visual examination of the prints, and to calibrate the system with a standard or representative negative.

Table 21.4 also gives the necessary corrective filtration for colour casts when positive–positive printing is being carried out. For this technique it should be noted that an increase in exposure gives a less dense print and vice versa, the reverse of the negative–positive case. Also addition of filtration of a particular colour, e.g. yellow, either gives a more yellow result, or, alternatively, removes a blue cast from a print. The advantages of white-light printing are numerous. There are no registration problems or intricate calculations of relative exposures. More efficient use is made of the available light output. Local control of density and colour are possible by the usual shading and burning-in techniques with or without filtration. The necessary enlarger modifications may be incorporated in an accessory colour head. One disadvantage is the higher initial cost of a large number of colour filters or of a colour head for the enlarger. Also dye-based filters may fade with use.

Colour enlarger design

The majority of enlargers used for conventional black-and-white printing may be used for colour printing by the introduction of a few modifications,

Table 21.4 Corrective adjustments when colour printing by the subtractive method

Appearance of test print on assessment	Negative–positive printing		Positive–positive printing	
	Remedy		*Remedy*	
	Either	Or	Either	Or
	Add filters of this hue	*Remove filters of this hue*	*Add filters of this hue*	*Remove filters of this hue*
Too dark	Reduce exposure		Increase exposure	
Too light	Increase exposure		Decrease exposure	
Yellow	Yellow	Magenta and cyan	Magenta and cyan	Yellow
Magenta	Magenta	Yellow and cyan	Yellow and cyan	Magenta
Cyan	Cyan	Magenta and yellow	Yellow and magenta	Cyan
Blue	Magenta and cyan	Yellow	Yellow	Magenta and cyan
Green	Yellow and cyan	Magenta	Magenta	Yellow and cyan
Red	Yellow and magenta	Cyan	Cyan	Yellow and magenta

such as a different lamphouse complete with colour filtration arrangements, (colour head). Enlargers constructed specifically for colour printing are also available. The particular requirements for a colour enlarger may be considered under the following headings.

Light source

The light source must have a high light output with a continuous spectrum. Cold-cathode lamps are unsuitable because of their deficiency in red light. The additional requirements of a useful life with constant output and colour temperature as well as compact size make tungsten–halogen lamps an obvious choice. One or two of these lamps are used in most colour heads. The lamp envelope may be positioned in an ellipsoidal reflector that reflects visible light but transmits infrared radiation, called a 'cold mirror'. Additional forced cooling using a blower may be needed.

Optical components

The enlarger lens should be a well-corrected achromat with a flat field. Optical condensers and other glass components such as negative carriers should be of optical-quality glass and colourless. Pure condenser enlargers are unsuitable for colour printing; a completely diffused illumination system is preferred as the dye images in the colour negative do not scatter light, so there is no appreciable difference in contrast in the results given by either a condenser or diffuse illumination system. But scratches and marks on colour negatives do scatter light, so diffuse illumination is preferred to reduce the need for retouching of colour prints. The loss of efficiency due to this form of illumination is more than offset by the reduction in retouching requirements. The diffuse illumination is usually provided by an integrating box above the negative. The filtered light from the enlarger light source is admitted through a small entry port into the integrating box (see Figure 21.7).

Electrical supply and exposure timing

To prevent the occurrence of random colour casts in colour prints it is necessary to stabilize the lamp voltage to within plus or minus 1 per cent. The best way to achieve this is via a constant-voltage mains transformer and an electronic stabilizer. Low-voltage tungsten–halogen lamps, which operate from stepdown transformers, are usually less susceptible to mains voltage fluctuations. Control units are available for colour enlargers which incorporate step-down transformers, constant voltage transformers, an elec-

tronic timer and various unstabilized outlets for safelights and footswitch control, all in one convenient package.

It is important to have an accurate timer. Digital timers may now be bought off the shelf, and in their versatility and accuracy they completely supersede the older electromechanical versions.

Filters

Provision must be made for the various forms of filtration. An infrared-absorbing filter or 'heat filter' must be incorporated in the light path adjacent to the light source to protect filters, optical components and the negative. The use of cold mirrors alone is insufficient. The heat filter has another function of absorbing the infrared radiation to which colour paper is sensitive and so removes a possible source of variable results. Similarly, an ultraviolet-absorbing filter must be located in the light path, removing this radiation, to which colour paper is sensitive and which constitutes another source of error. This filter may be glass or plastic.

The colour-printing filters may be the tricolour or subtractive varieties. Tricolour filters are of gelatin or glass-mounted. Subtractive filters may be of gelatin, acetate, glass-mounted or interference (dichroic). Location of the filters is discussed in the evolution of colour enlarger design (see below).

Types of colour enlarger

Colour enlargers have evolved over a number of years and some examples are given in Figure 21.12 The simplest method is to place individual tricolour filters below the enlarger lens for each exposure by the triple-exposure method. A simple filter turret may be used for convenience. Subtractive filtration is also possible in the same position, using gelatin colour-compensating filters. A selection of densities in the primary and subtractive colours is necessary to allow a filter pack to be made up using the minimum number of filters. This, however, requires some calculation. Filter placed in this position must be of high optical quality.

The simplest modification to an enlarger is to provide a filter drawer above the condenser lenses or diffuser. Colour-printing filters of low optical quality may then be used. However, it is tedious to make up a filter pack from individual filters, errors are easily made, and the process is time-consuming when an on-easel colour negative analyser is being used. Consequently, the next stage in colour enlarger design was the provision of a graduated filtration set adjusted by use of calibrated dials. By positioning the filters close to the light source only a small effective filter area

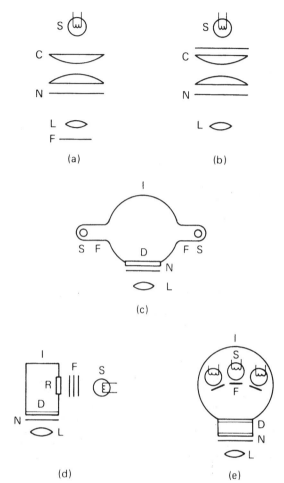

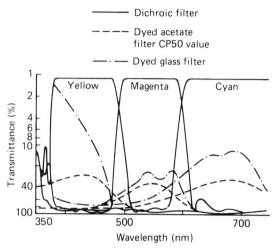

Figure 21.13 Spectral transmittance curves for different types of subtractive colour printing filters

Figure 21.12 Examples of colour enlarger: S, light source; C, condensers; N, negative; L, lens; I, integrating box or sphere; D, diffuser; F, filter; R, infrared absorbing filter. (a) Filters below lens (tricolour or subtractive). (b) Filters above condenser (subtractive). (c) Integrating sphere with subtractive filtration. (d) Dichroic filters (subtractive). (e) Three lamps with tricolour filters and integrating sphere

in optical densities. Yellow, magenta and cyan filters are used. The comparative spectral transmission characteristics of dyed acetate, dyed glass or gelatin-on-glass and interference filters are given in Figure 21.13. The advantages of interference filters are improved spectral transmission properties and freedom from fading.

A hybrid form of colour head on an enlarger uses three identical light sources that are filtered red, green and blue respectively to the required amount, the three coloured beams being integrated to give a synthesized white light of the desired spectral energy distribution for the colour printing conditions (Figure 21.12e).

Further refinements to colour enlargers include the provision of some form of colour negative evaluation

was needed and the filtered light was then integrated in a suitable manner.

Typical designs included a fan-shaped array of colour printing filters dialled-in, with two lamps and an integrating-sphere; other designs used dyed gelatin-in-glass filters of uniform density, inserted progressively into the light path to increase their filtration effects. The first type was calibrated in filter density values, the second type in arbitrary numbers.

A more recent stage in development has been the introduction of interference filters whose effective filtration is varied by progressive insertion or removal from the light path using calibrated controls reading

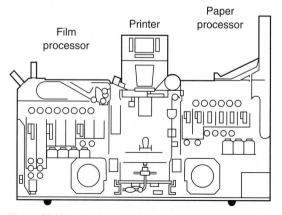

Figure 21.14 A typical colour printer processor used in mini-labs (Agfa)

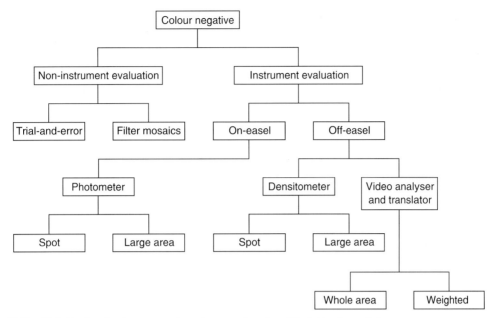

Figure 21.15 Methods of evaluating or assessing colour negatives for white-light colour printing

to assist selection of the correct filtration to give an acceptable result. This may take the form of filtered photocells inside the enlarger bellows or a unit that is inserted below the lens. They are simplified versions of the highly automated circuitry of colour printers and are a worthwhile addition.

More recent innovations in colour enlargers include the automation of changes in magnification by computerized motor control, autofocus and full automation of exposure assessment. There is also a trend towards daylight operation and the combination of enlargers with paper-processing machines for mini-labs. Figure 21.14 shows an example of this type of equipment. These daylight enlarger/print processors have been derived from equipment that has been used for many years by large-scale processing laboratories to cater for the requirements of the increasingly popular mini-labs.

Methods of evaluating colour negatives for printing

Unlike black-and-white printing, it is not possible to estimate printing conditions by visual inspection of a colour negative. Consequently, in the absence of any other aid, test prints combined with trial-and-error methods are necessary to obtain a satisfactory result. Colour-print materials are expensive and their processing times are significantly longer than those of

monochrome print paper. Consequently, any instrumental methods of evaluation of a colour negative to give a correct or near-correct estimate of the colour filtration and exposure requirements for an acceptable result are of considerable value. There are a number of possible methods of determining printing conditions, summarized in Figure 21.15.

Non-instrumental methods

Colour printing by trial and error is not recommended as a routine but it is the only method of obtaining a good quality print when first using new equipment and new batches of print material. Additionally, even when an instrument evaluation method is to be used with the enlarger, it is first necessary to produce such a print by trial and error from a master negative. From the printing data thus obtained, the colour negative evaluation system may be set up for subsequent use. A master negative is one taken specially for the purpose, containing a selection of suitable reference areas, colours and a reflectance grey scale. Care is taken over its exposure and processing. A master negative is required for each colour negative material to be used.

The use of a filter mosaic may be an improvement over trial-and-error methods. For white-light printing an array of representative filter packs are assembled and put in contact with the negative or print material during exposure. The image area with

best colour balance is selected and the corresponding filter values used as a basis for more tests or for a final print. Alternatively, an integrating method may be used with the mosaic on the print material, by putting a piece of diffusing material over the enlarger lens. The image patch closest to neutral grey is then determined and the corresponding filtration used. Exposure determination is a separate problem. Suitably filtered step-wedge arrays may be used to determine exposure data for additive printing. A ring-around procedure is a very good way of producing a large number of colour and density variations when setting up colour printers. Even if the original estimated filtration is incorrect one of the results obtained will almost certainly be correct and the ring-around results can be kept for reference in determining the colour and extent of colour casts in subsequent printing sessions. In the ring-around series shown in Plate 28, filtrations have been changed by units of 10 so that 10 unit shifts in the primary and secondary colours are produced. The '+' and '−' values indicate the amount by which the original filter value should be changed. Other closer ring-arounds, using smaller shifts, can also be produced centred on the correct filtration.

Instrumental methods

Various instruments are available for use either off-easel or on-easel. Off-easel evaluation consists of measuring or evaluating the colour negative alone, before insertion into the enlarger. A colour densitometer may be used and can service a number of enlargers. The technique depends on setting up with a master negative. The known filter pack densities for this negative with a particular enlarger are added to the corresponding image dye densities of the chosen reference area, as measured by the colour densitometer. A negative to be printed is measured similarly, and its densities subtracted from the total densities of the master negative plus filter pack to give the required filter pack. No direct indication of exposure is given, and separate on-easel photometry may be required for this purpose, though exposure may be determined from off-easel measurements and knowledge of the example required to print the master negative. Although this method uses a densitometer, and evaluation is done in room light conditions, calculations are necessary and no allowances are made for the fading of colour filters, the ageing of the enlarger lamp or any alteration in magnification.

A very accurate method of off-easel evaluation, when printing conditions such as magnification and paper batch characteristics are accurately known, is by the use of a colour video analyser. The colour negative is scanned in a closed-circuit colour television system and a positive colour image on a monitor screen is manipulated until the required result is given. The calibrated colour balance and density control settings are recorded and related to printing conditions by a translator device during printing. On-easel evaluation is an application of image photometry with measurements of image illuminance made in the image plane on the enlarger baseboard. Such photometers, or colour negative analysers, require high sensitivity for this task as measurements are taken through tricolour filters. This is especially so when coupled with difficult printing conditions such as a dense negative, high-value filter pack and high magnification. On-easel measurements are conveniently made using a small probe on the baseboard connected to a fibre-optics light pipe to convey the light from the area sampled to the main body of the instrument.

To use an easel photometer, a master negative with known filter pack is inserted into the enlarger, and image illuminance measured in the chosen reference area through red, green and blue tricolour filtered sensors, and finally without filters over the photocell. The instrument scale is zeroed for each condition by means of attenuators (small potentiometers). Many instruments have resettable attenuators, or several sets of four forming a 'memory' unit for different batches of paper. The new negative to be printed is inserted and, for the same photocell filter conditions, the subtractive filtration and lens aperture are altered to zero the instrument at each setting. Zeroing the instrument may be by setting a meter or digital display reading to zero, or by adjustment of the attenuators to light a small lamp. Dial-in filtration is a great help. After evaluation, a fixed exposure time at a suitable aperture is given to the colour paper to reduce the effects of reciprocity-law failure. The great advantage of the easel photometer technique is that measurements allow for filter fading, lamp ageing and image magnification. Exposure and filtration are given directly. A disadvantage is that readings have to be made in darkroom conditions. Both on-easel and off-easel methods of evaluation rely for their potential accuracy on the choice of an appropriate reference area, as mentioned above. There are two methods available, small-area or spot measurements and large-area or integrated measurements. Small-area measurements coupled with an on-easel technique are more accurate. The colour negative should contain a suitable reference area such as an 18 per cent reflectance grey card or a skin tone or other preferred colour. This area should receive the same lighting as the significant subject matter but can be positioned in an unimportant region such as the edge of the negative area.

Unfortunately, it is not always possible to include a small reference area. The subject may be back-lit or inaccessible to the photographer. Also, amateur colour negatives are not made with such requirements in mind. Consequently large-area measure-

ments have to be made, usually from the whole negative area, hence the term 'integrated' readings. For off-easel densitometers, a large photocell may be used to take such readings. Alternatively, as for on-easel photometers, the image may be integrated by interposition of diffusing material between negative and photocell. The various filter readings may then be taken.

The integration technique must also be set up on the basis of a master negative, but one that is also typical in terms of both colour and tonal distribution of the subject matter. The integration-to-grey of such a typical subject is the evaluation principle used, as in automatic colour printers. Unfortunately, a small but significant number of negatives contain non-typical colour or tonal distributions. One consequence is that predominance of one colour in the subject leads to a colour print with an overall colour cast of the complementary colour. Such a result is called a 'subject anomaly' or, incorrectly, 'subject failure'. Corrective measures are possible with automatic printers.

An interesting approach to this problem is a technique of off-easel evaluation whereby a large number of asymmetrically distributed spot readings are taken of the colour negative and average values calculated for determination of printing conditions. This is a form of weighted large-area measurement. With the advent of microcomputers, sophisticated systems of assessment can be manufactured at modest cost. These are capable of carrying out complex calculations on a large number of readings to give a high proportion of acceptable prints even with awkward subject anomalies.

Digital output

Figure 21.1 shows a variety of routes to hard copy and in Chapter 20 the different hard copy output media were described. This chapter has, so far, only discussed output via conventional photographic media. The technology in this area is changing very rapidly. Currently there are hybrid devices which produce photographic quality colour prints from photographic originals via computers which allow image manipulation and processing before writing the data (Plate 26) to photographic paper or other hard copy output media (see Chapter 20). Hybrid systems are able to cope with a wide variety of image input data and to provide output in a variety of differing formats and media which modern applications demand. In order to print via this route from a photographic original it must first be digitized by a scanner. Scanners convert analogue information into digital data in the form of raster images of pixels by sampling the original image at set intervals.

Scanning

Scanners may be divided in to two types:

- drum scanners, which employ photomultiplier tube (PMT) detectors and have the original material wrapped around a drum.
- flatbed scanners, which use linear array CCD detectors and are available for large area scanning of reflection and transparent materials and as high resolution film scanners for 35 mm, APS and other film formats.

Flatbed scanners are less costly and are more widespread for desktop publishing and professional prepress applications than drum scanners, which are used mainly by the printing and related industries for high quality commercial reproduction. These scanners are shown in Plate 29 and Figure 21.16. However, the quality and resolution of flatbed scanners is increasing and rapidly catching up with that of drum scanners. Drum scanners use a high intensity source such as a xenon or tungsten–halogen lamp which is focused on to a small area of the original wrapped around a drum. Plate 29 shows a drum scanner for transparent material with the focused light source coming from inside the drum. For reflection materials the light source is outside the drum. The drum rotates and the focused beam moves along the cylinder at right-angles to the direction of rotation. The light beam transmitted (or reflected) by the original travels to dichroic mirrors which divide and divert the light into red, green and blue beams through red, green and blue filters to the photomultiplier tube detectors. The analogue signals formed by the PMTs are then digitized by an A/D converter.

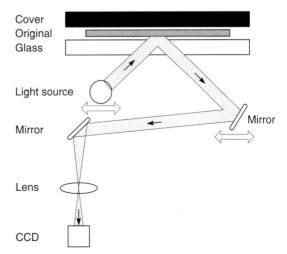

Figure 21.16 Cross-section of a flatbed scanner

Drum scanners have high dynamic ranges and are capable of scanning at high resolution but are relatively expensive to buy and maintain. Also, materials for scanning must be wrapped around a drum and held in close contact. This restricts their use to flexible originals and irreplaceable originals have to be duplicated before scanning.

Flatbed scanners, although generally capable of scanning at lower resolutions and dynamic ranges, are inexpensive. The principle of operation of a flatbed scanner for a reflection material is shown in Figure 21.16.

Flatbed scanners generally use a linear light source in the form of a fluorescent tube or halogen lamp which moves in conjunction with a mirror which directs scanned lines of the image on to a linear CCD via a second mirror. Figure 21.16 shows a flatbed scanner for reflection materials. Some may also be used for transparent material in which case they are supplied with a top cover containing the light source. In film scanners scanning may be carried out by movement of the film in the scanning device with the light source and CCD remaining stationary. Some scanners record colour information in three passes using red, green and blue filters (or light sources) whilst single pass scanners may use three linear CCD arrays filtered to detect red, green and blue light, or three colour flash exposures and a monochrome CCD.

Key factors in determining the quality of scanning are the *resolution, dynamic range* and *bit depth* which are determined by the hardware and the software. *Digital resolution* is a measure of the overall resolution and expressed as the number of pixels in the horizontal dimension and those in the vertical dimension, 3072×2048 pixels, for example. This relates to file size by the calculation given in Chapter 1.

Input resolution is a measure of the scanners sampling rate, usually described in *pixels per inch (ppi)*. Scanners have variable input resolutions, the pixel size decreases as the scanning rate in ppi increases. The term *dots per inch (dpi)* strictly applies to *output resolution,* although many suppliers and users use this term for describing input resolution, which can lead to confusion. When scanning it is important to note that the input resolution should relate to the output resolution. For example, it is very inefficient in data handling to scan an image at 600 ppi if the only application is to display it at 72 dpi on a computer monitor. It is also important to realize that if an image is scanned at say 300 ppi, which relates to a required printed output resolution of 300 dpi the image seen on the computer monitor will be very large and only a part of the image displayed on the screen. This is because a typical monitor has a fixed resolution of say 72 dpi and so the image will appear approximately four times as big (300/72).

Also the *sizing factor* (equivalent to magnification) must be taken into account and *Agfa* have devised the following rule for determining the scanning resolution or rate:

$$\frac{\text{Required scanning}}{\text{resolution}} = \frac{\text{Resolution of output device} \times}{\text{Sizing factor}}$$

Where,

$$\text{Sizing factor} = \frac{\text{Desired size}}{\text{Original size}}$$

For example, for a print of size 7.5 in \times 5 in (191 mm \times 127 mm) with a resolution of 300 dpi the required scanning resolution for a 35 mm negative (36 mm \times 24 mm) is given by:

$$\text{Required scanning resolution} = 300 \times \frac{191}{36}$$

$$= 1600 \, \text{ppi}$$

If, however, the same size image is to be viewed on a display with a resolution of 72 dpi the required scanning resolution is reduced to 380 ppi and there is no benefit to be gained by scanning at 1600 dpi unless it is envisaged that at some time in the future a print is required.

Optical resolution may be different from the quoted resolution for some scanners. The optical resolution is the true scanner resolution based on the information that the scanner's optical system can sample. Quoted values can be twice as high as the optical resolution. This apparent increase in resolution is achieved by software that interpolates data by algorithms that average the data of neighbouring pixels and insert an additional pixel between two pixels. This is spurious extra information which does not improve resolution or image quality. It is always better to avoid this and use a scanner of the highest optical resolution in relation to the application and the required output.

The *dynamic range* or *density range* of a scanner places limitations on the density range of the input material that can be read by the scanner. Photographic materials have density ranges from around 2.3 for photographic prints to as high as 4 for high quality slides, whilst inexpensive scanning devices may have a dynamic range of 2.5 or less. Although the dynamic range of scanners will improve due to improvements in sensor technology, compression of tones is a current limitation because of the mismatch between the dynamic range of the scanner and the photographic input.

The *bit depth* defines the number of grey levels the scanner can accommodate per pixel and determines the smoothness of changes between grey levels. The bit depth is expressed as the number of grey levels as the power of two. An 8-bit system captures 2^8 (256)

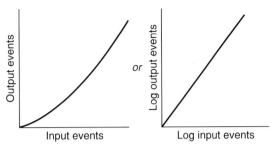

Figure 21.17 Transfer function

grey levels and a 12-bit system 2^{12} (4096) levels per colour channel. Since there are three colour channels (R, G, B) a 24-bit colour scanner will sample at 8 bits per pixel. This gives $2^8 \times 2^8 \times 2^8$ (2^{24}, or 16 777 216) possible colours. At the time of writing most software and devices are 8-bit systems. Whilst some scanners are 12-bit scanners the data is down-sampled to 8-bit and decisions are made within the software of the scanner as to which grey levels are lost or converted.

Contrast and tone reproduction is controlled by gamma correction which is applied to adjust the overall system's contrast to the desired value. This is determined by a *transfer function* which relates the input and the output events of the scanner. The transfer function for a scanner (or other imaging device) is shown in Figure 21.17, which shows graphs plotted on linear and logarithmic units, according to the following equations:

$$PV = T^{\gamma}s$$

(Output event = input raised to the power of gamma)

or,

$$\log PV = \gamma_S \log T$$

(Log output event = gamma × log input event)

Where PV is the pixel value, γ_S is the gamma value for a scanner and T is the transmittance of the film (or reflectance of hard copy).

Gamma correction may be applied, during acquisition (scanning) or to pixel values of the image file with appropriate software. Tone reproduction has been described earlier in Chapter 15 and also applies to digital systems. The particular value required for the output medium depends on the viewing conditions, the scene, fashion and personal preferences and is affected by each stage in the imaging chain. The final system gamma is obtained by cascading all the gamma values for the components and media involved in the imaging chain according to the following equation for scanning a hard copy original and viewing the image on a CRT display:

$$\gamma_{system} = \gamma_{hard\ copy} \times \gamma_{scanner} \times \gamma_{display} \times \gamma_{correction}$$

where the subscripts refer to the components in the imaging chain from the hard copy input to the output image (display) in this case, and correction is the gamma correction necessary to achieve the required system gamma.

Whatever the overall system gamma which may result from an embedded $\gamma_{correction}$ in the software being used, software also provides means of adjustment of contrast according to user preferences.

Output scanning

One method of output of digital data is via output scanning (Plate 26), which is also a subset of *non-impact printing* methods and includes all those hard copy outputs of Figure 21.1 (laser, ink-jet, thermal, optical). Writing to photographic paper via lasers or other high intensity sources is a direct exposing method, whilst laser printers are indirect and write to a light-sensitive photoconductive web or drum that attracts coloured toners. These toners are then transferred and fused to a receiving sheet.

In order to write to a sensitive material the laser beam must be modulated in relation to the stream of data. Data rates may be calculated if the output resolution, image size, number of prints/second are known:

$$D = \frac{N_H N_V H V T}{D_u}$$

where N_H and N_V are the output resolutions for the horizontal and vertical directions in dpi, H and V are the horizontal and vertical dimensions in inches, T is the number of prints per second and D_u is the duty cycle due to electronics and beam retrace in seconds. If, for example, the output resolution (N_H and N_V) is 256 dpi., the image size($H \times V$) is 8 in × 10 in, T is 0.25/s and D_u is 0.5, the data rate, D, becomes:

$$D = \frac{256 \times 256 \times 8 \times 10 \times 0.25}{0.5}$$

$$= 2.6 \times 10^6 \text{ Hz}$$

The advantages of this form of output are that they make use of the high quality of photographic materials for their output, which includes the high sensitivity for rapid writing of data, high resolution, colour reproduction and light stability of conventional, dye-bleach or dye-diffusion media. The main disadvantage is the need for wet processing chemicals other than for dye-diffusion materials (*Pictrography*).

Laser printers use analogous technology for indirectly transferring toner particles to a receiving layer. Lasers are used to form colour output in four channels: red, green, blue and black. These are scanned on to charged photoconductive drum, web or

belt which becomes discharged on exposure. The unexposed areas carry charges to which toner particles adhere and are then transferred to a receiving sheet to which they are fused. This process is repeated four times, once for each channel.

The advantages of laser printers are that they are well proved technology, rapid and can print to plain paper, but their disadvantages are their high cost and that their quality is not as good as that from photographic, thermal dye-diffusion or sublimation or ink-jet printers, although they are capable of producing high quality 24-bit colour images. Also, like other computer output devices, such as ink-jet printers, the RGB additive data must be transformed to CMY(K) densities (K is black) that conform to the specific printer. Dithering (see Figure 1.4) has to be used to reproduce grey levels adequately.

Thermal printing

Thermal output media were described in the previous chapter (for terminology see Table 20.3). Currently there are two main types that provide high-quality output. These are *Fujifilm's Thermo-Autochrome* (D1T1) and *Kodak's* dye diffusion thermal transfer (D2T2), often called dye sublimation (see Plate 25), which can produce continually varying amounts of dye and hence continuous tone images of photographic quality. This has the highest image quality and is a true professional system, capable of printing very large images, but has the disadvantages of high capital cost, requiring consumables and relatively high running costs. Similar disadvantages apply to the Thermo-Autochrome system, which is designed mainly for personal use.

Ink-jet printing

For photographic quality output special paper is required (see Chapter 20). This is perhaps the most versatile of the newer technologies for providing hard copy. There are two basic types, one is *drop-on-demand*, in which a drop of ink is emitted according to a signal received, and the other is *continuous jet*, in which droplets of ink are continuously emitted from a nozzle and deflected by an electric field to produce an image. Most desktop applications involve the former and some make use of the piezo-electric effect in certain crystals which generate a pressure pulse to emit droplets of ink. Other printers use *thermal ink-jet* or *bubble-jet* in which ink droplets are formed on evaporation of the ink in the printhead by current flowing through resistive elements. This forces the ink through nozzles to form droplets which are propelled towards the paper.

Printing devices are available in wide range of sizes for most applications, from simple and inexpensive forms for personal use to very large-scale printers for printing advertising material. Generally printing speeds are slow but they are capable of providing photographic quality with low cost consumables, although the special photographic quality paper is relatively expensive.

Evaluating the results

The evaluation or judgement of the colour balance of hard copy output for acceptance or rejection and subsequent correction is perhaps the most difficult part of printing. To begin with, the printer may have no knowledge of the subject matter or the print colour balance that the client prefers. It is possible, however, to reduce some of the variables involved in appraisal so that final judgement is subjective and dependent on the printer's experience and opinion.

It is essential that the viewer has normal colour vision. A variety of clinical tests are available and used to determine the degree of normal or defective vision, as some 8 per cent of the male population are colour-deficient. Viewing conditions are of the greatest importance. If possible, colour balance should be assessed under the same conditions as those under which the finished colour print will be viewed. The properties of the light source can influence the apparent colour balance markedly. In the absence of such knowledge, assessment under standard viewing conditions is advised. The current recommendation is to use a suitable light source, which, if of the fluorescent type, has a colour rendering index close to 100 and a correlated colour temperature of 5000 K. Illuminance should be 220 ± 47 lux for viewing prints or a luminance of $1400 \pm 300 \, \text{cd/m}^2$ for viewing colour transparencies.

Assistance as to the necessary corrective change in colour filtration in photographic printing may be given by using a ring-around set (see Plate 28). A similar procedure can and should be adopted in setting up computer hard copy output devices as to calibrate and set up the printer. The image viewed on the screen often does not relate to that which is printed. 'What You See Is What You Get' (WYSIWYG) should not be assumed, although screen/printer calibration software is becoming more readily available. The fundamental problems associated with colour reproduction via digital systems are addressed more fully in Chapter 16, but one of the major reasons for mismatches between colours on the screen is the different gamuts (ranges of colours) of the display and the print, i.e., some colours that can be reproduced on the display cannot be reproduced in the print. The mapping of colour information from display to print is complex and non-linear. It is further complicated by the different viewing conditions and dynamic ranges of the two media.

Bibliography

Agfa (1994) *An Introduction to Digital Scanning.* Agfa-Gevaert NV, Mortsel, Belgium.

Anchell, S. (1997) *The Variable Contrast Printing Manual.* Focal Press, Oxford.

Coote, J. (1996) *Ilford Monochrome Darkroom Practice*, 3rd edn. Focal Press, Oxford.

Current, I. (1987) *Photographic Color Printing: Theory and Technique.* Butterworth–Heinemann, Boston.

Evening, M. (1998) *Adobe Photoshop 5.0 for Photographers.* Focal Press, Oxford.

Hunt, R.W.G. (1995) *The Reproduction of Colour*, 5th edn. Fountain Press, Kingston-upon-Thames, esp. ch. 16.

Ihrig, S. and Ihrig, E. (1995) *Scanning the Professional Way.* Osborne McGraw-Hill, Berkeley, CA.

Jackson, R., MacDonald, L. and Freeman, K. (1994) *Computer Generated Colour.* Wiley, Chichester.

Langford, M. (1998) *Advanced Photography*, 6th edn. Focal Press, Oxford.

Proudfoot, C.N. (ed.) (1997) *Handbook of Photographic Science and Engineering*, 2nd edn, Section 9. IS&T, Springfield, VA.

Ray, S. (ed.) (1994) *Photographic Printing and Enlarging.* Focal Press, Oxford.

Sturge, J.M., Walworth, V. and Shepp, A. (1989) *Image Processes and Materials*, Neblette's 8th edn. Van Nostrand Reinhold, New York.

22 Life expectancy of imaging media

In this chapter we will consider general aspects of the *archival* or *life expectancy* of different imaging media. Previously the term archival was used to describe materials with a long life, which is now taken to mean a minimum of 100 years. The new electronic media have expected lifetimes of less than 100 years and it is now generally agreed that the term archival be substituted by the term life expectancy. All materials degrade over time and differing imaging media are subject to many causes of degradation, many of which are now well understood. Steps may be taken to ensure that their life expectancy is as long as possible. As imaging systems advance and new systems evolve the initial prime criterion is to provide a system that works and fulfils the needs of the consumer. In these initial stages of providing new products their longevity is not necessarily a high priority. This was the situation at the start of the negative–positive photographic process when W.H.F. Talbot experimented with various fixing methods to achieve a stable image and this approach continues to this day. However, as our knowledge advances, both manufacturers and users are more aware of the need for imaging media to have reasonably long life expectancies and much research is undertaken to achieve this. This may then become a useful strategy in marketing imaging products. A recent example is in colour hard copy output using ink-jet or thermal dye-diffusion systems in which the early products had very poor stability to light, as did colour photographic print materials before them. This problem has been researched thoroughly and more recent products have much improved light stability.

With the newer digital technologies a number of other considerations concerning their life expectancy have to be taken into account in addition to degradations of the recording medium itself. Of particular concern is for how long the hardware and software will be available for inputting, reading and outputting the stored image data. Some suggested answers to this question can be found in Figure 22.8. Black-and-white photographic analogue materials, however, do have a number of advantages with respect to their life expectancy, which include the following:

- *Viewing:* they may be viewed with the unaided eye (or for very small images with a simple magnifier) without the need for hardware to convert stored data in to images

- *History:* we know that properly processed and stored black-and-white photographic records have a life expectancy of at least 150 years. This is known because many examples exist of images recorded more than 150 years ago and accelerated ageing tests in the laboratory can predict that images can last for over 150 years.

The known causes of degradation of imaging media involve a variety of chemical and physical reactions of the material. These reactions are widely differing in nature and are affected by the nature of the image and the ambient conditions:

- Relative humidity
- Temperature
- Chemical nature of the image
- Residual chemicals
- Atmospheric gases
- Light and other radiation
- Storage materials
- Chemical after-treatments
- Laminating
- Mounting
- Lacquers

Life expectancy of photographic media

In Chapters 17 and 20 attention was drawn to the importance of properly fixing and washing black-and-white films and prints to avoid fading and yellowing on storage. However, even if photographic materials are properly processed they may suffer from any of several forms of degradation in the long term. A summary of the types of degradation and their causes for both black-and-white and colour materials is given in Table 22.1.

All of the degradations listed in Table 22.1 can be avoided or at least minimized by eliminating as far as possible their known causes. A number of international standards exist for proper storage environments, display conditions and protective treatments of photographic media which, if followed, will prolong the life expectancy, as will following the recommended processing conditions.

Table 22.1 Some causes of deterioration in photographic materials

Effect	*Cause*
Overall yellow stain	Residual chemicals (thiosulphate, silver-thiosulphate complexes)
Image fading and yellowing	As above
Brown spots	Localized retention of above
Local or general damage	Bacterial or fungal attack on gelatin, degradation of gelatin and paper fibres by acidic atmospheric gases
Microspots (red/yellow)	Oxidizing atmospheric gases
Dye fading	Dark reactions and/or light-induced reactions of image dyes

Processing conditions

Development conditions recommended by the manufacturer should be followed. Generally fine-grain silver images are more susceptible to degradations than larger-grain images. Prints are more susceptible than negative materials. Acidic stop baths can influence the keeping properties of silver images. Excess acetic acid in the stop bath may cause some papers to become brittle on drying and subsequent storage. Also, with carbonate-buffered developers excess acetic acid may cause bubbles of carbon dioxide gas to be formed in the paper fibres of prints. Thiosulphate and silver-thiosulphate complexes can become trapped in these bubbles and may not be readily washed out. This in turn can cause localized spots of silver sulphide to be formed on storage. The importance of proper fixing and washing, together with appropriate procedures and test methods, has been described in detail in Chapters 17 and 20. Minimum permissible levels of thiosulphate ion for some photographic materials are specified in standards. For maximum stability of silver images it is usually recommended that all thiosulphate be removed by thorough washing or with the aid of a hypo eliminator when a short wash time is used. However, it has been suggested that for prolonged life expectancy it is better that the material contains a very small amount of thiosulphate, e.g. $0.03\,\text{g/m}^2$ for microfilms. Archival keeping properties are greatly improved by the use of protective toning treatment which is why it may be better to include a small residue of thiosulphate in the processed material to form a protective layer of silver sulphide on the silver grains.

Incorrect processing of colour materials, which may leave residual chemicals in the layers or provide a processed record with an unfavourable pH value, can lead to destruction or fading of image dyes known as dark fading as opposed to light fading, which is discussed later.

Dark fading of colour media

The fading of dyes has two causes, categorized as 'dark fading' and 'light fading'. Different mechanisms for the destruction of the dyes are involved for these two types of fading; dark fading involves chemical reactions that depend upon on the structure of the dye. These aspects will be considered separately. As with silver-based materials, the dark fading of image dyes is influenced by temperature, relative humidity and the chemistry of the environment. Common atmospheric gases that can cause dark fading of dyes are oxides of sulphur and of nitrogen, and ozone; but these are insignificant when compared with other causes. As with black-and-white images, dye images are affected by errors in processing. Dark fading is accelerated by the presence of residual thiosulphate ions. Inefficient washing of colour materials not only leads to incomplete removal of thiosulphate and other harmful chemicals but also can leave the material with a low pH value, which has also been shown to accelerate dark fading. These causes of poor keeping properties are avoidable if correct processing procedures are adopted.

The main reactions responsible for dark fading in chromogenic materials are those involving hydrolysis and oxidation–reduction reactions which cause the dye to be converted into a colourless form, or into forms that are different in colour from the original dye. Hydrolysis is decomposition by water and is accelerated by extremes in pH value as well as humidity and temperature. Yellow dyes are particularly susceptible to this form of destruction, whereas cyan dyes are susceptible to reduction to a colourless form by residual thiosulphate ions, ferrous ions or other reducing agents present in the material or the environment. An understanding of the mechanisms involved has led to the present generation of chromogenic materials which contain colour couplers that form image dyes with greater resistance to dark fading than earlier materials. The predictive tests for dark fading involve accelerated ageing tests carried

out under a fixed relative humidity (40 per cent) at elevated temperatures for long periods of time.

This procedure is based on the classical Arrhenius equation, which is given below in a simplified form:

$$\log_e k\alpha \, \frac{1}{T}$$

where k is a measure of the rate of dye fading and T is the thermodynamic temperature in Kelvins. If a plot of $\log_e k$ against $1/T$ for a number of temperatures gives a straight line, then it is possible to extrapolate the straight line to other temperatures to predict the rate of fading. Also it has been shown for dark fading that:

$$\log_e k\alpha \, \log_e t_{10\%}$$

where $t_{10\%}$ is the time required to fade 10 per cent of dye from an original density of 1.0. Hence from the simplified form of the Arrhenius equation:

$$\log_e t_{10\%} \, \alpha \, \frac{1}{T}$$

In practice $1/T$ may be plotted against $\log_{10} t_{10\%}$, as shown in the lower graph in Figure 22.1.

The application of this procedure for the dark fading of a magenta dye is shown in Figure 22.1 and its use for predicting dark fading, at a temperature at which fading would take too long to measure, is given below. Dark fading figures for temperatures ranging from 24 to 93 °C at 40 per cent RH are shown as the full curves in the top graph of density to green light against \log_{10} time (in days). A horizontal line is drawn at the 10 per cent fade level criterion. Where this line crosses the actual fading curves, a vertical line is drawn to the lower graph where the temperature ($1/T$ in Kelvins) is plotted against the log of the fading time ($\log_{10} t_{10\%}$). The linear relationship obtained is shown by the line joining the full circles. Extrapolation of this line to the required temperature of 24 °C is shown as the broken line. Translation of this point vertically back to the top graph horizontal line labelled 10 per cent gives the predicted value for the fading of the dye to the 10 per cent level, from which it can be seen that this dye would fade 10 per cent in antilog 4.1 days, i.e. 34 years. This procedure could be repeated for other fading levels and by this means a complete fading curve would be predicted.

All dyes fade and dye images cannot be regarded as of archival quality. However, manufacturers have paid considerable attention to minimizing dye fading, and modern colour photographic materials are capable of lasting for many decades if properly stored and processed. Manufacturers claim a 100-year dark-storage capability for their colour-print materials. However, the only really effective method for achieving extended life expectancy of colour materials is to

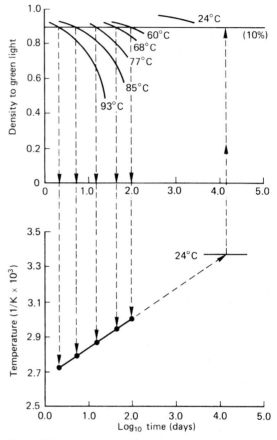

Figure 22.1 Arrhenius plot for dark fading of a magenta dye

convert them to black-and-white records by making separation positives or negatives (see Chapter 14) and to process and store these under the conditions discussed in the earlier sections. These black-and-white separations can then be reconstituted as full colour images as required, using appropriate photographic or electronic techniques.

Some dyes are inherently more stable than others. For example, those used in photographic dye-transfer process, those present in silver-dye-bleach materials, and metal-based dyes, are generally more resistant to certain types of fading than those formed in chromogenically developed materials. Unless stated otherwise, considerations of dye fading which follow have been applied to chromogenic materials.

A problem with colour materials is that image dyes fade at different rates; this results in a change in colour balance. Also, there is no universally agreed criterion by which fading is judged or of the degree of fading that can be tolerated. Originally manufacturers adopted a criterion of a reduction in density of 10 per cent (i.e. 0.1 from an original density of 1.0), though

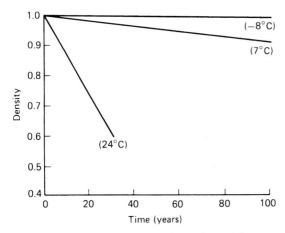

Figure 22.2 Dark fading of a cyan image dye at various temperatures

it has been argued that greater changes than this may be acceptable to the average observer. This quantitative measure of dye fading, rather than one concerned with quality, has been termed a *just noticeable difference*. It provides a useful criterion for the comparison between different products when treated in the same way for laboratory evaluations of dye stability. However, more recent standards use a 30 per cent density loss from a density of 1.0 as the criterion for predictive aspects of dye fading. This 30 per cent loss in density is regarded as the density change that becomes noticeable to the consumer. There may well be some confusion as to what represents a *just noticeable difference* or a *minimum acceptable difference*. This is a controversial area of colour appearance which is dependent on the colour content of real scenes.

Predictive tests for dye fading are being undertaken by all manufacturers, but at present there is no guarantee that these tests will predict precisely what will happen under actual conditions of storage. A further difficulty is that many claims use different test conditions and criteria for acceptability of fading. This means that published data must be interpreted and compared with care, especially if differing test conditions have been used.

This procedure provides a predictive technique for manufacturers and researchers, and typical fading results are shown in Figure 22.2. From this it can be seen that in order to reduce dye fading to a minimum a low storage temperature should be used. If refrigerated storage conditions are used to minimize dark fading, the materials will have to be enclosed in suitable sealed containers and, because the relative humidity increases as the temperature is lowered, the photographic materials must be preconditioned at low relative humidities (25–30 per cent at 20 °C) before they are sealed in their

containers. The practical conditions for storage given earlier also apply to colour materials and are relatively easy to achieve without the use of costly refrigeration facilities. Colour materials such as slides can be duplicated every few years and good colour fidelity maintained for generations; colour negatives can be reprinted.

Storage conditions

Most of the harmful effects summarized in Table 21.1 are aggravated by high temperatures and high relative humidities. In fact, subjecting processed photographic materials to such conditions is used as a test procedure for accelerated ageing techniques to find optimum processing and storage conditions and for research into the causes of deterioration. One Standard specifies as an image stability test incubating the material for 30 days at 60 °C ± 2 °C and a relative humidity of 70% ± 2%, and states that 'The film image shall show no degradation that would impair the film for its intended use'. When storing photographic materials the temperature should not exceed 21 °C and the relative humidity should be kept within the range of 30–50 per cent. For archival storage, a lower temperature and relative humidity is recommended (10–16 °C and relative humidity of 30–45%). This represents a practical compromise for air-conditioning. Also the materials should be protected from harmful atmospheric gases (discussed in the next section). More recent recommendations are to keep photographic materials in sealed polypropylene bags containing a visible humidity indicator, in a controlled humidity environment at temperatures of –20 °C. This provides the highest standard of conservation whilst achieving maximum chemical stability without harmful physical change. The main limitation is that rigorous warm-up procedures have to be adopted when removing material from cold storage to avoid condensation and physical changes due to thermal shock. Figure 22.3 shows the McCormick-Goodhart recommendations for storage of photographic materials in terms of the interrelationships between temperature and relative humidity.

Photographic materials should be protected from the light. Recent tests have shown that subjecting silver materials to high-intensity simulated daylight (5.4 kilolux or 5400 lumens per square metre) accelerates the yellowing of images in processed materials containing small amounts of thiosulphate ion.

The materials in which photographic records are stored as well as the processing conditions and the storage environment, are also of the utmost importance. Suitable materials for the storage of processed photographic films, plates and papers also are specified in Standards. Generally, wood and wood

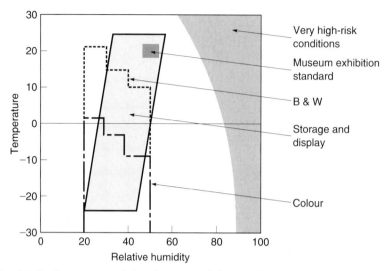

Figure 22.3 McCormick-Goodhart recommendations for storage of photographic materials (adapted from a paper presented at 14th Annual National Archive and Records Administration Preservation Conference: Alternative Archival Facilities, Washington, DC, March 1999; reproduced by permission of M.H. McCormick-Goodhart)

products (plywood, chipboard, hardboard etc.), form-aldehyde-based plastics, polyvinyl and acrylic plastics containers should not be used. These materials may contain residual solvents, catalysts, plasticizers etc. which are known to have harmful effects on photographic materials, as can many adhesives, inks and marking pens. Preferred storage containers are those made from anodized aluminium or stainless steel, or cardboard boxes made from acid-free high-alphacellulose fibres that are lignin-free and sulphur-free. The latter also applies to mounting boards for prints, envelopes for negatives etc. Fortunately there is now an increasing number of specialist suppliers of archival storage materials for processed photographic records; these are able to supply 'archival' polypropylene or polythene sleeves and envelopes for the storage of negatives and slides, also files and boxes of appropriate archival materials.

Atmospheric gases

There are many pollutants present in the environment which can have deleterious effects on photographic materials. These include oxidizing gases such as hydrogen peroxide, ozone, oxides of nitrogen, peroxides and peroxy radicals emitted by car exhausts, paints, plastics, acid rain and sulphur compounds. The general effects of oxidizing gases are to induce yellowing and fading of the image at the edges of the print or negative where the atmosphere has been able to penetrate most readily. This staining may be dichroic, appearing grey by

reflected light and yellow by transmitted light. Low concentrations of oxidizing gases such as hydrogen peroxide can produce microspots. In prints these spots appear as yellow, orange or red spots depending on the size of the silver particles, and if clustered near the surface may appear as a silver mirror. The mechanism by which microspot formation occurs involves an initial oxidation by the gas, which converts silver metal to mobile silver ions, and is shown in Figure 22.4. The silver ions migrate away from the silver filaments of the image and become reduced to metallic silver by the action of light, or are converted to silver sulphide by hydrogen sulphide present in the environment. This process forms microspots of approximately $60\,\mu$m or larger in diameter, comprising a concentric ring structure of particles of 5–10 nm to $0.5\,\mu$m in diameter. In laboratory experiments, using accelerated ageing techniques at 49 °C and 80 per cent RH, it has been shown that microspot formation occurs with a concentration of hydrogen peroxide of 500 ppm.

Protection against attack by oxidizing gases can be given by selenium toning. Figure 22.5 shows the degree of protection that is possible with this toning treatment when the material is subjected to an extreme test using 5 per cent hydrogen peroxide. From Figure 22.5 it can be seen that toning (curve c) leads to very little change in the characteristic curve after attack by hydrogen peroxide, whereas an untoned image (curve a) shows a considerable change. Acidic atmospheric gases, often present in the environment, can degrade gelatin and paper base materials and some form of protection from these in storage is necessary for archival permanence.

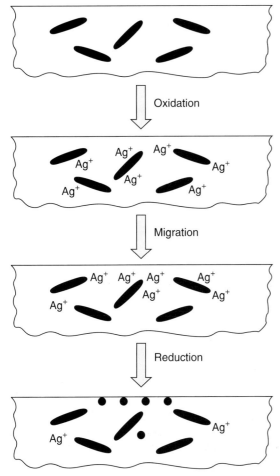

Figure 22.4 The mechanism of microspot formation in silver photographic materials

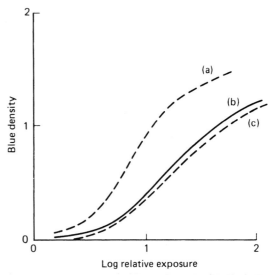

Figure 22.5 Effect of toning on image stability to hydrogen peroxide. (a) Untoned image after 3 hours, 5 per cent hydrogen peroxide. (b) Original image, no treatment. (c) Toned image, after 3 hours, 5 per cent hydrogen peroxide

Toning

Certain toning processes are now known to increase the life expectancy of silver images. Originally toning was carried out to change the colour of a photographic image by means of chemical solutions. Toning is mainly applied to prints but may also be used to confer additional stability on films or plates and most manufacturers offer proprietary toning solutions to enhance the life expectancy of their silver photographic products. The principle of obtaining enhanced stability of silver images through toning is to convert or coat the silver image into a silver compound that it is more inert, less finely divided and less soluble than the original silver image particles.

The silver image may be converted into silver sulphide (or silver selenide). Silver sulphide and silver selenide have brown and purple colours, much warmer than that of the usual silver image, so that these processes are often referred to as sepia toning. Silver selenide toning provides a means of obtaining very stable images and is less expensive than gold toning, which provides the most stable images. However, selenium compounds are toxic, as are sulphides, and should be handled with caution. Indeed, all toning solutions should be handled carefully and discarded with caution. Sulphide toning is probably the most widely used form of toning, and properly carried out yields images of great permanence. Various formulae for sulphide toning exist. In one example the image is first bleached in a ferricyanide-bromide solution and then redeveloped in a solution of sodium sulphide or thiourea, according to the following reactions:

Silver + ferricyanide + bromide → silver bromide + ferrocyanide

Silver bromide + sodium sulphide → silver sulphide

In another solution, toning takes place in a single operation by immersing the prints in a 'hypo-alum' solution (sodium thiosulpate and aluminium potassium sulphate) at 50 °C.

A protective gold solution has been proposed for the archival permanence of prints which involves immersing the thoroughly washed print material in a mixture of dilute gold chloride and sodium thiocyanate (Kodak gold protective solution GP-1).

Light fading

Predictions from light fading tests carried out in the laboratory are less easily made than those from dark fading, which use the more reliable Arrhenius method. Light fading of dyes depends on the intensity, duration and spectral energy distribution of the light to which they are subjected. These vary considerably with the display conditions under which the materials are viewed. The fading of dyes is a photochemical reaction in which oxygen is involved, and leads to destruction of the dye. This photochemical fading is increased by high humidities.

Two laboratory methods are used for investigating light stability, relating to the viewing and display conditions for the particular material. Slides can be subjected to hundreds of projections in a slide projector and decreases in density for neutral and colour patches measured and plotted against the number of projections. Results for a reversal film neutral patch of density 1.0 are shown in Figure 22.6. Most reversal films follow the trends shown in this figure, but there are variations between different products, and current films show less steep curves and better light stability.

Colour-print materials are usually exposed to an intense xenon source at 5.4 kilolux, 40 per cent RH at 22 °C and the time taken for a fixed loss in density (10, 20 or 30 per cent as mentioned earlier under dark fading) is used as a measure of the light stability which are obtained from graphs of density against time. Extrapolations are made from 5.4 kilolux to 120 lux which is regarded as a typical light level in the home environment where the pictures may be displayed. Chromogenic colour photographic papers have made substantial improvements in their light stability over the last fifty years. Current materials showing considerable resistance to light fading. Colour photographic prints are now claimed to have a useful life of 150 years in typical home-display conditions of around 120 lux 40 per cent RH at 22 °C. Improvements are being made by all manufacturers of chromogenic print materials; modern materials are almost as stable to light as dye-transfer prints. The latter have been regarded as a standard with which other materials are compared. Silver-dye-bleach materials are particularly resistant to light fading.

As mentioned earlier, the instability of dye images is due to a combination of light absorption and dark storage effects, although the latter are often ignored when accelerated light fading is carried out. There exist many additional complicating factors which are involved in light fading. Examples of these include: staining, the influence of UV radiation and UV absorbers, the presence of residual chemicals and colour couplers in chromogenic materials, antioxidants and stabilizers which may be included in modern materials, the influence of the substrate and

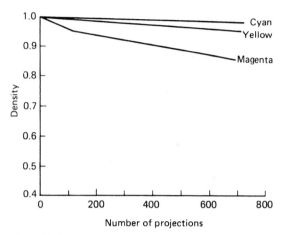

Figure 22.6 Light fading of a neutral-patch image of a colour-reversal film

environmental factors, such as temperature, humidity, pH and the presence of oxygen. Because of the possibility of reciprocity effects all accelerated light fading studies which use high intensity and relatively short duration exposures, are subject to the criticism that the effects may not relate directly to longer exposures to lower intensities. It is possible that the conditions used for accelerated light fading may induce reactions that are not found for ambient conditions under which the materials are displayed. There is, however, little alternative if fading studies are to be carried out within reasonable periods of time and most investigations involve the use of high intensity sources and an extrapolation to other conditions when predictions are being made.

An additional problem is in the choice of assumed typical ambient display conditions when predictive calculations are made for fading by a specified amount. One manufacturer has used a value of 500 lux for 12 hours per day in such calculations. This was based on the assumption that in common domestic situations sunlight varies between 1000 lux during the day, decreasing to 300 lux in the evening and an average value of 500 lux for 12 hours per day appears to be a reasonable estimate. Whilst others have adopted 450 lux for the same time period at a temperature of 24 °C and 60 per cent RH, yet others use 120 lux as mentioned earlier. This further illustrates the difficulties and the caution that must be exercised in making comparisons between claims for the light stability of imaging materials.

Modern chromogenic printing papers have evolved over a period of at least 50 years and much research has been carried out to improve their stability. Particular attention has been concentrated on improvements in the intrinsic stability to light of magenta dyes, which are regarded as having the most

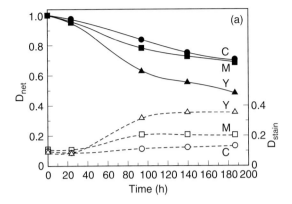

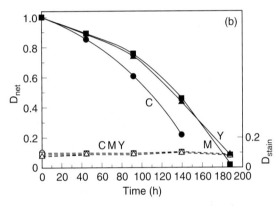

Figure 22.7 Fading of dyes of (a) chromogenic colour material and (b) an early version of a thermal dye diffusion material (D2T2). A neutral image of density 1.0 exposed to a high-intensity xenon lamp source

noticeable fading and were the least stable of the image dyes. In addition, UV absorbers and other minor chemical components are included in modern materials to reduce their rates of fading. These are mature products, whereas materials for hard copy output from electronic systems have evolved over a period of less than a decade and fade more rapidly than colour photographic materials.

From Figure 22.7 it can be seen that the thermal dye diffusion material (b) fades more rapidly than the chromogenic colour material (a) but the photographic material gives rise to more staining, which is yellow. Also it is apparent that in photographic materials the yellow dye fades most rapidly whereas in the D2T2 material it is the cyan dye. However, these thermal dye diffusion and other modern hard copy output media are showing substantial improvements in light stability. For example, early ink-jet inks and papers would show a noticeable fade in around 1 year whereas more recent versions claim a life expectancy of between 2 and 36 years, depending on the

particular material. This is an area of much research activity which ultimately will benefit the end-user in providing materials of much enhanced life expectancy.

Life expectancy of digital media

At the start of this chapter we saw that electronic media have, in addition to potential physical and chemical degradation, the problem of obsolescence. This has been realized for some years but the solution is neither simple nor obvious. One suggestion is that digital data should be transferred from the old storage media to the new media as it becomes available. This is a process known as migration. Depending on the amount of image data, this may not be the simple solution it appears to be. It is time-consuming and requires whole systems of data management which themselves may become obsolete. In Chapter 12 we saw that there is a potential for a similar and related problem in the very different file formats and compression techniques which may be standards now but not necessarily in the future. It is extremely unlikely that existing materials and formats will be readable in a few decades let alone 100 years or more. This poses very difficult problems for archivists who wish to preserve our visual heritage for future generations and individuals who want to pass on images to their children and grandchildren. The migration of digital data from one medium to another as it becomes the standard is an essential requirement despite the difficulties.

Modern storage media have two life expectancies: one for the physical and chemical degradations and the other for the expected obsolescence. Figure 22.8 gives an indication of these times for some commonly used electronic storage media and further reinforces the view that migration of data is essential. New storage media are being introduced and life expectancy data on these newer media for the storage of image data, such as *Flash SSSDs* is difficult to obtain. Electro-optical storage media for rewritable discs are also included in Figure 22.8 and have been used for more than 12 years, with a claimed life expectancy of at least 40 years.

Figure 22.8 also indicates that migration must be carried out within the time span of the medium's physical/chemical life expectancy. In the current hybrid imaging era in which much data is recorded on film and then digitized, the film serves as an additional backup, which it is wise to keep. This can be re-scanned at a later date, assuming scanners still exist at that time. In view of the many billions of photographic images that are stored worldwide and are still being produced in vast quantities, it is highly likely that scanners will be available for many decades to come. Obviously the strategy must be to provide storage media with the longest possible life

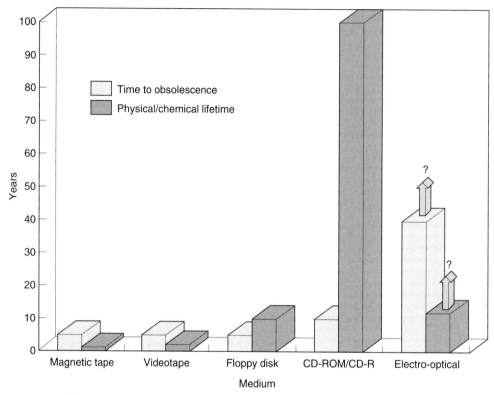

Figure 22.8 Life expectancies of electronic recording media (based on data of Rothenberg with additions)

expectancy to make data migration less frequent. In addition, a solid state storage medium is being introduced. This has the advantage of being a compact storage medium which does not involve any moving parts for writing and reading data, which is required by most of the storage media in current use.

The current most popular storage for images is the CD, in both read-only (CD-ROM) and writable forms (CD-R). The basic structure of a CD-ROM is shown in Figure 22.9. A spiral groove is moulded in the plastic, which on writable CDs is continuous. CD-ROMs have *pits* impressed on one side which encode the data which interrupts a laser beam which reads the data. The laser beam is reflected back by a shiny metallic surface (the *land*) to the sensor, whereas when a pit is encountered the beam is not reflected. The writable CD-Rs have a slightly different structure, also shown in Figure 22.9, in which the pits are recorded in a dye layer in the guiding grove where the recording beam converts the dye to products that block reflection. Above the dye layer is a reflective gold layer and above this is a layer of protective lacquer. CD-ROMS have a characteristic reflective appearance on both sides which enables them to be

distinguished from CD-Rs which usually appear a shiny green, golden-green, or silvery green on the bottom and show a golden or silvery, less shiny coloration on the top (label) surface.

CDs are subject to deterioration, and a lifetime of around 100 years is a reasonable estimate based on moderate storage conditions, which is indicated in Figure 22.8. Like other non-electronic media, they may be affected by poor storage conditions, handling, scratches etc., although they are more tolerant to scratches than most other media. This is because the reading laser beam is focused on the pits (see Figure 22.9), some distance away from the surface of the disc where the scratches are located, and they are out of focus. Apart from the more obvious physical damage, CDs may deteriorate through oxidation of the reflective metallic layer, which in early CDs was aluminium. In more recent CDs aluminium alloys are used, which are more resistant to oxidation, and gold is used in writable CDs, which does not oxidize readily. Like hard copy media, slow chemical changes will cause degradation of the data over long periods of time, such as dark and light fading of dyes in CD-R discs and the oxidation of metallic reflective layers in CD-ROMs.

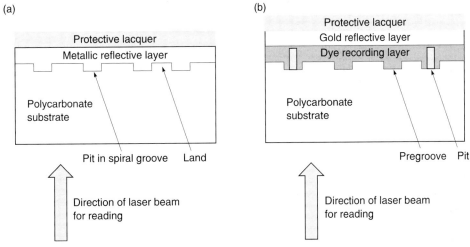

Figure 22.9 (a) Cross-section of a read only CD-ROM and (b) of a writable CD-R

Other problems that can occur in CDs and must be guarded against are:

- Diffusion of solvents from labels.
- Peeling off labels which may cause localized delamination.
- Diffusion of solvents from felt tip pens for marking and identifying the discs.
- Writing on discs with a ball-point pen or pencil.
- Cleaning with solvents.
- Exposure to sunlight.
- Storage at temperatures greater than 25 °C and relative humidities greater than 50 per cent.
- Sudden and rapid changes in temperature and humidity.
- Exposure to dust and dirt.
- Handling the surface.

Predictions of the life expectancy of CDs come from accelerated ageing tests very similar to those previously described for photographic and related media and extrapolation to storage conditions of 25 °C at 40 per cent RH. Life expectancy is based on readability errors in the data stored on the disc. It may be determined as *block error rates (BLER)*. The BLER is the number of errors detected in a 10 second period and can be expressed as a $BLER_{max50}$, where max refers to the maximum BLER found on reading the disc and 50 refers to the end-life of 50 errors. This is the electronic data equivalent of a 10 per cent fade value for a hard copy material for example. However, it has been pointed out that most discs are still readable with a $BLER_{max50}$ and that this test provides a pessimistic measure of life expectancy.

Like all materials that suffer chemical degradation over long periods of time, the life expectancy of CDs can be substantially prolonged by storage at a reduced temperature of 10 °C and a relative humidity within the range of 20–50 per cent. This slows down the rate of any chemical reactions that may be taking place. Discs that are in daily use are likely to last less long than those that are back-up archival copies kept under consistent and controlled conditions.

Bibliography

Brown, K.C. and Jacobson, R.E. (1985) Archival permanence of holograms?, *Journal of Photographic Science*, **33**, 177–82.

Eastman Kodak (1995) *Permanence, Care and Handling of CDs*, DCI-350, Rochester, NY.

Jacobson, R.E., Attridge, G.G., McDermott, D., Mitchell, C. and Tong, B. (1996) Light stability of colour hardcopy materials. *Journal of Photographic Science*, **44**, 27–30.

McCormick-Goodhart (1996) The allowable temperature and relative humidity range for the safe use and storage of photographic materials. *Journal of the Society of Archivists*, **17**, No.1.

Photographic & Imaging Manufacturers Association (PIMA) http://www.pima.net/standards.htm.

Rothenberg, J. (1995) Ensuring the longevity of digital documents, *Scientific American*, January, 24–9.

Standards: Current standards for conservation, preservation, storage and life expectancy testing can be found at: http://www.nssn.org/.

Sturge, J.M., Walworth, V. and Shepp, A. (1989) *Image Processes and Materials*, Neblette's 8th edn, ch. 20. Van Nostrand Reinhold, New York.

Wallace, J. (1993) Considerations regarding the long-term storage of electronic images, *Journal of Electronic Imaging*, **2**, 35–7.

Ware, M. (1994) *Mechanisms of Image Deterioration in Early Photographs*. Science Museum and National Museum of Photography, Film and Television, London.

Wilhelm, H. and Brower, C. (1993) *The Permanence and Care of Color Photographs: Traditional and Digital Color Prints, Color Negatives, Slides, and Motion Pictures*. Preservation Pub Co.

23 Colour matters

Colour is of ever-increasing importance in photography and digital imaging, and we are given more and more information about the colours we use in digital systems. Digital camera outputs are described by red, green and blue (RGB) values. The output of computer software in graphics and imaging applications is also described by RGB pixel values and, frequently, in terms of Lab, HCL or HSL values. This chapter seeks to clarify what these descriptors mean and why they are of importance. In each case the quantities are parts of systems of colour description or specification, so that is where we shall start. (A full and rigorous survey is beyond the scope of this chapter and the reader is referred to the Bibliography section for further details.)

We may think in terms of three methods of specifying colour. The first is very familiar and of great practical significance – *specification by sample*. We have already encountered the second – *physical specification* – and the third – *specification by synthesis* –- may not be at all familiar to most readers but is the basis of most of the numbers which we encounter in the description of colour in imaging.

Specification by sample

Most of us have had to buy cotton to make or mend clothing. If we were wise we took a sample of the fabric to the shop when we bought the cotton and made a careful match so that the stitching would not be noticeable. This is the basis of colour specification by sample. A *careful* match is made in order to specify what we want. The care taken may involve taking the thread and fabric to the shop doorway to use the available daylight for colour matching or, nowadays, we hope that the shop is equipped with *colour matching* illuminants. These are usually fluorescent tubes designed to mimic lighting quality such as daylight or a mixture of light sources in such a way as to minimize the adverse effects of *metamerism*, described in Chapter 14. In this way our match can be made with some confidence that it will still hold when we are out of the shop, provided that we have normal colour vision. If the viewer of the match has anomalous colour vision then the result may be merely inaccurate or, in severe cases, it may be quite bizarre.

Paint shade cards are made available so that we can judge the effect of paint colours in the location and with the lighting conditions which are planned. Such shade cards may use simple hue names, or numerical descriptions where paints are mixed to produce a wide range of colours. These numbers may describe the mixing proportions of basic paints directly, but are sometimes more complicated and relate to standard systems of colour specification. In this context we have *colour order systems* which comprise ordered collections of colour patches, against which colour samples may be evaluated or by which colour specifications may be made.

Examples include the Swedish Natural Colour System (NCS), the Pantone system used in graphic arts and the Munsell Book of Colour, originated by the American artist Munsell. Each of these provides an *atlas* of carefully spaced colour samples designed to be stable in use and storage, of *standard colour* and to be arranged in a useful way. The numerical descriptions fit into a systematic order so that an atlas is easy to use. Once again a standardized light source is desirable for the best match data to be gained. The construction of the *Munsell system* is illustrated in Figure 23.1, which shows a Munsell Value scale between 0 and 10 as a central column. Radiating from the central column, like pages of a book, are planes of constant Munsell Hue. Each page appears as a real page in the Munsell Book of Colour, which includes 40 Munsell Hues, our example shows a reduced set of principal and intermediate hues. In the figure we see only a central strip of each 'page', at Munsell Value 5.0. The 'page' for Munsell Hue 5R is graduated in steps of Munsell Chroma extending from neutral, Chroma/0 in the central Value column, to/8. A representation of the Munsell 5R page is shown in Plate 30 for Values 2/to 8/, and where Chroma steps of 2 units are employed. It is immediately obvious that a boundary exists at a different Chroma level for each Value and this is, in fact, often set by the stability and reproducibility of the colorants necessary to achieve high Chromas. It also depends upon the Hue concerned. Yellows are much lighter than blues so the highest Chroma yellows appear at much higher values than high Chroma blues. The colour patches in the Munsell Book of Colour are systematically arranged so that constant Value differences are visually identical throughout. Constant Chroma differences are also visually identical, as are constant Hue differences provided they are assessed at

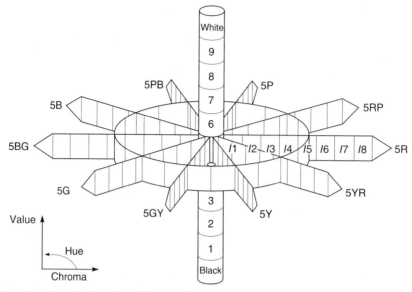

Figure 23.1 Three dimensions of colour: hue, lightness and chroma exemplified by the Munsell colour order system in which Munsell Hue, Value and Chroma are used to map the three dimensions.

constant Value and Chroma. If samples are of low Chroma, the visual hue difference is much less than at high Chroma because the actual separation of the samples is greater in the three dimensional array.

The notation used to designate a particular colour in the Munsell Book of Colour is of the form 5R 6/10, describing a colour of Hue 5R, Value 6 and Chroma 10. Such descriptions may be interpolated for greater precision so that we might have, for example, 6.2R 5.5/9.5.

The physical specification of colour

This method of specifying colour avoids difficulties due to anomalous colour vision of observers, the necessity to specify an illuminant and the instability or irreproducibilty of colour patches. It merely specifies the luminance factor at all wavelengths of the visible spectrum. The luminance factor, β_λ is defined as:

$$\beta_\lambda = \frac{I_t}{I_o}$$

where I_o is the incident illuminance and I_t is the transmitted (or, in the case of surface colours, reflected) illuminance. It may be expressed as a fraction less than one or as a percentage. Sometimes, and particularly in the case of photographic images or colour filters, it is useful to convert the

spectral luminance factor to a spectral density, defined as:

$$D_\lambda = \log_{10}\left(\frac{1}{\beta_\lambda}\right)$$

The measurement of such spectral data requires specialist spectrophotometric equipment, not normally available outside a laboratory. This makes it impossible for most of us to specify colours in this way, but the manufacturers of photographic materials and equipment frequently use such data to describe filter transmissions. There are a number of descriptions of colour elsewhere in this book which are made in this way.

The physical measurements made can be very precise and accurate but do not directly indicate to the reader the colour of the sample measured. Some of the filter data in earlier chapters is fairly simple to visualize, but the metameric examples in Chapter 14 would be difficult to understand without additional information. The final area of colour specification, by synthesis, is firmly rooted in visual observation (by observers of normal colour vision).

Specification of colour by synthesis

An important observation by *Newton* in 1666 was that white light from the sun, passed through a triangular

glass prism, was separated into the seven hues which he identified. Further observations involved the separation of narrow bands from the spectrum and the mixing of such isolated bands. It was observed that a whole range of spectral hues could be obtained by varying the proportions of each of two bands in the mix. Later experiments led to the trichromatic theory of colour vision, usually associated with *Young* and *Helmholtz*, who separately worked in this area. The fundamental basis of the theory is that, if three narrow spectral bands are selected, one each from the blue, green and red parts of the spectrum, then mixing the three together in appropriate proportions will *synthesize* all other spectral hues, a white and also a range of purples that are not present in the visible spectrum. The basic experiment is illustrated in Plate 31.

CIE RGB colorimetry

The ability of observers to make precise repeatable matches of colours by such colour mixing experiments led eventually to the Commission Internationale de l'Eclairage, the CIE, establishing a system of colorimetry in 1931. The process of visual matching of a colour is shown in Figure 23.2, where the observer sees a rather small field, half of which is illuminated by the colour to be specified, sometimes called the *object colour*, the other half of the field is illuminated by a controllable mixture of the primary coloured lights. The specified field for optimum colour matching occupies only the *fovea* of the observer's retina, thus avoiding the involvement of

retinal rod receptors, and this is achieved by keeping the angle subtended at the observer's eye at $\theta = 2°$ or less. The CIE specified the three stimuli to be spectral colours with wavelengths of: blue 435.8 nm, green 546.1 nm and red 700 nm.

The experiment is complete when a match is achieved. This yields the *matching equation*:

$$C(C) = R(R) + G(G) + B(B)$$

which states that C units of stimulus (C) were matched by the sum of R units of the stimulus (R), G units of (G) and B units of (B). The values R, G and B are termed *tri-stimulus values*. The match specification is very similar to setting up a colour palette in computer graphics applications, where it is usually possible to specify colour in terms of R, G and B pixel values.

When such matching experiments are carried out, it is found that, for a considerable range of absolute values of the units of (C), (R), (G) and (B), the match is valid if the proportionality of the mixture is maintained: e.g. the following two matches may be obtained:

$$10(C) = 6(R) + 3(G) + 1(B)$$

$$50(C) = 30(R) + 15(G) + 5(B)$$

This enables us to normalize the matching equation by dividing it by the sum of the tri-stimulus values, which numerically equals the C units of the object colour (C). Equation (1) can then be rewritten as:

$$1.0(C) = \frac{R}{R + G + B}(R) + \frac{G}{R + G + B}(G) + \frac{B}{R + G + B}(B)$$

This can be made less cumbersome if we rewrite it as:

$$1.0(C) = r(R) + g(G) + b(B)$$

where:

$$r = \frac{R}{R + G + B}, \quad g = \frac{G}{R + G + B}$$

and

$$b = \frac{B}{R + G + B}$$

and the quantities r, g and b are termed *chromaticity coordinates*. Since

$$r + g + b = 1.0$$

it follows that any two of the chromaticity coordinates specify the third and, hence, that only two are therefore needed to describe the colour. This may

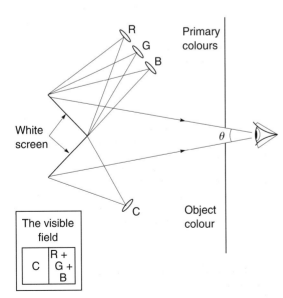

Figure 23.2 Specification of colour by synthesis: a diagrammatic representation of a visual colorimeter including, inset, the appearance of the bipartite visual field.

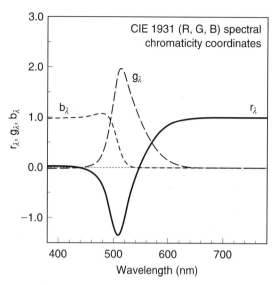

Figure 23.3 *r, g, b* chromaticity coordinates of spectral colours shown plotted against wavelength

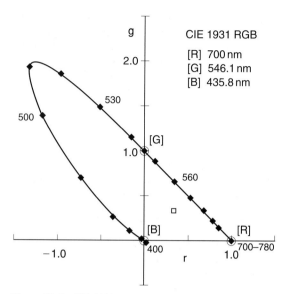

Figure 23.4 CIE 1931 *r, g* chromaticity diagram showing the locus of spectral colours, the *spectral locus*

seem quite odd when we needed three stimuli to make the match in the first place. What we have done is to lose all information about the amounts of the stimuli involved. Normalization, the operation of dividing through by the total amount of the three stimuli, has removed that information, but we still know it because we record the tri-stimulus values first. Requiring only two chromaticity coordinates to describe a colour means that we can plot them on a conventional two-dimensional graph. It is useful to see what happens when we plot the chromaticity coordinates of the purest colours available, the monochromatic spectral colours, against wavelength, and this is shown in Figure 23.3.

This graph is surprising, in that it shows negative amounts of red and green primaries, in combination with positive quantities of other primaries, being required to match some spectral colours. This may be inconvenient, but it is not in conflict with experimental evidence. It merely reflects what happens when we try to match spectral cyans in particular. The situation is that the observer can usually match the hue of the spectral cyan by mixing appropriate proportions of green and blue primaries, but the match looks less saturated (or vivid). The experimental set-up then has to be varied so that the object colour can be desaturated by the addition of some red light to it. The matching equation then becomes:

$$C(C) + R(R) = G(G) + B(B)$$

or, subtracting $R(R)$ from both sides, we have:

$$C(C) = -R(R) + G(G) + B(B)$$

A chromaticity diagram for the visible spectrum may be drawn by plotting *g* against *r*, and this is shown in Figure 23.4. A substantial area within the limit imposed by the spectral locus lies in the quadrant specified by negative value of *r* and positive *g*. The symbol □ represents the location of the *equal energy white*, an illuminant giving a uniform amount of energy at all visible wavelengths.

In order to be able to evaluate chromaticity coordinates from spectral data, rather than from

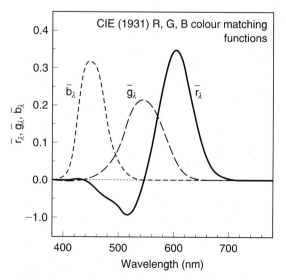

Figure 23.5 CIE 1931 *R, G, B* colour matching functions

colour matching experiments, the CIE established *colour matching functions*. These functions represent the amounts of the three stimuli *R*, *G* and *B* required to match an equal energy spectrum at each wavelength. The three colour matching functions are identified as $\bar{r}(\lambda)$, $\bar{g}(\lambda)$ and $\bar{b}(\lambda)$ and are shown in Figure 23.5.

CIE XYZ colorimetry

It was considered inconvenient, and a likely source of error, to have negative lobes in the colour matching functions, and corresponding negative tri-stimulus values. The CIE therefore set up, in 1931, an alternative all-positive colorimetric system based on the use of three new stimuli *X*, *Y* and *Z*. The new *X*, *Y*, *Z* tri-stimulus values were related to the *R*, *G*, *B* set by three new mathematical equations. These were carefully chosen so that all luminance information is carried by the *Y* value, the *Y* value is proportional to the luminance of the object colour. The equations used are suitable only for transforming the specific CIE *R*, *G*, *B* tri-stimulus values to *X*, *Y*, *Z*, any other *R*, *G*, *B* stimuli would have different colour matching functions and a different set of equations. The CIE transform equations from *R*, *G*, *B* tri-stimulus values are:

$$X = 0.49R \quad + 0.32G \quad + 0.20B$$

$$Y = 0.17697R + 0.81240G + 0.01063B$$

$$Z = 0.00R \quad + 0.01G \quad + 0.99B$$

Transformed colour matching functions $\bar{x}(\lambda)$, $\bar{y}(\lambda)$, $\bar{z}(\lambda)$ were derived from $\bar{r}(\lambda)$, $\bar{g}(\lambda)$, $\bar{b}(\lambda)$ and are shown in Figure 23.6. Comparison with Figure 23.5 shows the all-positive nature of CIE 1931 *XYZ* colorimetry. The corresponding chromaticity diagram is shown in Figure 23.7, and the locus of Planckian radiators, black bodies, is plotted on the diagram together with a number of important CIE Illuminants. A and C are CIE Standard Illuminants representing domestic tungsten lighting at a correlated colour temperature of 2856 K, and an average daylight at 6774 K, respectively. The D Illuminants represent various phases of daylight with correlated colour temperatures approximately indicated by the numerals following the D. Thus D65 is a Standard Illuminant representing daylight of correlated temperature very close to 6500 K.

An application of such CIE 1931 *x*, *y* chromaticity charts is in the mapping of colours to enhance our understanding of them. In Figure 23.8 we see the results of an experiment into the use of six colour-reversal films for the objective reproduction of saturated object colours. It is immediately clear that the reproductions are not generally very accurate. In fact they may not need to be, since the manufacturers of such films try to give us the kind of reproduction

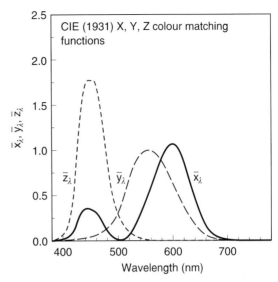

Figure 23.6 CIE 1931 *X, Y, Z* colour matching functions

that we prefer, and this may not be an accurate description of the originals. It is of interest that the reproductions occupy a very large proportion of the area within the spectral locus and that reds and yellows in particular lie on or close to that locus. The position of a colour plotted in the *x, y* chart is some indication of its saturation, which can be numerically expressed by its *purity*. The hue of a colour can be

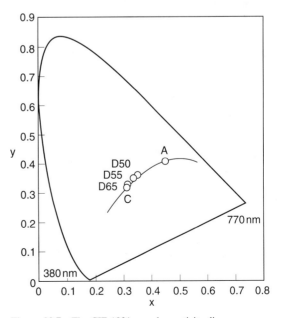

Figure 23.7 The CIE 1931 *x, y* chromaticity diagram, showing the Planckian locus and useful illuminants

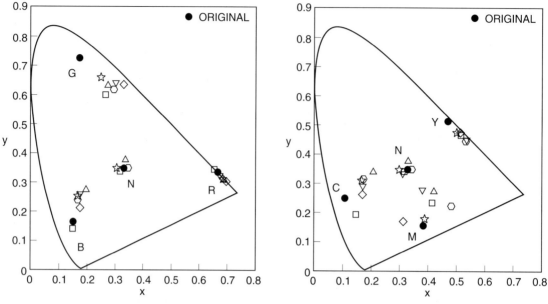

Figure 23.8 Colour reproductions using six reversal films, plotted in a CIE 1931 *x, y* chromaticity diagram

expressed numerically as its *dominant wavelength*. The derivation of both these objective measures is illustrated in Figure 23.9 and gives a more informative description of the object colours than, perhaps, the chromaticity coordinates.

Figure 23.9 shows the daylight dominant D65 as the white, or neutral, point roughly in the middle of the diagram. Two colours, 1 and 2, are also plotted. Taking colour 1 first, we note that a dotted line has been drawn from the white point through the plotted location of the colour to the intersection with the spectral locus. The distances a and b are used to calculate the purity as the fraction a/b = 0.71 and the result is commonly expressed as a percentage, in this case 71 per cent. The intercept on the spectral locus is used to interpolate between known wavelength points to derive the dominant wavelength, in this case about 558 nm, corresponding to a green. Colour 2 raises some complications. The line through the colour location from the white point does not cut the spectral locus unless it is extended backwards on the opposite side of the white point. On the other hand it does cut the line of purples linking the two ends of the spectral locus. The purity is assessed as if the line of purples were the spectral locus, as c/d = 0.74 or as 74 per cent. The dominant wavelength is expressed as that of the complementary colour on the opposite side of the white point, in this case at 496 nm, the suffix c is used to indicate that this is the complementary colour. Such complementary dominant wavelengths are only used when the colour lies within the triangle bounded by the line of purples, the line between the white

point and the red end of the spectral locus, at 780 nm, and the line between the white point and the blue end of the spectral locus at 380 nm.

The CIE 1931 *x, y* chromaticity diagram, or chart, is still in use today and has proved to be a useful map

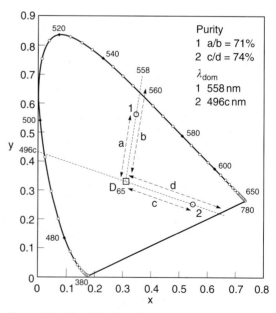

Figure 23.9 The derivation of purity and dominant wavelength for two colours plotted in a CIE 1931 *x, y* chromaticity chart

on which to plot colours. It is, however a rather unusual map in that equal distances on the map at different locations do not necessarily represent equal visual changes in colours. It is as if a map used on a walking tour could not be relied on to indicate walking distances in a consistent fashion. This would be inconvenient in walking, and in the chromaticity chart it means that geometrical separations between colours cannot simply be used to indicate colour differences. This may not matter in some applications but in trying to judge colour differences we are up against a 20:1 variation in the relationship between distance and colour difference in different parts of the chart.

The CIE 1976 Uniform Chromaticity Scale Diagram

This particular problem was addressed when the CIE, in 1976, proposed the current Uniform Chromaticity Scale Diagram employing a new set of coordinates u' and v', which superseded a related u, v diagram introduced in 1960. The u', v' diagram reduces the inequality of colour scaling to a maximum of about 4:1 at the worst case.

CIE 1976 CIELAB Uniform Colour Space

The issue of colour difference should really be considered to include differences in luminance, which cannot be shown in a chromaticity diagram. It introduces another dimension and requires a three-dimensional uniform colour space if colour differences are to be adequately quantified. The CIE introduced two such uniform colour spaces in 1976, the CIE 1976 (L*a*b*) colour space, or CIELAB, and the CIE 1976 (L*u*v*) colour space, or CIELUV. Of the two, CIELAB is more commonly encountered, has been extensively used in studies of photographic images and is widely applied in software packages such as Adobe Photoshop applied to digital imaging. Important features of CIELAB colour space are illustrated in Figure 23.10. The vertical axis, L*, represents lightness and corresponds to the Munsell Value scale. The colours increase in Chroma, C^*_{ab}, radially away from the neutral scale of the L* axis, and a surface of constant C^*_{ab} is a cylinder centred on the L* axis. A plane parallel to that of the a* and b* axes is a plane of constant L*. The hue-angle, h_{ab}, ranges from $0°$ for a red at about 700 nm wavelength through yellow at $90°$, green at $180°$, blue at $270°$ and back to red at $360/0°$. Any pair of colours in CIELAB space can differ in L*, a* and b*. The overall colour difference between them is defined as the Pythagorean distance between them:

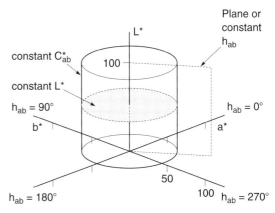

Figure 23.10 The three-dimensional CIE 1976 L*a*b* Uniform Colour Space also includes Chroma, C^*_{ab}, and hue angle, h_{ab}

$$\Delta E^*_{ab} = \sqrt{[(\Delta a^*)^2 + (\Delta b^*)^2 + (\Delta L^*)^2]}$$

It is also useful to define the colour difference in terms of hue, chroma and lightness:

$$\Delta E^*_{ab} = \sqrt{[(\Delta L^*)^2 + (\Delta H^*_{ab})^2 + (\Delta C^*_{ab})^2]}$$

Computer software packages in imaging may offer the choice between working in Lab or HCL values. These generally refer to CIELAB parameters, and the software may offer screen CIE colorimetry. Provided the CRT in use has been calibrated the screen colorimetry can be good. Its usefulness is reduced if the monitor has not been calibrated.

Colour gamuts

We have now introduced two-dimensional chromaticity diagrams and a three-dimensional uniform colour space and it is time to review some applications of colorimetry in imaging, particularly in the field of colour gamuts. The colour gamut of a reproduction system is usually represented graphically as the range of colours available in images, mapped in some appropriate colour space. The gamut limit can be defined as a boundary, beyond which colour changes in the subject are not represented by changes in the reproduction. The gamut limit implies a lack of discrimination in reproducing colours of differing hue, chroma or lightness.

Computer software packages such as Adobe Photoshop allow the specification of colours in RGB pixel values and normally include a 'gamut warning' when colours on screen cannot be shown in hard copy output. So there is a real significance in this concept.

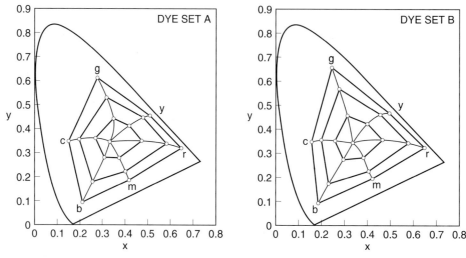

Figure 23.11 Colour gamuts, in a CIE 1931 *x, y* chromaticity diagram, for two sets of subtractive image dyes

The CIE 1931 *x, y* chromaticity diagram, whatever its deficiencies, remains widely used as a colour map. An example of a gamut study is shown in Figure 23.11, which illustrates two image dye sets, A and B, used in colour-reversal films. In each case concentration series of each of the three image dyes were prepared photographically, by sensitometric exposure, and patches of complementary densities of 0.5, 1.0 and 1.5 were selected for colorimetric study. In Figure 23.11 each of the hue loci identified by y (yellow), m (magenta) and c (cyan) has three plotted points representing the three specified densities. The hue loci designated as b (blue), g (green) and r (red) have three plotted points representing the combination of the two neighbouring dye patches of the specified densities. Owing to the imperfect nature of subtractive image dyes such combinations tend to have rather low luminance, much lower than is implied by the densities of the individual dye patches before combination to give the primary colours. In Figure 23.11 it is just apparent that dye set B yields a greater enclosed area than set A. Luminance information is, of course, missing from chromaticity diagrams so that we know nothing about the lightness of the two sets of primary and complementary colours formed. It is therefore useful to draw iso-luminance boundaries to compare the two dye sets at some fixed luminance factor. Figure 23.12 shows such boundaries drawn for a luminance factor of 10 per cent. The much greater area enclosed by dye set B means that it gives higher chroma colours at that luminance level than set A. This indicates the clear superiority of dye set B.

A related, but not identical, use of the CIE 1931 *x, y* chromaticity chart is shown in Figure 23.8, where the reproductions of very colorimetrically pure col-

ours are examined. Errors of hue and chroma are clearly seen in the diagrams. At this stage one might reasonably wonder whether the tests were too severe – after all we do not normally photograph filters of very high purity. An experiment with a reflection test object, the Macbeth ColorChecker chart, was conducted using colour-negative film and making prints of the entire chart with a wide range of systematic colour perturbations. The results for two test colours

Figure 23.12 As Figure 23.11 but plotted at a constant, 10 per cent, luminance

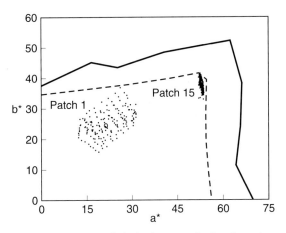

Figure 23.13 Gamut limited colour reproduction shown in an a*, b* diagram (see text)

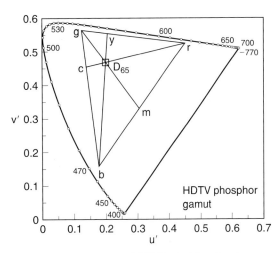

Figure 23.15 The gamut of HDTV television phosphors shown in a u', v' chromaticity diagram

of similar L* value are shown, using an a*,b* diagram, in Figure 23.13. Patch 1 shows a systematic hexagonal spread of reproduction colorimetry around the standard reproduction; the higher chroma patch 15, on the other hand, shows remarkably little variation. The dashed boundary in the figure represents the gamut of the colour printing paper used, determined by a separate experiment. This reveals that the reproduction of patch 15 lies roughly at the gamut boundary and we may conclude that the lack of variation is because it is *gamut limited*. The solid boundary in the figure represents the gamut of real surface colours. It is clear that the printing paper gamut lies well within that of the real surface colours

and that there exists a range of real surface colours which cannot be discriminated in a photographic print.

The CIE 1976 u', v' uniform chromaticity scale diagram has been particularly widely used in studies of television and other electronic imaging systems. In Figure 23.14 we have a comparison of the colour gamut of a computer monitor, or video display unit (VDU), with that of a reversal colour film. The VDU has a triangular gamut with the three phosphors at the corners. It is a property of chromaticity diagrams that the effect of combining two colours, say red and blue, is to give a third colour which is located on the straight line joining the two. This is confirmed in the case of the additive primaries given by the phosphor set. While the two gamuts have quite a large overlap, it is clear that the reversal film can give less orange reds than the monitor and reds and magentas of higher chroma. On the other hand, the VDU gives a more saturated blue reproduction. This reproduction is also much lighter than the most saturated blue obtained from the subtractive dye of the reversal film. The obvious departure from the simple triangular form of the gamut of the VDU, in the reversal film, may be due to the inherent properties of subtractive primaries. The two, rather different, white points shown are identified by OG for the open gate slide projector, and VDU for the monitor.

Broadcast television phosphors give a greater colour gamut than some monitors, and the gamut of the high definition television (HDTV) phosphor set is shown in Figure 23.15, together with the locations of the subtractive primaries formed by pairs of primaries. When we see the area of the diagram, within the spectral locus which is out of gamut, it is a little surprising that television pictures can be so satisfactory.

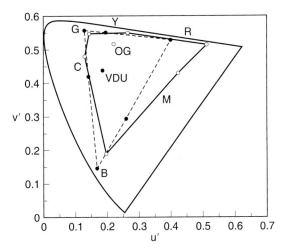

Figure 23.14 Comparison between the gamut of a computer monitor (– – – –) and that of a reversal colour film (——)

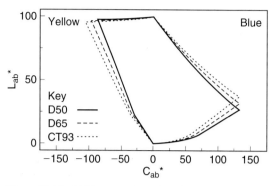

Figure 23.16 L*C* gamuts for a complementary pair of HDTV colours, showing the effect of the choice of white point

Use of the three-dimensional CIELAB uniform colour space is shown in Figure 23.16, where the lightness, L*, is plotted against chroma, C*, for HDTV yellow and blue. The different behaviour of the colours is of interest. Yellow, for instance, is very light at maximum chroma because both red and green phosphors are at maximum light output. Blue is much darker because only the lowest luminance phosphors, blue, are excited. In Figure 23.16 it has been possible to show the effect of changing the white point of the display from CIE D50, through the preferred D65 to 9300 K.

Summing up

This chapter has reviewed important aspects of colour science as applied to images. Use has been made of two-dimensional x, y and u', v' chromaticity diagrams and the two-dimensional a*,b* diagram, which is not a chromaticity chart although it can be a useful representation of colorimetric data. The concept of quantified colour gamuts is also realized in practice through colorimetry. The quantification of colour differences is made possible by the use of CIELAB colour space and this, in principle, can be a good objective test of colour reproduction. An example has been shown of CIELAB colour space in the examination of TV gamuts as a function of the white point adopted.

Colorimetric data is commonly used in setting up computer graphics and digital imaging packages and is becoming a common-place tool in this context. This chapter has sought to give an over-view of the principles and imaging applications of colorimetry.

Bibliography

Hunt, R.W.G. (1995) *The Reproduction of Colour*, 5th edn. Fountain Press, Kingston-upon-Thames.

Hunt, R.W.G. (1998) *Measuring Colour*, 3rd edn. Fountain Press, Kingston-upon-Thames.

24 Theory of image formation

How might the image shown in Figure 24.1 be described? Clearly we recognize the features of an aircraft. Enthusiasts might recognize the make and model. We could also comment on such attributes as lighting and composition. These aspects of visual perception are a consequence of the subtle processes of physiology and psychology operating when we view the two-dimensional luminance pattern contained in the figure. The processes are poorly understood and are not covered in this work.

When we are asked to comment on the *quality* of the image, the same complex processes are involved and we make what is known as a *subjective* judgement. The processes operate on identifiable physical properties of the image, such as the structure of edges and the distribution of tone. The measurement of these physical properties forms the basis of *objective* image evaluation.

The purpose of this chapter is to introduce and develop the *Fourier theory of image formation*. This theory allows us to unify many objective measures of image quality and to evaluate and compare different imaging systems in a meaningful way. Most textbooks covering this subject require familiarity with physics and mathematics at undergraduate level. The presentation here includes a liberal sprinkling of important mathematical expressions but it is not necessary to understand their manipulation in order to

Figure 24.1

understand the ideas of the chapter. In most cases the mathematics is included as an illustration of, and a link to, the more thorough treatments found elsewhere.

Returning to Figure 24.1, we can usefully describe the image as a large array of small closely spaced image elements (pixels) of different luminances. If the pixels are sufficiently small, we don't notice them. All we see is a continuous luminance pattern. The way adjacent pixels vary in luminance over a small region determines image qualities such as *sharpness*, *resolution* and *graininess*.

We can extend this idea to scenes in general. What lies in front of our camera lens when we take a photograph is a continuous luminance pattern, but with a little imagination it can be considered as an infinite array of infinitesimal points of varying luminance. The manner in which the imaging process translates these scene points (the *input*) into the image elements (the *output*) is then a fundamental physical process contributing to the quality of the image.

The physical relationship between input and output clearly depends on the technology of the particular imaging process. For example, an image element from a photographic film is best described as a localized group of developed silver grains (a *point spread function*). A charge coupled device (*CCD*) imaging array produces more recognizable discrete cells (pixels) related to the distribution of the detector elements.

Despite these technological differences, the Fourier theory of image formation can be applied, with certain conditions, to all imaging systems. It enables us to model the input to output relationship in a general manner. It supplies us with an important tool, the *modulation transfer function*, with which imaging performance can be assessed. The theory can be applied quite generally to colour images by treating individual luminance and colour channels independently.

To understand the Fourier theory of image formation requires a special treatment of images and their structure. We need to consider decomposing the luminance pattern, not into points or image elements, but into *waves* or *spatial frequencies*.

Sinusoidal waves

Figure 24.2(a) shows an amplified sine wave plotted as a function of distance, x. It exhibits the characteristic periodic behaviour where the number of repetitions (*cycles*) in unit distance is known as the spatial frequency, ω. The amplitude of the wave is a. The function is derived from the familiar trigonometric ratio by setting the angle equal to $2\pi\omega x$ radians and multiplying the resulting ratio by the required amplitude.

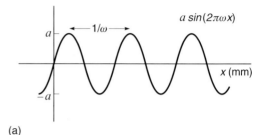

(a)

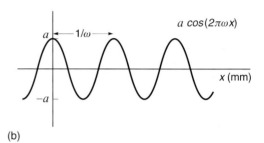

(b)

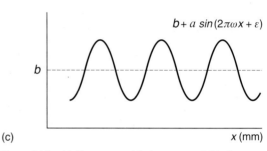

(c)

Figure 24.2 (a) Shows a spatial sine wave and (b) shows a spatial cosine wave. A general sinusoidal wave is illustrated in (c)

Figure 24.2(b) shows a cosine wave of the same spatial frequency and amplitude. The two waves differ only in their positions on the x-axis. If the cosine wave is shifted a distance $\pi/2$ in the positive x direction it becomes a sine wave.

A sine or cosine wave, shifted an arbitrary distance along the x-axis, is termed a *phase shifted* sine wave.

If we add a constant to a phase-shifted sine wave to produce an all-positive result, we obtain what will be referred to in this work as a *sinusoidal* wave (see Figure 24.2c). This is appropriate for our work where the varying quantity is, for example, luminance. Also, for much of the work, the phase is unimportant.

Modulation

The modulation of a sinusoidal wave is a formal measure of contrast. It is defined in Figure 24.3. The modulation of a real luminance wave must lie

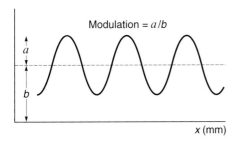

Figure 24.3 The modulation of a wave

between the two limits zero and one. A modulation of zero implies the wave does not exist; a modulation of one is the maximum possible without invoking negative luminance.

Images and sine waves

Figure 24.4(a) shows a sinusoidal luminance pattern. It is characterized by a particular spatial frequency, a direction of variation (x-direction) and a modulation. Figure 24.4(b) shows the same information plotted as a three-dimensional figure. The luminance value of the image at any point is plotted upwards. Figure 24.4(c) is an end-on view. It shows the profile and clearly illustrates the sinusoidal character.

Figure 24.5 shows a second sinusoidal luminance pattern, of a lower spatial frequency and a lower modulation.

If we add together these two sinusoidal patterns, we obtain Figure 24.6. The result is no longer sinusoidal. The profile shows a slightly more complicated pattern.

We can continue this process by including many more sinusoidal patterns. Figure 24.7 shows an image containing 30, all of which vary in the x-direction but have different frequencies and modulations. The profile is now very complicated and does not appear to be periodic, unlike the individual sinusoidal components.

Note that in all of the above cases the images are invariant in the y-direction. We would describe them as functions of x only.

Figure 24.8 shows the result of adding more sinusoidal patterns but this time their direction of variation is vertical (y-direction). Finally we can add some sinusoidal patterns that vary in directions other than the horizontal or vertical. Figure 24.9 shows two examples, and the result of adding them to the image. We now have a complicated image that varies in both the x- and y-directions.

This demonstration could be continued to include many more sinusoidal components. We would create some very complicated patterns. With a large enough variety of components, we could create any pattern we choose. In other words, any image can in principle be built up (or synthesized) from sine and cosine wave components. We would need to include waves of many different frequencies, amplitudes, orientations and phases. The French mathematician Fourier first demonstrated this principle, although he dealt with functions of one variable rather than two.

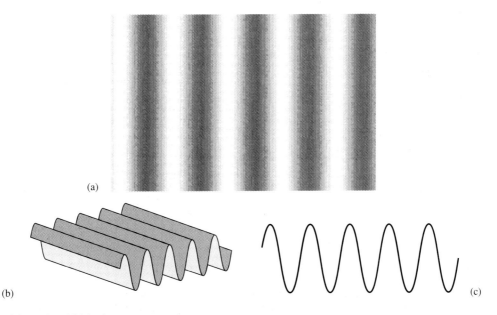

Figure 24.4 A sinusoidal luminance pattern

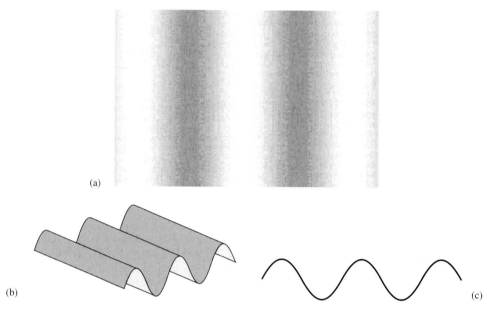

Figure 24.5 A sinusoidal pattern with a lower spatial frequency and modulation compared with Figure 24.4

It follows from this discussion that real scenes can be, in principle, decomposed into sets of sinusoidal components of varying frequencies and modulations. The basis of Fourier theory of image formation is that if we know the performance of the imaging system to different sinusoidal inputs, we can use the principle known as *superposition* (adding together) to determine the performance for a real scene.

As we shall see, the mathematical process known as the *Fourier transform* supplies the means of decomposing arbitrary functions into sinusoidal components. This is a mathematical transformation of a

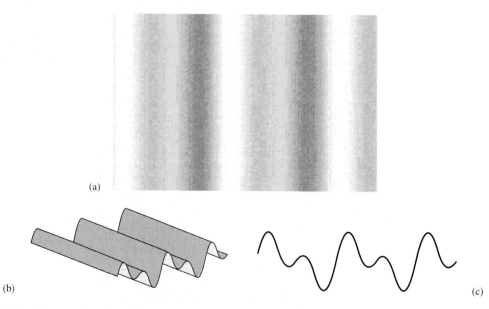

Figure 24.6 The sum of two sinusoidal patterns

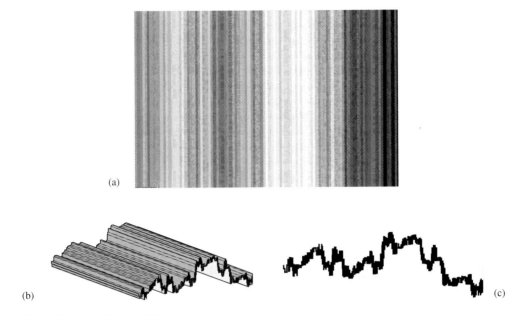

(a)

(b) (c)

Figure 24.7 The sum of 30 sinusoidal patterns

function $f(x)$ into a different form, $F(\omega)$, that represents the amplitudes of the contained frequencies ω. The term Fourier transform is commonly used to represent both the process and the resulting function $F(\omega)$.

Imaging sinusoidal patterns

Suppose we take a picture of a sinusoidal pattern using an 'ideal' imaging system. If we consider an object to be made up of an infinite number of infinitesimally small points, then an ideal imaging

system is one that is capable of reproducing every point faithfully. Then the image will be an exact copy of the object. Furthermore, we would know that each region in the image, no matter how small, corresponds to an identical region in the object.

Now, as was suggested at the beginning of this chapter, real imaging processes are not ideal. Points in the object are not reproduced as points in the image. Depending on the particular imaging process an object point may appear in the image as a fuzzy circular patch of varying density (photographic film), small concentric rings of light (a diffraction limited lens), a uniform rectangular pixel (digital system),

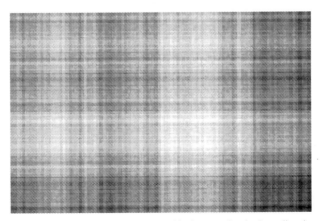

Figure 24.8 The result of adding a set of sinusoidal components, this time varying in the *y*-direction

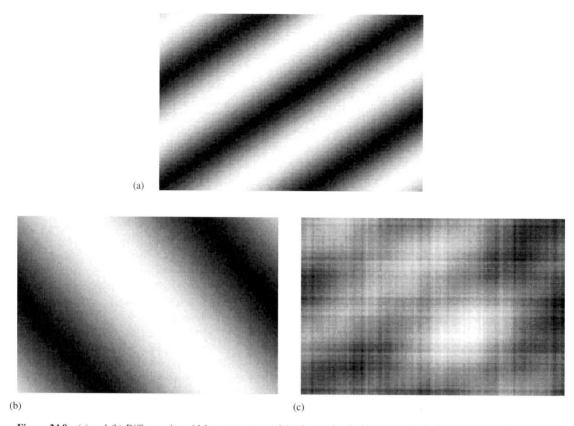

(a)

(b) (c)

Figure 24.9 (a) and (b) Different sinusoidal components, and (c) the result of adding them to the image of Figure 24.8

etc. These examples are illustrated in Figure 24.10. It is customary to refer to these image elements as *point spread functions (PSF)*. The designers of imaging systems (photographic emulsion chemists, optical engineers and solid state physicists) are constantly striving to reduce the size of the PSFs for their systems.

Of major importance is the fact that images are formed from the summation of an infinite number of overlapping PSFs. This is fairly easy to visualize for the photographic and optical systems. In the case of the typical digital process a *sampling* mechanism confuses the process, although overlapping PSFs are still effectively at work. This mechanism of image formation (summation of overlapping PSFs) is an example of a very important process known as *convolution*. It will result in images that are blurred when compared with the original scene.

A remarkable fact when imaging a sinusoidal pattern is that the result retains its sinusoidal form, even though the convolution process has blurred it. There will generally be a change (usually a reduction) in modulation, and there may be a phase shift. The reduction in modulation depends on the spatial frequency of the pattern and the size of the PSF. An important consequence of this is that the reproduction of sinusoidal patterns can be described very simply. Usually the reduction in modulation is all that is required. Furthermore the results can be presented in clear graphical form (the modulation transfer function) and systems can be meaningfully and usefully compared.

Fourier theory of image formation

In order to use the theory, the system must be *linear* and *spatially invariant*.

Linear, spatially invariant systems

Suppose a general input I_1 causes an output O_1 at a particular position in the image, and a different input I_2 causes an output O_2 at the same position. If an input $k_1I_1 + k_2 I_2$ causes an output $k_1O_1 + k_2O_2$

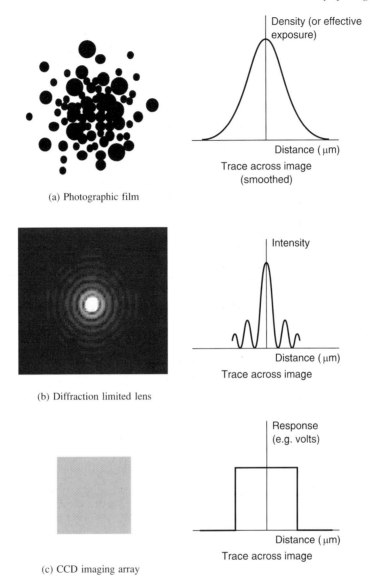

(a) Photographic film

Trace across image
(smoothed)

(b) Diffraction limited lens

Trace across image

(c) CCD imaging array

Trace across image

Figure 24.10 Example point spread functions

where k_1 and k_2 are any arbitrary constants, the system is said to be *linear*. A consequence of linearity is that the output vs. input characteristic will be a straight line.

If the only change caused to an image by shifting the input an arbitrary distance is an equivalent shift in the image, then the system is said to be *spatially invariant* (or *stationary*).

In practice, most imaging systems violate these conditions. The photographic process is notoriously non-linear, with well-known characteristic curves linking the output with the input. CCD arrays are not spatially invariant. On a micro scale, moving a point source across a single detector will not change the detector output. The sampling process, a feature of CCD arrays, acts as a special kind of non-linearity generating new spatial frequencies in the image. Lenses will not be stationary if they contain aberrations, which is generally the case.

In spite of these violations, most imaging systems can be treated as quasi-linear and stationary over a restricted operating region to take advantage of the wealth of tools available in Fourier theory.

Spread functions

Spread functions arise from important fundamental physical processes acting in real imaging systems. A few of these are described in the following paragraphs.

Lens systems are limited by light diffraction, and often suffer from aberrations. These effects spread the light laterally in the image. Even in the case of a '*perfect*' lens (one with no aberrations) the wave nature of light causes a point to appear as a disk surrounded by fainter rings (the '*Airy disk*').

A photographic emulsion causes light passing into it to be diffused. It is said to be *turbid*. This diffusion arises as a result of reflection, refraction, diffraction and scattering by the silver halide crystals, and depends on such factors as the mean crystal size, ratio of silver halide to gelatin and the opacity of the emulsion to actinic light.

A CCD imaging array integrates the light falling over the area of a single detector element. Light is effectively spread over a rectangular area defined by the dimensions of the element. Further spreading can occur as a result of charge diffusion and charge transfer inefficiencies operating within the device.

Cathode ray tube (CRT) displays can be considered to exhibit a spread function in the form of a display dot generated by the scanning electron beams. The profile of the dot is usually Gaussian and in colour systems is sampled by a *shadow mask*.

We have already noted that point spread functions are the '*building blocks*' of real images and will be responsible for the degradations in image quality (sharpness, resolution, definition, fidelity etc.) that occur in imaging systems. We have also seen that the degradation in image quality can be explained by the reduction in modulation of sinusoidal components, summarized by the modulation transfer function. As we shall see, it is another remarkable fact of Fourier theory that these two quite different views of image formation are intimately connected. In particular the spread function and the modulation transfer function are related by the Fourier transform.

The point spread function (PSF)

The image of a point in a linear, stationary imaging system is the point spread function (PSF). It is a function of two orthogonal variables (x, y), usually taken in the same directions as the image plane variables x_p and y_p. If the system is isotropic (i.e. it has the same physical properties in all directions), the PSF will be rotationally symmetrical. It can thus be represented by a function of one variable, r say, where $r^2 = x^2 + y^2$.

Notation: $I(x,y)$ general representation, suitable for optical systems, CCDs, monitor screens, scanners etc.

$I(r)$ for isotropic systems, e.g. photographic emulsions.

Units: Light intensity (optical systems). Voltage, equivalent to effective exposure (CCDs). Luminance (monitor screens). Effective exposure (photographic emulsions).

Generally, we will not refer to any specific unit. We only need to assume that the output units are linear with the input units.

The shape of the PSF (in particular its extent in the x and y directions) determines the sharpness and resolution aspects of image quality produced. If the PSF is very small in the x and y directions, we can expect the image sharpness and resolution to be good. (A hypothetical perfect system would have a PSF of zero size – i.e. a point.) A system with a PSF extending over a large area would produce very poor images.

The line spread function (LSF)

The profile of the image of a line (a function of just one variable) is the line spread function (LSF). It is formed from the summation of a line of overlapping point spread functions. If the system is not isotropic the LSF will depend on the orientation of the line.

If the system is isotropic, the LSF is independent of orientation. In this case the LSF contains all the information that the PSF does. Since the LSF is much easier to measure and use than the PSF, imaging is nearly always studied using the LSF.

Figure 24.11 shows the relationship between the LSF and the PSF for a typical diffusion type imaging process (for example a photographic emulsion). It should be noted however that the diagram applies to all linear, stationary imaging systems. Only the shapes of the spread functions will differ.

The edge spread function (ESF)

The profile of the image of an edge is the edge spread function (ESF). It can be considered as formed from a set of parallel line spread functions finishing at the position of the edge. The value of the ESF at any point is thus given by the integral of a single LSF up to that point. Since the reverse relationship must apply, we find that the first derivative of the ESF gives the LSF. In other words the slope of the edge profile at any point is the value of the LSF at that point. Imaging an edge is therefore a very important method of obtaining the line spread function.

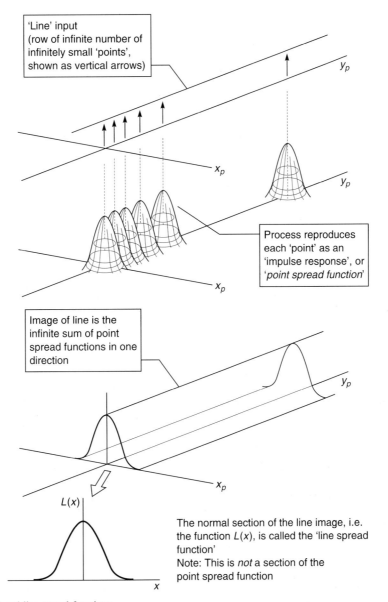

Figure 24.11 Point and line spread functions

The imaging equation (from input to output)

We have seen that the input to an imaging system can be thought of as a two-dimensional array of very close points of varying value (luminance). Provided the system is linear and stationary we can consider the image to be formed from the addition of overlapping, scaled PSFs in the x_p and y_p directions. We would expect the image to be less detailed than the original input distribution.

We denote the input scene as $Q(x_p, y_p)$, the output image as $Q'(x_p, y_p)$ and the PSF as $I(x, y)$. Mathematically, the relationship between them is given by the *imaging equation*:

$$Q'(x_p, y_p) = \int_{-\infty}^{\infty} \int_{-\infty}^{\infty} Q(x, y) I(x_p - x, y_p - y) dx dy \quad (1)$$

This is a two-dimensional *convolution* integral. It represents the previously described process of adding up the scaled PSFs over the surface of the image. The

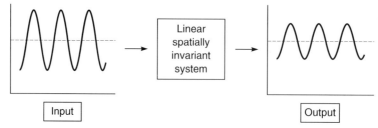

Figure 24.12 Imaging a sinusoidal exposure

integrals represent the summation process when the individual PSFs are infinitesimally close together.

Notation:

Often written as: $Q'(x,y) = Q(x,y) \otimes I(x,y)$ (2)

or even just: $Q' = Q \otimes I$ (3)

where \otimes denotes convolution. Note also the dropping of subscripts on x and y.

In all that follows, subscripts will be dropped if there is no danger of ambiguity.

The imaging equation in one dimension

Using the LSF instead of the PSF allows us to write a one-dimensional simplification:

$$Q'(x_p) = \int_{-\infty}^{\infty} Q(x)L(x_p - x)dx$$ (4)

where $L(x)$ is the line spread function, $Q(x)$ is the one-dimensional input and $Q'(x)$ is the one-dimensional output. In this case, input scenes of the form illustrated in Figure 24.7 are considered as an infinitesimally close set of lines. The image is formed from the addition of overlapping weighted line spread functions.

This may also be written as:

$$Q'(x) = Q(x) \otimes L(x)$$ (5)

or as

$$Q' = Q \otimes L$$ (6)

The modulation transfer function (MTF)

In an earlier section we highlighted an important property of linear, stationary systems. If the input is sinusoidal in form, then the output is also sinusoidal in form. It will have a different modulation (usually reduced) and may be shifted along the x-axis. The image will have the same frequency as the input. This is illustrated in Figure 24.12.

The degree of modulation reduction depends on the spatial frequency. Low frequencies (corresponding to coarse detail) suffer only a minor reduction in modulation (if at all). High frequencies suffer much greater loss of modulation. If the frequency is high enough, it will not be reproduced at all (i.e. it is not resolved).

The reduction in modulation of a particular spatial frequency, ω, is known as the modulation transfer factor. A plot of the modulation transfer factor against spatial frequency, ω, gives the modulation transfer function (MTF). Some typical MTF curves for black-and-white photographic films are illustrated in Figure 24.13.

The MTF describes the reduction in modulation, or contrast, occurring in a particular imaging system, as a function of spatial frequency. Note that it does not include information about any '*phase shift*', i.e. if any frequencies undergo a shift on imaging owing to an asymmetric spread function, this will not be shown by the MTF.

In Figure 24.13 curve (c) shows an initial rise above unity at low spatial frequencies. This is evidence of development adjacency effects and represents a non-linearity of the system. Accordingly the MTF curve is not unique. It is of limited value as it does not represent the behaviour of the film for all input exposure distributions.

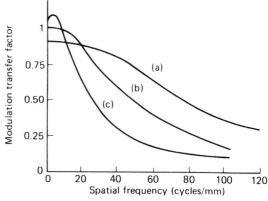

Figure 24.13 MTFs for (a) fine grain film, (b) medium speed film and (c) fast panchromatic film

The Fourier transform

In order to complete this introduction to the Fourier theory of image formation, we need to introduce the main tool for decomposing functions into their component spatial frequencies, the Fourier transform.

For a non-periodic function $f(x)$, the *Fourier transform* $F(\omega)$ is defined as:

$$F(\omega) = \int_{-\infty}^{\infty} f(x)e^{-2\pi i \omega x}dx \qquad (7)$$

$F(\omega)$ represents the amount of frequency ω present in the non-periodic $f(x)$. Equation (7) can be interpreted as follows: To establish the amount of a frequency ω present, the function $f(x)$ is multiplied by a sine or cosine of that frequency. The area of the result (denoted by the integral) yields the required amount in terms of amplitudes.

$F(\omega)$ is called the Fourier spectrum (or sometimes just the spectrum) of $f(x)$. $F(\omega)$ is generally a continuous frequency spectrum.

The units of the variable ω are the reciprocal of those of x. $f(x)$ is a function of distance (e.g. x in mm.) and therefore $F(\omega)$ is a function of spatial frequency (mm^{-1}, which means cycles per mm).

The function $F(\omega)$ is in general complex. This means it has two distinct components at each frequency, namely $R(\omega)$, the amplitude of the cosine component of frequency ω, and $I(\omega)$ the amplitude of the sine component. Using the notation of complex mathematics, this is written:

$$F(\omega) = R(\omega) + iI(\omega) \qquad (8)$$

If we are only interested in the total amplitude of the frequency ω, we form the modulus of the Fourier transform, i.e.

$$|F(\omega)| = \sqrt{R^2(\omega) + I^2(\omega)} \qquad (9)$$

Special Fourier transform pairs
The rectangular function

One of the most important functions for which we need the Fourier transform is also one of the simplest functions, namely:

$$f(x) = \text{rect}(x/a) \qquad (10)$$

where rect stands for *rectangular* and a is a constant representing the width of the rectangle. The function is thus a rectangular '*pulse*' of width a and height 1. Its importance lies in the fact that it is used to represent many important imaging apertures (e.g. the width of a scanning slit, the one-dimensional transmittance profile of a lens, a single detector element of a CCD imaging array, etc.). When the Fourier transform expression is evaluated for this function, we obtain the result:

$$F(\omega) = \frac{\sin(\pi a \omega)}{\pi \omega} = \frac{a\sin(\pi a \omega)}{\pi a \omega} = a\,\text{sinc}(a\omega) \qquad (11)$$

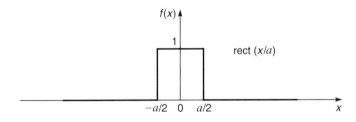

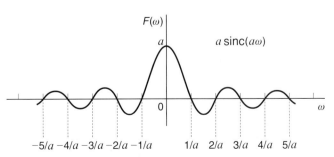

Figure 24.14 The rectangular function and its Fourier transform

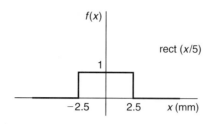

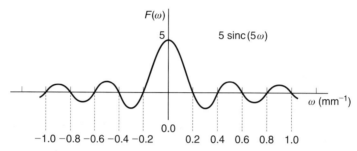

Figure 24.15 A rectangular function of a particular dimension, and its Fourier transform

where the function sinc $(a\omega)$ is the common notation for the function

$$\frac{\sin(\pi a\omega)}{\pi a\omega}$$

This Fourier transform pair is illustrated in Figure 24.14.

As a further example, a rectangular function of width 5 units is presented together with its Fourier transform in Figure 24.15. In both of these cases the rectangular functions are symmetrical about the origin. This means that they contain only cosine waves. The Fourier transforms therefore represent the amplitudes of the cosine components present in the rectangular functions.

The Dirac delta function

The Dirac delta function, $\delta(x)$, is a special function in Fourier mathematics. It is widely used in signal processing and has a particular significance in image science.

The Dirac delta function is defined with two statements:

$$\delta(x) = 0, \quad x \neq 0 \quad \text{and} \quad \int_{-\infty}^{\infty} \delta(x)dx = 1 \quad (12)$$

The first statement says that $\delta(x)$ is zero everywhere except at the origin. The second statement says

that $\delta(x)$ has an area of unity. The only reasonable interpretation of this definition is to suppose that $\delta(x)$ has infinitesimal width but infinite height, so that its *width times height = 1.*

We usually interpret the function as representing an *impulse of unit energy.* It is shown graphically as a vertical arrow of unit height situated at the origin. The height of the arrow represents the energy (or area) of the impulse.

Properties of $\delta(x)$

(a) *Its Fourier transform is 1*

This means an infinitely brief pulse of energy contains an infinite range of frequencies, all of the same amplitude. In imaging terms it implies that a perfect point image contains an infinite range of frequencies of constant amplitude. $\delta(x)$ and its transform are illustrated in Figure 24.16.

(b) *The sifting property of the Dirac delta function*

The convolution of any function $f(x)$ with $\delta(x)$ yields $f(x)$: i.e.

$$\int_{-\infty}^{\infty} f(x_1)\delta(x - x_1)dx_1 = \int_{-\infty}^{\infty} f(x - x_1)\delta(x_1)dx_1$$

$$= f(x) \quad (13)$$

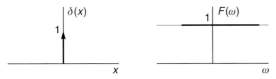

Figure 24.16 The Dirac delta function and its Fourier transform

Importance of δ(x)

- $\delta(x)$ is used to represent a 'point' of unit magnitude input to a system. The image of the point is the point spread function (PSF). In spatial frequency terms, the input is a *flat* (or '*white*') spectrum; the output is the MTF.
- If a hypothetical system has a perfect response, its PSF is identical to $\delta(x)$. Output images will then be identical to the input exposure (the sifting property).
- The process of *sampling* a continuous function uses a row or comb of delta functions to represent the sampling function. Sampled data values are obtained by multiplying the continuous function by the sampling function. Digital images are obtained using a two-dimensional sampling function.

The modulation transfer function revisited

Starting with the imaging equation in one-dimension:

$$Q'(x_p) = \int_{-\infty}^{\infty} Q(x)L(x_p - x)dx \quad (14)$$

the image of a one-dimensional sinusoidal wave of frequency ω is obtained as follows.

Let

$$Q(x) = b + a \cos(2\pi\omega x) \quad (15)$$

This is a sinusoidal function with a modulation equal to a/b.

The imaging equation can be developed to arrive at:

$$Q'(x_p) = b + a \left| \int_{-\infty}^{\infty} L(x)e^{-2\pi i\omega x}dx \right| \cos(2\pi\omega x + \varepsilon) \quad (16)$$

$$= b + aM(\omega) \cos(2\pi\omega x + \varepsilon) \quad (17)$$

This says that the output is also a one-dimensional sinusoidal wave, of the same frequency ω but different modulation, namely $aM(\omega)/b$. The symbol ε represents a phase shift (this will be zero if the line spread function is symmetrical).

Figure 24.17 Relationships between one- and two-dimensional spread functions and corresponding MTFs

The modulation transfer factor for frequency ω is given by:

$$\frac{\text{output modulation}}{\text{input modulation}} = \frac{\dfrac{aM(\omega)}{b}}{\dfrac{a}{b}} = M(\omega) \quad (18)$$

and a plot of $M(\omega)$ against ω is the MTF.

We therefore have the very important result:

$$M(\omega) = \left| \int_{-\infty}^{\infty} L(x)e^{-2\pi i\omega x}dx \right| = |T(\omega)| \quad (19)$$

where $T(\omega)$ is sometimes called the *optical transfer function* or *OTF*: i.e., the modulation transfer function is the modulus of the Fourier transform of the line spread function.

Fourier theory is thus seen to unify two apparently independent image models: the *array of points* and the *sum of sinusoidal components*. This and other important relationships are presented in Figures 24.17 and 24.18.

Figure 24.18 The imaging equation (convolution) and the spatial frequency equivalent

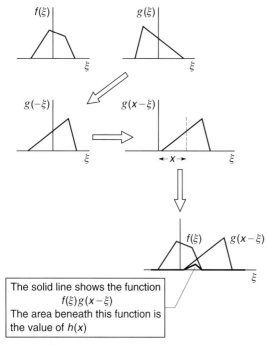

The solid line shows the function
$$f(\xi)g(x-\xi)$$
The area beneath this function is the value of $h(x)$

Figure 24.19 Geometric interpretation of convolution

Cascading of MTFs

A system comprising a chain of linear processes, each with its own MTF, has a system MTF, $M_s(\omega)$, given by:

$$M_s(\omega) = M_1(\omega) \cdot M_2(\omega) \cdot M_3(\omega) \cdot \ldots \quad (20)$$

where $M_n(\omega)$ is the MTF of the *n*th process. In other words, the individual MTFs for the components of an imaging chain combine by simple multiplication to yield the system MTF.

This result follows directly from a consideration of the '*image of an image*'.

A geometric interpretation of convolution

Convolution is such an important process in linear systems theory that it is useful to be familiar with the following geometrical interpretation. The convolution of two functions *f(x)* and *g(x)* yields a third function *h(x)* where:

$$h(x) = \int_{-\infty}^{\infty} f(\xi)g(x-\xi)d\xi \quad (21)$$

It can be considered an averaging process between the two functions *f* and *g*. Suppose we have the two functions *f* and *g* shown in Figure 24.19. The convolution process involves flipping *g* left to right as

shown to form $g(-\xi)$ and then sliding $g(-\xi)$ across $f(\xi)$. At each position, *x*, the two functions are multiplied together. The area of the result is the value of the convolution at this position *x*.

As we have seen, the two dimensional version of this process is the basis of imaging in a linear, stationary imaging system.

The convolution theorem

The Fourier transform of a convolution of two functions is the product of the Fourier transforms of those two functions: i.e.

If *F* is the Fourier transform of *f*, *G* is the Fourier transform of *g*, and *H* is the Fourier transform of *h* (the convolution of *f* with *g*) then:

$$H = F \times G \quad (22)$$

The convolution of two functions has a Fourier transform given by the product of the separate transforms of the two functions. This is a very important result and is the basis of all systems analyses using frequency response curves.

Measuring modulation transfer functions (MTF)

There are two main measurement classifications:

- Wave recording
- Edge methods

Wave recording – sine wave methods

This is a fairly traditional approach for the analysis of optical and photographic systems. A chart containing a range of spatial frequencies (i.e. sinusoidal intensity patterns) is recorded by the system under test. The dynamic range of the signal (i.e. the exposure range) is made low enough to ensure effective linearity.

For each frequency the image modulation is determined from a scan of the image. This is divided by the corresponding input modulation to obtain the modulation transfer factor. A plot of modulation transfer factor vs. spatial frequency is the MTF.

Wave recording – square wave methods

Because of the ease of production of accurate square wave objects, so called *square wave frequencies* are often employed. Using the same steps as in the sine wave method, the square wave MTF $M_{SQ}(\omega)$ is constructed. Fourier series theory gives the conversion to obtain the correct MTF as:

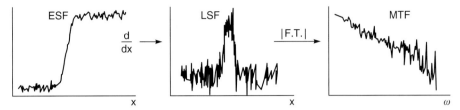

Figure 24.20 Derivation of an MTF from an edge spread function

$$M(\omega) = \frac{\pi}{4} \left[M_{SQ}(\omega) + \frac{1}{3} M_{SQ}(3\omega) - \frac{1}{5} M_{SQ}(5\omega) + \frac{1}{7} M_{SQ}(7\omega) - \dots \right] \quad (23)$$

Edge input method

This method is important because it requires no special patterns for input. Edges are commonplace objects in most scenes. The main disadvantage of the method lies in its sensitivity to noise, because of the small area of image used.

The method involves scanning the image of the edge to produce the edge spread unction. This is differentiated to obtain the system LSF. The modulus of the Fourier transform of the LSF, normalized to unity at $\omega = 0$, is the required MTF. The procedure is illustrated in Figure 24.20.

It should be noted that noise will influence the highest frequencies the most, because of the differentiation stage. Even if the edge spread function is smoothed prior to differentiation, the uncertainty in the resulting MTF still remains.

MTF correction

With all the above methods, the measured MTF will generally be that for a system containing a chain of processes. For example, in the analysis of photographic film some form of scanning device is required to extract the spread function. When measuring the MTF of a CCD array, a lens will normally be included.

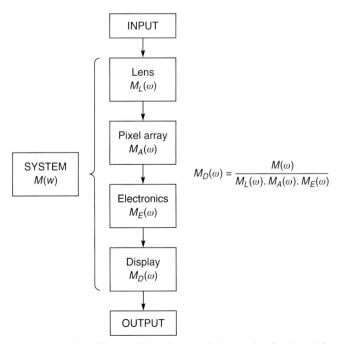

Figure 24.21 The relationship between the MTF of a display device and the complete imaging chain, assuming linearity

Each of these processes has its own MTF. The cascading property states that these multiply together to produce the system MTF (provided that the processes and the links between them are linear).

The effect of an individual process may therefore be removed from the overall measurement by dividing by that MTF (at least, up to the frequency at which noise dominates). Figure 24.21 illustrates this procedure for a digital acquisition and display chain.

Discrete transforms and sampling

In the previous sections we have seen how important Fourier theory is in understanding the formation and properties of images formed in imaging systems. For example, the modulation transfer function (MTF), describing the attenuation of amplitude as a function of spatial frequency, can be obtained by taking the Fourier transform of the line spread function. Fourier space multiplication (corresponding to real space convolution) forms the basis of many established techniques in image processing (see Chapter 26).

In most cases the functions we wish to transform are not available in an analytical form, so we cannot apply the integral definition of the Fourier transform. Instead, we generally have some experimentally determined function $f(x)$ that is digitized (sampled) at regular intervals of x, (i.e. δx), to yield a finite set of numbers (f_i say) that represent the function. The Fourier transform is taken of this discrete set of values (using a *discrete Fourier transform* or *DFT*). The result is another finite set of numbers (F_j) that represents the required Fourier transform $F(\omega)$ at regular intervals along the spatial frequency axis.

Correct *sampling* is essential if the digital values are to properly represent the continuous functions they are derived from. The set f_i must obviously be taken at an interval δx small enough to resolve all the detail in $f(x)$.

Note the wording here. It is necessary to resolve *all* the detail present, even if we are not interested in the fine structure. The reason for this will become clear shortly.

In a similar manner, the set F_j must be determined by the DFT at intervals of $\delta \omega$ sufficiently close to display the details of the function $F(\omega)$.

Conditions for correct sampling are embodied in the well-known *sampling theorem*. If we choose our sampling interval δx according to the sampling theorem, then the results will be as accurate as the measurement noise will allow. If we undersample, *the results will be wrong*. The unwanted process of *aliasing* will have occurred.

The rest of this section deals with the sampling theorem and aliasing. The topic is introduced by first considering the process of undersampling a cosine wave. We then define the sampling function and apply the convolution theorem to derive the sampling theorem and to explain the phenomenon of aliasing.

Undersampling a cosine wave

Figure 24.22 illustrates the consequence of sampling a waveform using a sampling interval that is too great. Curve (a) shows the original cosine wave being sampled. This has a spatial frequency of 40 cycles per mm. The sampling interval is 30 μm and the sample points are shown as spikes. The resulting set of sampled values appears to come from a much lower frequency, as shown by curve (b). This is the reconstructed frequency and in this case has a value of 6.67 cycles per mm.

This process of reconstructing a lower frequency than was sampled is known as *aliasing*. It occurs to a greater or lesser extent in all digital systems and means that a digitized image may not be a true record of the original analogue image. In the next two sections we study aliasing and its relation to the sampling conditions in more detail.

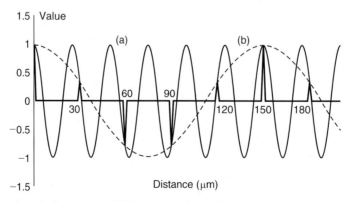

Figure 24.22 Undersampling a cosine wave. (a) Original cosine wave, frequency $\omega = 0.04$ cycles per μm. (b) Reconstructed cosine wave, frequency ω 0.00667 cycles per μm

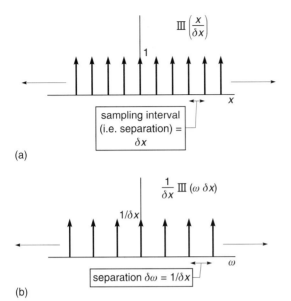

Figure 24.23 The sampling function (a) and its Fourier transform (b)

The Dirac Comb (the sampling function)

An infinitely extending row of impulses (regularly displaced Dirac delta functions) is represented as

$$\text{III}\left(\frac{x}{\delta x}\right).$$

This is known as a Dirac Comb and in our application represents the *sampling function*. The impulses are of unit energy and are spaced a distance δx (i.e. the sampling interval is δx).

An important result:

The Fourier transform of a Dirac comb is another Dirac comb with inverse scaling.

The sampling function and its Fourier transform are shown in Figure 24.23.

The process of sampling

The process of sampling a continuous function $f(x)$ amounts to multiplying $f(x)$ by a Dirac Comb. By the convolution theorem, multiplication in distance space is equivalent to convolution in frequency space. $F(\omega)$ is replicated at intervals $1/\delta x$. The separate repetitions are known as aliases. The DFT will evaluate the quantity $F(\omega) \otimes \text{III}(\omega \delta x)$ over just one period (usually between $\omega = 0$ and $\omega = 1/\delta x$). The result is correct (i.e. equivalent to $F(\omega)$) provided the individual aliases do not overlap. However, if δx is not fine

enough, overlap will occur, as shown in Figure 24.24. The DFT gives the sum of the aliases and in this case the result is incorrect as shown by the dotted line. *Aliasing* is said to have occurred.

In order to avoid aliasing, the function $f(x)$ must be sampled at an interval δx such that

$$\frac{1}{2\delta x} \geq \omega_c \tag{24}$$

where ω_c is the maximum significant frequency contained by $f(x)$.

The frequency $\omega_N = 1/2\delta x$ is known as the *Nyquist frequency*. It represents the highest frequency that can be faithfully reconstructed.

The *sampling theorem* states that all input frequencies below the Nyquist frequency can be unambiguously recovered, while input frequencies above the Nyquist frequency will be aliased. Such aliased frequencies are reconstructed in the frequency range $0 - \omega_N$, their amplitudes being added to the true signal in that range.

A formal enunciation of the sampling theorem is:

> **A function $f(x)$ whose Fourier transform is zero for $|\omega| > \omega_c$ is fully specified by values spaced at equal intervals δx not exceeding $1/2\omega_c$.**

Note that $f(x)$ is assumed to be bandlimited.(i.e. there is an upper limit to the range of frequencies contained by $f(x)$).

The sampling theorem means it is possible to recover the intervening values of $f(x)$ with full accuracy!

In practice, the DFT will evaluate (i.e. sample) the quantity $F(\omega) \otimes \text{III}(\omega \delta x)$ at intervals $\delta \omega$, which is itself determined from the sampling theorem, i.e. $\delta \omega = 1/S$ where S is the total extent, in units of x, of the function $f(x)$.

It is equivalent to replicating the sampled function

$$f(x) \, \text{III}\left(\frac{x}{\delta x}\right)$$

at intervals S, although we only actually handle one period. This is illustrated in Figure 24.25.

Suppose $f(x)$ is sampled correctly, at intervals δx, over the range S. N data values will be produced, where $N = S/\delta x$. The DFT will produce N_1 values, representing one alias of the Fourier transform sampled at intervals $\delta \omega$.

$$N_1 = 2\omega_N/\delta \omega = 2(1/2\delta x)/(1/S) = S/\delta x = N. \tag{25}$$

i.e. *N input values to the DFT will yield N output values.*

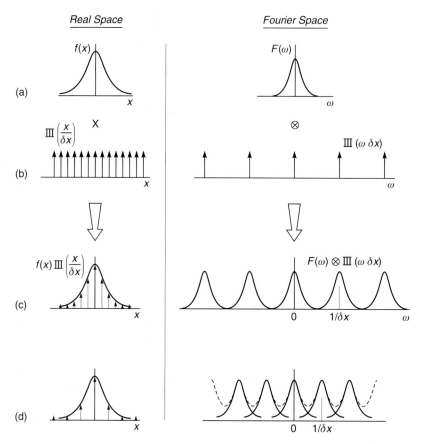

Figure 24.24 The mechanism of aliasing in undersampled functions. (a) A function $f(x)$ and its transform. (b) Sampling function of interval δx, and its transform. (c) Sampled version of $f(x)$ and its transform. (d) Sampled version of $f(x)$ and its transform when δx is not small enough

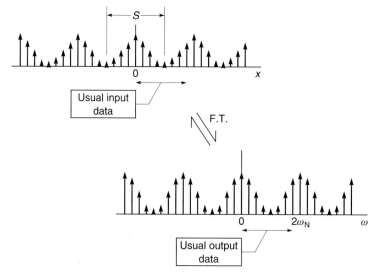

Figure 24.25 Sampled data and the result of a discrete Fourier transform

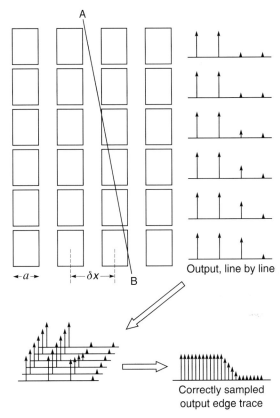

Figure 24.26 Schematic of CCD detector array and illustration of the principle of the slanted-edge method for edge analysis

Finally, note that DFTs are calculated using a so-called 'fast Fourier transform' method. It is essential that N be a power of 2 (e.g. 16, 32, 64 etc.). If necessary digitized functions of x must have sufficient zeros added to the ends to satisfy this requirement.

The MTF for a CCD imaging array

One important example of the correct use of the sampling theorem occurs in the slanted edge method for determining the MTF of CCD image arrays. Figure 24.26 shows a schematic representation of such an array. The detector elements have a width a in the x-direction. The centre-to-centre separation (the sampling interval) is δx.

The MTF in the horizontal direction will be determined mainly by the element width a. In fact the line spread function for this aspect is given by

$$\frac{1}{a} \operatorname{rect}\left(\frac{x}{a}\right)$$

and the corresponding MTF is $|\operatorname{sinc}\,(a\omega)|$. Other degradations, such as charge diffusion, will contribute to the MTF in a less significant manner.

A study of the sinc function reveals that spatial frequencies up to $1/a$ and beyond are capable of being recorded. The sampling interval δx will generally be greater than a, depending on the structure of the device (individual detector elements cannot physically overlap). This means that the Nyquist frequency cannot be higher than $1/2a$. We therefore have a situation of undersampling and the potential for much aliasing of the higher image frequencies. Readers may be familiar with Moire patterns visible in images formed with CCD systems. These are the consequence of aliasing of fine periodic structure. Many CCD imaging systems (for example, film scanners) have anti-aliasing mechanisms built in. One of the simplest is to ensure that the preceding imaging lens has an MTF that will filter out frequencies above the Nyquist frequency of the detector.

To measure the horizontal MTF without aliasing corrupting the result we use the slanted-edge method, illustrated in Figure 24.26. An edge (A–B) is projected onto the detector at a slight angle to the vertical as shown. The output from any one row will be an undersampled edge trace. However, if successive rows are combined in the correct interlaced order, we obtain a single edge trace that has been very closely sampled. This trace is then differentiated and the Fourier transform taken to yield an accurate measure of the horizontal MTF measured well beyond the practical Nyquist limit.

Image quality and MTF

We saw at the beginning of this chapter that image quality involves psychophysical processes acting on various physical attributes of the image. The MTF summarizes those attributes that contribute to such subjective impressions as *sharpness* and *resolution*. The term 'sharpness' refers to the subjective impression produced by an edge image on the visual perception of an observer. The degree of sharpness depends on the shape and extent of the edge profile, but being subjective the relationships are complex and difficult to assess. Traditionally, an objective measure of photographic sharpness, known as 'acutance', can be calculated from the mean-square density gradient across the edge. This involves very careful microdensitometry and is subject to high error. The result only partly correlates with visual sharpness.

The density profile of a photographic edge depends on the turbidity of the emulsion and on the development process. When adjacency effects are significant, enhanced sharpness often results. This phenomenon is used to advantage in many developer formulations, and is illustrated in Figure 24.27. The density in the

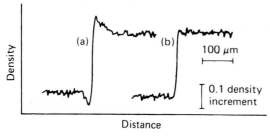

Figure 24.27 Edge traces for a typical medium speed film (a) in the presence of and (b) in the absence of edge effects

immediate neighbourhood of the high-density side of the edge is increased by the diffusion of active developer from the low-density side. Development-inhibiting oxidation products diffusing from the high-density side reduce the density in the immediate neighbourhood of the low-density side of the edge. The luminance overshoots created at the edge boundaries in the final image produce the sensation of increased sharpness.

The same phenomenon forms the basis of image sharpening procedures used in digital image processing (see Chapter 26). For example, the '*crispening*' operator, based on the *Laplacian*, creates the sensation of increased sharpness by producing similar overshoots in the grey-levels of pixels close to edges.

We noted earlier that the line spread function of a system can be obtained from the first derivative of the edge profile (see p. 400). This suggests that there could be a relationship between sharpness and MTF.

In recent years much research has been conducted to establish models of image quality. In all cases MTF curves feature prominently in the derived expressions. The MTFs are for components of the imaging chain, including the human eye and visual system,

and are weighted according to factors such as the type of image and the viewing conditions. As a simple example of this weighting process, consider an imaging system in which the luminance channel is separate from the colour channels. It is well known that the luminance MTF is more important than the colour MTFs as far as the perceived quality of the resulting images is concerned. In other words, provided that the grey-scale image component is sharp, the final image can appear acceptable even if the colour component is blurred.

MTF theory is considered to be one of the most important tools available to the image scientist. The underpinning Fourier theory is also essential for a greater understanding of other imaging aspects such as *information*, *noise* and *image processing*. These and related subjects are covered in the next two chapters.

Bibliography

Bracewell, R.N. (1999) *The Fourier Transform and its Applications*, 3rd edn. McGraw-Hill, New York.

Castleman, K.R. (1996) *Digital Image Processing*. Prentice Hall, Englewood Cliffs, NJ.

Gleason, A. (translator) *et al.* (1995) *Who Is Fourier? A Mathematical Adventure*. Transnational College of LEX/Blackwell Science, Oxford.

Gonzalez, R.C. and Woods, R.E. (1993) *Digital Image Processing*, 3rd edn. Addison-Wesley, Reading, MA.

Goodman, J.W. (1996) *Introduction to Fourier Optics (Electrical and Computer Engineering)*, 2nd edn. McGraw-Hill, New York.

Hecht, E. (1987) *Optics*, 2nd edn. Addison-Wesley, Reading, MA.

Proudfoot, C.N. (1997) *Handbook of Photographic Science and Engineering*, 2nd edn. IS&T, Springfield, VA.

25 Images and information

All imaging systems are communication systems and can be analysed using the procedures developed for other types of communication systems. In the previous chapter we introduced and developed one of the most important of these procedures, the analysis of frequency response. In the context of images, this gives us the means of assessing the progress of information carrying spatial signals through an imaging chain.

In common with other communication systems, this signal transfer proceeds against a background of *noise*. Indeed, the true effectiveness of a system for transmitting information can only be measured in terms of the *signal-to-noise ratio*. Most objective image quality metrics involve some form of signal-to-noise component. In this chapter we study image noise, and the ways in which image noise limits the usefulness of images and imaging systems as carriers of information. Fundamental *measures*, such as DQE and information capacity, can then be defined without reference to the internal technology involved in the imaging system. The definitions use signal-to-noise ratios, which in turn depend on the system MTF and output noise power. These can all be measured from the output image. When applied to specific imaging systems and processes, these fundamental *measures* offer additional scope for modelling, which in turn allows a greater understanding of the limits of the various technologies.

Image noise

Image noise is essentially the unwanted fluctuations of light intensity over the area of the image. It is a quantity that usually varies over the image plane in some random way, although there are examples of image corruption from structured patterns such as sinusoidal interference patterns (sometimes referred to as *coherent* noise). In this chapter we will concentrate on the far more common random noise.

Figure 25.1 shows an image with and without noise. We usually consider the noise to be a random pattern added to (or superimposed upon) the true image *signal*.

Although there is an intrinsic unpredictability, a random process can be defined statistically, for example by its *mean value*, *variance* or *probability distribution*. The spatial properties can be summa-

rized by the *autocorrelation function* and the *power spectrum*.

Causes of noise in an image

(1) Random partitioning of exposing light.
(2) If an image is converted from a light intensity or exposure distribution to an electrical form, there will be photoelectric noise.
(3) Electronic noise will occur in any system with electronic components.
(4) Quantization noise occurs at the digitization stage in digital systems.
(5) Poisson exposure noise means there is a randomness of photons in a nominally uniform exposure distribution.

The first of these is the cause of image noise in photographic systems where images exhibit noise due to the random grain structure of photographic negatives. The second and third examples are the main cause of image noise at the output of a CCD imaging array. Example 4 occurs to a greater or lesser extent in all digital systems where a brightness value is quantized (or *binned*) into one of a finite number of values (typically 256). Poisson exposure noise is present in all images. It arises because the photons of light captured by the imaging system arrive randomly in space and time. The relative magnitude, and hence significance, of quantum noise will depend on the system and its use.

The best known examples of noisy images occur with photographic systems. Anyone who has attempted an enlargement of more than about 10× from a photographic negative will be familiar with the appearance of a grainy structure over the image. Photographic noise is well studied and the procedures for quantifying it are straightforward. We will first present a discussion of photographic noise with reference to the traditional black-and-white negative–positive process.

Photographic noise
Graininess

The individual crystals of a photographic emulsion are too small to be seen by the unaided eye, even the

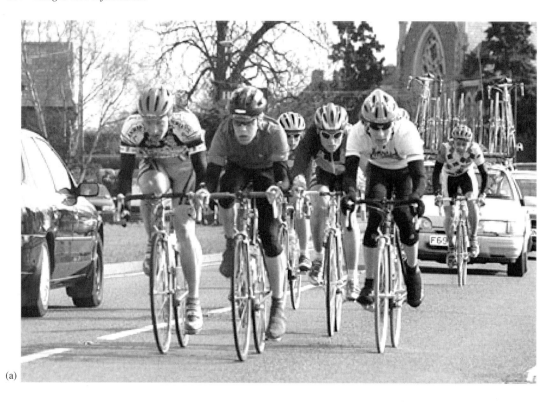

(a)

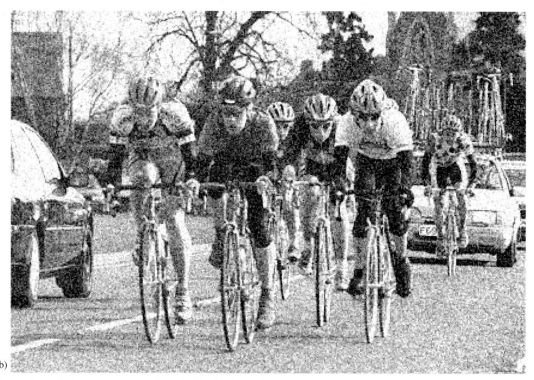

(b)

Figure 25.1 An image (a) and the effect of adding random noise (b)

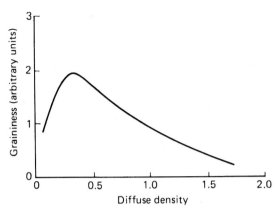

Figure 25.2 Graininess–density curve for a typical medium speed film

largest being only about 2μm in diameter. A magnification of about 50× is needed to reveal their structure. A grainy pattern can, however, usually be detected in photographic negatives at a much lower magnification, sometimes as low as only three or four diameters. There are two main reasons for this:

(1) Because the grains are distributed at random, in depth as well as over an area, they appear to be clumped. This apparent clumping forms a random irregular pattern on a much larger scale than the individual grain size.
(2) Not only may the grains appear to be clumped because of the way in which they are distributed in the emulsion, but they may actually be clumped together (even in physical contact) as a result either of manufacture or of some processing operation.

The sensation of non-uniformity in the image produced in the consciousness of the observer when the image is viewed, is termed *graininess*. It is a subjective quantity and must be measured using an appropriate psycho-physical technique, such as the *blending magnification* procedure. The sample is viewed at various degrees of magnification and the observer selects the magnification at which the grainy structure just becomes (or ceases to be) visible. The reciprocal of this 'blending magnification factor' is a measure of graininess. Graininess varies with the mean density of the sample. For constant sample illumination, the relationship has the form illustrated in Figure 25.2. The maximum value, corresponding to a density level of about 0.3, is said to result from the fact that approximately half of the field is occupied by opaque silver grains and half is clear, as might intuitively be expected. At higher densities, the image area is more and more covered by agglomerations of grains, and, because of the reduced acuity of the eye

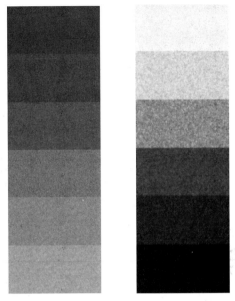

Figure 25.3 Graininess in negative and print. *Left:* enlargement of negative. *Right:* corresponding areas of print

at the lower values of field luminance produced, graininess decreases.

We have so far referred only to the graininess of the negative material. The feature of interest in pictorial photography is likely to be the quality of a positive print made from that negative. If a moderate degree of enlargement is employed the grainy structure of the negative becomes visible in the print (the graininess of the paper emulsion itself is not visible because it is not enlarged). Prints in which the graininess of the negative is plainly visible are in general unacceptable in quality. Although measures of negative graininess have successfully been used as an index to the quality of prints made from the negative materials, the graininess of a print is not simply related to that of the negative, because of the reversal of tones involved. Despite the fact that the measured graininess of a negative sample decreases with increasing density beyond a density of about 0.3, the fluctuations of microdensity across the sample in general increase. This follows from the increase in grain number involved. As these fluctuations are responsible for the resulting print graininess, and as the denser parts of the negative correspond to the lighter parts of the print, we can expect relatively high print graininess in areas of light and middle tone (the graininess of the highlight area is minimal because of the low contrast of the print material in this tonal region). This result supplements the response introduced by variation of the observer's visual acuity with print luminance.

Figure 25.3 shows the graininess relationship between negative and positive samples.

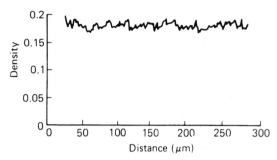

Figure 25.4 Granularity trace for a medium speed film, using a scanning aperture of $50\,\mu$m diameter

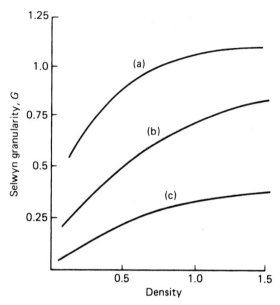

Figure 25.5 Granularity as a function of density level for (a) high, (b) medium and (c) slow speed films

It is clear that print graininess is primarily a function of the fluctuations of microdensity, or *granularity*, of the negative. The graininess of the negative itself is of little relevance. Hence, when a considerable degree of enlargement is required, it is desirable to keep the granularity of the negative to a minimum.

Factors affecting the graininess of prints

(1) The granularity of the negative. As this increases, the graininess of the print increases. This is the most important single factor and is discussed in detail in the next section.
(2) Degree of enlargement of the negative.
(3) The optical system employed for printing and the contrast grade of paper chosen.
(4) The sharpness of the negative. The sharper the image on the film, the greater the detail in the photograph and the less noticeable the graininess. It can be noted here that graininess is usually most apparent in large and uniform areas of middle tone where the eye tends to search for detail.
(5) The conditions of viewing the print.

Granularity

This is defined as the objective measure of the inhomogeneity of the photographic image, and is determined from the spatial variation of density recorded with a *microdensitometer* (a densitometer with a very small aperture). A typical granularity trace is shown in Figure 25.4. In general, the distribution of a large number of readings from such a trace (taken at intervals greater than the aperture diameter) is approximately normal, so the standard deviation σ (sigma) of the density deviations can be used to describe fully the amplitude characteristics of the granularity. The standard deviation varies with the aperture size (area A) used. For materials exposed to light the relationship $\sigma\sqrt{(2A)} = G$ (a constant) holds

well and the parameter G can be used as a measure of granularity. It is discussed in more detail below.

Factors affecting negative granularity

The following are the most important factors affecting the granularity of negatives:

(1) Original emulsion employed. This is the most important single factor. A large average crystal size (i.e. a fast film) is generally associated with high granularity. A small average crystal size (i.e. a slow film) yields low granularity.
(2) The developing solution employed. By using fine-grain developers it is possible to obtain an image in which the variation of density over microscopic areas is somewhat reduced.
(3) The degree of development as granularity is the result of variations in density over small areas, its magnitude is greater in an image of high contrast than in one of low contrast. Nevertheless, although very soft negatives have lower granularity than equivalent negatives of normal contrast, they require harder-papers to print on, and final prints from such negatives usually exhibit graininess similar to that of prints made from negatives of normal contrast.
(4) The exposure level, i.e. the density level. In general, granularity increases with density level. Typical results are shown in Figure 25.5. This result leads to the conclusion that over-exposed negatives yield prints of high graininess.

The first two factors are closely related, for just as use of a fast emulsion is usually accompanied by an increase in granularity, so use of a fine grain developer often leads to some loss of emulsion speed. Consequently, it may be found that use of a fast film with a fine-grain developer offers no advantage in effective speed or granularity over a slower, finer-grained film developed in a normal developer. In fact, in such a case, the film of finer grain will yield a better *modulation transfer function* and higher resolving power, and in consequence is to be preferred.

Quantifying image noise

Methods for quantifying image noise are presented in the next sections in terms of the photographic imaging process, where noise fluctuations are measured in density units (denoted D). The methods can be applied quite generally to other imaging systems where the fluctuations might, for instance, be *luminance* or *digital value*.

Although we are dealing with two-dimensional images it is usual to confine noise analysis to one spatial dimension. This simplifies the methods and is entirely adequate for most forms of noise.

We begin by assuming we have a noise waveform $D(x)$ – the variation of output in one direction across a nominally uniform sample of image.

Variance

This is the mean square noise, or the total noise power, and is useful for summarizing the amplitude variation of the (Gaussian) random function. It is defined:

$$\sigma^2 = \lim_{X \to \infty} \frac{1}{2X} \int_{-X}^{X} \Delta D^2(x)dx \qquad (1)$$

where $\Delta D(x)$ is the deviation of $D(x)$ from the mean.

Estimating σ^2

The expression for variance, σ^2, is replaced by a discrete version for the purpose of calculation:

$$\sigma_A^2 = \frac{1}{N-1} \sum_{i=1}^{N} \Delta D_i^2 \qquad (2)$$

ΔD_i is the i_{th} measured value of the deviation. N values are recorded (where N is 'large', for example 1000) using a measuring aperture of area A. Note that this is just the formula for sample variance found in textbooks on statistics.

Selwyn's law

Studies of photographic granularity show that, provided the scanning aperture area A is 'large' compared with the grain clump size, the product of σ_A^2 with A is a constant for a given sample of noise. This is known as Selwyn's law and means that $A\sigma_A^2$ is independent of the value of A. Hence $A\sigma_A^2$ can be used as a measure of image noise (granularity). Other measures include $\sigma\sqrt{A}$ and $\sigma\sqrt{2A}$. The latter expression is known as Selwyn Granularity. This is often written:

$$G = \sigma\sqrt{2A} \qquad (3)$$

where G is the measure of granularity.

Although σ or σ^2 can be used to describe the amplitude characteristics of photographic noise, a much more informative approach to noise analysis is possible using methods routinely used in communications theory.

As well as amplitude information, these methods supply information about the *spatial structure* of the noise.

The autocorrelation function

Instead of evaluating the mean square density deviation of a noise trace, the mean of the product of density deviations at positions separated by a distance τ (tau) is measured for various values of τ. The result, plotted as a function of τ, is known as the *autocorrelation function* $C(\tau)$. It is defined mathematically as:

$$C(\tau) = \lim_{X \to \infty} \frac{1}{2X} \int_{-X}^{X} \Delta D(x)\Delta D(x + \tau)dx \qquad (4)$$

It includes a measure of the mean square density deviation ($\tau = 0$), but equally important, contains information about the spatial structure of the granularity trace.

The importance of the function is illustrated in Figure 25.6, where a scan across two different (greatly enlarged) photographic images is shown. The granularity traces, produced using a long thin slit, have a characteristic which is clearly related to the average grain clump size in the image. The traces are random, however, so to extract this information the autocorrelation function is used. The two autocorrelation functions shown summarize the structure of the traces, and can therefore be used to describe the underlying random structure of the image.

The noise power spectrum

The autocorrelation function is related mathematically (via the Fourier transform) to another function

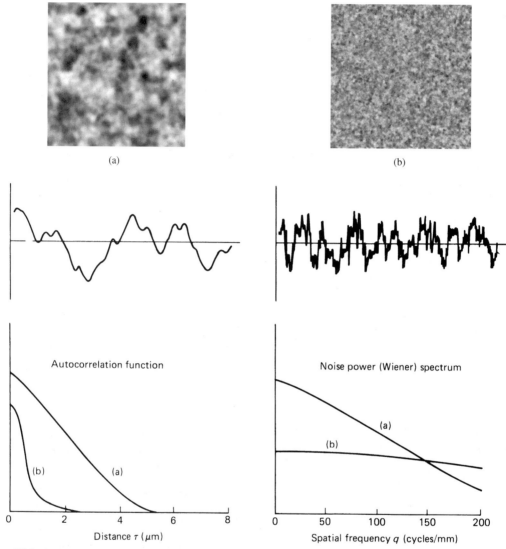

Figure 25.6 Autocorrelation functions and noise-power (Wiener) spectra for two different image structures: (a) coarse-grain; (b) fine-grain

of great importance in noise analysis, the *Wiener* or *power spectrum*. This function can be obtained from a frequency analysis of the original granularity trace, and expresses the noise characteristics in terms of spatial frequency components.

A practical definition of the noise power spectrum is:

$$N(\omega) = \frac{1}{X} \left| \int_0^X \Delta D(x) e^{-2\pi i \omega x} dx \right|^2 \qquad (5)$$

It is essentially the squared modulus of the Fourier transform of the deviations, divided by the range of integration, X.

Formally the noise power spectrum represents the noise power per unit bandwidth plotted against spatial frequency.

The power spectra of the two granularity traces is also shown in Figure 25.6. It will be noticed that the trend in shape is opposite, or reciprocal, to that of the autocorrelation functions. The fine-grain image has a fairly flat spectrum, extending to quite high spatial frequencies. This reflects the fact that the granularity trace contains fluctuations that vary rapidly, as compared with the coarse-grain sample in which the fluctuations are mainly low in frequency.

Relationships between noise measures

For a given noise waveform the three measures are related as follows:

$$\sigma^2 = \int_{-\infty}^{\infty} N(\omega)d\omega \ \text{ and } \ N(\omega) = \int_{-\infty}^{\infty} C(\tau)e^{-2\pi i\omega\tau}d\tau \quad (6)$$

i.e.

- the variance is the area under the noise power spectrum;
- the noise power spectrum is the Fourier transform of the autocorrelation function.

Although the noise power spectrum and the autocorrelation function are closely related (one may be readily calculated from the other), they have very distinct roles in image evaluation. The autocorrelation function relates well to the causes of image noise while the power spectrum is important in assessing its effects.

In all the above, the equivalent two-dimensional versions of the definitions and relationships exist for the more general case of two-dimensional image noise 'fields'.

Practical considerations for the autocorrelation function and the noise power spectrum

In practice, image noise is sampled, either intrinsically as in the case of digital systems, or following some external scanning as in the evaluation of photographic images.

The expressions for the autocorrelation function and the power spectrum defined in the previous sections have discrete equivalents for the purpose of calculation. To use them, the *sampling theorem* must be obeyed for the results not to be distorted by aliasing.

The noise field (i.e. a two-dimensional image containing noise alone) is scanned and sampled using a long thin slit to produce a one-dimensional trace for analysis. In the case of photographic noise this is an optical scanning process and would typically use a slit of width $2-4\,\mu$m. The sampling interval δx must be selected to avoid aliasing, i.e.

$$\frac{1}{2\delta x} \geq \omega_C \quad (7)$$

where ω_C is the maximum significant frequency contained by the noise. In the photographic case ω_C is

likely to be determined by the MTF of the scanning slit (see Chapter 24). This means that the sampling interval δx may need to be as small as $1-2\,\mu$m.

For a digital imaging system, the philosophy is a little different. Whatever the source of noise the digital image itself can only contain frequencies up to the Nyquist frequency (defined by the pixel separation). To evaluate the noise in the x-direction and up to the Nyquist frequency for this *virtual image*, columns of data are averaged to produce a one-dimensional noise trace. To deal with noise in the y-direction, rows of data are averaged.

The total number N of noise samples used must be large (e.g. 10 000) to obtain a reasonable degree of accuracy. In the photographic case a scan distance of $10-20$ mm is required to achieve this. For a digital system, many frames containing noise will need to be evaluated.

Using the autocorrelation function

Calculate the first $(n/2 + 1)$ points of the autocorrelation function (this includes $\tau = 0$) using:

$$C_j' = \frac{1}{N-j} \sum_{i=1}^{N-j} \Delta D_i \Delta D_{i+j} \ \ j = 0,1,2,\ldots \ n/2 \quad (8)$$

where n is selected from the sampling theorem:

$$\frac{1}{n\delta x} = \delta\omega \quad (9)$$

where $\delta\omega$ is the required bandwidth of the measurement (i.e. the interval along the spatial frequency axis at which the noise power spectrum values are required).

Fourier transform the n values of the (symmetrical) autocorrelation function to obtain the noise power spectrum. To ensure the values of the spectrum correctly represent the power in the original two-dimensional image, the function should be re-scaled as follows.

Determine the variance, σ_A^2, when the noise field is scanned with a '*large*' aperture of area A (i.e. *large* compared to the above slit width). In the photographic case this might be an aperture of size $50 \times 50\,\mu\text{m}^2$. In the case of a digital image it will be an equivalent simulation.

Form the quantity $A\sigma_A^2$. This is the required value of the noise power spectrum at the origin, i.e.

$$N(O) = A\sigma_A^2 \quad (10)$$

Direct Fourier transformation of noise samples

The N values of noise are Fourier transformed directly. The squared modulus of the result is the

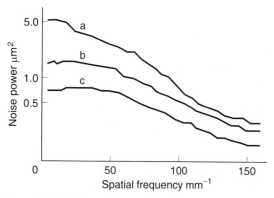

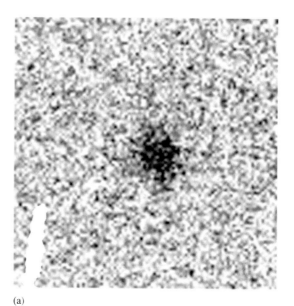

(a)

Figure 25.7 Noise power spectra for developed single layer coatings of silver halide/cyan coupler with increasing concentrations of coupler DIR (a–c). (The curves have been redrawn from: Graves, H.M. and Saunders, A.E., 'The Noise-Power Spectrum of Colour Negative Film with Incorporated Couplers', paper presented at the RPS Symposium on Photographic and Electronic Image Quality, Cambridge, September 1984

noise power spectrum. This will have an extremely narrow bandwidth since

$$\delta\omega = \frac{1}{N\delta x}$$

In other words, the spectrum is determined at very close intervals along the spatial frequency axis. Because noise is non-deterministic (averaging successive samples does not converge to a 'true' noise trace), each computed point in the spectrum is subject to high error which does not reduce as the noise sample is lengthened. To get a reasonable estimate of the spectrum, blocks of adjacent spectrum values are averaged to increase the effective bandwidth and reduce the error per point (this is known as *band averaging*). The resulting noise power spectrum should be scaled as described in the previous paragraph.

Figure 25.7 shows noise power spectra for developed single layer coatings of silver halide/cyan coupler with increasing concentrations of coupler DIR. The noise power spectra were measured with a microdensitometer fitted with a red filter. The sampling interval δx was $3\,\mu$m, giving a Nyquist frequency of $167\,\mu$m$^{-1}$. A slit of width $4\,\mu$m was used to supply optical low pass filtration to avoid aliasing of unwanted high frequencies into the region of interest. The sample size, $N = 40\,960$, gives a measurement bandwidth $\delta\omega = 8.14 \times 10^{-6}\,\mum^{-1}$.

Blocks of approximately 600 points were averaged to give the final curves, which have an effective bandwidth of $5 \times 10^{-3}\,\mu$m^{-1}.

Note that some aliasing is likely to have occurred.

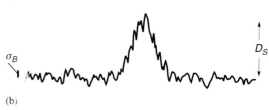

(b)

Figure 25.8 (a) Image of a star (circular disk) and (b) trace across image, recorded with a scanning aperture the same size as the star

Note: If the noise values are uncorrelated, the noise power spectrum will be constant ('white'). There is no point in evaluating the spectrum. All that is required is the value of $A\sigma_A{}^2$.

Signal-to-noise ratio

In communication theory the signal-to-noise ratio (S/N) is the ratio of the information carrying signal to the noise that tends to obscure that signal. In the case of images, the signal is some measure of the amplitude, or contrast, of the wanted image structure. The noise is the equivalent measure of the unwanted, usually random, superimposed fluctuations.

The particular measures of signal and noise employed will depend on the type of image and the application. A simple example is obtained from the field of astronomical image recording. Figure 25.8(a) shows a star image in the form of a disk of area $A\,\mu$m^2 superimposed on a noisy background. If we imagine scanning across the image with an aperture of the same size as the star image, we would produce a trace

(a)

(b)

Figure 25.9 Typical resolving-power test charts. (a) Sayce chart. (b) Cobb chart

of the form shown in Figure 25.8(b). The maximum deflection, recorded when the aperture just sits on top of the star image, is shown as the signal strength, D_S. The standard deviation of the background fluctuations, σ_B, gives the corresponding measure of noise. The signal-to-noise ratio is defined as:

$$\frac{S}{N} = \frac{D_S}{\sigma_B} \tag{11}$$

For more general images, particularly in digital form, a signal-to-noise ratio can be calculated by evaluating the total variance of the image, σ_T^2 and the variance σ_N^2 of a nominally uniform portion of the image (the noise). The variance of the signal is then the difference $\sigma_T^2 - \sigma_N^2$ (assuming the noise is uncorrelated with the signal). The signal-to-noise ratio is just:

$$\frac{S}{N} = \frac{\sqrt{(\sigma_T^2 - \sigma_N^2)}}{\sigma_N} = \sqrt{\frac{\sigma_T^2}{\sigma_N^2} - 1} \tag{12}$$

A more rigorous treatment of signal-to-noise is afforded by utilizing the ideas of Fourier theory. The signal is considered to be a set of spatial frequencies determined by the MTF of the image-forming system. The noise is represented by the image noise power spectrum. The signal-to-noise ratio is then dependent on the MTF of the system 'viewing' the image. Where the viewing system is the human observer the noise power spectrum is often presented in the form of a modulation threshold curve. This displays the minimum modulation necessary for a sinusoidal signal to be visible above the noise, as a function of spatial frequency. Expressions for perceived image quality can then be constructed.

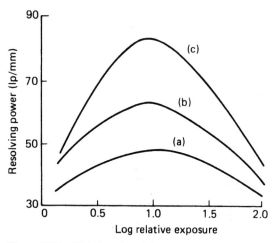

Figure 25.10 Variation of resolving power with exposure using test charts of increasing contrast (a) to (c)

Resolving power

A good example of a signal-to-noise based decision is illustrated by the traditional measure of photographic resolving power. Generally speaking, resolving power measures the detail-recording ability of photographic materials. It is determined by photographing a test object containing a sequence of geometrically identical bar arrays of varying size, and the smallest size in the negative the orientation of which is recognizable by the eye under suitable magnification is estimated. The spatial frequency of this bar array, in line pairs per millimetre, is called the resolving power. Figure 25.9 shows two typical test objects.

The test object is imaged on to the film under test either by contact printing or, more usually, by use of optical imaging apparatus containing a lens of very high quality. A microscope is used to examine the developed negative. The estimate of resolving power obtained is influenced by each stage of the complete lens/photographic/microscopic/visual system, and involves the problem of detecting particular types of signal in image noise. However, provided the overall system is appropriately designed, the imaging properties of the photographic stage are by far the worst, and one is justified in characterizing this stage by the measure of resolving power obtained.

Because of the signal-to-noise nature of resolving power, its value for a particular film is a function of the turbidity of the sensitive layer, the contrast (luminance ratio) and design of the test object and the gamma and graininess of the final negative. It is influenced by the type of developer, degree of development and colour of exposing light, and depends greatly on the exposure level. Figure 25.10 shows the influence of test object contrast and

exposure level on the resolving power of a typical medium-speed negative material.

The chief merit of resolving power as a criterion of image quality lies in its conceptual simplicity, while taking account of several more fundamental properties of the system, including the MTF of the emulsion and optics, the noise power spectrum of the developed image, and the qualities and limitations of the human visual system. Very simple apparatus is required and the necessary readings are straightforward to obtain. Although it is not a measure of image quality, resolving power has been widely used as an indicator of the capabilities of photographic materials in reproducing fine image structure.

Detective quantum efficiency (DQE)

General considerations

Imaging systems work by detectors responding to light energy. The information contained in an exposure can in principle be measured in terms of the number and distribution of energy quanta in the exposure.

The efficiency of an imaging process in recording the individual quanta in an effective manner is therefore a valuable measure, particularly in applications such as astronomy where exposure photons may be in short supply. Such a measure is *detective quantum efficiency (DQE)*. Strictly it is a function of spatial frequency, involving the MTF and normalised noise power, together with a quantity $\varepsilon(0)$ which represents the effective fraction of quanta counted. These three parameters are responsible for degrading the image and thus lowering the information recording efficiency.

If we assume our exposures are low frequency, the MTF and normalised noise power are both unity, and DQE becomes identical to the quantity $\varepsilon(0)$. This is defined in terms of signal-to-noise ratios as follows:

$$DQE = \varepsilon(0) = \frac{\left(\dfrac{S}{N}\right)_{out}^{2}}{\left(\dfrac{S}{N}\right)_{in}^{2}} \qquad (13)$$

where $(S/N)_{out}^{2}$ is the squared signal-to-noise ratio of the image and $(S/N)_{in}^{2}$ is the squared signal-to-noise ratio of the exposure. $(S/N)_{out}^{2}$ takes into account all the system inefficiencies associated with the effective recording of quanta (random partitioning of exposure, quantum efficiency of detector, random processes in amplification etc.). It must be expressed in equivalent input exposure units. $(S/N)_{in}^{2}$ depends on the number of quanta in the exposure.

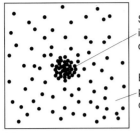

Star disk, area A μm^2 and intensity above background of I_S photons μm^{-2} s^{-1}

Background intensity I_B photons μm^{-2} s^{-1} on average

(a)

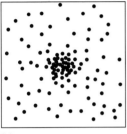

(b)

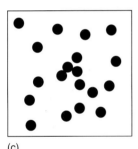

(c)

Figure 25.11 (a) Representation of a photon exposure pattern following an exposure time of T seconds. (b) Image where all photons are recorded but an MTF operates. (c) Typical image from real system where an MTF operates and only a fraction of the exposure photons are recorded

An ideal imaging system would have DQE = 1 (100%). Real imaging systems have DQE < 1: e.g.:

TV camera (orthicon)	DQE ~ 0.1
CCD camera (cooled)	DQE ~ 0.5
Photographic emulsion	DQE ~ 0.01

The concept of DQE can be illustrated with the help of Figure 25.11. In (a) a representation of an input photon pattern is shown.. It comprises a disk of area A μm^2 and intensity above background of I_S photons μm^{-2} s^{-1}. The background intensity is I_B photons μm^{-2} s^{-1} on average. Suppose an exposure lasts for T seconds. The total number of photons contained in the disk (the signal strength) will be AI_ST. The mean number of photons present in an

equivalent area A of the background is AI_BT. Because the distribution of photons follows Poisson statistics, the background is accompanied by a noise level of $\sqrt{(AI_BT)}$. The signal-to-noise ratio for this exposure is given by

$$\left(\frac{S}{N}\right)^2_{IN} = \frac{AI_S^2T}{I_B}. \tag{14}$$

In other words the signal-to-noise ratio increases as the square root of the exposure time. Since the background exposure level is just $q = I_BT$ photons μm^{-2}, we can substitute for T in equation (14) to obtain:

$$\left(\frac{S}{N}\right)^2_{IN} = \frac{AI_S^2q}{I_B^2} = kq \tag{15}$$

where k is a constant for the particular photon pattern, i.e. the squared input signal-to-noise ratio is proportional to the exposure level.

An 'ideal' imaging system would record the positions of each photon contained in this input pattern, and display an image identical in all respects. In other words, the image, or output signal-to-noise, $(S/N)_{OUT}$ would equal $(S/N)_{IN}$.

Figure 25.11(b) shows an image of (a) in which all quanta have been uniquely recorded, but the image elements corresponding to their detected positions have been moved, at random, a small distance to simulate light diffusion. This corresponds to an MTF, which is not unity over the range of spatial frequencies contained. The disk is still visible although its edges are less well defined. In this example the signal-to-noise ratio is only slightly less than that for the exposure.

Figure 25.11(c) illustrates an image typical of a real process where only a fraction of the quanta is effectively recorded after light diffusion. The system amplifies the image elements to render the image visible. The image is now very noisy and the star is barely detectable. The signal-to-noise ratio for this image is very much less than that for the exposure. In terms of signal-to-noise, this image could be matched by an image from an 'ideal' system operating at a much lower background exposure level (q' say). In other words, although the actual exposure level is q, the result is only 'worth' the lower exposure level q'.

If the signal-to-noise ratio for this image is denoted

$$\left(\frac{S}{N}\right)_{OUT, REAL}$$

we can write:

$$\left(\frac{S}{N}\right)^2_{OUT, REAL} = kq' \qquad (16)$$

Using equation (15), we can write the DQE for the real system as:

$$DQE = \frac{\left(\frac{S}{N}\right)^2_{OUT, REAL}}{\left(\frac{S}{N}\right)^2_{IN}} = \frac{q'}{q} \qquad (17)$$

Equation (17) says that the DQE of a real image recording process at an exposure level q is given by the ratio q'/q, where q' is the (lower) exposure level at which the hypothetical 'ideal' process would need to operate in order to produce an output of the same quality as that produced by the real process.

DQE for the photographic process

By expressing the signal-to-noise ratio of the photographic image in terms of sensitometric parameters, we can derive the following working expression for the DQE of a photographic emulsion:

$$DQE = \frac{\gamma^2 (\log_{10} e)^2}{qA\sigma^2} \qquad (18)$$

Here γ represents the slope of the photographic characteristic curve at the exposure level q quanta μm^{-2}, $\log_{10}e$ is a constant and $A\sigma^2$ is the image granularity at the exposure level q.

Equation (18) is equivalent to writing:

$$DQE = speed \times contrast^2/granularity \qquad (19)$$

Such a relationship, happily, agrees with conclusions arrived at from a more intuitive common-sense approach to the problem of improving the quality of photographic images.

Figure 25.12 shows a DQE vs. log exposure curve for a typical photographic material. It can be seen that the function peaks around the toe of the characteristic curve and has a maximum value of only about 1 per cent at best. Either side of the optimum exposure level, the DQE drops quite rapidly. This very low DQE is a characteristic of all photographic materials. They are not particularly efficient in utilizing exposure quanta. Fortunately this is not significant in normal photography where exposure levels are high enough to ensure an adequately high output signal-to-noise ratio. In situations involving low light levels however, such as may be encountered in astronomical

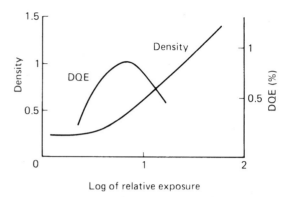

Figure 25.12 Detective quantum efficiency (DQE) as a function of exposure for a typical photographic material. The function peaks at an exposure level near the toe of the characteristic curve

photography, this low DQE is a severe limitation, and has led to the development of far more efficient image-recording systems to replace or supplement the photographic material.

DQE for a CCD imaging array

CCD imaging arrays are now the detector of choice in many imaging applications. So-called *mega-pixel* cameras are available that offer MTF characteristics comparable to photographic emulsions of camera speed. They also exhibit significantly higher DQE than the photographic emulsion. In this section we introduce the processes that determine the DQE for such a device.

We begin by defining some necessary terms with reference to Figure 25.13, which shows the characteristic curve of a CCD array prior to analogue-to-digital conversion.

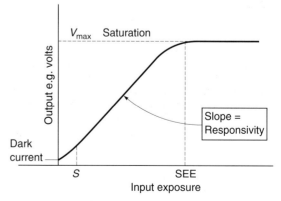

Figure 25.13 Characteristic curve of a CCD array prior to analogue-to-digital conversion

Responsivity, R

This is the slope of the straight line section of the output–input characteristic curve. Possible units are volts/joules cm^{-2}, volts/quanta μm^{-2}. etc.

R depends on a number of factors (wavelength, temperature) but can be broadly expressed as $R = g\eta$ where g is the output gain (volts per electron) and η is the quantum efficiency.

Dark current

This is output that occurs without an input. It is caused by thermal generation and diffusion of charge and can be reduced by cooling the device. Dark current exhibits fluctuations (shot noise) so while the dark current average value can be subtracted from the output to provide the signal due to photoelectrons, the noise cannot.

Saturation equivalent exposure (SEE)

This is the input exposure that saturates the charge well. If the dark current is considered negligible then we have (approximately):

$$SEE = V_{max}/R \qquad (20)$$

Noise equivalent exposure (NEE)

This is the exposure level that produces a signal-to-noise ratio of one. If the measured output noise is σ_{tot} (rms) and if the dark current is considered negligible, then:

$$NEE = \sigma_{tot}/R \qquad (21)$$

Sometimes the NEE is used as a measure of the *sensitivity, S,* of the detector.

Noise

There are many sources of noise in a CCD based system. Assuming all these noise sources to be uncorrelated, the total system noise σ_{sys}, can be obtained by adding together the individual noise powers. This requires that all noise sources be specified in equivalent output units (e.g. electrons, or volts). A useful summary of noise sources is included in the following *total* noise equation:

$$\sigma_{sys}^2 = \sigma_{dark}^2 + \sigma_{pattern}^2 + \sigma_{readout}^2 + \sigma_{ADC}^2 \qquad (22)$$

where

σ_{dark}^2 = Dark current shot noise
$\sigma_{pattern}^2$ = Noise caused by physical non-uniformity and can have the same pattern from frame to frame.

$\sigma_{readout}^2$ = Reset noise (from charge reading) and amplifier noise. This is sometimes referred to as the noise floor.
σ_{ADC}^2 = Quantization noise generated by the analogue-to-digital conversion.

In addition, the noise at the output, σ_{tot}^2 will include a contribution from the input photon noise σ_q^2 so that:

$$\sigma_{tot}^2 = \sigma_{sys}^2 + \sigma_q^2 \text{ (expressed in output units)} \qquad (23)$$

Detective quantum efficiency (DQE)

Consider an exposure level q photons per unit area. The noise associated with this is $q^{1/2}$ photons per unit area (because photon arrival in space and time is governed by Poisson statistics).

Therefore, the signal-to-noise ratio of the exposure, $(S/N)_{in}$, is just:

$$(S/N)_{in} = q/(q^{1/2}) = q^{1/2} \qquad (24)$$

So

$$(S/N)_{in}^2 = q \qquad (25)$$

This exposure will yield ηq photoelectrons per unit area and $g\eta q$ volts. The noise at the output due to these photoelectrons will be $\sigma_q = (\eta q)^{1/2}$ e⁻rms or $g(\eta q)^{1/2}$ volts rms. The variance is then $\sigma_q^2 = g^2\eta q$ (using volts as the output unit).

The total output noise is therefore:

$$\sigma_{tot}^2 = \sigma_{sys}^2 + \sigma_q^2 = \sigma_{sys}^2 + g^2\eta q \qquad (26)$$

We must now express this output noise in terms of the input exposure units (i.e. we transfer the noise level back through the response curve):

Output noise, $\sigma_{eff} = \sigma_{tot}/R$ so that
$\sigma_{eff}^2 = (\sigma_{sys}^2 + g^2\eta q)/(\eta g)^2$. Hence:

$$(S/N)_{out}^2 = q^2/\sigma_{eff}^2 = q^2\eta^2 g^2/(\sigma_{sys}^2 + g^2\eta q) \qquad (27)$$

and

$$\varepsilon(0) = (S/N)_{out}^2/(S/N)_{in}^2 = q\eta^2 g^2/(\sigma_{sys}^2 + g^2\eta q) \qquad (28)$$

NB: If there is no system noise, then the low frequency DQE $\varepsilon(0) = \eta$.

Example: A photodetector has a quantum efficiency $\eta = 25\%$ and system noise σ_{sys} equivalent to 20 electrons rms per unit area. What is the low frequency DQE $\varepsilon(0)$ at an exposure level of (a) 1000 photons per unit area and (b) 10^5 photons per unit area?

Solution: Since output noise is given in terms of electrons per unit area, we can set $g = 1$ in equation (28):

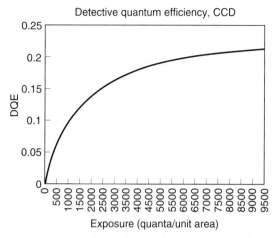

Figure 25.14 The DQE of a CCD imaging array. For high exposures (limited by the SEE) the DQE approaches the quantum efficiency, which in this example is 25%

(a) $\varepsilon(0) = (0.25)^2\ 1000/(0.25\ 1000 + 20^2)$
 $= 62.5/650 = 9.6\%$

(b) $\varepsilon(0) = (0.25)^2\ 10^5/(0.25\ 10^5 + 20^2)$
 $= 6250/25400 = 24.6\%$

The DQE function of equation (28), with the parameters of this example, is plotted in Figure 25.14. The curve is significantly higher than the peak DQE for typical photographic materials. For high exposure levels (up to the SEE) the DQE approaches the quantum efficiency of the device.

Information theory

Information theory supplies a mathematical framework within which the generation or transmission of information can be quantified in an intuitive manner. In other words, information can be measured precisely and unambiguously in a way easily understood and applied in practice.

The process of gaining information is equivalent to the removal of uncertainty. We speak of a *source of information* containing a number of possible *outcomes*. The uncertainty in the source depends on the probabilities of the individual outcomes. When a particular outcome is generated, that uncertainty has been removed. We have gained information. The uncertainty in a source is measured using the concept of *source entropy*. If a source has n possible outcomes, and the i^{th} outcome occurs with probability p_i, then the source entropy is defined:

$$H = \sum_{all\ i} p_i \log_2 \left(\frac{1}{p_i}\right) \text{ bits} \qquad (29)$$

If the outcomes are all equally likely, this reduces to:

$$H = \log_2 (n) \text{ bits} \qquad (30)$$

In a sequence of independent trials, where each trial generates an outcome, we gain H bits of information per outcome on average.

Information capacity of images

Suppose we have an image containing m independent pixels per unit area where each pixel can take on one of n different values (assumed equally likely). Each pixel can be considered as a source of information. According to equation (30) the entropy per pixel is given as $H = \log_2 (n)$ bits. Regarding the image as an information channel, this means that each pixel is capable of carrying $\log_2 (n)$ bits. We say that the information capacity is $\log_2 (n)$ bits per pixel, or, more generally:

Capacity, $C = m \log_2 (n)$ bits per unit area (31)

As an example, consider a CCD image array comprising 1800 pixels horizontally by 1200 pixels vertically. If each pixel can independently take on one of 256 different levels, the information capacity of one frame is given as:

$$C = 1800 \times 1200 \times \log_2 (256)$$
$$= 17\,280\,000 \text{ bits (over 2 megabytes)}$$

The information capacity of a photographic emulsion is less easy to evaluate, since there is no readily identified pixel. The area of the point spread function at the 10 per cent level has been used as an equivalent area. The number of recording levels, n, depends on the level of granularity. Such calculations yield values for the information capacity of camera speed materials of the order 10^5 bits cm^{-2}. A 35 mm frame will therefore have a capacity of approximately 8.5×10^6 bits. It would appear that the digital system has overtaken the photographic process with respect to this measure of performance.

Note that the information content for a typical image will be much less than the information capacity, since for most meaningful images many neighbouring pixel values will be the same. We say there is *redundancy*. An image in which the information content equals the information capacity will look like random noise.

Bibliography

Bolton, W. (1995) *Fourier Series*. Longman, London.
Bracewell, R.N. (1999) *The Fourier Transform and Its Applications*, 3rd edn. McGraw-Hill, New York.

Castleman, K.R. (1996) *Digital Image Processing.* Prentice Hall, Englewood Cliffs, NJ.

Dainty, J.C. and Shaw, R.(1974) *Image Science.* Academic Press, New York.

Gleason, A. (translator) *et al.* (1995) *Who Is Fourier? A Mathematical Adventure.* Transnational College of LEX/Blackwell Science, Oxford.

Gonzalez, R.C. and Woods, R.E. (1993) *Digital Image Processing*, 3rd edn. Addison-Wesley, Reading, MA.

Goodman, J.W. (1996) *Introduction to Fourier Optics (Electrical and Computer Engineering)*, 2nd edn. McGraw-Hill, New York.

Hecht, E. (1987) *Optics*, 2nd edn. Addison-Wesley, Reading, MA.

Holst, G.C. (1996) *CCD Arrays, Cameras and Displays.* JCD Publishing, Winter Park, FL and SPIE Optical Engineering Press, Bellingham WA.

James, J. (1995) *A Student's Guide to Fourier Transforms with Applications in Physics and Engineering.* Cambridge University Press, Cambridge.

Proudfoot, C. N. (1997) *Handbook of Photographic Science and Engineering*, 2nd edn. IS&T, Springfield, VA.

Smith, F.G. and Thomson, J.H. (1988) *Optics*, 2nd edn. Chichester, John Wiley & Sons.

Thomas, W. (ed.) (1973) *SPSE Handbook of Photographic Science and Engineering.* IS&T, New York, Wiley.

26 Digital image processing and manipulation

A digital image is a rectangular array of numbers representing the luminance and colour at discrete positions in a scene. The image can be thought of as a matrix of pixels, each pixel carrying three numeric values. The pixel position identifies a spatial co-ordinate and the pixel values represent luminance and colour at that position. The three values of a pixel depend on the colour model employed. For example, they may represent the primary spectral components of red, green and blue (RGB), or they may represent the luminance and two normalized colour values.

It should be noted that this structure does not necessarily relate easily to the source of the digital image. A CCD camera for example produces raw data in the form of an array of alternating R, G and B pixels because of the physical structure of the detector. Full colour pixels are obtained by inter-polation using on-board software.

The power of digital image processing and manip-ulation lies in the simple fact that with modern computers it is very easy to manipulate numbers. Pixel values can be re-scaled, combined arithmet-ically and logically with adjacent values, and new pixel values can be generated (interpolated) between existing pixels. A vast range of image manipulations is thus possible and there are many image processing packages available for this purpose. The range of applications of digital image processing is equally vast, covering scientific data extraction (e.g. astron-omy), medical imaging, advertising and illustration, and pure art.

The purpose of this chapter is to introduce some of the important objective methods of digital image processing. These methods are, to all intents and purposes, context independent and lie somewhere between the activities of image capture and image use. Manipulation processes driven solely by aes-thetic goals are not covered.

Since colour images can be regarded as an overlay of three appropriate monochrome images, most of the processing operations can be understood by concen-trating on one monochrome image. We will therefore consider a digital image as a matrix of pixels in which each pixel contains just one value. This value is referred to as the pixel grey-level.

One of the major tools in image processing is known as *digital filtering*. There are two basic classes of spatial filter: *linear* and *non-linear*. Linear spatial

filters have an equivalent Fourier (or frequency domain) implementation. We will look at each in turn.

Linear spatial filtering (convolution)

A small spatial filter array (usually square of size 3 × 3 or 5 × 5) of appropriate values is convoluted with the image. The values in the filter array are chosen in accordance with the effect that is required on the image. The convolution process was described in Chapter 24 when dealing with image formation. Here it is implemented in a discrete digital fashion. The formula for digital convolution is:

$$g(i, j) = \sum_{m=-(M-1)/2}^{(M-1)/2} \sum_{n=-(M-1)/2}^{(M-1)/2} h(m, n)f(i - m, j - n) \tag{1}$$

i.e.

$$g = h \otimes f \tag{2}$$

In these two equations, f represents the original image and h is the filter array of size $M \times M$ where M is an odd number (typically 3 or 5). The output of the convolution, g, is the required processed image.

Digital convolution, described by equation (1), can be understood by referring to Figure 26.1. Here, the large array of numbers is a small portion of a digital image, f. The small 3 × 3 array is the filter array h. The convolution process involves the positioning of h above f, in the position (i, j) as shown by the shaded area. The corresponding pairs of values are multiplied together and the resulting nine products are added together. This final value is the pixel value of the processed image at position (i, j). This process is repeated for all values of (i, j) starting in the top left of the image and finishing in the bottom right.

A little thought will suggest a problem at the edges of the image with this operation. If all nine filter values are to be used, the filter array must stay within the boundary of the image array. This means that the processed image will be smaller (by two rows and columns) than the original image. To retain the same image size, the filter array must be allowed to overlap the edges of the original image, extrapolating pixel values as appropriate.

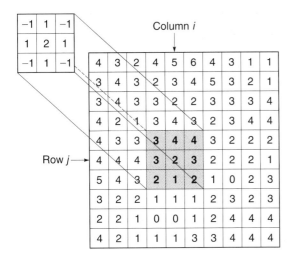

The pixel value of the processed image
at position (i, j) is the value
$(-1) \times (3) + (1) \times (4) + (-1) \times (4) + (1) \times (3) + (2) \times (2)$
$+ (1) \times (3) + (-1) \times (2) + (1) \times (1) + (-1) \times (2)$
$= 4$

Figure 26.1 Digital convolution

A more rigorous approach is to assume the original image is periodic as illustrate in Figure 26.2. When the filter array is overlapping the edge of the original image, values from the opposite edge are included in the multiplication. This approach will clearly result in meaningless edge values in the processed image

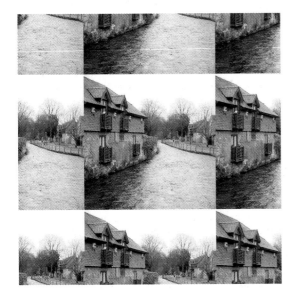

Figure 26.2 For many filtering operations, a digital image is assumed to be periodic

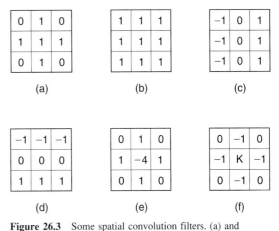

Figure 26.3 Some spatial convolution filters. (a) and (b) Averaging filters. (c) *x*- differentiation. (d) *y*-differentiation. (e) Laplacian edge detector. (f) Crispening operator based on the Laplacian. *K* is a positive number greater than 4 whose value determines the strength of the effect

unless there is indeed such a relationship, or there is a degree of uniformity of the image at its boundary and beyond. The advantage of this approach is that the convolution produces results identical to the equivalent frequency domain method implemented by the ubiquitous Fourier transform.

Some sample convolution filters are shown in Figure 26.3, and examples of their implementation are included in Figure 26.4.

Linear filters have two important properties:

(1) Two or more different filters can be applied sequentially in any order to an image. The total effect is the same.
(2) Two or more filters can be combined by convolution to yield a single filter. Applying this filter to an image will give the same result as the separate filters applied sequentially.

Frequency domain filtering

The convolution theorem implies that linear spatial filtering can be implemented by multiplication in the spatial frequency domain. In other words, the convolution of equation (2) can be implemented by the relationship:

$$G = H \times F \qquad (3)$$

F is the Fourier transform of the original image f, H is the Fourier transform of the filter h and G is the Fourier transform of the processed image g. Most Fourier transform routines will require that the image is square, with the number of pixels on a side being a power of 2 (256, 512, 1024 etc.). This is a requirement of the fast Fourier transform (FFT)

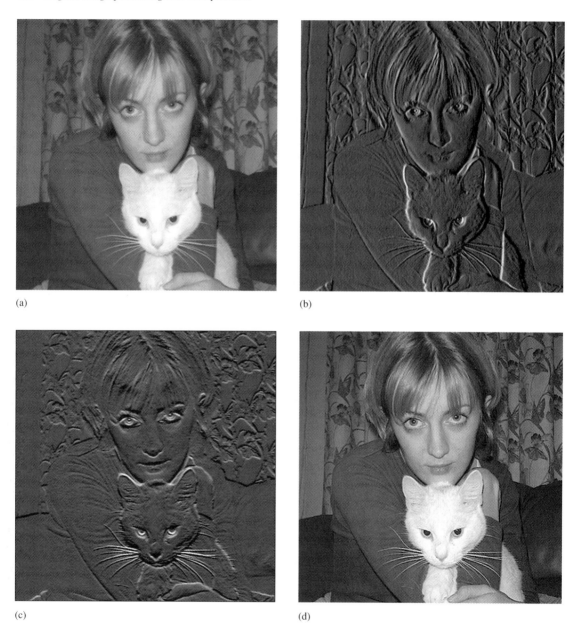

Figure 26.4 Examples of the use of some of the convolution filters in Figure 26.3

(a) Original image
(b) *x*-differentiation
(c) *y*-differentiation
(d) The Laplacian crispening operator with $K = 5$

algorithm used. An image is processed by taking its Fourier transform, multiplying that transform by a frequency space filter, and then taking the inverse Fourier transform. The rationale for such a procedure is often developed from a consideration of the frequency content of the image and the required modification to that frequency content, rather than an alternative route to a real space convolution operation. Figure 26.5 illustrates such a procedure. The image in (a) fades into the distance at the top of the

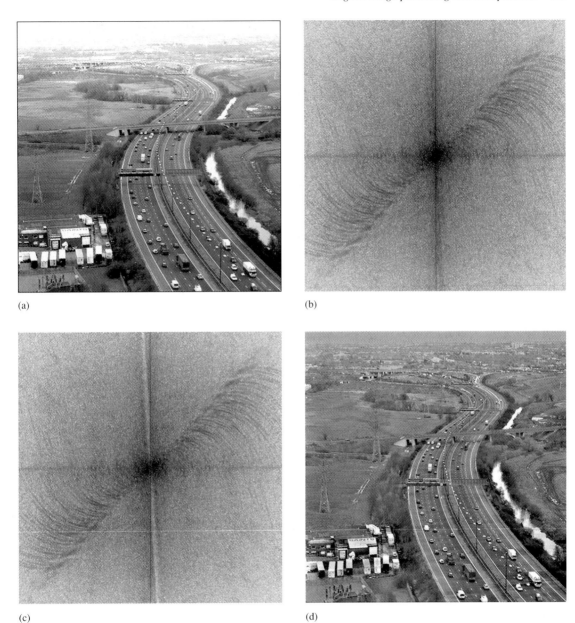

Figure 26.5
(a) Original image
(b) The Fourier transform of (a)
(c) The Fourier transform from (b) with frequencies in selected direction attenuated as indicated by the pale line
(d) The processed image. Note the removal of the very low frequency component responsible for the fade at the top of the original image. The motorway bridge is also reduced in prominence

frame. This indicates a very strong low frequency component varying in the vertical, *y*-direction. There is also a prominent motorway bridge. This feature contains a wide range of spatial frequencies in a direction perpendicular to the alignment of the bridge.

The modulus of the Fourier transform of the image is displayed as a grey-scale distribution in (b). The spatial frequencies contained by the bridge and by the fade feature are distributed along an almost vertical line through the centre (the origin). If these are

(a)

(b)

(c) (d)

Figure 26.6
(a) Original image
(b) The Fourier transform of (a)
(c) The Fourier transform in (b) multiplied by a low pass filter of the form of equation (4)
(d) The inverse Fourier transform of (c), showing severe 'ringing' due to the abrupt filter cut-off

removed (c) and the inverse Fourier transform taken, we arrive at the processed image in (d). The bridge is still visible, but it is far less obvious. The fading has been completely removed. Other features aligned in the same direction as the bridge will also be reduced in contrast, but they are less significant. The same effect could be achieved by operating directly on the appropriate pixels in the original image, but this would require considerable care to produce a 'seamless' result.

Low-pass filtering

A filter that removes all frequencies above a selected limit is known as a low-pass filter. It can be defined:

$$H(u, v) = 1 \quad \text{for} \quad u^2 + v^2 \le \omega_0^2$$
$$= 0 \quad \text{else} \qquad (4)$$

u and v are spatial frequencies measured in two orthogonal directions (usually the horizontal and vertical). ω_0 is the selected limit. Figure 26.6 shows the effect of such a 'top-hat' filter. As well as 'blurring' the image and smoothing the noise, this simple filter tends to produce 'ringing' artefacts at boundaries. This can be understood by considering the equivalent operation in real space. The Fourier transform (or inverse Fourier transform) of the top-hat function is a *Bessel* function (a kind of two-dimensional *sinc* function). When this is convoluted with an edge, the edge profile is made less abrupt (blurred) and the oscillating wings of the *Bessel* function create the ripples in the image alongside the edge. To avoid these unwanted ripple artefacts, the filter is usually modified by replacing the abrupt transition at ω_0 with a gradual transition from 1 to 0 over a small range of frequencies centred at ω_0. Gaussian, Butterworth and trapezoidal are example filters of this type.

High-pass filtering

If a low-pass filter is reversed, we obtain a high-pass filter:

$$H(u, v) = 0 \quad \text{for} \quad u^2 + v^2 \le \omega_0^2$$

$$= 1 \quad \text{else} \qquad (5)$$

This filter removes all low spatial frequencies below ω_0 and passes all spatial frequencies above ω_0. With this filter, ringing is so severe, it is of little practical use. Instead a gradual transition version (Gaussian or Butterworth) is used. Figure 26.7 shows the result of a Gaussian type high-pass filter.

Non-linear filtering

This process differs from linear convolution illustrated in Figure 26.1 by the inclusion of a decision making step (an *operator*) in place of the addition of the nine products, to form the output pixel value. Figure 26.8 illustrates this difference. Unlike linear filters, two or more non-linear filters cannot be combined into a single filter, and the result of two or

Figure 26.7 The result of applying a high-pass Gaussian filter to the image of Figure 26.6(a)

more filters will depend on the order in which they are applied. Because the decision making step can be arbitrarily complex, a vast range of effects is possible. Some simple examples are illustrated in the following sections.

Shrink filter

The filter elements are set to unity and the operator is '*use minimum value*'. The minimum pixel value in a local neighbourhood is therefore selected as the output pixel at that position. This is sometimes called a *minimum* filter. The effect is to cause dark areas to expand by the size of the filter and to remove all detail.

Expand filter

This is the same as the shrink filter except the operator is '*use maximum value*'. It causes light areas to expand. It may be referred to as a *maximum* filter.

Shrink and expand filters are commonly used sequentially on images. Shrink, followed by expand, will cause bright regions smaller than the filter size to be completely removed. Larger regions are virtually unaltered. Figure 26.9 illustrates the effect of shrink and expand filters, used individually and in sequence.

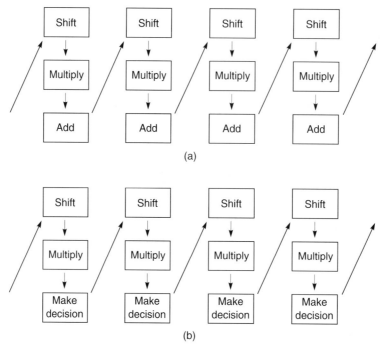

Figure 26.8 (a) The linear spatial convolution process. (b) The non-linear spatial process

Threshold average filter

The filter values are set to produce the local average about but not including the central pixel, i.e

$$h = \begin{pmatrix} 1/8 & 1/8 & 1/8 \\ 1/8 & 0 & 1/8 \\ 1/8 & 1/8 & 1/8 \end{pmatrix}$$

This average is then compared with the central pixel value, and if it differs by more than a pre-set threshold, the central pixel is replaced by the local average. This is a useful process for dealing with corrupted pixels of a random nature (so-called 'data drop-outs').

Median filter

For this important filter, the operator is 'select the median'. Normally the filter values are set to unity, in which case the output pixel is just the median (middle value) of the neighbourhood. defined by the filter size. The effect of the median filter is to preserve the edges of larger objects while removing all small features. In other words it smoothes the image whilst retaining the significant edges as sharply defined luminance discontinuities. It is useful as a noise reduction filter for certain types of image noise.

Statistical operations (point, grey-level operations)

Given an 8-bit deep image $f(i, j)$, it is useful to consider the pixel values f as a random variable taking values between 0 and 255. For randomly selected pixels we can define the *probability distribution function, P(f)* as:

$P(f)$ = probability that pixel value is less than or equal to f.

It follows that

$$0 \le P(f) \le 1 \quad \text{and} \quad P(255) = 1.$$

The first derivative of the probability distribution function is known as the *probability density function* (PDF). If we denote this as $p(f)$ we have:

$$p(f) = \frac{dP(f)}{df} \tag{6}$$

For a digital image the value of the PDF for $f = f_k$ can be estimated from the number of image pixels taking the value f_k, i.e.

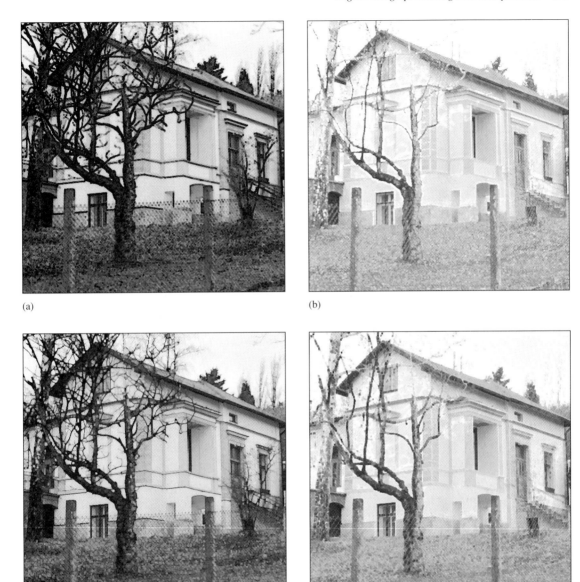

Figure 26.9 Various non-linear filters applied to the image of Figure 26.6(a)

(a) Shrink filter
(b) Expand filter
(c) Shrink followed by expand
(d) Expand followed by shrink

$$p(f_k) \approx \frac{N_k}{N}$$

where N_k = the number of pixels of value f_k, and N = the total number of pixels in the image. The PDF is

therefore the normalized grey-level histogram. If the histogram is denoted $hg(f)$, we have:

$$p(f) \approx \frac{hg(f)}{N} \qquad (7)$$

The mean and variance of a digital image

Using the usual definitions of mean and variance, we have:

$$\mu = \frac{1}{N} \sum_{f=0}^{255} f.h(f) \tag{8}$$

$$\sigma^2 = \frac{1}{N} \sum_{f=0}^{255} (f - \mu)^2.h(f) \tag{9}$$

These are the simplest measures of image statistics. They are important in many areas of image processing, including image restoration and image classification. Note that any image processing operation that changes the image histogram also changes the image statistics.

Histogram modification techniques

These are operations affecting the image grey-levels on a point-by-point basis. They can be represented by the 1-d transform:

$$g = T(f) \tag{10}$$

where f is the input grey-level and g is the output grey-level.

Negative transform

The transform is given by:

$$T(f) = 255 - f \tag{11}$$

and is illustrated in Figures 26.10(a) and 26.11.

Selective grey-level stretch

The transform is given by:

$$T(f) = 0 \quad f < t_0, \quad T(f) = 255 \quad f > t_1$$

$$T(f) = 255 \; \frac{f - t_0}{t_1 - t_0} \quad t_0 \le f \le t_1 \tag{12}$$

It is plotted in Figure 26.10(b).

Pixels less than t_0 are set to zero. Pixels greater than t_1 are set to 255. The remaining pixel values are stretched linearly between zero and 255. Note that information is generally lost with this transformation (because some pixels are set to zero or 255), although the resulting image may be visually enhanced.

Binary segmentation

$$T(f) = 0 \quad f < t_0, \quad T(f) = 255 \quad t_0 \le f \le t_1$$

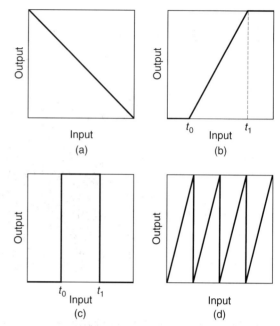

Figure 26.10 Example transformations. (a) Negative. (b) Selective grey-level stretch. (c) Binary segmentation. (d) Sawtooth

$$T(f) = 0 \quad f > t_1 \tag{13}$$

This is illustrated in Figures 26.10(c) and 26.11.

Saw-tooth grey-level transformation

This transformation, shown in Figure 26.10(d), is useful for displaying images with a large dynamic range, e.g. astronomical images where the scene may be quantized to 16 bits. To see the detail in these images on a simple 256 grey-level display the sawtooth transformation is employed.

Histogram equalization

If we assume that the important information in an image is contained in the grey-level values that occur most frequently, then it makes sense to apply a grey-level transformation that stretches the contrast in regions of high PDF and compresses the contrast in regions of low PDF. The derivation of the required transformation can be understood by referring to Figure 26.12.

The number of pixels in the grey-level interval Δf (input) is the same as the number of pixels in the

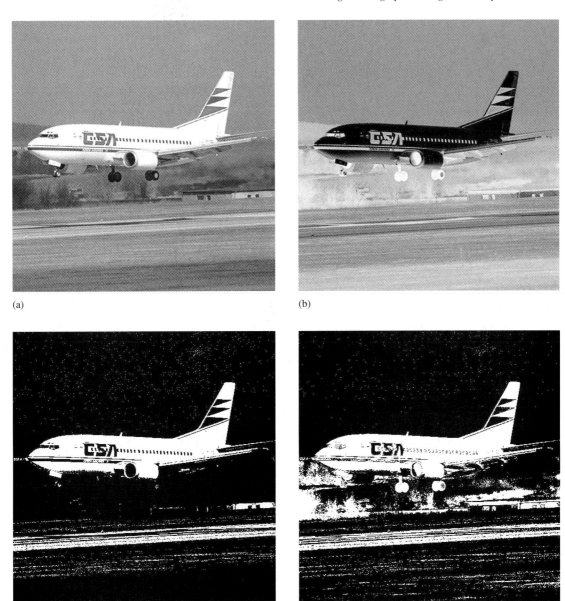

(a)

(b)

(c)

(d)

Figure 26.11 The negative of (a) is shown in (b). The image in (c) is a binary segmentation in which the upper threshold, t_1, is set to 255. The process is essentially binary thresholding. The image in (d) arises from binary segmentation using the transformation 26.10(c)

grey-level interval Δg (output), i.e.:

$$p_f(f).\Delta f = p_g(g).\Delta g \quad \text{so that}$$

$$p_g(g) = p_f(f). \frac{\Delta f}{\Delta g} = \text{constant} \qquad (14)$$

Letting Δf and Δg tend to zero yields:

$$p_g(g) = p_f(f). \frac{df}{dg} = \text{constant} \quad \text{so that}$$

$$\frac{dg}{df} = kp_f(f). \qquad (15)$$

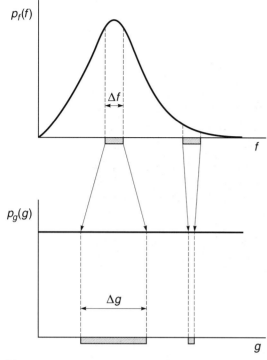

Figure 26.12 The principle of histogram equalization. The top diagram shows a hypothetical PDF for the input image. The lower diagram shows the constant PDF achieved by appropriate stretching and compression of the input contrast

If we integrate both sides of this expression with respect to f, we obtain the required relationship between g and f:

$$g = k \int_0^f p_f(x)dx = kP_f(f) \tag{16}$$

Hence the required grey-level transformation, $T(f) = kP_f(f)$, is a scaled version of the probability distribution function of the input image. The scaling factor k is just g_{max} (usually 255).

In practice, pixel values are integers and $T(f)$ is estimated from the running sum of the histogram. Since the output image must also be quantized into integers, the histogram of the output image is not flat as might be expected. The histogram is stretched and compressed sideways so as to maintain a constant local integral. As a result, some output grey-levels may not be used.

It is crucial to understand that if the most frequently occurring pixel values do not contain the important information, then histogram equalization will probably have an adverse effect on the usefulness of the image. For the process to be controllable most image processing packages offer an option to con-

struct the input histogram from a selected sub-region of the image. An example of histogram equalization is shown in Figure 26.13.

Image restoration

The process of recovering an image that has been degraded, using some *a priori* knowledge of the degradation phenomenon, is known as image *restoration*. In contrast, those image processing techniques chosen to manipulate an image to improve it for some subsequent visual or machine based decision are usually termed *enhancement* procedures. Image restoration requires that we have a model of the degradation, which can be reversed and applied as a filter. The procedure is illustrated in Figure 26.14.

We assume linearity so that the degradation can be regarded as a convolution with a point spread function together with the addition of noise, i.e.

$$f(x, y) = g(x, y) \otimes h(x, y) + n(x, y) \tag{17}$$

where $f(x, y)$ is the recorded image, $g(x, y)$ is the original ('ideal') image, $h(x, y)$ is the system point spread function and $n(x, y)$ is the noise.

We need to find a correction process $C\{\}$ to apply to $f(x, y)$ with the intention of recovering $g(x, y)$: i.e. $C\{f(x, y)\} \rightarrow g(x, y)$ (or, at least, something close). Ideally the correction process should be simple such as a convolution.

Inverse filtering

This is the simplest form of image restoration. It attempts to remove the effect of the point spread function by taking an inverse filter. Writing the Fourier space equivalent of equation (17) we obtain:

$$F(u, v) = G(u, v).H(u, v) + N(u, v) \tag{18}$$

where F, G, H and N represent the Fourier transforms of f, g, h and n respectively. u and v are the spatial frequency variables in the x- and y-directions.

An estimate for the recovered image, $G_{est}(u, v)$ can be obtained using:

$$G_{est}(u, v) = \frac{F(u, v)}{H(u, v)} = G(u, v) + \frac{N(u, v)}{H(u, v)} \tag{19}$$

If there is no noise, $N(u, v) = 0$ and if $H(u, v)$ contains no zero values we get a perfect reconstruction. Generally noise is present and $N(u, v) \neq 0$. Often it has a constant value for all significant frequencies. Since, for most degradations, $H(u, v)$ tends to zero for large values of u and v, the term

$$\frac{N(u, v)}{H(u, v)}$$

(a)

(b)

(c) (d)

Figure 26.13 Histogram equalization
(a) Original image
(b) Equalized image
(c) Histogram of original image
(d) Histogram of equalized image

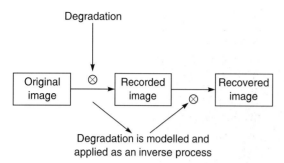

Original image ⊗ Recorded image ⊗ Recovered image

Degradation is modelled and applied as an inverse process

Figure 26.14 A simple model for image recovery from degradation

will get very large at high spatial frequencies. The reconstructed image will therefore often be unusable because of the very high noise level introduced.

This problem can be illustrated very easily using a simple sharpening filter. Although a specific degradation process is not involved in the derivation of the filter, some typical form for $h(x, y)$ is implied. The effect of such a filter is broadly equivalent to the application of equation (19) followed by an inverse Fourier transform. Figure 26.15 shows an example.

Optimal or Wiener filtering

A better approach to image restoration is to modify the inverse filtering approach to take into account information about the noise level. The Wiener filter is derived for this purpose. It attempts to reconstruct the image by finding, not the 'ideal' or 'true' version, but an optimal image that is statistically the best reconstruction that can be formed. The optimal image is defined as that image which has the minimum least-square error.

Consider a reconstruction $g_{est}(x, y)$ of the 'ideal' image $g(x, y)$. We wish to minimize the least square difference, i.e. we require:

$$\langle |g_{est}(x, y) - g(x, y)|^2 \rangle$$

to be a minimum. The $\langle \rangle$ brackets denote an average over all values of x and y. It would also be useful to do this by convolution. In other words we want to find a filter $y(x, y)$ say, such that:

$$g_{est}(x, y) = f(x, y) \otimes y(x, y) \qquad (20)$$

and the above minimum condition applies.

In Fourier space equation (20) can be written:

$$G_{est}(u, v) = F(u, v).Y(u, v) \qquad (21)$$

where $Y(u, v)$ is the Fourier transform of $y(x, y)$.

Using equation 26.18, this result becomes:

$$\begin{aligned} G_{est}(u, v) = &\; G(u, v).H(u, v).Y(u, v) \\ &+ Y(u, v).N(u, v) \end{aligned} \qquad (22)$$

The minimization condition can be reformulated as:

$\langle |G_{est}(u, v) - G(u, v)|^2 \rangle$ should be a minimum

This minimization takes place with respect to the filter $Y(u, v)$ and is written:

$$\frac{\partial}{\partial Y} \langle |G_{est} - G|^2 \rangle = 0 \qquad (23)$$

(where the subscripts u and v are dropped for clarity).

Equation 26.23 becomes:

$$\frac{\partial}{\partial Y} \langle |GHY + NY - G|^2 \rangle = 0 \qquad (24)$$

If we assume the noise $n(x, y)$ has a zero mean and is independent of the signal, it follows that all terms of the form $\langle N(u, v) \rangle$ will be zero and can be ignored. If the squared term in equation (24) is expanded out and simplified, the minimization condition can be solved to yield:

$$Y(u, v) = \frac{H^*(u, v)}{|H(u, v)|^2 + \dfrac{|N(u, v)|^2}{|G(u, v)|^2}} \qquad (25)$$

where $H^*(u, v)$ is the complex conjugate of $H(u, v)$ (this is a notation from complex mathematics and arises because the general function $H(u, v)$ has separate real and imaginary terms to allow for an asymmetric spread function $h(x, y)$). If we assume the degrading spread function is symmetrical, equation (25) reduces to:

$$Y(u, v) = \frac{H(u, v)}{|H^2(u, v)|^2 + \dfrac{|N(u, v)|^2}{|G(u, v)|^2}} \qquad (26)$$

Note that in the noise-free case where $N(u, v) = 0$, equation (26) reduces to:

$$Y(u, v) = \frac{1}{H(u, v)} \qquad (27)$$

which is just the ideal inverse filter.

The term:

$$\frac{|N(u, v)|^2}{|G(u, v)|^2}$$

in equation (26) can be approximated by the reciprocal of the squared signal-to-noise ratio as defined in equation (12) in Chapter 25. Therefore equation (26) above can be approximated by:

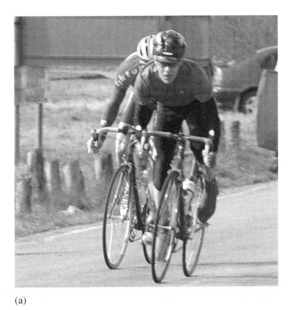

(a)

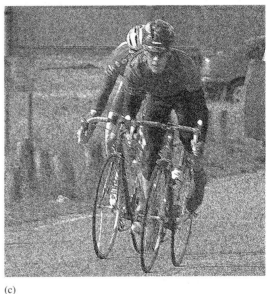

(b)

(c)

Figure 26.15 The original image (a) has been subject to a complicated convolution process at the capture stage. A Wiener filter correction yields (b). Simple inverse filtering gives the very noisy result in (c)

$$Y(u, v) = \frac{H(u, v)}{H^2(u, v) + \frac{\sigma_N^2}{(\sigma_T^2 - \sigma_N^2)}} \qquad (28)$$

Equation 28 offers a useful means of devising a frequency space filter to combat a known degradation (e.g. uniform motion blur) when the image is noisy.

Maximum entropy reconstruction

In common with other reconstruction techniques, this aims to find the 'smoothest' reconstruction of an image, given a noisy degraded version. It does so by considering the pixel values of an image to be probabilities, from which the entropy of an image can be defined. The entropy of the reconstructed image,

formed in the absence of any constraints, will be a maximum when all the probabilities are equal. In other words it will comprise a uniform grey. When constraints are applied by using the information in the original degraded image, an optimum reconstruction for that image is formed. The process involves iteration (repeated approximations) and will include the deconvolution of a known or estimated point spread function. The technique is computationally expensive and care is required to avoid divergent or oscillatory effects. It is used widely for the reconstruction of noisy astronomical images where information at the limits of resolution and detectability is sought.

Interactive restoration

In many applications of digital image processing the operator will have the opportunity to react to the outcome of a particular process. It then becomes advantageous to utilize the intuition of an experienced observer for the interactive restoration of images. Given the uncertain nature of noise measures and degradation processes, most restoration procedures will benefit from this flexibility. For example, the noise-to-signal power term of equation (28) can be replaced by an operator determined constant, chosen by trial and error to yield the most appropriate correction.

Geometric image correction

This is necessary in those cases where the recorded image has been subject to geometric distortions. These may arise, for example, from the limitations of an imaging lens. Pincushion and barrel distortions are common examples. The correction procedures are considered as two-dimensional curve-fitting problems. The image is fitted onto a non-linear sampling grid calculated to remove the distortions.

Edge detection and segmentation

In many instances, the enhancement and/or restoration of images is a precursor to the objective extraction of information. The image is analysed by first subdividing it into regions of relevance to the application. This is known as *image segmentation*. The procedures for achieving image segmentation are based on two observations:

(1) regions are defined by edges;
(2) regions are defined as areas of uniformity.

 The first of these requires that we have a procedure to adequately detect the edges contained in an image. Detected edges are then 'cleaned up' and linked to

complete the segmentation. The principles of edge detection are introduced in the next section. The second observation leads to various iterative procedures to explore the image for uniformity of some chosen statistic (e.g. a local grey-level average, local variance or other 'pattern'). Boundaries are assumed to exist where the statistic changes by more than a pre-set threshold value. Binary segmentation is a simple example of this process. Most practical algorithms for image segmentation using statistical properties are quite complex and will not be covered here. They are well documented in the literature.

Edge detection

Figure 26.16 shows the profile of a typical edge $E(x)$ and its first and second derivatives. It can be seen that edges may be located as maxima of the first derivative or as zero crossings of the second derivative. These simple facts explain the wide use of derivative filters as edge detectors.

First derivative 3×3 filters

The first derivative in the y-direction can be estimated by convolution with the 2×3 filter:

$$\frac{1}{2} \begin{pmatrix} -1 & -1 \\ 0 & 0 \\ 1 & 1 \end{pmatrix} = \begin{pmatrix} -1/2 & -1/2 \\ 0 & 0 \\ 1/2 & 1/2 \end{pmatrix}.$$

Note that this will produce a value at an on-pixel location in the y-direction, but between pixels in the x-direction. We can obtain an estimate at an on-pixel location in the x-direction by averaging two such estimates:

$$\frac{1}{4} \begin{pmatrix} -1 & -1 & 0 \\ 0 & 0 & 0 \\ 1 & 1 & 0 \end{pmatrix} + \frac{1}{4} \begin{pmatrix} 0 & -1 & -1 \\ 0 & 0 & 0 \\ 0 & 1 & 1 \end{pmatrix}$$

This yields the well known 'Sobel' operator for the derivative in the y-direction:

$$\frac{\partial}{\partial x} = \frac{1}{4} \begin{pmatrix} -1 & -2 & -1 \\ 0 & 0 & 0 \\ 1 & 2 & 1 \end{pmatrix}$$

The derivative in the x-direction can be obtained similarly:

$$\frac{\partial}{\partial x} = \frac{1}{4} \begin{pmatrix} -1 & 0 & 1 \\ -2 & 0 & 2 \\ -1 & 0 & 1 \end{pmatrix}$$

 Figure 26.17 illustrates results obtained with these two filters, together with a combination of the two

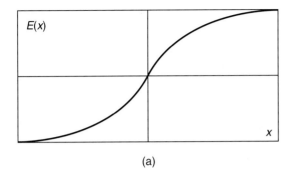

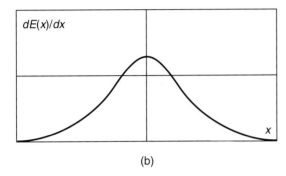

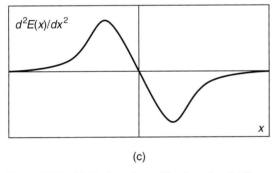

Figure 26.16 (a) The intensity profile of an edge. (b) The first derivative. (c) The second derivative

formed by taking the square root of the sum of the squares of the separate results.

First derivative edge detectors tend to be sensitive to image noise and the edge localization is poor. Figure 26.17 shows the fairly wide locii obtained.

Second derivative 3 × 3 filters

In the *x*-direction the simplest approximation to the second derivative of $f(x, y)$ is:

$$\frac{\partial^2}{\partial x^2} = (1 \quad -1 \quad 0) \otimes f(x, y) - (0 \quad 1 \quad -1) \otimes f(x, y)$$

$$= (1 \quad -2 \quad 1) \otimes f(x, y)$$

It follows that 3×3 approximations for the *x*- and *y*-directions are:

$$\frac{\partial^2}{\partial x^2} = \begin{pmatrix} 0 & 0 & 0 \\ 1 & -2 & 1 \\ 0 & 0 & 0 \end{pmatrix} \quad \text{and} \quad \frac{\partial^2}{\partial y^2} = \begin{pmatrix} 0 & 1 & 0 \\ 0 & -2 & 0 \\ 0 & 1 & 0 \end{pmatrix}$$

Combining these yields an approximation to the Laplacian filter:

$$\nabla^2 = \begin{pmatrix} 0 & 1 & 0 \\ 1 & -4 & 1 \\ 0 & 1 & 0 \end{pmatrix}$$

Other approximations can be obtained by deriving the second derivatives in different ways. For example:

$$\nabla^2 = \frac{1}{2} \begin{pmatrix} 1 & 0 & 1 \\ 0 & -4 & 0 \\ 1 & 0 & 1 \end{pmatrix} \quad \text{and} \quad \nabla^2 = \frac{1}{6} \begin{pmatrix} 1 & 4 & 1 \\ 4 & -20 & 4 \\ 1 & 4 & 1 \end{pmatrix}$$

An example of use of the Laplacian is shown in Figure 26.18.

These filters tend to give a better localization of edge information than do filters based on the first derivative. However, because they are very sensitive to high frequency noise, they are often used in conjunction with a Gaussian smoothing function. The Laplacian and the Gaussian filters can be combined by convolution to yield the well-known Marr–Hildreth edge operator.

Image data compression

Image data compression refers to the process of reducing the amount of data needed to represent a digital image. Without any data reduction, images would occupy data files so large that transmission and storage would be a major problem. A square 8-bit image of side 2048 contains over 4 megabytes of data. The fact that the image will not contain this much information (because there will be areas of uniform tone and other *redundancy*) means that it can be compressed into a much smaller data file without any loss of information. If some loss of information can be tolerated, the data can be compressed even further. This leads to two basic types of compression procedure:

(1) Lossless, or error free.
(2) Lossy (information is lost).

To analyse these procedures in detail requires a level of information theory beyond the scope of this work. This section, and chapter will conclude with some simple ideas on data compression, and a very brief description of the important JPEG compression standard.

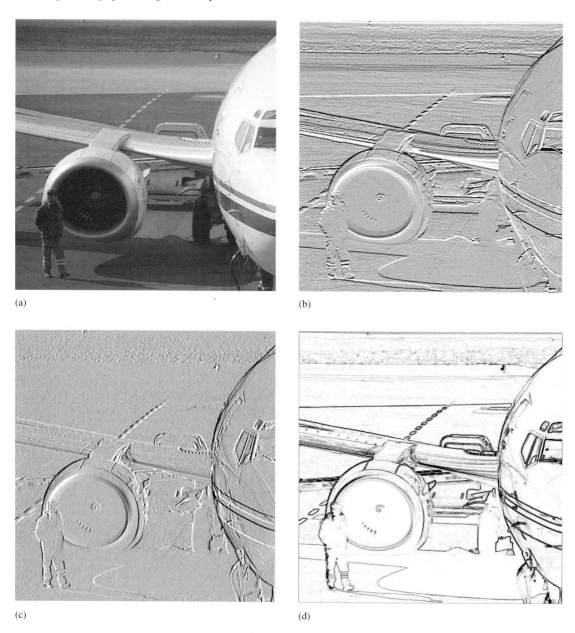

(a)

(b)

(c)

(d)

Figure 26.17
(a) Original image
(b) The Sobel operator for the first derivative in the *y*-direction shows the horizontal component of edges
(c) The Sobel operator for the first derivative in the *x*-direction. Only vertical edge components are shown
(d) The full Sobel operator

Run-length coding

This is an efficient method for compressing many images although it is usually used in conjunction with other compression procedures. The principle of run-length coding is illustrated in Figure 26.19, which shows a portion of one row of a digital image containing runs of pixels of the same grey value. If these are replaced by pairs of numbers describing the grey value and the number of pixels of that value,

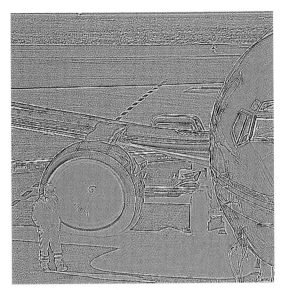

Figure 26.18 The Laplacian second derivative filter can give better localization of edges compared with the Sobel operator. The edge position is the boundary between the black and white components

Symbol	Probability	Equal-length code	Huffman code
A	0.5	00	1
B	0.25	01	10
C	0.125	10	110
D	0.125	11	111

A long string of symbols with the above probabilities would have an average code-word length L given by:

L = (0.5 × 1) + (0.25 × 2) + (0.125 × 3) + (0.125 × 3) = **1.75** bits per symbol when using the Huffman code.
With the equal-length code **L = 2** bits per symbol.

In this case the Huffman code is ideal, since the source entropy is **H = 1.75** bits per symbol also.

Figure 26.20 The advantage of the Huffman code

significant compression can be achieved. The process can be extended into two-dimensions, and the binary version of the method represents the current standard for facsimile (FAX) transmission.

Variable length coding

The principle here is to devise a variable length binary code in which the shortest code word is assigned to the most frequently occurring value of the set being coded. A long string of coded values will then occupy less space than would a fixed length code. The most popular scheme for achieving this is known as 'Huffman coding'. This approach uses the probabilities of the values being coded in a systematic manner to generate a uniquely decodable binary code. The average bit length for coded values is often only slightly greater than the source entropy (see Chapter 25, p. 426), indicating high code efficiency. Figure

Figure 26.19 The principle of run-length coding

26.20 shows an example of a Huffman code and a fixed length code for a hypothetical set of source symbols and probabilities.

Joint Photographic Experts Group (JPEG) standard

This is the original standard for the compression of continuous-tone (monochrome and colour) image data. The details are beyond the scope of this work, but the important stages in the JPEG procedure can be identified:

(1) The image is divided into pixel blocks of size 8 × 8. Each block is operated on in turn, from top left to bottom right, using steps 2 to 5.
(2) The two-dimensional cosine transform of the block is taken. This is a simplified Fourier transform in which only the cosine components are considered.
(3) The 64 coefficients from step 2 are quantized according to the compression level required.
(4) The 64 quantized coefficients are reordered from top left to bottom right following a zigzag path to yield a one-dimensional sequence of values. Many of these values at the high frequency end will be zero.
(5) The sequence is coded into binary using a modified run-length/Huffman technique.

Decompressing a JPEG compressed image involves executing these steps in reverse. Because of the quantization of step 3, the decompressed image will have lost information and 'blocking' artefacts may appear. For compression ratios less than about 20:1 such artefacts are often imperceptible.

Bibliography

Bracewell, R.N. (1999) *The Fourier Transform and its Applications*, 3rd edn. McGraw-Hill, New York.

Castleman, K.R. (1996) *Digital Image Processing*. Prentice Hall, Englewood Cliffs, NJ.

Gleason, A. (translator) *et al.* (1995) *Who Is Fourier? A Mathematical Adventure*. Transnational College of LEX/Blackwell Science, Oxford.

Gonzalez, R.C. and Woods, R.E. (1993) *Digital Image Processing*, 3rd edn. Addison-Wesley, Reading, MA.

www.scioncorp.com 'Scion Image': free image processing package written by the American National Institute of Health.

Index

Aberration, 42
 axial chromatic, 72–4
 lateral chromatic, 74–5
 spherical, 55, 75–6
 types, 72
Abney, 238
Acceptance angle, exposure meter, 322
Accommodation (eye focusing), 52
Acid-hardening fixing solutions, 294–5
Actinity (light source efficiency), 24
Additive colour mixing, 14
Additive (triple-exposure) colour printing, 190, 214,
 215–17, 361
 process imperfections, 258–9
Advanced Photographic System (APS), 104, 201,
 202
 camera features, 109
 data recording, 162
 film coding, 201–202
Aerial photography, use of infrared materials, 209
Afocal attachments, 100–101
Agfa-Gevaert:
 coupler immobilization, 264
 dye release by reduction, 271
Airy diffraction pattern, 50, 79
Airy disc, 79–80, 81
Aliasing, 123, 408, 409, 410
Alkalis, in developing solutions, 276–7
Aluminium potassium sulphate, as hardening agent,
 294
Amidol developers, 274
Ammonium thiosulphate, as fixing agent, 294
Amplitude, wave, 9
Analogue control systems, 115–17
Analogue-to-digital (A/D) converter, 118, 127
Anamorphic lens converter, 101
Anastigmat lenses, 77, 88
Anti-foggants see Restrainers
Anti-reflection coatings:
 multiple, 70–71
 single, 69–70
Aperture, eye, 11
Aperture stop, camera, 61
Aplanatic correction, 75
Apostilb (unit), 21, 324
Archival storage materials, 375–6
Arrhenius equation, 374
Aspheric surfaces, 75, 90
Astigmatic surfaces, 77

Atmospheric gases, effect on photographic media,
 376
Autocorrelation function, 417, 419
Autofocus systems, 127, 151
 active ranging, 151
 phase detection, 152–4
Automatic exposure (AE) mode, 160, 324–6
 aperture-priority, 160
 memory lock, 316
 programmed, 160, 326–7
 scene classification, 329
 shutter-priority, 160
Average gradient (characteristic curve), 228
Azo dyes, 268, 271

Barlow, 99
Barrel distortion, 78–9
Battery power, 160–61
 digital camera, 129
 flash unit, 32–3
Bayer colour filter array, 121, 125, 195
Beam candle power (BCP), 29
Between-lens shutters, 131–3, 143
Binning technique, pixel data, 122
Bit depth, scanner, 368
Bitmap (raster) image files, 202
Black body see Planckian radiator
Black-and-white reproduction, 250–51
Bleach-fixing, 342
Bleaching of silver images, 298–9
Blending magnification factor, 415
Blind spot (eye), 12
Block error rate (BLER), 381
Blue-sensitive materials, 206
Blur circle, 50
Bounce flash lighting, 32, 333
Brewster angle, polarization, 187
Brightness see Luminance
Bromide printing papers, 233, 337
Bunsen and Roscoe, 238

Cadmium sulphide (CdS) photoresistors, 155,
 321–2
Callier coefficient/Q factor, 220–21
Camera exposure, 219
Camera types, 107
 aerial, 113
 APS see Advanced Photographic System (APS)
 automatic, 115–20

Camera types – *continued*
 box, 107
 compact, 109
 digital *see* Digital cameras
 digital back conversions, 127–8
 folding-baseboard, 112, 113, 163
 large format, 163–4
 Mamiyaflex, 111
 monorail, 112, 163
 panoramic, 114–15
 pocket, 107
 Polaroid, 113
 rangefinder, 109–110
 Rolleiflex, 110
 shift, 174–5
 simple, 107–108
 single use, 107–108
 single-lens reflex (SLR), 111–12
 still-video (SV), 120
 technical, 112–13, 163
 twin-lens reflex (TLR), 110–11
 ultrawide-angle, 114
 underwater, 113–14
Cameras:
 battery power, 160–61
 components, 104
 development, 104–106
 image formats, 104, 105
 rotational movements, 165–6
 translational movements, 165
 use of analogue systems, 115–17
 versatile functions, 106–107
Candela (unit), 21
Candle-power (unit), 21
Cardinal points, lens, 43–5
Cardioid response diffuser, 320
Cassegrainian mirror system, 94
Catadioptric system *see* Lenses, catadioptric
Catechol developers, 274
Cathode ray tube (CRT), colour reproduction, 217
Cellulose triacetate, as base material, 198
Central processing unit (CPU), 117–18, 119
Centre of curvature, lens, 42
Centre-focus lens attachment, 103
Characteristic curve, 222–3, 227
 average gradient, 228
 construction, 239–40
 main regions, 223–5
 neutral-exposure, 254
 variation with development, 225–6
 variation with material, 225
Charge injection device (CID), 122
Charge-coupled device (CCD), 120, 122
 for image sensing, 122, 191–6, 201
 production process, 200
 spectral sensitivity, 122, 211, 245–6
Chemical fog, 226
Chloro-bromide papers, 233, 337
Chroma, Munsell system, 383–4

Chromatic aberrations, 72
Chromatic adaptation, eye, 248
Chromatic difference of magnification, 74–5
Chromaticity diagrams, 386–8
Chromogenic developers *see* Colour developers
Chronotron, 333
CIE:
 CIELAB Uniform Colour Space, 389, 392
 RGB colorimetry, 385–7
 Uniform Chromacity Scale Diagram, 389, 391
 XYZ colorimetry, 387–9, 390
CIELAB Uniform Colour Space, 389, 392
Circle of acceptable definition, 49
Circle of confusion, 50, 52–3, 55
Clock circuits, 117, 118
Close-up lenses, 42, 101, 147
Close-ups:
 depth of field, 55–6
 exposure compensation, 67–8
Cobb chart, 421
Cold-cathode lamps, 353–4
Colorimetric density, 222
Colour cast, 20
Colour coupler/former, 254, 263
 location, 264–5
 oil-dispersed, 265
Colour developers *see* Developers, colour
Colour enlargers *see* Enlargers, colour
Colour filter array (CFA), 194–5
Colour filters *see* Filters, colour
Colour gamuts, 389–92
Colour image formation, 263–7
Colour masking, 255–6, 260
Colour matching, 213, 383
 constancy, 16
 physical specification, 384
 reproduction, 6–7
 specification by sample, 383
 specification by synthesis, 384–5
Colour mixture principles, 13–14
Colour order systems, 383–4
Colour printing, 359–60
 filtration, 190, 360–61
 imperfections, 258–9
 negatives evaluation, 365–7
 papers, 339
 variables, 360
Colour processes, 251–3, 265–7
 additive (triple-exposure), 190, 214, 215–17, 361
 Eastman Kodak instant, 271
 historical development, 214
 instant, 269–71
 Polaroid instant, 271
 subtractive (white-light), 14, 214–15, 217, 362
Colour rendering index (CRI), 20, 27
Colour temperature (CT), 18, 19
 correlated, 18
 measurement and control, 20
Colour-blind materials, 206

Colour-negative films, 256
 exposure latitude, 311
 speed rating, 306–307
Colour-reversal films, 256–8
 additive systems, 258
 exposure latitude, 312
 processing, 265–6
 speed rating, 307
Colour-sensitive materials, 207–209, 210
Colours:
 at low light levels, 250
 complementary, 249–50
 effect of light source, 248
 eye response, 248–9
 natural objects, 247–8
 primary, 249–50
 range, 247
 rendering, 18, 20
Coma effects, 66, 76–7
Compact cameras, zoom lenses, 98
Compact Disc (CD), as image storage media,
 380–81
Compact-source iodide (CSI) lamps, 27
Complementary colours, 249, 250
Complementary metal oxide semiconductors
 (CMOS), 122, 127, 191
Composition, picture, 5
Compression processes, image, 124, 443–5
Condenser enlargers, 349–51
Condenser-diffuser enlargers, 352–3
Cones (light-sensitive receptors), 11
Conjugate (image distance), 43, 45–8
Consistency principle, colour reproduction, 7
Contact printing, 349
Continuous spectra, 18
Contrast, subject, 230
Contrast index, Kodak, 228
Contrast sensitivity function (CSF), 13
Convolution process:
 digital, 428–9
 image formation, 398, 401–402, 406
Cornea, 11
Corpuscular theory, 9
Correlated colour temperature, 27
Cosine response diffuser, 320
Covering power, lens, 49
Crispening operator, 412
Critical value of incidence, 40
Curvature of field, 77
Curvilinear distortion, 78–9
 lens, 50
Cut-off *see* Vignetting, mechanical
Cycolor *see* Cylithographic process
Cylithographic process, 346

Dallmeyer, 87
Dark adaptation, eye, 12
Dark current output, 123, 425
Dark fading, colour media, 373–7

Darkroom safelights, 189–90
Data compression, 204, 443–5
Data imprinting, 161–2
Davis-Gibson liquid filter, 25
Day vision, 12
Daylight, as light source, 25
Decamired (unit), 21
Decoder, 117
Densitometers, 241
 automatic plotting, 243
 colour, 243–4
 measuring wedge, 242
 single-beam, 241–2
 Status A, 244
 Status M, 244
 transmission, 241
 twin-beam, 242–3
Density, image, 219, 220, 221–2
Density range, scanner, 368
Depth of field, 50–53
 close-ups, 55–6
 equations, 53–6
Depth of focus, 51, 56–7
Detective quantum efficiency (DQE), 422–4, 425–6
 for CCD imaging array, 424–5
 for photographic process, 424
Developing agents, 273–6
 for colour printing papers, 263–7, 282, 340
 extreme-contrast, 281–2
 fine-grain, 279–80
 high definition, 280–81
 liquid concentrates, 285
 low-contrast, 280
 for monochrome printing papers, 279, 340
 POTA, 280
 powdered chemicals, 285
 pre-packed, 284–5
Developing solutions:
 alkali content, 276–7
 changes with use, 282–3
 composition, 273
 other additions, 277–8
 preparing, 284–5
 preservatives, 276
 replenishment, 283
 restrainers, 277
 safety precautions, 284
Development techniques, 285, 340–44
 criteria, 289–91
 machine processing, 287–9
 quality control, 292–3
 roll films, manual processing, 286–7
 sheet films, manual processing, 286
 tank lines, 287
 time and speed variation effects, 291–2, 313
 variation effect on negative, 228–9
Deviation *see* Refraction effects
Dichroic filters, 190
Diffraction effects, 72, 79–80

Diffraction gratings, for special effects, 103
Diffuser, 23, 32
 for light readings, 319–20
 types, 319–20
Diffuser enlargers, 351–2
Digital cameras, 120
 additional features, 129–30
 dynamic range, 245
 image data, 127
 image resolution, 124–5
 internal circuitry, 125–7
 noise, 122–3
 photosensor array, 120–21
 power supply, 129
 printer performance, 125
 resolution, 368
 sensitometry, 245–6
 signal, 121–2
 spectral sensitization, 211–12
 speed ratings, 307–308
 tonal range, 124
 viewfinders, 128–9
 zoom lenses, 98, 129
Digital data:
 control systems, 117–20
 filtering, 428–34
 histogram, 123, 124
 image file formats, 202–204
 image processing, 3–4, 174, 428
 media life expectancy, 379–81
 migration process, 379
Digital-to-analogue (D/A) converter, 118
Diode lasers, 38
Dioptre (refracting power), 42
Dirac Comb, 409
Dirac delta function, 404
Direct thermal imaging, 346–7
Discontinuous spectra, 18
Discrete Fourier transform (DFT), 408, 410–11
Dispersion effect, 40
Dispersive power, 72
Distortion:
 barrel, 78–9
 curvilinear, 78–9
 pincushion, 78–9
 uncorrected, 66
Dodging devices, 358
Dollond, 72, 87
Drum scanners, 367–8
Dry Silver process, 345–6
Drying processes, film, 301
Dufaycolor process, 216
Duplex method (illuminance measurement), 320
Duplication requirements, 261–3
Durst laser imager, 354
DX film coding, 109, 201, 312
Dye sensitivity, 207–210
Dye sublimation process, 370
Dye-developer compound, Polacolor system, 270

Dye-diffusion materials, printing papers, 339
Dyes, subtractive image, 254
Dynamic range, scanner, 368

E-6 reversal processing procedure, 266
Eastman Kodak:
 coupler immobilization, 264
 imaging chain concept, 6
 instant process, 271
Eberhard effects, 259, 281
Edge detection, 442–3
Edge spread function (ESF), 400
Efficacy, light source, 24
Electrolytic silver-recovery units, 297
Electromagnetic spectrum, 10–11
Electromagnetic waves, 9–10
Electron beam coating, lens, 70
Electronic distance measurement (EDM) system, 152
Electronic flash:
 automatic, 333–4
 circuitry, 29–30
 duration, 31
 exposure guide numbers, 331
 modelling lights, 330–31
 output, 30
 portable units, 32
 power, 30
 properties, 329–30
 self-developing materials, 330
Electronic flash metering, 329–30
 automatic, 333–4
 matrix system, 335
 OTF systems, 334–5
Electronic noise, 122
Elongation factor, image, 50
Emulsions:
 coating process, 199–200
 grain types, 197, 198
 layer sensitivity, 252–3
 panchromatic, 208
 preparation, 197
Energy equations, 30
Enhancement procedures (image restoration), 438
Enlargers, 349
 ancillary equipment, 355
 colour, design, 362–3, 363–5
 condenser, 349–51
 condenser-diffuser, 352–3
 diffuser, 351–2
 easels, 355
 lenses, 354–5
 light sources, 353–4
 paper holders, 355
 rectifying, 170
Enlarging attachments, exposure meter, 322
Enlarging processes, 349
 soft-focus, 359
Equal energy spectrum, 249
Equivalent focal length, 44

Equivalent focal plane, 158
Evaporation coating, lens, 70
Expand filter, 433
Exposure, 218–19, 310–11
 analogue sequence, 116
 aperture variation effect, 356
 correction factors, 67
 enlargement degree variation effect, 356
 latitude, 230–31, 311
 measurement by luminance of subject, 315
 practical tests, 315
 time determination, 313–15, 355–8
 useful range, 230
 variation effect on negative, 229
Exposure factor *see* Filter factor
Exposure guide numbers, 29, 331
Exposure memory lock, 159, 316, 326
Exposure meter, 154–6
 acceptance angle, 322
 automatic, 160, 313
 calibration, 316–18
 components, 320–22
 digital readouts, 323
 electronic flash *see* Electronic flash metering
 for enlarging process, 357–8
 in-camera, 324–9
 integral, 156–7, 160
 optical attachments, 322–3
 sensitivity, 159
 spot, 324
 type of reading, 158–9
Exposure range, paper, 232
Exposure value (EV), 133, 312, 318, 319
 relationships, 323
Extended sensitivity materials, 208–209
Extension tubes and bellows, 147–8
Extra covering power, lens, 49
Extra-low dispersion glass, 74
Extreme-contrast developers, 281–2
Eye:
 components and operation, 11–12
 lens, 11
 mesopic mode, 250
 photopic mode, 250
 response to colours, 248–9
 scotopic mode, 250
Eyepiece adaptor attachments, exposure meter, 322

f-number:
 aperture range, 61, 62
 effective, 67
f-stop *see* Lens aperture
Fading, colour media, 373–9
Farmer's reducer, 299
Ferric EDTA, as oxidizing agent, 299
Fibre-optics probe attachments, exposure meter, 322
Field stop, 61
Field of view (FOV), 166
File formats, digital image data, 202–204

Fill factor, image formation, 194
Fill-in flash technique, 313
Film speed *see* Speed
Filter factor, 176
Filter type:
 absorption, 176
 colour, 251
 colour-compensating (CC), 183
 colour-conversion, 183
 colour-printing (CP), 190
 contrast, 179–80
 correction, 179
 Davis-Gibson, 25
 dichroic, 190
 expand, 433
 graduated, 186
 haze, 181
 high-pass, 433
 infrared-absorbing, 184
 infrared-transmitting, 184
 interference, 70, 176, 190
 inverse, 438
 light-balancing, 20, 182
 low-pass, 127, 433
 maximum, 433
 median, 434
 minimum, 433
 neutral-density, 186
 non-linear, 433
 photometric, 182
 polarizing, 186–9
 shrink, 433
 skylight, 182
 spot, 66
 threshold average, 434
 ultraviolet-absorbing, 184
 ultraviolet-transmitting, 184
Filters:
 materials, 177
 sizes, 178
Filtration process:
 colour, 190, 360–61
 for b&w photography, 179–82
 for colour photography, 182–6
 colour-conversion (CC), 20
 convolution, 428–9
 dark-room use, 189–90
 exposure factors, 176–7
 focusing, 178
 linear spatial, 428–9
 use of colour arrays, 194–5
Fine-grain developers, 279–80
Fish-eye lenses, 66
Fixed density systems, speed criterion, 302–303
Fixing process, 342
 time required, 295
Fixing solutions, 294, 294–6
 acid, 294
 acid-hardening, 294–5

Fixing solutions – *continued*
 changes with use, 295–6
 preparation, 295
 silver recovery, 296–8
Flare, camera, 68
Flare factor (FF), 68
Flash:
 automatic exposure, 33–6
 circuitry, 29–30, 35
 duration and exposure, 31–2
 electronic *see* Electronic flash
 exposure guide numbers, 29, 331
 indirect, 32
 integral units, 36
 output and power, 30–31
 portable batteries, 32–3
 portable units, 32–3
 studio units, 33
Flash factor, 29, 331
Flash meter, 331–3
 integrating, 33
Flash synchronization, 35–6, 143
 between-lens shutters, 143
 connections, 144
 focal-plane shutters, 144
Flash-cubes, 28
Flashbulbs:
 expendable, 28–9
 firing circuits, 28–9
 use in arrays, 28
 use of slave units, 28
Flashguns, 23
Flashmatic system, 36, 109
FlashPix, 204
Flatbed scanners, 367–8
Fluorescent lamps, 27
Fluorite, for lens construction, 74–5
Focal length:
 effective, 44
 eye, 11
 lens, 42, 43
Focal plane array (FPA), 18, 120
Focal-plane shutter, 133–6, 144
Focusing scales, 148
Focusing screen, ground-glass, 148
Focusing systems, 144–8
 extension tubes, 147–8
 front-cell, 146
 internal, 147
 microprism grids, 150–51
 see also Autofocus systems
Fog level, 225, 226
Forea, 12
Fourier theory of image formation, 393–4, 396, 398–402
Fourier transform process, 396–7, 403–404
 Dirac delta function, 404
 of noise samples, 419–20
 rectangular function, 403–404

Fractional gradient systems, speed criterion, 304
Frequency, vibration, 9
Frequency domain filtering, 429–32
Fresnel lens, 23
Front-cell focusing, 146
Fujifilm:
 Neopan film, 198
 Pictrography process, 344, 345, 369
 Pictrostat process, 344
 Thermo-Autochrome process, 346–7, 370
Full radiator *see* Planckian radiator
Fully-automatic diaphragm (FAD), 112

Gamma (sensitometric contrast), 223–4, 225, 228
 scanning process correction, 369
 variation with wavelength, 227
Gamma-ray region, 206
Gamma-time curve, 226–7
Gauss points, 43
Gaussian optics, 43
Gaussian plane, 77
Gelatin, 195–7, 294
Geometrical distortion, lens, 49–50
Geometrical optics, 10
 image correction, 442
Glass, as base material, 198
Global Positioning System (GPS), interfacing, 162
Glycin developers, 274–5
Goerz Hypergon lens, 66
Gold solution protective toning process, 377
Graded refractive index (GRIN), 83
Graininess, 413, 415–16
 negatives, 415
 prints, 358, 416
Granularity, 416–17
 negatives, 416
Gray code, 118
Ground-glass focusing screen, 148
Guide numbers, 29, 31

H and D curve *see* Characteristic curve
Half-watt value, 24
Hard copy:
 production, 336, 348
 quality assessment, 370
Heat filters, enlarger, 355
Helmholtz, 14, 249
High contrast subjects, 235–6
High definition television (HDTV), colour gamut, 391, 392
High-definition developers, 280–81
High-pass filtering, 433
Highlight, artificial, 314–15
Histogram:
 equalization, 436–8
 image data, 124
 modification techniques, 436
Honeywell Visitronic system, 152
Hotshoe connection, 144

Hues, 16, 20, 247
 Munsell system, 383–4
 spectral, 247
Huffman coding, 445
Human visual system (HVS):
 discrimination ability, 13
 see also Eye, components and operation
Hurter and Driffield:
 characteristic curve *see* Characteristic curve
 tone reproduction experiments, 236
Hybrid imaging, 6
Hydragyrum metal iodide (HMI) lamps, 27
Hydroquinone developers, 275
Hyperfocal distance, 55
Hypo *see* Sodium thiosulphate
Hypo eliminators, 300

Ilfochrome process, 268, 271
Ilford XP-2 film, 198, 282
Illuminaires, 23
Illuminance, 22, 63–6
 units, 323
 with wide-angle lens, 66
Illumination, 5, 22, 63–6
Image conjugate distance, 45
Image formation, 5, 393–4
 compound lens, 43–5
 Fourier theory *see* Fourier theory of image
 formation
 graphical construction, 45, 46
 information capacity, 426
 manipulation, 358–9
 optical systems, 41
 panoramic, 106
 pinhole method, 41
 simple positive lens, 42–3
 sinusoidal, 397–8
 use of charge-coupled devices, 193–5
Image noise, 413
 causes, 413
 quantifying, 417–18
 spatial structure, 417
Image production:
 data compression, 443
 file formats, 104–106, 124, 202–204
 permanency, 5
 principles, 1–2, 5
 quality expectations, 7–8
 resolution in digital systems, 124–5
 segmentation procedures, 442
 shape control, 171–2
 sharpness, 50–52, 168–70
 statistical operations, 434–8
Image restoration, 438–42
Image scale, 45
Imaging chain, 6
Imaging equation, 401
 in one dimension, 402
Impulse of unit energy (Dirac delta function), 404

Incident light, measurement, 316, 318–20
Inconel, in filter construction, 186
Indium tin oxide (ITO), 122
Inertia systems, speed criterion, 303
Information exchange (IX) system, 162
Information theory, 426
Infrared (IR) materials, 209
Infrared (IR) wavelengths, 11
Ink-jet printing, 347, 370
Instant return mirror, 142
Integral flash units, 36–7
Integral masking, 260
Integral tripack process, 217, 253
Inter-image effects, 256, 258, 259–60
Interactive restoration, 441
Interference filters, 70
Intermediate negative film, 262–3
Intermittancy effect, 239
International Organization for Standardization
 (ISO), 305
 equivalent speed, 121
 speed ratings, 305–306
 speed ratings for colour materials, 306–307
Internegative film, 262–3
Interpolation technique, pixel data, 122
Inverse filter, 438
Iris diaphragm shutter system, 61, 136–7
Iris (eye), 11

Jones, L A, 237
JPEG (Joint Photographic Experts Group)
 compression standard, 124, 204, 445

Kelvin scale, 18
Kepler type viewfinder system, 128, 140–2
Key tone measurement, 315–16
Kodak:
 C-41 colour negative process, 268
 D-23 developing agent, 280
 D-76 developing agent, 280
 dye diffusion thermal transfer process, 370
 Dye Transfer method, 217
 E-6 reversal processing procedure, 266
 gold solution protective toning process, 377
 Photo CD, 204
 RA4 negative colour process, 268
 T-grain technology, 198
Kostinsky effects, 281

L-ascorbic acid developers, 274
Lambertian surface, 39
Lambert's cosine law, 22, 320
Lamps, photographic *see* Light sources
Laplacian filter, 443
Laser printers, 369–70
Lasers, as light sources, 354
Latent image formation, in silver halides, 191–3
Lateral chromatic aberration, 74–5

Lens design:
 aperture and performance, 62, 80
 aspheric surfaces, 90
 cardinal points, 43–5
 coatings, 69–71, 89
 compound, 43–5
 computer-aided, 90
 conjugate equation, 45–8
 covering power, 49, 165, 166–8
 development, 85–8
 double-Gaussian configuration, 75, 77
 for enlargers, 354–5
 floating elements, 90
 focal length, 43, 49
 formulae, 47
 geometric distortion, 49–50
 graphical image construction, 46
 image evaluation, 90–91
 materials, 90
 modern forms, 88–91
 optical attachments, 100–102
 perspective control (PC), 49
 resolution, 80–81
 speed, 61
 transmission light losses, 68
Lens flare, 68
Lens hood, 101–102
Lens tilt, 170–71
Lenses:
 achromatic, 40
 afocal converter, 100–101
 anastigmat, 77, 88
 Aplanat, 87
 apochromatic, 73
 apochromatic copying, 85
 catadioptric, 74, 94–5
 cemented achromatic doublet, 73
 close-up, 42, 101, 147
 compound, 43–5, 83–5
 deep-field, 55
 double-Gauss, 75, 77, 88
 fish-eye, 66, 92–3
 landscape, 87
 long-focus, 93–5
 macro, 76, 98–9
 macro-zoom, 96–7
 micro, 121
 mirror, 74, 94–5
 multiplier *see* Teleconverters
 PC projection, 174
 perspective-control, 173–4
 Petzval, 87
 portrait, 102
 Rapid Rectilinear, 87
 retrofocus, 91
 Rodenstock Imagon, 76
 simple, 42, 83
 special effects attachments, 102–103
 Steinheil Periskop, 87

 superchromat, 73
 symmetrical doublets, 87
 symmetrical-derivative, 91
 telephoto, 93
 telephoto wide-angle, 98
 triplets, 88
 varifocal, 95, 98
 wide-angle, 49, 91–3
 Zeiss Biogon, 98
 Zeiss Tessar, 88
 zoom, 95–8
 see also Teleconverters
Life expectancy:
 digital media, 379–81
 imaging media, 372
Light:
 eye adaptation, 12
 losses, 68
 measurement, 315–16
 properties, 9–10
 scatter in negative, 220
Light emitting diode (LED):
 as digital display, 117
 as light source, 38
Light fading, colour media, 373, 378–9
Light guide attachments, exposure meter, 322
Light meter *see* Exposure meter
Light sources:
 characteristics, 16–20
 colour temperatures, 19
 daylight, 25
 effect on colour appearance, 248
 efficiency, 24
 for enlarging and printing, 353–4
 maintenance, 25
 methods of production, 16
 operation, 25
 output, 21–5
 properties used in photography, 17
 variation in output, 358
 see also under individual types
Light value (LV), 155, 318
Light waves, 9
Light-pipe, 353
Light-sensitive materials, 195–8
 emulsion coating, 199–200
 sizes and formats, 200–201
 support base, 198–9
Lighting ratio, 312, 320
Line spectra, 18
Line spread function (LSF), 400, 401
Linear spatial filtering, 428–9
Lithographic developers, 281–2
Log exposure range, 311, 313
Log-luminance range, 230
Lossless/lossy compression coding, 124, 204
Low-contrast developers, 280
Low-pass filtering, 433
Lumen (unit), 21

Luminance, 21, 39, 218
 darkest shadow measurement, 315
 discrimination, 12–13
 formed by lens, 63
 lightest highlight measurement, 315
 units, 323
Luminance factor, 384
Luminance ratio, 312–13
Luminous flux, 21, 22, 63
Luminous intensity, 21
Lux (unit), 218, 323

3M Company, Dry Silver system, 345–6
Macbeth ColorChecker chart, 390
McCormick-Goodhart storage recommendations,
 375, 376
Mackie lines, 281
Magicubes, 28
Magnification, 45
Mangin mirror, 94
Marr-Hildreth edge operator, 443
Matrix flash metering, 335
Matrix metering *see* Photocells, segmented systems
Maximum black (density), 231–2
Maximum entropy reconstruction, 441–2
Maximum filter, 433
Maxwell, James Clerk, 214
Mead Corporation, dry colour process, 346
Mean noon sunlight, 25
Media, life expectancy, 372
Median filter, 434
Metal oxide semiconductor (MOS) circuitry, 118
Metal-halide lamps, 27
Metallic replacement silver-recovery methods,
 297–8
Metameric pairs, 213
Metering systems, in-camera, 324–9
Metol developers, 275
Micro reciprocal degree *see* Mired value
Micro-flash units, 31
Microdensitometers, 243
Microlasers, as light source, 38
Microprism grids and screens, 150–51
Microprocessor systems, 117–18, 127
Microscope attachments, exposure meter, 322–3
Migration process, digital data, 379
Minimum filter, 433
Minimum useful gradient, characteristic curve,
 303–304
Mired scale, 21
Mired shift value (MSV), 20, 21, 182
Mired value (MV), 21
Mirror lenses, 74, 94–5
Mixed lighting effects, 20
Modelling lights, 330–31
Modulation transfer function (MTF), 81–2, 402,
 405, 406, 417
 for CCD imaging array, 411
 correction, 407–408

edge input method, 407
image quality, 411–12
theory, 412
wave recording, 406–407
Moiré effects *see* Aliasing
Monochrome developer formulae, 279
Multiple-image prisms, 103
Multiplexer, 117
Munsell system, standard colours, 383–4

Near distance of distinct vision, 52
Near-UV radiation, 206
Negative:
 density range, 313
 effect of variation in exposure, 229
Negative carriers, 355
Negative-positive colour process, 254–6, 266–7
Neutral-density filter, 186
Newton, 13, 384
Newtonian finder, 139
Nickel-cadmium (NiCd) batteries, 32–3
Night vision, 11
Nodal points, lens, 43–4
Noise:
 CCD system sources, 122, 425
 photographic, 413–17
Noise equivalent exposure (NEE), 425
Noise measures, relationships, 419
Noise power spectrum, 417–19
Non-colour-sensitive materials, 206
Non-impact printing methods, 369
Non-linear filtering, 433
Nyquist frequency, 409

Object conjugate distance, 45
Off-the-film (OTF) flash measurement, 33, 158,
 326, 334–5
Off/on-easel negative evaluation, 366–7
Opacity, 219
Optic nerve, 11
Optical filters *see* Filters
Optical image formation, 41
Optical resolution, 368
Optical spread function, 81
Optical transfer function (OTF), 81, 405
Optics, 10–11
Optimal filtering, 440
Orthochromatic materials, 208
Output scanning, digital data, 369–70

Panchromatic materials, 208
Panoramic formats, 106
Pantone colour system, 383
Paper:
 as base material, 198–9
 printing *see* Printing paper
Para-aminophenol developers, 275
Paraphenylenediamine developers, 275
Paraxial conditions, 43

Peltier effect, 122
Pentaprism viewfinder, 112
Permanence tests, negatives and prints, 300
Perspective, 5, 53, 57–60
 correction/introduction techniques, 172, 358
 distortion, 60
 use of lenses, 49, 173–4
Petzval lenses, 87
Petzval sum, 77
Petzval surface, 77
Phenidone developers, 275
Photo-transistor, for flash exposure, 33
Photocells, 155–6
 in exposure meters, 320–22
 positioning, 157–8
 segmented arrangement, 158–9, 327–8
Photoelectric effect, 9–10
Photoflood lamps, 25, 26
Photographic paper *see* Printing paper
Photographic process, basics, 2–3
Photometer *see* Exposure meter
Photometry, units, 323–4
Photon (quantum of light), 9
Photopic vision, 12
Photoresistor devices, 155
Photosensor, 33
 array, 120–21
Photoshop, Adobe, (software package), 389
Photovoltaic cells, 155
Physical optics, 10
Pictrography system, 344, 345, 369
Pictrostat system, 344
Picture Disk, 204
Piezo-electric ceramic vibrator (PECV), 151
Piggy-back mirror, 158
PIMA/IT10 technical committee, 307
Pincushion distortion, 78–9
Pinhole image formation, 41
Planck, 9
Planckian radiator, 18
Planck's constant, 10
Point spread function (PSF), 398, 400, 401
Polachrome process, 216, 217, 271
Polacolor process, 269–71
Polar distribution curve, 23
Polarizing filter:
 circular, 189
 linear, 186–8
Polaroid, 271–2
 active ranging system, 151
 exposure test, 315
Polyethylene terephthalate, as base material, 198
Post-development processing stages, 293
POTA developing agent, 280
Potassium metabisulphite, as developer
 preservative, 276
Precipitation method, for silver recovery, 298
Preflashing, paper, 235
Preservatives, in developing solutions, 276

Primary colours, 249–50
Principal focal plane, 43
Printing paper, 336
 base paper, 339
 bleach-fixing, 342
 bromide, 233, 234, 337
 colour, 339
 contrast, 234–5, 337–8
 exposure latitude, 234
 exposure range, 232
 modern chromogenic, 378
 resin-coated, 339
 response curve, 231
 spectral sensitivity, 337
 speed, 336
 surface finish, 338–9
 variable-contrast, 338
 variation of print curve with development, 233–4
 variation of print curve with emulsion, 232–3
Printing processes, 349
 density, 222
 development processes, 340–44
 drying, 344
 effect of conditions on life expectancy, 373–5
 fixation, 342
 from digital data, 369–70
 glazing, 344
 preflashing, 235
 quality requirements, 125, 234
 washing, 342–4
 see also Colour printing
Probability functions, 434–8
Programmed exposure modes, 326–7
Projection printing, 349
Projector lamps, 26
Prontor-Compur (PC) socket, 144
Pulsed xenon lamps, 27–8
Pupil magnification/factor, 62
Purkinje shift, 250
Pyrogallol developers, 275

Quadrant diagram, tone reproduction, 237–8
Quantifying image noise, 417–18
Quantum optics, 10
Quantum theory, 9
Quarter-wave coating, lens, 70
Quarter-wave plate, polarizing filter, 189
Quartz ultraviolet radiation, 205
Quartz-iodine lamps, 27
Quasi-Planckian source, 18

Rangefinder:
 coincidence type, 148–9
 focusing, 109
 split-image, 142, 149–50
Raster (line pattern), 217
Ratio of reproduction, 45
Rayleigh criterion, 80
Read only memory (ROM), 118

Reciprocity failure, 238
 effects, 238–9
Reciprocity law, 238
 failure, 182
Red-eye reduction, 37–8, 144
Reflectance, 39, 231
 average, 313
Reflectance ratio, 312
Reflected light measurement, 316
Reflection densitometers, 241
Reflection density, 231
Reflection effects, 39
Reflector factor, 23
Reflectors, 23
Refraction effects, 40
Refractive index, 40
Refractive power formula, 42
Repro attachments, exposure meter, 322
Réseau (mosaic), 215–16
Resin-coated printing papers, 339, 340
Resolving power (RP), 80, 81, 422
 test charts, 421
Responsivity, characteristic curve, 424–5
Restrainers, in developing solutions, 277
Retina, 11
Reversal processing, 265–6
Reversal-colour film, 256–8
 colour gamut, 391
RGB colorimetry, 385–7
RGB high-intensity lamps, 354
Rinse and stop baths, development process, 293
Rodenstock Imagon lens, 76
Rods (light-sensitive receptors), 11
Roll films, 104, 106, 200
Run-length coding, 444

Safelights, darkroom, 189–90
Sampling process, 408–409
Saturation equivalent exposure (SEE), 425
Sayce chart, 421
Scanners, 367–8
Scanning process, 368–9
 output, 369–70
Scatter *see* Light scatter
Scelera, 11
Scheimpflug's rule, 168–70, 358
Schmidt corrector plate, 94
Schneider Componon, 354, 355
Schumann emulsions, 205
Scotopic vision, 11
Seidel aberrations, 72
Selenium cells, 155
Selenium toning protection, 376, 377
Self-developing materials, 113
Selwyn granularity, 417
Selwyn's law, 417
Sensitivity (photographic materials), 205
 short-wave radiation, 205–206
 visible radiation, 206

Sensitization, spectral *see* Spectral sensitization
Sensitizing dyes, 208–10
Sensitometers, 240–41
Sensitometry, 218, 239–40
 colour, 254–8
 contrast, 223–5
 density, 219
 digital cameras, 245
 elementary form, 244
 exposure, 218–19
 opacity, 219
 subject, 218
 transmittance, 219
Shading devices, 358
Sharpness, image, 50–52, 411–12
Shrink filter, 433
Shutter systems, 131
 between-lens, 131–3, 143
 electronic, 132–3
 focal-plane, 133–6, 144
 iris diaphragm, 136–7
 leaf, 132
Signal-to-noise ratio (S/N), 122, 308, 413, 420–22
Silicon photodiode (SPD), 29, 33, 115, 122, 155–6, 321–2
Silver, tests for residual, 300
Silver halide emulsion systems, 191
 basics, 2–3
 latent image formation, 191–3
 photographic printing papers, 336–7
Silver images, bleaching, 298–9
Silver recovery, fixing process, 296–8
Silver selenide toning, 376, 377
Silver-dye-bleach process, 268–9
Sinusoidal waves, 394
 and image formation, 395–7
 modulation, 394–5
Sizing factor, digital scanning, 368
SLR cameras, TTL metering systems, 324
Sludging method, for silver recovery, 298
Slussarev effect, 66
Snell's Law, 40
Sobel operator, 442, 444
Sodium sulphite, as developer preservative, 276
Sodium thiosulphate:
 as fixing agent, 294
 tests for residual, 300
Soft-focus attachments, 102–103
Soft-focus enlargements, 359
Solarizattion region, 224
Source entropy, 426
Spectral absorption, 176
Spectral dispersion, 72
Spectral power distribution (SPD), 16, 18, 19
Spectral quality *see* Hues
Spectral sensitization, 207–210, 252–3
 digital cameras, 211–12
Spectrograms, wedge, 207, 210–11
Spectroradiometer, 16

Spectrum:
 electromagnetic, 10–11
 secondary, 73
Speed:
 alternative systems and standards, 305–306
 digital systems, 307–308
 DX film coding, 109, 201, 312
 ISO ratings, 305–308
 standard based on noise, 308
 standard based on saturation, 308
 table for monochrome film materials, 304
 use of numbers, 302–305, 308
Speed point *see* Minimum useful exposure
Spherical aberrations, 72, 75–6
Split-field close-up device, 103
Spot filter, 66
Spot meter, 324
Spotlights, 23
Spread functions, 400
Square wave recording, 406–407
Star-burst and twinkle devices, 103
Steinheil, 87
Stilb (unit), 324
Still-video (SV) camera, 120
Stops, optical, 61–2
Storage conditions, photographic media, 375–6
Strobe mode, flash tube operation, 31
Studio flash, 33
Subject correction factor, 313
Subtractive colour mixing, 14
Subtractive (white-light) system, 217
 colour printing, 362
 colour process deficiency correction, 259–60
Sunshade, lens, 101–102
Superadditivity *see* Synergesis
Swedish Natural Colour System (NCS), 383
Synchro-sunlight techniques, 313, 331
Synergesis, of developing agents, 278–9

T-numbers (lens transmittance), 69
Tagged image file format (TIFF), 127
Technical cameras, 112–13
Technicolor method, 217
Teleconverter, 93, 99–100
Telephoto lenses *see* Lenses, telephoto
Thermal imaging processes, 346–7, 370
Thermo-Autochrome (TA) process, 346–7
Thermodynamic scale *see* Kelvin scale
Thermoelectric cooling effect, 122
Third-order aberrations *see* Seidel aberrations
Threshold average filter, 434
Threshold systems, speed criterion, 302
Through-the-finder (TTF) metering systems, 110, 140
Through-the-lens (TTL) metering systems, 67–8, 112, 156–7, 158–9, 324, 325–6
Thyristor switches, 33–4, 35
Tilt movements, 170–71
Tone distribution, 329

Tone reproduction, 6, 236
Toning processes, for media stability, 377
Total internal reflection (TIR), 40
Total scene luminance measurement, 316
Transfer function, scanner, 369
Transistor-transistor logic (TTL), 118
Transmission, effects, 39
Transmittance, 176, 213, 219
Triangulation, rangefinder, 149
Trichromatic theory of colour vision, 248–9, 385
Tripack process, 263–4
 integral, 217, 253
Triple-sensitivity theory, 14
Tungsten lamps, 353
Tungsten-filament lamps, 20, 25–8
Tungsten-halogen lamps, 20, 26–7, 353

Ultraviolet (UV) radiation, 205–206
 wavelengths, 11
Undersampling process, cosine wave, 408
Uniform Chromacity Scale Diagram, 389, 391
Unit focusing, 145–6

Vacuum spectrography, 206
Van Albada finder, 139
Vanishing point, 58, 171–2
Variable length coding, 445
Variable-contrast printing papers, 338
Vector graphics files, 202
Veiling flare, 68
Video display unit, colour gamut, 391
View cameras *see* Camera types, technical
Viewfinder systems, 128–9
 direct-vision optical, 139–40
 frame, 139
 function, 138
 ground-glass screen, 142–3
 Kepler type, 128, 140–2
 Newtonian, 139
 pentaprism, 143
 real image, 140–2
 reversed Galilean, 128, 140, 141
 simple, 139
 suspended frame, 139
 van Albada, 139
Viewing distance, 58
Viewpoint:
 camera, 58
 eye, 57–8
Vignetting, 49, 101
 mechanical, 62–3
Virtual focus, 42
Visible spectrum, 11
Visual acuity (eye resolution), 52
Vogel, 207

Washing process, after fixing, 299–300
Waterhouse stops, 136

Wave recording:
 sine wave methods, 406
 square wave methods, 406
Wave theory, 9
Wavelength, radiation, 9
Weber-Fechner Law, 12–13
Wedge spectrograms, 207, 210–11
Weston exposure meter, 316, 320, 322
White light, 16
 balance control, 129
 dispersion, 13–14
Wiener filtering, 440

Wiener (noise power) spectrum, 418
Wollaston, 87

X-ray region, 206
XYZ colorimetry, 387–9, 390

Young, 14, 249
Young-Helmholtz theory of colour vision, 14, 385

Zone System (exposure determination), 313
Zoom flash action, 23
Zoom lenses, 23, 95–8

Focal Press

http://www.focalpress.com

Visit our web site for:

- The latest information on new and forthcoming Focal Press titles
- Technical articles from industry experts
- Special offers
- Our email news service

Join our Focal Press Bookbuyers' Club

As a member, you will enjoy the following benefits:

- Special discounts on new and best-selling titles
- Advance information on forthcoming Focal Press books
- A quarterly newsletter highlighting special offers
- A 30-day guarantee on purchased titles

Membership is FREE. To join, supply your name, company, address, phone/fax numbers and email address to:

USA
Christine Degon, Product Manager
Email: christine.degon@bhusa.com
Fax: +1 781 904 2620
Address: Focal Press,
225 Wildwood Ave, Woburn,
MA 01801, USA

Europe and rest of World
Elaine Hill, Promotions Controller
Email: elaine.hill@repp.co.uk
Fax: +44 (0)1865 314572
Address: Focal Press, Linacre House,
Jordan Hill, Oxford,
UK, OX2 8DP

Catalogue

For information on all Focal Press titles, we will be happy to send you a free copy of the Focal Press catalogue:

USA
Email: christine.degon@bhusa.com

Europe and rest of World
Email: carol.burgess@repp.co.uk
Tel: +44 (0)1865 314693

Potential authors

If you have an idea for a book, please get in touch:

USA
Terri Jadick, Associate Editor
Email: terri.jadick@bhusa.com
Tel: +1 781 904 2646
Fax: +1 781 904 2640

Europe and rest of World
Christina Donaldson, Editorial Assistant
Email: christina.donaldson@repp.co.uk
Tel: +44 (0)1865 314027
Fax: +44 (0)1865 314572